A SURVEY OF MANUSCRIPTS ILLUMINATED IN FRANCE

ROMANESQUE MANUSCRIPTS

THE TWELFTH CENTURY

by Walter Cahn

VOLUME TWO

A SURVEY OF MANUSCRIPTS ILLUMINATED IN FRANCE

General Editors: François Avril and J·J·G·Alexander

Volumes in preparation:

FRANKISH MANUSCRIPTS, SEVENTH TO TENTH CENTURIES
by Lawrence Nees

GOTHIC MANUSCRIPTS, THE THIRTEENTH CENTURY
by Alison Stones

RENAISSANCE MANUSCRIPTS 1515-1560
by Myra Orth

Further volumes will cover the following periods:

THE TENTH AND ELEVENTH CENTURIES

THE FOURTEENTH CENTURY

THE FIFTEENTH CENTURY

A SURVEY OF MANUSCRIPTS ILLUMINATED IN FRANCE

General Editors: François Avril and J·J·G·Alexander

WALTER CAHN

Romanesque Manuscripts

The Twelfth Century

VOLUME TWO

CATALOGUE

HARVEY MILLER PUBLISHERS

Originating Publisher: HARVEY MILLER PUBLISHERS
Knightsbridge House, 197 Knightsbridge, London SW7 1RB, U.K.
An Imprint of G + B Arts International

British Library Cataloguing in Publication Data

Cahn, Walter
 Romanesque manuscripts: the twelfth century. – (A survey
 of manuscripts illuminated in France)
 1. Illumination of books and manuscripts, Romanesque –
 France
 I. Title
 745.6'7'0944

ISBN 1872501605 (2 volume set)

We acknowledge with gratitude
the assistance given towards this publication
by the Frederick W. Hilles Publication Fund of Yale University

Composition by Jan Keller, London
Monochrome Origination by Quantock Studios, Sidcup, Kent
Colour Origination and printing
by BAS Printers Ltd, Over Wallop, Stockbridge, Hampshire

Contents

MAP OF FRANCE showing locations of manuscript production

The Author and Publishers wish to express their gratitude to the many Libraries, Collections, Institutions and scholars who have made photographs available for this publication and given kind permission for their reproduction. Particular thanks are due to the Centre National de la Recherche Scientifique, Orléans; Bibliothèque Nationale, Paris; British Library, London; Conway Library, Courtauld Institute of Art, London; The Royal Library, The Hague.

Abbreviations

AA.SS	J. Bollandus et al., *Acta Sanctorum …*, Antwerp, 1643 ongoing
Art du moyen âge en Artois	Exh. Cat. *L'Art du moyen âge en Artois*, Arras, 1951
Art roman	Exh. Cat. *L'Art roman*, Barcelona and Santiago de Compostela, 1961
Avril, *Royaumes d'Occident*	X. Barral i Altet, F. Avril and D. Gaborit-Chopin, *Les Royaumes d'Occident*, Paris, 1983
Avril, *Temps des Croisades*	X. Barral i Altet, F. Avril and D. Gaborit-Chopin, *Le Temps des Croisades*, Paris, 1982
Berger, *Préfaces*	S. Berger, 'Les préfaces jointes aux livres de la Bible dans les manuscrits de la Vulgate', *Mémoires présentés par divers savants à l'Académie des Inscriptions et Belles-Lettres*, 1. Ser., II, 1904, 1–78
Berger, *Vulgate*	S. Berger, *Histoire de la Vulgate pendant les premiers siècles du moyen âge*, Paris, 1893 (repr. New York, n.d.)
B.H.L.	*Bibliotheca hagiographica latina, antiquae et medieae aetatis*, Brussels, 1900–1
Boeckler, *Abendländische Miniaturen*	A. Boeckler, *Abendländische Miniaturen bis zum Ausgang der romanischen Zeit*, Berlin, 1930
Boutemy, *Enlumineurs de l'abbaye de Saint-Amand*	A. Boutemy, 'Les enlumineurs de l'abbaye de Saint-Amand', *Revue belge d'archéologie et d'histoire de l'art*, XII, 1942, 131–67
Boutemy, *Trésor*	A. Boutemy, 'Un trésor injustement oublié: Les manuscrits enluminés du Nord de la France', *Scriptorium*, III, 1949, 110–22
Byzance et la France médiévale	Exh. Cat. *Byzance et la France médiévale. Manuscrits à peintures du IIe au XVIe siècle*, Paris, 1958
Cahn, *Romanesque Bible Illumination*	W. Cahn, *Romanesque Bible Illumination*, Ithaca, 1982
Catalogue général	*Catalogue général des manuscrits des bibliothèques publiques de France*, Paris, 1885 ongoing
Catalogue général, Quarto Series	*Catalogue général des manuscrits des bibliothèques publiques des Départements*, Paris, 1849-85
Cerny, *Marchiennes*	P. Cerny, 'Les manuscrits à peintures de l'abbaye de Marchiennes jusqu'à la fin du 12e siècle', *Bulletin de la Commission départementale d'histoire et d'archéologie du Pas-de-Calais*, XI, 1981 (1982), 49–70
Cerny, *Anchin*	P. Cerny, 'Die romanische Buchmalerei in der Abtei Saint-Sauveur in Anchin', *Nederlands Kunsthistorisch Jaarboek*, XXXVI, 1985, 31–70

Colophons	Bénédictins du Bouveret, *Colophons de manuscrits occidentaux des origines au XVIe siècle* (Spicilegii Friburgensis subsidia, 2–7), Fribourg, 1965–82, 6 vols.
D.A.C.L.	F. Cabrol and H. Leclercq, eds., *Dictionnaire d'archéologie chrétienne et de liturgie*, Paris, 1907–53, 15 vols. in 30
Delisle, *Cabinet des manuscrits*	L. Delisle, *Cabinet des manuscrits de la Bibliothèque Impériale*, Paris, 1868–81, 3 vols.
Dix siècles d'enluminure en Languedoc	Exh. Cat. *Dix siècles d'enluminure et de sculpture en Languedoc*, Toulouse, 1954–5
Dodwell, *Painting in Europe*	C. R. Dodwell, *Painting in Europe, 800–1200* (Pelican History of Art), Harmondsworth, 1971
Gaborit-Chopin, *Saint-Martial de Limoges*	D. Gaborit-Chopin, *La Décoration des manuscrits à Saint-Martial de Limoges et en Limousin du IX au XIIe siècle* (Mémoires et documents publiés par la Société de l'École de Chartes, 17), Paris-Geneva, 1969
G.C.	*Gallia Christiana in provincias ecclesiasticas distributa …*, Paris, 1856–99, 16 vols.
Garborini, *Der Miniator Sawalo*	N. Garborini, *Der Miniator Sawalo und seine Stellung innerhalb der Buchmalerei des Klosters Saint-Amand*, Cologne, 1978
Grabar and Nordenfalk, *Romanesque Painting*	A. Grabar and C. Nordenfalk, *Romanesque Painting from the Eleventh to the Thirteenth Century*, Lausanne, 1958
Haseloff, *Miniature*	A. Haseloff, 'La miniature dans les pays cisalpins depuis le commencement du XIIe jusqu'au XIVe siècle', in A. Michel, *Histoire de l'Art*, Paris, 1906, 297–307
Lauer, *Enluminures romanes*	P. Lauer, *Les Enluminures romanes de la Bibliothèque Nationale*, Paris, 1927
Lauer et al., *Manuscrits latins*	P. Lauer et al., *Bibliothèque Nationale. Catalogue général des manuscrits latins*, Paris, 1939 ongoing
Leroquais, *Psautiers*	V. Leroquais, *Les Psautiers manuscrits latins des bibliothèques publiques de France*, Mâcon, 1940–1, 2 vols.
Leroquais, *Sacramentaires*	V. Leroquais, *Les Sacramentaires et les missels manuscrits des bibliothèques publiques de France*, Paris, 1924
Manuscrits à peintures	Exh. Cat. *Manuscrits à peintures du VIIe au XIIe siècle*, Paris, 1954
Manuscrits datés	C. Samaran and R. Marichal, eds., *Catalogue des manuscrits en écriture latine portant des indications de date, de lieu ou de copiste*, Paris, 1959 ongoing
Mérindol, *Corbie*	C. de Mérindol, *La Production des livres peints à l'abbaye de Corbie au XIIe siècle. Étude historique et archéologique*, Université de Lille III, 1976, 3 vols.
Oursel, *Miniature du XIIe siècle à Cîteaux*	C. Oursel, *La Miniature du XIIe siècle à l'abbaye de Cîteaux*, Dijon, 1926
Porcher, *French Miniatures*	J. Porcher, *French Miniatures from Illuminated Manuscripts*, London, 1960

Ronig, *Verdun* — F. Ronig, 'Die Buchmalerei des 11. und 12. Jahrhunderts in Verdun', *Aachener Kunstblätter*, 38, 1969, 207–8

Saint Bernard et l'art des Cisterciens — Exh. Cat. *Saint Bernard et l'art des Cisterciens*, Dijon, 1953

Schapiro, *Parma Ildefonsus* — M. Schapiro, *The Parma Ildefonsus. A Romanesque Illuminated Manuscript from Cluny and Related Works* (Monographs on Archaeology and Fine Arts Sponsored by the Archaeological Institute of America and the College Art Association of America, XI), New York, 1970

Survey II — E. Temple, *Anglo-Saxon Manuscripts 900-1066* in A Survey of Manuscripts Illuminated in the British Isles, Vol. II, London, 1976

Survey III — C. M Kauffmann, *Romanesque Manuscripts 1066-1190* in A Survey of Manuscripts Illuminated in the British Isles, Vol. III, London, 1975

Swarzenski, *Monuments of Romanesque Art* — H. Swarzenski, *Monuments of Romanesque Art. The Art of Church Treasures in North-Western Europe*, London, 1954

Walther, *Initia carminum* — H. Walther, *Initia carminum ac versuum medii aevi posterioris latinorum* (Carmina Medii Aevi posterioris latina), Göttingen, 1959

Zaluska, *Cîteaux* — Y. Zaluska, *L'Enluminure et le scriptorium de Cîteaux au XIIe siècle*, (Cîteaux, Commentarii cistercienses. Studia et documenta, IV), Cîteaux, 1959

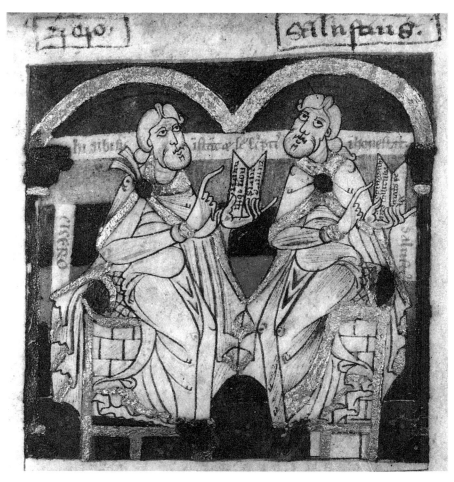

Disputation of Cicero and Sallust. Lucca, Bibl. statale, 1405, f. 1 (cat. 53)

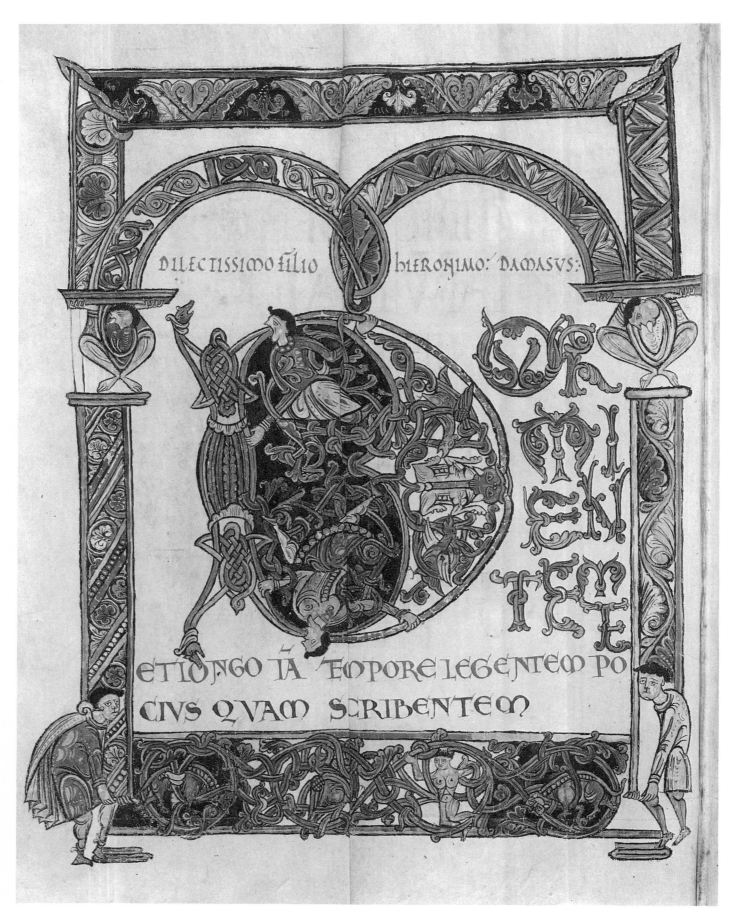

DILECTISSIMO FILIO HIERONIMO· DAMASVS·

ETLONGO TA ENPORE LEGENTEM PO
CIVS QVAM SCRIBENTEM

Incipit initial and words to Jerome, Epistles. Angers, Bibl. Mun. 154 (146), f. 3v (cat. 10)

CATALOGUE

I. LOIRE VALLEY, WESTERN FRANCE, NORMANDY

1. Tours, Bibliothèque Municipale MS 1018

Life and Miracles of St. Martin
220 × 160 mm., ff. 217, 15 long lines
c. 1100. Saint-Martin de Tours *Ills. 2, 3, 4, 5*

Five drawings: St. Martin divides his cloak, and he
sees Christ in heaven in a vision with the garment (f.
9v); Martin asks the Emperor Julian to dispense him
from fighting (f. 11); Martin confronts two thieves (f.
13); Martin, after having consumed a poisonous
nourishment, asks God to save him (f. 15); Martin
resuscitates a slave (f. 18); other spaces for illustra-
tions were left blank (ff. 21v, 23, 24v, 27, 28, 29v, 30,
31, 32v, 34, 35, 36, 57v, 66, 70v, 73v, 77, 80, 82, 84v, 87,
89v, 91, 93, 97, 98, 99v, 102v, 106, 108, 113, 114, 115v,
116v, 118, 120, 123, 125, 131, 132v, 134, 145v, 146, 147,
148, 153v, 154, 155, 156, 157v, 159, 160v), or provided
with miniatures in the 15th century (ff. 36v, 37, 37v,
38, 38v, 39v, 42, 42v, 49v).

Ornamental initials: I (f. 5v); A (f. 176v).

The manuscript is a collection of hagiographical and
homiletical writings in honour of St. Martin of Tours.
Marginal indictions show that it was used for litur-
gical readings. The illustrations occur in the first text
of the anthology, Sulpicius Severus's 5th-century bio-
graphy of the saint (ff. 1–53v), an inevitable compo-
nent of the collection diffused by the monks of Tours
under the title *Martinellus*. Only five chapters of the
Vita (Bk. I, iii–vii), however, received drawings in the
12th century. Afterwards, there are blank spaces
from Chapters IX to XIX. A 15th-century illuminator
contributed nine additional gouache paintings (Ch.
XX–XXVI), but the remainder of the illustrations
planned for the text from Bks. II to IV were also left
unexecuted. On the basis of the even distribution of
a single illustration for each of the books, the entire
cycle would have comprised some seventy-four
separate drawings, some of them containing more
than one scene. Sulpicius Severus's *Vita* and extracts
concerning St. Martin drawn from the *Historia Fran-
corum* of Gregory of Tours are introduced by painted
ornamental initials of interlace with stylized foliage
(f. 5v) and paired beasts (f. 176v). The subsequent

chapters of the *Vita Martini* begin with a simple
four-line pen-drawn ornamental initial letter in red
with touches of yellow, and the first line of each
chapter is also written in red capital letters. It has
been conjectured that the five 12th-century drawings
may reflect a cycle of paintings or mosaics concerned
with miracles of St. Martin which Gregory of Tours
commissioned for his cathedral, reconstructed by
him in the years from 573 to 590. The subject of seven
of these scenes is known on the basis of *tituli* com-
posed for them by the poet Venantius Fortunatus.
Two of them (St. Martin dividing his cloak, Resusci-
tation of a slave) are also found among the drawings
in the manuscript, but the relationship between the
two cycles is regarded by Kessler as 'altogether tenu-
ous'. Two scenes of the life of St. Martin, recently
discovered in the church of Saint-Hilaire at Poitiers,
have also been connected with the manuscript to
which they must be fairly close in date. The five
drawings, which have in places been eroded (faces
of the thieves, f. 13) or 'improved' (addition of a halo,
f. 18), are somewhat awkwardly positioned, crowd-
ing the text (ff. 9v, 18) or spilling into the margins (ff.
9v, 11, 15). This is partly the result of the scribe's habit
of beginning the writing of the text at the top of the
page, leaving empty whatever space was available
at the bottom of the preceding one — and where the
verso is concerned, on the preceding recto. The
drawings also may well be copies of older illustra-
tions that were prepared for differently propor-
tioned spaces and so had to be adapted for another
kind of setting. The ill-fitting aspect of the two scenes
on f. 9v, for example, is perhaps best explained in this
way. The action is vigorously delineated, the figures
gesturing demonstratively with large hands. They
have squarish heads and bodies articulated by re-
peated parabolic curves composed of double lines.
The style has parallels in a Lives of the Saints from
Le Mans (Bibl. Mun. MSS 214, 217, 227; no. 3) and
J. J. G. Alexander (Oxford, 1970) also cites for com-
parison the Bible of Redon, a manuscript probably
made at Mont Saint-Michel (Bordeaux, Bibl. Mun.
MS 1). This style has nonetheless some roots in the
Middle Loire region. It is adumbrated in the crouch-
ing figures bearing arches in a manuscript containing
the lives of several bishops of Angers, datable before

1047, in the Vatican Library (Reg. Lat. 456, ff. 81v–82) and it also connects with the wall-paintings discovered in the Tour Charlemagne of Saint-Martin de Tours and those of the basilica of Saint-Julien in the same city.

PROVENANCE: Saint-Martin de Tours, MS 155 (f. 1).

LITERATURE: A. Dorange, *Catalogue descriptif et raisonné des manuscrits de la Bibliothèque de Tours*, Tours, 1875; M. Collon, *Catalogue général*, XXXVII, 2, 1905, 734–76; E. K. Rand, *A Survey of the Manuscripts of Tours*, Cambridge, 1929, 200–201, no. 225; T. Sauvel, 'Les miracles de Saint Martin. Recherches sur les peintures murales de Tours au Ve et au VIe siècle', *Bulletin monumental*, CXIV, 1956, 153–79; F. Wormald, 'Some Illustrated Lives of the Saints', *Bulletin of the John Rylands Library*, 1952, 252 [repr. in *Collected Writings*, II, London, 1988, 46]; J. J. G. Alexander, *Norman Illumination at Mont Saint-Michel, 966–1100*, Oxford, 1970, 202; Dodwell, *Painting in Europe*, 185; J. Wettstein, *La Fresque romane. La Route de Saint-Jacques, de Tours à León. Études comparatives*, II, Geneva, 1978, 44–45; J. Van der Straeten, *Les Manuscrits hagiographiques d'Orléans, Tours et Angers* (Subsidia Hagiographica, 64), Brussels, 1982, 129–30; L. Cochetti Pratesi, *Pittori e miniatori dell'XI secolo in Francia*, Rome, 1984, 95–100; H. Kessler, 'Pictorial Narrative and Church Mission in Sixth-Century Gaul', *Pictorial Narrative in Antiquity and the Middle Ages* (Studies in the History of Art, 16) Washington, 1985, 75–91; C. de Mérindol, 'Deux scènes de la vie de Saint Martin: "La porte d'Amiens" et "L'apparition du Christ", à propos de peintures murales récemment découvertes en l'église Saint-Hilaire de Poitiers', *Bulletin de la Société Nationale des Antiquaires de France*, 1985, 219; *Manuscrits datés*, VII, 539; F. Garnier, *Le Language de l'image au moyen âge*, II, Paris, 1989, 336–42; M. Carrasco, 'Sanctity and Experience in Pictorial Hagiography: Two Illustrated Lives of Saints from Romanesque France', *Images of Sainthood in Medieval Europe*, ed. R. Blumenfeld-Kosinski and T. Szell, Ithaca and London, 1991, 37, 40–41.

EXHIBITED: *Manuscrits à peintures*, Paris, 1954, 83, No. 228.

2. Auxerre, Treasure of the Cathedral

Two Leaves from a Sacramentary or Missal
285 × 190 mm.
Early 12th century. Tours *Ills. 7, 8*

Two full-page drawings: Crucifixion, surrounded by scenes of the Passion — Arrest of Christ, Christ brought before Pilate, Denial of Peter (upper zone); Flagellation, Christ struck on the head, which is covered by a cloth, Crucifixion of the Good Thief, Entombment, Appearance of Christ to Mary Magdalene in the Garden (left); Christ on the Mount of Olives, Mocking of Christ, Crucifixion of the Bad Thief, Descent into Limbo (?), unidentified scene, nearly erased (right); Christ appears to the Pilgrims of Emmaus, Supper at Emmaus; unidentified, nearly erased scene (bottom).

Christ in Majesty with the four Evangelist symbols, surrounded by the lamb of God and the twenty-four Apocalyptic Elders.

The two leaves with pen-drawn illustrations stem from a Sacramentary or Missal. Two lines of text from the Preface of the Mass are preserved on the verso of the sheet with the Crucifixion, followed by more text that was rewritten in the 14th century. The Crucifixion therefore preceded the *Majestas* in the lost manuscript, a fairly unusual sequence which is contrary to the customary order. Emile Mâle, who in his *Art religieux du XIIe siècle en France* (1922) brought the Auxerre leaves to general attention, thought that they were of southern French origin and held their illustrations to be derived from manuscripts of Beatus's Apocalypse Commentary. These opinions were refuted by Meyer Schapiro, who demonstrated their connection instead with Tours. As indicated by Schapiro, the style of the drawings has parallels in manuscripts from this centre generally dated around 1100, like the copy of Augustine's Commentary on the Psalms from the Cathedral of Saint-Gatien (Tours, Bibl. Mun. MS 294) and the *Vita* of the titular saint, in the same library, from the church of Saint-Martin (Bibl. Mun. MS 1018; no. 1). Schapiro also noted that certain details of the iconography of the drawings were to be found in manuscripts of the Carolingian period from Tours. Among these is the small disk ostentatiously displayed between the thumb and the finger of the Lord's right hand, a motif that occurs in the *Majestas* pictures of the 9th-century Dufay Gospels (Paris, Bibl. Nat. lat. 9585) and the Vivian Bible (Bibl. Nat. lat. 1). Schapiro interpreted this motif as a eucharistic host, to be connected with the doctrinal controversies in Carolingian times over Transubstantiation and their revival in the middle of the 11th century focused on the heretical figure of Berengar of Tours. Other elements that can be associated with painting of the School of Tours are the precedence given in the Auxerre *Majestas* to the Evangelist John, whose eagle symbol carries a scroll rather than a book, and perhaps also the double mandorla of Christ.

The more or less customary juxtaposition of Crucifixion and *Majestas* is amplified in the Auxerre leaves by additional subjects arranged in compartmented frames around these images. The Crucifixion is surrounded by an extensive cycle of scenes of the Passion carrying the narrative both backwards and forwards from the moment commemorated by the representation at the centre. The placement of the Crucifixion scenes in the middle of the lateral sides is so conceived as to bring the main subject into a

larger composition of Christ crucified between the two thieves. Other extended narratives of the Passion in Western France around this time in book illumination are not known, but occur in wall painting of the region, notably at Vicq in Berry. The frame of the *Majestas* page transposes the subject into an Adoration of the Twenty-Four Elders based on Revelation (IV:1–11).

The drawings on both sheets have suffered some erosion, which is especially pronounced in the lower zone, where some areas no longer present a readable image. A small section of the parchment has been excised at the lower right corner of the Crucifixion page. The leaves were at Saint-Julien de Tours in the 14th century, and the manuscript from which they came may well have been made for that house, as Schapiro suggests.

PROVENANCE: Saint-Julien, Tours (14th-century inscription enumerating possessions of a monk of this community on the verso of the second leaf). Bequeathed to the treasure of Auxerre Cathedral by Mme Eugénie Baudoin, widow of the local collector and scholar Germain Duru, in 1868.

LITERATURE: M. Prou, 'Deux dessins du XIe siècle au trésor de l'église Saint-Étienne d'Auxerre', *Gazette archéologique*, XII, 1887, 138–44; H. Monceaux, G. Bonneau and F. Molard, 'Inventaire du trésor actuel de la cathédrale d'Auxerre', *Bulletin de la Société des sciences historiques et naturelles de l'Yonne*, XLVI, 1892, 194–95; E. Mâle, *L'Art religieux du XIIe siècle en France*, Paris, 1922, 8, 9, 30–2; M. Schapiro, 'Two Romanesque Drawings in Auxerre and Some Iconographic Problems', *Studies in Art and Literature for Belle da Costa Greene*, ed. D. Miner, Princeton, 1954, 331–49, repr. in the author's *Selected Papers. Romanesque Art*, New York, 1977, 306–27; E. Delaruelle, '"Le Christ élevant l'Hostie" de la Cathédrale de Rodez', *Rouergue et ses confins* (Fédérations des Sociétés savantes Languedoc-Méditerranée et Languedoc-Pyrénées. Congrès de Rodez, 1958), Rodez, s.d., 195; L. Grodecki, 'Le problème des sources iconographiques du tympan de Moissac', *Moissac et l'Occident au XIe siècle* (Actes du Colloque international de Moissac, 3–5 Mai 1963), Toulouse, 1964, 64–7; M. W. Evans, *Medieval Drawings*, London, New York, Sydney and Toronto, 1969, 27 and pl. 41; J. Zink, 'Moissac, Beaulieu, Charlieu — Zur ikonologischen Kohärenz romanischer Skulpturen-Programme im südwesten Frankreichs und in Burgund', *Aachener Kunstblätter*, 56/57, 1988–89, 118; H. Toubert, 'Dogme et pouvoir dans l'iconographie grégorienne. Les Peintures de La Trinité de Vendôme', *Un Art dirigé. Réforme grégorienne et iconographie*, Paris, 1990, 77–9.

3. Le Mans, Bibliothèque Municipale MSS 214, 217 and 227

Lives of the Saints
378 × 253, 366 × 255 and 370 × 260 mm.,
ff. 232, 139 and 210; 2 cols., 35 to 40 lines
Early 12th century. Le Mans *Ills. 1, 11, 12*

MS 214

Independent panel of four haloed figures in half-length (f. 33v).

Historiated and ornamental initials: T (f. 7v); F (f. 12); O, standing St. Fulgentius bearing a crozier within an arcade (f. 13); B (f. 13v); I (f. 25v); M, two gesticulating men supporting the letter (f. 26v); B (f. 28v); S (f. 33v); P (f. 37); E (f. 45v); I (f. 63); D (f. 68v); Q (f. 70); D (f. 73); F (f. 74v); I (f. 75v); V (f. 77); F (f. 78); P (f. 79); B (f. 79v); H (f. 90); A (f. 110); C (f. 123v); TE (f. 124); M (f. 132); P (f. 140v); R (f. 144v); E (f. 167v); I (f. 175v); D (f. 182); S (f. 189); I (f. 192v); D (f. 193); T (f. 194v); V, St. Vincent standing with book (f. 196); D, standing youth gesturing in speech (f. 201v); I (f. 206); I (f. 207); TE (f. 208); S, a pair of naked acrobatic figures (f. 211); C (f.233v).

MS 217

Historiated and ornamental initials: P (f.1); I (f. 1v); T (f. 2); S (f. 4); I (f. 5); I (f. 6v); R (f. 10); Q (f. 18); C (f. 21v); P (f. 27); R (f. 28v); C, C (f. 30v); T (f. 32); T (f. 33v); N (f. 34); I (f. 38v); I (f. 42v); D (f. 43v); A (f. 44); T (f. 45); I (f. 49); S (f. 53v); Q (f. 54); I (f. 55v); T (f. 56v); B (f. 58); O (f. 65v); B (f. 77); B (f. 81); B (f. 82); F (83v); T (f. 85v); S (f. 87); T (f. 98); O (f. 99); T (f. 101); S (f.102v); V (f. 103); I (f. 105v); T (f. 110); I (f. 111v); D (f. 114v); T (f. 116v); C (f. 118v); C (f. 122); P (f. 127); S (f. 137). Cut out: ff. 13v, 46v, 99 bis verso.

MS 227

Historiated and ornamental initials: C (f. 1); I (f. 10); T, Saints Processus and Martinianus (f. 13); P (f. 14); I (f. 18v); C (f. 21v); V (f. 23v); T (f. 26); Q, veiled woman in three quarter length, perhaps Mary Magdalene (f. 27); N, unfinished (f. 28v); I (f. 32); T (f. 35v); T (f. 45); I (f. 48); F (f. 53); T (f. 80); I, crowned and seated figure (St. Germanus?); below, acrobatic figure in a falling stance (f. 83); D (f. 90v); I (f. 98v); R (f. 106); F (f. 114); S (f. 115); I (f. 116v); A (f. 120); I, enthroned saint in a mandorla (St. Bartholomew?); below, enthroned and crowned woman with sceptre in a mandorla (f. 122); T, athletic figure wielding club (f. 123); S (f. 128); E (f. 129); M (f. 138); D (f. 140v); I (f. 143); I (f. 143v); S, S (f. 145); P (f.147); I (f. 148); Q (f. 149); C (f. 149v); D (f. 151); F (f. 153v); S (f. 158); A (f. 163); A (f. 164v); T (f. 170); I (f. 174v); T (f. 177); T (f.178); T (f. 179); G (f. 182v); C (f. 185); Q (f. 185v); S (f. 190v); Q, St. Cyprian standing (f. 199); T (f. 203v);

Cut out: ff. 15, 16, 25, 38, 42, 67v, 78, 80v, 87, 93, 95, 116v, 158, 192, 193, 196.

These battered and much-used volumes are the surviving parts of a larger set constituting a lectionary for the Office throughout the entire year. MS 214 covers the period from 11th November (*Passio S. Martini*) to the feast of St. Julian on 27th January. MS 217 contains readings for the period from the feast of St. Philip on 11th May to that of Constantia, variously celebrated near the end of June, and MS 227 embraces the period from the feast of St. Calais (Carilephus) on 1st July to that of Saints Cyprian and Justina, celebrated on 26th September. The set in its entirety must have comprised five or possibly six volumes. The remaining three tomes were illuminated by several distinctive hands, who provided initials for every *vita* or *passio*, along with a single independent panel with an as yet undetermined subject (MS 214, f. 33v). The work was evidently begun on a fairly luxurious scale, which could not be maintained. The opening pages of the first volume have three-line gold ornamental letters within the body of text (MS 214, ff. 3, 4v and 5) as well as numerous initials constructed of a painted gold (of rather poor quality) framework outlined in red and consolidated with painted areas of blue, green and ochre. The effect evokes Carolingian book production of the Loire Valley, and notably the richer works of the School of Tours. The figurative elements, which play only a modest role in the decoration, recall the illustrations of the Tours *Vita Martini* (Tours, Bibl. Mun. MS 1018; no. 1). Beyond the opening series of saints' lives, a sumptuously elaborate treatment is accorded to the *Vita* of St. Maur (ff. 77, 78), whose prefatory letter by Odo of Glanfeuil must have been of special interest, since it is addressed to a certain Adelmodus, who was archdeacon of Le Mans.

A second illuminator, who makes his appearance in the final initial of MS 214 (f. 233v), executed the wholly ornamental initials of MS 217 and a certain number of those found in MS 227. His work can also be seen in other manuscripts of La Couture, as in several initials of a copy of Augustine's *Enarrationes in Psalmos* (Le Mans, Bibl. Mun. MS 228, ff. 2bis, 120 and 146), which look like additions to a somewhat older book; his manner can also be detected among the manuscripts of Angers, for example, in the Florus Commentary on the Pauline Epistles from Saint-Aubin (Angers, Bibl. Mun. 65–66). His letters are drawn in outline, with the interstices of the design filled with green, blue, slate grey and a kind of yellowish wash. Gold has disappeared altogether, and anthropomorphic or zoomorphic components are fairly rare. A recurring construction among his initials is the letter T with a canopy of intertwined foliage sprouting from the vertical stem and serving as the crossbar, or the letter I, where this stylized vegetation grows in lateral 'pods' on each side of the upright

shaft. In MS 227, which is quite worn and has lost a number of leaves at the end, there are, in addition, initials of a more Franco-Saxon orientation, combined in a few instances with crisply delineated figures in the Turonian manner, as well as contributions by several lesser hands; like the two major illuminators of the work, they exhibit more or less pronounced ties with Normandy to the north and the scriptoria of the Loire region to the south.

A table of contents was added at the conclusion of MS 217 (f. 139v) near the end of the 12th century; at the same time a life of Bertrand, the 6th-century Bishop of Le Mans, whose body was venerated at Saint-Pierre de la Couture, was inserted in the appropriate place within the volume (ff. 88–97v).

PROVENANCE: Saint-Pierre de la Couture, Le Mans. *Ex libris monasterii S. Petri de Cultura Congregationis S. Mauri* (17th century, MS 214, f. 1); *Liber beati Petri de cultura cenomanis* (12th–13th century, MS 217, f. 139v); 15th century *ex libris*, MS 227, f. 169v.

LITERATURE: C. Couderc, *Catalogue général*, XX, 1893, 139–44, 144–50, 156–63; 'Catalogus codicum hagiographicorum latinorum bibliothecae publicae Cenomanensis', *Analecta Bollandiana*, XII, 1893, 44, 48, 54; A. Wilmart, 'Membra disiecta', *Revue bénédictine*, XXXIX, 1927, 188–89; Nordenfalk, *Romanesque Painting*, 96; Porcher, *French Miniatures*, 29–30; Alexander, *Norman Illumination at Mont Saint-Michel*, 210–202; P. Cordonnier, 'De quelques beaux manuscrits enluminés de la Bibliothèque du Mans', *Revue historique et archéologique du Maine*, LIII, 1973, 90–91; G. Philippart, *Le Légendiers latins et autres manuscrits hagiographiques* (Typologie des sources du moyen âge occidental, 24–25), Turnhout, 1977, 34–35, 38–39, 40–43, 69.

EXHIBITED: *Manuscrits à peintures*, Paris, 1954, 80, No. 216.

4. Poitiers, Bibliothèque Municipale MS 40 (132)

Missal
277 × 163 mm., ff. 194, 20 long lines
Early 12th century.
Sainte-Radegonde, Poitiers *Ills. 13, 14*

Two full-page miniatures: Christ in Majesty (f. 14v); Crucifixion (f. 15v).

J. Lièvre and A. Molinier's description in the inventory of Poitiers manuscripts for the *Catalogue général* associates this sparsely decorated work with Saint-Benoît de Quinçay, an old Benedictine abbey located near Vouillé, south of the city. In favour of this attribution are two feast days in the Calendar for the translation of St. Benedict (18th February and 4th

December) and the entry *Quinciaco S. Benedicti* on 23rd October. However, greater stress is laid on St. Radegund, the Thuringian princess and spouse of the Merovingian king Clothar I, who founded a nunnery in Poitiers where she retired and died in 587. Her name is capitalized in the Calendar and in the Litany, where she heads the list of female saints, preceding even Mary Magdalene. Hers is also the only Mass for which there is a musical setting (f. 125v). It is therefore highly probable that the manuscript was made instead for the chapel of Saint Mary outside the walls, later transformed into the collegiate foundation of Sainte-Radegonde at Poitiers, as Cousseau had earlier maintained.

The manuscript, written by several sober and not too elegant hands, has red and blue pen-work initials throughout. Some additions were made toward the middle of the 12th century (ff. 24v–26v and 45v–51v). The two miniatures, which along with the *Te Igitur* initial, constitute the only embellishment of note, are on separate leaves that are otherwise blank. They are fairly small in relation to the available space and give the impression of having found their way into the volume as an afterthought. The two compositions are delicately drawn in fine pen line and given body through a selective application of an opaque shading in pastel colours: salmon pink, light blue, grey-green, ochre and dull violet in the *Majestas Domini*, a more limited choice of hues in the Crucifixion. The *Majestas* in a similar way has a complex, fully painted frame, with a twisted, interlaced border emerging from beast heads at the corners, while the Crucifixion is plainly outlined with three red lines enhanced with touches of yellow. The crisp and metallic quality of the drawing is related to the art of the Loire Valley as exemplified in the *Vita Martini* from Tours (Tours, Bibl. Mun. MS 1018; no. 1) and the Missal of Saint-Père at Chartres (Troyes, Bibl. Mun. 894; no. 5) to which it gives a more angular inflection. The painted passages, like the garment of the grieving Virgin Mary in the Crucifixion or the draperies of the seated Christ in the *Majestas Domini* recall the effects of modelling in contemporaneous western French fresco painting.

PROVENANCE: Belonged to Hugues de Combarel, Bishop of Poitiers from 1424 to 1438 (note on f. 194v). MS 179 (19th century, flyleaf).

LITERATURE: Abbé Cousseau, 'Mémoire sur l'ancienne liturgie du diocèse de Poitiers et sur les monuments qui nous en restent', *Mémoires de la Société des Antiquaires de l'Ouest*, III, 1837, 336–41; S. Lièvre and A. Molinier, *Catalogue général*, XXV, 1894, 11–12; Leroquais, *Sacramentaires*, I, 245–46; E. Burin, 'Réflexions sur quelques aspects de l'enluminure dans l'Ouest de la France au XIIe siècle: le manuscrit latin 5323 de la Bibliothèque Nationale', *Bulletin monumental*, CXLIII, 1985, 209.

5. Troyes, Bibliothèque Municipale MS 894

Missal
295 × 190 mm., ff. 238, 2 cols., 35–36 lines
First half of the 12th century.
Saint-Père de Chartres *Ills. 9, 10*

One full-page miniature: Crucifixion (f. 113v).

Historiated initials: *Per Omnia*, standing Christ in Glory, Evangelist symbols (f. 114); *Te Igitur*, standing angel with book (f. 114v).

The collegiate church of Saint-Étienne de Troyes was founded in 1157 by Henry the Liberal as a palatine chapel and burial place of the Counts of Champagne. The present Missal antedates that foundation by several decades and its Calendar, as Leroquais has shown, indicates that the manuscript was made for Saint-Père at Chartres (*Dedicatio Ecclesiae S. Mariae* [Cathedral of Chartres] on 22nd October, and *Dedicatio Ecclesiae S. Petri* on the same day). Some saints of the region of Sens and Troyes are later additions, and notes of the 13th century (ff. 115–117) refer to the service of an altar in Saint-Étienne. How the book reached Troyes is not known, but Chartres lay close to the ancestral domains of the Counts of Champagne around Blois and along the Loire, where Henry or one of his successors must have obtained it. The volume is very worn through use, and its decoration essentially concentrated in the Preface and Canon of the Mass. It is drawn in a very fine outline and fortified by flatly-laid colours in the garments and some of the backgrounds. Many of the finer details of the drawing, however, are now eroded. Some unusual aspects of the iconography deserve to be noted. In the place of the usual *Majestas Domini*, the artist has offered an image of the standing, resurrected Christ, while the *Te Igitur* initial incorporates a large standing angel displaying an open book reminiscent of similar figures in the Echternach *Codex Aureus* (Nürnberg, Germanisches Nationalmuseum). The delicate yet lively draughtsmanship of these designs calls to mind the Auxerre leaves from Tours and the illumination of the life of Saint Martin from the same centre (nos. 1, 2). It is also echoed, though more distantly so, in other manuscripts of western France like the Le Mans Missal in the Pierpont Morgan Library (MS G. 17) and a Missal fragment in the Bibliothèque Nationale (nouv. acq. lat. 2659). Among the few surviving manuscripts from Saint-Père thus far identified, a copy of Augustine's *Enarrationes in Psalmos* (Rome, Bibl. Angelica MS 1085) gives some additional evidence for the character of local book production in this period or in the immediately preceding years. The incisively drawn Beatus initial in this work has much the same verve as the illumination of the Troyes Missal, though its style is more closely allied with Norman

art (Avril, *Mélanges de l'École Française de Rome*, LXXVII, 1965, 237ff).

PROVENANCE: Saint-Étienne de Troyes

LITERATURE: Harmand, *Catalogue général*, Quarto Series, II, 1855, 370; Leroquais, *Sacramentaires*, I, 233–36; Avril, *Royaumes d'Occident*, 191, 366.

EXHIBITED: *Manuscrits à peintures*, Paris, 1954, 85, No. 236.

6. Paris, Bibliothèque Nationale MS lat. 9865

Cartulary of Vierzon
340 × 235 mm., ff. 29, 2 cols., 35–36 lines
Middle or third quarter of the 12th century.
Saint-Pierre, Vierzon *Ill. 6*

Fifteen drawings connected with the documents transcribed in the cartulary: Ecclesia with St. Peter (left) and Ecclesia with St. Paul (right); Pope Callixtus II (f. 1); Pope Hadrian IV (f. lv); King Charles the Bald and Archbishop Rodolphus of Bourges (f. 2v); Louis the Pious (f. 3v); Abbot Syon of Vierzon with book and crozier (f. 4); Ambrannus, Lord of Vierzon, accompanied by his wife and a relative giving a book (charter) to Abbot Aimericus of Vierzon, attended by two monks (f. 5v); Abbot Asinarius with book and crozier (f. 7v); Abbot Odo (f. 8); Abbot Raimundus (f. 8); Abbot Girbertus (f. 8v); Abbot Andreas (f. 9); Abbot Christianus (f. 10v); Abbot Martinus (f. 11); Abbot Constabulus (f. 12v); Abbot Berengarius (f. 14v); spaces left for two further portraits on ff. 17v and 25v, not executed.

The monastery of St. Peter at Vierzon was initially established at the nearby site of Dèvres, apparently in 843. Several charters concerning this first foundation that are included in the present manuscript, however, are regarded as 11th-century forgeries. The monks seem to have moved to Vierzon in the 10th century, though the circumstances which surrounded this event are obscure and controversial. In the High Middle Ages, the monastery was a place of some importance, graced by a spacious early Gothic church, which along with the rest of the monastic complex (*Monasticon Gallicanum*, ed. A. Peigné-Delacourt, Paris, 1871, pl. 26), has entirely disappeared. The cartulary of Vierzon comprises transcriptions of 116 documents, the latest of which is a Bull of Hadrian IV, dated 1154 (ff. lv–2). According to G. Devailly, the manuscript was probably compiled under Abbot Peter, who was elected after 1155. The style of the work supports a date in the fifth or sixth decade of the 12th century.

The manuscript is written on parchment leaves of different sizes and was left in an incomplete state. The illustrations cease after f. 14v, though there are

blank spaces for additional drawings on ff. 17v and 27. Of the initials, only that of the first charter (f. 1), a six-line ornamental letter in red, blue and green was executed. The drawings of lay and ecclesiastical patrons, as well as of different Abbots of Vierzon, are carried out in outline, reinforced in some cases with a summary modelling with a pale brown wash. In the rather more elaborate illustrations of the first folio, the garments are coloured green and blue, or red and green (f. 1v). The articulation of the figures by means of reiterated curving double lines perpetuates at a distance of some fifty years the stylistic conventions deployed in the drawings of the *Vita Martini* at Tours (Tours, Bibl. Mun. MS 1018; no. 1).

PROVENANCE: 'Cart. 97' (18th century, f. 1). Acquired by the Bibliothèque Nationale in 1822.

LITERATURE: E. de Toulgoët-Tréanna, *Histoire de Vierzon et de l'abbaye de Saint-Pierre*, Paris, 1884, *passim;* M. Daiguson, 'Note sur le cartulaire de l'abbaye de Saint-Pierre de Vierzon', *Congrès archéologique*, XL, 1874, 576–606; H. Stein, *Bibliographie générale des cartulaires français*, Paris 1907, 559, No. 4090; Lauer, *Enluminures romanes*, 121–2; G. Tessier, 'Les chartes du monastère de Dèvres et la valeur historique du cartulaire de Vierzon', *Bibliothèque de l'École des Chartes*, XCLI, 1931, 23–42; Boeckler, *Abendländische Miniaturen*, 100; Nordenfalk, *Romanesque Painting*, 145; G. Devailly, *Le Cartulaire de Vierzon*, Paris, 1963; M. Kupfer, *Romanesque Wall Painting in Central France*, New Haven and London, 1993, 56.

EXHIBITED: *Manuscrits à peintures*, Paris, 1954, 85, No. 237.

7. Tours, Bibliothèque Municipale MS 291

Augustine, Homilies on the Gospel of John
375 × 285 mm., ff. 155, 2 cols., 34 lines
Beginning of the 12th century. *Ills. 26, 27*

One historiated and numerous ornamental initials: D (f. 1); I (f. 9); D (f. 12v); D (f. 16); L (f. 20v); Q (f. 23v); Q (f. 28v); I, standing figure with joined hands (f. 32); H, walled city and combat of armed men (f. 39); P (f. 42); P (f. 44); P (f. 48); L, man standing on his head and displaying an overturned vase (f. 51); C (f. 54); C, lion (f. 55v); N (f. 56v); I (f. 58v); A (f. 59v); N (f. 60v); H, palace or architectural prospect (f. 62); S (f. 63); I (f. 64); A (f. 65v), D (f. 66v); C (f. 67v); E (f. 68v); D (f. 69v); N (f. 70v); V (f. 72); A (f. 73); Q, figure with stick, dog (f. 74); M (f. 75); A (f.76v); P (f. 77v); I, haloed warrior spearing and trampling an adversary (f.78v); I (f. 79v); A (f. 81); D, warrior on horseback (f. 82); I, siren with fish (f. 83); V (f. 84); M (f. 85); A (f. 86); P, figure pruning (f. 87); C (f. 88); A, man bending tree (f. 94); D (f. 95); D, dragon (f. 96); I, seraph (f. 97); E (f. 105v); Q, centaur (f. 107v); C (f. 109v); H, eagle

and lion (f. 110); D (f. 111v); Q (f. 113); A (f. 114v); G (f. 116); D, man with monkey (f. 118v); C (f. 121); L, male busts in roundels (f. 122v); D (f. 123v); C, man with feline (f. 125); I (f. 128); T, woman with arms outstretched, tendering a globe-like vessel and a bowl (f. 130v); P, cleric writing, bystander with books and a figure offering a bowl (f. 132); Q (f. 134); Q, bust of Christ in the form of the Holy Face (f. 135); C (f. 136v); I, goat eating from tree (f. 138); E (f. 139v); C, bear and trainer (f. 141v); P (f. 142v); S (f. 144); P (f. 146); I (f. 149); N (f. 151v).

The volume begins with a poem of four distichs on John the Evangelist (f. 1; Walther, *Initia carminum*, 1959, No. 9619), followed by Augustine's Sermon *De decem cordis* (ff. 1–8v; *Corpus Christ.* XLI, 105–51). This first gathering appears initially to have been destined for another book, and found its way into the present manuscript as an afterthought. The body of the text consists of Sermons 43 to 124 of Augustine's *Tractatus in Evangelium Iohannis* (*Pat. Lat.* XXXV, 1076–1976). The division of this work in the present codex differs from the customary presentation, grouping Sermons 1–54 and 55–124 in the manuscript recension, but occurs in two earlier copies of the *Tractatus* from Tours: Bibl. Mun. MS 290, from Marmoutiers, containing Sermons 43–124, and MS 293, from the Cathedral, with Sermons 1–42.

The distinction of the manuscript is based on its rich and varied sequence of painted initials. That which stands at the beginning of Augustine's *Tractatus* (f. 9), originally intended as the opening page of the volume, is the largest and is accompanied by an elaborate *incipit* in red capitals and *incipit* words on silver, blue and yellow painted strips joined to the body of the letter. The initials are executed in flat unmodelled colours, with some silver and gold. Their design is remarkable for variety and invention. Some, like the letter I in the form of a column wrapped with a garland (f. 58v) and others incorporating roundels filled with busts (ff. 60v, 122v) appear to revive initial types of mid 9th-century manuscripts of Tours. The same source is reflected in the rendering of the titles in red rustic capitals. Another, more important, stylistic component of this illumination is Norman art, which contributed the typical inhabited rinceaux with figures in the act of pruning plants or engaged with animals (ff. 9, 87). Many of the designs, on the other hand, are indigenous improvisations of no known pedigree. Some take the form of architectural structures (ff. 39, 62, 89), while others are single figures whose stance defines the shape of the letter. Most are composed of foliage that is bent or twisted to approximate the form required for legibility, yet not wholly subordinated to the configuration of the alphabet.

PROVENANCE: Cathedral of Tours, MS 139 (f. 1, lower margin).

LITERATURE: A. Dorange, *Catalogue descriptif et raisonné des manuscrits de la Bibliothèque de Tours*, Tours, 1875, 162–64; M. Collon, *Catalogue général*, XXXVII, 1900, 213–14; E. K. Rand, *A Survey of the Manuscripts of Tours*, Cambridge, 1928, I, 202, No. 229; D. F. Wright, 'The Manuscripts of St. Augustine's "Tractatus in Evangelium Iohannis": A Preliminary Survey and Check-List', *Recherches Augustiniennes*, VIII, 1972, 135.

EXHIBITED: *Manuscrits à peintures*, Paris 1954, 83, No. 229.

8. Amiens, Bibliothèque Municipale Lescalopier MS 2

Glossed Psalter
253 × 205 mm., ff. xix + 201,
17 long lines (Text), 28 (Prefaces), 23 (Litany)
c. 1100. Angers *Ills. 15, 16, 17, 18*

Schemata of the four cardinal directions and winds; the four elements and temperaments (f. xviii verso). Full-page miniatures: Christ in Majesty with the four Evangelist symbols (f. 11 bis verso); Crucifixion (f. 11 ter); Harping David (f. 11^5 verso); the Four Musicians (f. 11^6); Beatus page with ornamental initial and decorative *incipit* words (f. 11^6 verso); Altar with the Book of the Seven Seals and Dove with the Gifts of the Holy Spirit (f. 19 bis); Virgin and Child enthroned (f. 19^5).

The decoration of this Psalter embraces two stylistically and iconographically unrelated sets of miniatures, somewhat fortuitously brought together. The manuscript was initially planned as a liturgical Psalter with a seven-partite subdivision, prefaced with images of David and the four sacred musicians of the Psalms on facing pages, along with a full-page decorative treatment of the Beatus initial and the *incipit* words enclosed within a frame. These three pages are by the hand of the painter who carried out the illustrations of the Life of St. Albinus of Angers (Paris, Bibl. Nat. nouv. acq. lat. 1390; no. 9) and of a Bible from the monastery of Saint-Aubin also in Angers (Angers, Bibl. Mun. MS 3–4). The harping David is frontally seated on a throne hung with a large open cloth and equipped with animal-headed finials and claws. The four musicians with their instruments are seated on the recto opposite — Asaph with a cithara, Eman playing bells, Idithun with a harp and Ethan blowing a horn. Both pages have vividly patterned architectural frames surmounted by domes and turrets.

Not long after the completion of the manuscript, interlinear and marginal glosses were added, along with seven new folios comprising four additional full-page miniatures accompanied by versified texts (Walther, *Initia carminum*, I/1, Nos. 12922, 9997 and

871 records three of these). Two of the new miniatures, one showing Christ in Majesty trampling a pair of deferential beasts and the other the Crucifixion, precede the portrait of David and his musicians executed by the first painter. The remaining pair, whose subject is the Dove with the Gifts of the Holy Spirit and the Virgin with the Child enthroned, are inserted without discernible logic in the midst of the text of Psalm 9. The subjects depicted in these paintings indicate that this group of miniatures was very likely made for a service book, perhaps a Sacramentary. Their style has a nervous and wind-blown effect that must reflect the painter's reliance on a model belonging to the 10th-century School of Winchester. The assertive frames filled with stringy foliage, and the presence of acanthus rosettes at the four corners (f. 11 ter) point in the same direction.

The Calendar (ff. i–xix) gives special emphasis to the *Depositio* of St. Maurilius (22nd September) and the Nativity of St. Maurice and his companions (16th October). Both are saints of Angers — St. Maurice patron of the cathedral. Maurilius and Maurice are also given special stress in the Litany. Two documents concerning the church of Angers, the first a charter of Bishop Guillaume of Beaumont dated 1209, are copied in the manuscript (f. xiv verso to f. xv), which was probably made for the cathedral.

PROVENANCE: Collection of Toussaint Grille, Angers (d. 1851); Count Charles de l'Escalopier, and bequeathed by him to the city of Amiens in 1870.

LITERATURE: *Catalogue des collections du feu Monsieur Toussaint Grille*, Angers, 1851, No. 930; J. F. Delion, *Catalogue de la Bibliothèque de M. le Comte Charles de l'Escalopier*, Paris, 1866–7, I, 2, No. 12; E. Coyecque, *Catalogue général*, XIX, 1893, 456–61; L. de Farcy, *Monographie de la cathédrale d'Angers*, Angers, 1901–10, III, 259–62; Leroquais, *Psautiers*, I, 16–19, No. 11; L. W. Jones, 'The Library of St. Aubin's at Angers in the Twelfth Century', *Classical and Medieval Studies in Honor of Edward Kennard Rand*, ed. L. W. Jones, New York, 1938, 155; A. Katzenellenbogen, *Allegories of the Virtues and Vices in Medieval Art*, London, 1939, 73 n. 3; Boutemy, *Manuscrits enluminés du Nord de la France*, 259–62; C. R. Dodwell, The *Canterbury School of Illumination, 1066–1200*, Cambridge, 1954, 119; J. Porcher, *Anjou roman* (Coll. Zodiaque), 1959, 182–206; id., *French Miniatures*, 30; E. Wickersheimer, *Les Manuscrits latins de médecine du haut moyen âge dans les bibliothèques de France*, Paris, 1966, 13, No. 1; J. Vezin, *Les Scriptoria d'Angers au XIe siècle*, Paris, 1974, 60–61, 233–35, and *passim*; R. Kahsnitz, *Das Werdener Psalter in Berlin, Ms. theol. lat. fol. 358. Eine Untersuchung zu Problemen mittelalterlichen Psalterillustration*, Düsseldorf, 1979, 149, 151–2, 154, 157, 159, 163, 180, 192.

EXHIBITED: *Manuscrits à peintures*, Paris, 1954, 81, No. 220; *Art roman*, Barcelona and Santiago de Compostela, 52, No. 70.

9. Paris, Bibliothèque Nationale MS nouv. acq. lat. 1390

Scenes from the Life of St. Albinus
295 × 205 mm., ff. 7
c. 1100. Angers *Ills. 22, 23, 24, 25*

Fourteen full-page miniatures, accompanied by *tituli*: Cure of a woman possessed by a demon (f. 1); St. Albinus excommunicates an incestuously married couple (f. lv); St. Albinus blesses eucharistic hosts presented to him by a group of prelates (f. 2); Death of the excommunicated bridegroom in the presence of the consecrated host (f. 2v); Grief of the family and friends of the victim (f. 3); Group of men mourning on St. Albinus' death (f. 3v); Miraculous return from Vannes of the body of one of St. Albinus' deceased followers (f. 4); Miraculous cure of Gennomar from blindness (f. 4v); St. Albinus on his deathbed, attended by a group of monks (f. 5); Funeral of St. Albinus (f. 5v); Miraculous cure of Berfridus of Cunault, afflicted with a skin disease (f. 6); Invasion of Norman pirates in a boat at Guérande (f. 7); St. Albinus in the guise of a magnificently armed warrior encourages the men of Guérande (f. 7v).

These illustrations of the life of St. Albinus, Bishop of Angers (d. 500) comprise a set of fourteen full-page miniatures distributed over the rectos and versos of seven folios. The miniatures bear verse inscriptions added in the 16th century in the upper margins. The last two pages in the sequence have suffered damage, evidently inflicted after the inscriptions were set in place. The text which these illustrations accompanied is lost, and the number of paintings originally extant is not known. The life of St. Albinus was written by Venantius Fortunatus (530 to *c.* 610), and a collection of posthumous miracles was assembled in the 11th century in the Abbey of Saint-Aubin at Angers (*AA.SS.* Mart. I, 57–63). The surviving miniatures concern incidents related in both of these texts. According to the calculations of M. Carrasco, which are predicated on a more or less even distribution of the illustrations in the Fortunatus text and a more selective one in the *Miracula*, the cycle must initially have embraced a total of forty miniatures at a minimum. The artist who executed these paintings is identified in two other Angers manuscripts. He illuminated a two-volume Bible for Saint-Aubin (Angers, Bibl. Mun. 3–4), and he contributed to the decoration of the Glossed Psalter of the Lescalopier Collection (Amiens, Bibl. Mun., Lescalopier 2; no. 8). Frescoes in the transept of the church of Château-Gontier (Mayenne) have also been attributed to him, though their condition makes it difficult to bear out

this ascription. J. Porcher proposed to identify the painter with a certain Fulco, a layman who at the behest of Abbot Gérard (1082–1108) undertook to furnish the Abbey with painting and stained glass in return for the gift of a house during his lifetime, a vineyard, and his personal freedom (P. Marchegay, 'Documents du XIe siècle sur les peintures de l'abbaye de Saint-Aubin', *Bulletin de la Société industrielle d'Angers*, XVII, 1846, 218–23). Carrasco, who has made to date the fullest study of this entire group of monuments, suggests instead that they are the work of a number of different hands.

A date toward the end of the 11th century or around the year 1100 for the miniatures of the *Vita Albini* is now generally accepted, though it remains necessarily hypothetical. The outburst of figurative illustration on an expansive scale and in a brilliant, fully painted style is something new in Angevin illumination. An earlier life of St. Albinus, datable between 1004 and 1047 (Vat. Reg. Lat. 465) contains only a single miniature with a representation of two miracles, sparingly drawn and tinted. Porcher, basing himself on Fulco's lay status, took him to be a travelling artist who brought with him to Angers a familiarity with such works as the frescoes of Saint-Savin-sur-Gartempe and the illustrated *Vita Radegundis* of Poitiers (Bibl. Mun. MS 250). M. Schapiro more plausibly views the style of the *Vita Albini* miniatures as one of a number of reflections of Italian influence in French manuscript illumination of the late 11th and early 12th centuries, and cites as a parallel for the Angers paintings a Roman Evangeliary of the early 12th century in Florence (Bibl. Laurenziana, Plut. 17.27). Carrasco discerns some connections with Ottonian book illumination, particularly manuscripts from the later phase of the School of Cologne, but lays particular stress on the internal development of Angers illumination from the early 11th century onward.

Although they now represent only a fortuitous ensemble, the miniatures of the *Vita Albini* include some arresting images bearing on significant concerns of their time. The saint's intervention against a couple judged to have married within the prohibited degrees (f. 1v) is best understood in the light of the greater severity of church doctrine on this issue in the aftermath of the Gregorian Reform movement. Three scenes concerning a eucharistic miracle (ff. 2–3) may well bear some relation to the 11th-century controversies surrounding the teachings of Berengar of Tours. Albinus is presented as a model of episcopal sanctity for his day, a vigorous activist and administrator rather than an otherworldly ascetic, a defender of reform, an indispensable bulwark of justice in a strife-ridden time.

PROVENANCE: At Saint-Aubin, Angers, until the end of the 18th century. A. Ménard, Nantes. Acquired by the Bibliothèque Nationale between 1876 and 1878.

LITERATURE: A. Ramé, 'Notice sur une vie de Saint Aubin en images, présumée du XIe siècle', *Revue des Sociétés savantes des Départments*, Ser. VII, 2, 1880, 168–82; L. Delisle, *Catalogue des manuscrits des fonds de la Tremoïlle*, Paris, 1889, 7–8; A. Boinet, 'Quelques oeuvres de peinture exécutées à l'abbaye de Saint-Aubin d'Angers du XIe au XIIe siècle', *Congrès archéologique*, 1910, 166–73; Lauer, *Enluminures romanes*, 146–8; F. Wormald, 'Some Illustrated Manuscripts of the Lives of the Saints', *Bulletin of the John Rylands Library*, 1952, 257 [repr. F. Wormald, *Collected Writings*, Oxford and New York, 1988, II, 49]; J. Porcher in *Anjou roman* (Coll. Zodiaque), 1959, 182, 206–16; Grabar and Nordenfalk, *Romanesque Painting*, 148; J. Porcher, *French Miniatures*, 30; M. Schapiro, *Parma Ildefonsus*, 49 n. 208, 50 n. 213; J. Vezin, *Les Scriptoria d'Angers au XIe siècle*, Paris, 1974, 61–2, 87, 182–3; F. Dolbeau, 'Anciens possesseurs des manuscrits hagiographiques latins conservés à la Bibliothèque Nationale de Paris', *Revue d'histoire des textes*, IX, 1979, 232; M. Carrasco, 'Notes on the Iconography of the Romanesque Manuscript of the Life of St. Albinus of Angers', *Zeitschrift für Kunstgeschichte*, XLVII, 1984, 333–48; *Saint-Aubin d'Angers du VIe au XXe siècle* (Exh. Cat.), Angers, 1985, 79; B. Brenk, 'Le texte et l'image dans la "vie des saints" au moyen âge: rôle du concepteur et rôle du peintre', *Texte et Image* (Actes du Colloque International de Chantilly, 13–15 Oct., 1982), Paris, 1984, 36–8. M. Carrasco, 'Spirituality and Historicity in Pictorial Hagiography: Two Miracles by St. Albinus of Angers', *Art History*, XII, 1, 1989, 1–21; M. Carrasco 'Sanctity and Experience in Pictorial Hagiography: Two Illustrated Lives of Saints from Romanesque France', *Images of Sainthood in Medieval Europe*, ed. R. Blumenfeld-Kosinski and T. Szell, Ithaca and London, 1991, 33–66.

EXHIBITED: *Manuscrits à peintures*, Paris, 1954, 81, No. 221.

10. Angers, Bibliothèque Municipale MS 154 (146)

Jerome, Epistles
395 × 310 mm., ff. 282, 2 cols., 40 lines
Early 12th century. Angers

Ill. 35; Fig. page 12

Framed *incipit* page (f. 3) and framed page with initial and *incipit* words (f. 3v).

Painted ornamental initials: B (f. 4); N (f. 83); N (f. 109v); N (f. 110v); A (f. 118v); S (f. 123v); M (f. 125); Z (f. 126); S (f. 128v); N (f. 133); H (f. 137); X (f. 151); R (f. 151v); A (f. 153v); C (f. 165); S (f. 165); A (f. 183v); U (f. 186v); D (f. 191v); P (f. 191v); V (f. 197v); M (f. 225v); B (f. 227); G (f. 234v); F (f. 240); S (f. 245); P (f. 255v); S (f. 260v); S (f. 263v); Q (f. 265v).

Pen-drawn ornamental initials, of which the most important are found on ff. 81v, 83, 90, 103, 127, 128, 129, 132v, 133, 137v, 144v, 164, 177v, 194, 200v, 213v, 224v, 226, 226v, 228v, 229, 233v, 254v, 258, 271, 273v, 276, 278v.

Listed in a mid 12th-century inventory of the library of Saint-Aubin (Jones, *The Library of Saint-Aubin*, 149, No. 35), this volume comprises a collection of 127 letters of St. Jerome and some of his correspondents (ff. 3–273), followed by three biographies of anchorite saints of the Egyptian desert by the same author: *Vita Malchi*, *Vita Pauli primi eremitae*, and *Vita Hilarionis* (ff. 273v–282v. *Pat. Lat.* XXIII, 18–60). The work is prefaced by Augustine's epistle to Jerome touching on the latter's quarrel with Rufinus *(Pat. Lat.* XXII, 909–915), followed by *capitula* (ff. 2–2v). The first of Jerome's letters, addressed to Pope Damasus *(Pat. Lat.* XXII, 452–61) is the occasion for an elaborate framed *incipit* (f. 3) and an even more ornate treatment of the author's salutation, opening initial and *incipit* words (f. 3v). Some aspects of the ornament, but especially the figurative elements employed — *atlantes* bearing columns and squatting under arches — show a derivation from the style of the Saint-Aubin Bible (Angers, Bibl. Mun. 3–4) and the *Vita Albini* (Paris, Bibl. Nat. nouv. acq. lat. 1390; no. 8), but the manner is here more exuberant, linear and nervous, while colour is more limited in its tonality, with blue-grey and olive green predominating. Each of the epistles in the collection and the short biographies of the desert saints are introduced by ornamental letters, of which there are two types. One group of letters, formed in the main of stringy foliage, is painted in the same combination of sheer brio and mild negligence as the frontispiece design, using primarily grey, olive green and red, outlined in black. One letter takes the shape of a kneeling stag (f. 109v), others incorporate beasts spewing foliage (ff. 197v, 234v), and acrobats or *atlantes* (ff. 255v, 259v). The second group of initials is drawn rather than painted, using red with yellow accents. The most striking is an acrobat in the form of an N (f. 137v) and several transform the rounded body of the letter into a face (ff. 144v, 194, 233v). Similar initials can be found in several other Saint-Aubin manuscripts of a roughly comparable date, among which a copy of Haymo of Auxerre's Commentary on the Pauline Epistles (Angers, Bibl. Mun. MS 67 [59]). The kind of initials constructed of acrobatic figures that are found in these books manifests itself earlier in the illumination of the Loire Valley in an 11th-century volume of works of Horace, likely from Fleury (Bern, Bürgerbibliothek, Cod. 542. See J. Weitzmann-Fiedler, *Studien zur Buchmalerei und Goldschmiedekunst des Mittelalters. Festschrift für Karl Hermann Usener*, Marburg, 1967, 155–60).

PROVENANCE: Saint-Aubin, Angers *(Ex libris monasterii S. Albini Andegavensis Congreg. S. Mauri*, 17th century [f. 4]).

LITERATURE: A. Molinier, *Catalogue général*, XXXI, 1898, 236–40; L. W. Jones, 'The Library of St. Aubin's at Angers in the Twelfth Century', *Classical and Medieval Studies in Honor of Edward Kennard Rand*, New York 1938, 149, No. 35. J. Vezin, *Les Scriptoria d'Angers au XIe siècle*, Paris, 1974, 191 n. 22 *Saint-Aubin du VIe au XXe siècle* (Exh. Cat.), Angers, 1985, 66, 82.

EXHIBITED: *Manuscrits à peintures*, Paris, 1954, 82, No. 225.

11. Tours, Bibliothèque Municipale MS 924

Terence, Comedies
280 × 185 mm., ff. 77, 34 long lines
First quarter of the 12th century.
Loire Valley (?) *Ills. 19, 20, 21*

Illustrations in the text: *Andria*–I, Simo with Sosia and a servant with provisions (f. 1); I.ii, Simo and Davus (f. 2v); I.iv, building, Archilis and Mysis (f. 3); I.v, Mysis and Pamphilus (f. 3v); II, Byrria, Charinus and Pamphilus (f. 4); II.ii, Davus, Pamphilus and Charinus (f. 4v); II.iv, Simo and Davus, partly cut out (f. 5v); II.v, Byrria, Simo and Pamphilus, partly cut out (f. 5v); II.vi, Davus and Simo, partly cut out (f. 6); III, Mysis, building, partly cut out (f. 6v); III.ii, cut out (f. 6v); III.iii, cut out (f. 7v); III.iv, Davus, Simo and Chremes (f. 8); III.v, Davus and Pamphilus (f. 8); IV, cut out (f. 9v); IV.ii, cut out (f. 9); IV.iii, Mysis, Davus, partly cut out (f. 9v); IV.iv, Chremes with Mysis and Davus, discovering Glycerium's baby (f. 10); IV.v, Crito with Mysis (f. 10v); V, Chremes with Simo (f. 11); V.ii, Davus, Simo, Chremes and Dromo (f. 11); V.iii. Pamphilus, Simo and Chremes (f. 11v); V.iv, Arrival of Crito, with Mysis, Chremes, Simo and Pamphilus (f. 12); V.v, Charinus and Pamphilus (f. 13); V.vi. Davus, Pamphilus and Charinus (f. 13).

Eunuchus–Prologue, author enthroned, speaking to his audience (f. 13v); I, Phaedria and Parmeno (f. 14v); I.ii, Thais, with Phaedria and Parmeno (f. 15); II, Phaedria and Parmeno (f. 16); II.ii, Gnatho, Pamphila and Parmeno (f. 16v); II.iii, Chaerea and Parmeno (f. 17); III, Thraso, Gnatho and Parmeno (f. 18v); III.ii, Parmeno, with Thais, Thraso and Gnatho (f. 19); III.ii, Chremes with Pythias and Dorias (f. 20); III.iv, Chaerea with Antipho (f. 20); IV, Dorias (f. 20v); IV.ii, Phaedria (f. 21); IV.iii, Pythias, Phaedria, building (f. 21); IV.iv, Dorus, Phaedria, Pythias, Dorias, building (f. 21v); IV.v, Chremes and Pythias (f. 22); IV.iv, Thais, Pythias and Chremes (f. 22v); IV.vii, Traso, Gnatho, and a group of slaves with household implements (f. 23); V, Thais and Pythias (f. 23v); V.ii, Chaerea with Thais and Pythias (f. 24); V.iii, Pythias,

Chremes and Sophronia (f. 24v); V.iv, Parmeno and Pythias (f. 25); V.iv, Parmeno and Pythias (f. 25); V.v, Laches and Parmeno (f. 25v); V.vi, Parmeno and Pythias (f. 26); V.vii, Thraso, Gnatho and Chaerea (f.26); V.viii, Chaerea, Parmeno, Gnatho and Thraso (f. 26v); V.ix, Phaedria, Chaerea, Thraso and Gnatho (f. 26v).

Heautontimorumenos–I, Menedemus plowing his land, Chremes with a rake (f. 28v); I.ii, Clitipho, Chremes, building (f.29v); II, Clitipho (f. 30); II.ii, Clinia and Clitipho (f. 30); II.iii, Syrus, Dromo, with Clinia and Clitipho (f. 30v); II.iv, Bacchis and Antiphila with servants, Syrus and Clinia (f. 32); III, Chremes and Menedemus, Building (f. 32); III.ii, Syrus, Chremes and Clitipho, building (f. 33); III.iii, Chremes, Clitipho, Syrus and Sostrata (f. 33v); IV, Sostrata, Chremes and Syrus (f. 34v); IV.ii, Syrus (f. 35); IV.iii, Clinia, Syrus and Bacchis (f. 35); IV.iv, Bacchis, Phrygia, Syrus, Clinia and Dromo (f. 35v); IV.iv, Chremes, Syrus, Dromo (f. 36); IV.vi, Clitipho with Syrus and Chremes (f. 36v); IV.vii, Chremes with Clitipho and Syrus (f. 37); IV.viii, Menedemus and Chremes (f. 37); V, Menedemus, Chremes and Sostrata (f. 37v); V.ii, Clitipho, Syrus, Chremes, Menedemus (f. 38v); V.iii, Sostrata, Chremes, Clitipho (f. 39); V.iv, Clitipho, Sostrata and Chremes (f. 39v); V.v, Menedemus, Sostrata, Clitipho and Chremes (f. 40).

Adelphoe–I, Micio, Storax and Demea (f. 41); I.ii, Demea and Micio (f. 41v); II, Sannio, Aeschinus, Parmeno with an axe, building (f. 42v); II.ii, Aeschinus, Syrus, Sannio and Ctesipho (f. 43); II.iii, Ctesipho, Syrus, Aeschinus in a building (f. 43v); II.iv, Aeschinus, Ctesipho, Syrus, Sannio, building (f. 44); III, Sostrata and Canthara (f. 44v); III.ii, Geta, Sostrata and Canthara (f. 44v); III.iii, Demea with Syrus, house with Dromo cleaning a fish (f. 45v); III.iv, Hegio, Geta and Demea (f. 46); IV, Ctesipho, Syrus and Chremes (f. 47); IV.ii, Demea and Syrus (f. 47); IV.iii, Micio, Hegio, building (f. 48); IV.iv, Aeschinus, building (f. 48); IV.iv, Demea and Micio (f. 49v); V, Syrus and Demea (f. 50); V.ii, Dromo, Syrus and Demea (f. 50); V.iii, Sostrata, Micio and Demea (f. 50v); V.iv, Demea and Syrus (f. 51); V.vi, Sostrata, Geta, Demea, Aeschinus and Micio (f. 51v); V.viii, Micio, Demea and Aeschinus (f. 52); V.ix, Syrus, Demea, Micio and Aeschinus (f. 52v).

Hecyra–I, Philotis and Syra (f. 53v); I.ii, Parmeno, with Philotis and Syra (f. 54); II, Laches and Sostrata (f. 55); II.ii, Phidippus, Laches and Sostrata (f. 55v); II.iii, Sostrata (f. 56); III, Pamphilus, Parmeno, building (f. 56); III.ii, Sostrata, Parmeno, Pamphilus, building (f. 57); III.iii, Pamphilus, with Parmeno, and servants with luggage (f. 57v); III.iv, Pamphilus, Parmeno, Sosia, Pamphilus, building (f. 58); III.v, Laches, Phidippus, and Pamphilus (f. 60); IV.iii, Pamphilus, Laches, Sostrata and Phidippus (f. 60v); IV.iv, Phidippus, Laches, Pamphilus and building (f.

61); V, Bacchis and Laches (f. 62); V.ii, Nurse, Phidippus, Laches and Bacchis (f. 62v); V.iii, Parmeno, Bacchis, building (f. 63); V.iv, Pamphilus, Parmeno and Bacchis (f. 63v).

Phormio–I, Davus hands a purse to Geta (f. 65); I.iii, Antipho, Phaedria and Geta (f. 66); I.iv, Geta, Antipho, Phaedria and Demipho (f. 66v); II, Demipho, Phaedria, Geta in a building (f. 67); II.ii, Phormio, Geta, bystanders (f. 68); II.iii, Demipho with a lawyer, Phormio and Geta (f. 68v); II.iv, Bystanders, Demipho, Geta, Antipho in a building (f. 69v); III, Antipho, Geta and Phaedria in a building (f. 69v); III.ii, Phaedria with Dorio, Antipho and Geta (f. 70); III.iii, Phaedria, Antipho and Geta (f. 70v); IV, Demipho and Chremes (f. 71); IV.ii, Geta, Demipho and Chremes (f. 71v); IV.iii, Antipho, Geta, Demipho and Chremes (f. 71v); IV.iv, Antipho, Geta and Demipho (f. 73); V.ii, Demipho and Geta (f. 73v); V.iii, Demipho, Nausistrata, Chremes, building (f. 74); V.iv, Antipho (f. 74v); V.v, Phormio, Antipho, and Geta in a building (f. 74v); V.vi, Geta, Antipho and Phormio (f. 75); V.viii, Demipho, Chremes, Phormio, Nausistrata (f. 75v); V.ix, Nausistrata, Chremes and Phormio (f. 76v).

Ornamental initials on ff. 1, 1v, 14, 14v, 25, 25v (head of a man), 26 (speaking hand), 26v, 27, 28, 28v, 29v, 30, 30v, 32, 32v, 41, 47, 48, 54 and 65.

The Tours manuscript of the plays of Terence seems to have been overlooked by students of the text and its illustrations until the publications of E. K. Rand, L. W. Jones and C. R. Morey in the late Twenties and early Thirties. In Jones's and Morey's comprehensive study of Terence illustrations, it is characterized as a 'mixed' text, affiliated primarily with the y-family, but modified with elements from the d-source — their two hypothetical 4th-century archetypes of the Calliopean recension. Where the manuscript was written and illuminated is not known. Rand, followed by Jones and Morey, considered it a product of Tours, while Porcher thought it Angevin, but neither of these attributions is for the moment well grounded. It should be noted that two 11th-century copies of the illustrated Terence have connections with the Loire Valley: Leiden, University Library, Voss. 4° 38, which is listed in an inventory of 1472 of the library of the Cathedral of Saint-Maurice at Angers, though this manuscript was not necessarily made there (Vezin, *Scriptoria d'Angers*, 31) and Paris, Bibl. Nat. lat. 7903, which is thought to come from Fleury.

The text is written in a somewhat angular and informal minuscule hand. The first letter of the protagonists' names is accentuated in combinations of red and yellow, blue and yellow, or simply one of these colours. The names of the protagonists which accompany the illustrations are written in rustic capitals brushed over with a yellowish wash. Three

to five-line decorative initials, loosely painted in gold, silver, or body colour, introduce the individual plays, their prologues, and sometimes subdivisions of the text. The beginning of the individual scenes is marked by two-line red or blue pen-work initials enlivened by dots in the opposite colour. The illustrations are inserted in blank spaces of eight lines. As Jones has pointed out (*Art Bulletin*, X, 1928, 103), the manuscript lacks the expected illustrations of the aedicule containing theatrical masks and a portrait of the author. On the other hand, there is an original illustration at the beginning of *Eunuchus* showing Calliopus reading his edition of the play to an assembled audience (f. 13v). There are blank spaces preceding the other plays, and two of these (ff. 27v, 40) are large enough to have housed similar miniatures. The painterly technique employed throughout the work is unusual. The figures are rendered with flat and loosely applied semi-opaque pigment, which leaves the pen outline of the faces and limbs showing through. The outlines of the garments and of the architectural staffage are delineated in another colour, red or blue, and apparently with the brush. The result has a sketchy and mildly coarse effect, which preserves a good deal of the flavour of the antique model or a Carolingian intermediary like the Lotharingian manuscript, perhaps once at Corbie (Vat. Lat. 3868), whose illustrations are also painted rather than only pen-drawn. In the earlier parts of the book (roughly up to f. 58), a warmer range of colours prevails and the figures tend to be outlined in red. Afterwards, a more sulphurous combination of blue, yellow and aquamarine is dominant, with outlines in green and brown. Some medieval intrusions are apparent: Crito in the Andria wears a pilgrim's purse decorated with a Greek cross (f. 12), and the hoods worn by some of the figures (ff. 19, 20) have a distinctly monastic air.

PROVENANCE: Written by a scribe named Leo, according to a seven-line poem at the end (f. 77v). Saint-Martin de Tours, MS 1 (19th century, flyleaf).

LITERATURE: A. Dorange, *Catalogue descriptif et raisonné des manuscrits de la Bibliothèque de Tours*, Tours, 1875, 407–8; M. Collon, *Catalogue raisonné*, XXXVII, 1900, 2, 663–5; L. W. Jones, 'The Archetype of the Terence Miniatures', *Art Bulletin*, X, 1927, 102–20; E. K. Rand, *A Survey of the Manuscripts of Tours*, Cambridge, 1929, I, 202, No. 231; L. W. Jones and C. R. Morey, *The Miniatures of the Manuscripts of Terence*, Princeton, London and Leipzig, 1931, I, 175–92; Samaran-Marichal, *Manuscrits datés*, VII, 1984, 586; C. Villa, *La 'lectura Terentii'*, I (Studi sul Petrarca) 17, Padua, 1984, 421, No. 562; B. Munk Olsen, *L'Étude des auteurs classiques latins aux XIe et XIIe siècles*, Paris, 1985, II, 638, No. C92.

EXHIBITED: *Manuscrits à peintures*, Paris, 1954, 83, No. 230.

12. Angers, Bibliothèque Municipale MS 25 (21)

Four Gospels
310 × 220 mm., ff. 99 + 1, 28 long lines
c. 1125. Angers *Ill. 33*

Historiated and ornamental initials: MATTHEW, L, Christ enthroned in a mandorla, displaying a book; below, Evangelist symbol, holding a book and trampling a dragon (f. 1); MARK, I (f. 31v); LUKE, Q, ornamental with half roundel showing a bust of Christ bearing a scroll (f. 52); F, ornamental, with Evangelist symbol (f. 52); JOHN, I, standing Christ with book (f. 85v).

The manuscript is in an incomplete state, now coming to an end at John XVIII: 18; the prefatory matter along with the *capitula* of Matthew are missing. The other prefaces and summaries have blue and red pen-work initials, and in Matthew's Gospel, *In illo tempore* headings marking the pericopes in the manner of a Gospel Lectionary are set off in the same way. The painted initials, the work of an artist who also participated in the illumination of a *Vitae sanctorum* from Saint-Serge at Angers, preserved in Rouen (Bibl. Mun. MS 1381), are conceived in a more luxurious vein than the text and its modest scribal embellishments would lead one to anticipate. Neither are they well coordinated with the layout of the text, standing as they do in isolation on the parchment, suggesting an *ad hoc* intervention by a talented guest performer. There is no evenly weighted scheme of decoration to render visible the unity and equal status of four separate and distinctive parts. Instead, Matthew's Gospel as the opening matter, receives the greatest possible emphasis in the manner of a frontispiece. The painter's style imparts both solidity and a sinuous sense of movement. Forms are strongly modelled in a refined combination of colours ranging from deeply saturated reds, blues and purple, along with some touches of gold, to a more neutral slate grey and grey green, that are overlaid with a supple linear shading punctuated with highlights. The dating of the work has ranged from the late 11th century (Vezin) to the first half of the 12th (Porcher), but it is best situated around 1125 or in the following decade. Avril discerns in it mannered echoes of the frescoes of Saint-Savin, and Hayward cites the style of the related manuscript in Rouen as a source of the considerably later stained glass of Saint-Serge (*Gesta*, XV/1–2, 1976, 259–60).

PROVENANCE: Saint-Serge, Angers (notes concerning benefices of the monastery for the years 1396–98, end flyleaf).

LITERATURE: A. Molinier, *Catalogue général*, XXXI, 1898, 198–9; J. Vezin, *Les Scriptoria d'Angers au XIe*

siècle, Paris, 1974, 93, 143 n. 7, 187; Avril, *Royaumes d'Occident*, 176.

13. Tours, Bibliothèque Municipale MS 321

Gregory, Moralia in Job
525 × 370 mm., ff. 341, 2 cols., 50 lines
Second quarter of the 12th century *Ills. 28, 29*

Historiated and ornamental initials: Dedicatory preface, R, Gregory, seated at a pulpit, presents his book to a group of monks; below, Gregory hands his book to Leander of Seville (f. 2); Prologue, I, acrobatic figures (f. 3); Bk. I, V, remade in the 17th century (f. 6); Bk. II, S (f. 11v); Bk. III, B (f. 21v); Bk. IV, Q, St. Michael fighting the dragon (f. 29v); Bk. V, C (f. 39); Bk. VI, S (f. 53); Bk. VII, Q, naked man attacked by a bird (f. 62); Bk. VIII, P, warrior fighting dragon (f. 70v); Bk. IX, P (f. 84); Bk. X, Q (f. 98); Bk. XI, Q, acrobatic figure (f. 106v); Bk. XII, M (f. 114); Bk. XIII, E (f. 121v); Bk. XIV, S (f. 127); Bk. XV, Q (f. 136v); Bk. XVI, Q (f. 146); Bk. XVII, Q (f. 155v); Bk. XVIII, P (f. 162); Bk. XIX, Q (f. 176); Bk. XX, Q (f. 185v); Bk. XXI, I (f. 197v); Bk. XXII, Q (f. 203v); Bk. XXIII, P (f. 212v); Bk. XXIV, H, man fighting bird (f. 222); Bk. XXV, I (f. 230); Bk. XXVI, I (f. 236v); Bk. XXVII, Q (f. 248v); Bk. XXVIII, P (f. 259); Bk. XXIX, D (f. 266v); Bk. XXX, B (f. 276); Bk. XXXI, I (f. 286v); Bk. XXXII, S (f. 302); Bk. XXXIII, A (f. 310); Bk. XXXIV, Q (f. 322v); Bk. XXXV, Q, the Lord with book and globe; below, Job tempted by the demon (f. 330v).

This enormous volume containing Gregory's *Moralia in Job* in its entirety has large initials enclosed in quadrangular panels, painted in a uniform style throughout, and placed at the beginning of the prefatory letter addressed to Bishop Leander of Seville, the Prologue, and the 35 following books which make up the work. The painter uses a brilliant and fairly saturated range of colours, with deep red, blue and green predominating, and some gold in the structure of the letters. The colour is applied in flat and sharply delineated areas, and the general effect can be described as Romanesque in its most hermetically stylized phase. The sluggish and faintly lifeless forms are close to the work of the Vendôme group of manuscripts around the Chambre des Députés Bible (no. 15). But while the Vendôme group consists of books of a fairly small scale with a decoration of appropriately-sized initials, the Tours *Moralia* has a grand monumentality. The repertoire of ornament is also richer. In these mostly foliage-filled initials, a recurring motif is a naked, putto-like combatant, single or paired, confronting dragons (ff. 222, 248, 259), goat-headed men (ff. 197v, 236v), or attacked by a bird (ff. 62, 222). The I of the Prologue (f. 3) consists of four naked figures standing on each others' heads or shoulders, and the body of the Q of Bk. XI is defined by a pair of acrobats whose feet and forearms are joined.

PROVENANCE: Cathedral of Tours, MS 149 (f. 2, lower margin).

LITERATURE: A. Dorange, *Catalogue descriptif et raisonné des manuscrits de la Bibliothèque de Tours*, Tours, 1875, 180–81; M. Collon, *Catalogue général*, XXXVII, 1900, 240–1; M. Schapiro, 'Two Romanesque Drawings in Auxerre and Some Iconographic Problems', *Studies in Art and Literature for Belle da Costa Greene*, ed. D. Miner, Princeton, 1954, 324 n. 55, and 325 n. 75.

14. Vendôme, Bibliothèque Municipale MS 193

Geoffrey of Vendôme, Works
210 × 120 mm., ff. 97, 24 long lines
First half of the 12th century.
La Trinité, Vendôme *Ill. 30*

Frontispiece miniature: Geoffrey of Vendôme commends himself to Christ (f. 2v).

This small volume is a collection of sermons and letters on spiritual topics written by Geoffrey, Abbot of the monastery of the Trinity at Vendôme from 1093 to 1132. According to Samaran and Marichal, the writing of the text was carried out by as many as twelve distinct, though fairly similar hands, working under the supervision of the abbot at a time between 1129 — the date of the last sermon (f. 90) — and Geoffrey's death three years later. The book is prefaced by an unframed miniature somewhat awkwardly positioned on the page, which constitutes the only decorative feature of any significance in the volume. The painting depicts the author, inscribed *Goffrid(us) peccator*, humbling himself before Christ. The two figures, painted in body colour and outlined in black (perhaps a later addition), overlap an arched structure topped by an architectural prospect drawn in light brown ink. It seems conceivable that the design in its present form resulted from a change in the initial plan, and that the arch was originally intended to house a standing portrait of the author. The grouping of the figures now in evidence has in any case a more horizontal orientation. Christ, in an unstable, half-striding stance, sits on the globe of the world and grasps the kneeling Geoffrey's wrist. As pointed out by Bouchet, the inscription recording his address to the Lord (*Christe, in te sperabo occideris si me etiam*) paraphrases words of Job (XIII:15). The basis of the scene lies in the first two pieces in the collection, which are cast in the form of invectives by the author against himself as sinner. Christ's gesture in gripping Geoffrey's wrist also alludes to the

Lord's release of Adam from the underworld in the traditional iconography of the *anastasis*. Christ wears a green robe over which a red garment is draped, and Geoffrey's chasuble, worn over a surplice and an ankle-length robe, are rendered in the same combination of contrasting colours. Toubert points out that Geoffrey wears some of the *pontificalia*, which he was authorized to do by Pascal II in 1103, when he received the title of Cardinal-Priest of Santa Prisca. Hair and beards are tinted in green, and flesh tones have some greenish accents. The style of the painting is connected with illumination of nearby Tours, as illustrated in the Gregory *Moralia* from the Cathedral Library (Tours, Bibl. Mun. MS 321; no. 13). It has other local offshoots on a monumental scale in the frescoes of the Chapter House at La Trinité, which, following Toubert, Geoffrey may have commissioned, and in the stained glass panel of the enthroned Virgin with the Child now set in a later window of the axial chapel of the abbey church.

BINDING: wooden boards covered with calf or pigskin.

PROVENANCE: 17th-century *ex libris*: *Congregationis Sancti Mauri monasterii Vindocensis* (ff. 1, 4). Inv. No. C. 193 (f. 1).

LITERATURE: H. Omont, *Catalogue général*, III, 1885, 457–60; C. Bouchet, 'Une miniature de manuscrit du XIIe siècle', *Bulletin de la Société archéologique, scientifique et littéraire du Vendômois*, XXIII, 1884, 146–58; E. Sackur, 'Zur Chronologie der Streitschriften des Gottfried von Vendôme', *Neues Archiv*, XVII, 1892, 327–47; A. Wilmart, 'La collection chronologique des écrits de Geoffroi, abbé de Vendôme', *Revue bénédictine*, XLIII, 1931, 239–45; P. D. Johnson, *Prayer, Patronage and Power. The Abbey of La Trinité, Vendôme*, New York and London, 1981, 146–8; J. Taralon, 'Les fresques romanes de Vendôme. I. Étude stylistique et technique', *Revue de l'art*, 53, 1981, 12–14; *Manuscrits datés*, VII, 401; J. Taralon, 'Les peintures murales romanes de la salle capitulaire de l'ancienne abbaye de Vendôme', *Congrès archéologique*, CXXXIX, 1981 (1986), 415, 428; H. Toubert, 'Peinture, iconographie et histoire. La salle capitulaire de La Trinité de Vendôme', *Peintures murales romanes* (Cahiers de l'Inventaire, 15), Paris, 1988, 29.

EXHIBITED: *Manuscrits à peintures*, Paris, 1954, 84, No. 233.

15. Paris, Bibliothèque de la Chambre des Députés MS 2

Bible
320 × 220 mm., ff. 284, 2 cols., 56 lines
Middle of the 12th century.
Vendôme *Ills. 31, 32*

Historiated and ornamental initials: PREFACE TO THE OLD TESTAMENT, F, Jerome and Paulinus (f. 12); PREFACE TO PENTATEUCH, Jerome and Desiderius (f. 13); GENESIS, I, Days of Creation (f. 14); EXODUS, V, Moses leading the Children of Israel from Egypt (f. 24); LEVITICUS, V, the Lord speaks to Moses (f. 32v); NUMBERS, L, the Lord speaks to Moses (f. 38v); DEUTERONOMY, cut out (f. 47); JOSHUA, E, the Lord designates Joshua as Moses' successor (f. 54v); JUDGES, P, the Lord speaks to the Israelites (f. 60); RUTH, I, standing Ruth (f. 65), I KINGS, F, Elkanah with his two wives (f. 66v); II KINGS, F, the Amalekite messenger brings to David the insignia of Saul (f. 73v); III KINGS, E, Abisag the Sunnamite presented to David (f. 79v); IV KINGS, P, Elijah brings down the divine fire on the messengers of King Ahaziah (f. 86v); I CHRONICLES, A (f. 92v); II CHRONICLES, C, enthroned Solomon (f. 97v); EZRA, I, standing Prophet (f. 105); ISAIAH, V, Vision of Isaiah (f. 110v); JEREMIAH, V, Vision of the boiling cauldron (f. 121); EZEKIEL, E, Vision of the four living creatures (f. 134); DANIEL, A, the three Hebrews before Nebuchadnezzar (f. 144); HOSEA, V, Hosea with Gomer (f. 149); JOEL, V, standing Prophet with scroll (f. 150v); AMOS, V (f. 151); OBADIAH, V, (f. 152); JONAH, E (f. 152v); MICAH, V (f. 153); NAHUM, D (f. 154); HABAKKUK, O (f. 154v); ZEPHANIAH, V (f. 155); HAGGAI, I, standing Prophet with scroll (f. 155v); ZECHARIAH, I, standing Prophet with book (f. 156); MALACHI, O (f. 158v); JOB, V, the Lord within a mandorla, Job and Satan (f. 159); PSALMS, B, David fighting the lion, David and Goliath (f. 164); Psalm 109, D, Christ in Majesty (f. 180); Psalms (Gallican version), B, David as shepherd, David and Goliath (f. 185); PROVERBS, P, Solomon admonishes his son (f. 189); ECCLESIASTES, V, monarch pointing to the sun (f. 194); SONG OF SONGS, O, the Bride and Bridegroom (f. 195v); WISDOM, D (f. 196v); ECCLESIASTICUS, O, personification of Wisdom (f. 200v); TOBIT, T, Tobit following the angel Raphael (f. 209); JUDITH, A, Beheading of Holophernes (f. 211); ESTHER, I, standing Esther (f. 213v); I MACCABEES, E (f. 216v); II MACCABEES, F (f. 223); *Passio Maccabeorum*, P, Eleazar before Antiochus (f. 227v); BARUCH, H. (f. 229v); MATTHEW, L (f. 231); MARK, I, standing Evangelist with book (f. 239); LUKE, Q, seated Evangelist (f. 244); JOHN, I, Evangelist symbol (f. 251); ACTS, P, Ascension of Christ (f. 256); JAMES, I, standing Apostle (f. 262); I PETER, P (f. 262v); I JOHN, Q (f. 264v); JUDE, cut out (f. 265v); REVELATION, A, Vision of the Lord with the sword and the seven candelabras (f. 266); ROMANS, P, Paul speaks to a group of Romans (f. 269v); I CORINTHIANS, P (f.272); II CORINTHIANS, P (f. 274v); GALATIANS, P (f. 276); EPHESIANS, P, Paul and an Ephesian (f. 277); PHILIPPIANS, P (f. 278); COLOSSIANS, P, bust of Paul (f. 278v); I THESSALONIANS, P (f. 279v); II THESSALONIANS, P, Paul with book (f. 280); I TIMOTHY, P (f. 281); II TIMOTHY, P, Paul gives a book to Timothy (f. 281); TITUS, P (f. 281v); PHILEMON, P (f. 281v); HEBREWS, M, Paul speaks to a group of Hebrews (f. 282).

The Chambre des Députés Bible is a work of a comparatively small size, with an attractive sequence of initials. These letters, painted in opaque and saturated colours, are built of thick and sluggish interlace formations. The curving parts of the design are defined by elongated dragons. Wide-eyed and boldly patterned little figures with garments defined by means of broad parallel stripes outlined in black constitute the artist's special trade mark. A. Boinet, who first brought the manuscript to general attention, tentatively attributed it to Alsace. It must, however, stem from the region of the Middle Loire and can be tentatively localized in Vendôme, where four more manuscripts illuminated by the same painter are preserved: a Glossed Pauline Epistles (Vendôme, Bibl. Mun. MS 23); an Augustine, *Contra Faustum* (Vendôme, Bibl. Mun. MS 34); a Peter Lombard, *Sententiae* (MS 61) and an Epistolary (MS 115). These books come from the important Benedictine community of La Trinité, founded in 1040 by Count Geoffrey Martel and his wife Agnes, and the second of these volumes bears an inscription indicating that it was written for that house by a man named Aubertus (*Colophons*, I, No. 113). Three other manuscripts can be added to the record of his production: a Homiliary of unknown provenance in the Bibliothèque de l'Arsenal (MS 471), and a copy of works of Hugh of St. Victor in the Bibliothèque Mazarine (MS 729) from the library of the Jacobins in Paris, and according to Avril (Granboulan, 52 n.28), a Sacramentary of Chartres in the Bibliothèque Nationale (lat. 1096). The not too distant relationship of the Vendôme group with the Gregory *Moralia in Job* from the cathedral in Tours (Tours, Bibl. Mun. MS 321; no. 13), has already been noted.

PROVENANCE: At Bourges in the early 15th century, according to a note on f. 2: *Biblia sacra manuscripta Biturigibus 1411*, and at the end of the volume: *Bituri IIIIcXI, Explicit omnis Bibliorum disciplina … Ita est, Jaupitre*. Later, Capucins of Nigeons (Minimes de Passy), founded in 1493 (f.2).

LITERATURE: E. Coyecque and H. Debraye, *Catalogue général… Paris: Chambre des Députés*, 1907, 3–6; A. Boinet, 'Les principaux manuscrits à peintures de la Bibliothèque de la Chambre des Députés à Paris', *Bulletin de la Société française de Reproduction de Manuscrits à Peintures*, VI, 1922, 36–9; Cahn, *Romanesque Bible Illumination*, 274–5, No. 80; L. Eleen, *The Illustration of the Pauline Epistles in French and English Bibles of the Twelfth and Thirteenth Centuries*, Oxford, 1982, 56, 58, 68; J. M. Sheppard, *The Giffard Bible. Bodleian Library Ms. Laud Misc. 752*, New York and London, 1986, 73–4; A. Granboulan, 'De la paroisse à la cathédrale: une approache renouvelée du vitrail roman dans l'Ouest', *Revue de l'Art*, 103, 1994, 42–52.

16. Rouen, Bibliothèque Municipale MS A.5 (7)

Octateuch, I–II Chronicles and
Gospel Fragments
495 × 340 mm., ff. 205, 2 cols., 51 lines
c. 1125. La Trinité, Fécamp *Ills. 37, 38*

Historiated and ornamental initials: PREFACE TO THE PENTATEUCH, D (f. 2); GENESIS, missing; EXODUS, H (f. 20); LEVITICUS, V (f. 35); NUMBERS, missing; DEUTERONOMY, H (f. 59v); JOSHUA, E, the Lord speaks to Moses in the Burning Bush (f. 72v); JUDGES, initial not executed (f. 81); RUTH, I (f. 90); PREFACE TO KINGS, V (f. 91); I KINGS, missing; II KINGS, F (f. 104); III KINGS, E (f. 115); IV KINGS, P (f. 127v); PREFACE TO CHRONICLES, S (f. 138); I CHRONICLES, A, Adam with the generations (f. 138v); II CHRONICLES, C, enthroned Solomon (f. 148).

This work is in a very worn condition and has also suffered damage through humidity and the loss or partial mutilation of a number of folios, including the beginning of Genesis and I Kings, where the major decoration is likely to have been found. What remains of the original text extends through II Chronicles, itself repaired in a hand of the mid 12th century (ff. 175–76) and amplified with sections of the four Gospels (ff. 181–204), which must originally have been intended for another volume. The decoration consists of large and handsome initials, with *incipits*, incipit words and *explicits* rendered in alternating lines of acid green, red and blue. The initials lack uniformity, having been brought to varying degrees of completion, apparently over a certain period of time. Some have remained in the state of line drawings (ff. 2, 104, 138, 138v, 148), while others have been brought along further with the application of patches of blue, ochre and green (ff. 20v, 35, 59v). The P of IV Kings shows some touches of gold as well, while the initials of Ruth (f. 90) and the Preface of Kings (f. 91) alone are fully finished in body colour. The Joshua initial (f. 81), whose style reminded H. Swarzenski of the older masters of the Winchester Bible, is an isolated creation within the manuscript, never brought by the artist to a full or consistent finish. The work appears to have been begun in the period 1120–30, in a manner still containing perceptible echoes of the agile draughtsmanship of 11th-century Norman illumination. Typical elements of the pen-drawn initials are panelled shafts with angular interlace terminations, beast heads spewing foliage and large animal masks at the points of intersection. The framework of the letters and their foliage filling incorporates birds (ff. 104, 115), dragons (ff. 20v, 59v, 127v, 138), as well as squatting men and other animated figures (ff. 59v, 127, 148). F. Avril (*Manuscrits normands*, 1975), who sees in this Bible the beginning of a revival of the production of the Fécamp scriptorium after a period of relative inac-

tivity at the end of the 11th century, attributes to the major artist the decoration of several other manuscripts from this Channel Coast abbey: a Commentary on Origen by Rufinus (Rouen, Bibl. Mun. MS 424), Jerome's Commentary on Ezekiel (MS 445) and a compendium of Lives of the Saints (MS 1404).

PROVENANCE: No indication in the manuscript.

LITERATURE: Omont, *Catalogue général*, I, 1888, 2; Swarzenski, *Monuments of Romanesque Art*, 62–63, No. 135; Cahn, *Romanesque Bible Illumination*, 280–81, No. 105; J. M. Sheppard, *The Giffard Bible. Bodleian Library Ms. Laud Misc. 752*, New York and London, 1986, 73–74.

EXHIBITED: *Manuscrits normands, XI–XIVe siècles*, Rouen, 1975, 109–110, No. 121.

17. Paris, Bibliothèque Nationale MS lat. 10

Bible
575 × 350 mm., ff. 364, 2 cols., 60 lines
c. 1125 or second quarter of the 12th century.
Western France (?) *Ills. 34, 36*

Historiated and ornamental initials: PREFACE TO THE OLD TESTAMENT, F (f. 1); PREFACE TO THE PENTATEUCH, D (f. 2v); GENESIS, I, Creation scenes (f. 3v); EXODUS, H, (f. 17v); LEVITICUS, V, the Lord speaks to Moses (f. 29); NUMBERS, L (f. 37); DEUTERONOMY, H, man fighting lion (f. 49v); PREFACE TO JOSHUA, T (f. 60); JOSHUA, E (f. 60v); JUDGES, P (f. 68); RUTH, I (f. 75v); PREFACE TO KINGS, V (f. 76v); I KINGS, E (f. 77v); II KINGS, (f. 87); III KINGS, E (f. 95); IV KINGS, P (f. 104); PREFACE TO ISAIAH, N (f. 113); ISAIAH, V, standing Prophet with book (f. 113v); JEREMIAH, V, enthroned Prophet with book and staff (f. 127); EZEKIEL, E (f. 145v); DANIEL, A, enthroned ruler (f. 160v); HOSEA, V, seated Prophet with book (f. 167); JOEL, seated Prophet with book (f. 169); AMOS, V (f. 169v); OBADIAH, V (f. 171v); JONAH, E (f. 171v); MICAH, V, enthroned Prophet with book (f. 172); NAHUM, O (f. 173v); HABAKKUK, O, seated Prophet with scroll (f. 174); ZEPHANIAH, V (f. 174v); HAGGAI, I, standing Prophet (f. 175); ZECHARIAH, I (f. 175v); MALACHI, O, enthroned Prophet (f. 178); JOB, V (f. 179v); PSALMS, B, man fighting lion (f. 187); PROVERBS, P (f. 201); ECCLESIASTES, V, seated monarch with sceptre and flowering rod (f. 206v); SONG OF SONGS, O, enthroned personification of Ecclesia (f. 208v); WISDOM, D (f. 210); PREFACE TO ECCLESIASTICUS, M (f. 214); ECCLESIASTICUS, O, enthroned personification of Wisdom (f. 215); I CHRONICLES, A (f. 228); II CHRONICLES, C (f. 236v); PREFACE TO EZRA, U (f. 246v); EZRA, I (f. 246v); ESTHER, I, standing Ahasuerus (f. 253); TOBIT, T (f.257); JUDITH, A, beheading of Holophernes (f. 260); I MACCABEES, E (f. 264); II MACCABEES, F, figure with pennant (Judas Maccabeus?) (f. 273v); GOSPEL PREFACES, B, S, E (ff.

280, 280v, 283); CANON TABLES (ff. 281–282v); MATTHEW, L, Evangelist writing (f. 284); MARK, I, symbol of Mark with book (f. 293v); LUKE, Q, symbol of Luke with book (f. 299v); JOHN, I, symbol of John with book (f. 309); ACTS, P, dialogue of two haloed figures, perhaps Luke and Theophilus (f. 320); JAMES, I (f. 329); I PETER, P (f. 329v); II PETER, S (f. 331); I JOHN, Q (f. 331v); II JOHN, S (f. 332); III JOHN, S (f. 332v); JUDE, I, standing Apostle (f. 332v); PREFACE TO ROMANS, P (f. 333); PRISCILLIAN PREFACE, D (f. 334); ROMANS, P, seated Apostle (f. 336v); I CORINTHIANS, P (f. 341); II CORINTHIANS, P (f. 344v); GALATIANS, P, fighting figures (f. 347v); EPHESIANS, P (f. 349); PHILIPPIANS, P, struggling figure (f. 350); COLOSSIANS, P (f. 351); I THESSALONIANS, P, acrobatic figures (f. 352v); II THESSALONIANS, P (f. 353); TIMOTHY, P (f. 354); II TIMOTHY (f. 355); TITUS, P, man struggling with lion (f. 355v); PHILEMON, P (f. 356); HEBREWS, M (f. 356v); REVELATION, A, man struggling with beasts (f. 360).

This interesting manuscript has yet to be convincingly localized. Berger considered the text to be a kind of amalgamation of elements borrowed from the recension of Tours and the text of the Theodulph Bibles, but also incorporating features of southern French and Spanish ancestry, including the Peregrinus edition of the Pauline Epistles with the preface of Priscillian; he regarded the work as of meridional origin. Some aspects of its appearance support this view. The parchment has a typically yellowish character, the *incipits* are rendered in the highly ornate manner of southerly productions, and two initials (ff. 331v and 334) are in an unmistakably south-western French style that calls to mind the illumination of manuscripts like the Albigeois Bible of the Beinecke Library at Yale University (no. 36). The body of the decoration, however, could only be at home much further north. It appears to be the work of a single painter, though there is some fluctuation in the quality of the initials, some of which might have involved the participation of assistants. The work of this painter, unlike that of the southern hand, places emphasis on figuration. His subjects are normally standing or seated author portraits in the manner of the Italian Giant Bibles, but they also include fantastic combats between human or animal opponents. The structure of the letter is as a rule done in gold coarsely outlined in black; the rest of the design is executed in outline with a linear shading of red, green and blue in the lively 'striped' manner reminiscent of the books illuminated in Normandy for William of Saint-Calais, Bishop of Durham. The Bible must thus have been written in a milieu where the southern and northern elements could most reasonably have come together. Porcher proposed the Loire Valley, and more tentatively the region of Le Mans. This remains for the moment a likely though unconfirmed hypothesis.

PROVENANCE: Nicholas Foucquet. N.-C. Fabri de Peiresc (1580–1637). Acquired by the Royal Library in 1668. Regius 3560.

LITERATURE: Delisle, *Cabinet des manuscrits*, I, 284, n. 4; Berger, *Histoire de la Vulgate*, 182, 401; Lauer, *Manuscrits latins*, I, 8; id., *Enluminures romanes*, 50; Cahn, *Romanesque Bible Illumination*, 276, No. 86.

EXHIBITED: *Manuscrits à peintures*, Paris, 1954, 80, No. 218.

18. Orléans, Bibliothèque Municipale MS 13

Bible
550 × 337 mm., 503 pp., 2 cols., 50 lines
Second quarter of the 12th century.
Fleury *Ills. 39, 40*

Historiated and ornamental initials: PREFACE TO THE OLD TESTAMENT, F (p. 1, partially cut out); PREFACE TO PSALMS, I (p. 8); PSALMS, B (p. 11); PREFACE TO PROVERBS, T (p. 69); PROVERBS, P, enthroned Solomon admonishing his son (p. 72); ECCLESIASTES, D (p. 89); SONG OF SONGS, Virgin enthroned and censed by a pair of angels (p. 95); WISDOM, cut out (p. 99); ECCLESIASTICUS, O, Christ enthroned as Wisdom (p. 112); PREFACE TO CHRONICLES, E (p. 142); I CHRONICLES, cut out (p. 145); II CHRONICLES, C, Judgement of Solomon (p. 165); PREFACE TO EZRA, V (p. 190); EZRA, I, combat of warriors and dragons (p. 192); NEHEMIAH, E (p. 198); PREFACE TO ESTHER, L (p. 218); ESTHER, I (p. 219, partially cut out); PREFACE TO JUDITH, (p. 227, cut out); JUDITH, A (p. 228); TOBIT, T (p. 237); PREFACE TO MACCABEES, M (p. 244); I MACCABEES, cut out (p. 246); II MACCABEES, F (p. 269); MARK, I, ornamental initial with Evangelist symbol (p. 306); PREFACE TO LUKE, G, Evangelist symbol (p. 322); LUKE *argumentum*, L (p. 322); LUKE, Q, man fighting dragon; F (p. 325); John Preface, cut out (p. 351); JOHN *argumentum*, I, ornamental initial with Evangelist symbol (p. 351); JOHN, I, bust of the Lord extending a scroll to the Evangelist symbol (p. 351); PREFACE TO ACTS, L (p. 372); ACTS, P (p. 374); PREFACE TO CATHOLIC EPISTLES, N (p. 400); JAMES, I (p. 401); I PETER, P (p. 404); II JOHN, S (p. 412); III JOHN, S (p. 413); JUDE, I (p. 414); PREFACES TO PAULINE EPISTLES, P, E, R (pp. 414, 416, 421); ROMANS (p. 422); CORINTHIANS, P (p. 434); II CORINTHIANS, P (p. 445); GALATIANS, P (p. 454); EPHESIANS, P (p. 457); PHILIPPIANS, P (p. 461); COLOSSIANS, P (p. 465); LAODICEANS, P (p. 468); I THESSALONIANS, P (p. 469); II THESSALONIANS, P (p. 472); I TIMOTHY, P, Paul addresses Timothy (p. 474); II TIMOTHY, P (p. 478); TITUS, P (p. 480); PHILEMON, P (p. 482); HEBREWS, M (p. 483); PREFACE TO REVELATION, I (p. 492); REVELATION, A (p. 492).

The library of Fleury, once one of the most substantial in medieval France, was pillaged in the Wars of Religion of the 16th century, and its books destroyed or dispersed, significant remnants eventually finding their way into the Vatican Library, the Bürgerbibliothek in Bern and the University Library at Leiden. From the standpoint of decoration this Bible is the most important surviving local creation of the 12th century, when the state of the collection, rich in books of the early Middle Ages, caused some concern. In 1147, Abbot Macarius, finding that the volumes in the library were worn through use or damaged by rodents, decreed a schedule of annual levies to be paid by priories and other dependencies of Fleury for the repair of books and the purchase of new ones (M. Prou and A. Vidier, *Recueil des chartes de l'abbaye de Saint-Benoît-sur-Loire*, I, Paris, 1903, 343–47, No. CLI). The Bible is severely mutilated, with the books of the Octateuch, I–IV Kings, Major and Minor Prophets, and Job, now lost. These books were possibly bound in a separate volume, though the numbering of the gatherings is continuous. In addition to their normal prefaces Mark and John have a second preface from the Theodulph recension, well anchored in the area, and Luke has an otherwise undocumented second preface, beginning *Gloriosus evangelista* … (Berger, *Préfaces*, 59, No. 235).

The parts of the text that remain have large painted initials carried out by a single illuminator, with the exception of those provided by a contemporary hand for the beginning of Revelation and its preface (p. 492). The ornate *incipits*, *explicits* and *incipit* words are executed in large blue, mauve, red and green majuscule letters, and there are fine pen-drawn three-line decorative letters in combinations of red, ochre, blue and green at the beginning of the chapters throughout the work. The painted initials, generally placed on panels of flat colour, have a gold and silver framework rather heavily outlined in black. The spiralling foliage which fills the body of the letter incorporates a rich population of men and beasts: a figure pecked by a bird (p. 1); lions, dragons and a putto (p. 11); a putto in foliage (p. 69); fantastic creatures (pp. 11, 190); warriors with lances fighting dragons (pp. 192, 325); a figure harvesting grapes (p. 412); man, griffon, lion and eagle (p. 416); a man wrestling with a lion, sphinx (p. 469); a man with a dog, blowing a horn, sheep (p. 445). The painting lends to these small-scale elements a lively feeling, perhaps derived from Carolingian or Anglo-Saxon antecedents, examples of which were available at Fleury. The style is unrelated to the better documented illumination of other centres of the Loire Valley like Tours and Angers, but there is unfortunately no clearly definable local context in which the work can be securely placed. The graphic verve of the inhabited scrollwork evokes Norman illumination. It is somewhat reminiscent of the work of one of the illuminators of a Bible in the Bibliothèque Nationale (Bibl. Nat. lat. 10; no. 17), itself not yet well localized, and, more surprisingly, the illumina-

tion of the Saint-Bénigne Bible (Dijon, Bibl. Mun. MS 2; no. 64).

BINDING: wooden boards covered with pigskin, traces of bosses at the four corners.

PROVENANCE: *Ex libris monasterii Sancti Benedicti Floriacensis* (flyleaf, 18th–19th century). The manuscript may well correspond to the entry No. 83 in a catalogue of the Fleury monastic library dated 1552 (Cuissard, *Catalogue général*, XII, vii–xviii).

LITERATURE: A. Jacob, 'Alphabet majuscule de XIIIe siècle', *Mémoires de la Société archéologique de l'Orléanais*, II, 1853, 487–500; C. Cuissard, *Catalogue général*, XII, 1889, 9–12; G. Chenesseau, *L'abbaye de Fleury à Saint-Benoît-sur-Loire*, Paris, 1931, 76ff. Fr. Denis, 'Les anciens manuscrits de Fleury', *Bulletin trimestriel de la Société archéologique de l'Orléanais*, N.S. II, 1962, 280; Dodwell, *Painting in Europe*, 178; Cahn, *Romanesque Bible Illumination*, 274, No. 78; E. Vergnolle, 'Un carnet de modèles de l'an mil originaire de Saint-Benoît-sur-Loire', *Arte Medievale*, II, 1985, 36; J.-M. Berland, 'Hagiographie et iconographie romane à Saint-Benoît-sur-Loire', *Cahiers de Saint-Michel de Cuxa*, XVI, 1985, 159–61; M. Mostert, *The Library of Fleury. A Provisional List of Manuscripts*. (Middeleeuwse Studies en Bronnen, III), Hilversum, 1989, 11, No. BF408.

19. Paris, Bibliothèque Nationale MS lat. 5323

Lectionary
480 × 340 mm., ff. I + 203, 2 cols., 57 lines
Middle of the 12th century.
Western France *Ills. 41, 42*

Historiated and ornamental initials: S (f. 1v); C (f. 4v); H, I (f. 5v); S (f. 9); B (f. 10v); P, cut out (f. 11); T (f. 13); S, A (f. 15); H (f. 17v); I (f. 19); S (f. 21); C (f. 22); D, confronted birds (f. 22v); U, T (f. 24); P (f. 24v); S (f. 25); T (f. 27v); E (f. 29); Q, grotesque mask (f. 32); P (f. 35); N (f. 36); A, A (f. 39); I (f. 39v); T (f. 45); S (f. 46); X, archer, crossed dragons (f. 46v); I (f. 47); T, man bearing fish (f. 48v); Q, grotesque mask (f. 49); F (f. 49); I, man drawing sword (f. 52); A (f. 52); I (f. 52v); O, I (f. 54); D, man fighting lion (f. 56); D (f. 57); B (f. 58); E, acrobatic men in foliage (f. 62v); U (f. 64); R, combat of man with monster (f. 68); B, bird overcoming hare, combat of man and lion (f. 69v); F (f. 70v); T (f. 71v); B (f. 72v); T, lion devouring man (f. 73v); I (f. 74); T, man and monsters (f. 75v); A, man and dragon (f. 76); D, addorsed peacocks (f. 77v); P (f. 78v); S (f. 79); S (f. 80); I (f. 81); S (f. 83); P, man and lion (f. 85); I (f. 89); P (f. 90v); P, B (f. 92); P, two men, one astride the other (f. 93v); E (f. 93v); L (f. 96v); P (f. 97); S, T, man spewing foliage (f. 97v); T, dragon devouring man (f. 99v); T (f. 100); S, A (f. 101v); T (f.

104); T (f. 104v); C (f. 105); R (f. 109); P, man grasping naked man by the hair (f. 117); C (f. 119); M (f. 120); I (f. 120v); R (f. 125); D, St. Columba in half length (f. 133); I (f. 133bis); S (f. 134); I (f. 136v); I, O (f. 140); M, man spewing foliage (f. 140v); E, B (f. 141); F, man blowing horn (f. 141v); P (f. 143); I (f. 145); E (f. 147); A (f. 149); S (f. 150v); B, man fighting dragon, combat of man and lion (f. 151v); F (f. 152v); I, man playing viol (f. 154v); T, men in foliage; O, lion devouring man (f. 159); C (f. 160); D, hair pullers; P (f. 162); I (f. 162v); I (f. 166); V (f. 170); C, man playing harp (f. 175); I, (f. 176); T, cut out (f. 176v); F, man with birds (f. 178v); D, lion devouring ox (f. 179); T, man bearing ram (f. 180v); I (f. 182); P (f. 182v); B (f. 184); R, I (f. 185).

Blank spaces for initials not executed: ff. 9v, 17v, 34v, 38, 38v, 184, 188, 191, 192, 193, 195, 195v, 200, 201, 203, 203v.

The manuscript is the second volume of a set which must originally have comprised at least four volumes, containing the saints' lives to be read in the months of April to August. The list of saints represented includes a substantial contingent of commemorations centred on the Poitou and neighbouring regions: Cybard, Eutropius, Austregisilus, Radegund, Savinus and Cyprianus, Maixent (Maxentius), Mexme, and others. The inclusion of a life of St. Mayolus (ff. 46–48v) to which marginal glosses have been added suggests that the work was made for a Cluniac community of the region. The decoration consists of splendid initials for each saint's life, though sometimes also for the preface or for the separate books of these biographies. The initials from f. 188 to the end of the volume were not executed. The work has also lost two folios at the beginning and several at the end. The initials are the work of two illuminators commanding different styles. The first hand, who can be credited with most of the initials in the opening section of the volume, was a fine draughtsman whose designs are carried out in brown outline, delicately shaded in washes of the same brownish tint, and set off by flat panels of green, red or red-violet and powder blue. His attachments are with the Loire Valley, and as suggested by E. Burin, with the region of Le Mans. Swirls of a stylized variety of intertwined foliage are the dominant element of his formal vocabulary, supplemented with a sprinkling of motifs of an anthropomorphic or zoomorphic character: paired or confronted birds (ff. 22v, 39, 49); a dog and a bird (f. 27v); a figure bearing a fish (f. 48v). The second artist executed some initials in the opening pages of the volume (ff. 15, 24v, 39v, 47, 51 and 52v) and after this point takes over exclusively in the remaining body of the text. His initials are of a Limousin type close to the decoration of the Second Bible of Saint-Martial (Bibl. Nat. lat. 8; no. 37). Gaborit-Chopin identified him as one of the artists responsible for the illumina-

tion of the New Testament from Deffech, a priory of Grandmont near Agen (Bibl. Nat. lat. 252). When MS lat. 5323 was in the Bigot Collection, it was associated with another volume of a Lectionary, which bore the same inventory number (No. 171). This manuscript, now Bibl. Nat. lat. 5318, contains saints' lives for the period from January to March. Its format is approximately the same as its companion, and the two volumes may therefore well be part of the same set. The initials in MS lat. 5318 are all in the Limousin-Aquitaine style of the second painter of lat. 5323, but the design is simpler and the quality of their execution, like the manuscript as a whole, somewhat coarser. The relationship of the two volumes is therefore a question not yet finally settled.

PROVENANCE: Jean Bigot, Rouen; Emeric Bigot (d. 1689); Robert Bigot (d. 1692), and No. 171 in this collection. Acquired by the Royal Library in 1706. Regius 3605.

LITERATURE: L. Delisle, *Bibliotheca Bigotiana manuscripta. Catalogue des manuscrits rassemblés au XVIIe siècle par les Bigot, mis en vente au mois de juillet 1706, aujourd'hui conservés à la Bibliothèque Nationale*, Rouen, 1877, 47, No. 171; *Catalogus codicum hagiographicorum latinorum Bibliothecae Nationali Parisiensis*, Brussels, 1890, II, 217–37; W. Levison, *M.G.H., Script. rer. Merov.*, VII, 640; Gaborit-Chopin, *Manuscrits de Saint-Martial*, 149, 179; L. Ayres, 'The Role of an Angevin Style in English Romanesque Painting', *Zeitschrift für Kunstgeschichte*, XXXVI, 1974, 213, 216; Avril, *Royaumes d'Occident*, 176, 364; E. Burin, 'Réflexions sur quelques aspects de l'enluminure dans l'Ouest de la France au XIIe siècle: le manuscrit latin 5323 de la Bibliothèque Nationale', *Bulletin monumental*, CXLIII, 1985, 209–25.

20. Sées, Bibliothèque de l'Evêché MS 5

Four Gospels
360 × 235 mm., ff. 98, 33 long lines
Second quarter of the 12th century.
Saint-Martin de Sées *Ill. 57; Col. pl. I*

Historiated initials and evangelist portraits: PREFACE TO GOSPELS, B, men and lion (f. 1v); CANON TABLES (ff. 3v–7v); Matthew portrait (f. 10v); MATTHEW, L, medallions with Christ enthroned, Abraham, Isaac offering a sacrifice, Jacob (f. 11); PREFACE TO MARK, M (f. 36); Mark portrait (f. 36v); MARK, I, figure astride a lion, animal musicians and juggler (f. 37).

The Benedictine monastery of Saint-Martin at Sées was founded in the 6th century, destroyed in the Norman incursions, and reestablished in 1045 or 1050, when it was placed in the care of the reforming Abbot of Saint-Evroul, Thierry of Mattonville. The surviving manuscripts of the house are now for the most part divided between the Bibliothèque Municipale at Alençon and the Episcopal Library of Sées. The present Gospel Book is one of a small number of finely illuminated liturgical or quasi-liturgical codices, which also includes a somewhat earlier, badly mutilated, Bible (Sées, Bibl. de l'Evêché, MSS 1–2) and a life of St. Martin (New York, Pierpont Morgan Library M. 504). The manuscript of the Sées Gospels is worn through use and has suffered from vandalism. Roughly twenty folios have been excised, the missing pages including the prefaces and beginning of Luke (ff. 52v–53) and John (ff. 78v–79) with their decoration. The large opening initial for Jerome's prefatory letter to Pope Damasus, placed on a framed purple panel, was left unfinished. Its sketchy style harks back to Norman illumination around 1100 and its execution may indeed represent an earlier stage in the decoration of the manuscript. The Canon Tables of triple or quadruple arcades with variously ornamented columns (ff. 3v–7) and a quadrangular, vertically divided frame (f. 7v) are, like the remaining illumination, painted in body colour, with touches of gold. The two extant author portraits, brilliantly modelled in a saturated range of colours and enriched with gold, are framed panels of different sizes placed in the left-over spaces below the respective *argumenta*. Matthew, wearing a red garment draped over a light blue robe, is seated on an elaborate chair in front of a lilac curtain suspended on a curving rod which is fastened on columnar supports with capitals on each side of the composition. Mark, whose red tunic is draped over a deep blue robe, is seated on the back of a lion, his symbol, and his open book is lodged in the jaws of the beast. The background is an arcaded structure surmounted by turrets and gables.

The motif of an Evangelist seated on his symbol has a parallel in the Mostyn Gospels, and English work of the first quarter of the 12th century (Pierpont Morgan M.777), which was the starting point for the scholarly discussion of this unusual iconography. Panofsky (New York Public Library, *The Pierpont Morgan Library*, 1933–43, 17) suggested that these Evangelist portraits might have been inspired by illustrations of the planets mounted on their zodiacal signs found in Islamic and Indian art, of which there are occasional western reflections. D. Tselos (*Art Bulletin*, XXXXIV, 1952, 257–77), on the other hand, connected them instead with a rare representation of the four elements seated on animals, found in a German astronomical manuscript of the 12th century (Vienna, Österreichische Nationalbibl. Cod. 12600, f. 30). In this interpretation, the Evangelists are understood in allegorical terms as figures of the constituent parts of the universe. But W. Hinkle, writing about the Sées Gospels, noted that since only the portrait of Mark in this manuscript was depicted in this way, it would be unlikely to have been the bearer of such a comprehensive quaternity symbolism. He pointed instead to a variety of uses of animal sup-

ports in Romanesque art and observed that a figure of David seated on a lion appears in the descender of the initial of Psalm 109 in the Sées Bible (Sées, Bibl. de l'Evêché, MS 2, f. 47).

The style of the Sées Gospels corresponds in a general way to the phase of English illumination exemplified by the Shaftesbury Psalter and the Bury Bible. The connection with English art may not be wholly fortuitous, since Saint-Martin de Sées had some English possessions. Hinkle presumes that the portrait of Mark depends, albeit indirectly, on the corresponding image in the Mostyn Gospels. He also discerns in the portraits of the Sées Gospels a reiteration of certain motifs in the Evangelist portraits of the late 11th-century Gospels of Saint-Pierre des Préaux near Rouen (London, Brit. Lib. Add. 11580), and he connects the initials in the Sées manuscript with those of another earlier book from Préaux, the Gregory *Moralia* at Rouen (Bibl. Mun. MS 498). At Sées itself, there are stylistically related initials in the *Vita Martini* of the Pierpont Morgan Library.

BINDING: stamped leather over wooden boards (17th century [?])

PROVENANCE: *Liber sancti Martin sagicii* (15th-century *ex libris*, f. 2) with the addition *Congreg. S. Mauri* (17th century). Shelfmarks T.5 (17th century) and No. 27 (19th century).

LITERATURE: W. Hinkle, 'A Mounted Evangelist in a Twelfth-Century Gospel Book at Sées', *Aachener Kunstblätter*, XLIV, 1973, 193–210; id., 'The Gospels of Cysoing: The Anglo-Saxon and Norman Sources of the Miniatures', *Art Bulletin*, LVIII, 1976, 501ff; Avril, *Royaumes d'Occident*, 163–4; B. Louatron, *Les enluminures de la Bibliothèque Municipale d'Alençon et de l'Evêché de Sées* (Mém. de Maîtrise, Université du Maine), Le Mans, 1983, I, 155–6; E. Klemm, 'Beobachtungen zur Buchmalerei von Helmarshausen. Am Beispiel des Evangelistenbildes', *Helmarshausen und das Evangeliar Heinrichs des Löwen* (Schriftenreihe für Niedersächsische Bau– und Kunstgeschichte bei der Braunschweigischen Wissenschaftlichen Gesellschaft, IV), ed. M. Gosebruch and F. N. Steigerwald, Göttingen, 1992, 156.

EXHIBITED: *Trésors des églises normandes*, Rouen-Caen, 1979, 151, No. 181.

21. Avranches, Bibliothèque Municipale E. Le Héricher MS 159

Chronicle of Robert of Torigny
300 × 212 mm., ff. 238, 31 long lines (2 cols., 34 lines [ff. 4–7])
1156–57. Mont Saint-Michel *Ills. 48, 49, 50*

Historiated and ornamental initials: V, St. Jerome writing (f. 4); M, Moses speaks to the Children of Israel (f. 5); P, Eusebius of Caesarea writing (f. 7v); V, Sigebert of Gembloux dictating his chronicle to a monk (f. 70); T, Theodosius and Gratian in dialogue (f. 74); I, gesticulating figure, and D (f. 169); D, two clerics receive croziers from lay personages (f. 170v); Q, Robert of Torigny shows Henry of Huntingdon a manuscript of Nennius (f. 174).

Robert of Torigny became a monk of Bec in 1128 and the prior of that house in 1149. Around this time, or shortly before 1150, he was able to obtain through the intermediary of a bishop of Beauvais — thought to have been either Eudes III (1144–48), or his successor Henry (1149–62) — a copy of Sigebert of Gembloux's world chronicle, with additions made at Beauvais. He revised and expanded it for the years from 1110 to 1153 through the addition of material concerning the Anglo-Norman realm, using for this purpose such sources as William of Jumièges, Henry of Huntingdon and Ordericus Vitalis. In 1154, he became Abbot of Mont Saint-Michel, where he continued the chronicle, completing it in 1184, two years before his death, when he presented a copy to King Henry II of England (f. 3). The present manuscript is a transcription of the author's autograph copy, now lost, which remained at Bec and is listed in the catalogue of the library there; this catalogue is copied on the opening folios of the volume (ff. 1v–3; Omont, *Catalogue général*, II, 1888, 385–88). As indicated by Bethmann and Delisle, the manuscript was written by several hands, the first embracing the earlier chronicles of Eusebius, Jerome and Prosper of Aquitaine that were incorporated into Sigebert's history, and Robert's own reworking and continuation down to the year 1156 (ff. 4–206v). The remainder, covering the period from 1156 to 1186 (ff. 206v–36) was added in successive stages by different hands, along with the inventory at the beginning of the volume, which includes a list of 115 books given to Bec by the bishop of Bayeux, Philip of Harcourt.

The manuscript is enlivened by a fine sequence of iconographically inventive initials placed at the head of the different subsections of the original body of the text. These letters are drawn in brown outline, with shading and backgrounds in red, blue and green. The modelling of the figures relies on a limited, wash-like application of coloured tints, and the sockets of their bulging eyes are emphasized by a greenish shadowing, lending them a curiously frenzied appearance. *Incipits* and *incipit* words are rendered in alternating combinations of red, slate blue and green capital letters. Based on internal evidence, this decoration must have been completed by 1156. In terms of style, it is closely connected with the illumination of a copy of William of Jumièges's *Gesta Normannorum ducum* from Bec (Leiden, University Library, MS 20), which Robert of Torigny himself revised and amplified through the addition of a life

of King Henry I. It is therefore not impossible, as Nortier has suggested, that our manuscript might have been begun when he was still at Bec, and only completed upon his arrival at Mont Saint-Michel. Or could he perhaps himself have been involved in the illumination? On the other hand, there is also a fairly close connection between the initials of the chronicle and the drawings of the Mont Saint-Michel Cartulary (Mont Saint-Michel, Bibl. Mun. 210; no. 22); indeed Avril holds both books to have been illuminated by the same hand, perhaps a professional 'attaché pour un temps à la personne de Robert de Torigny'. If this were so, the artist would not markedly have affected the character of local book production. In more general terms, the best stylistic parallels for the initials of the chronicle appear in manuscripts of southern England, like the somewhat earlier Josephus (Cambridge, St. John's College, MS A. 8) and works of Anselm (Oxford, Bodl. Lib. MS Bodley 271), both from Canterbury.

PROVENANCE: Mont Saint-Michel Nos. II.1 and 198.

LITERATURE: Abbé Desroches, 'Notice sur les manuscrits de la Bibliothèque d'Avranches', *Mémoires de la Société des Antiquaires de Normandie*, 2e série, 1, 1840, 87–9; L. C. Bethmann, *M.G.H., Script.*, VI, 1844, 293–4, 475–535; M. Taranne, *Catalogue général*, Quarto Series, IV, 1872, 511–12; L. Delisle, *Chronique de Robert de Torigni, Abbé du Mont Saint-Michel* (Société de l'histoire de Normandie), Rouen 1872–73, I, xiv–liii; H. Omont, *Catalogue général*, X, 1889, 77–8; F. Avril, 'La décoration des manuscrits du Mont Saint-Michel (XIe–XIIe siècles)', *Millénaire du Mont Saint-Michel*, Paris, 1967, II 233–4; G. Nortier, *Les Bibliothèques médiévales des abbayes bénédictines de Normandie*, Paris, 1971, 39–43; Samaran-Marichal, *Manuscrits datés*, VII, 1984, 73; R. Mellinkoff, 'More About Horned Moses', *Jewish Art*, XIII, 1986/87, 197; R.H. and M.A. Rouse, '"Potens in Opere et Sermone": Philip, Bishop of Bayeux and His Books', *Authentic Witnesses. Approaches to Medieval Texts and Manuscripts*, Notre Dame, Ind., 1991, 45-46, 52.

EXHIBITED: *Millénaire du Mont Saint-Michel, 966–1966*, Paris and Mont Saint-Michel, 1966, 74, No. 134; *Ornamenta Ecclesiae*, Cologne, 1985, I, 235, No. B 35.

22. Avranches, Bibliothèque Municipale E. Le Héricher, MS 210

Cartulary of Mont Saint-Michel
355 × 245 mm., ff. 138, 19 long lines (ff. 5–112); 38–39 lines (ff. 112v–115)
1154–58. Mont Saint-Michel *Ills. 43, 44*

Four independent illustrations: Apparition of St. Michael to Bishop Aubertus of Avranches in a vision (f. 4v); Donation of Duke Richard II of Normandy in 1026 (f. 19v); Donation of Gonnor, second spouse of Duke Richard I (1020–22) (f. 23v); Donation of Duke Robert (1027–28) (f. 25v). Ornamental initials: I, P (f. 5); P (f. 10); N (f. 17); I (f. 18v); I (f. 20); I (f. 24); I (f. 26); I (f. 27v); E (f. 29v); P (f. 30); I (f. 40); I (f. 46).

The body of the manuscript opens with the *Revelatio ecclesiae Sancti Michaelis*, the legendary account of the foundation of Mont Saint-Michel following the apparition of the archangel Michael to Bishop Aubertus of Avranches at the end of the 7th century (*Pat. Lat.* LXXXXVI, 1389–94) and a summary history of Normandy (ed. Robillard de Beaurepaire, *Mémoires de la Société des Antiquaires de Normandie*, 3e ser., IX, 1877, 864ff.) The latest charter in the cartulary which follows (ff. 17–112) is dated 1154. It is followed by an annalistic record of various events and transactions that took place between the years 1154–57 (ff. 112v–115), written in a hand that has been identified as that of Abbot Robert de Torigny (1154–86) on the basis of comparison with other examples of his writing found in the Annals of Mont Saint-Michel (Avranches, Bibl. Mun. MS 211, f. 76) and in the Bec manuscript of William of Jumièges's *Gesta Normannorum ducum* at Leiden (University Library, MS 20). The date 1158 occurs on f. 115v. The remainder of the manuscript contains additions made from the 12th to the 14th centuries.

The first of the four independent miniatures that embellish the manuscript precedes the text of the *Revelatio*, though its subject is derived from another source, the account of the translation of the relics of St. Aubert (Robillard de Beaurepaire, 884–86). The composition has been given an added measure of solemnity through the application of gold in the backgrounds and parts of buildings. The illustration focuses on the moment when the archangel appears to Aubertus for the third time and wounds him on the head in order to impress on him his wish for a sanctuary at the summit of the island Mount Tumba. The scene takes place within a fortified structure or city whose turrets and arches harbour fighting figures and musicians, while a one-legged man armed with shears pursues a hare and an archer aims his bow at a bird outside the walls in the foreground. The other three miniatures concern princely privileges bestowed on Mont Saint-Michel. Two are donation scenes in which the transfer of a charter, depicted in the form of an enormous unfurled scroll, is ceremoniously displayed in the presence of a crowd of onlookers. The donation of income and property by Duke Robert of Normandy (f. 25v) is illustrated in a more unusual manner, giving the transaction a circumstantial character by presenting it as a pact made with the archangel himself, who appears in person on an altar, rather than with his delegate, the abbot of the monastery. The sealing of the pact through the symbolic deposit of a glove on the altar documents a feudal custom occasionally mentioned

in the written sources (cf. J. Le Goff, *Pour un autre moyen âge*, Paris, 1977, 361).

The illustrations of the Mont Saint-Michel cartulary are drawn with a sure hand and great finesse. In the first instance they have reminded scholars of two other illuminated manuscripts associated with Robert de Torigny, the world chronicle with his additions in Avranches, Bibl. Mun. MS 159 (no. 21) and the copy of William of Jumièges's History at Leiden. Among the stylistic relations of the cartulary further afield, Avril cites the St. Albans *Terence* (Oxford, Bodl. Lib. Auct. F. 2. 13), but especially the drawing of the Crucifixion in the Missal of Le Mans in the Pierpont Morgan Library (MS G. 17) and the stained glass windows in the nave of the cathedral of Le Mans — the latter already connected with the cartulary illustrations by A. M. Friend. The pen-drawn initials of the manuscript, which are by the same artist as the independent illustrations, are designs principally composed of stylized foliage, twisting and dragon-like beasts, and animal masks often attached to or merged like finials to the end of letters.

The cartulary of Mont Saint-Michel is the outstanding example to have survived among a small number of illuminated cartularies from the Romanesque period that were produced in France. Other manuscripts in this group are the 11th-century cartulary of Saint-Martin-des-Champs (London, Brit. Lib. Add. 11662) and the 12th-century cartularies of Marchiennes (Lille, Archives Départementales du Nord MS 10 H 323; no. 124), Vierzon (Bibl. Nat. lat. 9865; no. 6), Baigne (Angoulême, Bibl. de l'Evêché; see J. Mallat, *Revue de l'art chrétien*, VI, 1888, 324–26) and Notre-Dame de Salles, Bourges, the latter destroyed by fire in the 19th century, but recorded in part through tracings made for Count Auguste de Bastard (Paris, Bibl. Nat., Cabinet des Estampes; see W. Cahn, *Revue de l'art*, 47, 1980, 13–14).

PROVENANCE: Mont Saint-Michel.

LITERATURE: Abbé Desroches, 'Notices sur les manuscrits de la Bibliothèque d'Avranches', *Mémoires de la Société des Antiquaires de Normandie*, 2e ser., I, 1840, 74, No. 80; L. Bethmann, *Archiv der Gesellschaft für ältere deutsche Geschichtskunde*, VIII, 1843, 381; M. Taranne, *Catalogue général*, Quarto Series, IV, 1872, 526; L. Delisle, *Chronique de Robert de Torigny, Abbé du Mont Saint-Michel* (Société de l'histoire de Normandie), Rouen, 1872–73, II, xvii and 237–60; H. Omont, *Catalogue général*, X, 1889, 93; H. Stein, *Bibliographie générale des cartulaires français ou relatifs à l'histoire de France*, Paris, 1907, 277, No. 2011; A. Boinet, 'L'illustration du cartulaire du Mont Saint-Michel', *Bibliothèque de l'École des Chartes*, LXX, 1909, 335–43; P. Gout, *Le Mont Saint-Michel*, Paris, 1910, I, 7ff., 95; Swarzenski, *Monuments of Romanesque Art*, 61, No. 130; Grabar and Nordenfalk, *Romanesque Painting*, 145; G. Nortier, *Les Bibliothèques médiévales de Normandie*, Paris, 1966, 94; F. Avril, 'La décoration des

manuscrits au Mont Saint-Michel (XIe–XIIe siècles)', *Millénaire du Mont Saint-Michel*, Paris, 1967, II, 207, 229–33; M. Bourgeois-Lechartier, 'A la recherche du scriptorium du Mont Saint-Michel', *Millénaire*, II, 184–6; F. Mütherich, *Propyläen Kunstgeschichte*, V, 1969, 275, No. 391a; Alexander, *Norman Illumination at Mont Saint-Michel, 966–1100*, 99–100; R. Mellinkoff, *The Horned Moses in Art and Thought*, Berkeley, Los Angeles and London, 1970, 96; M. H. Caviness, 'Images of Divine Order and the Third Mode of Seeing', *Gesta*, XXII/2, 1983, 113; *Manuscrits datés*, VII, 77; C. M. Carty, 'The Role of Gunzo's Dream in the Building of Cluny III', *Current Studies on Cluny* (*Gesta*, XXVII/1–2), 1988, 117–118.

EXHIBITED: *Manuscrits à peintures*, Paris, 1954, 74, No. 195; *Art roman*, Barcelona and Santiago, 48, No. 58; *Millénaire du Mont Saint-Michel, 966–1966*, Paris, 1966, 75–76, No. 139; *Trésors des abbayes normandes*, Rouen-Caen, 1979, 75, No. 63.

23. Le Mans, Bibliothèque Municipale MS 224

Actus Pontificum Cenomanis
380 × 260 mm., ff. 123, 2 cols., 35–36 lines
Middle of the 12th century. Le Mans *Ill. 45*

Full-page portrait of Hugh of Saint-Calais (f. 113). Ornamental initial G (f. 5).

This much-studied work is the principal witness of the lives and deeds of the Archbishops of Le Mans, from St. Julian, the first occupant of the See, to Geoffrey of Loudun, who died in 1255. It incorporates for the deeds of the first 24 incumbents a transcription of the celebrated forgery attributed to Bishop Robert (d. 889) designed to document the antiquity and privileges of the cathedral chapter against the rival claimants in the city and region, notably the abbey of Saint-Calais, together with a life of Robert's predecessor Aldricus (832–57). The manuscript is a composite volume, incorporating sections of different dates. The body of the text ends with the *Acta* of Bishop Hugh of Saint-Calais, who died in 1144 (f. 116v), and was probably written at the latter's behest, but the *vita* of Aldricus is a later interpolation (ff. 84v–90v), as is the material covering the period from 1067 to 1136 (ff. 91–112), and the lives of the bishops beginning with William of Passavant (1145–87; ff. 117–132). An elaborate *incipit* in red capital letters and a handsome, pen-drawn, initial with foliate sprays precede the opening life of St. Julian (f. 5), while modest red and blue flourished initials stand at the beginning of the individual biographies. The sole pictorial contribution of any note is a full-page portrait of a standing bishop, which prefaces the *Acta* of Hugh of Saint-Calais. The frontally positioned figure, wearing a 'horned' mitre (cf. R. Mellinkoff,

The Horned Moses in Medieval Art and Thought, Berkeley, London, Los Angeles, 1970, 94ff.) holds a crozier with a finely-worked crook in the right hand and a book inscribed UGO EPISCOPU(S) in the left one. The vigorous drawing in pen outline, abetted by shading in light tints of blue, brown, and green is a somewhat harder or schematic version of the style of the illustrations in the Mont Saint-Michel Cartulary (Avranches, Bibl. Mun. 210; no. 22). The figure is placed within a frame, partly shaded with fine red hatching (right and bottom) and a meandering tendril (left and top) which may have been an afterthought. Episcopal commemoration as a pictorial theme seems to have originated in German art of the Ottonian period. The Psalter of Egbert, Archbishop of Trier (Cividale, Museo Archeologico, MS sacr. N CXXXVI) and the Pontifical of the Bishop of Eichstätt, Gundekar II (Eichstätt, Diözesanarchiv, MS B. 4), present a complete sequence of episcopal portraits. West of the Rhine, a 12th-century historical and biographical compilation from Metz includes a gallery of early local bishops (Munich, Bayer. Staatsbibl. Clm. 28565; no. 145). The creation of episcopal effigies in series is documented somewhat later in funerary sculpture and in stained glass.

PROVENANCE: Cathedral of Le Mans.

LITERATURE: C. Couderc, *Catalogue général*, XX, 1893, 153–4; J. Havet, 'Questions mérovingiennes. VII. Les actes des évêques du Mans', *Bibliothèque de l'École des Chartes*, LIV, 1893, 645ff.; 'Catalogus codicum hagiographicorum latinorum bibliothecae publicae Cenomanensis', *Analecta Bollandiana*, XII, 1893, 224, No 5; G. Busson and A. Ledru, *Actus pontificum Cenomanis in urbe degentium* (Archives historiques du Maine, 2), Le Mans, 1901; R. Latouche, 'Essai de critique sur la continuation des *Actus* (857–1255)', *Le Moyen Age*, XX, 1907, 226–47; H. Leclercq, *D.A.C.L.*, X, 2, 1932, 1443ff.; W. Goffart, *The Le Mans Forgeries. A Chapter from the History of Church Property in the Ninth Century*, Cambridge, 1966, 42ff.; J. Van der Straeten, 'Hagiographie du Mans: notes critiques', *Analecta Bollandiana*, LXXXV, 1967, 474–501; M. Sot, *Gesta episcoporum, gesta abbatum* (Typologie des sources du moyen âge occidental, 37), Turnhout, 1981, 13 and *passim*; *Manuscrits datés*, VII, 179–81.

24. Santiago de Compostela Archivo de la Catedral

Liber Sancti Jacobi (*Jacobus*)
295 × 212 mm., ff. I + 225 + I, 34 long lines
Middle of the 12th century.
North or Western France (?) *Ills. 54, 55, 56*

Two illustrations preceding Book IV: St. James appears to Charlemagne in a dream and exhorts him to undertake a campaign against the Saracens (f. 162).

Full-page miniature in two registers: above, Charlemagne's army sets out from a fortified city; below, fortified city of Aachen, group of armed men (f. 162v).

Historiated and ornamental initials: C, Pope Calixtus writing (f. 1); I, St. James standing (f. 4); S (f. 24v); A (f. 31); D (f. 44v); P (f. 48); A (f. 53v); Q (f. 55v); S (f. 72); V (f. 74); S (f. 95); S (f. 107); G and I (f. 118v); S (f. 140); B (f. 141); T, seated Turpin (f. 163); G (f. 164); P (f. 179); Q (f. 192).

This famous and still problematic book bears the title *Jacobus* (f. 1) though the text is now better known as *Liber Sancti Jacobi*, of which the present copy is the *Codex Calixtinus*. It is a compilation of historical, hagiographical and liturgical material concerning St. James, said to have been made by Pope Calixtus II (1119–1124) with the intention that it be adopted by the church of Compostela, where the body of the saint was venerated. The colophon-like *explicit* of Bk. IV (f. 18v) states that the compilation had already been transcribed a number of times earlier, in Rome, Jerusalem, Gaul, Italy, Frisia, and especially in the monastery of Cluny. The prefatory epistle, falsely attributed to Calixtus II, which opens the volume addresses the work to the Abbot and monks of Cluny, to the Patriarch of Jerusalem, William of Messina, and to Diego Gelmírez, Archbishop of Compostela. According to an equally spurious letter of Pope Innocent II (f. 221) it was brought to Compostela by one Aymericus Picaud, from Parthenay-le-Vieux in Poitou (Western France), and his companion, a woman from Flanders named Girberga. As is further indicated, this same Aymericus was also for some reason known as, or possibly associated with, a certain Oliverus de Iscani — the Latin *qui etiam* connecting the two names is obscure. Iscani has been identified as the village of Asquins located in the vicinity of Vézelay in Burgundy.

The *Liber Sancti Jacobi* comprises five sections, with some miscellaneous additions (ff. 214–221). The first is an anthology of liturgical pieces, prayers and sermons in honour of the saint (ff. 139v–155v), and is followed by the legendary history of the conversion of Spain and the transfer of the saint's body to Galicia (ff. 156–162v). Next comes the legendary account of Charlemagne's expedition to Spain by the Pseudo-Turpin (ff. 163–191v), while the final part consists of the celebrated pilgrims' guide to Santiago de Compostela (ff. 192–213v). The purpose of this compilation and its true author are still much discussed issues, as is the role in the entire affair of the otherwise mysterious Aymericus. The date of the manuscript cannot be fixed with certainty. The forged letter of Innocent II has subscriptions by eight cardinals who were in office in the period 1139–40, and the latest miracle in the original hand to which a date can be assigned stems from the year 1135 (Miracle XIII; f. 148). Most authors agree that the Codex Calix-

tinus is the volume which Aymericus brought to Compostela. Some, following R. Louis, believe that it arrived there in 1139 or 1140, while others take these dates as a *terminus post* only and favour a date around the middle of the 12th century (P. David) or shortly before (A. Stones). For M. Díaz y Díaz, on the other hand, whose opinion is endorsed by M. Huglo, the *Codex Calixtinus* is an adaptation or local reworking of the materials brought to Compostela earlier, to be dated somewhat later, in the third quarter of the 12th century. The terminus *ante* is 1173, since in that year a monk of Ripoll, named Arnaldus de Monte, is known to have made a partial copy of the manuscript.

According to A. Hämel (*Überlieferung und Bedeutung*, 11–21), the body of the Codex Calixtinus (ff. 1–213v) was written by four main scribes, while a number of other hands are in evidence in the added material at the end (ff. 214–225v). Bk. IV, consisting of the chronicle of the Pseudo-Turpin, was separated from the volume in 1619, but reintegrated in a restoration of the manuscript carried out in 1964. The decoration was also restored at that time, though not in a manner that is accurate in all respects. This decoration is most heavily concentrated in the chronicle of the Pseudo-Turpin, which alone has independent miniatures, as well as a large opening initial with an author portrait in the quasi-formal manner of a frontispiece. In their somewhat incidental character the subjects treated in the two framed miniatures give the impression of having been excerpted from a larger cycle. The prefatory page with a pair of scenes (f. 162v) is awkwardly composed, leaving a wide empty zone with sluggish linear flourishes along the bottom. The puzzling second scene in the middle register showing the fortified cityscape of Aachen and six warriors has not thus far received a convincing interpretation. The story of Charlemagne's dream vision of St. James (f. 162), occurs among the frescoes in the nave of the church of Santa Maria in Cosmedin in Rome, which were, interestingly, commissioned by Calixtus II. Stones, however, has noted that the composition in the *Codex Calixtinus* is much closer to the corresponding subject on the shrine of Charlemagne in the cathedral of Aachen (1200–1215). The decoration includes pen-drawn ornamental initial letters and zoomorphic elements in simple combinations of colours, executed by different hands, as well as more elaborate multi-coloured initials drawn in outline and reserved on panelled grounds.

Where the manuscript was produced is as yet an unresolved question. Burgundy was proposed by R. Louis and has some support on the musicological side. The case for a Compostelan origin was recently made by M. Díaz y Díaz, though with a clear recognition of elements of French origin. The stylistic parallels that can be cited for the illumination — a Psalter and Ritual from Fleury at Orléans (Bibl. Mun. MS 123), a Bible from Loches (Paris, Bibl. Sainte-Geneviève, MS 1) and other books from Tours and Le Mans — point in the direction of western France or Normandy, though not in such a fashion as to be decisive. The draughtsmanly verve which marks the initials and the habit of the artist of rendering forms in multiple parallel pen lines recall Anglo-Norman illumination of a somewhat earlier time, and in particular, the manuscripts associated with William of Saint-Calais, as Avril has observed. Three copies of the *Codex Calixtinus* are known, all of them of Spanish origin, and datable in the late 13th and 14th centuries (Bibl. Apost. Vatic., Arch. S. Pietro C. 128; London, Brit. Lib. Add. 12213; Salamanca, Bibl. Univ. Cod. 2631). They reproduce with varying degrees of fidelity the decoration of the 12th-century model.

PROVENANCE: Said to have been brought to Santiago de Compostela by the Poitevin priest Aymericus Picaud (f. 221).

LITERATURE: V. Friedel, 'Études compostellanes', *Otia Merseiana*, I, Liverpool, 1889, 75–112; A. López Ferreiro, *Historia de la Santa S.M. Iglesia de Santiago de Compostela*, Santiago de Compostela, 1898–1909, I–V, *passim*; J. Domínguez Bordona, *Exposición de códices miniados españoles*, Madrid, 1929, 51, 53, 56; id., *Manuscritos con pinturas*, Madrid, 1933, I, 120–1, No. 226; C. Meredith-Jones, *Historia Karoli magni et Rotholandi ou Chronique du Pseudo-Turpin*, Paris, 1936; A. Hämel, 'Aus der Geschichte der Pseudo-Turpin Forschung', *Romanische Forschungen*, LVII, 1943, 229–45; W. M. Whitehill and Dom G. Prado, *Liber Sancti Jacobi, Codex Calixtinus*, Madrid, 1944, 3 vols; P. David, 'Études sur le livre de Saint-Jacques attribué au pape Calixte II', *Bulletin des études portugaises*, X, 1946, 1–41; XI, 1947, 1–73; XII, 1948, 1–154; XlII, 1949, 1–53; R. Louis, 'Aimeri Picaud, compilateur du "Liber Sancti Jacobi"', *Bulletin de la Société Nationale de Antiquaires de France*, 1948–9, 80–97; L. Vázquez de Parga, J. M. Lacarra and J. Uría Ríu, *Las Peregrinaciones a Santiago de Compostela*, Madrid, 1948, I, 172–200, 202; A. Hämel, 'Überlieferung und Bedeutung des "Liber Sancti Jacobi" und des Pseudo-Turpin', *Sitzungsberichte der Bayerische Akademie der Wissenschaften*, Phil.-Hist. Klasse, Munich, 1950, Heft 2; A. Moralejo, C. Torres and J. Feo, *Liber Sancti Jacobi. Codex Calixtinus*, Santiago de Compostela, 1951; J. Richard, 'Pour la connaissance d'un type social. Un "jongleur" bourguignon du XIIe siècle', *Annales de Bourgogne*, XXV, 1953, 182–5; A. de Mandach, *Naissance et développement de la chanson de geste en Europe. I. La geste de Charlemagne et de Roland*, Geneva-Paris, 1969, 121–3; *Art roman*, 532–3, Nos. 1768–1769; J. Vielliard, ed., *Le Guide du pèlerin de Saint-Jacques de Compostelle*, Mâcon, 1963; A. Hämel, *Der Pseudo-Turpin von Compostela. Aus dem Nachlass herausgegeben von André de Mandach* (*Sitzungsberichte der Bayerische Akademie der Wissenschaften*, Phil.-Hist. Klasse, Heft 1), 1965; A. de Mandach, 'La genèse du guide du

pèlerin de Saint-Jacques, Orderic Vital et la date de la geste de Guillaume', *Mélanges offerts à Rita Lejeune*, Gembloux, 1969, II, 811–27; R. Lejeune and J. Stiennon, *The Legend of Roland in the Middle Ages*, London, 1971, 51–60; C. Romero de Lecea, J. Guerra Campos and J. Filguerira Valverde, *Libro de la peregrinación del Códice Calixtino*, Madrid, 1971; C. Hohler, 'A Note on Jacobus', *J.W.C.I.*, XXXV, 1972, 31–80; A. Stones, 'Four Illustrated Jacobus Manuscripts', *The Vanishing Past. Studies of Medieval Art, Liturgy, and Metrology Presented to Christopher Hohler*, ed. A. Borg and A. Martindale, (BAR International Series, III), Oxford, 1981, 197–222; J. López Calo, *La música medieval en Galicia*, La Coruña, 1982; Avril, *Royaumes d'Occident*, 259; K. Herbers, *Der Jakobskult des 12. Jahrhunderts und der 'Liber Sancti Jacobi'. Studien über das Verhältnis zwischen Religion und Gesellschaft im hohen Mittelalter* (Historische Forschungen im Auftrag der Historischen Kommission der Akademie der Wissenschaften und der Literatur, VII), Wiesbaden, 1984, 21ff.; S. Moralejo Álvarez, 'El patronazgo artístico del arzobispo Gelmírez (1100–1140): su reflejo en la obra e imagen de Santiago', *Atti del Convegno Internazionale di Studi. Pistoia e il Cammino di Santiago*, Pistoia, 1984, 264–6; A. Moisan, 'Aimeri Picaud de Parthenay et le "Liber Sancti Jacobi"', *Bibliothèque de l'École des Chartes*, CXLIII, 1985, 5–52; id., 'Le séjour d'Aimeri Picaud à l'église Saint-Jacques d'Asquins et la composition du "Liber sancti Jacobi"', *Annales de Bourgogne*, LVII, 1985, 49–58; J. van Heerwarden, 'L'integritá di testo del Codex Calixtinus, *Il Pellegrinaggio a Santiago de Compostela, e la letteratura jacopea'. Atti del Convegno internazionale di studi* (Perugia 23–25 Settembre 1983), Perugia, 1985, 251–70; K. Herbers, *Der Jakobsweg, mit einem mittelalterlichen Pilgerführer unterwegs nach Santiago de Compostela*, Tübingen, 1986; M. Díaz y Díaz, *El Códice Calixtino de la Catedral de Santiago. Estudio codicológico y de contenido*, Santiago de Compostela, 1988. M. Huglo, 'Le "Codex Calixtinus" et le tombeau de Saint-Jacques à Compostelle', *Cahiers de civilisation médiévale*, XXXII, 1989, 100–103; J. Williams and A. Stones, eds., *The 'Codex Calixtinus' and the Shrine of St James* (Jakobus Studien, 3), Tübingen, 1992; A. Shaver-Crandell, P. Gerson, A. Stones, *The Pilgrim's Guide to Santiago de Compostela: A Gazetteer*, London, 1995; A. Stones, J. Krochalis, *The Pilgrim's Guide to Santiago de Compostela: A Critical Edition*, forthcoming.

25. Tours, Bibliothèque Municipale MS 93

Gilbert de la Porrée, Commentary on the Pauline Epistles
303 x 121mm., ff. 211, 2 cols., 18–27 lines (text), 42–44 lines (gloss)
Middle of the 12th century. *Ill. 51*

Historiated and ornamental initials: Psalm 1, B (f. 2v); Psalm 26, D (f. 32v); Psalm 38, D (f. 49v); Psalm

51, Q, David and Ahimelech (f. 67); Psalm 52, D (f. 68v); Psalm 68, S (f. 88); Psalm 80, E (f. 113); Psalm 96, C (f. 132); Psalm 101, D, Christ in Majesty (f. 134); Psalm 109, D (f. 151).

Gilbert de la Porrée's Commentary on the Psalms is an early work of that author, later a teacher in Paris and Bishop of Poitiers (1142–54), completed when he was still attached to the circle of his master, Anselm of Laon. The Tours manuscript, one of some twenty known 12th-century copies of the commentary (Stegmüller, *Repertorium*, II, 345–46, No. 2510) shares the characteristic layout of the series. The gloss, a very copious *catena* of patristic sources, is written in a small hand and in a wide single column along the outer margin of the page. A narrower column on each side of the central gutter encompasses the biblical text, written in a larger format, and in order to coordinate it with the much more extensive commentary, more widely spaced. The date of the Tours manuscript places it among the initial efforts to give this type of compilation, a product of the biblical and theological studies promoted in the newly thriving schools, a much more than merely functional presentation. There are large painted initials for the Psalms of the ten-partite subdivision, and smaller, three-line ornamental letters in gold, outlined in black and flourished in red and blue for the ordinary Psalms. Smaller, two-line initials of the same type introduce the corresponding sections of the gloss. The *tituli* are written in red and the individual verses marked by one-line initials in an alternating sequence of blue and red. The major initials are executed in body colour, chiefly red, light blue, light green and white, and set on gold grounds. Their design consists in the main of wiry spiralling foliage, inhabited in two instances by naked, battling men (ff. 32v, 132). A copy of Gilbert's Commentary on the Pauline Epistles in the Beinecke Rare Book and Manuscript Library at Yale University (Marston MS 152), for which a southern English attribution had earlier been proposed (W. Cahn and J. Marrow, *Yale University Library Gazette*, LII, 2, 1978, 187–8, No. 15), exhibits comparable features, though in a less refined mode.

BINDING: stamped calfskin binding with traces of bosses, with stamped signature IEHDEL/ ANGLE/ MELIOIA (Jehan de l'Angle me lia), 15th or early 16th century.

PROVENANCE: Cathedral of Saint-Gatien, Tours, No. 23 (f. 2).

LITERATURE: A. Dorange, *Catalogue descriptif et raisonné des manuscrits de la Bibliothèque de Tours*, Tours, 1875, 37–38; M. Collon, *Catalogue général*, XXXVII, 1900, 57–58. Leroquais, *Psautiers*, II, 231; M. Schapiro, 'Two Romanesque Drawings in Auxerre and Some Iconographic Problems', *Studies in Art and*

Literature for Belle da Costa Greene, ed. D. Miner, Princeton, 1954, 314 and nn. 55, 75; N. M. Häring, 'Handschriftliches zu den Werken Gilberts, Bischof von Poitiers (1142–54)', *Revue d'histoire des textes*, VIII, 1978, 184–85, No. 155.

26. Tours, Bibliothèque Municipale MS 193

Sacramentary
279 × 217 mm., ff. 197, 2 cols., 22 lines
Third quarter of the 12th century.
Saint-Martin, Tours *Ills. 52, 53; Col. pl. II*

Two full-page miniatures: Christ in Majesty surrounded by the Evangelist symbols (f. 69v); Crucifixion with Mary and John, and Moses raising the Brazen Serpent (f. 70). Historiated and ornamental initials: D (f.15v); C (f. 17); D, Adoration of the Magi (f. 21v); D, Three Maries at the Sepulchre (f. 48v); C, Ascension or Mission of the Apostles (f. 54); D, Descent of the Holy Spirit (f. 56v); O, Trinity (f. 59); Framed page and ornamental initial for *Per omnia* (f. 70v); Framed page and half-page *Vere Dignum* monogram, with bust of Christ blessing in an ornamental panel (f. 71v); D, St. Martin preaching and felling of the sacred pine tree (f. 78v); D (f. 85); D, busts of Peter and Paul (f. 86v); D, consecration of St. Martin as Bishop of Tours (f. 89); V, Assumption of the Virgin (f. 98); S (f. 104v); D, Ordination of St. Florentinus by St. Martin (f. 109); D, combat of St. Michael with the dragon (f. 110v); O, Christ with the Virgin and the choir of the saints (f. 115); D, quarrel over the body of St. Martin between the monks of Ligugé and Marmoutiers. The latter remove the body through a window. Below, transportation of the body of St. Martin to Tours on the Loire (f. 116v).

This handsomely illuminated manuscript is not mentioned in the inventory of manuscripts of Saint-Martin at Tours found in Montfaucon's *Bibliotheca Bibliothecarum* (1739), and Collon suggests that it was probably preserved with the most precious objects of the church in its treasure. As might be expected, St. Martin is heavily represented in the Calendar, with commemorations of the major feast day (12th May), Vigil (3rd July), *Translatio, Ordinatio* and *Dedicatio basilice sue* (4th July), *Transitus* (11th November), Octave (18th November), and *Reversio*, the anniversary of the return of Martin's relics from their exile in Burgundy after the Norman invasions (11th December). The volume also includes a collection of votive masses for the saint (ff. 121ff.) The original 12th-century nucleus comprising the Sacramentary comes to an end on f. 142v. It is followed by the antiphonal, added in a 13th-century hand (ff. 143–85), and transcriptions of oath formulas and documents concerning the rights and possessions of the canons of Saint-Martin in various hands from the late 12th to the 14th centuries (ff. 185–96). The date

of the original core of the work can only be established approximately. The feast of St. Thomas of Canterbury, canonized in 1173, is an addition. Samaran-Marichal have found a similar script and *mise-en-page* in two manuscripts executed at nearby Marmoutiers between 1177–87 (Tours, Bibl. Mun. 308 and 344), and on this basis, they reason that the Sacramentary might have been written there rather than at Saint-Martin in these same years. The genesis of the work is probably near the earlier of these two dates, around the end of the third quarter of the 12th century.

The manuscript has splendid, stylistically homogenous painted decoration, moderately affected by wear. The choice of colours — red, blue, brown, green with gold backgrounds — adheres to the general tonality of the earlier Psalm Commentary of Gilbert de la Porrée from the Tours Cathedral library (Tours, Bibl. Mun. MS 93; no. 25), but the forms are more energetically modelled, as well as heavily outlined in black. Flaking in a few places reveals a sketchy underdrawing in red (f. 18v). The illumination imparts to the text a purposeful visual hierarchy. In the Canon of the Mass, the painter emphasizes the typological interpretation of the sacrificial rite through the inclusion of Moses raising the Brazen Serpent in the Crucifixion, and the confrontation of the triumphant Ecclesia with the 'unveiled' Synagoga in the *Vere Dignum* monogram. The major feasts are singled out with historiated initials, two of them accompanied by descriptive titles (ff. 98, 109). Among these festivals, those which concern St. Martin exhibit scenes of the saint's life and posthumous fame, with emphasis on the role of Tours as the centre of his activities and cult (ff. 78v, 89, 109, 116v). Secondary feast days have smaller initials in gold, flourished in red and blue, while the separate sections of each Mass are introduced by still more modest three-line flourished ornamental letters in red and blue.

PROVENANCE: Saint-Martin de Tours.

LITERATURE: A. Dorange, *Catalogue descriptif et raisonné des manuscrits de la Bibliothèque de Tours*, Tours, 1875, 101–106; M. Collon, *Catalogue général*, XXXVII, 1900, 135–39; E. K. Rand, *A Survey of the Manuscripts of Tours*, Cambridge, 1929, I, 201–202, No. 228; Leroquais, *Sacramentaires*, I, 313–17; H. Leclercq, *D.A.C.L.*, XV, 2, 1953, col. 2671; M. Schapiro, 'Two Romanesque Drawings in Auxerre and Some Iconographic Problems', *Studies in Art and Literature for Belle da Costa Greene*, ed. D. Miner, Princeton, 1954, 324 n. 55; B. Blumenkranz, *Le Juif médiéval au miroir de l'art chrétien*, Paris, 1966, 110; *Manuscrits datés*, VII, 535; S. Farmer, *Communities of Saint Martin. Legend and Ritual in Medieval Tours*, Ithaca, 1991, 12, 235–43.

27. Paris, Bibliothèque Nationale MSS lat. 55 and 116

Bible (in two volumes)
525 × 360 mm., ff. 228 and 224, 2 cols.,
49–50 lines
Middle of the 12th century.
Region of Chartres (?) *Ills. 46, 47*

MS lat. 55

Historiated and ornamental initials: PREFACE TO PEN-
TATEUCH, D (f. 1v); GENESIS, I, ornamental, with the
Lord enthroned and holding a book (f. 2v); EXODUS,
H (f. 22v); LEVITICUS, V, the Lord with Moses, who
holds the tablets of the Law (f. 38v); NUMBERS, L, the
Lord speaks to Moses (f. 49v); DEUTERONOMY, H (f.
65v); PREFACE TO JOSHUA, T (f. 78); JOSHUA, E (f. 78v);
JUDGES, P (f. 87); RUTH, I (f. 96); PREFACE TO KINGS, V
(f. 97v); I KINGS, F (f. 98); II KINGS, F (f. 110); III KINGS,
E (f. 119v); IV KINGS, P (f. 130v); PREFACE TO ISAIAH, N
(f. 141v); ISAIAH, V (f. 141v); PREFACE TO JEREMIAH, H
(f. 158); JEREMIAH, V, the Lord speaks to Jeremiah (f.
158v); PREFACE TO EZEKIEL, H (f. 179v); EZEKIEL, E (f.
179v); PREFACE TO DANIEL, D (f. 196v); Daniel, A (f.
197); PREFACE TO MINOR PROPHETS, N (f. 204); HOSEA,
V, enthroned Prophet, addressed by the Lord (f.
204v); JOEL, V (f. 207); AMOS, V (f. 208); OBADIAH, V,
half-length prophet with book (f. 210); JONAH, E, the
Lord speaks to Jonah (f. 210); MICAH, V, the Lord
speaks to the Prophet (f. 211); NAHUM, O (f. 212);
HABAKKUK, O, enthroned Prophet with book (f. 213);
ZEPHANIAH, V, enthroned Prophet with book (f. 214);
HAGGAI, I (f. 214v); ZECHARIAH, I (f. 215v); MALACHI,
O, enthroned Prophet with book, addressed by the
Lord (f. 218v); PREFACE TO JOB, C (f. 219); JOB, V (f.
219v).

MS lat. 116

Historiated and ornamental initials: PREFACE TO
PROVERBS, I, T, (f. 1); PROVERBS, P (f. 1v); ECCLESI-
ASTES, V (f. 9); SONG OF SONGS, O, the Bride and
Bridegroom as Christ and Ecclesia (f. 12); Wisdom,
D, enthroned personification of Wisdom (f. 13v); PRE-
FACE TO ECCLESIASTES, M (f. 19); ECCLESIASTICUS, O,
Christ in Majesty with Evangelist symbols (f. 19v);
PREFACE TO CHRONICLES, S (f. 34v); I CHRONICLES, A (f.
35); II CHRONICLES, C (f. 45); PREFACE TO EZRA, V (f.
57v); EZRA, I (f. 58); PREFACE TO ESTHER, L, Ahasuerus
extends his sceptre to Esther (f. 65v); ESTHER, I (f. 66);
PREFACE TO TOBIT, C (f. 70); TOBIT, T (f. 70v); PREFACE
TO JUDITH, A (f. 74); JUDITH, A (f. 74); I MACCABEES, C
(f. 79); II MACCABEES, F (f. 91v); CANON TABLES (ff.
101–102v); MATTHEW, L, standing Evangelist with
book (f. 103v); MARK, I (f. 116v); LUKE, Q and F, Evan-
gelist at a lectern (f. 124v); JOHN, I (f. 138); PREFACE TO
ACTS, L (f. 147); ACTS, P (f. 147v); PREFACE TO CATHO-
LIC EPISTLES, N (f. 159); I JAMES, standing Apostle with
book (f. 159v); I PETER, P (f. 160); II PETER, S (f. 162); I
JOHN, Q (f. 163); II JOHN, S (f. 164); III JOHN, S (f. 164v);

JUDE, I (f. 164v); PREFACE TO ROMANS, E (f. 165); RO-
MANS, P (f. 167); PREFACE TO I CORINTHIANS, C (f. 172);
I CORINTHIANS, P (f. 172); II CORINTHIANS, P (f. 176v);
GALATIANS, P (f. 179v); EPHESIANS, P (f. 181); PHILIP-
PIANS, P (f. 182v); I THESSALONIANS, P, seated Paul
with book (f. l83v); II THESSALONIANS, P (f. 184v);
COLOSSIANS, P (f. 185); I TIMOTHY, P (f. 186v); II TIMO-
THY, P (f. 187v); TITUS, P (f. 188v); PHILEMON, P (f.
189); HEBREWS, M (f. 189v); REVELATION, A, Christ
enthroned and flanked by a pair of angels (f. 193).
Psalms, B (f. 199v); Psalm l09, D (f. 215).

The first of this set of two volumes carries a Saint-
Denis shelfmark of the middle of the 13th century,
but judging from the relatively sparse and uneven
body of 12th-century illumination from that centre
to have survived, it seems not to have been made
there. There are large painted initials for all the
biblical books and some of the prefaces, which are
executed in bold colours, chiefly red, maroon, light
blue, light green, a kind of warm off-white, along
with silver and gold, the latter tooled here and there
with dots and diaper patterns with the help of a blunt
instrument. The modelling is linear in its effect and
the designs, outlined in black, are large in scale,
though a trifle stiff and lifeless. The ornamental
initials, which predominate, feature men and beasts
clambering in foliage (MS 55, ff. 22v, 65, 66, 141v,
206v; MS 116, f. 149), along with finials in the form,
of dragons, birds, or helmeted men. A remarkable
letter M (MS 116, f. 19v) is constructed of two drag-
ons with necks intertwined, devouring a naked
woman. The illustrative matter of the historiated
initials is largely confined to single figures or simple
groups that have no clear anchor in space or setting.
A single painter seems to have carried out the illu-
mination of both volumes, though a tendency to-
wards economy manifests itself toward the end of
the work, as is often the case in such large projects.
According to F. Avril, the palaeography and secon-
dary elements of the decoration, which consist of
incipits and *explicits* in blue and red capitals, along
with blue and red pen-work initials throughout the
text, point to the region of Chartres. A manuscript
with works of Suetonius, Florus, Frontinus and other
classical authors has initials in the same style (Bibl.
Nat. lat. 5802), and some further broadly compara-
ble examples of book illumination from the Paris
milieu have also been signalled by Mérindol: a copy
of Augustine's *Enarrationes in Psalmos* from Saint-
Victor (Bibl. Nat. lat. 14289) and the Glossed books
left by Prince Henry, a son of Louis VI, to Clairvaux,
for which a Paris origin is now generally assumed.
Stahl speculates that the Bible may have been pro-
duced at Chartres for Saint-Denis.

PROVENANCE: Saint-Denis shelfmark Ṙ, 13th cen-
tury (MS 55, f. 1v); Nicolas Rigault and Frères Du-
puy, MSS 175 and 176. Acquired by the Royal Library
in 1636. Regius 3565 and 3566.

LITERATURE: Lauer, *Manuscrits latins*, I, 25, 43; D. de Bruyne, 'Membra disiecta', *Revue bénédictine*, XXXVI, 1924, 123; Lauer, *Enluminures romanes*, 52–4; E. Van Moë, *La Lettre ornée dans les manuscrits du VIIIe au XIIe siècle*, Paris, 1949, *passim*; Porcher, *French Miniatures*, 41; C. de Mérindol, *La Production des livres peints à l'abbaye de Corbie au XIIe siècle*, Lille, 1976, I, 522–24; Cahn, *Romanesque Bible Illumination*, 276–77, No. 88; Avril, *Royaumes d'Occident*, 191; H. Stahl, 'The Problem of Manuscript Painting at Saint-Denis during the Abbacy of Suger', *Abbot Suger and Saint-Denis*, ed. P. L. Gerson, New York, 1986, 174; D. Nebbiai-Dalla Guarda, *La Bibliothèque de l'abbaye de Saint-Denis en France du IXe au XVIIIe siècle*, Paris, 1985, 202–3, No. 65.

II. AQUITAINE AND CENTRAL FRANCE

28. Paris, Bibliothèque Nationale MSS lat. 52 and lat. 135

Bible
440 × 310 mm., ff. 136 and 227, 2 cols., 39 lines
Last quarter of the 11th century.
Saint-Pierre, Moissac *Ills. 58, 59*

MS lat. 52

Ornamental initials: PREFACE TO OLD TESTAMENT, F (f. 1); EXODUS, H (f. 29); LEVITICUS, V (f. 50); NUMBERS, L (f. 63v); DEUTERONOMY, H (f. 86); JOSHUA, E (f. 107); JUDGES, P (f. 121); RUTH, I (f. 134v). Jerome's Pentateuch Preface and the beginning of Genesis are missing between present ff. 2v–3.

MS lat. 135

Ornamental initials: PREFACE TO EZEKIEL, H, two standing figures in dialogue (f. 1); EZEKIEL, E (f. 1v); PREFACE TO DANIEL, D (f. 32); DANIEL, cut out (f. 32v).

This Bible, which must initially have comprised at least two more volumes, is arranged in the order of the readings *per circulum anni*. Only the first volume with the books of the Octateuch, along with Ezekiel and Daniel in the second tome, received their intended initials; the rest were left unexecuted. The handsome initial letters that remain are pen-drawn designs, partly filled with flatly-laid areas of yellow, green, blue and red. Some, like the F of Jerome's Old Testament Preface (MS 52, f. 1) are characteristic constructions of Aquitanian art, with interlace finials and palmette foliage as the chief components. Others are more freely composed and show an eclectic mixture of fantastic imagery: foliage stems curiously terminating in bird or animal heads (f. 29); *atlantes* or acrobatic figures spewing foliage (f. 50); intertwined quadrupeds and birds (f. 86). The *incipits* are indicated with the help of large majuscule letters that may be ornamentally joined or imbricated, while the *incipit* words are rendered in the elongated display script normally employed in charters and chancery documents. According to Dufour, the hand of the scribe is found in two other manuscripts from Moissac: a volume of writings by St. Cyprian and Tertullian (Bibl. Nat. lat. 1656A) and a Commentary on St. Matthew by Hilary of Poitiers (Bibl. Nat. lat. 1715A). The first of these books has initials in a comparable style, as does another volume of patristic writings from Moissac in the Bibliothèque Nationale (lat. 2154).

PROVENANCE: Saint-Pierre, Moissac (Shelfmark N [f. 1], 15th century). Acquired by J.-B. Colbert, 1678: MSS 146 and 138 in his collection. Acquired by the Royal Library in 1732. Regius 3608.3 and 3573.2.

LITERATURE: Lauer, *Catalogue général*, I, 48; A. Wilmart, 'Membra disiecta', *Revue bénédictine*, XXXVI, 1924, 22; Lauer, *Enluminures romanes*, 52; J. Evans, *Cluniac Art of the Romanesque Period*, Cambridge, 1950, Figs. 78, 80a, 93a; J. Gutbrod, *Die Initiale in Handschriften des 8. bis 13. Jahrhunderts*, Stuttgart, 1965, 114, 116–17; J. Vezin, 'Observations sur l'emploi des réclames dans les manuscrits latins', *Bibliothèque de l'École des Chartes*, CXXV, 1967, 24–25; J. Dufour, *La Bibliothèque et le scriptorium de Moissac*, Geneva-Paris, 1972, 109, Nos. 37 and 38; id., 'La composition de la Bibliothèque de Moissac à la lumière d'un inventaire du XVIIe siècle nouvellement découvert', *Scriptorium*, XXXV, 1981, 2, 175–215 [lat. 52 and 135 figure as Nos. 3 and 4 in this inventory]; Cahn, *Romanesque Bible Illumination*, 276, No. 87.

EXHIBITED: *Manuscrits à peintures*, Paris, 1954, 108, No. 318.

29. Paris, Bibliothèque Nationale MS lat. 7

Bible
510 × 345 mm., ff. 366, 2 cols., 60 lines
c. 1100. Aquitaine. Moissac (?)

Ills. 60, 61, 62, 63

Historiated and ornamental initials: OLD TESTAMENT PREFACE, F (f. l); PENTATEUCH PREFACE, D (f. 3); GENESIS, I (f. 3v); EXODUS, H (f. 18); LEVITICUS, V, the Lord speaks to Moses (f. 30); NUMBERS, partly mutilated (f. 38v); DEUTERONOMY, H (f. 50); JOSHUA, E (f. 61); JUDGES, P (f. 67v); I KINGS, F, Elkanah dining with his two wives (f. 77); II KINGS, F (f. 86v); III KINGS, E (f. 94); IV KINGS, P, enthroned figure gesturing in speech (f. 103); ISAIAH, V (f. lllv); JEREMIAH, V, musician playing viol (f. 125v); EZEKIEL, E (f. 144v); HOSEA, V (f. 166v); JOEL, V (f. 168v); MICAH, V (f. 172); NAHUM, O, man on the back of a lion (f. 173v); HABAKKUK, O (f. 174v); ZEPHANIAH, V (f. 175); PSALMS, B (f. 181); PROVERBS, P (f. 196v); JONAH, V (f. 225v); EZRA, I (f. 252v); TOBIT, T (f. 259v); ESTHER, I (f. 266v); I MACCABEES, E (f. 271); II MACCABEES, F (f. 280); CANON TABLES, I–IV (ff. 288–288v); MATTHEW, L (f. 289); MARK, I (f. 298v); LUKE, Q (f. 305v); ACTS, P (f. 323v); JAMES, I (f. 334); I PETER, P (f. 335); ROMANS, P (f. 339); I CORINTHIANS, P (f. 343v); EPHESIANS, P (f. 352); PHILIPPIANS, P (f. 353v).

Samuel Berger classified the text of this Bible within his Languedocian family of manuscripts and noted the presence of Spanish elements in its composition. The decoration is the work of a single artist and consists of large pen-drawn initials of Franco-Saxon derivation, with palmette foliage. The forms are given body with the help of shading through networks of fine parallel lines separated by chains of tiny dots. The backgrounds and some parts of the design are painted with thinly-laid patches of yellow, orange, red, cabbage green, blue and mauve, along with a few touches of a dull pasty gold. The highly decorative initials are of a distinctly meridional quality, with fanciful letter forms joined, imbricated or superimposed on each other. On the other hand, a good number of the books and prefaces have only large penwork letters in red, with occasional touches of a second colour, instead of elaborate initials. The placement of these simple initials is fairly unpredictable, and they must have been executed by an assistant. The origin of the work before its entry into the collection of Cardinal Mazarin is not known. Sometimes connected with Limoges illumination, it is stylistically as well as chronologically not too distant from the Second Saint-Martial Bible (Bibl. Nat. lat. 8; no. 37). But a better case can be made for a more southerly provenance, and at least a tentative attribution to the scriptorium of Moissac. The principal artist of the Bible seems to have illuminated a copy from Moissac of Jerome's Commentary on Isaiah (Paris, Bibl. Nat. lat. 1822) and the initials of another Moissac manu-script, a partially preserved multi-volume Bible (Bibl. Nat. lat. 52 and 135; no. 28) are also close to his work.

PROVENANCE: Jehan poniel (?) de massans (or marsans), and Jehan poines (ff. 31, 159, 15th-century marginal inscriptions). Collection of Jules Mazarin (1602–61), MS 11. Acquired by the Royal Library in 1668. Regius 3567.

LITERATURE: J.-B. Silvestre, *Universal Palaeography,* ed. F. Madden, London, 1850, pls. CLXXVII–CLXXVIII; Berger, *Histoire de la Vulgate,* 401; H. Quentin, *Mémoire sur l'établissment du texte de la Vulgate,* Rome-Paris, 1922, 412–13; Lauer, *Manuscrits latins,* I, 6; id., *Enluminures romanes,* 47; G. L. Micheli, *L'enluminure du haut moyen âge et les influences irlandaises,* Brussels, 1939, 147; Cahn, *Romanesque Bible Illumination,* 275–76, No. 84.

30. Paris, Bibliothèque Nationale MS lat. 5058

Flavius Josephus, De bello Judaico
365 × 245 mm., ff. 169, 33 long lines
c. 1100. Saint-Pierre, Moissac *Ills. 66, 67*

Frontispiece in the form of two facing pages: Josephus presents his book to the Emperors Titus and Vespasian (ff. 2v–3).

Ornamental initials: Prologue, A (f. 4); Preface, Q (f. 7); Bk. I, C (f. 9); Bk. II, A (f. 45v); Bk. III, C (f. 75); Bk. IV, Q (f. 93v); Bk. V, A (f. 104); Bk. VI, T (f. 115); Bk. VII, C (f. 134v).

In his *Contra Apionem* (I, 48–52), Flavius Josephus records that after he had been taken prisoner by the Roman armies, he wrote a narrative of the Jewish Wars, which he presented to the commanders of the imperial armies, Titus and Vespasian. The frontispiece of the present manuscript, which contains the Latin translation of the *Jewish Wars* supposedly made by Rufinus of Aquileia, depicts this event on a pair of facing pages. On the left, Titus and Vespasian are seated side by side on high, ornate thrones. On the right, Josephus strides forward to present his book, which he carries with veiled hands. Behind him, in the distance, a crowd of men seeming to emerge from a space beyond a wall or frame, presses ahead in the same direction. The composition is firmly and precisely delineated, with outlines tending to be reinforced by parallel pen strokes. Details of the draperies, attributes and parts of the thrones are filled with flatly-laid colours of burgundy, ochre, olive green, grey-blue and red. Weitzmann has postulated that the design reflects a pictorial archetype in which two rulers were separately represented on facing pages, as in the portraits of Constantius II and Gallus Caesar in the Calendar of 354. This author

further supposes that the two princes were relegated to a single page in order to make some room for the figure of Josephus, transforming the composition into a scene of dedication. The elaborate frontispiece appears to have no parallels or antecedents in either the Greek or Latin families of manuscripts of this work.

The text, which was written by several scribes, has an unrefined, even somewhat coarse appearance. With the exception of the excellent ornamental letter Q on f. 7, all the initials which introduce the preface, prologue and the seven books of the *Jewish Wars* are of an archaizing and rather mediocre quality. At the end, there are two short texts written in red, the first narrating the vision of the Emperor Augustus on the Ara Coeli (f. 164), the second a hymn in honour of Saints Peter and Paul (ff. 165–165v, see D. Schaller and E. Könsgen, *Initia carminum latinorum saeculo undecimo antiquiorum*, Göttingen, 1977, 716, No. 16167). Additions, including a list of Roman emperors from Augustus to Frederick II (f. lv), an account of the martyrdom of St. Timothy (*B.H.L.* 8295) and a chronology of the popes to Innocent IV (ff. 167v–169) were made in the 13th century.

PROVENANCE: Sent with the manuscripts of Moissac to J.-B. Colbert in 1678 by J.-N. Foucault, Intendant of Montauban, and catalogued as MS 3000 in Colbert's collection. Acquired by the Royal Library in 1732. Regius 3730.1.

LITERATURE: Delisle, *Cabinet des manuscrits*, I, 519; J. Porcher, 'Un manuscrit à peintures de Moissac', *Bulletin de la Société Nationale des Antiquaires de France* 1848–48, 145; id., 'Enluminures françaises du Midi', *Revue française*, 1954, May, 9–16; E. Delaruelle, 'Une miniature de Moissac et la "Majestas Domini"', *Annales du Midi*, LXVIII, 1956, 153–63; Grabar and Nordenfalk, *Romanesque Painting*, 96; Porcher, *Quercy roman* (Coll. Zodiaque), 1959, 139; id., *French Miniatures*, 27–8; *L'art roman*, 52–3, No. 71; J. Vezin, 'Observations sur l'emploi des réclames dans les manuscrits latins', *Bibliothèque de l'École des Chartes*, CXXV, 1967, 31; Gaborit-Chopin, *Manuscrits à Saint-Martial de Limoges*, 76, 82, 106; K. Weitzmann, 'Book Illustration of the Fourth Century', *Studies in Classical and Byzantine Manuscript Illumination*, ed. H. L. Kessler, Chicago and London, 1971, 117–18; Dodwell, *Painting in Europe*, 77; J. Dufour, *La Bibliothèque et le scriptorium de Moissac*, Geneva-Paris, 1972, 140–41, No. 89.

EXHIBITED: *Manuscrits à peintures*, Paris, 1954, 107, No. 313; *Dix siècles d'enluminure et de sculpture en Languedoc*, Toulouse, 1954, 19, No. 15; *Byzance et la France médiévale*, Paris, 1958, 63, No. 114; *Colbert, 1619-1683*, Paris, 1983, 418, No. 584; *De Toulouse à Tripoli. La puissance toulousaine au XIIe siècle (1080–1208)*, Toulouse, 1989, 222–23, No. 323.

31. Paris, Bibliothèque Nationale MS lat. 254

New Testament
260 × 160 mm., ff. 149, 2 cols., 40 lines
c. 1100. South-western France
Ills. 68, 69; Col. pl. III

Decorated Canon Tables (ff. 4–8). Four Evangelist portraits: Matthew (f. 10); Mark (f. 32); Luke (f. 46v); John (f. 67v).

Historiated and ornamental initials: MATTHEW, L (f. 10); MARK, I (f. 32); LUKE Q (f. 46v); JOHN, I, Evangelist symbol in a medallion (f. 68); ACTS, P (f. 84v); PREFACE TO CATHOLIC EPISTLES, N (f. 100).

Under the designation *Codex Colbertinus* this small volume has received much attention from students of the Bible text since it contains the Old Latin version of the Gospels. It is written in an exquisite small hand on yellowish parchment with black stubble, indicative of a southerly origin. The appearance of the page is very sober, with only simple red titles, *incipits* and little red or blue initials at the beginning of the chapters. Of the Canon Tables, which occupy seven pages, only the first was brought to completion. It has golden arches and columns, with lion capitals drawn in outline and bases with animal masks, beasts, vegetation and a naked figure, while the rest were left unfinished (ff. 4v–6) or carried out in a more summary way (ff. 6v–8). The only other decorative elements of any importance are the opening pages of the Four Gospels, each one featuring an Evangelist portrait and a large initial, accompanied by *incipit* words in floridly ornamented majuscule letters. In the layout of these pages, the illuminator was guided by the dry point rulings intended for the text. The Evangelists thus occupy a space equivalent to the width of a single column. The sacred authors are shown as standing, frontalized figures within an arcade surmounted by a fanciful architectural prospect. This type of Evangelist portrait is unusual, and it might be asked whether the painter did not discover his models in the same necessarily archaic textual source which contained the Old Latin redaction. The standing portraits of Christ and of David in the late 8th-century Mondsee Psalter (Montpellier, Bibl. de l'École de Médecine, MS 409) make it possible to envisage hypothetically the existence of such models. Emile Mâle, on the other hand, drew attention to the resemblance of the Evangelist portraits in the *Codex Colbertinus* to the pier reliefs of the cloister of Moissac. Mâle's view that these sculptures were influenced by conventions of manuscript illumination has not found many adherents, but the comparison has furnished some grounds for the now generally accepted localization of the manuscript to the region of Moissac and Agen and its dating around 1100. Among the illuminated books of Moissac, the volume containing Julianus Pomerius's *De vita con-*

templativa and Sermons of Augustine (Bibl. Nat. lat. 2154) has initials of a roughly comparable type, and Porcher saw in the standing effigy of Isidore of Seville, in a collection of patristic writings from Saint-Maurin in the diocese of Agen (Bibl. Nat. lat. 2819), a simplified version of the *Colbertinus* Evangelists.

PROVENANCE: Given to J.-B. Colbert by Étienne de Rignac, counsellor of the Cour des Aides at Montpellier on 6th February, 1682: MS 4051 in Colbert's collection. Acquired by the Royal Library in 1732. Regius 3139⁵⁻⁵.

LITERATURE: J. E. Belsheim, *Codex Colbertinus*, Christiania, 1888; Berger, *Histoire de la Vulgate*, 74–5, 402; Haseloff, *Miniature*, 754; E. Mâle, *L'art religieux du XIIe siècle en France*, Paris, 1922, 16–18; Lauer, *Enluminures romanes*, 54; id., *Manuscrits latins*, I, 93–4; H.-J. Vogels, *Evangelium Colbertinum, Cod. Lat. 254 der Bibl. Nat. zu Paris* (Bonner Biblische Beiträge, 4– 5), Bonn, 1953; Grabar and Nordenfalk, *Romanesque Painting*, 178–9; Porcher, *Quercy roman* (Coll. Zodiaque), 1958, 138; Gaborit-Chopin, *Manuscrits à Saint-Martial de Limoges*, 33, 105–6, 118, 217; Avril, *Royaumes d'Occident*, 366; M. Durliat, 'Les cloîtres historiés dans la France méridionale à l'époque romane', *Cahiers de Saint-Michel de Cuxa*, 7, 1976, 67.

EXHIBITED: *Manuscrits à peintures*, Paris, 1954, 107, No. 314; *Dix siècles d'enluminure et de sculpture en Languedoc*, Toulouse, 1954, 19, No. 16.

32. Paris, Bibliothèque Nationale MS lat. 1618

Pseudo-Dionysius, De caelesti hierarchia, De divinis nominibus, and De mystica theologia; Pseudo-Quintilianus, Declamationes majores (ff. 91v–141) 410 × 270 mm., ff. II + 143, 41 long lines (Pseudo-Dionysius) and 45 lines (Pseudo-Quintilianus) Early 12th century. South-western France

Ills. 64, 65

Ornamental Initials: I (f. 1); V (f. 2v); L (f. 4); O (f. 5v); O (f. 6); E (f. 8v); I (f. 9v); H (f. 10v); Q (f. 11); H (f. 11v); T (f. 13v); R (f. 14v); C (f. 16); H (f. 16v); Q (f. 17); A (f. 17v); E and P (f. 19v); Q (f. 23); D (f. 24v); S (f. 25); H (f. 26); S (f. 27v); S (f. 28); V (f. 28v); T (f. 33); I, I (f. 33v); L (f. 37); S, C (f. 38v); H (f. 40); S (f. 40v); Q (f. 41); H (f. 42); C (f. 42v); S (f. 43); N (f. 46v); D (f. 49v); E (f. 53); S (f. 54v); A (f. 59v); Q, A (f. 60v); T, seated haloed figures in dialogue (f. 66); S (f. 68v); F (f. 69); S (f. 71); Q (f. 73); H (f. 75); A (f. 75v); S (f. 77v); T (f. 78); T (f. 79v); I, I (f. 80v); D (f. 81); I (f. 81v); T, Q, E (f. 82); D, Q (f. 82v); N, E (f. 83); E (f. 84); S (f. 87v); A (f. 90); S (f. 91v); A (f. 95); Q (f. 104); E (f. 107); S (f.

111); Q (f. 112v); D (f. 115); Q (f. 118v); E (f. 121); Q (f. 122v); C (f. 126v); S (f. 129); E (f. 130v); O (f. 132v); P (f. 134); V (f. 136v); P (f. 138v).

In 827, the Byzantine emperor Michael the Stammerer sent to Louis the Pious a copy of the works of the mysterious 6th-century Syrian author commonly known as Dionysius the Areopagite. This manuscript, which is preserved in the Bibliothèque Nationale (gr. 437) was translated into Latin in the years from 832 to 835 by Abbot Hilduin of Saint-Denis. Some three decades later, towards 862, John the Scot (Eriugena) made another translation of the Dionysian *corpus*. It is now thought that after further study of these writings, he later made a second, improved version. H.-F. Dondaine considers the copy of the *Celestial Hierarchy* contained in the present volume, which he designates with the *siglum* A, to be a fairly faithful version of the first recension. J. Barbet, on the other hand, has argued that it is a mixed text conflating the two translations and perhaps further modified through consultation of another Greek manuscript.

MS lat. 1618 was written and illuminated in southwestern France near the end of the 11th or the beginning of the 12th century. The prefaces of Anastasius Bibliothecarius (f. 1), the two dedications to Louis the Pious and Charles the Bald (ff. 2v, 4), each of the chapters of the work, as well as the divisions of the Pseudo-Quintilian's *Declamationes majores* which completes the volume, is introduced by handsome, pen-drawn initials, fortified with applications of wash-like tints of mauve, green, pink, yellow and a dark, greenish brown. Generally enclosed within panels the corners of which have a stepped design, these initials exhibit a rich variety of ornamental inventions: interlace constructions, a pair of mermaid-like creatures (f. 11), beasts spewing foliage (ff. 11v, 46v, 54v), entwined dragons (ff. 24v, 28, 33, 75), animal combats or combinations (ff. 17v, 19v), acrobatic figures (ff. 38, 38v, 41) and crossed beasts reminiscent of the similarly arranged creatures on the trumeaux of Moissac and Souillac. Comparable decoration is found in manuscripts generally attributed to the region of Toulouse-Moissac, like the copy of Gregory's Homilies of Ezekiel of the Pierpont Morgan Library (MS G. 16) and the Gradual of Saint-Étienne of Toulouse in the British Library (Harley 4951).

PROVENANCE: Chapter of the collegiate church of Saint-Emilion in the 14th century (inscription, f. 141v). Claude Dupuy (1546–94), MS 229, and later Jacques Dupuy (1591–1656). Bequeathed to the Royal Library in 1656. Regius 3626.

LITERATURE: Delisle, *Cabinet des manuscrits*, II, 404; H. Dessauer, *Die handschriftliche Grundlage der 19 grösseren Pseudoquintilianischen Deklamationen*, Leipzig, 1898, 11–14; G. Lehnert, *Quintiliani quae*

feruntur Declamationes XIX maiores, Leipzig, 1905, ix–x; Lauer, *Manuscrits latins*, II, 93; H.-F. Dondaine, *Le Corpus dionysien de l'Université de Paris au XIIIe siècle*, Rome, 1953, 36, 39 and *passim*; J. Châtillon, 'Note sur quelques manuscrits dionysiens, érigéniens et victorins de l'abbaye du Mont Saint-Michel', *Millénaire monastique du Mont Saint-Michel*, II, Paris, 1967, 315; J. Barbet, 'La tradition du texte latin de la Hiérarchie Céleste dans les manuscrits des "Expositiones in Hierarchiam caelestem"', *The Mind of Eriugena*, ed. J. J. O'Meara and L. Bieler, Dublin, 1973, 83–90; L. Håkanson, ed., *Declamationes XIX maiores Quintiliano falso ascriptae* (Bibliothecae scriptorum graecorum et romanorum Teubneriana), Stuttgart, 1982, vii–viii [siglum π]; E. Jeauneau, 'Le renouveau érigénien du XIIe siècle', *Eriugena redivivus* ed. W. Beierwaltes (Abh. der Heidelberger Akademie der Wissenschaften, Phil.-Hist. Klasse), 1987, 1, 39.

33. Vatican, Biblioteca Apostolica MS Lat. 3305

Terence, Comedies
245 × 181 mm., ff. 108, 28 long lines
First quarter of the 12th century.
South-western France *Ills. 70, 71, 72*

Full-page miniature in a pedimented frame, with several tiers of scenes: Terence's editor or *recitator* Calliopus seated at a lectern flanked by Terence (left) and one of his older rivals, Luscius Lanuvinus (right), accompanied by a second adversary of the playwright. Below, seven gesticulating Romans observe the argument. In the lower tier of the miniature, dialogue of Simo and Davus (left), and Pamphilus with Glycerium (right), characters in Terence's *Andria* (f. 8v).

Illustrations in the text: single figure, perhaps a portrait of the author (f. 9). *Andria*: I.i, Simo with a slave and several birds, and Sosia as cook with a kettle over a fire (f. 9v); I.ii, Simo pointing, Sosia throwing a hare into a skillet (f. 11v); I.iv, Mysis calling to Archilis (f. 12v); III.iii, dialogue of Simo and Chremes (f. 17v); III.iv, Davus, Simo and Chremes, the latter pointing to a large fish about to be cut up by an attendant (f. 18v); IV.iii, Mysis points to a house with a curtain, Davus holds a naked child (f. 21). *Eunuchus*: I.ii, Phaedria embraces Thais, marginal drawing (f. 26v). *Heautontimouromenos*: II.iv, Clinia and Antiphila embracing; Clitipho points to them and speaks to Syrus (f. 49); IV.iv, erased illustration (f. 54v).

The volume contains the six comedies of Terence, written in the years 166–160 B.C., and bears the *siglum* S in the stemma of the author's works. The plays are preceded in the manuscript by excerpts from Persius's *Satires* (ff. 1, 4–8), and an *accessus*, the

Commentum Brusianum, for several of the plays (ff. 1v–4). The medieval illustrations of the comedies of Terence ultimately depend on a classical archetype of uncertain date whose most faithful reflections are two Carolingian copies of a model thought to date from the end of the 5th century, a Reims manuscript in Paris (Bibl. Nat. lat. 7899) and a Fulda manuscript in the Vatican Library (Vat. Lat. 3868). The present manuscript contains illustrations for only the first three plays, and most of them are attached to the first, the *Andria*. These illustrations, drawings heightened with colour, are uneven in the degree of their finish. The full-page prefatory miniature is the most carefully worked out, with a range of colours embracing ochre, red and green. The following four illustrations are tinted in part, but those beginning with the scene on f. 18v are left in the state of outline drawings. The illustration on f. 49 is by another, more summary hand, and the last drawing, apparently by the same artist, has been erased. With the exception of the frontispiece and one drawing placed in the margin through a miscalculation (f. 26v), the method adheres to the ancient practice of placing the figures, accompanied by simple props, in unframed spaces within the text column. The frontispiece, however, in which Calliopus is disputing with two of Terence's rivals in the presence of the author and a group of Roman spectators is not encountered in any of the other surviving Terence manuscripts. The vigorous Romanesque stylization also leaves the classicizing model substantially transformed. Jones and Morey, in their basic study of the entire corpus of Terence illustrations, compared the style of the Vatican manuscript to the *Vita Martini* from Saint-Martin de Tours (Tours, Bibl. Mun. MS 1018; no. 1) but rightly observed that this style also had a southerly flavour which they assumed to have been the contribution of a migrant artist from the Midi active in the Tours scriptorium. In fact, the drawings in the Vatican codex with their strongly accented contours and shading by means of this parallel lines are entirely at home in the area of Toulouse and Moissac, comparing well enough with the frontispiece of the Josephus from Moissac (Bibl. Nat. lat. 5058; no. 30) and the New Testament (*Codex Colbertinus*) attributable to the same area (Bibl. Nat. lat. 254; no. 31).

PROVENANCE: Fulvio Orsini (1529–1600). Entered the Vatican Library in 1600.

LITERATURE: P. de Nolhac, *La Bibliothèque de Fulvio Orsini* (Bibliothèque de l'École des Hautes-Études, fasc. 74), Paris, 1887, 275, 359; E. Bethe, *Terentius Codex Ambrosianus H.75 inf.*, Leiden, 1903, 8; K. E. Weston, 'The Illustrated Terence Manuscripts', *Harvard Studies in Classical Philology*, XIV, 1903, 37; O. Engelhardt, *Die Illustrationen der Terenz-Handschriften* Diss. Jena, 1905, 13, No. 9; M. Palma, 'Le mani del Vaticano Lat. 3305', *Studi di poesia latina in onore di Antonio Traglia*, Rome, 1919, I, 99–104; E. M.

Sanford, 'The Use of Classical Latin Authors in the *Libri Manuales*', *Transactions and Proceedings of the American Philological Association*, LV, 1924, 214, No. 110; L. W. Jones, 'The Archetype of the Terence Manuscripts', *Art Bulletin*, X, 1927, 106; C. Lenz, 'Über das Verhältnis der frühmittelalterlichen zur Antiken Terenzillustration', *Repertorium für Kunstwissenschaft*, L, 1929, 181–91; L. W. Jones and C. R. Morey, *The Miniatures of the Manuscripts of Terence*, Princeton, London and Leipzig, 1931, I, 163ff.; D. M. Robathan, 'The Differentiation of Hands in a Vatican Terence (3305)', *Transactions and Proceedings of the American Philological Association*, LXVII, 1936, xlv; W. V. Clausen, *A. Persii Flacci Satirarum Liber accedit vita*, Oxford, 1956, 41; Y.-F. Riou, 'Essai sur la tradition manuscrite du "Commentum Brusianum" des comédies de Térence', *Revue d'histoire des textes*, III, 1973, 99–100; B. Munk Olsen, *L'Étude des auteurs classiques latins aux XIe et XIIe siècles*, II, Paris, 1985, 643, No. C 103; C. Villa, *La 'lectura Terentii'*, I (Studi sul Petrarca, 17), Padua, 1984, 35 n. 108, 435, No. 643; D. H. Wright, 'The Forgotten Early Romanesque Terence Illustrations in Vat. lat. 3305', *Zeitschrift für Kunstgeschichte*, LVI, 1993, 183–206.

EXHIBITED: *La Survie des classiques latins*, Biblioteca Vaticana, 1973, No. 74.

34. Paris, Bibliothèque Nationale MS lat. 7211

Musical Theory Collection
270 × 175 mm., ff. 151, 2 cols., 32 lines
(ff. 133–149v)
Late 11th or early 12th century.
South Central France *Ills. 73, 74*

Drawings within the text: roundel with the seated Pythagoras holding a quill and book; musician playing a lyre or pointing to a scroll; seated author with scroll (f. 133v); seated author with scroll; musician with drum and mallet, musician blowing a horn; two seated musicians playing a zither-like instrument (f. 134); seated Pythagoras writing on a tablet (f. 135v); musician playing a cithara, possibly intended as King David (f. 137v); musician playing a guitar-like instrument (f. 138v); musician playing an angle harp (f. 139); musician playing a lyre (f. 140); musician playing a lyre (f. 140v); a pair of musicians playing a zither-like instrument (f. 141v); diagrams of harmonic ratios (ff. 147v, 148v, 149), Guidonian hand (f. 149v).

The volume is an anthology of tracts on musical theory composed of pieces of disparate date and origin. The section here described (ff. 133–149v) consists of Martianus Capella's *De Nuptiis Philologiae et Mercurii*, Cassiodorus' *Institutiones*, Aurelianus of Reome's *De Musica* and several other anonymous short texts, terminating with a drawing of the Guidonian hand. This section is written in a refined Carolingian minuscule hand, with headings in rustic capitals. The ink has faded and individual letters have here and there been strengthened by a later scribe. On first sight the writing suggests a date in the 9th or 10th century, and must undeniably be judged as archaic around 1100 when, based on the style of the illustrations, the manuscript was most probably executed. These illustrations are pen drawings of standing or seated musicians, along with a pair of authors with scrolls and two portraits of Pythagoras, one of them in a roundel — the only figure so presented and to be identified by an inscription. With this single exception, the figures are placed in blank spaces within the text column, without a frame or any indication of the setting. The drawings are firmly delineated, with a shading of thin parallel lines reinforcing the heavier outlines of forms. It seems probable that they reflect models of a livelier, more illusionistic character, which the draughtsman abbreviated or did not always accurately construe. The work has yet to be precisely localized. According to L. Gushee, the added musical notation (ff. 135v–140) is of an Aquitanian type. For the style of the drawing, the initials and Consanguinity Tree in a *Decretals* of Burchard of Worms from the library of Le Puy Cathedral (Bibl. Nat. lat. 3861) presents some analogies.

PROVENANCE: Collection of J.-B. Colbert, MS 2415. Acquired by the Royal Library in 1732. Regius 5365.3.

LITERATURE: A. de la Fage, *Essais de diphtérographie musicale*, Paris, 1864, I, 180ff.; E. Buhle, *Die musikalischen Instrumente in den Miniaturen des frühen Mittelalters*, Leipzig, 1903, 48, 71, 73; L. Royer, 'Catalogue des écrits de théoriciens de la musique conservés dans le fonds latin des manuscrits de la Bibliothèque Nationale', *L'Année musicale*, III, 1913, 215–18; C. de Tolnay, 'The Music of the Universe. Notes on a Painting by Bicci di Lorenzo', *Journal of the Walters Art Gallery*, VI, 1943, 87; *The Theory of Music from the Carolingian Era up to 1400*, ed. J. Smits van Waesberghe, et al., (RISM), Munich and Duisburg, 1961, 101–105; J. Smits van Waesberghe, *Musikerziehung. Lehre und Theorie der Musik im Mittelalter*, Leipzig, 1969, 58–9, 72–3, 88–9, 94–5, 98–9, 108–9, 150–1; T. Seebass, *Musikdarstellung und Psalterillustration im früheren Mittelalter*, Bern, 1973, 83, 85, 94, 96, 129, 136f., 183; L. Gushee, ed., *Aureliani Reomensis Musica Disciplina* (Corpus Scriptorum de Musica, 21), 1975, 46–47; M. Huglo, 'Les instruments de musique chez Hucbald', *Hommages à André Boutemy* (Coll. Latomus, 145), Brussels, 1976, 186, n. 29.

35. Albi, Bibliothèque Municipale Rochegude MS 6

Sacramentary
275 × 170 mm., ff. 164 + III, 20 long lines
Beginning of the 12th century. Albi

Ills. 75, 76

Drawing of Christ in a mandorla, flanked by a pair of seraphs bearing books.

Ornamental initials: *Vere Dignum* monogram (f. 3); D (f. 8v); C (f. 10v); D (f. 14); O (f. 22); D (f. 58); C (f. 69); D (f. 72); D (f. 91); D (f. 93); D (f. 95v); V (f. 104v); S (f. 112); D (f. 113v); D (f. 114v); O (f. 125); D (f. 129v); O (f. 157v). Smaller initials of the same type: ff. 13, 27, 28, 30, 44, 47v, 52, 56v, 61, 64v, 76, 87v, 91, 100, 102v, 109v, 127v, 129.

This Sacramentary is one of several liturgical books written for the Cathedral of Sainte-Cecile at Albi by the scribe Sicardus, who identifies himself in a versified dedication preceding the text on the opening folio. There is no Calendar, but the origin of the work is reflected in the presence of painted initials in the Sanctorale for the Masses of the Vigil of St. Cecilia (f. 129), the saint's feast day on 22nd December (f. 129v), as well as that of another Albigeois saint of note, Salvius (f. 113v). The text includes yet another Mass *In commemoratione sanctae Ceciliae* (f. 141v), and folios 1v–2 carry an *ordo*, dated 1248, concerning processions and stipulating the occasions when the Bishop of Albi and the Chapter were to take their meals together. The body of the text (ff. 3–164) is written in a refined and compact Carolingian minuscule, with rubrics in rustic capitals. The somewhat improvisatory pen drawing preceding the *Te Igitur*, based on Isaiah (6:1–3), is a surprising touch in a place where an ornamental monogram might be expected. In line with the generally aniconic leaning of Albigeois illumination of this period, the Masses of the major feast days are singled out by five-line initials drawn with the pen and filled with flatly-applied colours of bright yellow, red, green and deep blue. These letters are usually placed in square frames consisting of double lines or a red band. Their design derives from Franco-Saxon art with its interlace strips and large terminal knots, here combined with palmette foliage and rendered in the Aquitanian manner already well implanted in the region during the 11th century. One letter shows a sort of braided frame (f. 22); others, a feline creature or birds spewing foliage (ff. 27, 69 and 76), confronted peacocks (f. 91) and a fabulous bird in a heraldic stance, entwined in foliate tendrils (f. 113v). Lesser feast days have smaller and more modest initial letters in the same style.

Beyond the present manuscript, Sicardus identifies himself as the writer of another Albi Sacramentary (Bibl. Mun. Rochegude, MS 5) which has orna-

mental initials in the same mode, though by another hand; and a Ritual of the Cathedral (Albi, MS 3), with only simple decorative letters in different colours. Connolly and Krochalis also plausibly attribute to him an Evangeliary in the same Library (Albi, MS 13) with initials in a more economical version of the style of those in the Sacramentary. The name of the scribe is also entered in a marginal addition for 12th September in an 11th-century Martyrology of the cathedral (Albi MS 7, p. 182) where it is placed within a little decorative panel drawn in red and brown: '*Ipse die obiit Sicardus archidiaconus nostre congregationis canonicus presbiter*'. Both the absolute and the relative chronology of his work remains to be clarified. Porcher (*Manuscrits à peintures*, 106) places MS 6 at the beginning and MS 5 in the first half of the 12th century. Connolly and Krochalis, on the other hand, suggest that MS 5 may be the earlier of the two works, and this is also my own tentative impression. As noted by these authors, Sicardus is mentioned as Archdeacon of the Cathedral in a Bull of Pope Innocent II dated 12th June 1136 (Bibl. Nat., Fonds Doat 105, f. 46) and again in two Albi Cathedral documents dated eight years later (ff. 54 and 57). He died some time between 1144 and 1150, when a new archdeacon named Vidianus is cited in these sources.

BINDING: Original binding of purple damask (?) over wooden boards, replaced in the 13th or 14th century by calfskin.

PROVENANCE: Written by Sicardus for the Cathedral of Sainte-Cécile, Albi (f. 3), *ex libris* (inner front cover) and Inv. Nos. 8 and 36 (19th century).

LITERATURE: G. Libri and F. Ravaisson, *Catalogue général*, Quarto Series, I, 1849, 482; L. Delisle, 'Mémoire sur d'anciens sacramentaires', *Mémoires de l'Académie des Inscriptions et Belles-Lettres*, XXXII, 1886, No. LXXXVII, 228–9; C. Portal, 'Lettres ornées d'un manuscrit (No. 6) de la Bibliothèque d'Albi', *Revue historique, scientifique et littéraire du Tarn*, VII, 1890–91, 284–85; R. Twigge, 'The Medieval Service Books of Aquitaine. I. Albi', *The Dublin Review*, CXV, 1894, 283, 288–91; H. Leclercq, *D.A.C.L.*, I, 1, 1907, cols. 1063–64; Leroquais, *Sacramentaires*, I, 185–87; J. Moor, 'Abhandlung über die Technik einiger Einbandarten des XI. Jahrhunderts. Ein merkwürdiger Einband: Das Sakramentbuch von Albi', *Allgemeinen Anzeigers für Buchbindereien*, LXXII, 1959, 251-54; B. van Regemorter, 'Note sur l'emploi de fils métalliques dans la tranchefile', *Scriptorium*, XV, 1961, 327–28; *Manuscrits datés*, VI, 29; *Colophons*, V, 293, No. 17.038; T. Connolly and J. Krochalis, 'The Archdeacon Sicardus, a Twelfth-Century Scribe of Albi', *Manuscripta*, XXIV, 1980, 106–13.

EXHIBITED: *Manuscrits à peintures*, Paris, 1954, 106, No. 309; *Dix siècles d'enluminure et de sculpture en Languedoc*, Toulouse, 1954, 18, No. 10; *De Toulouse à*

Tripoli. La puissance toulousaine au XIIe siècle (1080–1208), Toulouse, 1989, 225–26, No. 327.

36. New Haven, Yale University, Beinecke Rare Book and Manuscript Library MS 414

Bible (Isaiah to I Corinthians)
273 × 187 mm., ff. 197, 2 cols., 48 lines
First half of the 12th century.
South Central France. Albi (?) *Ills. 77, 78*

Ornamental initials: ISAIAH, V (f. 1); JEREMIAH, V (f. 18); BARUCH, E (f. 38v); EZEKIEL, E (f. 41); PREFACE TO DANIEL, D (f. 59); DANIEL, A (f. 59v); HOSEA, V (f. 67); JOEL, V (f. 69); AMOS, V (f. 70); OBADIAH, V (f. 72v); JONAH, E (f. 73); MICAH, V (f. 74); NAHUM, O (f. 75v); ZEPHANIAH, V (f. 77); HAGGAI, I (f. 78); ZECHARIAH, I (f. 78v); MALACHI, O (f. 81v); JOB, V (f. 88); PROVERBS, P (f. 93); ECCLESIASTES, V (f. 100); SONG OF SONGS, O (f. 102); WISDOM, D (f. 104v); ECCLESIASTICUS, O (f. 109v); MATTHEW, L (f. 127); MARK, I (f. 138v); LUKE, Q (f. 144); JOHN, I (f. 159v); ACTS, P (f. 169v); APOCALYPSE, A (f. 186v); ROMANS, P (f. 193).

The second part of a two-volume Bible, this work has an unusually small format. Script and parchment are of a meridional type. Among the particularities of the text is the sequence of four prefaces for Job, including the rare piece beginning *Philippus quidam expositor* (Berger, *Préfaces*, 40, No. 65) which is also found in the Limousin Bible of the Mazarine Library (MSS 1–2; no. 40), as is the short composition attributed to Jerome *Iob exemplar patientie*, which follows the Book of Job here. The New Testament (extant up to I Corinthians, 1:15) is preceded by a brief chronicle from Creation to the reign of Solomon, taken from Isidore of Seville (*Pat. Lat.* LXXXIII, 1017ff.), which has been added by another hand on a blank leaf (f. 124). Many of the books have stichometric indications. There are fine, wholly ornamental initials at the beginning of each of the biblical books. They are linear designs of Franco-Saxon derivation on flat and brightly coloured grounds composed of zones of blue, red, green and yellow. The letter form is constructed of wiry interlace, with knots at mid-points and extremities, and a filling or intertwined palmette foliage. *Incipits* and *incipit* words are treated in the highly ornate fashion of manuscripts from Aquitaine, with fancifully drawn letters joined or imbricated into one another. Millar, who first studied the manuscript, tentatively connected it with Limoges, but this view was rejected by Gaborit-Chopin. The style of the decoration is most closely allied with book illumination of the region of Albi and echoed in a number of liturgical books from that centre, notably Albi, Bibl. Mun. MSS 5, 6 (no. 35), 13, and Paris, Bibl. Nat. lat. 776.

PROVENANCE: Léon Gruel, Paris. Purchased in 1920 by A. Chester Beatty, Dublin, MS 30 in his collection. Sotheby's Sale, 24th June, 1969, Lot 44. Purchased from H. P. Kraus, New York, in 1969 as a gift of Edwin J. Beinecke.

LITERATURE: E. G. Millar, *The Library of A. Chester Beatty*, Oxford, 1927, I, 104–107; Sotheby's Sale, 24th June 1969, Lot 44; Gaborit-Chopin, *Manuscrits à Saint-Martial de Limoges*, 219; W. Cahn and J. Marrow, 'Medieval and Renaissance Manuscripts at Yale: A Selection', *Yale University Library Gazette*, LII, 4, 1978, 186–87, No. 13; Cahn, *Romanesque Bible Illumination*, 274, No. 77; B. Shailor, *Catalogue of the Medieval and Renaissance Manuscripts in the Rare Book and Manuscript Library, Yale University*, II, Binghamton, 1987, 325–27.

EXHIBITED: *The Medieval Book*, New Haven, 1988, 38–39, No. 38.

37. Paris, Bibliothèque Nationale MS lat. 8

Bible (Second Bible of Saint-Martial)
540 × 305 and 540 × 400 mm., ff. 226 and 364, 2 cols., 50 lines
Beginning of the 12th century.
Saint-Martial, Limoges *Ills. 79, 80, 81, 82, 83*

Vol. I

Historiated and ornamental initials: PREFACE TO OLD TESTAMENT, F, Jerome presents a book to Paulinus (f. 1); PREFACE TO PENTATEUCH, D (f. 5v); EXODUS, cut out (f. 25v); LEVITICUS, V, the Lord speaks to Moses (f. 41); NUMBERS, L, the Lord in heaven speaks to Moses (f. 52); DEUTERONOMY, H (f. 67v); PREFACE TO JOSHUA, T, Jerome writing (f. 81); JOSHUA, E, the Lord speaks to Joshua (f. 82); JUDGES, P, the Lord in the Tabernacle designates Judah as Joshua's successor (f. 91); RUTH, I (f. 101v); PREFACE TO ISAIAH, N (f. 102v); ISAIAH, V (f. 102v); JEREMIAH, V (f. 122v); EZEKIEL, E (f. 149); DANIEL, A (f. 170v); HOSEA, V (f. 180); JOEL, V (f. 183); PREFACE TO AMOS, A (f. 184); AMOS, V (f. 184v); OBADIAH, cut out (f. 187); JONAH, E (f. 187v); MICAH, V (f. 188); NAHUM, O (f. 190); HABAKKUK, cut out (f. 190v); ZEPHANIAH, V (f. 191v); HAGGAI, I (f. 192v); ZECHARIAH, I (f. 193); MALACHI, O (f. 196v); PREFACE TO JOB, C (f. 197v); JOB, V (f. 198); PSALMS: B (f. 208v); Psalm 41, Q (f. 213v); Psalm 72, Q (f. 217); Psalm 106, C (f. 221).

Vol. II

Historiated and ornamental initials: PREFACE TO KINGS, V (f. 1); I KINGS, F (f. 4); II KINGS, F (f. 17); III KINGS, E (f. 28); IV KINGS, C, Elijah brings down the fire on the followers of King Ahaziah (f. 41); PREFACE TO PROVERBS, C (f. 53); PROVERBS, P, Solomon with sceptre and scroll (f. 54); ECCLESIASTES, D (f. 62v);

SONG OF SONGS, O (f. 65v); WISDOM, D (f. 67v); ECCLE-
SIASTICUS, O, personification of Wisdom (f. 74v); I
CHRONICLES, A (f. 91); II CHRONICLES, C, Solomon
enthroned (f. 102); EZRA, I (f. 117); ESTHER, I (f. 127);
TOBIT, T, the angel appears to Tobit on the banks of
the river with the miraculous fish (f. 132v); JUDITH, A
(f. 136v); I MACCABEES, E (f. 142); II MACCABEES, F (f.
156); CANON TABLES, PREFACE TO GOSPELS, B, P (ff.
164v, 165); CANON TABLES (ff. 166–171v); MATTHEW, L
(f. 173); MARK, I (f. 184v); LUKE, Q (f. 192v); JOHN, I (f.
205); ACTS, P (f. 215); JAMES, I, standing Apostle with
scroll (f. 223); I PETER, P, standing apostle with scroll
(f. 229v); II PETER, S (f. 231); I JOHN, Q, standing Apos-
tle with book (f. 232); II JOHN, S (f. 233); III JOHN, S (f.
233v); JUDE, I (f. 233v); PREFACE TO PAULINE EPISTLES,
P (f. 234v); ROMANS, P, Paul with scroll (f. 236); I
CORINTHIANS, P (f. 242); II CORINTHIANS, P (f. 245);
GALATIANS, P (f. 248); EPHESIANS, P (f. 250v); PHILIP-
PIANS, P (f. 252); COLOSSIANS, P (f. 253); I THESSALONI-
ANS, P, Paul addressing a group of Thessalonians (f.
254v); II THESSALONIANS, P (f. 256); I TIMOTHY, P (f.
256v); II TIMOTHY, P, Paul speaks to Timothy (f. 258);
TITUS, P (f. 259); PHILEMON, P (f. 259v); HEBREWS, M
(f. 260).

The text of this two-volume Bible follows the earlier
First Bible of Saint-Martial (Bibl. Nat. lat. 5) in its
main lines, though shifting the Books of Kings from
their normal position after the Octateuch to follow
Job, and omitting the Revelation. The Psalms have
an exceptional quadripartite subdivision, with em-
phasis on Psalms l, 41, 72 and 106. At the end of the
second volume (f. 264), the scribe wrote the *incipit* of
the apocryphal letter of St. Martial, *apostolus aqui-
tanorum*, to the people of Bordeaux, but left out the
text of the epistle. The decoration constitutes the
high point of the Aquitanian style as practised in
Limoges around the end of the 11th century, with
initials for the biblical books, the major prefaces, and
Canon Tables in brilliantly coloured combinations of
interlace and palmette foliage. The initials typically
have a broadly proportioned structure of Franco-
Saxon derivation, with inlaid strips of interlace re-
served against dark grounds. Large knots of thin and
angular interlace mark the extremities and points of
intersection. A few are monograms or combinations
of letters forming an entire word or part thereof. The
predominantly abstract ornament is enlivened by a
variety of beasts, jousting or fighting scenes and
figures in acrobatic stances. A fine array of these
motifs is found in the capitals and bases of the Canon
Tables. Figurative illustration, entirely lacking in the
First Saint-Martial Bible, occupies an appreciable
place in the work, though the location of the histori-
ated initials is rather random. This illustrative mate-
rial includes single figures and conventional scenes
of dialogue, but also a few more elaborate narrative
compositions like those incorporated in the initials

of Judges (Vol. I, f. 82) and IV Kings (Vol. II, f. 41).
Most of the initials and the Canon Tables appear to
be the work of one painter, who has a strong impact
on the book illumination of Saint- Martial in the
immediately ensuing period. A number of initials
were executed by a second hand using heavy and
opaque colours brightened by silver and gold. This
painting seems to cover the drawing of the first
artist, as Gaborit-Chopin has observed, suggesting
that the Bible was perhaps completed and 'enriched'
in a second campaign undertaken a few years after
the body of the work had been carried out. The
character of this painting is close to the decoration of
the Life of Saint Martial by the Pseudo-Aurelian
(Bibl. Nat. lat. 5296A; no. 39) and also calls to mind
the Rule of Saint Benedict from Saint-Martial (Bibl.
Nat. lat. 5243). The *oeuvre* of the principal artist of the
Second Saint-Martial Bible has been reconstituted by
Porcher and Gaborit-Chopin, who attribute to him
three other Saint-Martial manuscripts: a copy of
Augustine's Sermons (Bibl. Nat. lat. 2027), a volume
of Biblical Commentary by St. Paterius (Bibl. Nat.
lat. 2303) and Gregory's *Liber Pastoralis* (Bibl. Nat.
lat. 2799). Other books which he or his workshop
illuminated are a copy of Ambrose's Commentary
on the Pauline Epistles, and a composite volume of
works by Augustine, Jerome and Ambrose, both pre-
served in the Bodleian Library, Oxford (MSS Bodley
689, 866), and further, the Lectionary-Collectar from
Saint-Pierre at Uzerche in the Bibliothèque de l'École
des Beaux-Arts, Paris (MS lat. 11). Leaves from a
Gilbert de la Porrée Commentary on the Pauline
Epistles in the Victoria and Albert Museum, London
(Inv. Nos. 9037, A, B, D, E) that must be dated in the
middle of the 12th century suggest that the style had
a longer life than is generally assumed.

PROVENANCE: Saint-Martial MSS 3 and 4. Acquired
by the Royal Library in 1730. Regius 3560[4–5].

LITERATURE: Berger, *Histoire de la Vulgate*, 401; A.
Haseloff in A. Michel, *Histoire de l'art*, 754–5; Boeck-
ler, *Abendländische Miniaturen*, 101; Lauer, *Manuscrits
latins*, I, 7; id., *Enluminures romanes*, 49–50; E. B. Gar-
rison, *Studies in the History of Medieval Italian Painting*,
I, 1953, 46; Grabar and Nordenfalk, *Romanesque
Painting*, 167; Schapiro, *Parma Ildefonsus*, 49–50; Ga-
borit-Chopin, *Manuscrits à Saint-Martial de Limoges*,
86ff., 176–77; Dodwell, *Painting in Europe*, 76; Cahn,
Romanesque Bible Illumination, 166, 276, No. 85; C.
Rudolph, *The 'Things of Greater Importance'. Bernard
of Clairvaux's 'Apologia' and the Medieval Attitude To-
ward Art*, Philadelphia, 1990, 133–57.

EXHIBITED: *Manuscrits à peintures*, Paris, 1954, 110,
No. 325; *Byzance et la France médiévale*, Paris, 1958, 64,
No. 115; *L'art roman à Saint-Martial de Limoges*, Limo-
ges, 1950, 66–7, No. 33.

38. Paris, Bibliothèque Nationale MS lat. 9438

Sacramentary
270 × 165 mm., ff. 144, 28 long lines
Early 12th century.
Cathedral of Saint-Étienne,
Limoges *Ills. 84, 85, 86; Col. pl. IV*

Full-page paintings: Nativity and Adoration of the Shepherds (f. 19v); Christ in Heaven and Stoning of St. Stephen (f. 20v); Baptism of Christ and Wedding at Cana (f. 24); Presentation in the Temple (f. 29); Christ with two disciples and Entry into Jerusalem (f. 44v); Last Supper and Washing of the Feet (f. 46v); Christ in Majesty (f. 58v); Crucifixion (f. 59); Three Women at the Sepulchre (f. 76v); Ascension (f. 84v); Descent of the Holy Spirit (f. 87). Full-page painted designs with decorative imbricated letters: *Vere Dignum* (f. 57); *Te Igitur* (ff. 68v–59).

Ornamental initials: Vigil of the Nativity, D (f. 18); Nativity, C (f. 20); Easter, D (f. 77); Ascension, C (f. 85); Pentecost, D (f. 67v); Invention of the Body of St. Stephen, O (f. 106); Assumption of the Virgin, V (f. 109); All Saints, O (f. 116v); Trinity, O (f. 129). Smaller decorative initials in the same style throughout the volume.

The Sacramentary of the Cathedral of Saint-Étienne of Limoges is a book of comparatively small dimensions whose rich illumination represents a summit of local book art. The Calendar includes three commemorations for St. Martial, the first Bishop of Limoges, the feast day (31st May), Octave (5th June) and *Translatio S. Martialis episcopi* (10th October). There are also three entries for St. Stephen, the Octave (3rd January), feast day (2nd August) and *Translatio* (19th October). A blessing for St. Martial is also found among the episcopal benedictions which follow, where he is styled *confessor* (f. 10v), though nowhere in the manuscript *apostolus*. The anniversary of the consecration of the Cathedral of Saint-Étienne is celebrated on 29th December. This feast recalls the consecration of the new monument by Pope Urban II on that day in 1095. The latter date is therefore the earliest that can be assigned to the manuscript. Gaborit-Chopin notes that the city of Limoges and the cathedral were devastated by fire in 1105, and concludes that the manuscript must have been executed before that time. The second deduction is bound to be much less certain, since it is at least conceivable that the work might have been written and illuminated after the disaster.

The treatment of the text contains a number of decorative elements. Two- or three-line red or gold letters outlined in red appear throughout. The headings, with the names of the feast days, are painted in majuscule letters on thin stripes of blue, green, red or gold. Painted ornamental initials introduce the different Masses, and larger initials of the same kind mark the Masses for the major feast days. Fourteen full-page paintings constitute the major burden of the decoration, three of them with ornate designs of imbricated letters for the Preface and Canon of the Mass, and the rest illustrations for the Canon and the Masses of the major feasts. These striking images, unprecedented in Limousin illumination, are in a somewhat eroded state, the blue backgrounds in particular having suffered some paint losses. Porcher has conjectured that the cycle may reflect German models of the end of the tenth and first half of the 11th century, an idea endorsed by Gaborit-Chopin, who argues that the closest parallels for the Limoges cycle are to be found in Salzburg illumination, and particularly in the Pericopes of St. Erentrud (Munich, Bayer. Staatsbibl. Clm. 15.903). The date of the latter work, usually placed around 1125, makes this connection problematic, and the sources of the cycle remains an open question. The composition and the iconography of the individual miniatures take some unusual forms. In the Baptism (f. 24), the Jordan River is represented in the form of a pool of water poured from vases by a pair of river gods. In the Washing of the Feet (f. 46v), Christ appears to be exhorting St. Peter rather than wiping his foot, and it is possible that the figure behind the Lord represents St. Martial who, according to legend, actually performed this office. In the *Majestas Domini* (f. 58), the Evangelist symbols are of the beast-headed type, and in the Descent of the Holy Spirit (f. 84v), the fire which descends on the assembled Apostles issues from the ears of the enthroned Christ. The *oeuvre* of the painter of the Sacramentary of Saint-Étienne includes the Bibles of Saint-Yrieix (Saint-Yrieix, Hôtel de Ville), the Bible of the Bibliothèque Mazarine (MS 1 and 2; no. 40), and a volume of Gregory's Homilies on Ezekiel formerly in the Chester Beatty Collection (MS 18). The frontispiece of a Rule of St. Benedict from Saint-Martial (Bibl. Nat. lat. 5243, f. 45v) is close to his work, if perhaps not by his own hand. Fragmentary remains of fresco painting in the crypt of the Cathedral of Saint-Étienne have also been attributed to him (M.-M. Gauthier, *Bulletin de la Société archéologique et historique du Limousin*, XCVI, 1969, 85ff.); other partially preserved wall paintings in the nave of the church of Saint-Junien, east of Limoges, are in a related style (A. Mingaud, *Bulletin de la Société archéologique et historique du Limousin*, CXII, 1985, 20–28). The intense range of colours and certain aspects of the stylization have also reminded some authors of Limousin enamels, though this analogy is of a very general order only.

PROVENANCE: Seminary of Limoges (18th or early 19th century, *ex libris*). Shelfmark 'Finet 1' (19th century, f. 1). Acquired by the Bibliothèque Nationale between 1848 and 1852. Supplément latin 1314.

LITERATURE: Boeckler, *Abendländische Miniaturen*, 100, 122; Leroquais, *Sacramentaires*, I, 213–15; Lauer, *Enlu-*

minures romanes, 30, 110, 116; J. Porcher, *Le Sacramentaire de Saint-Étienne de Limoges*, Paris, 1953; E. Garrison, *Studies in the History of Medieval Italian Painting*, 1955–56, II, 42–45; J. Porcher, *Limousin roman* (Coll. Zodiaque), 1960, 245–46; id., *French Miniatures*, 23–24; Gaborit-Chopin, *Manuscrits à Saint-Martial de Limoges*, 127ff., 211–212; Dodwell, *Painting in Europe*, 77, 91; *Manuscrits datés*, III, 1974, 113; D. Gaborit-Chopin, 'Le peintre du sacramentaire de Limoges', *Enluminure carolingienne et romane* (Les dossiers de l'archéologie, No. 14), Jan.-Feb. 1976, 108–15; M. Durliat, *L'art roman*, Paris, 1982, 276, 427; J.-C. Bonne, 'Rituel de la couleur. Fonctionnement et usage des images dans le Sacramentaire de Saint-Étienne', *Image et signification* (Rencontres de l'École du Louvre), ed. D. Ponna, Feb. 1983, 129–39; A. Mingaud, 'Les fresques romanes de la nef de l'église de Saint--Junien', *Bulletin de la Société archéologique et historique du Limousin*, CXII, 1985, 20–28.

EXHIBITED: *L'art roman à Saint-Martial de Limoges*, Limoges, 1950, No. 40; *Manuscrits à peintures*, Paris, 1954, 110–11, No. 326; *Art roman*, Barcelona and Santiago de Compostela, 1961, 51–2, No. 69.

39. Paris, Bibliothèque Nationale MS lat. 5296A

Life of Saint Martial
350 × 215 mm., ff. 40, 29 long lines
c. 1100. Saint-Martial, Limoges *Ill. 87*

Framed *incipit* pages (ff. 1v–2); full-page designs with majuscule ornamental letters PRE (f. 2v) and initial words (f. 3).

Historiated and ornamental initials: P (f. 4); C (f. 4v); D (f. 5); I, C (f. 5v); N (f. 6v); I (f. 7); A (f. 8); A, C (f. 10); Q (f. 12v); H (f. 13); S (f. 14); I (f. 14v); C (f. 15v); A (f. 19v); H (f. 20); I (f. 21); R (f. 23); C (f. 23v); N (f. 24); P (f. 25); I (f. 26); Q (f. 26v); I (f. 33); M, seated haloed St. Martial in an arched frame, writing a letter (f. 35).

The Life of Saint Martial contained in this volume (*B.H.L.* 5552) is said in a full-page *incipit* composed of golden majuscule letters on a purple ground (f. 1) to have been written by Aurelianus, who was his disciple and successor as Bishop of Limoges. However, the work, sometimes called *Vita prolixior*, seems to have been composed between *c*. 950 and 1025, being mentioned by that indefatigable promoter of the apostolicity of Martial, Adhemar de Chabannes, in his letter in support of this cause to the synod of Limoges in 1029. Bernard Itier, the chronicler of Saint-Martial (d. 1225) records that Adhemar had a life of St. Martial 'with golden letters' executed; an entry in a 12th-century necrology of the abbey (Bibl. Nat. lat. 5239, f. 3) commemorates a certain Aimardus, who

made a precious book of the life of the same saint. Assuming that Aimardus is a garbled rendering of Adhemar, 19th-century authors contended that this Life of St. Martial might be the work mentioned in these two sources. L. Duchesne, though highly critical of the case made by Limousin defenders of Martial's apostolicity, accepted the association of the manuscript with Adhemar. However, Delisle rejected the idea that Adhemar and Aimardus could be the same person and expressed grave doubts that this Life of St. Martial is the work mentioned by Itier. Since the manuscript was in all likelihood executed roughly three-quarters of a century after Adhemar's death (1034), this conclusion is irrefutable. There is a possibility that the work is the book credited to Aimardus, about whom, unfortunately, nothing further is known.

The manuscript is a luxury book written in a good minuscule hand. *Incipit* words are treated in majuscule letters of black, panelled with green and powder blue. Titles are in red or green, or alternating lines of green and purple. First letters of verses are done in gold, outlined in red, or little purple panels. Whenever it occurs in the text the word *Martialis* is rendered in the same manner. The numerous painted initials which mark the beginning of each chapter are golden letters outlined in red and placed on purple panels bordered in the same way. The body of these letters is filled with interlace in the manner of Italian Geometric Style initials. The single historiated initial (f. 35) prefaces Martial's apocryphal letter to the people of Bordeaux following the *Vita* (*D.A.C.L.*, IX, 1, 1930, 1100) and shows a haloed author writing at a pulpit within an architectural enclosure. The style is connected to the Italo-Byzantine mode illustrated in the Parma Ildefonsus (no. 57) and the Cluny Lectionary (no. 56), as pointed out by M. Schapiro. A pen drawing (f. 1) shows the full-page design of elaborate initial letters which appears on f. 2v, though in turned on its head. The purpose of this drawing and the method of its execution are not entirely clear, but it seems authentic and medieval in origin. Within the production of Saint-Martial, the decoration of the manuscript stands closest to the copy of Augustine's *Enarrationes in Psalmos* in two volumes (Bibl. Nat. lat. 1987 and 1993) and also has some ties with the Second Saint-Martial Bible (Bibl. Nat. lat. 8; no. 37). The luxurious, yet largely aniconic *parti* is paralleled in some other saints' lives of the period: the Life of St. Philibert of Tournus (Tournus, Bibl. Mun. MS 1) or the Life of St. John of Reome from Moutiers Saint-Jean (Semur-en-Auxois, Bibl. Mun. MS 1).

PROVENANCE: Charles-Maurice Le Tellier, Reims, MS 53 (f. 1). Acquired by the Royal Library in 1700. Regius 3863.3.

LITERATURE: L. Surius, *De probatis sanctorum historiis*, Cologne, 1618, VI, 365–74; Delisle, *Cabinet des manuscrits*, I, 389, 397; Abbé F. Arbellot, 'Etude historique

et littéraire sur Adémar de Chabannes', *Bulletin de la Société archéologique et historique du Limousin*, XXII, 1873, 149–50; A. Duplès-Agier, ed., *Chroniques de Saint-Martial de Limoges* (Publ. de la Société de l'histoire de France), Paris, 1874, 47, 296; *Catalogus codicum hagiographicorum latinorum Bibliothecae Nationali Parisiensis*, Brussels, 1889, I, 585, No. CCLXXIII; L. Duchesne, 'Saint-Martial de Limoges', *Annales du Midi*, IV, 1892, 302–6; id., *Fastes épiscopaux de l'ancienne Gaule*, Paris, 1894–1900, II, 111; L. Delisle, 'Notice sur les manuscrits originaux d'Adémar de Chabannes', *Notices et extraits des manuscrits de la Bibliothèque Nationale*, XXV, 1896, 353–55; E. B. Garrison, *Studies in the History of Medieval Italian Painting*, I, 1953, 46, n. 6; Schapiro, *Parma Ildefonsus, 50*; Gaborit-Chopin, *Manuscrits à Saint-Martial de Limoges*, 121–22, 205; *Manuscrits datés*, II, 496; D. F. Callahan, 'The Sermons of Adhemar de Chabannes and the Cult of St. Martial de Limoges', *Revue bénédictine*, LXXXVI, 3–4, 1976, 251–95; R. Landes, 'The Dynamics of Heresy and Reform in Limoges: A Study of Popular Participation in the "Peace of God" (994–1033)', *Historical Reflections*, XIV, 3, 1987, 483, n. 56; A. Sohn, *Der Abbatiat Ademars von Saint-Martial de Limoges (1063–1114)* (Beiträge zur Geschichte des Alten Mönchtums und des Benediktinerordens, 37), Maria Laach, 1989, 129–30.

EXHIBITED: *L'art roman à Saint-Martial de Limoges*, Limoges, 1950, No. 32; *Manuscrits à peintures*, Paris, 1954, 324, No. 110.

40. Paris, Bibliothèque Mazarine, MSS 1–2

Bible (Mazarine Bible)
540 × 379 mm., ff. 214 and 247, 2 cols., 50 lines
First quarter of the 12th century. Limousin

Ills. 88, 89, 90

MS 1

Historiated and ornamental initials: PREFACE TO OLD TESTAMENT, F (f. 2); PREFACE TO PENTATEUCH, D (f. 2); GENESIS, I (f. 5); EXODUS, H (f. 20); LEVITICUS, V, the Lord speaks to Moses (f. 31); NUMBERS, L, the Lord presents the Tablets of the Law to Moses (f. 41v); DEUTERONOMY, H (f. 54v); JOSHUA, E (f. 66); JUDGES, P (f. 74); RUTH, I, female personification with pennant (f. 82); PREFACE TO KINGS, V (f. 83); I KINGS, F, Eli before an altar, Elkanah and his two wives (f. 85); II KINGS, F (f. 96v); III KINGS, E (f. 106); IV KINGS, P (f. 118); PREFACE TO ISAIAH, N (f. 128); ISAIAH, V (f. 128); PREFACE TO JEREMIAH, I, standing Prophet with scroll (f. 144); JEREMIAH, V (f. 144v); BARUCH, E (f. 162v); PREFACE TO EZEKIEL, I (f. 167); EZEKIEL, E (f. 167); PREFACE TO DANIEL, D (f. 184v); DANIEL, A (f. 185); PREFACE TO MINOR PROPHETS, N (f. 192); HOSEA, V (f. 192); PREFACE TO JOEL, I (f. 194v); JOEL, V (f. 194v); PREFACE TO AMOS, A (f. 195v); AMOS, A (f. 195v); OBADIAH, V (f. 197); JONAH, E (f. 197v); MICAH, V (f. 198); NAHUM, O,

bust of the Prophet (f. 199v); HABAKKUK, O (f. 200); ZEPHANIAH, V (f. 201); ZECHARIAH, I (f. 201v); MALACHI, O (f. 204); PREFACES TO JOB, C, S (f. 205); JOB, V (f. 206v).

MS 2

Historiated and ornamental initials: PSALMS, B (f. 1); PREFACE TO PROVERBS, I (f. 49); PROVERBS, P, standing Solomon with scroll (f. 49v); ECCLESIASTES, D (f. 57); SONG OF SONGS, O, crowned half-length personification of *Ecclesia* (f. 60); WISDOM, D (f. 61); ECCLESIASTICUS, O (f. 67v); PREFACE TO CHRONICLES, S (f. 72v); I CHRONICLES, A (f. 73); II CHRONICLES, C (f. 92); PREFACE TO EZRA, U (f. 104); EZRA, I (f. 104v); ESTHER, I, standing Esther (f. 112); TOBIT, T, the elder Tobit carrying a corpse (f. 116v); JUDITH, A, Decapitation of Holophernes (f. 120); I MACCABEES, E (f. 125); II MACCABEES, F, medallion with the Lamb of God (f. 136v); PREFACE TO GOSPELS, S, P (f. 145); PREFACE TO MATTHEW, M (f. 146); CANON TABLES (ff. 154–156); MATTHEW, L, standing Christ with book (f. 157); MARK, I, Christ presents a book to the lion of Mark (f. 169); LUKE, F, Christ presents a book to the calf, symbol of Luke (f. 178); JOHN, I, Hand of God with compass-like object, perhaps a symbol of the Trinity (f. 190v); ROMANS, P, Paul grasps a winged beast which forms the loop of the letter (f. 207v); I CORINTHIANS, P (f. 212); GALATIANS, P (f. 220); PHILIPPIANS, P (f. 223); I THESSALONIANS, P (f. 224); COLOSSIANS, P (f. 226); II TIMOTHY, P (f. 228v); PHILEMON, P (f. 230); HEBREWS, M (f. 230); ACTS, P (f. 233); APOCALYPSE, beginning missing.

According to Y. Zaluska, the work originally formed a single volume. Certain particularities of its text occur also in the Bible of Saint-Yrieix (Saint Yrieix, Hôtel de Ville) to which the decoration of the Mazarine Bible is closely related. The ornament and figure style point to a Limousin origin. D. Gaborit-Chopin considers the manuscript with the Saint-Yrieix Bible and a copy of Gregory's Homilies, formerly in the Chester Beatty Collection (MS 18) and now in a German Private Collection, to be a product of the workshop of the Sacramentary of Saint-Étienne of Limoges (Bibl. Nat. lat. 9438; no. 38). Some of the initials in the two Bibles are very similar in their subject matter and design. The figure of *Ecclesia* in the Mazarine Bible (MS 2, f. 60) echoes the personification of Wisdom in the Saint-Yrieix manuscript (f. 228), and both works have similar T initials showing Tobit carrying a corpse across his shoulders. Also comparable are the illustrations of Judith or the type of P initial in which a standing figure displays a curving scroll forming the loop of the letter (Mazarine MS 1, f. 49v and Saint-Yrieix, f. 359). But there are also differences in the choice of books that have figurative matter, and in the Mazarine Bible the number of historiated initials is somewhat larger than in the Saint-Yrieix manu-

script. The relative chronology of the entire group is uncertain. Gaborit-Chopin considers the Mazarine Bible to be the latest in the series and a single painter to have been responsible for the illumination of all four books. The same author tentatively proposes that this painter may have been Petrus del Casta, a Canon of Limoges, who is named in the colophon of the Chester Beatty Homilies, written for an Augustinian priory of the region, Saint-Jean de Côle. The wording of the colophon, however, leaves it unclear whether he was a scribe, as seems more likely, or an illuminator.

PROVENANCE: Transcription of a document of 1341 in the name of the royal provost of Palluau (Indre) recovered from the binding (MS 2, f. 202). *Ex libris*, library of the Grands-Augustins, Paris, 1707, and shelfmark No. 662 (MS 1, f. 1; MS 2, f. 11).

LITERATURE: A. Molinier, *Catalogue des manuscrits de la Bibliothèque Mazarine*, Paris, 1885, I, 1; G. de la Batut, 'Les principaux manuscrits à peintures conservés à la Bibliothèque Mazarine de Paris', *Bulletin de la Société française de Reproduction de Manuscrits à peintures*, XVII, 1933, 8–9; Gaborit-Chopin, *Manuscrits à Saint-Martial de Limoges*, 172ff, 176; id., 'Le peintre du Sacramentaire de Limoges', *Les dossiers de l'archéologie*, 14, Jan.-Feb. 1976, 108–115; Y. Zaluska, 'La Bible limousine de la Bibliothèque Mazarine à Paris', *Actes du 102e Congrès des Sociétés savantes*, Limoges, 1977, 6–98; Cahn, *Romanesque Bible Illumination*, 166, 275, No. 81.

41. Auch, Bibliothèque Municipale MS 1

Old Testament
540 × 370 mm., ff. 336, 2 cols., 44 lines
Middle of the 12th century. Gascony
Ills. 91, 92, 93

Historiated and ornamental initials: PREFACE TO OLD TESTAMENT, F, standing Jerome with staff (f. 1); PREFACE TO PENTATEUCH, D (f. 3v); GENESIS, IN monogram, the Lord with a book, Temptation in the Garden (f. 5); EXODUS, H, haloed figure standing with book (f. 24); LEVITICUS, V (f. 37); NUMBERS, L (f. 50); DEUTERONOMY, H, haloed figure seated (f. 64v); JOSHUA, E (f. 78); JUDGES, P (f. 86v); RUTH, I (f. 95v); PREFACE TO JOB, C (f. 96v); JOB, V (f. 98); PREFACE TO KINGS, V (f. 106v); I KINGS, F (f. 107); II KINGS, P (f. 140v); PROVERBS, P (f. 152); ECCLESIASTES, V (f. 160); SONG OF SONGS, O (f. 163); WISDOM, D (f. 165); ECCLESIASTICUS, O, standing figure (f. 171v); PREFACE TO CHRONICLES, S (f. 186v); I CHRONICLES, A (f. 187); II CHRONICLES, C (f. 197); PREFACE TO EZRA, U (f. 209v); EZRA, I (f. 210); NEHEMIAH, cut out (f. 213v); NEHEMIAH 7:70, N (f. 215v); PREFACE TO ESTHER, L (f. 218v); ESTHER, I (f. 218v); PREFACE TO TOBIT, C (f. 223); TOBIT, T (f. 223); PREFACE TO JUDITH, A (f. 226v); JUDITH, A (f. 226v); I MACCABEES, E (f. 231v); II MACCABEES, F (f. 242v); PREFACE TO EZEKIEL, I (f. 250v); EZEKIEL, E (f. 250v); DANIEL, A (f. 269); HOSEA, V (f. 277); JOEL, V (f. 279v); AMOS, V (f. 280v); OBADIAH, V (f. 282v); JONAH, E (f. 282v); MICAH, V (f. 283v); NAHUM, O (f. 284); HABAKKUK, O (f. 284v); ZEPHANIAH, V (f. 286); HAGGAI, I (f. 286v); ZECHARIAH, I (f. 287v); MALACHI, O (f. 290v); Chronographic sequence of biblical, Assyrian and Babylonian Kings within arcaded frames (ff. 292v–293); PREFACE TO ISAIAH, N (f. 294v); ISAIAH, V, two haloed figures standing with books (f. 294v); JEREMIAH, V (f. 312 bis); LAMENTATIONS, Q (f. 334).

This large volume has painted initials enclosed in framed panels at the beginning of the biblical books and prefaces, accompanied by *incipit* words in the form of flourished display capitals or ornate, more formally composed capitals set in reserve on painted strips. The most important among these comparatively small initials are those of Genesis and Isaiah. Preceding the Book of Isaiah, there is a set of facing pages with arcades housing an enumeration of the biblical, Assyrian, Babylonian and Persian dynasties, chronologically coordinated with the careers of the Hebrew Prophets. The tabulation of the Six Ages of the World which accompanies this chronographic material ends with the year 1138, the likely *terminus post* for the execution of the work. The Auch manuscript carries no indication of provenance. Previous authors have tentatively associated it with Gimont, a Cistercian abbey located some 15 kilometres west of the city and affiliated with Morimond in 1143, from which a number of books are also preserved in the municipal library. But the elaborate painted decoration and especially the fairly conspicuous use of gold in the work would argue against a Cistercian origin and make another source, like Auch Cathedral or the important Cluniac priory of Saint-Orens more probable.

The Auch Bible is an archaizing, stylistically isolated creation. The initials, which appear to be the work of a single artist, are constructed of wiry bands linked at the extremities and points of junction by interlace knots, while the broad spaces enclosed within the framework of the letter are filled with gold. The hollow areas within show tapestries of spiralling foliage reserved against darker grounds. The colours, among which blue, ochre, green, violet and several shades of red and pink predominate, are flatly laid, with only a simple linear shading. The illustrative component concentrated in the earlier parts of the work, consists in the main of single figures that seem disengaged and more like part of the ornamental furniture of the initial than carriers of an explicit meaning. There is a substantial contingent of zoomorphic imagery: a large bird and a dragon (f. 119), a fabulous creature spewing foliage confronted or addorsed quadrupeds (ff. 160, 223), confronted birds (ff. 162, 226v, 242v) and numerous

variations of these motifs. There are reminiscences in this decoration of the illumination of the Second Saint-Martial Bible of Limoges, and also a certain stylistic kinship with the initials of another major work of this southerly setting, equally isolated within its sphere, the Burgos Bible (Burgos, Bibl. Provincial, MS 846).

PROVENANCE: Unknown.

LITERATURE: X. Cadier, *Catalogue général*, IV, 1886, 390–91; A. Tarbouriech, 'Une Bible manuscrite et enluminée de la Bibliothèque d'Auch', *Bulletin d'histoire et d'archéologie de la province ecclésiastique d'Auch*, III, 1862, 17–23; Berger, *Histoire de la Vulgate*, 338; Cahn, *Romanesque Bible Illumination*, 166, 267, No. 52.

EXHIBITED: *Dix siècles d'enluminure en Languedoc*, Toulouse, 1954, 27, No. 38; *Art roman*, Barcelona and Santiago de Compostela, 54, No. 75.

42. Clermont-Ferrand, Bibliothèque Municipale MS 63

Sacramentary
305 × 215 mm., ff. 130, 19 long lines,
with contemporary marginal additions
Last quarter of the 12th century.
Clermont-Ferrand (?) *Ills. 94, 95*

Two miniatures, three-quarter page: Christ in Majesty with the Evangelist symbols (f. 55); Crucifixion (f. 58).

Historiated and ornamental initials: E (f. 2); C (f. 6); D (f. 9); O (f. 27); D, Lamb of God with Cross (f. 34v); C (f. 39); D (f. 41); O (f. 44); D (f. 45); D (f. 54v); *Vere Dignum* (f. 55v); *Te Igitur* (f. 56); D (f. 61); O (f. 65v); D (f. 67); D (f. 68); D (f. 75); D (f. 76v); V (f. 85v); S (f. 90); D (f. 94); O (f. 97v).

The origin of this manuscript is uncertain. The usually incisive Leroquais could find no basis for a localization in the liturgy, though the celebration of the feast of Saints Agricol and Vital on 4th November may well point to the Cathedral of Clermont-Ferrand, as Brisac has argued. The presence of both the feasts of *Natalis* and *Translatio* of St. Benedict, however, would make a monastic provenance more likely. Prayers for St. Austremoine, an Auvergnat saint whose cult was centred at Mozac, were added in the margins (f. 98) soon after the completion of the work. The manuscript was illuminated in two separate stages. The miniatures of the *Majestas Domini* and the Crucifixion along with three initials, one at the beginning of the Temporale and those of the Preface (*Vere Dignum*) and Canon of the Mass (*Te Igitur*) were originally the only painted embellishment of the volume; the other large decorative

capitals are pen-drawn letters with ornamental flourishes only. The pen-drawn initials were subsequently overpainted by a second illuminator in an effort, presumably, to give the manuscript a more luxurious or 'modern' appearance, though traces of the earlier designs are still visible in places and when the page is held up to the light. The two campaigns exhibit distinctive styles. The art of the first painter has strong ties to the Byzantine tradition, though refracted in a somewhat schematized manner which carries reminiscences of the 'Italo-Byzantine' current in the earlier decades of the 12th century. Although the existence of a Byzantinizing mode in manuscript illumination of Clermont-Ferrand is not otherwise documented, a series of stained glass panels reemployed in the Chapel of Saint-Anne of the 13th-century Cathedral presents stylistic parallels for the painting of the Sacramentary. The additions made by the second illuminator point to an entirely different sphere, his initials being typical Channel Style designs found in books from Paris and north-eastern France from the 1170s onward.

PROVENANCE: Unknown. MS 58 and Inv. No. 'b. A 4' (19th century).

LITERATURE: C. Couderc, *Catalogue général*, XVI, 1890, 21; Leroquais, *Sacramentaires*, II, 8; C. Brisac, 'Le sacramentaire MS 63 de la Bibliothèque de Clermont-Ferrand: nouvelles données sur l'art figuré à Clermont autour de 1200', *Bulletin historique et scientifique de l'Auvergne*, LXXXVI, 1974, 303–19.

43. Moulins, Bibliothèque Municipale MS 1

Bible (Souvigny Bible)
560 × 390 mm., ff. 392, 2 cols, 49 lines
(ff. 213–225v and 318–342, 59 lines)
Late 12th century. Saint-Pierre, Souvigny
 Ills. 96, 97, 98; Col. pl. V

Independent illustrations: GENESIS, Days of Creation (f. 4v); I KINGS, scenes of the life of David (f. 93); ESTHER, Esther before Ahasuerus, Hanging of Haman (f. 284); TOBIT, Tobit bids farewell to his father, Capture of the miraculous fish, Marriage of Tobit, Healing of Tobit's father from his blindness (f. 288v); ACTS, Ascension of Christ (f. 342v). A painting which preceded Judith has been excised.

Historiated and ornamental initials: PREFACE TO OLD TESTAMENT cut out (f. 1); PREFACE TO PENTATEUCH, D (f. 3); EXODUS, H, Moses and the Burning Bush, Moses' staff is transformed into a serpent (f. 22v); LEVITICUS, V, the Lord speaks to Moses (f. 36v); NUMBERS, L (f. 46v); DEUTERONOMY, H, Moses speaks to the Children of Israel (f. 61); PREFACE TO JOSHUA , T (f. 73); JOSHUA, E, Carrying the Ark and Destruction of Jericho (f. 73); JUDGES, P, Samson fighting the lion

(f. 81v); RUTH, I, standing male figure (f. 90); PREFACE TO I KINGS, V (f. 91v); I KINGS, F (f. 93v); II KINGS, F, the Amalekite messenger brings to David the insignia of Saul, Slaying of the Amalekite (f. 105v); III KINGS, Abisag the Sunnamite brought to the aged King David (f. 114v); IV KINGS, E, C, Ascension of Elijah (f. 126); PREFACE TO ISAIAH, N (f. 136); ISAIAH, V, Vision of Isaiah (f. 136); PREFACE TO JEREMIAH, H (f. 150v); JEREMIAH, Vision of the boiling cauldron (f. 151); LAMENTATIONS, E, Prophecy of the Destruction of Jerusalem (f. 168); PREFACE TO EZEKIEL, H (f. 170); EZEKIEL, E, Vision of the Living Creatures (f. 170); PREFACE TO DANIEL, D (f. 185); DANIEL, A, Daniel in the lions' den (f. 185v); PREFACE TO MINOR PROPHETS, N (f. 191v); HOSEA, V (f. 191v); JOEL, V, the Lord speaks to Joel (f. 193v); AMOS, V, Amos as shepherd (f. 194v); OBADIAH, V (f. 196); JONAH, E, Jonah cast into the sea and swallowed by the whale (f. 196v). MICAH, V, seated prophet with scroll (f. 197); NAHUM, O, (f. 198); HABAKKUK, O (f. 199); ZEPHANIAH, seated prophet with scroll (f. 199v); HAGGAI, I, standing prophet (f. 200); ZECHARIAH, I, standing prophet (f. 200v); MALACHI, (f. 203); PREFACE TO JOB, C (f. 204); JOB, V, Job on the dunghill (f. 204v); PSALMS, B, David writing and harping (f. 215); PREFACE TO PROVERBS, C, Jerome addresses Chromatius and Heliodorus (f. 226); PROVERBS, P (f. 226v); ECCLESIASTES, D, Solomon enthroned (f. 232v); SONG OF SONGS, O, Christ in dialogue with Ecclesia (f. 235); WISDOM, D, Solomon dispensing justice (f. 236v); PREFACE TO ECCLESIAS-TICUS, (f. 241v); ECCLESIASTICUS, O (f. 242); PREFACE TO CHRONICLES, S (f. 254v); I CHRONICLES, A, Adam and the generations (f. 256); II CHRONICLES, C, enthroned Solomon (f. 265); PREFACE TO EZRA, U (f. 276); EZRA, I, standing Cyrus (f. 276v); ESTHER, I, standing Esther (f. 284); PREFACE TO TOBIT, C, Chromatius and Heliodorus (f. 288); PREFACE TO JUDITH, A, Decapitation of Holophernes (f. 291v); JUDITH. A, Judith delivers the head of Holophernes to her maid (f. 292); PREFACE TO MACCABEES, M (f. 296); I MACCABEES, E (f. 296); II MACCABEES, F (f. 306v); CANON TABLES (ff. 314–316); PREFACE TO GOSPELS, B, S, P (ff. 317–317v); PREFACE TO MATTHEW, M (f. 317v); MATTHEW, I, writing Evangelist, symbol (f. 318); PREFACE TO MARK, M (f. 325); MARK, I, standing Evangelist (f. 325); PREFACE TO LUKE, L, standing Evangelist (f. 329); LUKE, Q, writing Evangelist, symbol (f. 329v); PREFACE TO JOHN, H (f. 336v); JOHN, standing Evangelist (f. 336v); PREFACE TO ACTS, L, Luke writing (f. 342)); ACTS, P, Vision of St. Peter (f. 342v); PREFACE TO CATHOLIC EPISTLES, N (f. 353); JAMES. I, standing Apostle (f. 353); I PETER, P, seated Apostle with keys (f. 354v); II PETER, S (f. 355v); I JOHN, Q, seated Apostle (f. 356v); II JOHN, S, John speaks to a woman and two children (f. 358); III JOHN, S, John speaks to Gaius (f. 358); JUDE, I, standing Apostle (f. 358v); PREFACE TO APOCALYPSE, I, standing Apostle (f. 358v); APOCALYPSE, A, Vision of the Lord with the sword and the seven candelabra (f. 359); PREFACE TO PAULINE EPISTLES, E, P (ff. 364v–365v); PREFACES TO ROMANS, R, R (ff. 365–365v); RO-MANS, P, Paul speaks to a group of Romans (f. 365v); PREFACE TO I CORINTHIANS, C (f. 369); I CORINTHIANS, P, Paul speaks to a group of Corinthians (f. 369v); PREFACE TO II CORINTHIANS, P (f. 373); II CORINTHIANS, P, Paul speaks to a group of Corinthians (f. 373v); PREFACE TO GALATIANS, G (f. 376); GALATIANS, P (f. 376); PREFACE TO EPHESIANS, E (f. 377v); EPHESIANS, P (f. 377v); PREFACE TO PHILIPPIANS, P (f. 379); PHILIPPIANS, P (f. 379); PREFACE TO COLOSSIANS, C (f. 380); COLOSSIANS, P, Paul speaks to a group of Colossians (f. 380v); PREFACE TO I THESSALONIANS, T (f. 381); I THESSALONIANS, P (f. 381); PREFACE TO II THESSALONIANS, A (f. 382v); II THESSALONIANS, P (f. 382v); PREFACE TO TIMOTHY, T (f. 383); TIMOTHY, P, Paul and Timothy (f. 383v); PREFACE TO II TIMOTHY, I, (f. 384v); II TIMOTHY, P (f. 384v); PREFACE TO TITUS, T (f. 385v); TITUS, P (f. 385v); PREFACE TO PHILEMON, P (f. 386); PHILEMON, P (f. 386); PREFACE TO HEBREWS, Q (f. 386v); HEBREWS, M (f. 387); LAODICEANS, P (f. 389v); BARUCH, H (f. 390).

The illumination of the Souvigny Bible has been described by J. Porcher as 'the most important series of Romanesque biblical paintings in France'. The manuscript is mentioned for the first time by two learned Benedictines, Edmond Martène and Ursin Durand, in their account of an inspection tour of the archives of French cathedrals and monasteries, published in 1717. The two authors praise the restoration of Souvigny and its library by a 15th-century prior, Geoffroy Chollet. This has led some authors, including Porcher himself, to assume that the Bible was brought to Souvigny by Chollet, presumably from Mont Saint-Michel in Normandy, where he had earlier been a monk. But this conclusion clearly rests on a misreading, and it is highly probable that the manuscript was executed for Souvigny itself, one of the major priories of Cluny and the resting place of two of its early abbots, Mayolus and Odilo. It is perhaps the 'very precious Bible containing the Old and the New Testament' that, according to an entry in the *Liber anniversarium* of the monastery (Moulins, Bibl. Mun. MS 13, f. 60), was made for the community, along with other liturgical books, by the sacristan Bernard. Unfortunately, we know nothing further about this personage.

The manuscript presently has a velvet binding, restored in 1833, which incorporates a number of heterogenous bronze ornaments of Limousin workmanship, arranged in a rather unsatisfactory way (see M.-M. Gauthier, *L'oeuvre de Limoges*, 1, Paris, 1987, 142–44, No. 145). These ornaments must have been made for another purpose, most likely a reliquary casket or similar object. The text is identical with the corresponding parts of the Clermont-Ferrand Bible (Clermont-Ferrand, Bibl. Mun. MS 1; no. 44). But the style of the illumination has a different set of relations. It is echoed in the Bible of Saint-Sulpice of Bourges (Bourges, Bibl. Mun. MS 3), and in a more summary fashion, in a Bible of the Bib-

liothèque Nationale (lat. 58) which in the 13th century belonged to a church at Fressac, a dependency of the Cathedral of Le Puy, near Le Vigan in the diocese of Nîmes. Three cuttings with ornamental initials in the library of the École des Beaux-Arts in Paris (Donation Masson, MSS 22, 23, and 25) must come from another Bible closely related in its style to the Souvigny manuscript. More distant reflections are found in the initials of the second volume of the Lyons Bible (Lyons, Bibl. Mun. MS 411; no. 55) and in the Evangelist portraits added towards the end of the 12th century to the Odilo Bible (Paris, Bibl. Nat. lat. 15176). The Fressac manuscript, the only work in the group with a documented medieval provenance, was in all likelihood executed in Le Puy. Remnants of wall painting in the cathedral complex of that city, especially the Transfiguration in the Chapel of St. Giles and the Crucifixion in the Salle des Morts, suggest that the broadly diffused idiom found in the Moulins Bible was well implanted there. The only other 12th-century Souvigny manuscript of some artistic interest, the Sacramentary of the abbey (Moulins, Bibl. Mun. MS 14), has no connection with the style of the Bible.

The illumination of the Souvigny Bible shows no very pronounced stylistic contrasts, but the quality of the execution varies considerably. A few initials, like the superb Haggai (f. 200), have a degree of refinement and an emotional charge comparable to the paintings associated with the Master of the Morgan Leaf in the Winchester Bible, a work that resembles the Souvigny manuscript on more than one point. Other paintings in the Bible, including the five remaining independent miniatures, are rendered in a more schematic manner, and the initials in the final pages of the manuscript are decidedly repetitive and of a fairly summary quality. The late Romanesque flowering of painting in Central France of which the Souvigny Bible is the prime exhibit, was strongly affected by Byzantine art. In the Bible, this eastern influence is most telling in the David cycle of I KINGS, derived from a model like the painting in the Psalter of Basil II In the Biblioteca Marciana, Venice, and in the Ascension preceding Acts. Not surprisingly, it is less pronounced in the illustrations of the Apocrypha, whose antecedents must be sought in the art of the Latin West. The date of the work remains conjectural. The script compares well with the writing of a dated document of the region, the list of relics of the Cathedral of Sens made in 1192 for Archbishop Guy des Noyers (M. Prou and E. Chartraire, *Bulletin et Mémoires de la Société Nationale des Antiquaires de France*, 1898, 129–40). The execution of the manuscript is best situated around the same time.

PROVENANCE: Saint-Pierre, Souvigny.

LITERATURE: H. Omont, *Catalogue général*, III, 1885, 173; L. Bréhier, 'La Bible de Clermont et la Bible de Souvigny', *Études archéologiques*, 1910, 49–90; id.,

'L'art de la miniature au moyen âge: La Bible de Souvigny', *Notre Bourbonnais*, 1923, 39–51; J. Porcher, 'Byzance et la peinture romane en France: La Bible de Souvigny', *Revue des arts*, 1958, 137–40; H.-G. Franz, *Spätromanik und Frühgotik* (Kunst der Welt), Baden-Baden, 1959, 172–73; J. Porcher, 'La Bible de Souvigny', *Trésors des musées de France*, V, 1965, 133–44; M. Labrousse, 'Etude comparative des initiales de la Bible de Souvigny', *Cahiers de civilisation médiévale*, VIII, 1965, 397–412; Dodwell, *Painting in Europe*, 206; C. Brisac, 'Les grandes Bibles romanes de la France du sud', *Les dossiers de l'archéologie*, Jan.-Feb. 1976, 102; W. Cahn, 'Autour de la Bible de Lyon: Problèmes du roman tardif dans le centre de la France', *Revue de l'art*, 47, 1980, 11ff.; M.- M. Gauthier, 'Un style et ses lieux: les ornaments métalliques de la Bible de Souvigny', *Gesta*, XX/I, 1981, 141–53. Cahn, *Romanesque Bible Illumination*, 8, 180, 184, 202, 204, 214, 236, 273–4, No. 76; M.-M. Gauthier, *Emaux méridionaux. Catalogue international de l'oeuvre de Limoges. I. L'époque romane*, Paris, 1987, 142–44, Nos. 145–146; F. Garnier, *Le Language de l'image au moyen âge*, II, Paris, 1989, *passim*.

EXHIBITED: *Manuscrits à peintures*, Paris, 1954, 113, No. 331; *Byzance et la France médiévale*, Paris, 1958, 68–9, No. 130; *La Vie mystérieuse des chefs d'oeuvre*, Paris, 1980, 239–41, No. 117.

44. Clermont-Ferrand, Bibliothèque Municipale MS 1

Bible (Psalms to New Testament)
525 × 370 mm., ff. 254, 2 cols., 48 lines
Third quarter of the 12th century.
Central France (?) *Ills. 99, 100, 101*

Historiated and ornamental initials: PSALMS, B (f. 1); PREFACE TO PROVERBS, I, standing figure with book (f. 23); PROVERBS, P (f. 24); ECCLESIASTES, V (f. 33); SONG OF SONGS, O (f. 36); WISDOM, D (f. 37v); ECCLESIASTICUS, O (f. 44); PREFACE TO CHRONICLES, S (f. 61v); I CHRONICLES, A (f. 62); II CHRONICLES, C (f. 73); PREFACE TO EZRA, U (f. 87); EZRA, I, standing prophet with scroll (f. 87v); PREFACE TO ESTHER, L (f. 96v); ESTHER, I, standing Esther (f. 97); PREFACE TO TOBIT, C, Jerome with Chromatius and Heliodorus (f. 102); TOBIT, T, the blind Tobit with his son led away by the angel Raphael (f. 102); PREFACE TO JUDITH, A (f. 106); JUDITH, A, Decapitation of Holophernes (f. 106); PREFACE TO MACCABEES, M (f. 112); I MACCABEES, E, battle of knights on horseback (f. 112); II MACCABEES, F (f. 126); CANON TABLES (ff. 136v–138v); PREFACES TO GOSPELS, B, S, P (ff. 139–140); PREFACE TO MATTHEW, M (f. 140v); MATTHEW, L, medallion with Evangelist and his symbol (f. 141v); PREFACE TO MARK, M (f. 153); MARK, I, medallions with writing Evangelist, Baptism of Christ, Lamb of God (f. 153v); PREFACE TO LUKE, medallions with writing Evangelist and symbol (f.

161v); LUKE, Q, (f. 162v); PREFACE TO JOHN, H, writing Evangelist and medallions with his symbol and John the Baptist (f. 177); JOHN, I, medallions with Evangelist symbol, bust of John, symbol of Luke (f. 177v); PREFACE TO ACTS, L, standing Luke on a dragon (f. 189); ACTS, P (f. 189v); PREFACE TO CATHOLIC EPISTLES, N (f. 203v); JAMES, I, standing Apostle with book (f. 204); I PETER, P (f. 205v); II PETER, S (f. 207v); I JOHN, Q (f. 208v); II JOHN, S (f. 210); III JOHN, S (f. 210v); JUDE, I, standing Apostle with book (f. 211); PREFACE TO APOCALYPSE, I, standing John (f. 211v); APOCALYPSE, A, vision of the Lord with the sword and the seven candelabra (f. 212); PREFACES TO PAULINE EPISTLES, E, P (f. 219v–220); PREFACES TO ROMANS, R, R (ff. 220–220v); ROMANS, P, Paul speaking to a group of Romans (f. 220v); PREFACE TO I CORINTHIANS, C (f. 226v); I CORINTHIANS, P, Paul seated among Corinthians (f. 227); PREFACE TO II CORINTHIANS, P (f. 232v); II CORINTHIANS, P, Paul speaking to a group of Corinthians (f. 233); PREFACE TO GALATIANS, G (f. 236v); GALATIANS, P, seated Paul with a group of Galatians (f. 237); PREFACE TO EPHESIANS, E (f. 239); EPHESIANS, P, Paul addressing a group of Ephesians (f. 239); PREFACE TO PHILIPPIANS, P (f. 241); PHILIPPIANS, P, Paul speaking to a group of Philippians (f. 241v); PREFACE TO COLOSSIANS, C (f. 242v); COLOSSIANS, P, Paul seated with followers (f. 243); PREFACE TO I THESSALONIANS, T (f. 244v); I THESSALONIANS, P, Paul with Thessalonians (f. 244v); PREFACE TO II THESSALONIANS, A (f. 246); II THESSALONIANS, P (f. 246); PREFACE TO I TIMOTHY, T (f. 247); I TIMOTHY, P, Paul speaking to a group of men (f. 247); PREFACE TO II TIMOTHY, T (f. 248v); II TIMOTHY, P, Paul speaking to a group of men (f. 249); PREFACE TO TITUS, T (f. 250); TITUS, P, Paul speaking to a group of men (f. 250); PREFACE TO PHILEMON, P (f. 250v); PHILEMON, P, Paul speaks to Philemon (f. 251); PREFACE TO HEBREWS, H (f. 251); HEBREWS, M (f. 251v).

Nothing is known about the history of this work prior to the end of the 18th century, when it was in the possession of a noble Auvergnat family. The second tome of a two-volume Bible, it was introduced into the scholarly literature by L. Bréhier, who found close analogies between its decoration and that of the late 12th-century Souvigny Bible in Moulins (Moulins, Bibl. Mun. MS 1; no. 43). This comparison does not stand up to scrutiny. But some sort of relationship between these stylistically dissimilar manuscripts does exist, since the text of the work in Clermont is identical to the corresponding section of the Souvigny Bible so far as both the order of the biblical books and the apparatus of prefaces and summaries are concerned. Such a measure of agreement, exceptional within the corpus of Bibles of the early Middle Ages, is best explained through the assumption that the Moulins and Clermont

manuscripts were transcribed from a common text model.

The historiated initials in the Clermont volume feature a fairly standard range of subject. The letter I is usually represented by a standing figure and the Pauline Epistles by stereotyped compositions showing the Apostle addressing recipients of his letters clustered before him. A striking detail, on the other hand, is the prone figure of St. John under the feet of the Apocalyptic Christ, apparently in the throes of his vision (f. 212). The initials are painted in a range of high-toned colours, bright red, deep blue, light green and gold predominating, the latter sometimes embossed with a star-shaped stamp. As tends to be the case in certain luxury manuscripts of this period, the *incipit* and *incipit* words are painted on bands joined to the edge of the initial and combined with it into a single compositional unit. The style has no known local roots, but derives from the north, and in particular from Channel Style illumination also in evidence in the work of one of the hands in the Sacramentary, possibly from Clermont, in the same library (Bibl. Mun. MS 63; no. 42). The northern connection is especially apparent in the ornamental components of the decoration and the structure of some of the initials. Letters with vertical stems, for example, in which medallions with diminutive figurative elements alternate with spiralling foliage (ff. 141v, 153v, 161v, 177v) are close cousins of initials found in manuscripts like the set of Glossed books of the Bible made for Herbert of Bosham (no. 88), and several copies of Gratian's *Decretum* (no. 89) works now thought to be products of Parisian ateliers. The mixture of animation and intensity which marks the rendering of the figures in the historiated initials would seem on first glance to belong to another realm, but something like it can be seen on a much smaller scale in the curious marginal illustrations of Bosham's Commentary on the Psalms (no. 88) and in the illumination of the same group of books.

PROVENANCE: Given to the Library of the Puy-de-Dôme Department in 1795 by Countess Dauphin Montrodet de Villemont (inscription on f. 1 and elsewhere in the manuscript).

LITERATURE: H. Omont, *Catalogue général*, XIV, 1980, 1; L. Bréhier, 'La Bible de Souvigny et la Bible de Clermont', *Études archéologiques*, 1910, 49–90; W. Cahn, 'Autour de la Bible de Lyon. Problèmes du roman tardif dans le centre de la France', *Revue de l'art*, 47, 1980, 13; id., *Romanesque Bible Illumination*, 270, No. 263.

EXHIBITED: *Manuscrits à peintures*, Paris, 1954, 112, No. 329.

III. LANGUEDOC, RHÔNE VALLEY, SOUTH-EASTERN FRANCE

45. Aix-en-Provence
Bibliothèque Méjanes MS 7

Four Gospels
320 × 230 mm., pp. 286, 27 long lines
c. 1100. Aix-en-Provence *Ills. 105, 106*

Canon Tables (pp. 5–15). Evangelist Portraits with initials: Matthew (p. 57); Mark (p. 123); Luke (p. 169); John (p. 234).

The volume contains transcriptions of several documents concerning the Cathedral of Saint-Sauveur at Aix-en-Provence during the episcopacy of Peter III (1101–1112): a charter of 1103 recording the consecration of the new church (p. 3; J.-L. Albanès, *Gallia Christiana Novissima*, I, 1899, *Instrumenta*, 6–7, No. IV); a second document recording the dedication in 1110 by Peter of an altar of the Resurrection in the cathedral (id., 7, No. V); a Bull of Paschal II dated 1102 which confirms the rights of the church of Aix and grants Peter the *pallium* (p. 281. id., 6, No. III); and a letter of Pope Celestine III dated 1191 which seeks to compel the Templars to restore a parish to the Chapter of Aix, copied into the manuscript in a hand of the later 12th century (p. 4; Jaffé-Loewenfeld, *Regesta pontificum romanorum*, 1885, No. 5904). The manuscript was quite likely made for Peter in connection with the rebuilding and dedication of Aix Cathedral, which took place in the context of Peter's vigorous efforts to establish the independence of the see against the claims of the powerful neighbouring churches of Arles and Narbonne. In the body of the manuscript, the four Gospels and their prefaces are preceded by Canon Tables distributed over twelve sides (pp. 5–16), a set of verses beginning *Virgo parens hac luce deumque virumque creavit* attributed in the heading to Pope Gregory (Walther, *Carmina*, I, l, No. 20527) and a directory of Gospel readings for the church year. The painted arcades of the Canon Tables, sumptuous in their effect, feature a pedimented gable (p. 6) and a variety of round, segmented and intersecting arches carried on imitation marble and other kinds of ornamented columns bearing Corinthian capitals. The Gospel text is written in a fairly small and angular hand, with simple red penwork initials for the chapter divisions as well as a few decorative letters of a larger format, left unfinished (pp. 120, 121, 162). At the beginning of the four Gospels, there are large painted initials and portraits of the Evangelists seated on massive benches and writing under the inspiration of their symbols, shown swooping down upon them from the skies denoted by quarter circles. These unframed frontispiece compositions are completed by an assertive rendering of the *incipit* words by means of ornate capital letters in red and blue colours. The initials derive from Franco-Saxon designs, with panelled sections filled with ornament, including naked men intertwined with beasts (pp. 169, 234), joined or terminated by large interlace knots with beast finials. Matthew is depicted in profile, while Mark, Luke and John are more or less frontalized. Matthew, Luke and John display the clerical tonsure. This painted decoration is carried out in a subtle range of opaque colours, red, slate blue, mauve and green predominating, with gold for the haloes and gold combined with silver employed for the definition of the interlace knots. As Porcher has surmised, the style of this illumination has some connection with Lombardy. The Evangelist portraits call to mind in particular the corresponding images in the Gospels of Mathilda of Tuscany from Polirone (New York, Pierpont Morgan Library, M. 492).

PROVENANCE: Cathedral of Saint-Sauveur, Aix-en-Provence. J.-F.-P. Fauris or A.-J.-A. Fauris de Saint-Vincent. Acquired by the Bibliothèque Méjanes in 1820. No. N.44 (16th century [?], p. 3). No. 1042 (19th century).

LITERATURE: J. H. Albanès, *Catalogue général*, XVI, 1894, 2–5; E. Marbot, *Notre liturgie Aixoise. Étude bibliographique et historique*, Aix-en-Provence, 1899, 17–20, No. I; id., *Histoire de Notre-Dame de la Seds d'Aix*, Aix-en-Provence, 1904, 339; H. Leclercq, *D.A.C.L.*, I, 1, 1907, col. 1039; J. Billioud, 'Manuscrits à enluminures exécutés pour les Bibliothèques provençales (890–1704)', *Bouches-du-Rhône. Encyclopédie Départementale*, II, Marseille, 1924, 9–11; Avril, *Temps des croisades*, 182–83; D. Perrier, 'Die spanische Kleinkunst des ll. Jahrhunderts. Zur Klärung ihrer stilistischen Zusammenhänge im Hinblick auf die Frage ihrer Beziehungen zur Monumentalplastik', *Aachener Kunstblätter*, 52, 1984, 85, 87.

EXHIBITED: *Manuscrits à peintures*, Paris, 1954, 103 No. 301.

46. Nîmes, Bibliothèque Municipale MS 36

Florus, Commentary on the Pauline Epistles
457 × 355 mm., ff. 207, 2 cols., 46 lines
1086–1108. La Grasse *Ills. 103, 104*

Historiated and ornamental initials: ROMANS, cut out (f. 1); I CORINTHIANS, P, standing Apostle (f. 61v); II CORINTHIANS, P (f. 112v); GALATIANS, P (f. 128); EPHESIANS, P (f. 142v); PHILIPPIANS, P, the Lord, within a medallion, speaks to the Apostle (f. 156v); COLOSSIANS, P (f. 167v); I THESSALONIANS, P (f. 174);

II THESSALONIANS, P (f. 178); I TIMOTHY, P (f. 180); II TIMOTHY, P (f. 189v); TITUS, P (f. 195); PHILEMON, P, the Apostle presents his book to Christ (f. 196v); HEBREWS, M (f. 196v).

The text of this commentary on the Pauline Epistles, attributed on the present manuscript to one Peter, Abbot of San Pietro in Ciel d'Oro at Pavia, is in reality a *catena* made by Florus of Lyons from the writings of St. Augustine in the 9th century, as A. Wilmart's studies have established. According to an inscription in red and black letters which appears on f. 1, the manuscript was 'annotated' by Abbot Robert of La Grasse. These annotations are presumably the marginal citations of Augustine's works from which the commentary was pieced together. The abbey of Notre-Dame at La Grasse (Aude), earlier known as Notre-Dame d'Orbieu, was founded by Nimphridius (or Nefridius), a friend of the Carolingian monastic reformer Benedict of Aniane, in 777 or 778. Robert I, the nineteenth abbot, who was in office from 1086 to 1108, is said to have been particularly devoted to the enlargement of the temporal possessions of the house (DeVic and Vaissètte, *Histoire générale du Languedoc*, IV, 2, 477–85, No. 92). A charter issued by Count Bernard Guillem of Cerdagne, in 1114, ceding the monastery of Saint-Martin de Canigou to La Grasse, which is transcribed on a guard sheet of the manuscript, documents the same concern for possessions. The body of the work has large pen-drawn initials sparingly embellished with a few touches of colour before the sections of the commentary corresponding to the fourteen Pauline Epistles. The *incipits* and *incipit* words are written in ornate majuscule letters imbricated or otherwise joined to form monograms in a distinctly southern vein. The design of the initials, on the other hand, is made up primarily of figurative and foliate elements rendered in a comparatively free and vivacious spirit that evokes the classicism of the Mediterranean coastline from Provence to Catalonia rather than the brilliant colouristic abstraction of illumination in Aquitaine to the west. Stylistically comparable are initials of a manuscript fragment from Aniane (Montpellier, Bibl. du Grand Séminaire, MS R. 2) and a *recueil* from Saint-André at Avignon (Nîmes, Bibl. Mun. MS 50, f. 45v), as pointed out by J. Claparède (*Miniatures médiévales au Languedoc méditerranéen*, 30–31, No. 10)

PROVENANCE: Compiled (?) by Abbot Robert of La Grasse (f. 1). Georges Paviot (1580) (f. 1v). Owned by François Massip, Royal Councillor of the Presidial at Nîmes in 1698. Library of J.-F. Seguier (1705–84) and bequeathed by him to the Academy of Nîmes in 1778.

LITERATURE: B. de Montfaucon, *Diarium Italicum*, Paris, 1702, 7; A. Molinier, *Catalogue général*, Quarto Series, VII, 1855, 545–7; M. Schapiro, 'New Docu-

ments on Saint-Gilles', *Art Bulletin*, XVII, 1935 [repr. in *Selected Papers. Romanesque Art*, New York, 1977, 336–37]; C. Charlier, 'La compilation augustinienne de Florus sur l'Apôtre', *Revue bénédictine*, LVII, 132, n. 4 and 136, n. 6; W. S. Stoddard, *The Facade of Saint-Gilles-du-Gard. Its Influence in French Sculpture*, Middletown, 1973, 139; R. Saint-Jean, *Languedoc roman* (Coll. Zodiaque), 1975, 382; *Manuscrits datés*, VI, 1983, 339.

EXHIBITED: *Dix siècles d'enluminure et de sculpture en Languedoc*, Toulouse, 1954, 22, No. 54; *Art roman*, Barcelona and Santiago de Compostela, 1961, 41, No. 48; *Miniatures médiévales en Languedoc méditerranéen*, Montpellier, 1963, 30–31, No. 10; *De Toulouse à Tripoli. La puissance toulousaine au XIIe siècle (1080–1208)*, Toulouse, 1989, 228, No. 333.

47. Grenoble, Bibliothèque Municipale MSS 16–18 [1, 3 and 8]

Bible, in three volumes
(Grande Chartreuse Bible)
567 × 367, 525 × 350, 547 × 330 mm., ff. 256, 234 and 256, 2 cols., 48 lines
Beginning of the 12th century.
Grande Chartreuse *Ills. 107, 108, 109*

MS 16

Ornamental initials: PREFACE TO PENTATEUCH, D (f. 1); GENESIS, IN (f. 2v); EXODUS, H (f. 31); LEVITICUS, V (f. 54v); NUMBERS, L (f. 72); DEUTERONOMY, H (f. 96v); PREFACE TO JOSHUA, T (f. 117v); JOSHUA, E (f. 118v); JUDGES, P (f. 133); RUTH, I (f. 147); PREFACE TO KINGS, V (f. 149); I KINGS, F (f. 151v); II KINGS, F (f. 171); III KINGS, E (f. 187); IV KINGS, P (f. 205); PREFACES TO CHRONICLES, S (f. 221v); E (f. 222); I CHRONICLES, A (f. 223); II CHRONICLES, C (f. 238).

MS 17

Ornamental initials: PSALMS (Hebrew Version): B (f. 1); Psalm 26, D (f.5v); Psalm 38, D (f. 9); Psalm 52, D (f. 12); Psalm 68, S (f. 15); Psalm 80, I (f. 19); Psalm 96, C (f. 22v); Psalm 109, D (f. 26v); PREFACE TO ACTS, L (f. 34); ACTS, P (f. 34v); PREFACE TO CATHOLIC EPISTLES, N (f. 53); JAMES, I (f. 53); I PETER, P (f. 55); II PETER, S (f. 57); I JOHN, Q (f. 58v); II JOHN, S (f. 61); III JOHN, S (f. 61v); JUDE, I (f. 62); PREFACE TO APOCALYPSE, I (f. 63); APOCALYPSE, A (f. 63); PREFACES TO PROVERBS, T (f. 73); C (f. 73v); PROVERBS, P (f. 74); ECCLESIASTES, V (f. 86); SONG OF SONGS, O (f. 88v); PREFACE TO JOB, C (f. 122); JOB, V (f. 123); PREFACE TO TOBIT, T (f. 137); TOBIT, T (f. 137); PREFACE TO JUDITH, A (f. 143); JUDITH, A (f. 143v); PREFACE TO ESTHER, L (f. 150v); ESTHER, I (f. 151); PREFACE TO EZRA, U (f. 158); EZRA, I (f. 158v); I MACCABEES, E (f. 171v); Psalm 1, B (f. 200v); Psalm 26, D (f. 205); Psalm 38, B (f. 208); Psalm 52, D (f. 211); Psalm 68, S (f. 213v); Psalm 80, E (f. 217); Psalm 96, C (f. 220v); Psalm 109 (f. 224).

MS 18

Ornamental initials: PREFACE TO ISAIAH, N (f. 1); ISAIAH, V (f. 1v); PREFACE TO JEREMIAH, I (f. 29v); JEREMIAH, V (f. 30); PREFACE TO EZEKIEL, I (f. 66v); EZEKIEL, E (f. 67); PREFACE TO DANIEL, D (f. 96); DANIEL, A (f. 97); PREFACE TO MINOR PROPHETS, N (f. 108); HOSEA, V (f. 108v); PREFACE TO JOEL, I (f. 112); JOEL, V (f. 112v); PREFACE TO AMOS, O (f. 114); AMOS, V (f. 114v); PREFACE TO OBADIAH, I (f. 117v); OBADIAH, V (f. 118); PREFACE TO JONAH, S (f. 118); JONAH, E (f. 119); PREFACE TO MICAH, T (f. 120); MICAH, V (f. 120); PREFACE TO NAHUM, N (f. 122v); NAHUM, O (f. 123); PREFACE TO HABAKKUK, Q (f. 124); HABAKKUK, U (f. 125); PREFACE TO ZEPHANIAH, T (f. 126); ZEPHANIAH, V (f. 126v); PREFACE TO HAGGAI, I (f. 128); HAGGAI, I (f. 128v); PREFACE TO ZECHARIAH, I (f. 129v); ZECHARIAH, I (f. 129v); PREFACE TO MALACHI, (f. 133v); MALACHI, O (f. 134); CANON TABLES (ff. 136v–138); PREFACE TO GOSPELS, P (f. 139); MATTHEW, L (f. 147); MARK, I (f. 163v); LUKE, Q (f. 175); JOHN, I (f. 194); PREFACE TO PAULINE EPISTLES, P (f. 209); ROMANS, P (f. 211); I CORINTHIANS, P (f. 219); II CORINTHIANS, P (f. 226v); GALATIANS, P (f. 232v); EPHESIANS, P (f. 234v); PHILIPPIANS, P (f. 237v); COLOSSIANS, P (f. 239v); I THESSALONIANS, P (f. 241v); II THESSALONIANS, P (f. 243v); TIMOTHY, P (f. 245); II TIMOTHY, P (f. 247); TITUS, P (f. 248v); PHILEMON, P (f. 249v); HEBREWS, M (f. 250v).

The monastery of Grande Chartreuse was founded in 1084 in a rugged Alpine setting near Grenoble by St. Bruno, a Canon of the Cathedral of Cologne, accompanied by four clerics and two laymen. The customs instituted there, and later codified by Bruno's successors, represent an original blend of the eremitic traditions of eastern monasticism with the cenobitic ideals more prevalent in the West. The present work contains instructions for the reading of the Bible throughout the year (MS 16, f. 256) and was no doubt designed for the performance of the Office in the choir. Also found in the manuscript is a transcription of the charter recording the gift of land in the desert of *Cartusia* to St. Bruno, confirmed by Bishop Hugh of Grenoble in 1086, as well as other Carthusian documents down to the year 1133 (MS 18, ff. 231v-234v; B. Bligny, *Recueil des plus anciens actes de la Grande-Chartreuse, l086–1196*, Grenoble, 1958, 29ff.).

Whether the work was executed locally or brought there by Bruno and his companions, as has sometimes been suggested, depends in the absence of any other criteria almost entirely on the date which is assigned to it. Since it is unlikely to antedate the later years of the 11th or the early 12th century, it seems best to assume that it originated in the first monastery on the site, designated as Sancta Maria de Casalibus, which was destroyed by an avalanche in 1132.

Given the paucity of surviving manuscript illumination from south-eastern France in the early Middle Ages, we do not know what kind of models or artistic tradition might stand behind this oldest of Carthusian books. The Grande Chartreuse Bible is a strange work, with a decorative scheme founded on Carolingian antecedents, chiefly from the Franco-Saxon School. Each of the books has a large aniconic initial, in some instances filling the entire text column, and complemented by a decorative treatment of the *incipits* in red capital letters and an ornamental elaboration of the *incipit* words. Many of the initials are monograms, and the letters following them are sometimes rendered as a sequence of self-standing ornamental initials on a smaller scale. Two illuminators carried out the work; the first was responsible for the major part of the decoration, the second one is in evidence only in the third volume, where he executed the Canon Tables and a few initials at the beginning of the New Testament. The initials of the principal hand are drawn in a thin dark outline, the design generally appearing in reserve on multicoloured fields in which purple is dominant, though used in accord with light blue, green, ochre, red and yellow. The Franco-Saxon basis of the initials is reflected in the panelled construction of the shafts, the interlace knots at the extremities and points of junction, and the finials in the form of biting beasts. But the knotwork is very irregular and the spaces within the letters filled with stylized foliage and fantastic creatures. Some letters have bevelled outlines as if to be construed as ornaments mounted on the page like jewels. They make a mildly gauche, though highly inventive impression. Few comparable works are known, though the bevelled treatment of the initial outline and the wilful deformation of the interlace can also be found in the Languedocian Bible of the British Library (Harley 4772–3; no. 49). M. Schapiro (quoted by Porcher) relates to the manuscript a copy of Remy of Auxerre's Commentary on the Minor Prophets (Bibl. Nat. lat. 3000), and there are comparable initials on a smaller scale in a copy of Augustine's *City of God* that can be associated with the Cluniac priory of Pont Saint-Esprit in the Rhône Valley (Bibl. Nat. lat. 2060; no. 48).

PROVENANCE: *Iste liber est domus maioris Cartusiae* (14th-century inscription MS 16, f. 254, and MS 17, ff. 2v, 233).

LITERATURE: P. Fournier, E. Maignien and A. Prudhomme, *Catalogue général*, VII, 1889, 9–12; P. Vaillant, *La Lettre ornée à travers les manuscrits cartusiens de la Bibliothèque de Grenoble*, Grenoble-Paris, 1945, No. 52; Porcher, *French Miniatures*, 25–26; R. Saint-Jean, *Languedoc roman* (Coll. Zodiaque), 1975, 381; Cahn, *Romanesque Bible Illumination*, 229–30, 245, 272, No. 71; C. de Mérindol, 'Les grandes Bibles cartusiennes d'époque romane', *Actes du l08e Congrès des Sociétés Savantes, Section d'archéologie*, Grenoble, 1983 [1987], 353–74; C. de Mérindol, 'Les premières Bibles cartusiennes', *La Naissance des Chartreux* (Actes du VIe Colloque international d'histoire et de spiritualité

cartusiennes), ed. B. Bligny and G. Chaix, Grenoble, 1984 [l986], 69–102; R. Etaix, 'Les manuscrits de la Grande Chartreuse et de la Chartreuse des Portes. Etude préliminaire', *Scriptorium*, XLII, 1988, 1, 61.

EXHIBITED: *Manuscrits à peintures*, Paris, 1954, 114–15, No. 338; *Les Chartreux, le désert et le monde*, Grenoble, 1984, 63, No. 7.

48. Paris, Bibliothèque Nationale MS lat. 2060

Augustine, City of God
360 × 240 mm., 2 cols., 45 lines
First quarter of the 12th century.
Rhône Valley or Languedoc *Ill. 112*

Full-page frontispiece: Heavenly City (f. 1).

Ornamental initials: Bk. I, G (f. 1v); Bk. II, S (f. 10); Bk. III, I (f. 17v); Bk. IV, D (f. 26); Bk. VI, Q (f. 42v); Bk. VII, Q (f. 47v); Bk. VIII, N (f. 55v); Bk. IX, E (f. 64); Bk. X, O (f. 70); Bk. XII, C (f. 80v); Bk. XII, A (f. 89); Bk. XIV, D (f. 102v); Bk. XVI, P (f. 121v); Bk. XVII, P (f. 133); Bk. XX, D (f. 167v); Bk. XXI, C (f. 181). The remaining books have simple red pen-work initials (ff. 33v, 96, 111v, 121v, 142, 157, 192).

The provenance of the manuscript is suggested by a charter that is dated 1164, copied on the verso of the last folio, by which the Count of Toulouse, Raymond V, confirms the rights and possessions of the Cluniac priory of Saint-Saturnin-du-Port (DeVic and Vaissètte, *Histoire générale du Languedoc*, IV, 2, 867–69). The monastery in question, located on the west bank of the River Rhône near the site where the medieval bridge of Pont Saint-Esprit (Gard) was later built, was founded by a bishop named Gerald (of Uzès?) in 948 and ceded by him to Abbot Aymar of Cluny (A. Bernard and A. Bruel, *Recueil des chartes de l'abbaye de Cluny*, I, Paris, 1876, No. 724). It is later mentioned among the monasteries reconstructed by Abbot Odilo (d. 1049), but suffered ruin at the hands of Huguenot bands in the course of the 16th century. The present volume is the only manuscript from the monastery thus far identified. Its full-page frontispiece is a many-storeyed and arcaded structure with turrets and crenellations guarded by an angel, no doubt intended as an evocation of Augustine's City of God. Drawn in a fine brown outline with the different elements of the architecture vividly painted in flatly-laid yellow, red, orange, violet and green, the design also serves as a kind of title page, the double arcade supported by lions constituting the lowest tier of the structure housing the *incipit* ornately inscribed in majuscule letters on dark brown bands. The initials at the beginning of the books of Augustine's work are lively designs enclosed in darker framed panels, executed in a delicate, yet sure

hand. The illuminator combined irregular and somewhat stolid interlace formations with palmette foliage and equipped the extremities of his wholly ornamental letters with animal masks spewing foliage. *Incipit* words are rendered in large, ornamented and imbricated capital letters, sometimes executed white on black (ff. 1v, 2), while *explicits* are written in majuscule lines gone over for emphasis with strokes of ochre or red.

PROVENANCE: Collection of J.-B. Colbert, MS 827. Acquired by the Royal Library in 1732. Regius 3766².

LITERATURE: Lauer, *Manuscrits latins*, II, 303; A. de Laborde, *Les Manuscrits à peintures de la Cité de Dieu de Saint Augustin*, Paris, 1909, I, 108; A. Wilmart, 'La tradition des grands ouvrages de Saint Augustin', *Miscellanea Augustiniana*, II, Rome, 1931, 287, No. 223; M. M. Gorman, 'The Maurists' Manuscripts of Four Major Works of St. Augustine', *Revue bénédictine*, XCI, 1981, 255, 256, 260, No. 9.

49. London, British Library MSS Harley 4772 and 4773

Bible (Harleian Bible)
510 × 370 mm., ff. 30l and 218, 2 cols., 50 lines
First quarter of the 12th century
with additions of the middle or third quarter
of the 12th century. Languedoc
 Ills. 110, 111; Col. pl. VI

Harley 4772

Historiated and ornamental initials: PREFACE TO OLD TESTAMENT, F, angel with Cross Staff and book (f. 1); GENESIS, I, Creation of the sun and moon, Creation of the firmament, the Lord with the scales, Creation of the beasts of the earth, Raising of Eve from Adam's side (f. 5); EXODUS, H, two figures struggling, one pulling the other's hair (f. 27v); LEVITICUS, V, the Lord speaks to Moses (f. 47); NUMBERS, L, the Lord appears to Moses in the Burning Bush (f. 61)v); DEUTERONOMY, H, figure with staff seated on a faldstool, with two men before him (Moses and Aaron before the Pharaoh?) (f. 81); JOSHUA, E, the Lord speaks to Joshua (f. 99); JUDGES, P, the Lord speaks to two kneeling Israelites (f. 108v); RUTH, I, Ruth and Elimelech on their journey to Moab (f. 120v); I KINGS, F, the Lord addresses Hannah (f. 124); II KINGS, F, murder of Eglon (f. 140v); III KINGS, E, Abisag comforts the aged King David (f. 153v); IV KINGS, P (f. 169); ISAIAH, V, standing Prophet with book (f. 185); JEREMIAH, V, standing Prophet with staff (f. 209v); BARUCH, E (f. 240); EZEKIEL, E, the Prophet points to the sky (f. 244); DANIEL, A, Daniel in the lions' den (f. 269v); HOSEA, V, standing Prophet with book (f. 280); JOEL, V, Prophet with book standing on a beast (f. 283v); AMOS, V, Prophet with book (f. 285v); OBADIAH, V (f. 288); JONAH, E, the prophet emerging from the whale

(f. 289); MICAH, V, Prophet with book (f. 290); NA-HUM, O (f. 292); HABAKKUK, O, Prophet with hook and staff (f. 293v); ZEPHANIAH, V (f. 294v); HAGGAI, I (f. 296); ZECHARIAH, I (f. 297); MALACHI, O, Prophet with book (f. 300v).

The two-volume Harleian Bible figures in Berger's study of the history of the Vulgate as a representative of a Languedocian recension. The illumination is not evenly weighted. The historiated initials are concentrated in Vol. I, which was decorated in a fairly ambitious spirit. The original plan, however, was not maintained, and the second tome has a more summary decoration consisting of smaller initial letters of a more restrained and unassuming design. The initials in the first volume are the work of two hands. One was responsible only for the initial of Jerome's Preface *Ad Paulinum* and the large initial I of Genesis, which are remarkable for their delicate and loosely articulated drawing in brown ink, reinforced by shading in slate grey and red lines, backed by a foil of dark blue. Their style is not typical of southern French work, and may well reflect the intervention of an artist schooled in Italy. The motif of the Lord in half length between personifications of the sun and moon in the upper part of the Genesis initial looks indeed like a quotation from the Creation cycles of Roman Giant Bibles. The second hand, responsible for the rest of the initials in the volume, is a thoroughly native talent. His boldly patterned drawings in brown line and bright tints combine figures, fantastic beasts, foliage and ornamental motifs with more exuberance than control. He favours letter forms of an Aquitanian type, with interlace formations of a loose and sketchy construction in reserve against bright yellow and red panels, to which the *incipit* word of imbricated majuscule letters on dark stripes may be attached. The body of the work in this style must have been executed around 1120. The two initials by the Italianate hand are likely to be later additions, as F. Avril has suggested. These additions should probably be dated in the middle or third quarter of the 12th century.

PROVENANCE: Given to the Capucins at Montpellier in 1621 by François Ranchin, Chancellor of the University; No. 3 in the monastic library (f. 1). Lord Robert Harley (1661–1724). Acquired by the British Museum with Harley's Library at the Museum's foundation in 1753.

LITERATURE: B. de Montfaucon, *Bibliotheca bibliothecarum*, II, 1281; H. Wanley, et al., *Catalogue of the Harleian Manuscripts…Preserved in the British Museum*, London, 1759–63, III, 203; Berger, *Histoire de la Vulgate*, 76; M. Schapiro, 'New Documents on Saint-Gilles', *Art Bulletin*, XVII, 1935 (repr. in *Selected Papers, Romanesque Art*, New York, 1977, 336–37); R. Saint-Jean, *Languedoc roman* (Coll. Zodiaque), 1975, 382–83;

Cahn, *Romanesque Bible Illumination*, 272–73, No. 74; Avril, *Royaumes d'Occident*, 187–88.

50. Perpignan, Bibliothèque Municipale MS 1

Four Gospels
310 × 230 mm., ff. 155, 24 long lines
First quarter of the 12th century.
Roussillon or Catalonia *Ills. 113, 114, 115, 116*

Full-page miniatures: Christ in Majesty (f. 2); the Trinity as the Throne of Grace (f. 2v); Adoration of the Lamb of God by prophets, saints and Evangelist symbols (f. 3); CANON TABLES, (Canons I–IV) (ff. 8–13v); Virgin and Child surrounded by saints (f. 14v); Wedding at Cana (f. 107); Multiplication of the Loaves and Fishes, Resurrection of Lazarus (f. 107v); Supper in the House of Simon, Entry into Jerusalem (f. 108); Last Supper, Washing of the Feet (f. 108v); St. John presents his book to the enthroned Christ (f. 111v).

Large initials: MATTHEW, missing; MARK, I (f. 52); LUKE, F (f. 72); JOHN, I, medallions with Evangelist symbol and *Agnus Dei* (f. 112).

Smaller ornamental initials for the PREFACES: B (f. 4); M (f. 6); M (f. 49); I (f . 68); I (f. 109); H (f. 109v) .

The text of the four Gospels in this volume is preceded by a set of Canon Tables, presently incomplete (Canons I–IV) and accompanied by prefatory texts, some of them uncommon, as well as being unequal in number and uneven in distribution. A set of verses not otherwise recorded, beginning *In primo vero canone quatuor ordine* (Walther, *Initia Carminum*, I, 458, No. 9061) prefaces the Eusebian concordances. MARK has three additional prefaces (Berger, *Préfaces*, Nos. 227, 229 and 228), the third and fourth with a distinctly Spanish pedigree. Luke's two prefaces *Cum in divinis atque sacris voluminibus* and *Igitur caritatis duribus* are unrecorded, while John's Gospel has as an extra prefatory text a sermon ascribed to Isidore of Seville (Berger, *Préfaces*, No. 237) and is followed by a directory of Gospel readings for the church year (*Capitulare evangeliorum*). In addition to the missing Canons V–X between present folios 13v and 14, there are other losses: summaries I–XVII of Matthew, the prefaces and the beginning of Matthew (l, 1–19), and the opening passages of Mark's first preface. The last five folios of the manuscript (ff. 150–155v) consist of a transcription of part of the Gospel of Mark (l–6:55) in the same hand as the body of the text.

The illustrations are distributed in separate groups at strategic points within the manuscript. The three which fill the opening pages constitute an appropriate and no doubt deliberately chosen ensemble of visionary and dogmatic images. A single picture prefaces the Gospel of Matthew and none are

61

present at the head of Mark and Luke. But since there are losses at the beginning of the first two Gospels, additional illustrations may originally have been extant, devoted, in all likelihood, to the story of the Infancy. The remaining pictures all precede John's Gospel, which is also the only one to feature an author portrait, an unorthodox image showing the Evangelist presenting a book to the seated Lord for which there antecedents in Carolingian art and some later parallels (C. Nordenfalk, 'Der inspirierte Evangelist', *Wiener Jahrbuch für Kunstgeschichte*, XXXV, 1983, 179ff.) Among the dogmatic images, the illustration of the Trinity in the form of the Throne of Grace must count among the oldest examples of this theme thus far discovered. The image of the Virgin surrounded by an aureole filled with busts of the saints has no exact counterpart with the exception of the image of John before Christ. These illustrations are carried out in the form of rather sketchy drawings, though the opening miniature with the enthroned Christ in a mandorla is more elaborately worked out than the rest. The John portrait, the Canon Tables, and the initials at the head of the Gospels and prefaces, on the other hand, are painted in a subdued range of colours, chiefly ochre, grey, green, red and brown, flatly though somewhat loosely applied. It might be conjectured that the drawn illustrations were also initially meant to be painted, but this seems unlikely, since they are in all respects complete and fully worked out. That they could be later additions, as the comparative freedom of their execution might suggest, is also rendered unlikely by a comparison with the painted elements of the decoration. Deserving of note is the exuberant design of the Canon Table arcades, showing horseshoe-shaped arches, sometimes intersecting one another, supported on ornamented columns or *atlantes*. The capitals and bases are composed of a variety of anthropomorphic and zoomorphic motifs, among which are found goats, a rooster (ff. 9v–10), eagles (ff. 10v–11), busts of men (f. 11v); birds grasping hares and human *atlantes* (ff. 12v–13), elephants and peacocks (f. 13v).

The manuscript is no doubt a regional product. The drawing technique favoured in the illustrations recalls the practice of Catalonian scriptoria. Within the rather small body of Roussillon illumination that has survived, the Missal of Arles-sur-Tech (Perpignan, Bibl. Mun. MS 4) contains a drawing of the Crucifixion in a not too distantly related style.

PROVENANCE: Given to the Bibliothèque Municipale of Perpignan by the historian Henry towards 1840, and said by him to have come from Saint-Michel de Cuxa. Ancien No. 41.

LITERATURE: L. Cadier, *Catalogue général*, XIII, 1891, 79–81; A. Boinet, 'Notice sur un Evangéliaire de la Bibliothèque de Perpignan', *Congrès archéologique*, LXXIII, 1906 (1907), 534–51; W. Cook, 'The Earliest Painted Panels of Catalonia', *Art Bulletin*, V, 1923, 91, 95; VI, 1923, 55; Boeckler, *Abendländische Miniaturen*, 63; M. Durliat, *Arts anciens du Roussillon*, Perpignan, 1954, 26–7; W. Braunfels, *Die heilige Dreifaltigkeit*, Düsseldorf, 1954, 40; Porcher, *French Miniatures*, 26–7; L. Grodecki, 'Les vitraux allégoriques de Saint-Denis', *Art de France*, I, 1961, 21; J. Dominguez Bordona, *Ars Hispaniae*, XVIII, 1962, 93; R. Noell, 'Trésors de la Bibliothèque de Perpignan', *Enluminure carolingienne et romane* (Les dossiers de l'archéologie, 14), Jan.-Feb. 1976, 126–7; R. Amiet, 'La liturgie dans le diocèse d'Elne du VIIe au XVIe siècle. La liturgie romano-franque', *Cahiers de Saint-Michel de Cuxa*, 11, 1980, 74; id., 'Les livres liturgiques et le calendrier du diocèse d'Elne', *Cahiers de Fanjeaux*, XVII, 1982, 143; A. José i Pitarch, *Historia de l'art català, I. Els inicis i l'art romànic, s. IX-XII*, Barcelona, 1986, 269; J. Ainaud de Lasarte, *Catalan Painting*, Geneva and New York, 1990, 44–5; R. Favreau, 'Épigraphie et miniatures. Les vers de Sedulius et les évangiles', *Revue des savants*, 1993, 1, 68.

EXHIBITED: *Manuscrits à peintures*, Paris, 1954, 103–4, No. 302; *Dix siècles d'enluminure et de sculpture en Languedoc*, Toulouse, 1954–55, 22, 55, No. 25; *Art roman*, Barcelona and Santiago de Compostela, 73, No. 102.

51. London, British Library MS Add. 16979

Obituary and Rule of St. Benedict
275 × 175 mm., ff. 63, 26 long lines
1129. Saint-Gilles *Ill. 102*

One miniature: St. Benedict hands a copy of his Rule to St. Maurus, accompanied by two monks (f. 21v). Ornamental initials: M (f. 25); A (f. 25v). Large ornamental KL monograms in the Calendar (ff. 1–21).

The Saint-Gilles Obituary and Rule of St. Benedict is one of the few surviving manuscripts from the important abbey and pilgrimage centre of Saint-Gilles, situated near the dividing line between Provence and Languedoc. The decoration of the manuscript, concentrated at the beginning of the Rule, consists of a prefatory miniature showing the enthroned saint handing a book to his disciple Maurus, and painted ornamental initials on gold grounds at the beginning of the first two chapters. From f. 26 onwards, there are only modest decorative capital letters drawn in colour in combinations of red, green, or blue. The miniature is framed by a border lined by a strip of pearly ornament. The figures are placed on a gold ground. St. Benedict's habit is deep blue, his throne green, while Maurus wears a purple habit and the two monks behind him have garbs of red and blue. The painting is solidly modelled, and in a pliantly linear manner that seems to carry forward, in a mildly diluted fashion, the Italo-Byzantine style of

the Cluny Lectionary (no. 56) and Parma Ildefonsus (no. 57). Petrus Guillelmus, who executed the manuscript during the reign of Abbot Peter de *Situlvero* or d'Anduze, can be associated with several other books from Saint-Gilles. The Martyrology of Usuard and Homiliary in the British Library (Add. 16918), written by the same hand and decorated in a comparable manner, once completed the present volume. Petrus is also in evidence in a third manuscript, completed in the course of several campaigns, in which he wrote the beginning of the Second Life of St. Gilles, and possibly several miracles added later (Bibl. Nat. lat. 13779, ff. 8–31, 98–113, 124–29). In 1128, a year before he completed the present manuscript, he wrote a collection of historical texts comprising Rorico's *Historia Francorum*, Julian of Toledo's *Historia Wambae*, and a *Vita Karoli* made up of sections of the biographies of Einhard and Notker the Stammerer. This manuscript is lost, but was known to the 17th-century historian André Duchesne (*Scriptores historiae francorum*, Paris, 1636, II, 93, and R. Poupardin, *Annales du Midi*, XVII, 1905, 252–62). In the colophon, the scribe identifies himself as *Guillelmus armarius*. Earlier, under the preceding Abbot of Saint-Gilles, Hugh, and probably in the years 1121–4, he compiled a book of miracles of St. Gilles (Bibl. Nat. lat. 11018). Finally, in the course of a stay at Acey (Champagne) in 1142, he transcribed a recension of the *Liber Pontificalis*, now in the Vatican Library (Vat. Lat. 3762). In this volume, he is identified as *Petrus Guillermus Bibliothecharius* (ff. 91v–92, 93v–94, 94v–95).

PROVENANCE: Written by Petrus Guillelmus at Saint-Gilles in the year 1129 (f. 62). Library of the Jacobins at Chambéry, 18th century (*G.C.*, VI, 710). Purchased by the British Museum from Payne and Foss in 1847.

LITERATURE: J. Mabillon, *Acta sanctorum ordinis Sancti Benedicti*, Venice, 1668–1710, V, 880; P. Marchegay, 'Cartulaires français en Angleterre', *Bibliothèque de l'École des Chartes*, XVI, 1855, 120–1; C. Devic and J. Vaissètte, *Histoire générale du Languedoc*, Toulouse, 1872–9, V, 37; A. Molinier, *Les Obituaires français au moyen âge*, Paris, 1890, 276, No. 260; *Palaeographic Society*, I, 62; M. Schapiro, 'New Documents on Saint-Gilles', *Art Bulletin*, XVII, 1935, 414–31 [repr. in *Selected Papers. Romanesque Art*, New York, 1977 328–42];. P. David, 'La Pologne dans l'Obituaire de Saint-Gilles en Languedoc au XIIe siècle', *Revue des études slaves*, XIX, 1939, 217–26; S. H. Thompson, *Latin Bookhands in the Later Middle Ages, 1100–1500*, Cambridge, 1969, No. 2; C. Hohler, 'A Note on Jacobus', *J.W.C.I.*, XXXV, 1972, 53–4; *Manuscrits datés*, VI, 1, 39; A. G. Watson, *Catalogue of Dated and Datable Manuscripts, c. 700–1600, in the Department of Manuscripts, the British Library*, London, 1979, 49, 174; *Colophons*, V, 1979, 92, No. 15.570; J.-L. Lemaître, *Répertoire des documents nécrologiques français* (Recueil des historiens de la France, VII), Paris, 1980, II, 1307–1308, No. 3071; U. Winzer, *St. Gilles. Studien zur Rechtsstatus und Beziehungsnetz einer Abtei im Spiegel ihrer Memorialüberlieferung* (Münstersche Mittelalter-Schriften, 59), Munich, 1988, 97ff.

52. Berlin, Staatsbibliothek Preussischer Kulturbesitz MS Lat. qu. 198

Medical and Pharmacological Anthology
190 × 120 mm., pp. 321, 24 to 38 long lines
1132. Southern France. Montpellier (?)
Ills. 120, 121, 122, 123

Fourteen miniatures, with one exception (p. 302), occupying an entire page: Seated figure, almost entirely erased, apparently an Evangelist portrait (p. l); Physician with ointment jar and plant, two men preparing medicines (p. 4); Hippocrates in dialogue with Galen, and below, a third physician (p. 20); four medicinal plants (p. 302); seven plants (p. 303); a crowned man leads a crowned woman towards a bishop, perhaps a depiction of marriage (above); below, the couple on horseback; both scenes are nearly erased (p. 304); a crowned figure giving his hand to a larger, standing man, who carries a palm, perhaps to be interpreted as a scene of feudal homage; above, Divine hand in the clouds, blessing (p. 305); four plants (p. 309); Mandragora plant pulled up by a dog; below, a man with a spade (p. 310); Crucifixion and Awakening of the Dead (p. 320); Christ in Majesty, superimposed on a large Eagle of St. John, surrounded by the three other Evangelist symbols (p. 321).

The text of this small volume is a collection principally of Pseudo-Hippocratic tracts on various medical disorders, pharmacology, physiognomics, veterinary medicine and other topics, including excerpts from Flavius Vegetius *De re militari*. It was written by several hands, all of them working in a very small, irregular and heavily abbreviated script. The date of the work is given in a Spanish reckoning found at the end of an enumeration of the Ages of the World which concludes the text of Flavius Vegetius (p. 271). The illustrations in the manuscript stand outside an identifiable stylistic context, though the reliance on drawing and the character of the draughtsmanship calls to mind another, somewhat earlier manuscript of the region, embellished in the same fashion, the Commentary on the Pauline Epistles from La Grasse (Nîmes, Bibl. Mun. MS 36; no. 46). The nature of the compilation makes Montpellier, with its university specializing in the study of medicine, the place where the manuscript was most likely to have been made.

The drawings in the Berlin manuscript divide into two groups. One set of images comprising representations of physicians, the preparation of medi-

cines and depictions of medicinal plants — the latter very stylized, and with the exception of Mandragora, difficult to identify — have an evident connection with the subject of the compilation. They must be regarded as free copies drawn from the illustration of the Herbal of the Pseudo-Apuleius, which is thought to derive from a Late Antique archetype. The artist, however, removed the plant pictures from their customary place within the text (not included in the Berlin manuscript) and grouped them in series of four, five or more on separate pages. The two pages with drawings of physicians and their assistants are not harmonious, organically-conceived compositions, but similarly give the impression of having been casually assembled from smaller and initially discrete elements. The second set of drawings is on the contrary entirely unrelated to the scientific content of the volume. These drawings are enclosed within frames, and unlike the medical illustrations, they are formally composed images. The two drawings on facing pages (pp. 304–305), one of them partially erased, may well be scenes from a saint's life. The Crucifixion and facing *Majestas* picture, the latter a striking design of great interest, would be at home in a Sacramentary or Missal. Why these pictures were included in the manuscript is unclear. They were perhaps simply discards from another project for which the artist or his patron felt some esteem and wanted to preserve in whatever form.

PROVENANCE: Purchased by the Preussische Staatsbibliothek in 1855 from an unrecorded source.

LITERATURE; K. Sudhoff, 'Die pseudohippokratische Krankheitsprognostik nach dem Auftreten von Hautausschlagen, "Secreta Hippocratis" oder "Capsula eburnea" genannt', *Archiv für Geschichte der Medizin*, IX, 1916, 82; H. Knaus, 'Apothekerbilder in einer südfranzösischen Handschrift des 12. Jahrhunderts', *Medizinischer Monatspiegel*, 1968, 1, i–iv; H. I. P. Bachoffner, *Revue d'histoire de la pharmacie*, XIX, 1968, 138–39; W.-H. Hein and D. A. Wittop Koning, *Bildkatalog zur Geschichte der Pharmazie*, Stuttgart, 1969, 37, 145; H. Grape-Albers, *Spätantike Bilder aus der Welt des Arztes*, Wiesbaden, 1977, 5, 122, 124; W.-H. Hein and D. A. Wittop Koning, *Die Apotheke in der Buchmalerei* (Monographie zur Pharmazeutischen Kulturgeschichte, 6), Frankfurt-am-Main, 1981, 14–15.

EXHIBITED: *Zimelien*, Berlin, 1975–76, 100–101, No. 85; *Das Christliche Gebetbuch im Mittelalter*, Berlin, 1980, 61–62, No. 20; *Europa und der Orient, 800–1900*, Berlin, 1989, 126–27 and 671–72, No. 6/47.

53. (a) Lucca, Biblioteca Statale, MS 1405
Rhetorica ad Herennium
221 × 135 mm., ff. 63, 26 long lines

(b) Oxford, Bodleian Library MS Barlow 40
Cicero, De inventione rhetorica
227 × 135 mm., ff. II + 98, 26 long lines

Second quarter or middle of the 12th century.
Southern France *Fig. page 11; Col. pl. VII*

(a) Lucca 1405
Disputation of Cicero and Sallust (f. 1); Disputation of two confronted men (f. 28).

(b) Bodleian, Barlow 40
Cicero flanked by Cato and Caesar, triumphing over the Catiline conspirators (f. 1).

Ornamental initial: C (f. 4v).

The Lucca and Oxford manuscripts were clearly made as a set, their format and decorative characteristics being identical. Cicero's early and incomplete *De inventione rhetorica* contained in the Bodleian codex and the anonymous *Rhetorica ad Herennium*, accepted as a work of Cicero during the Middle Ages, appear to have circulated together, the first customarily termed *rhetorica prima*, the second *rhetorica secunda*. For the rather more elaborate frontispiece of the *De inventione*, the artist drew on Cicero's Orations and on the account of the Catiline conspiracy contained in Sallust's *Bellum Catilinae*, where the speeches of Gaius Caesar and Marcus Porcius Cato delivered against the plotters in the Senate during the consulship of Cicero are recorded (Ed., J. C. Rolfe, Loeb Classical Library, London and Cambridge, 1971, 89–109), and the actions of the two leading conspirators Lentulus and Cethegus, are described. These, shown seated in pensive or dejected poses at the feet of the regally enthroned and axe-wielding Cicero, are identified in the miniature by inscriptions. The scene is placed under a double arch surmounted by a turreted architectural prospect and festooned by parted curtains. No earlier illustrations of the trial of the Catiline conspirators is known, but the two-tiered and symmetrical arrangement of the composition resembles in general terms the depiction of consular audiences on the 5th-century Probianus Diptych, or, as noted by Pächt and Alexander, the enigmatic scene, perhaps showing Virgil declaiming before a courtly gathering, on the ivory sheath of the 9th-century flabellum of Tournus (L. Eitner, *The Flabellum of Tournus* [*The Art Bulletin, Suppl. 1*], New York, 1944, 18–23 and fig. 41).

The frontispiece of the Lucca *Rhetorica ad Herennium* with its scene of disputation between Cicero and Sallust has its source most likely in the existence among the probably inauthentic works of the two authors of invective orations that they directed

against each other (Sallust, *Works*, Loeb Classical Library, 492–521). The two seated figures, framed by a summarily outlined double arch, face one another and argue their positions with the help of open books bearing short sentences from their diatribes to which they point for emphasis. Both illustrations are drawn in brown outline, reinforced with red, green and light blue linear shading. The backgrounds are composed of flat bands of light blue, brown and green bands, with gold and silver employed for the borders of the garments, shoes, the arches and a few other elements of architecture and furniture. The *incipit* words are painted on coloured bands with letters in an alternating sequence of contrasting hues, followed by an additional line of text rendered in ornate and imbricated pen-drawn letters.

The localization of these books remains to be definitively settled, with northern Italy and southern France having been tentatively proposed as their place of origin. On stylistic grounds, the second of these alternatives has a much greater degree of plausibility, and F. Avril, who drew attention to the artistic interest of the decoration of the Oxford volume, assigns it to Languedoc and, more hypothetically, to Toulouse.

PROVENANCE: **(a)** Collection of Cesare Lucchesini, Cod. 117 (note on the inner cover, 1782). **(b)** No. 157 (17th century, flyleaf). Bequeathed by Thomas Barlow (1607–1691). MS Auct. F. 5. 14 (19th century, flyleaf).

LITERATURE: A. Mancini, 'Index codicum latinorum publicae bybliothecae Lucensis', *Studi italiani di filologia classica*, VIII, 1900, 204; F. Madan, H. H. E. Craster and N. Denholm-Young, *Summary Catalogue of the Western Manuscripts in the Bodleian Library at Oxford*, Oxford, 1937, II, 2, 1061, No. 6480; O. Pächt and J. J. G. Alexander, *Illuminated Manuscripts in the Bodleian Library*, Oxford, 1970, II, 103, No. 1047; Avril, *Royaumes d'Occident*, 186; B. Munk Olsen, *L'étude des auteurs classiques latins aux XIe et XIIe siècles*, Paris, 1985, I, 220, No. C 267, and 245, No. C 353; *Milano e la Lombardia in età comunale, secoli XI-XIII*, Milan, 1993, 430, No. 349.

EXHIBITED: *The Survival of Ancient Literature*, Oxford, 1975, 64, No. 116.

54. Lyons, Bibliothèque Municipale MSS 410–411

Bible (Lyons Bible)
485 × 350 mm., ff. 237 and 249, 2 cols., 43 lines
Last quarter of the 12th century. Lyonnais (?)
Ills. 117, 118, 119

MS 410

Historiated and ornamental initials: PREFACE TO PENTATEUCH, D (f. 1v); GENESIS, I, three Creation scenes (f. 2); EXODUS, H, the Lord speaks to Moses (f. 21v); LEVITICUS, V, the Lord speaks to Moses (f. 37v); NUMBERS, L, the Lord speaks to the Children of Israel (f. 64v); PREFACE TO JOSHUA, T, Jerome writing (f. 79); JOSHUA, E (f. 79v); JUDGES, P, Samson wrestling with the lion (f. 90); RUTH, I, Ruth standing (f. 101); PREFACE TO KINGS, V (f. 102v); I KINGS, F, Anointing of David (f. 105); II KINGS, F, David in sorrow, two dead warriors (f. 119v); III KINGS, E, David with Abisag the Sunnamite (f. 132v); IV KINGS, P, Ascension of Elijah (f. 147v); PREFACE TO CHRONICLES, S (f. 162); I CHRONICLES, A (f. 162v); II CHRONICLES, C, monarch playing the harp, angel (f. 170v); PREFACE TO PROVERBS, C, Chromatius and Heliodorus in dialogue (f. 193v); PROVERBS, P, Solomon exhorting his son (f. 193v); ECCLESIASTES, V (f. 204); SONG OF SONGS, O, Virgin and Child (f. 207v); WISDOM, D, monarch conversing with cleric, angel (f. 209v); ECCLESIASTICUS, O, bust of the lord (f. 217); Prayer of ECCLESIASTICUS, C (f. 236v).

MS 411

Historiated and ornamental initials: PREFACE TO JOB, C, standing Jerome or monk (f. 1); JOB, V, Job on the dunghill (f. 1v); PREFACE TO TOBIT, T, Chromatius and Heliodorus (f. 12v); TOBIT, T, Tobit bids farewell to his parents and is led away by the angel (f. 12v); PREFACE TO JUDITH, A, combat of knights (f. 17); JUDITH, A, decapitation of Holophernes (f. 17); PREFACE TO ESTHER, L (f. 23); ESTHER, I, Esther before Ahasuerus (f. 23); PREFACE TO EZRA, U (f. 29); EZRA, I, the Prophet preaching on a mountain (f. 29v); I MACCABEES, E, combat of horsemen and foot soldiers (f. 41v); II MACCABEES, F, Expulsion of Heliodorus from the Temple (f. 57v); PREFACE TO ISAIAH, N (f. 68v); ISAIAH, V, Vision of Isaiah (f. 69); PREFACE TO JEREMIAH, H (f. 93); JEREMIAH, V, Vision of the boiling cauldron (f. 93); PREFACE TO DANIEL, D (f. 143v); DANIEL, A, Daniel in the lions' den, succoured by Habakkuk (f. 144v); PREFACE TO MINOR PROPHETS, N (f. 155v); HOSEA, missing; PREFACE TO JOEL, S (f. 159); JOEL, V, seated Prophet addressing his people (f. 159); PREFACE TO AMOS, O, King Uzziah censing an altar (f. 160v); AMOS, A, Amos as shepherd (f. 161); PREFACE TO OBADIAH, I (f. 164); OBADIAH, V, apparition of the Lord to the Prophet (f. 164); PREFACE TO JONAH, S, Jonah fleeing from the whale (f. l64v); JONAH, E, and angel appears to the Prophet, he preaches to the people of Niniveh (f. 165); PREFACE TO MICAH, T (f. 166); MICAH, V, apparition of the Lord to the reclining Prophet (f. 166v); PREFACE TO NAHUM, N (f. 168v); NAHUM, O, seated Prophet with scroll (f. 169); PREFACE TO HABAKKUK, Q (f. 170); HABAKKUK, O, seated Prophet with scroll (f. 171); PREFACE TO ZEPHANIAH, T (f. 171v); ZEPHANIAH, V, standing Prophet (f. 172); PREFACE TO HAGGAI, A (f. 173); HAGGAI, I, standing Prophet (f. 173v); ZECHARIAH, I, standing Prophet with scroll (f. 174); MALACHI, O, the Lord appears to the Prophet (f. 178); ROMANS, P, Paul addresses a group of Romans (f. 181v); I CORINTHIANS, P (f. 188v);

II CORINTHIANS, P, seated Paul with book (f. 195); GALATIANS, P, Paul speaks to a group of Galatians (f. 199); EPHESIANS, P (f. 201v); PHILIPPIANS, P, Paul and Timothy (f. 203v); COLOSSIANS, P (f. 205); I THESSALONIANS, P, Paul speaks to a group of Thessalonians (f. 206v); II THESSALONIANS, P (f. 208); I TIMOTHY, P, Paul and Timothy (f. 209); II TIMOTHY, P, Paul and Timothy (f. 211); TITUS, P, Paul speaks to Titus (f. 212v); PHILEMON, P, Paul speaks to a group of Hebrews (f. 214); LAODICEANS, P (f. 218); ACTS, P, Vision of Peter (f. 219v); PREFACE TO CATHOLIC EPISTLES, N (f. 235); JAMES, I, standing Apostle (f. 235v); I PETER, P, Peter with the keys (f. 237); II PETER, S, seated Peter with keys (f. 238v); I JOHN, Q, John writing, dove of the Holy Spirit (f. 239v); II JOHN, S (f. 241); III JOHN, S, seated Apostle with scroll (f. 241v); JUDE, I, standing Apostle with scroll (f. 241v); PREFACES TO APOCALYPSE, I, Jerome writing (f. 242v); B, standing Apostle with book (f. 242v); APOCALYPSE, A, Vision of the Lord with the sword and seven candelabra (f. 243).

The Lyons Bible is a difficult manuscript to localize and date, but some aspects of the text point to a regional origin. The summaries of I Kings and the uncommon preface of Revelation *Beatus Iohannes apostolus post passionem* (Berger, *Histoire de la Vulgate*, 347, and id., *Préfaces*, No. 313) are also found in an 11th-century Bible of Vienne Cathedral, a short distance south of Lyons (Bern, Bürgerbibl. Cod. A 9). A chronology of the Kings of Israel taken from Isidore of Seville which appears before I Chronicles occurs in the corresponding place in a Bible of the Grande-Chartreuse (Grenoble, Bibl. Mun. MS 15), and following IV Kings, in the Languedocian Bible of the British Library (Harley 4772; no. 49). The summaries of the Pauline Epistles, on the other hand, are apparently unique. With the exception of two ornamental initials in the first volume (ff. 201v, 236v), contributed by a secondary figure, the illumination of the manuscript is the work of two distinct hands. The first, who executed all the initials in the first volume and the first two initials in the second, is a painter of outstanding ability, who stands quite isolated. His initial letters, built of panelled elements derived from the Franco-Saxon tradition, show much interlace and are painted in a sombre, though subtly modulated range of colours. Some unusual motifs appear in his choice of imagery. The Virgin of the Eleousa type which introduces the Song of Songs is one of the oldest versions of this theme in Western art, and the half-length depiction of Christ as Divine Wisdom shares the same Eastern ancestry. A second painter finished the work in a very different style, related to the group of manuscripts around the Souvigny Bible in Moulins (no. 43). His style seems a good deal more advanced than that of his collaborator. It also lacks the expressive vigour of the best creations in the Moulins manuscript, and must be regarded as a belated offshoot. The second painter's palette is lighter and more conventional than that of

his colleague, and in contrast with the latter's purely abstract, ornament, he employs luxuriant foliage peopled with small figures or scenic groups: an archer shooting at a gigantic bird (MS 411, f. 29), a little man serenading an animal (f. 57v); a combat between a hunter and a lion (f. 68) and similar fanciful subjects. Given these contrasts, it may well be that the work was left unfinished for a time after the completion of a first campaign.

PROVENANCE: Jesuit College in Lyons, 1623 (MS 410, f. 1 and MS 411, f. 1).

LITERATURE: A. Molinier and F. Desvernay, *Catalogue général*, XXX, 1900, 100–102; Quentin, *Mémoire sur l'établissement du texte de la Vulgate*, Rome-Paris, 1922, 412; M.-L. Concasty, 'Vierge Eléousa d'une bible romane', *Actes du XIIe Congrès international d'Études byzantines (Ochrid)*, III, Belgrad, 1964, 31–4; F. Cotton, 'Les manuscrits à peintures de la Bibliothèque de Lyon', *Gazette des Beaux-Arts*, 1965, 272–3; J. Gutbrod, *Die Initiale in Handschriften des 8. bis 13. Jahrhunderts*, Stuttgart, 1965, 192–3; W. Cahn, 'Autour de la Bible de Lyon. Problèmes du roman tardif dans le centre de la France', *Revue de l'art*, 47, 1980, 11–20; C. Brisac, 'Byzantinismes dans la peinture sur verre à Lyon pendant le premier quart du 13e siècle', *Il Medio Oriente e l'Occidente nell'arte del XIII secolo*, ed. H. Belting (Atti del XXIV Congresso Internazionale di Storia dell'Arte, II), Bologna, 1979 (1982), 221; Cahn, *Romanesque Bible Illumination*, 273, No. 75; D. Mouriki, 'Variants of the Hodegetria on Two Thirteenth-Century Sinai Icons', *Cahiers archéologiques*, 39, 1991, 168, 173.

EXHIBITED: V. Leroquais, *Exposition de manuscrits à peintures du VIe au XVIIe siècle*, Lyons, 1920, Nos. 7–8; *Manuscrits à peintures*, Paris, 1954, 112, No. 30; *Byzance et la France médiévale*, 69, No. 131; *Art roman*, Barcelona and Santiago de Compostela, 1961, 48, No. 59.

55. Paris, Bibliothèque de l'École des Beaux-Arts MS 38

Foundation Charter of a Confraternity of
Saint-Martin de Canigou
490 × 202 mm.
1195. Saint-Martin de Canigou *Ill. 124*

Large miniature occupying the upper half or two-thirds of the document: Christ in Majesty with the Evangelist symbols, flanked by the Virgin Mary (left) and St. Martin (right); below, priest saying Mass at an altar with a group of faithful in attendance.

This unusual work is an illuminated charter which records the establishment of a confraternity in honour of St. Martin in the monastery of Canigou in the

Pyrenees mountains. The transaction took place on 2nd April, 1195. The founder of the confraternity was Abbot Peter III of Canigou, who is mentioned in documents of the monastery from 1172 onwards and in 1209 became abbot of Saint-Michel de Cuxa. The members of the association pledged themselves to subvent the burning of an eternal light before the main altar of the monastic church. A priest was charged with saying Mass once a week for the deceased members and for the well-being of the living. The former were entitled to an honourable funeral and burial in the monastic cemetery. The document is signed by Abbot Peter, the prior and the chaplain of the monastery, as well as a number of monks and lay persons. The last twenty names or so are subsequent additions, and a few more signatures at the bottom were lost when the parchment was trimmed.

The text is introduced by a decorative initial four lines high and the space above it features a large tinted drawing enclosed in a frame and divided in two tiers. In the upper part, the Virgin (left) and St. Martin (right) flank Christ in Majesty, surrounded by the symbols of the Evangelists. Below, a priest officiates at an altar in the presence of a group of the faithful. The scene evidently illustrates the substance of the transaction recorded in the charter. The miniature is drawn in a fine, unaccentuated dark brown line. The backgrounds, haloes and some other details are rendered as flat areas of red, maroon and ochre, while the space within the mandorla around the seated Christ is of a pale blue colour, which may have faded. Durliat has related the style of the Canigou Charter to a lost altar frontal from Saint-Génis-de-Fontaines, known through a 19th-century drawing (M. de Bonnefoy, *Épigraphie roussillonaise*, 1868, 178–80) which bore the signature of an artisan named Magister Alexander. The figure of Christ in Majesty at the centre, to the extent that the drawing can be relied upon, compares well with the corresponding subject in the miniature of the Charter. The *oeuvre* of Alexander and his workshop, as reconstructed by Durliat, also includes the altar frontal of Saint-André de Valltarga in Cerdagne (Barcelona, Museo de Arte de Catalunia) and a second, fragmentary altar frontal from Roussillon in the Suntag Collection, Barcelona.

PROVENANCE: M. Mouttet; given to L. Blancard, Marseille, in 1865, J. Masson Collection; given to the École des Beaux-Arts, Paris, in 1925.

LITERATURE: M. Puiggiari, 'Notice sur l'abbaye de St.-Martin de Canigo', *Bulletin de la Société agricole, littéraire et scientifique des Pyrenées-Orientales*, VII, 1848, 150; P. Lacroix, *Vie militaire et religieuse au moyen âge*, Paris, 1873, 303; L. Blancard, 'Rôle de la Confrérie de Saint-Martin de Canigou', *Bibliothèque de l'École des Chartes*, XLII, 1881, 5–7; C. Rohault de Fleury, *La Messe*, I, Paris, 1883, 77; V. Leroquais, 'La donation Jean Masson à l'École Nationale des Beaux-Arts. II. Manuscrits', *Trésors des Bibliothèques de France*, II, 1928, 93; M. Durliat, 'L'atelier du Maître Alexandre en Roussillon et en Cerdagne', *Études roussillonaises*, I, 1951, 103–19; id., *Arts anciens en Roussillon*, Perpignan, 1954, 30; J. Dominguez Bordona, *Ars Hispaniae*, XVIII, 1962, 95; Y. Labande-Mailfert, 'L'iconographie des laïcs dans la société religieuse aux XIe et XIIe siècles', *I laici nella 'Societas Christiana' dei secoli XI e XII* (Atti della Terza Settimana di Studio Mendola 1965), 1968, 488–522 [repr. in *Études d'iconographie romane et d'histoire de l'art*, Poitiers, 1982, 95]; J. Ainaud de Lasarte, *Catalan Painting*, Geneva and New York, 1990, 26–7.

EXHIBITED: *Première exposition de la donation Masson*, Paris, École des Beaux-Arts, 1927, 6, No. 8; *Chefs d'oeuvre de l'art français*, Paris, 1937, No. 744; *L'art graphique au moyen âge*, Paris, École des Beaux-Arts, 1953, 13, No. 9.

IV. BURGUNDY AND CHAMPAGNE

56. Paris, Bibliothèque Nationale
MS nouv. acq. lat. 2246

Lectionary
430 × 325 mm., ff. 262, 2 cols., 37 lines
End of the 11th or early 12th century.
Cluny *Ills. 125, 126, 127*

Six miniatures of varying sizes: Annunciation (f. 6); Crucifixion (f. 42v); bust of St. Mark (f. 70v); Pentecost (f. 79v); St. Peter in prison (severely mutilated, f. 113v); Dormition of the Virgin (f. 122v).

Ornamental initials: G (f. 2v); F (f. 3v); A (f. 6); M (f. 8); P (f. 9v); I (f. 17); D (f. 21v); I (f. 22); N (f. 26); L (f. 27v); S (f. 29v); A (f. 32); I (f. 34); H (f. 36v); V (f. 38v); I, M (f. 40v); Q (f. 42v); H (f. 47v); P (f. 56); A (f. 57); P (f. 59v); I (f. 61); P (f. 62v); E (f. 65); G (f. 67v); S (f. 69); V (f. 72); Q (f. 74); F (partly cut out, f. 76v); I (f. 78); A (f. 79v); H (f. 86v); D (f. 88v); V (f. 92); V (f. 95v); F (f.

96); E (f. 97v); G (f. 99v); S (f. 100v); N (f. 101v); D (f. 104); F (f. 106); I (f. 106v); H (f. 107v); I (f. 109); V (f. 111); I (f. 112v); M (f. 114); L (f. 116v); S (f. 119); T (f. 121); C (f. 122v); H (f. 126v); S (f. 128); L (f. 129); J (f. 131v); E (f. 133); S (f. 134v); H (f. 136); C (f. 138); T (f. 141v); N (f. 143v); D (f. 146); A (f. 148v); B (f. 151); S (f. 152v); P (f. 153v); G (f. 155v); P (f. 157); M (f. 158v); L (f. 160); G (f. 165); T (f. 167); I (f. 168v); Q (f. 173v); I (f. 174v); C (f. 175v); A (f. 177); H (f. 179); I (f. 180v); O (f. 182v); N (f. 187); T (f. 191); C (f. 193); H (f. 195); I (f. 197); N (f. 219); H (f. 222); Q (f. 226); F (f. 241); P (f. 241v); C (f. 242v); S (f. 244); F (f. 245); E (f. 245v); P (f. 246v); V (f. 247v); D (f. 248v); D (f. 249v); O (f. 250v); V (f. 251v); R (f. 252v); T (f. 253v); A (f. 255); E (f. 257); I (f. 258v); E (f. 260); H (f. 261v); F (f. 262v).

The Cluny Lectionary contains readings for the period from the feast of *Cathedra Petri* on 1st March (beginning now with *Lectio VIII*) to the second Sunday in November. The manuscript is worn through use and many pages were replaced or added in the course of the 12th century or at the beginning of the 13th (ff. 198–217, 222–5, 228–40). There are some losses at the beginning, at the end, and within the body of the volume. An Entry into Jerusalem probably preceded the lection for Palm Sunday (Matt. 21:1–11) above which an area roughly amounting to three quarters of a column is cut out (f. 40v). Other paintings probably preceded the readings for Holy Saturday (f. 45), the Vigil of Easter (f. 47) and the feast of the Ascension (f. 64v), where sections of parchment have also been excised, but an exact reconstruction of the entire programme is difficult because of the present condition of the manuscript. The remaining six miniatures of varying sizes have also suffered to a greater or lesser degree from an abrasion or flaking of the paint surface, revealing the finely executed underdrawing on the bare parchment underneath. In addition to these miniatures, the volume has *incipits* and *incipit* words in large red majuscule letters, and painted initials in an Ottonian-derived style at the beginning of the different lections, sermons and homilies that comprise the text. These are constructed of gold and silver stylized foliage, outlined in red, and placed on purple grounds, with a blue and green filling of the interstices of the form. As noted by Vezin, the writing almost identical to that of the Cluny martyrology from Saint-Martin des Champs (Bibl. Nat. lat. 17742) datable between 1087 and 1095, which features a similar decoration, and the same hand has also been recognized in a Cluny charter dated 1097 (Bibl. Nat., Collection de Bourgogne, LXXIX, No. 166; *Manuscrits datés*, IV, 1981, 235).

The illumination of the Cluny Lectionary can be connected with several other works on the basis of its style, to which the term Italo-Byzantine, coined by M. Schapiro, is now generally applied. This style is also exemplified in two miniatures of the Parma Ildefonsus (no. 57), executed by Schapiro's Hand B

or Colophon Painter. A cutting from a Bible in the Cleveland Museum of Art (No. 68.190) with a miniature for the beginning of the Gospel of Luke partakes of the same formal vocabulary, which is in evidence on a larger scale in the apse frescoes of the Cluniac priory at Berzé-la-Ville. The date of the Lectionary and related works remains somewhat conjectural. Most scholars tend to place the group around 1100 or in the first quarter of the 12th century, Schapiro preferring the earlier date. G. Cames, on the other hand, dates the Lectionary in the period 1130–40, while A. Grabar, followed by E. B. Garrison, maintained that the Berzé-la-Ville frescoes could not have been executed before 1150. From an inscription (*Bibliotheca Cluniacensis*, ed. M. Marrier and A. Duchesne, Paris, 1614, 1645), it is known that a fine jewel-covered Bible was written for Abbot Pontius of Cluny (1109–1122) by a team composed of a German scribe named Albert, the librarian Peter and a certain Opizo, the latter probably an Italian. The work is lost, but on the assumption that the Cleveland cutting might be a remnant of it, a point of anchor for the dating of the group would be at hand.

Among the illustrations of the Lectionary, particular interest attaches to the Pentecost miniature (f. 79v) in which Peter is given greatest prominence within the college of the Apostles and linked to the figure of Christ above through the central axis of the composition. This unusual rendering of the subject lays stress on Cluny's exclusive dependency on the Roman papacy. The scene of Peter's liberation from prison by an angel (f. 113v) touches on the same concerns and replicates a subject already treated in a Gradual from Cluny of the later 11th century (Paris, Bibl. Nat. lat. 1087, f. 75). The Crucifixion miniature (f. 42v) is exceptional for the presence of the figure of Isaiah to the right of the Cross. The Dormition and Assumption of the Virgin (f. 122v), also a rare theme at this date, adheres in its main lines to the treatment of the subject in the Pericopes of Henry II (Munich, Bayer. Staatsbibl. Clm. 4452, f. 161v). The miniature is in the Lectionary attached to the Pseudo-Jerome's Sermon *Cogitis me*, which seems to have had some currency in the ambient of Cluny. An earlier manuscript from the late years of the abbacy of Odilo (Bibl. Nat. nouv. acq. lat. 1455, ff. 91–91v) gives this text an elaborate presentation, and the 12th-century Lectionary from Saint-Arnoul de Crépy, a Cluniac house northeast of Paris, introduces it with a historiated initial in which the Dormition is seen again (Paris, Bibl. de l'Arsenal, MS 162, f. 181v).

PROVENANCE: No. 'C 3' (17th–18th century, f. 1). MS 95 (Inventory of the Cluny manuscripts of 1800). Bibliothèque Publique de Cluny, MS 12 (inscription and stamp, f. 1). Acquired by the Bibliothèque Nationale in 1881.

LITERATURE: L. Delisle, *Inventaire des manuscrits de la Bibliothèque Nationale. Fonds de Cluny*, Paris, 1884,

20–31, No. 15; A. Wilmart, *D.A.C.L.*, III, 2, 1914, cols. 2086–87; F. Mercier, *Les Primitifs français. La Peinture clunysienne en Bourgogne à l'époque romane*, Paris, 1931, 128ff.; Lauer, *Enluminures romanes*, 153–4; Grabar and Nordenfalk, *Romanesque Painting*, 190; Porcher, *French Miniatures*, 23–4; G. Cames 'Recherches sur l'enluminure romane de Cluny. Le Lectionnaire Paris. B. N. Nouv. Acq. lat. 2246', *Cahiers de civilisation médiévale*, VII, 1964, 145–59; Schapiro, *Parma Ildefonsus, passim*; C. Nordenfalk, 'Miniatures ottoniennes et ateliers capétiens', *Art de France*, IV, 1964, 58–59; W. Wixom, 'A Manuscript Painting from Cluny', *Bulletin of the Cleveland Museum of Art*, April, 1969, 130–5; O. Demus, *Byzantine Art and the West*, New York, 1970, 115–16; Dodwell, *Painting in Europe*, 174–5, 176; R. Etaix, 'Le lectionnaire de l'office à Cluny', *Recherches augustiniennes*, XI, 1976, 91–159, esp. 137–39; L. Cochetti Pratesi, 'Il lezionario di Cluny, Berzé-la-Ville e il problema degli influssi Italo-Bizantine', *Annali della Scuola speciale per Archivisti e Bibliotecari dell'Università di Roma*, XVII–XVIII, 1977–8 (1980), 171–93; Avril, *Temps des Croisades*, 173–6, J. Vezin, 'Un martyrologe copié à Cluny à la fin de l'abbatiat de Saint Hugues', *Hommages à André Boutemy* (Coll. Latomus, 145), ed. G. Cambier, Brussels, 1976, 404–12; *Manuscrits datés*, IV, 1981, 235; N. Stratford, 'Visite de Berzé-la-Ville', *Le Gouvernement d'Hugues de Semur à Cluny*, Actes de Colloque scientifique international, Cluny, 1968 (1990), 40–1.

EXHIBITED: *Manuscrits à peintures*, Paris, 1954, 101–2, No. 295; *Byzance et la France médiévale*, Paris, 1958, 65, No. 118.

57. Parma, Biblioteca Palatina Cod. Pal. 1650

Ildefonsus, De virginitate Beatae Mariae
230 × 160 mm., ff. 111, 19 long lines
End of the 11th or early 12th century.
Cluny *Ills. 128, 129, 130, 131, 132*

Nine full-page paintings: Bishop Julian speaks to a group of Jews (f. 1v); Ildefonsus at an altar saying Mass (f. 4); Ildefonsus writing, group of monks (f. 4v); Ildefonsus praying to the Virgin (f. 9v); Ildefonsus disputing with Jovinianus (f. 12v); Ildefonsus disputing with Helvidius (f. 15); Ildefonsus disputing with Jews (f. 22); Ildefonsus humbles himself before Christ in Majesty (f. 44v); the scribe Gomez presents his books to Bishop Gotiscalc of Le Puy (f. 102v); two-thirds or half-page illustrations: Isaiah speaks to a group of Jews (f. 26); David addresses a group of Jews (f. 26v); Ezekiel speaks to a group of Jews (f. 28); Hosea speaks to a group of Jews (f. 32v); Malachi speaks to a group of Jews (f. 36); Christ speaks to Moses (f. 36v); Ildefonsus speaks to two men (f. 37v); Zechariah speaks to a group of Jews (f. 38); Isaiah (vignette, f. 38v); Jacob blesses his sons (f.

39); an angel speaks to Daniel (f. 39v); Micah speaks to the people of Bethlehem (f. 40v); Isaiah (vignette); Habakkuk's prophecy of the fig tree (f. 41v); Zechariah (vignette); Isaiah speaks to a group of Jews (f. 42). Framed pages with historiated and ornamental initials: H (f. 2); D, Ildefonsus kneels before Christ (f. 5); D (f. 10); A (f. 13); A (f. 16); Q (f. 22v); A (f. 45); E (f. 103); E (f. 105).

The volume contains the treatise of St. Ildefonsus (607?–67) *De virginitate Beatae Mariae*, followed by the life of the author by Cixila written some years after his death. The text belongs to a sub-group within the extant copies of the *De virginitate* ultimately based on the copy written for Bishop Gotiscalc of Le Puy in 951 in the Spanish monastery of Saint Martin de Albelda and preserved today as lat. 2855 in the Bibliothèque Nationale. The Parma manuscript was introduced into the art-historical literature in G. Swarzenski's study of Salzburg illumination. Swarzenski judged its script to be Italian and its decoration the collaborative effort of a Bavarian painter and a Byzantinizing artist who was himself an Italian. The Cluny origin of the work was recognized by C. Nordenfalk and later convincingly established by M. Schapiro. The attribution rests on the similarity of the script to the writing in parts of the cartulary of the Burgundian abbey (Bibl. Nat. nouv. acq. lat. 1497–1498) and the Cluny Lectionary (Bibl. Nat. nouv. acq. lat. 2246; no. 56). The painted ornamental initials of the manuscript, of an Ottonian derivation, are also duplicated in a series of Cluny books from the late 11th and the early 12th century.

The decoration of the manuscript is unusually lavish. All the pages are enclosed by borders, many of an elaborate type. The major subdivisions of the text are introduced by framed title pages, and there are initials on smaller fields of colour at the beginning of the subsections of the book. The illustrations were the joint undertaking of two painters. The first, however, called by Schapiro the Ildefonsus painter (Hand A), was responsible for all but two of the 35 miniatures. A number of these are full-page paintings, while others are of the same width, but vary in height from approximately one to two-thirds of a page, with the left-over space filled out by the text. There are also smaller bust portraits of prophets in squarish panels which introduce citations in support of the arguments deployed by Ildefonsus. The two miniatures executed by the second illuminator, whom Schapiro calls the Colophon painter (Hand B), occur near the end of the manuscript and were inspired not by the text but by the colophon of the scribe Gomez, which follows it in all the members of the recension based on the Le Puy codex. The Ildefonsus painter, who is identical with Swarzenski's Bavarian hand, is indeed an artist with close ties to Ottonian art, as the German scholar recognized. Among the manuscripts of Cluny, his style can be recognized in one remaining, though partially muti-

lated miniature showing St. Peter in chains in the Gradual of the abbey (Bibl. Nat. nouv. acq. lat. 1087), which Schapiro regards as probably a somewhat earlier work by him. The openness of Cluny to German art during the abbacy of Hugh of Semur (1049-1109) was in all likelihood a reflection of the close relations of the abbey with the German imperial family during the 11th century, from which it received precious gifts of manuscripts and of liturgical objects. The Colophon painter — Swarzenski's Byzantinizing artist — is by contrast rooted in the art of Rome and Monte Cassino. He was presumably one of a number of Italian or Italian-influenced painters working at Cluny at this time, whose *oeuvre* includes the Lectionary (Bibl. Nat. nouv. acq. lat. 2246; no. 56), a fragment of a Bible (Cleveland Museum of Art, No. 68.190) and the frescoes of Berzé-la-Ville. The entire group of works is dated by Schapiro around 1100 or in the early 12th century, though its chronology, both relative and absolute, remains approximate. Schapiro has also demonstrated that a copy of Ildefonsus' *De virginitate* with rather coarse illustrations, made in Spain around 1200 and known to have been in the Cathedral of Toledo in the 14th century (Madrid, Bibl. Nac. MS 10087), must have had the Parma manuscript as its model. This suggests that the manuscript might have been made for an important Spanish patron of Cluny, possibly King Alphonsus VI of Castile and León (1072–1109), who is well known for the enormous tribute which he made towards the rebuilding of the abbey church undertaken in 1088 by Abbot Hugh.

PROVENANCE: Old shelfmark 171 (f. 1); Library of the Dukes of Parma, established in 1761.

LITERATURE: P. Paciaudi, *Il bibliotecario diretto nel formare, classare e continuare una publica biblioteca*, Vicenza, 1785, 51; F. Odorici, 'Memorie storiche della Nazionale Biblioteca di Parma', *Atti e Memorie della R. Deputazione di storia patria per le provincie Modenesi e Parmensi*, Modena, III, 1867, 425; F. Carta, C. Cipolla and C. Frati, *Monumenta Paleografico Sacra. Atlante Paleografico-artistico*, Turin, 1899, 19–20, pl. XXI. M. Manitius, *Geschichte der lateinischen Literatur des Mittelalters*, Munich, 1911, I, 235, n. 2; G. Swarzenski, *Die Salzburger Malerei von den ersten Anfängen bis zur Blütezeit des romanischen Stiles*, Leipzig, 1913, II, 83; A. Boselli, *Tesori delle Biblioteche d'Italia. I. Emilia e Romagna*, ed. D. Fava, 1932, 208–210; Grabar and Nordenfalk, *Romanesque Painting*, 189, 190; C. Nordenfalk, 'Miniature ottonienne et ateliers capétiens', *Art de France*, IV, 1964, 54–59; Schapiro, *Parma Ildefonsus*; O. Demus, *Byzantine Art and the West*, New York, 1970, 112; Dodwell, *Painting in Europe*, 175; L. Cochetti Pratesi, 'Il "Parma Ildefonsus". Cluny e la pittura Catalana', *Arte Lombarda*, LII, 1979, 21–30; D. Raizman, 'A Rediscovered Illuminated Manuscript of St. Ildefonsus's "De Virginitate Beatae Mariae" in the Biblioteca Nacional in Madrid', *Gesta*, XXVI/1,

1987, 38-39; E. A. Wischermann, *Grundlagen einer cluniacensischen Bibliotheksgeschichte* (Münstersche Mittelalter-Schriften, 62), Munich, 1988, 48; N. Stratford, 'Visite de Berzé-la-Ville', *Le Gouvernement d'Hugues de Semur à Cluny*, 40-41.

EXHIBITED: *Mostra storica nazionale della miniatura*, Rome and Florence, 1954, 108, No. 150; *Art roman*, Barcelona and Santiago de Compostela, 42, No. 47.

58. Dijon, Bibliothèque Municipale MSS 12–15

Bible (Cîteaux Bible)
474 × 326 and 442 × 325 mm., (MS 15), ff. 115, 150, 204 and 132, 2 cols., 44 lines (MSS 12–13) and 41 lines (MSS 14–15)
1109. Cîteaux *Ills. 133, 134, 135, 136, 137, 138*

MS 12

Ornamental initials: PREFACE TO PENTATEUCH, D (f. 2); GENESIS, I (f. 3v); EXODUS, H (f. 24v); LEVITICUS, V (f. 42); NUMBERS, L (f. 54v); DEUTERONOMY, H (f. 73); PREFACE TO JOSHUA, T (f. 88v); JOSHUA, E (f. 89v); JUDGES, P (f. 101); RUTH, l (f. 113).

MS 13

Ornamental initials: PREFACE TO KINGS, V (f. 2); I KINGS, F (f. 3v); II KINGS, F (f. 20); III KINGS, E (f. 33v); IV KINGS, C (f. 49); ISAIAH, V (f. 62v); JEREMIAH, V (f. 83v); EZEKIEL, E (f. 112); HOSEA, V (f. 132v). Smaller letters for Joel, V (f. 135v); AMOS, V (f. 137); OBADIAH, V (f. 139); JONAH, E (f. 139v); MICAH, V (f. 140v); NAHUM, O (f. 142); HABAKKUK, O (f. 143); ZEPHANIAH, V (f. 144); HAGGAI, I (f. 145); ZECHARIAH, I (f. 145v); MALACHI, O (f. 149).

MS 14

Two full-page illustrations preceding the Psalms. Scenes of the life of David: David rescues a lamb from a lion, Anointing of David by Samuel, Combat of David and Goliath, Decapitation of Goliath, David plays the harp in Saul's presence, David takes the sword from Ahimelech, David taken before Achisch, Doeg kills Ahimelech, Meeting of David and Abigail in the wilderness, David and Abishai find Saul asleep, Suicide of Saul and of his armour-bearer, the Amalekite messenger brings to David Saul's insignia, Killing of the Amalekite, David king of Judas, Achitophel with Absalom and Hushai, Achitophel hangs himself, Death of Absalom, David mourns over Absalom (f. 13), David with sceptre and harp and the four sacred musicians within a walled enclosure defended by warriors (f. 13v).

Smaller illustrations: ECCLESIASTES, monarch exhorting audience (f. 56); DANIEL, Nebuchadnezzar and the three Hebrew youths in the fiery furnace (f. 64);

PREFACE TO ESTHER, the eunuch Harbonah before Ahasuerus, Hanging of Haman (f. 122v); JUDITH, feast of Judith and Holophernes (f. 158); TOBIT, Tobit leaves his father in the company of the angel Raphael, return of Tobit with the fish, healing of the elder Tobit's blindness (f. 165v); II MACCABEES, combat of Judas Maccabeus, burial of Judas at Modin (f. 191).

Historiated and ornamental initials: JOB, beginning missing; PSALMS, B, Election of the Church and repudiation of the Synagogue (f. 60) ; DANIEL, A, the Archangel Gabriel raises Daniel prostrate before him (f. 64v); I CHRONICLES, A, Creation of Adam (f. 76); II CHRONICLES, C, hunting scene (f. 90v); EZRA, I, standing Prophet with scroll (f. 110v); ESTHER, I, standing Esther with book, trampling a dragon (f. 122v); WISDOM, D, fantastic subject (f. 128v); ECCLESIASTICUS, O (f. 136v); JUDITH, A, beheading of Holophernes (f. 158); TOBIT, T, man carrying serpent (f. 165v); I MACCABEES, E, Killing of the idolatrous Jew; death of Mattathias (f. 173); II MACCABEES, F, Martyrdom of the seven Maccabees (f. 191).

MS 15

Independent illustration: LUKE, Evangelist symbol with book (f. 41).

Historiated and ornamental initials: PREFACE TO GOSPELS, H, Jerome presents a book to Pope Damasus (f. 3v); E (f. 4); CANON TABLES (ff. 5v–9); MATTHEW, L, symbol of Matthew writing on a scroll (f. 11v); MARK, I, symbol of Mark with book (f. 29v); LUKE, F, Annunciation to Zacharias and Elizabeth, Suicide of Herod (f. 41); PREFACE TO JOHN, H, centaur blowing horn (f. 56v); JOHN, I, punishment of the heresiarch Arius (f. 56v); ACTS, P, Luke writing in the presence of Theophilus (?) (f. 68); JAMES, I, standing Apostle supported by a monk (f. 83v); ROMANS, P (f. 94); I CORINTHIANS, P, figure spewing foliage; (f. 99v); II CORINTHIANS, P (f. 105); GALATIANS, P (f. 108v); APOCALYPSE, A, combat of the Archangel Michael and the dragon (f. 125).

According to the colophon at the end of the second volume (MS 13, f. 150v) the Cîteaux Bible was written at the instigation of Stephen Harding, abbot of the monastery from 1108 to 1133, and the *monitum* which follows (*Pat. Lat.* CLXXXII, 1119) states that the text was corrected with the help of Jews consulted on doubtful readings of the Vulgate version at hand. The date given is 1109. Because of the location of the colophon and the differences in format, script and decoration between the first pair of volumes and the last, the latter were probably written after that date, though without a significant interruption of the work. It has been suggested that by the phrase forbidding the misuse of the Bible *auctoritate Dei et nostrae congregationis*, Harding intended to have it serve as a model for Cistercian use (R. Loewe, *Cam-bridge History of the Bible*, Cambridge, 1969, II, 143–44). So far as is known, however, the work did not achieve this authoritative status, and the illumination similarly inspired no very close imitations.

According to Charles Oursel, the manuscript originally consisted of three volumes, but Yolanta Zaluska has shown that it was planned as two separate tomes, the first consisting of present MSS 12–13, and the second of MSS 14–15. However, the present four-volume subdivision was carried out not long after the completion of the work. The decoration of the first two tomes — originally bound as one — consists of wholly ornamental initials in a dry and somewhat scratchy linear style, drawn in red and coloured in blue, green, along with a yellowish wash and placed on light blue grounds. *Incipit* words are executed in alternating lines of red and brown capital letters. The foliage of the initials, inhabited in a few instances by quadrupeds, suggests a derivation from the Psalter for Arras Use thought to have belonged to the founder of Cîteaux Robert of Molesme (Dijon, Bibl. Mun. MS 30). A volume of Gregory's Homilies on the Gospels (Dijon, Bibl. Mun. MS 177), as Oursel has pointed out, is decorated in the same manner and may have been brought from Molesme or written at Cîteaux close to the time of the foundation. The original second tome — MSS 14–15 — is illuminated in a very different manner, for which there are no antecedents at Cîteaux or in Burgundian illumination more generally. Justly famous, the brilliantly spirited initials and independent illustrations of the second master are drawn in outline, sometimes using red ink, and shaded in washes of light blue, green, red and orange, along with a few touches of gold for the borders of garments and crowns. *Incipits* and *incipit* words feature large capitals letters in red, green and black, and there are three-line capital letters for the chapter divisions. For the sources of the style of this illumination, which is in evidence also in the Gregory *Moralia* of 1111 (Dijon, Bibl. Mun. MSS 168–70, 173; no. 59), the miniature of the Flagellation in the already-mentioned Psalter of Robert of Molesme is difficult to overlook entirely. But English influence, personified by Harding himself, who had earlier been a monk of Sherborne, is clearly discernible, if as yet in need of being more sharply pinpointed. The rare scene of Herod's suicide with a knife (MS 15, f. 41) occurs also in the cycle of New Testament illustrations sometimes associated with the Eadwine Psalter (London, Brit. Lib. Add. 37472). The punishment of Arius at the beginning of the Gospel of St. John (f. 56v) is modelled in part on the Evangelist portrait in an Anglo-Saxon Gospel Book of the early 11th century signed by the scribe Eadwi (Hanover, Kestner Museum, WM XXIa 36). But the English illuminated Bibles, with comparably extensive schemes of illustration are later in date; nor does Bible illumination in Italy or in the Mosan region that is earlier or more or less contem-

poraneous offer decisive programmatic parallels for the work.

The Harding Bible is very worn through use and seems to have been subjected to unusual travails soon after its completion. The errors noted in the *monitum*, which affected particularly the Book of Kings, were scratched out and re-written. A number of pages were replaced in the late 13th or 14th century (MS 14, ff. 200–203) or rewritten over erasures near the middle or second half of the twelfth (MS 15, ff. 90–92v). MS 14 has lost its opening pair with the beginning of Job, which probably included an illustration of some ambition. In MS 15, a second set of Canon Tables (ff. 6–6v, 8–8v) was added to the original series, for reasons that remain unknown. There are signs of early repairs (ff. 41, 55), quite skilfully done, as well as additions to the illumination (f. 2v).

The hand of the scribes and illuminators of the Harding Bible can be found in a small group of Cîteaux manuscripts. This includes the Gregory *Moralia* (no. 59), a volume of Jerome's Epistles (Dijon, Bibl. Mun. MS 135; no. 60) and, as pointed out by Zaluska, copies of Augustine's City of God (Dijon, MS 158), Ambrose's Commentary on Luke (MS 127) and works of Augustine, Pseudo-Bede and Ambrose (MS 153). The P initial of Romans in the Bible (MS 15, f. 94) appears to be the work of the illuminator of MS 135.

PROVENANCE: Completed in 1109 (*liber iste finem sumpsit scribendi*) at Cîteaux during the governance of its second abbot, Stephen Harding (colophon, MS 13. f. 150v). *Liber sancte Marie Cistercii* (15th century, MS 12, f. 2).

LITERATURE: A. Molinier, H. Omont, S. Bougenot, P. Guignard, *Catalogue général*, V, 1889, 4–6; J. P. F. Martin, 'Saint Étienne Harding et les premiers recenseurs de la Vulgate latine', *Revue des sciences ecclésiastiques*, IV, 1886, 511–61; V, 1887, 5–44, 97–115, 213–38; D. Kaufmann, 'Les juifs et la Bible de l'Abbé Étienne de Cîteaux', *Revue des études juives*, XVIII, 1889, 131–3; Haseloff, *Miniature*, 298–9; P. T. Humpfner, 'Die Bibel des hl. Stephan Harding', *Cistercienser-Chronik*, XXIX, 1917, 73–81; Oursel, *Miniature de Cîteaux*, 15–29; Boeckler, *Abendländische Miniaturen*, 99; K. Lang, *Die Bibel Stephan Harding: Ein Beitrag zur Textgeschichte der neutestamentliche Vulgata*, Bonn, 1939; id., 'Die Bibel Stephan Hardings', *Cistercienser-Chronik*, LI, 1939, 247–56, 275–81, 294–98, 307–13; LII, 1940, 6–13, 17–23, 33–7; P. Gras, 'Aux origines de l'héraldique: la décoration des boucliers au début du XIIe siècle d'après la Bible de Cîteaux', *Bibliothèque de l'Ecole des Chartes*, CIX, 1951, 128-208; T. S. R. Boase, *English Art, 1100–1216*, Oxford, 1953, 155; C. Oursel, 'Les principes et l'esprit des miniatures primitives de Cîteaux', *Cîteaux in de Nederlanden*, VI, 1955, 161–72; id., 'La Bible de Saint Étienne Harding et le scriptorium de Cîteaux', ibid., X, 1959, 34–43; id., 'La genèse des manuscrits primitifs de l'abbaye de Cîteaux sous l'abbatiat de Saint Étienne Harding', *Mémoires de l'Académie des sciences, arts et belles-lettres de Dijon*, CXIV, 1957–59 (1961), 43–52; id., *Miniatures cistercienne*, Mâcon, 1960, 9–10, 17–18, 23, 28; Porcher, *French Miniatures from Illuminated Manuscripts*, 20–21; W. Cahn, 'A Defense of the Trinity in the Cîteaux Bible', *Marsyas*, XI, 1962–4, 58–62; J. Marilier, *Chartes et documents concernant l'abbaye de Cîteaux, 1098–1182* (Bibliotheca Cisterciensis, l), Rome, 1961, 56, No. 32; *Manuscrits datés*, VI, 169; J. Gutbrod, *Die Initiale in Handschriften des 8. bis 13. Jahrhunderts*, Stuttgart, 1965, *passim*; R. Loewe, *Cambridge History of the Bible*, ed. G. W. H. Lampe, Cambridge, 1969, II, 143–4; Dodwell, *Painting in Europe*, 91–2; A. Schneider, *Die Cistercienser. Geschichte, Geist, Kunst*, Cologne, 1954, 123, 437, 472, 474, No. II; P. Gras, 'Les manuscrits de Cîteaux', *Enluminure carolingienne et romane* (Les dossiers de l'archéologie, 14) Jan.-Feb. 1976, 94–9; R. Kahsnitz, *Das Werdener Psalter in Berlin, MS theol. lat. fol. 358. Eine Untersuchung zu Problemen mittelalterlicher Psalterillustration*, Düsseldorf, 1979, 187, 188, 191, 244; N. Stratford, 'A Romanesque Marble Altar in Beaune and Some Cîteaux Manuscripts', *The Vanishing Past. Studies of Medieval Art, Liturgy and Metrology Presented to Christopher Hohler*, ed. A. Borg and A. Martindale, Oxford, 1981, 226; G. Plotzek-Wederhake, 'Buchmalerei in Zisterzienserklostern', *Die Zisterziensern*, Cologne, 1980, 357–8; Cahn, *Romanesque Bible Illumination*, 136ff., 184, 189, 202, 244, 270–1, No. 66; id., 'The Structure of Cistercian Bibles', *Studies in Cistercian Art and Architecture*, III, 1987, 85, No. 9; id., 'Heresy and the Interpretation of Romanesque Art', *Romanesque and Gothic. Essays for George Zarnecki*, ed. N. Stratford, Woodbridge, 1987, 27–33; L. J. Harris, '"Thieves, Harlots and Stinking Goats": Fashionable Dress and Aesthetic Attitudes in Romanesque Art', *Costume*, XXI, 1987, 4–15; J.-B. Auberger, *L'unanimité cistercienne primitive: mythe ou réalité* (Cîteaux: Studia et documenta, III), Achel, 1986, 188, 190–93, 199, 201, 206, 214; Zaluska, *Scriptorium de Cîteaux*, *passim*, and 192–200, No. 1; C. Rudolph, *The 'Things of Greater Importance'. Bernard of Clairvaux's Apologia and the Medieval Attitude Toward Art*, Philadelphia, 1990, 133–57; *Saint Bernard et le monde cistercien*, ed. L. Pressouyre and T. N. Kinder, Paris, 1991, 202–3, No. 8; Y. Zaluska, *Manuscrits enluminés de Dijon*, Paris, 1991, 46–56, Nos. 22–23; R. Favreau, 'Épigraphie et miniatures. Les vers de Sedulius et les évangiles', *Revue des savants*, 1993, 1, 68; J. O'Reilly, 'St. John as a Figure of the Contemplative Life: Text and Image in the Art of the Anglo-Saxon Benedictine Reform', *St Dunstan. His Life, Times and Cult*, ed. N. Ramsay, M. Sparks, and T. Tatton-Brown, Woodbridge, 1992, 177–8.

EXHIBITED: *Manuscrits à peintures*, Paris, 1954, 97, No. 155; *Art roman*, Barcelona and Santiago de Compostela, 1961, 50–51, Nos. 65–66.

59. Dijon, Bibliothèque Municipale MSS 168–170, 173

Gregory, Moralia in Job

MS 168-170: 350 × 240 mm., ff. 93 + I, II + 103 + I, and I + 93 + I, 2 cols., 37–38 lines.

MS 173: 460 × 325 mm., ff. 181, 2 cols., 50 lines
1111. Cîteaux *Ills. 139, 140, 141, 142, 143*

MS 168

Historiated and ornamental initials: V, Job extract (f. 2); title page with prologue *incipit* (f. 4); *incipit* page of prologue with initial R, combat of men and dragons (f. 4v); Gregory presents his book to Leander (f. 5); Bk. I, I, standing Job with book (f. 7); Bk. III, B (f. 39v); Bk. IV, Q, dragon slayer (f. 52v); Bk. V, C (f. 71v).

MS 169

Historiated and ornamental initials: Bk. VI, S, *jongleurs* (f. 5); Bk. VII, Q (f. 20v); Bk. VIII, P, climbing men pursued by lions, man with sword (f. 36v); Bk. IX, P, two stags consuming foliage, man, beasts (f. 62v); Bk. X, Q, the Lord with scales protecting Job and trampling on bound Behemoth (f. 88v).

MS 170

Historiated and ornamental initials: Bk. XI, Q, angel with book, adoring monk (f. 6v); Bk. XII, M, two monks in dialogue (f. 20); Bk. XIII, E, figures harvesting grapes (f. 32); Bk. XV, Q, monks splitting a log (f. 59); Bk. XVI, monk scything grain (f. 75v).

MS 173

Historiated and ornamental initials: Bk. XVII, beginning missing ; Bk. XVIII, P, fantastic combination of men and beasts (f. 7); Bk. XIX, Q, man on horseback fighting dragon (f. 20); Bk. XX, Q, figure prying open the jaws of a dragon (f. 29); Bk. XXI, I, monks pruning tree and cutting it down (f. 41); Bk. XXII, Q, man thrown from a horse (f. 47); Bk. XXIII, P, fantastic combats of men and beasts (f. 56v); Bk. XXIV, M, *jongleurs* or satirical scene (f. 66); Bk. XXV, beginning missing; Bk. XXVI, I, standing haloed cleric (f. 80); Bk. XXVII, Q, two men haggling over a length of cloth (f. 92v); Bk. XXVIII, P, combats of monstrous creatures (f. 103v); Bk. XXIX, D, armed man trampling lion and dragon (f. 111v); Bk. XXX, B, man fighting dragons (f. 122); Bk. XXXI, I, three armed men in a turret (f. 133v); Bk. XXXII, S, man with a flail (f. 148); Bk. XXXIII, A, man grasping a pair of dragons (f. 156); Bk. XXXIV, Q, two monks warming themselves by a fire (partly rubbed, f. 167); Bk. XXXV, Q, hunter on horseback, aquatic birds (f. 174).

Simple penwork initials: MS 168, f. 21; MS 170, f. 41v.

This widely cited and published work presently consists of three volumes of a relatively modest format containing Bks. I–XVI of Gregory's *Moralia*, and a fourth, considerably larger one, with Bks. XVII–XXXV. It has been shown (*Manuscrits datés*, VI, 189) that the smaller manuscripts, 168, 169 and 170, originally formed a single tome. It was preceded by a gathering containing a section of the text of Job which Gregory explicates in this volume. When the volume was subdivided, the Job extract was reapportioned accordingly, though this operation required some awkward readjustments (cf. Davidson, *Cistercian Art and Architecture* III, 1986, 46ff.) Although the colophon is placed at the end of the initial first volume, and in spite of the different sizes of volumes I and II, the project seems to have been carried out without a significant interruption.

The subdivisions of the text are marked by two-line capital letters of red, blue and green. The *incipits* are rendered in black or red capitals, and the *incipit* words allied to the initials in larger red letters or alternating lines of red and black or red and blue. The major embellishment, consisting of the framed *incipit* page of the prefatory address to Bishop Leander and large, brilliantly inventive initials for most of the books of Gregory's commentary, was not brought to an even finish. Thus, in MS 168, the frontispiece and the first two initials (ff. 5, 7) are fully painted, while the rest are only drawn and shaded with green, red and blue. In the final volume (MS 173), the execution is more summary, the colours being laid on flat and without modelling. A few initials (cf. f. 122) appear to have been left unfinished.

The formal vocabulary of this illumination lies essentially within the stylistic limits of the Cîteaux Bible (no. 58). Some of the figurative components, especially in Vols. I and II, feature schematized draperies in the form of reiterated catenary curves, while others, like the celebrated images of monks engaged in agricultural labours in Vols. III and IV, seem remarkably unaffected by the devices of abstract stylization. This contrast is underscored by colour. In the more schematic initials of the first two volumes, blue, red and green prevail, while the more naturalistic and jocular scenes of the subsequent tomes feature a broader, more earthen palette, including shades of brown and slate blue. In the choice of imagery, however, the emphases are markedly different from those of the Bible. There are only a few subjects that are tied more or less directly to the text: the author's presentation of the book to Leander, the portrait of the standing Job, the Lord protecting Job and trampling Behemoth, and possibly the unidentified haloed cleric of Bk. XXVI (MS 168, ff. 5, 7; MS 169, f. 88v; MS 173, f. 80). The adoring monk at the feet of an angel (MS 170, f. 6v) may have been intended by the scribe or patron as a kind of pictorial colophon. The remaining and much larger propor-

tion of the initials can be divided into two groups. One exhibits various activities performed by monks and secular workers, perhaps lay brothers (*conversi*), along with a scene of men haggling over a length of cloth. The other consists of fanciful and fantastic subjects, including combats between men and wild beasts, hunters, musicians and *jongleurs*, and congeries of exotic and composite creatures. For the mainly agricultural occupations, the illustrations of an Anglo-Saxon Calendar from Winchester (B. L., Cotton Tiberius B.V) has been suggested as an antecedent, and one might mention as another possible source the lively workmen and hunters who disport themselves on the pediments of the Canon Tables of the Ebbo Gospels. But there is a novel strain of humour and realism in the Cîteaux manuscript that sets it apart from the older depictions of seasonal activities which it may call to mind. The no less striking initials with grotesque and fantastic imagery have certain parallels in Anglo-Norman illumination, like the Gregory *Moralia* from Préaux (Rouen, Bibl. Mun. MS 498, cited by Davidson, 1986, as above). Here as well, however, the ornamental subject seems less subordinated to structural or decorative concerns, and tends to assume the character of a self-standing *capriccio* (cf. MS 173, f. 174). Heslop has suggested that some of these initials may harbour moralizing glosses on Gregory's text, activated by the practice of meditative reading.

The artists of the *Moralia* and the Cîteaux Bible do not appear to have been active locally beyond the early years of Stephen Harding's rule. A Cîteaux copy of Augustine's *De Trinitate* (Dijon, Bibl. Mun. MS 141), however, contains an initial (f. 75) that clearly copies the E with vintagers in the *Moralia* (MS 170, f. 32).

PROVENANCE: Completed on the eve of Christmas of the year 1111, during the abbacy of Stephen Harding (**MS 170**, f. 92v). *Liber sancte Marie Cistercii* (12th century, **MS 168**, f. 93; **MS 169**, f. 103; **MS 170**, f. 92v; **MS 173**, f. 181v). *Liber cistercii* (15th century, **MS 168**, ff. 1, 52v; **MS 169**, ff. 5, 55; **MS 170**, ff. 3, 50, 92; **MS 173**, ff. 1, 72).

LITERATURE: A. Molinier, H. Omont, S. Bougenot, P. Guignard, *Catalogue général*, V, 1889, 49–50; C. Oursel, 'Les manuscrits à miniatures de la Bibliothèque de Dijon', *Bulletin de la Société française de Reproduction de manuscrits à peintures*, VII, 1923, 12–13; id., *Miniature du XIIe siècle à Cîteaux*, 29–33, 70–72; Boeckler, *Abendländische Miniaturen*, 65, 100, 122; R. Schilling, 'Die Engelberger Bilderhandschriften aus Abt Frowins Zeit in ihrer Beziehung zu burgundischer und schwäbischer Buchmalerei', *Anzeiger für Schweizerische Altertumskunde*, XXXV, 1937, 117ff.; A. Boeckler, 'Zur Freisinger Buchmalerei des 12. Jahr-

hunderts', *Zeitschrift des deutschen Vereins für Kunstwissenschaft*, VIII, 1941, 1–16; W. Weisbach, *Manierismus in mittelalterlicher Kunst*, Basel, 1942, 28; Grabar and Nordenfalk, *Romanesque Painting*, 176, 203–6; C. Oursel, *Miniatures cisterciennes, 1109–1134*, Mâcon, 1960, 11–12; J. Gutbrod, *Die Initiale in Handschriften des 8. bis 13. Jahrhunderts*, Stuttgart, 1965, 107–9, 119–26, 140–3, 159–61, 175–7, 185; *Manuscrits datés*, VI, 1968, 189, 492; H. Fillitz, ed. *Das Mittelalter* (Propyläen Kunstgeschichte), I, Berlin, 1969, 274; Dodwell, *Painting in Europe*, 92–3; A. M. Romanini, 'Il "Maestro dei Moralia" e le origine di Cîteaux', *Storia dell'arte*, 34, 1978, 221–45; R. Kahsnitz, *Der Werdener Psalter in Berlin, MS theol. lat. fol. 358. Eine Untersuchung zu Problemen mittelalterlicher Psalterillustration*, Düsseldorf, 1979, 224; A. Schneider, *Die Cisterzienser. Geschichte, Geist, Kunst*, Cologne, 1974, 437, 474–6, No. III; J. J. G. Alexander, *The Decorated Letter*, New York, 1978, 17–18; M. H. Caviness, 'Images of Divine Order and the Third Mode of Seeing', *Gesta*, XXII/2, 1983, 106; G. Schmidt, '"Belehrender" und "befreiender" Humor. Ein Versuch über die Funktionen des komischen in der bildenden Kunst des Mittelalters', *Worüber lacht das Publikum im Theater?...Festschrift zum 90. Geburtstag von Heinz Kindermann*, Vienna-Cologne, 1984, 17–19; F. O. Büttner, 'Ikonographisches Eigengut der Randzier in spätmittelalterlichen Handschriften. Inhalte und Programme', *Scriptorium*, XXXIX, 1985, 204–5; C. Treat Davidson, 'Sources for the Initials of the Cîteaux "Moralia in Job"', *Cistercian Art and Architecture*, III, 1986, 46–68; T. A. Heslop, 'Brief in Words but Heavy in the Weight of Its Mysteries', *Art History*, IX, 1986, 5–7 [repr. in *Romanesque and Gothic. Essays for George Zarnecki*, Woodbridge, 1987, I, 114–15]; O. Pächt, *Book Illumination in the Middle Ages*, London, 1986, 58f.; L. J. Harris, '"Thieves, Harlots and Stinking Goats": Fashionable Dress and Aesthetic Attitudes in Romanesque Art', *Costume*, XXI, 1987, 4–15; J.-B. Auberger, *L'unanimité cistercienne primitive: mythe ou réalité* (Cîteaux: Studia et documenta, III), Achel, 1986, 193–5, 211; M. Kilian Hufgard, 'An Inspirational and Iconographic Source for Two Early Cistercian Miniatures', *Studies in Cistercian Art and Architecture*, III, 1987, 69–73; Zaluska, *Scriptorium de Cîteaux*, passim and 200–3, Nos. 3 and 4; C. Rudolph, *The 'Things of Greater Importance'. Bernard of Clairvaux's Apologia and the Medieval Attitude Toward Art*, Philadelphia, 1990, 133–57; *Saint Bernard et le monde cistercien*, ed. L. Pressouyre and T. N. Kinder, Paris, 1991, 203–4, No. 9; Y. Zaluska, *Manuscrits enluminés de Dijon*, Paris, 1991, 56–61, Nos. 24–25.

EXHIBITED: *Saint Bernard et l'art des cisterciens*, Dijon, 1953, 49, Nos. 47–48; *Manuscrits à peintures*, Paris, 1954, 98, Nos. 282–3; *Ornamenta ecclesiae*, Cologne, 1985, 185, No. B 21.

60. Dijon, Bibliothèque Municipale MS 135

Jerome, Epistulae (ff. 2v–181bis) and
Sermons (ff. 182–186)
455 × 320 mm., ff. 186, 3 cols., 50 lines
First quarter of the 12th century.
Cîteaux *Ills. 144, 145; Col. pl. VIII*

Framed title page with *incipit* and initial Q (f. 2v).

Historiated and ornamental initials: P (f. 4); G (f. 6v); N (f. 8v); S (f. 11); D (f. 12); Q (f. 13); N (f. 15v); P (f. 17); Q (f. 17v); I (f. 17v); B (f. 18); I (f. 19v); VE (f. 23); O (f. 25); V, bound *atlante*, foliage (f. 27); I (f. 28v); S (f. 31); A (f. 36); Q (f. 36v); S (f. 38); P (f. 39v); U (f. 41); I (f. 44); N, quadruped spewing foliage (f. 48v); F (f. 52); I (f. 57v); P (f. 62v); I (f. 65); N, medallion with bird pecking foliage (f. 68); L, figure standing on a dragon and holding a dragon aloft (f. 70); B (f. 70v); Q (f. 74v); I (f. 75); D, M (f. 75v); S (f. 76); E, quadrupeds, fish (f. 76v); D (f. 77v); P (f. 78); E, acrobatic figure with fish (f. 79v); Q (f. 79v); D (f. 81); D, D (f. 82); D (f. 82v); D, fantastic bird (f. 83v); D (f. 83v); D (f. 84); D (f. 84v); C (f. 89); M (f. 89v); N, quadrupeds (f. 89v); B (f. 92v); B, figure spewing foliage (f. 92v); D, B (f. 92v); D, D, D (f. 93); D (f. 93v); P, figure eating fruit, bird (f. 95v); B (f. 100); T (f. 100v); M (f. 101v); I, horn blower (f. 102); V (f. 104); X (f. 104v); Q (f. 104bis); P, St. Paul with book (f. 107); P, H (f. 110); A (f. 112); S, figure planting vine (f. 114v); E (f. 114v); H (f. 120); L (f. 126v); D, P (f. 133v); Z, a pair of fishes as *pisces* (f. 134); M (f. 134v); D, quadruped spewing foliage (f. 135v); S (f. 136v); N (f. 137v); A (f. 138); M (f. 138v); I (f. 140v); Q (f. 141v); M (f. 142); E, rooster (f. 142v); Q, monstrous quadruped (f. 145); L (f. 145); N, F (f. 145v); Q, D (f. 146); T, A (f. 146v); S (f. 147); Q (f. 147v); L (f. 145); T, A (f. 146v); S (f. 147); Q (f. 147v); D, S (f. 148); F, climbing figure (f. 148v); S (f. 149v); C, H (f. 151v); I, St. John the Evangelist with palm branch (f. 152); A (f. 152); N (f. 153); D, C (f. 153v); S (f. 155v); C, figure in thought (f. 156v); L (f. 157v); D (f. 158); A, The Lord, St. Jerome with book and quill, haloed woman with palm and lamp; in the middle of the letter, the *Agnus Dei* (f. 163); M (f. 169); S (f. 171); S (f. 172v); S (f. 176); L (f. 176v); M (f. 177); N (f. 177v); N, clambering figure (f. 177v); B (f. 178); A (f. 178v); P (f. 179); C, fabulous bird (f. 179); N (f. 179v); M, quadruped spewing foliage (f. 180); H, Annunciation to the Shepherds (f. 182); N (f. 182); Q (f. 182v); H, seated figure with lamb (f. 182v); N, Resurrection of Christ (f. 183v); I, Heavenly hierarchy (?). At the top Christ in a mandorla; below, six busts of haloed male figures, each in an arched space (f. 184).

This collection of Jerome's Epistles is prefaced by a copy of a letter addressed to Guigo I, Prior of the Grande-Chartreuse (*c.* 1083–1136) to Lazarus, Prior of the Charterhouse of Durban in the diocese of Gap (*Pat. Lat.* CLIII, 593–94). In it, Guigo informs his correspondent that he has brought together Jerome's letters into a large single volume, eliminating those that were wrongly attributed to him and correcting errors introduced by copyists. He urges that his own letter be joined to the collection as an introduction. The manuscript thus attests to an early connection between Cîteaux and the Grande-Chartreuse, in all probability still during Guigo's lifetime. It contains one hundred and thirty-five letters of Jerome, and sermons by the same author on the Nativity, the Epiphany, Lent, Good Friday and Easter (ff. 182–186). The opening letter to the monk Heliodorus (No. XIV in the *C.S.E.L.* edition of I. Hilberg) provides the textual substance for the frontispiece combining the *incipit*, a large ornamental initial and *incipit* words within a frame filled with stylized palmette foliage. The text has a fairly sober appearance, with red accent marks and occasional simple four or five-line monochrome letters to indicate the subdivisions. *Incipits* and *explicits* are generally rendered in an unassuming red minuscule hand. With the exception of two items at the end of the volume (f. 184v), which have large monochrome initial letters, each of Jerome's epistles and sermons is introduced by a large, pen-drawn initial, shaded with red, light blue, green and lilac, supplemented with some touches of gold on the title page. *Incipit* words are in large coloured capital letters adjoining the initial. The manuscript belongs to the initial core of books produced at Cîteaux in the wake of the Harding Bible (no. 58). The very lively initial letters draw on the formal repertory and the stock motifs of the inhabited scroll, with twisting and spiralling foliage animated by birds, quadrupeds, and lithely proportioned figures engaged in various occupations. Porcher was inclined to connect this decoration with book illumination of western France and Lower Normandy more particularly, citing as a parallel for certain initials the late 11th-century Gregory *Moralia* of Bayeux Cathedral (MSS 57 and 58). Dodwell more plausibly cites English antecedents from Canterbury. There are initials of the same type in several other Cîteaux manuscripts in Dijon: Augustine, *De Trinitate* (Dijon, Bibl. Mun. MS 141); Ambrose, Hexameron (MS 126), and Jerome, Commentary on Daniel, Minor Prophets and Ecclesiastes (MS 132; no. 63) where the Joel initial (f. 144) reproduces the design of one of the ornamental letters in the present volume (f. 41). A similarly framed frontispiece enclosing a monumental initial is found in a copy of the third volume of Augustine's *Enarrationes in Psalmos* (Dijon, Bibl. Mun. MS 147).

PROVENANCE: Cîteaux Library shelfmark (f. 186); *Liber cistercii* (15th century, ff. 2, 76, 135, 186).

LITERATURE: A. Molinier, H. Omont, S. Bougenot, P. Guignard, *Catalogue général*, V, 1889, 36; A. Labitte, *Les Manuscrits et l'art de les orner*, Paris, 1893; C. Oursel, 'Les manuscrits à miniatures de la Bibliothèque de Dijon', *Bulletin de la Société française de*

Reproduction des manuscrits à peintures, VII, 1923, 14; id., *Miniature du XIIe siècle à Cîteaux*, 38–40, 75–77; J. Gutbrod, *Die Initiale in Handschriften des 8. bis 13. Jahrhunderts*, Stuttgart, 1965, 105–6; Porcher, *French Miniatures*, 20; Dodwell, *Painting in Europe*, 91–2; J.-B. Auberger, *L'unanimité cistercienne primitive: mythe ou réalité* (Cîteaux: Studia et documenta, III), Achel, 1986, 200–202, 206, 214, 233, 291; Zaluska, *Scriptorium de Cîteaux, passim*, and 207–9, No. 6; Y. Zaluska, *Manuscrits enluminés de Dijon*, Paris, 1991, 63–67, No. 27.

EXHIBITED: *Saint Bernard et l'art des cisterciens*, Dijon, 1953, 34–5, No. 57; *Manuscrits à peintures*, Paris, 1954, 100, No. 289.

61. Dijon, Bibliothèque Municipale MSS 641–642

Lectionary
450 × 320 mm., ff. 142 and 92, 3 cols., 56 lines
c. 1130–40. Cîteaux *Ills. 146, 147, 148*

MS 641

Title page with initial T (f. 2v); Daniel in the Lions' Den, Burning Bush, Gideon with the Golden Fleece, Tree of Jesse, Virgin and Child as the *Theotokos* (f. 40v).

Historiated and ornamental initials: B (f. 4); T, standing St. Taurinus with book (f. 4v); P (f. 6v); B (f. 7v); O (f. 9v); E, standing St. Symphorianus with flaming pot (f. 10v); I, standing St. Radegund with flowering stem (f. 11); I, standing St. Arnulph (f. 18); I, standing St. Mamet with palm and crown, trampling dragon (f. 20v); T, standing St. Agapitus with palm and crown, trampling dragon (f. 21v); I, standing St. Philibert with crozier and book (f. 22v); I, standing St. Bartholomew with book (f. 24v); T (f. 26); I, (f. 31); E, standing St. Augustine with book (f. 31v); standing St. Giles with staff and book (f. 37); I (f. 49v); seated St. Matthew with Evangelist symbol (f. 57); Archangel Michael slaying the dragon (f. 64); H, seated St. Jerome with book (f. 66); P (f. 68); I, standing St. Martin with book (f. 113).

MS 642

Historiated and ornamental initials: P (f. 24v); F (f. 52v); B (f. 52v); I (f. 53v); P (f. 54v); I (f. 56); I, standing St. Menulphus with staff and book (f. 57); I (f. 57v); C, warrior slaying dragon (f. 58); A (f. 58); V (f. 61); O (f. 62); B, standing St. Bertin with staff and book, addressing three monks (f. 62); R (f. 64); D, praying St. Audomarus (f. 65v); I, standing St. Maurilius (f. 67v); I (f. 69v); B (f. 71v); P (f. 72v); D (f. 74v); S (f. 75); V (f. 78); I (f. 78); D (f. 79); I (f. 79); Q (f. 82); M (f. 83v); I (f. 85v); S (f. 88); M, standing St. Hilarion with book (f. 88v).

The Cîteaux Lectionary belongs to the textual tradition of the *Liber de Natalitiis*, a lectionary type whose circulation seems to have been particularly sustained in Cistercian houses of Burgundy. Though no complete sets appear to survive, the contents of the work have been reconstructed by Rochais on the basis of a 17th-century description of the lost Lectionary of Acey, made for the Maurists. The Cîteaux Lectionary originally consisted of four volumes, the contents of MSS 641 and 642 corresponding to Vols. III and IV of the Acey Lectionary of which it was probably the model. The two volumes embrace readings of saints' lives for the period from 8th August to 11th November (MS 641) and 12th November to Christmas (MS 642). During the 13th century, the first two volumes were revised and rewritten in three tomes (Dijon, Bibl. Mun. MSS 638–640), and having become useless, they were probably discarded. In the course of the 17th century, the last volume was also stripped of a section of fifteen folios, now separately bound as MS 643.

The Master of the Cîteaux Lectionary executed the frontispiece design incorporating the title, initial and *incipit* words of the opening *Passio S. Ciriaci*, numerous initials and an independent panel with biblical figures of Mary's virginity preceding Fulbert of Chartres's sermon on the Nativity of the Virgin in MS 641. His work in the manuscript is supplemented by simpler, though elegant, penwork initials drawn in a combination of red, blue and green, which mark the beginning of many of the individual saints' lives. MS 642, which is very battered through use, presently lacks a title page, and the Cîteaux Lectionary Master is much more sparingly in evidence in it, being responsible only for the unfinished initial of St. Andrew (f. 24v), the head of the figure of St. Maurilius (f. 67v), the unfinished St. Hilarion (f. 88v) and some of the lesser ornamental initials. Large blue, red and green decorative letters were again supplied for a certain number of the lections, but a second illuminator, a modest talent given to rather sluggish forms, contributed most of the pictorially more ambitious initials. These, however, also remained in the unfinished state of outline drawings.

The Cîteaux Lectionary Master is a major artistic personality of Romanesque book illumination who, with the assistance of collaborators, produced a sizable *oeuvre*. The list of manuscripts produced under his auspices, initially assembled by Oursel, has been expanded by C. Nordenfalk, J.-B. Auberger, and Y. Zaluska. Its core consists of five codices from Cîteaux (Dijon, Bibl. Mun. MSS 129, 131, 132, 180 and 641–642; nos. 62, 63 and 61) and two from the Benedictine house of Saint-Bénigne at Dijon (Dijon, Bibl. Mun. MS 2 [no. 64] and Montpellier, Bibl. de l'École de Médecine MS 30), while offshoots of the style can be recognized in a volume from Fontenay (Paris, Bibl. Nat. lat. 2246), the La Ferté-sur-Grosne *Moralia in Job* (Chalon-sur-Saône, Bibl. Mun. MSS 7–9; no. 65) and a bifolium from a copy of Augustine's *Enarrationes in*

Psalmos from Pontigny, preserved in the museum at Clamecy (Nièvre). The fact that the painter or his workshop supplied manuscripts to both Cîteaux and Saint-Bénigne suggests that it may have exercised its activity on a professional basis, perhaps in Dijon. The manuscripts of the group exhibit the further peculiarity that in nearly all, the participation of the Master of the shop is limited to the frontispiece or the opening folios, the rest of the illumination having been entrusted to other hands, sometimes of routine or mediocre quality. The Lectionary is something of an exception, since in MS 641, the Master's share of the work is appreciable. It might have been even more considerable if the first two volumes of the set, now lost, were also illuminated by him. But even in MS 641, he was amply assisted, while in MS 642, he did no more than make a start. His customary *modus operandi* suggests that his exceptional ability was recognized by patrons who thought it preferable to obtain from him splendid frontispiece compositions for different manuscripts than a necessarily smaller number of books exclusively illuminated by him. This tendency was likely to have been abetted by the painter's fastidiously refined technique, which must have required a concentrated effort for each design, and did not lend itself easily to rapid, formulaic manipulation in the interest of large-scale production.

The style of the Lectionary Master counters the lively and fanciful draughtsmanship of the earliest group of Cîteaux manuscripts, derived from Anglo-Norman art, with refined and suavely modelled images of a severe and vaguely classical character. Figural elements in his art tend to be clearly set apart from purely ornamental components, and the latter, purged of anything monstrous or fabulous, consist primarily of precisely delineated foliage and abstract patterns. Since Oursel's pioneering monograph of 1926, a certain exposure of this body of illumination to Byzantine art is generally admitted. In the Lectionary, this illumination shows itself to be generally resistant to expansive narrative ambition, and this is another feature that sets it apart from the earlier group of manuscripts centred around the Cîteaux Bible (no. 58). The individual saints' lives are thus introduced exclusively by standing or seated portraits set against, or adjoining, the ornamental background in which the structure of the letter is incorporated. The iconographically charged panel of the Tree of Jesse and typological antecedents of Mary's virginity represents an obvious exception to this general tendency. Its oddly small size is due to the fact that the scribe allotted for it the same number of lines as that set aside for the initials of the manuscript. It is indeed quite possible that an initial with a single, isolated figure of the Virgin may originally have been intended. It might be noted that Fulbert's sermon to which the panel is connected, while centred on Isaiah's prophecy of Jesse's posterity, does not mention the Marial types illustrated by the painter. Zaluska, however, has pointed out that these are cited in the sermon on the Annunciation of Honorius Augustodunensis' *Speculum Ecclesiae* (*Pat. Lat.* CLXXII, 901–8), and they appear on Byzantine icons from the 11th century onwards.

None of the manuscripts illuminated by the Lectionary Master and his workshop is clearly dated. Oursel believed that all the Cîteaux manuscripts illuminated with any ostentation must have been executed before *c.* 1125, the assumed date of Bernard of Clairvaux's *Apologia ad Guillelmum*, where the grotesque imagery of Romanesque cloisters is severely censured, or by 1134 at the latest, when, he believed, the General Chapter of the Cistercian Order issued its decree against historiated initials and the use of gold in manuscripts. But Bernard's tract concerns fanciful carvings, not painted images in books, and the practical effect of its 'publication', whatever form it may have taken, is uncertain. The date accepted by Oursel for the Cistercian decree concerning the embellishment of books has also been shown to be unfounded, and it is now generally believed that this statute was first promulgated in 1151, though possibly slightly altered in 1152. There remains, for purposes of situating the activity of the workshop in time, some evidence of a comparative nature. The *Moralia in Job* of La Ferté-sur-Grosne, dated 1134 (no. 65), has palpable connections with the group of manuscripts around the Lectionary, as has a fragmentary marble altar frontal of Notre-Dame de Beaune, with a depiction of the Virgin and Child. The work is not dated, though following N. Stratford, it was probably carved some time after 1130.

PROVENANCE: *Liber sancte Marie cistercii*, (12th century, MS 642, f. 132v) *Sancte Marie cystercii* (15th century, MS 642, f. 1v). Cîteaux arms on binding (17th century).

LITERATURE: A. Molinier, H. Omont, S. Bougenot, P. Guignard, *Catalogue général*, V, 1889, 166–81; W. Levison, *Conspectus codicum hagiographicorum* (M.G.H., Scriptores rer. Merov., VII), Hannover and Leipzig, 1920, 581; C. Oursel, 'Les manuscrits à miniatures de la Bibliothèque de Dijon', *Bulletin de la Société française de Reproduction de manuscrits à peintures*, VII, 1923, 14–15; id., *Miniature du XIIe siècle à Cîteaux*, 35–38, 73–75; A. Watson, *The Early Iconography of the Tree of Jesse*, Oxford, 1934, 90–91; C. Oursel, *Miniatures cisterciennes, 1109–1134*, Oxford, 1934, 12; M. Coens, 'Analyse du légendier perdu d'Acey près de Besançon d'après les archives bollandiennes', *Analecta Bollandiana*, LXXIX, 1961, 364; Dodwell, *Painting in Europe*, 92, 93, 176–7, 204, 206; H. Rochais, *Un légendier cistercien de la fin du XIIe siècle. Le 'Liber de natalitiis' et autres légendiers du XIIe et XIIIe siècles* (La documentation cistercienne, 15), Rochefort, 1975, 21ff.; F. Dolbeau, 'Notes sur la genèse et sur la diffusion du "Liber de natalitiis"', *Revue d'histoire des textes*, VI, 1976, 147–8, No. 5; G. Plotzek-Wederhake,

'Buchmalerei in Zisterzienserklostern', *Die Zisterzienser*, Cologne, 1980, 358; N. Stratford, 'A Romanesque Marble Altar Frontal in Beaune and Some Cîteaux Manuscripts', *The Vanishing Past. Essays on Medieval Art, Liturgy and Metrology Presented to Christopher Hohler*, ed. A. Borg and A. Martindale, Oxford, 1981, 226–30; F. Dolbeau, 'Le Légendier d'Alcobaça. Histoire et analyse', *Analecta Bollandiana*, CII, 1984, 267–84; J.-B. Auberger, *L'unanimité cistercienne primitive: mythe ou réalité* (Cîteaux: Studia et documenta, III), Achel, 1986, 190, 199, 201, 212, 233; Zaluska, *Scriptorium de Cîteaux, passim*, and 219–21, No. 14. A. Vannugli, 'Il "Secondo Maestro" di Cîteaux e la sua attività in Borgogna', *Arte medievale*, IIe Ser., III, 2, 1989, 51–73; Y. Zaluska, *Manuscrits enluminés de Dijon*, Paris, 1991, 75–8, No. 34.

EXHIBITED: *Saint Bernard et l'art des cisterciens*, Dijon, 1953. No. 51; *Manuscrits à peintures*, Paris, 1954, 99, No. 286.

62. Dijon, Bibliothèque Municipale MS 129

Jerome, Commentary on Isaiah
480 × 330 mm., ff. 124, 2 cols., 53 lines
c. 1125–35. Cîteaux *Ills. 149, 150*

Full-column miniature: Tree of Jesse (f. 4v).

Historiated and ornamental initials: Preface, E (f. 4); V, standing Isaiah with scroll (f. 5).

Cîteaux produced what must have been intended as a comprehensive set of biblical commentaries of St. Jerome. The extant volumes of this collection, Dijon, Bibl. Mun. MS 129 (Jerome on Isaiah), MS 131 (Jerome on Ezekiel), and MS 132 (Jerome on Daniel, the Minor Prophets and Ecclesiastes) all exhibit the involvement of the leading figure of the workshop, the Master of the Cîteaux Lectionary, in the same dramatic, yet essentially restricted sense. The artist provided mainly the opening decor, consisting of a miniature and initials for the preface and the first chapter of the book, leaving the rest of the illumination to other, generally more unassuming hands. In the present manuscript, the Master drew the initial of the preface, accompanied by the *incipit* and *incipit* words in alternating lines of red and green capital letters, the Tree of Jesse preceding the text proper, the opening initial of the text on the facing page showing the Prophet pointing to the standing Virgin with the Child, and a more modest initial letter for the beginning of Bk. II (f. 11). The remainder of the books have simpler ornamental initials drawn in green, red and ochre, and the body of the text is embellished with two-line capital letters in the same choice of colours. The unfinished Tree of Jesse, which fills a space equivalent to a text column, was not carried out according to the original plan, which called for a tree with bifurcating branches that was only begun in

outline. The artist presumably intended to complete it with a canopy of foliate scrollwork containing depictions of kings of Judah and Israel. But no central trunk is indicated, suggesting that the design might have taken the form of a continuous figure 8, as in the Jesse Tree by the Master in the Cîteaux Lectionary (Dijon, Bibl. Mun. MS 642, f. 40v), or dispensing with the royal genealogy of Christ altogether, and showing only the seven doves of the Holy Spirit, as in the Isaiah initial of the Saint-Bénigne Bible (Dijon, Bibl. Mun. MS 2, f. 148). However this may be, the scene was changed before the reclining figure of Jesse was brought to completion, and in the place of the Tree, a standing figure of the Virgin of the Byzantine Eleousa type (Virgin of Tenderness) was substituted. The rather fragmentary evidence assembled by Alpatoff and Lazarev on the early history of this iconic type makes it possible to gauge the character of the eastern model that might have been available to the painter, if not to identify it precisely. It is likely to have been included the pair of adoring angels in the upper part of the composition, a motif that has a certain currency in Byzantine icons of the Madonna. G. Cames derives the attributes borne by these figures with veiled hands, one that is possibly a crown (right), the other a round vessel resembling an unguent jar (left) from the mourning and triumphant angels of Byzantine representations of the Dormition and the Assumption of the Virgin. The reference to Isaiah's prophecy, however, is maintained by the floral stem that Mary holds in her left hand, and by the dove of the Holy Spirit perched on the pearly outline of her nimbus. This splendid miniature and the three initials of the Lectionary Master are executed in the fairly restricted range of colours that he modulates in different ways, but does not depart from. These colours are substantially identical to those used in the stylistically different 'First' group of Cîteaux manuscripts around the Harding Bible (nos. 58, 59), and essentially tied to a scribal rather than a painterly practice: red, mauve, green and a brownish, wash-like tone. The shading and articulation of the draperies with their cascades of parallel and nested folds are accomplished by a linear gradation of tones, though the smoothness of the transitions achieve an effect akin to painting.

PROVENANCE: Remnant of a 12th-century inscription *Cistercii* (flyleaf, verso); *Liber Cistercii* (15th century, ff. 1, 51, 91, 124). Shelfmark, 15th century (f. 124v).

LITERATURE: A. Molinier, H. Omont, S. Bougenot, P. Guignard, *Catalogue général*, V, 1889, 34; C. Oursel, 'Les manuscrits à miniatures de la Bibliothèque de Dijon', *Bulletin de la Société française de Reproduction de manuscrits à peintures*, VII, 1923, 17–18; V. Lazarev and M. Alpatov, 'Ein byzantinisches Tafelwerk aus der Komnenenepoche', *Jahrbuch der preussischen*

Kunstsammlungen, XLVI, 1925, 140–55; C. Oursel, *Miniature du XIIe siècle à Cîteaux*, 44–47, 79; A. Watson, *The Early Iconography of the Tree of Jesse*, London, 1934, 89–90, 95; V. Lasareff, 'Studies in the Iconography of the Virgin', *Art Bulletin*, XX, 1938, 36–37; Boeckler, *Abendländische Miniaturen*, 100; W. Koehler, 'Byzantine Art and the West', *Dumbarton Oaks Papers*, I, 1941, 71–2; C. Oursel, *Miniatures cisterciennes, 1109–1134*, Mâcon, 1960, 12; Dodwell, *Painting in Europe*, 93, 117; G. Cames, 'Parfums et diadème: Le Cantique des Cantiques dans l'iconographie mariale romane', *Miscellanea codicologica F. Masai dicata MCMLXXIX*, ed. P. Cockshaw, M.-C. Garand and P. Jodogne, Ghent, 1979, I, 242–7; G. Plotzek-Wederhake, 'Buchmalerei in Zisterzierserklostern', *Die Zisterzienser*, Cologne, 1980, 358; N. Stratford, 'A Romanesque Marble Altar Frontal in Beaune and Some Cîteaux Manuscripts', *The Vanishing Past. Studies of Medieval Art, Liturgy and Metrology Presented to Christopher Hohler*, ed. A. Borg and A. Martindale, 1981, 225; J.-B. Auberger, *L'unanimité cistercienne primitive: mythe ou réalité* (Cîteaux: Studia et documenta, III), Achel, 1986, 198, 202; M. Kilian Hufgard, 'An Inspirational and Iconographic Source for Two Early Cistercian Miniatures', *Studies in Cistercian Art and Architecture*, III, 1987, 73–80; Zaluska, *Scriptorium de Cîteaux*, 18, 19, 29, 43, 51, 113, 118, 124–26, 136–38, 139–40, 146, 217–19, No. 13; A. Vannugli, 'Il 'Secondo Maestro' di Cîteaux e la sua attività in Borgogna', *Arte medievale*, II Ser., III, 1989, 2, 51–72; Y. Zaluska, *Manuscrits enluminés de Dijon*, Paris, 1991, 74–5, No. 33.

EXHIBITED: *Saint Bernard et l'art des cisterciens*, Dijon, 1953, 33–34, No. 53. *Manuscrits à peintures*, Paris, 1954, 98–99. No. 285; *Byzance et la France médiévale*, Paris, 1958, 64–65, No. 117.

63. Dijon, Bibliothèque Municipale MS 132

Jerome, Commentary on Daniel,
Minor Prophets and Ecclesiastes
450 × 315 mm., ff. 209, 2 cols., 51 lines
c. 1125–35. Cîteaux *Ill. 151; Col. pl. IX*

Jerome presents his book to Marcella and Principia (damaged, f. 1); full-page miniature of the Lord in a mandorla surrounded by the twelve Minor Prophets (f. 2); title page with initial A and Daniel in the Lions' Den, succoured by Habakkuk (f. 2v).

Ornamental initials: U (f. 164); M (f. 191).

Lesser ornamental initials on ff. 7v, 9v, 14, 20v, 31, 52, 66v, 74, 74v, 81, 84v, 93v, 103, 103v, 120, 126, 126v, 144, 154v, 181.

The decoration of the present manuscript is the most fully elaborated among the books of the 'Second' Cîteaux group, though it, too, exhibits the customary symptoms of the workshop's mode of production.

The Cîteaux Lectionary Master carried out the frontispiece miniatures, two of them full-page designs (ff. 2, 2v) that respectively signalize the commentaries on the Minor Prophets and of Daniel, contained within the volume, and two fine ornamental initials (ff. 164, 191), while the rest is the work of lesser hands, who provided modest decorative initials in blue or green and red, along with several more ambitious designs (ff. 103, 144), the former, an interlace knot, duplicated in the Cîteaux Lectionary (Dijon, Bibl. Mun. MS 641, f. 9v). The two frontispiece compositions, elicited from the artist an exceptionally attentive and sustained effort. The representation of the enthroned Lord seated on the rainbow in a mandorla and surrounded by the twelve Minor Prophets is his only truly independent composition. It has a deeply coloured background against which the figures are silhouetted, and gold, not otherwise encountered in Cîteaux manuscripts, is used for the haloes and the Lord's book, and in the Daniel frontispiece on the verso, on the prophet's throne. Daniel's light blue robe and darker overmantle are fully painted in opaque hues rather than merely shaded in the artist's usual lighter, more transparent manner. Both compositions are framed by intricately constructed and detailed borders, the minor prophets page with a design of pseudo-Cufic script interspersed with birds and quadrupeds, the Daniel composition by a pleated Greek key pattern housing dark recesses filled with a variety of birds. In spite of the painter's impressive attention to detail, or perhaps because of it, this is another of his productions which remained unfinished.

It has been shown that the leaf on which these images figure is an addition to the manuscript, replacing a simpler framed title page that was cut out. This indicates that the volume was originally conceived along artistically less ambitious lines, and also explains the pairing of the two prefatory images on one leaf, since the Minor Prophets painting would normally have been more at home at the beginning of the commentary text, which begins on f. 20. It also helps to explain the artist's choice of a wordless, independent composition for Minor Prophets, contrary to his usual habit of providing title pages with an initial and *incipit*, for which there was no need and no room in the existing manuscript. The appearance of the Lord in the midst of the assembled prophets, each of whom bears a book or scroll inscribed with the opening words of the prefaces drawn from Jerome's letter to Paulinus, is an unusual theme. The painter here based his composition on the traditional schema of the Ascension or the newly-emergent iconography of the Pentecost with a figure of the Pantocrator as the source of the Holy Spirit, for which the image in the Cluny Lectionary (Paris, Bibl. Nat. nouv. acq. lat. 2246, f. 79v) is an early example. The disposition of the prophets in a half-circle around the central seated figure echoes the depiction of Christ as teacher among the Apostles as found in

a Syrian (?) ivory of the fifth century in Dijon or an Ottonian reflection of the same composition in an ivory book cover of *c.* 1000 in the Kunstgewerbe-museum in Cologne. In the figure of Zechariah in the right foreground, who is seen from the rear and with the sole of the right foot exposed to the viewer, there is a recollection of classicizing representational conventions which the painter might have discovered in Carolingian or Ottonian art.

The combination of *incipit*, initial and *incipit* words forming a kind of title page for Jerome's Daniel Commentary is an invention already seen in some of the manuscripts of the older Cîteaux group (Dijon, Bibl. Mun. MS 135 [no. 60], f. 2v; MS 145, f. 5; MS 147, f. 3; MS 158, f. 1v) and for which the Cistercians appear to have had a certain predilection. The Daniel page is nonetheless atypical within this series of designs in that it incorporates pictorial elements. A certain inconsistency in scale, however, resulted from this integration: while the enthroned Daniel and the lions are accommodated to the proportions of the initial, the group of Habakkuk and the angel is larger, apparently having been tailored to the size of the prophets on the recto of the leaf. The iconography adheres to the version of the story with seven lions (14:31) favoured in Romanesque art, as M. Schapiro has shown (*Words and Pictures*, The Hague and Paris, 1973, 42) but the quasi-heraldic presentation imparted to the subject in the earlier Middle Ages is maintained through the prophet's hieratic frontality and the symmetrical distribution of the lions, made possible by the ingenious placement of one of the creatures under his feet.

PROVENANCE: 12th-century inscription *Liber sancte Marie cistercii* (f. 209v); *Liber cistercii* (15th century, ff. 1, 75, 140).

LITERATURE: A. Molinier, H. Omont, S. Bougenot and P. Guignard, *Catalogue général*, V, 1889, 35; Oursel, *Miniature du XIIe siècle à Cîteaux*, 40–44, 77–78; id., 'Les manuscrits à miniatures de la Bibliothèque de Dijon', *Bulletin de la Société française de Reproduction des manuscrits à peintures*, VII, 1923, 16; Boeckler, *Abendländische Miniaturen*, 100; A. Watson, *The Early Iconography of the Tree of Jesse*, Oxford, 1934, 30–1; C. Oursel, *Miniatures cisterciennes, 1109–1134*, Mâcon, 1960, 12; Dodwell, *Painting in Europe*, 177; G. Plotzek-Wederhake, 'Buchmalerei in Zisterzienserklöstern', *Die Zisterzienser*, Cologne, 1980, 358; N. Stratford, 'A Romanesque Altar Frontal in Beaune and Some Cîteaux Manuscripts', *The Vanishing Past. Studies in Medieval Art, Liturgy and Metrology Presented to Christopher Hohler*, ed. A. Borg and A. Martindale, 1981, 226; J.-B. Auberger, *L'unanimité cistercienne primitive: mythe ou réalité* (Cîteaux: Studia et documenta, III, Achel, 1986, 190, 197, 198; Zaluska, *Scriptorium de Cîteaux*, *passim* and 215–217, No. 12; A. Vannugli, 'Il 'Secondo Maestro' di Cîteaux e la sua attività in Borgogna', *Arte medievale*, IIe ser., 2, 1989, 51–72; Y.

Zaluska, *Manuscrits enluminés de Dijon*, Paris, 1991, 71–4, No. 32.

EXHIBITED: *Saint Bernard et l'art des cisterciens*, Dijon, 1953, 33, No. 52; *Manuscrits à peintures*, Paris, 1954, 98, No. 284; *Byzance et la France médiévale*, Paris, 1958, 64, No. 116; *Art roman*, Barcelona and Santiago de Compostela, 1961, 48–49, No. 60.

64. Dijon, Bibliothèque Municipale MS 2

Bible
520 × 370 mm., ff. 505, 2 cols., 48 lines
c. 1125–35. Saint-Bénigne, Dijon

Ills. 152, 154, 155

Historiated and ornamental initials: PREFACE TO PENTATEUCH D, Jerome writing (f. 6); GENESIS, I, ornamental initial within frame (f. 7v); EXODUS, H, Pharaoh's daughter presents the infant Moses to her father (f. 27v); LEVITICUS, V, Moses receives the tablets of the law (f. 41v); NUMBERS, L, the angel of the Lord barring Balaam's way (f. 52); DEUTERONOMY, H (f. 67v); PREFACE TO JOSHUA T, figure offering a sacrificial lamb at an altar (f. 80); JOSHUA, E (f. 81); JUDGES, P, the Lord speaks to the Children of Israel and gives the leadership to Judah (f. 89v); RUTH, I (f. 98v); PREFACE TO KINGS, V, Jerome writing (f. 100); I KINGS, F, Elkanah and his wife Hannah before Eli, Anointing of David (f. 101v); II KINGS, F, the Amalekite brings to David the insignia of Saul, Slaying of the Amalekite (f. 114); III KINGS, E, Nathan presents the crown to Solomon in the presence of David (f. 125); IV KINGS, P, King Ahaziah falling from his chamber; below, a demon appears to him (f. 135v); ISAIAH, V, Tree of Jesse, gifts of the Spirit (f. 148); JEREMIAH (f. 168); LAMENTATIONS, E, Jeremiah mourning over the destruction of Jerusalem (f. 192v); PREFACE TO EZEKIEL, I (f. 195); EZEKIEL, E, Vision of the Chariot, with two angels (f. 195); PREFACE TO MINOR PROPHETS, N (f. 218); HOSEA, V, figure piercing a beast with a lance (f. 218); JOEL, V, Prophet with scroll (f. 221); AMOS, V, Amos as shepherd (f. 222v); OBADIAH, V (f. 224v); JONAH, E, the Prophet cast into the sea (f. 225); MICAH, mounted warrior (f. 225v); NAHUM, O (f. 227v); HABAKKUK, O, standing prophet with scroll (f. 228); ZEPHANIAH, V (f. 229); HAGGAI, I (f. 230); ZECHARIAH, I, the Prophet stands over a cowering demon and is addressed by an angel (f. 235); PREFACE TO JOB, I, standing figure (f. 235v); JOB, V, Job on the dunghill with his wife and three friends (f. 235v); PSALMS (Gallican version), B, Adam and Eve eating from the fruit of the Tree of Life, David and Goliath; (Hebrew version), B (f. 246); Ps. 109, D, David harping (f. 278v); PREFACE TO PROVERBS, C, Chromatius and Heliodorus in dialogue (f. 288v); PROVERBS, P, Solomon enthroned, exhorting his son (f. 289); ECCLESIASTES, V (f. 298); SONG OF SONGS, O, Christ in Majesty with Ecclesia and Synagoga (f. 301); WISDOM, D (f. 302v);

ECCLESIASTICUS, O, personification of Wisdom (f. 308v); DANIEL, A, Daniel between a pair of lions (f. 324); I CHRONICLES, A, Adam and the generations (f. 332v); II CHRONICLES, C, enthroned Solomon (f. 343); EZRA, I, two standing figures in discourse (f. 357); TOBIT, T, capture of the fish, healing of the elder Tobit and defeat of the demon (f. 366v); JUDITH, A, beheading of Holophernes (f. 370); ESTHER, I, standing Esther (f. 375v); I MACCABEES, E, monarch on horseback, combat of knights (f. 380v); II MACCABEES, F, murder of Antiochus in the Temple (f. 393v); CANON TABLES: Prophets, Apostles, fantastic scenes (ff. 402v–405v); MATTHEW, L, Matthew writing, Tree of Jesse (?) (f. 406); PREFACE TO MARK, M (f. 418); MARK, I, writing Evangelist, medallions with the Lamb of God flanked by angels, two Prophets with scrolls (f. 419v); PREFACE TO LUKE, L (f. 428v); LUKE, Q, writing Evangelist (f. 429v); PREFACE TO JOHN, H (f. 442); JOHN, I, the Lord with a medallion showing a small figure with a book, writing Evangelist, Rivers of Paradise (f. 442v); ACTS, P (f. 452v); PREFACE TO CATHOLIC EPISTLES, N (f. 464v); JAMES, I, standing Apostle with scroll (f. 464v); PREFACE TO APOCALYPSE, I, standing Apostle, hand of God (f. 470v); APOCALYPSE, A, Vision of the Lord with the sword and the seven candelabra (f. 470v); PREFACE TO PAULINE EPISTLES, E (f. 476); ROMANS, P, enthroned Paul addressing a Roman (f. 477v); I CORINTHIANS, P (f. 482); HEBREWS, M (f. 498v).

This enormous manuscript is sometimes connected with the first entry of an early 12th-century inventory of the library of Saint-Bénigne at Dijon (Dijon, Bibl. Mun. MS 51, f. 225v) worded *Volumen unum continens vetus et novum testamentum ex integro*. It is likely, however, that this entry designates another one volume Bible at Saint-Bénigne, a 9th-century manuscript perhaps from Tours, of which the scribe Aldebaldus made a copy for the reforming Abbot William of Volpiano in the late years of the 10th century, according to a set of verses transcribed at the end of the volume (Berlin, Staatsbibl. Hamilton Cod. 82). A comparison between the text of the two manuscripts has yet to be made, though the order of the books is different, and a distinctive feature of the later work, the inclusion of the Gallican and Hebrew versions of the Psalms on parallel columns, does not occur in the earlier one. The source of these texts was apparently the late 9th-century or early 10th-century Double Psalter of undetermined origin, but known to have been in the library of Saint-Bénigne during the 12th century, now MS lat. 102 of the Bibliothèque Nationale.

The Saint-Bénigne Bible is an ambitious piece of book-making, which the comparatively modest local practice of book illumination during the 11th century does not lead one to anticipate (C. Oursel, 'La Bibliothèque de l'abbaye de Saint-Bénigne et ses plus anciens manuscrits enluminés', *Mémoires de la Commission des Antiquités de la Côte-d'Or*, XVIII, 1922–26,

113–40). Most of the biblical books and their prefaces have painted initials that may incorporate multiple subjects. The rest, notably the series of Catholic and Pauline Epistles, beyond the preliminary letters of John for the first and Romans for the second are introduced by elaborate pen-work decorative letters of the type described by Alexander as 'Arabesque initials'. Chapter headings throughout are headed by three or four-line capitals in red, blue, green or ochre. The manuscript was illuminated by three painters. The first of these, who was responsible for the initials of Jerome's Pentateuch Preface *Desiderii mei* and the Genesis initials with its *incipit* words placed within a handsome frame is the impressive figures whose major works are the Cîteaux Lectionary (Dijon, Bibl. Mun. MSS 641–42; no. 61) and two volumes of biblical commentary by St. Jerome of the same provenance (Dijon, Bibl. Mun. MSS 129 and 132; nos. 62, 63). This led Porcher to conjecture that the Bible might have been made at Cîteaux for Saint-Bénigne. The reliance of the scribe on a Saint-Bénigne manuscript for at least part of the text, however, makes this idea difficult to sustain. In addition to the Bible, the style of the Cîteaux Lectionary Master is in evidence also in an initial of a Lectionary of Saint-Bénigne (Montpellier, Bibl. de l'École de Médecine, MS 30) and that of workshop hands in two other Saint-Bénigne books, the Martyrology of the abbey (Dijon, Bibl. Mun. MS 634) and a volume of works by Gregory the Great and Gregory Nazianzus (Montpellier, Bibl. de l'École de Médecine, MS 411), as pointed out by Y. Zaluska. The fact that the first-mentioned manuscript belongs to the textual recension of the Cîteaux Lectionary tends to reinforce the as yet unexplained connection documented by the illumination. A second group of initials in the Saint-Bénigne Bible are in a style not too dissimilar from the work of the Cîteaux Lectionary Master (ff. 278v, 302v, 428v, 498v). Porcher indeed considered then by the same hand, though they are more likely the work of a follower. But the major share of the decoration is in a very different manner, more spontaneous, less controlled and not in evidence elsewhere among the surviving books of Saint-Bénigne or Cîteaux, so far as is known. This painter is notable especially for a kind of representational exuberance, his subject matter often barely contained by the framework of the initial or spilling out well beyond it. Iconography also tends towards a certain degree of elaboration, as can be seen, for example, in the unusually expansive imagery of the initials of Mark and John (ff. 419v, 442), or in the treatment of the visionary scenes of Ezekiel (f. 195) and Revelation (f. 470v). The treatment of the Canon Tables, combining scenes of fighting and fantastic subjects in the lunettes with standing figures of Prophets and Apostles in the framing columns gives a good idea of the painter's somewhat disorderly inventiveness.

The manuscript is usually thought to have been written and illuminated towards the beginning of

the 12th century, though the somewhat later date around 1125 advanced by O. Pächt (*The St. Albans Psalter*, London, 1960, 166, note 1) takes greater account of the Cîteaux production to which the initials of the first painter are connected. The date around 1130 at the earliest more recently advanced by Zaluska is determined by the same logic and rooted in a revised chronology of the related Cîteaux manuscripts.

PROVENANCE: Saint-Bénigne, Dijon (inscription, 17th-18th century, f. 502).

LITERATURE: A. Molinier, H. Omont, S. Bougenot, P. Guignard, *Catalogue général*, V, 1; C. Oursel, 'Les manuscrits à peintures de la Bibliothèque de Dijon', *Bulletin de la Société française de Reproduction de Manuscrits à Peintures*, VII, 1923, 23; id., 'La bibliothèque de l'abbaye de Saint-Bénigne et ses plus beaux manuscrits', *Mémoires de la Commission des Antiquités de la Côte-d'Or*, XVIII, 1924, 113–42; A. Watson, *The Early Iconography of the Tree of Jesse*, Oxford, 1934, 94, 124; Dodwell, *Painting in Europe*, 76; P. Gras, 'Les manuscrits de Cîteaux', *Enluminure carolingienne et romane* (Les dossiers de l'archéologie, 14), Jan.-Feb. 1976, 96–97; Cahn, *Romanesque Bible Illumination*, 136–8, 270, No. 265; Zaluska, *Manuscrits de Cîteaux*, 54, 58, 117, 137, 141–2, 143, 144–7, 156 and 262–3, No. 288; A. Vannugli, 'Il "Secondo Maestro" di Cîteaux e la sua attività in Borgogna', *Arte medievale*, II Ser., III, 2, 1989, 64f.; Y. Zaluska, *Manuscrits enluminés de Dijon*, Paris, 1991, 132–6, No. 104.

EXHIBITED: *Manuscrits à peintures*, Paris, 1954, 99, No. 287.

65. Chalon-sur-Saône, Bibliothèque Municipale MSS 7–9

Gregory, Moralia in Job
445 × 310 mm., ff. 231, 184 and 199, 2 cols.,
41 lines
1134. La Ferté-sur-Grosne *Ill. 153*

MS 7

Historiated and ornamental initials: Job extract, V (f. 3); Prologue, cut out (f. 11); Bk. I, I (f. 13v); Bk. II, S (f. 29v); Bk. III, B (f. 48); Bk. IV, cut out (f. 62); Bk. V, C (f. 81); Bk. VI, S (f. 102); Bk. VII, Q (f. 117v); Bk. VIII, cut out (f. 131v); Bk. IX, P (f. 156v); Bk. X, cut out (f. 181); Bk. XI, cut out (f. 195); Bk. XII, cut out (f. 209); Bk. XIII, cut out (f. 222).

MS 8

Historiated and ornamental initials: Bk. XIV, beginning missing; Bk. XV, Q (f. 17v); Bk. XVI, Q (f. 34); Bk. XVII, Q, Christ in a mandorla, held aloft by four angels (f. 50); Bk. XVIII, P, the Lord with the Dove of the Holy Spirit descending on Job (f. 63); Bk. XIX, cut out (f. 87); Bk. XX, Q, Job with four men and a woman seeking his counsel (f. 104v); Bk. XXI, I (f. 126v); Bk. XXII, cut out (f. 137); Bk. XXIII, P, figures in dialogue (f. 154); Bk. XXIV, H (f. 170).

MS 9

Historiated and ornamental initials: Bk. XXV, Gregory writing, two figures in dialogue below within an architectural structure (f. l); Bk. XXVI, I (f. 13); Bk. XXVII, Q, three figures in dialogue, two angels above (f. 36); Bk. XXVIII, P, the Lord in heaven, in dialogue with two figures below, perhaps Job and his wife (f. 55v); Bk. XXIX, D, Christ in Majesty with Evangelist symbols, Job arguing with Satan (f. 69); Bk. XXX, B (f. 87); Bk. XXXI, I (f. 107); Bk. XXXII, S (f. 134); Bk. XXXIII, A, seated man and woman (Pride and Humility?) addressed by a half-length figure behind them (f. 150); Bk. XXXIV, Q (f. 171v); Bk. XXXV, Q (f. 186).

With respect to decoration this three-volume set of Gregory's *Moralia in Job* is the outstanding work among a small group of 12th-century manuscripts from La Ferté-sur-Grosne to have survived. La Ferté was founded in 1113 near the forest of Bragny, south of Chalon, by Abbot Stephen Harding of Cîteaux, who sent half the monks of his own community there. It was the first 'daughter' of Cîteaux. Bartholomew, mentioned in the colophon, was the fourth abbot of the house and occupied this post between 1126–27 and 1158–59 (G. Duby, *Recueil des pancartes de l'abbaye de La Ferté-sur-Grosne, 1113–1178*, Paris, 1953, 8). The manuscript confirms the indication of the colophon that it was written by a single hand. It begins with a kind of false start (MS 7, f. 1), and in earnest with a versified piece of twenty lines beginning *Quisquis amas Christum nec mundum diligis istum* (f. 2v; Walther, *Initia Carminum*, 841, No. 16144) followed by an extract from the opening section of Job (f. 3) and Pope Gregory's prefatory letter to Bishop Leander of Seville (f. 11). The decoration of the work was carried out by two very distinct hands. The first, who executed the initials from the beginning through Bk. XVI (MS 8, f. 34), is a fairly unassuming talent, whose densely-packed and wholly aniconic pen-drawn designs are set on dark, contrasting panels and chiefly graced by spiralling convolutions of stringy foliage. Bk. XVII (MS 8, f. 50) inaugurates the work of the second illuminator with a splendid historiated initial set within a full-page design incorporating the *incipit* and *incipit* words in large capital letters arranged in lines of alternating colours. It is apparent that the page was conceived as the opening leaf of a separate codex for an edition planned as a two-volume set, the visual emphasis placed on Bk. XVII corresponding to the fourth in the sexpartite division of Gregory's original text. The second artist of the La Ferté *Moralia* contributed both

historiated and ornamental initials whose style is loosely allied to the work of the Cîteaux Lectionary Master, but the connection is not wholly straightforward. The artist is at some distance from the austere and finely calibrated manner of the Cîteaux illuminator, while his narrative approach and the occasionally whimsical touches of his designs suggest rather some links with the older generation of Cîteaux illuminators exemplified by the Harding Bible and its immediate relations (nos. 58, 59, 60).

PROVENANCE: Written by Peter of Toul (Tullensis), who finished his work in 1134, during the reign of Abbot Bartholomew (MS 9, f. 199).

LITERATURE: A. Molinier, *Catalogue général*, VI, 1887, 263; Porcher, *Art cistercien* (Coll. Zodiaque), 1962, 321–2; *Manuscrits datés*, VI, 1968, 149; *Colophons*, V, 1979, 141–42, No. 15969; G. Plotzek-Wederhake, 'Buchmalerei in Zisterzienserklöstern', *Die Zisterzienser*, Cologne, 1980, 358; N. Stratford, 'A Romanesque Marble Altar-Frontal in Beaune and some Cîteaux Manuscripts', *The Vanishing Past. Studies of Medieval Art, Liturgy and Metrology Presented to Christopher Hohler*, ed. A. Borg and A. Martindale, Oxford, 1981, 228–29; Zaluska, *Scriptorium de Cîteaux*, 69–70, 117, 211, 260, No. 84; A. Vannugli, 'Il "Secondo Mastro" di Cîteaux e la sua attività in Borgogna', *Arte medievale*, IIe Ser., 2, 1989, 63; *Saint Bernard et le monde cistercien*, ed. L. Pressouyre and T. N. Kinder, Paris, 1991, 232, No. 96; Y. Zaluska, *Manuscrits enluminés de Dijon*, Paris, 1991, 232, No. 96.

EXHIBITED: *Saint Bernard et l'art des cisterciens*, Dijon, 1953, Nos. 75–76; *Manuscrits à peintures*, Paris, 1954, 99–100, No. 288.

66. Cambridge, St. John's College MS B.18

Triple Psalter
254 × 175 mm., ff. 214, 2 cols. (ff. 2–30v, 208v–214v) and 3 cols. (ff. 31v–208), 32 lines
First quarter of the 12th century.
Reims *Ills. 157, 158, 159*

Full-page miniatures: David harping, flanked by musicians; below, musicians, acrobats, tumblers and onlookers (f. 1); Crucifixion and Three Maries at the Sepulchre (f. 31).

Historiated and ornamental initials: Preface, Q (f. 2); Psalm 1, B (f. 31v); Psalm 26, D (f. 58); Psalm 38, D (f. 73v); Psalm 51, Q, Christ seated with a book, piercing the head of a lion with a long cross (Gallican and Roman versions); standing Christ piercing the head of a man (Hebrew version) (f. 86v); Psalm 52, D (f. 87v); Psalm 68, S (f. 102); Psalm 80, E (Hebrew version, L, f. 120v); Psalm 96, C (f. 137); Psalm 101, D, kneeling supplicant, with bust of Christ (Gallican

version, f. 139); Psalm 109, D, Christ treading on the head of a man (Roman version, f. 155); Psalm 114, D, man and dragon (Roman and Hebrew versions) (f. 159); Psalm 118, B (f. 161v); Psalm 118, v. 81, D (f. 166v); Psalm 118, v. 129, M (f. 169v); Psalm 119, A (f. 172v); Psalm 121, L (f. 173); Psalm 126, N (f. 175v); Psalm 131, M (f. 177v); Psalm 137, C, musician, acrobats (f. 182); Psalm 143, B (f. 188); Canticle of Isaiah, C, haloed Prophet; seated woman, pointing (f. 195).

This manuscript contains the Gallican, Roman and Hebrew versions of the Psalms in three parallel columns, preceded by an extensive apparatus of prefatory material (ff. 2–30). The provenance is suggested by the emphasis given in the Litany to saints of Reims and its region, Nicasius, Remigius, Rigobertus and Gibrianus, among others. The single suffrage is addressed jointly to the Virgin and to Remigius. James tentatively localized the work in Reims, but noting the presence in the Litany of Saints Alban and Edmund, suggested that it might have been made for a possession of Saint-Remi at Reims in England, perhaps Lappley in Staffordshire. Whether this conclusion is fully warranted has been doubted by Farquhar, but it has found broad acceptance in the literature on the work. It has been determined (H. de Sainte-Marie, *Sancti Hieronymi Psalterium iuxta Hebreos*, Vatican, 1954, xli) that the text is a copy of the *Psalterium triplex* of the first half of the 11th century which the provost Odolricus (fl. 1049–1075) gave to Reims Cathedral (Reims, Bibl. Mun. MS 15).

The parallel presentation of the three different versions of the Psalms obliged the illuminator to provide three sets of initials of roughly equal weight where the division of the text was to be marked. He supplied lively, pen-drawn letters, enhanced with tints of pink, green, yellow, blue and violet, and constructed of sketchily-rendered foliage inhabited by fantastic beasts and naked figures. They are the work of the principal illuminator of the first two volumes of the Saint-Remi Bible (Reims, Bibl. Mun. MSS 16 and 17; no. 67) or of a close associate. In their theme, each group of initials manifests an overiding similarity, but the same subject is varied in its three presentations or only repeated twice. The *tituli* of the Psalms are rendered in irregularly accentuated rustic capitals, and the *incipit* words in alternating lines of black, red and green capital letters. The subdivision of the text adheres to the ten-part schema, enriched by the provision of initials in fairly unpredictable fashion for the text beyond Psalm 109. The initials of Psalms 1, 51, 102, 109 and 118 are larger in size for the main divisions.

The two independent miniatures are somewhat more deliberately drawn, and seem to have been left unfinished, though they do not appear to be decades earlier in date than the rest of the volume, as Farquhar has argued. The first, placed at the beginning of the prefatory texts, is a panel framed by an acanthus-filled border, with scenes of David harping,

surrounded by musicians (above) and a group of profane entertainers (below). David's concert features an organ pumped by men manipulating bellows, bells, a horn blower, a man playing pipes, and a singer. At the right of the enthroned David, there is a kneeling figure, perhaps a donor, who grasps the Psalmist's instrument with one hand and seems to steady it with the other. The scene below, dominated by a man dressed as a bear and pounding a drum, features tumblers, a group of mimes (?), a man playing the viol, and another playing a horn. Panofsky has interpreted the composition as intimating a contrast between David's sacred harmony and 'the sinful implications of worldly music'. The drawing is executed in light brown ink, with a few touches of pink in David's hands and face, the lion supports of his throne, and the kneeling figure, while a brownish wash has been applied to the fur of the bear-drummer in the scene below. The frame is much more densely drawn and accentuated with touches of violet. Left unfinished, it gives the impression of having been added as an afterthought or at a later time. The second drawing, which prefaces Psalm 1, has also suffered alterations through the addition of four crudely drawn Roman soldiers guarding Christ's tomb and the reworking of the tomb itself with bolder outlines and added tints of purple, green and grey. The theme, borrowed from a sequence of the Life of Christ of an Evangeliary, seems oddly chosen for this context. Perhaps the volume remained for a while without its intended, more fully elaborated frontispieces, and these had to be improvised in altered circumstances.

PROVENANCE: William Crashaw (1572–1626), bookplate. Henry Wriothesly, Earl of Southampton, c. 1613. Presented by his son Thomas to St. John's College in 1635.

BINDING: Oak boards covered with sheepskin, with traces of a boss in the middle of each cover (14th century).

LITERATURE: E. Buhle, *Die musikalischen Instrumente in den Miniaturen des frühen Mittelalter. Ein Beitrag zur Geschichte der Musikinstrumente. I. Die Blasinstrumente*, Leipzig, 1903, *passim*; M. R. James, *A Descriptive Catalogue of the Manuscripts in the Library of St. John's College, Cambridge*, Cambridge, 1913, 52–6, No. 40; H. Besseler, *Die Musik des Mittelalters und der Renaissance* (Handbuch der Musikwissenschaft, VI), Potsdam, 1931, 79; Swarzenski, *Monuments of Romanesque Art*, 60–1, No. 126; H. de Sainte-Marie, *Sancti Hieronymi Psalterium iuxta Hebreos* (Collectanea Biblica Latina, XI), Vatican, 1954, xli; H. Steger, *David, Rex und Propheta*, Nürnberg, 1961, 213, No. 38; E. Panofsky, *Renaissance and Renascences in Western Art*, Uppsala, 1965, 92–93, n. 3; J. Smits van Waesberghe, *Musikerziehung. Lehre und Theorie der Musik im Mittelalter*, Leipzig, 1969, 52–3; M. M. Farquhar, *A Cata-*

logue of the Illuminated Manuscripts of the Romanesque Period from Rheims, 1050–1130 (Univ. of London, Diss., 1968), 111–13, 131–50 and 274–85; T. Seebass, *Musikdarstellung und Psalterillustration im früheren Mittelalter*, Bern, 1973, 40f., 94, 96, 121, 139, 153; R. Hammerstein, *Diabolus in Musica. Studien zur Ikonographie der Musik im Mittelalter*, Bern and Munich, 1974, 59–61; R. Kahsnitz, *Der Werdener Psalter in Berlin, Ms. theol. Lat. fol. 358. Eine Untersuchung zu Problemen mittelalterlichen Psalterillustration*, Düsseldorf, 1979, 157, 158, 185, 186–7, 228.

EXHIBITED: *Romanesque Art, c. 1050–1200*, Manchester, 1959, 21–2, No. 32.

67. Reims, Bibliothèque Municipale MSS 16–19

Bible (Saint-Remi Bible)
MS 16: 435 × 310 mm., ff. 234, 2 cols., 34 lines
MS 17: 425 × 310 mm., ff. 149, 34 lines
MS 18: 470 × 335 mm., ff. 189, 37 lines
MS 19: 450 × 210 mm., ff. 133, 44 lines
First and second quarter of the 12th century.
Saint-Remi, Reims *Ills. 160, 161*

MS 16

Historiated and ornamental initials: OLD TESTAMENT PROLOGUE, F (f. 1); JEROME, *Ad Exuperantium*, I (f. 6); PREFACE TO PENTATEUCH, D (f. 6v); GENESIS, IN monogram, with half-length monk writing (f. 9); EXODUS, H, (f. 45); LEVITICUS, V (f. 74v); NUMBERS, L, Moses and the brazen serpent (f. 93); DEUTERONOMY, H (f. 121); PREFACE TO JOSHUA, T (f. 146v); JOSHUA, E (f. 147); JUDGES, P (f. 164); RUTH, I (f. 181); PREFACE TO JEREMIAH, I, standing Jeremiah with scroll (f. 183v); JEREMIAH, V (f. 184); BARUCH, E (f. 229).

MS 17

Historiated and ornamental initials: PREFACES TO ACTS, A, L, Luke standing on the back of his ox (f. 3); ACTS, P (f. 4); PREFACE TO APOCALYPSE, initial removed (f. 30); APOCALYPSE, initial removed (f. 30v); PREFACE TO CATHOLIC EPISTLES, initial removed (f. 43); JAMES, initial removed (f. 43v); I PETER, P (f. 46v); I JOHN, Q (f. 53); PREFACE TO KINGS, V (f. 56); I KINGS, initial removed (f. 57v); II KINGS, initial removed (f. 83); III KINGS, initial removed (f. 103); IV KINGS, beginning missing.

MS 18

Historiated and ornamental initials: ISAIAH *incipit*, standing prophet with scroll, hand of the Lord (f. 1); PREFACE TO ISAIAH, N (f. 1); ISAIAH, V (f. 1v); PREFACE TO EZEKIEL, H (f. 31); EZEKIEL, E (f. 31v); DANIEL *incipit*, I (f. 62); PREFACE TO DANIEL, D, figure feeding dragon (f. 62v); DANIEL, A (f. 63); PREFACE TO MINOR

PROPHETS, N (f. 76v); HOSEA, V, standing prophet with scroll (f.77); PREFACE TO JOEL, S (f. 81); JOEL, V (f. 81v); PREFACES TO AMOS, O, seated monarch; A (f. 83v); AMOS, V (f. 84); PREFACES TO OBADIAH, I, A (ff. 87v, 88); OBADIAH, V (f. 88); PREFACE TO JONAH, I (f. 88v); JONAH, E, Jonah swallowed by and emerging from the whale (f. 89); PREFACE TO MICAH, T, M (ff. 90, 90v); MICAH, V (f. 90v); PREFACE TO NAHUM, N (f. 93); NAHUM, O (f. 93v); PREFACES TO HABAKKUK, Q, A (ff. 95, 95v); HABAKKUK, O (f. 96); PREFACES TO ZEPHANIAH, T, S (ff. 97, 97v); ZEPHANIAH, V (f. 98); PREFACES TO HAGGAI, H, A (ff. 99v, 100); HAGGAI, I (f. 100); PREFACES TO ZECHARIAH, S, Z (f. 101, 101v); ZECHARIAH, I (f. 102); PREFACE TO MALACHI, D (f. 107); MALACHI, O (f. 107v); PREFACE TO JOB, C (f. 109v); JOB, V (f. 111v); PREFACE TO PROVERBS, I (f. 129); PROVERBS incipit, I, upright fish (f. 130); PROVERBS, P (f. 130v); ECCLESIASTES, V (f. 145v); SONG OF SONGS, O, the Bride and Bridegroom embrace on a couch (f. 149); WISDOM, D, personification of Wisdom (f. 151v); ECCLESIASTICUS, O (f. 161).

MS 19

Ornamental initials: ROMANS, P (f. 3v); I CORINTHIANS, P (f. 9); II CORINTHIANS, P (f. 14v); GALATIANS, P (f. 18v); EPHESIANS, P (f. 20v); PHILIPPIANS, P (f. 23); LAODICEANS, P (f. 24); I THESSALONIANS, P (f. 26); II THESSALONIANS, P (f. 27); I TIMOTHY, P (f. 28); II TIMOTHY, P (f. 29v); HEBREWS, M (f. 31v); TOBIT, T (f. 35v); PREFACE TO CHRONICLES, S (f. 82); I CHRONICLES, A (f. 83); II CHRONICLES, C (f. 99).

The Saint-Remi Bible, now very worn through use and partly mutilated, is the work of a number of scribes and illuminators who probably laboured on this enterprise over approximately two decades, from c. 1120 to the end of the 1130s. The four volumes, which were employed in the annual cycle of readings for the Divine Office, differ in their size and codicological aspect. The text includes St. Jerome's letter *Ad Exuperantium* as one of the Pentateuch Prefaces (MS 16, f. 6), following in this respect the 9th-century Bible of Hincmar (Reims, Bibl. Mun. MS 1, f. 7), and places the irregular Pauline Epistle to the Laodiceans between Philippians and Colossians (MS 19, f. 24). MS 16 has initials drawn in a refined and precise way, with a fairly minimal shading of red, yellow ochre and green. Their design contains reminiscences of Ottonian art, though the presence of interlace knots and elements of the inhabited scroll point to a more northerly direction. MS 17, which is badly mutilated, has initials drawn by different hands, most of them of a fairly scratchy quality, and more or less following the manner of the artist of the first volume. An exception is the handsome letter for the preface to the Book of Kings (f. 56), a brightly coloured design in orange, yellow and green, with birds and a lion inserted within the foliage. A particular feature here is the use of smaller ornamental initials for the *incipits*, which like the *incipit* words, are rendered in alternating lines of red, green and black majuscule letters. MS 18 introduces several new scribes and illuminators, one of them an excellent draughtsman who executed most of the initials from the Minor Prophets through the Wisdom Books. His vigorous, yet delicate draughtsmanship, as well as his primary reliance on foliage inhabited by beasts opposes a vaguely Norman sensibility to the Ottonian echoes in the work of the illuminator of MS 16. In the final volume (MS 19), the writing is more compact and the treatment of the decoration more economical, many of the books having penwork initials, while the ornamental treatment of the *incipit* and *incipit* words is eliminated altogether. Yet another illuminator is principally in evidence, whose designs seem to depend on the work of the major artist of MS 18, though they have a simpler and more sluggish quality.

PROVENANCE: *Liber sancti Remigii Remensis, volumen XXXI* (13th century, MS 16, ff. 1, 81) and identical inscriptions for No. XXXII (MS 17, ff. 1, 75), XXXIII (MS 18, ff. 1, 129) and XXXIV (MS 19, ff. 2, 83).

LITERATURE: H. Loriquet, *Catalogue général*, XXXVIII, 1904, 25–27; H. de Lemps and R. Laslier, *Trésors de la Bibliothèque municipale de Reims*, Reims, 1978, No. 22; Cahn, *Romanesque Bible Illumination*, 115, 136, 216, 279–80, No. 100.

EXHIBITED: *Manuscrits à peintures*, Paris, 1954, 91, No. 256; *Les plus beaux manuscrits de la Bibliothèque de Reims*, 19, No. 11.

68. Paris, Bibliothèque Nationale MS lat. 15307

Gregory, Moralia in Job (Bks. I–XVI)
370 × 255 mm., ff. 166, 2 cols., 48 lines
First quarter of the 12th century. Saint-Urbain
Ill. 156

Frontispiece miniature with the Lord in a mandorla and angels, in dialogue with Satan (left), and Job on the dunghill, scraping his boils in the presence of his wife and the three temptors (right). Below, Gregory, inspired by the Dove of the Holy Spirit and observed by his secretary (f. 1v).

Ornamental initials: Preface, R (f. 2); Bk. I, I (f. 3v); Bk. II, S (f. 12); Bk. III, B (f. 22v); Bk. IV, S (f. 54); Bk. X, Q (f. 110v); Bk. XII, M (f. 127); Bk. XVI, Q (f. 155). Other initials left in outline and unfinished (ff, 72, 110v, 144v); crude penwork letters (ff. 30v, 41v, 86v, 133v); spaces left blank (ff. 101v, 119).

The manuscript, which must originally have comprised a second volume, comes from Saint-Urbain, a Benedictine community established in 862 near

Wassy (Haute-Marne) in the diocese of Langres. The provenance, indicated rather unusually in the running titles of the upper margin of the book, was recorded by the ever-vigilant Delisle, but overlooked by later authors. The illumination was carried out by a single draughtsman who, however, did not complete his task, leaving some of the initials in the state of underdrawing or simple outline. Others remained undone altogether and the blank spaces provided for them are filled with crude penwork letters improvised by another hand. One of the initials incorporates a drawing of a monk at a pulpit in the act of writing, perhaps to be interpreted as a portrait of the scribe (f. 127). The decoration is executed in a brown outline, with some shading in a yellow ochre wash, and pale green, red and blue. While the drawing is in a delicate, yet firm hand, the shading has a rather scratchy quality especially in the garments, having been laid down in quick and irregular strokes of the pen. The principal component of this embellishment is the frontispiece, a composition seemingly assembled from smaller and self-sufficient units, and incorporating an *incipit* rendered in ornately elaborate majuscule letters. The work is isolated and difficult to place. It was described by H. Swarzenski as Franco-Flemish and dated it *c.* 1140. Its closest connections are with book illumination of Verdun of a slightly earlier date, like the life of St. Airy (Verdun, Bibl. Mun. MS 8; no. 139) or the Homiliary of Saint-Vanne (MSS 1 and 119; no. 141).

PROVENANCE: Inscription in the hand of the scribe *Liber sancti Urbani* (f. 78). List of persons connected with Maconcourt, Annonville, Bettoncourt, all in the neighbourhood of Wassy (Haute-Marne), 12th century (f. 166v). Bequeathed to the Sorbonne by Jean de Lausanne, priest of Saint-Christophe-en-la-Cité, Paris, 14th century (inscription, inner cover). Sorbonne Library, MS 331 and 19th-century inventory No. 634 (f. 1). Acquired by the Bibliothèque Royale in 1796.

LITERATURE: Delisle, *Cabinet des manuscrits*, II, 413; Swarzenski, *Monuments of Romanesque Art*, 67, No. 353; P. Glorieux, *Aux origines de la Sorbonne. I. Robert de Sorbon*, Paris, 1966, 315, 332.

EXHIBITED: *Manuscrits à peintures*, Paris, 1954, 95, No. 173.

69. Reims, Bibliothèque Municipale MSS 22–23

Bible (Saint-Thierry Bible)
MS 22: 470 × 355 mm. ff. 270
MS 23: 510 × 370 mm., ff. 136, 2 cols, 41 lines
c. 1125–35. Saint-Thierry, Reims

Ills. 162, 163, 164

MS 22

Historiated and ornamental initials: OLD TESTAMENT PROLOGUE, F (f. 1v); PREFACE TO PENTATEUCH, D, medallion portraits of Jerome and Desiderius (f. 4v); GENESIS, IN monogram (f. 5); EXODUS, H, Jacob and the Twelve Tribes of Israel (f. 28); LEVITICUS, V, the Lord speaks to Moses in the Tabernacle (f. 47); NUMBERS, L (f. 59v); DEUTERONOMY, H, Moses speaks to the Children of Israel (f. 78v); PREFACE TO JOSHUA, T (f. 95); JOSHUA, ET monogram (f. 95v); JUDGES, P (f. 106v); RUTH, I, standing Ruth (f. 118v); PREFACE TO JEREMIAH, I (f. 120); JEREMIAH, V (f. 120); BARUCH, L, E (f. 148); PREFACE TO ACTS, L (f. 151v); ACTS (f. 151v); PREFACE TO APOCALYPSE, I (f. 166v); APOCALYPSE, A (f. 167); PREFACE TO CATHOLIC EPISTLES, N (f. 174); JAMES, I, standing Apostle with book (f. 174); I PETER, P (f. 175v); II PETER (f. 177v); I JOHN, Q (f. 178v); JUDE, I (f. 180); PREFACE TO KINGS, V (f. 180v); I KINGS, F, Elkanah and his two wives (f. 181v); II KINGS, F (f. 197); III KINGS, E (f. 210); IV KINGS, C (f. 225); PREFACES TO I CHRONICLES, S, E (ff. 239v–240); I CHRONICLES, A (f. 240v); II CHRONICLES, C (f. 253v).

MS 23

Historiated and ornamental initials: PREFACE TO PROVERBS, T, I (ff. 1v, 2); PROVERBS, P, enthroned Solomon (f. 2v); ECCLESIASTES, V (f. 12v); SONG OF SONGS, O, dialogue of Christ and Ecclesia (f. 16); WISDOM, D, female figure with sword and shield (f. l8); PREFACE TO ECCLESIASTICUS, M (f . 25); ECCLESIASTICUS, O, personifications of *Philosophia, Physica* with the Quadrivium, *Logica* with the Trivium, and *Ethica* with the Cardinal Virtues (f. 25); PREFACE TO JOB, C (f. 44v); JOB, V, Job on the dunghill in dialogue with the Lord, his wife and the three temptors (f. 45v); TOBIT, T, Tobit blinded and the angel Raphael leading his son away (f. 58); JUDITH, A (f. 62v); ESTHER, Esther before Ahasuerus, Hanging of Haman (f. 69v); PREFACE TO EZRA, U (f. 75v); EZRA, I, standing Prophet with scroll (f. 76); NEHEMIAH, E (f. 80v); PREFACE TO MACCABEES, M (f. 87v); I MACCABEES, E, Judas Maccabeus and his four brothers (f. 87v); II MACCABEES, F (f. 102v); PREFACE TO EZEKIEL, I (f. 113); EZEKIEL, E (f. 113v).

The Saint-Thierry Bible is a work of high quality and beauty, but now in a worn and incomplete state, the second volume coming to an end at Ezek. 48:13 and lacking Isaiah, Daniel, the Minor Prophets, Psalms, Gospels and the Pauline Epistles. The manuscript seems to have been written by one scribe and illuminated by a single painter. The initials are executed in an arresting combination of drawing in red outline and full-fledged painting in body colour, mainly blue, green, wine red and light yellow. Gold is employed sparingly for the outline of some letters, or more commonly, for the *clavi* of garments. The structure of the initials is inventive. They may incorporate medallions (MS 22, ff. 4v, 28) or consist of a kind of

architectural structure (MS 22, f. 78v). The illustrative matter for Esther is incorporated into a monogram, and the upright member of the letter N serves as a gallows for the wicked Haman (MS 23, f. 69v). Of particular iconographic interest is the initial of Ecclesiasticus with it depiction of *Philosophia* with its tri-partite subdivision of *Logica, Physica and Ethica* (MS 23, f. 25). *Incipits* and *incipit* words consist of alternating lines in red and blue or green, sometimes highlighted with yellow. The date of the manuscript is uncertain. M.-P. Laffitte places it in the second half of the 12th century, and H. de Sainte-Marie around 1170, which on a comparative basis, seems too late. The style of the initials is based on Mosan illumination of the late 11th and early 12th century and could be described as a not too distant offshoot of the art of Goderamnus, the scribe-illuminator of the Stavelot and Lobbes Bibles. The Leviticus initial of the Saint-Thierry Bible (MS 22, f. 57) showing Moses receiving the tablets of the law and the *menorah* evokes the display of the Tabernacle vessels in the Deuteronomy initials of the Lobbes Bible (Tournai, Grand Séminaire, Cod. 1, f. 77). The lively and small-scaled approach of the illuminator also perpetuates a certain impressionism traditional in Reims since the 9th century and exemplified at the end of the 11th century in the Lectionary of the Cathedral (Reims, Bibl. Mun. MS 294).

PROVENANCE: Saint-Thierry, Reims, MS 1.

LITERATURE: H. Loriquet, *Catalogue général*, XXXVIII, 1904, 27–9; M.-P. Laffitte, 'Esquisse d'une bibliothèque médiévale. Le fonds des manuscrits de l'abbaye de Saint-Thierry', *Saint-Thierry. Une abbaye du VIe au XXe siècle* (Actes du Colloque international d'histoire monastique, ed. M. Bur), 1976 (1979), 73–100, esp. 89; H. de Sainte-Marie, 'Les quatre manuscrits latins d'Ancien Testament à la bibliothèque de Saint-Thierry', ibid., 113–31, esp. 126–31; M. de Lemps and R. Laslier, *Trésors de la Bibliothèque Municipale de Reims*, Reims, 1978, No. 24; G. Cames, 'Parfums et diadème: Le Cantique des Cantiques dans l'iconographie mariale romane', *Miscellanea codicologica F. Masai dicata MCMLXXIX*, ed. P. Cockshaw, M.-C. Garand and P. Jodogne, Ghent, 1979, I, 244; Cahn, *Romanesque Bible Illumination*, 115, 136, 216, 180, No. 102.

EXHIBITED: *Manuscrits à peintures*, Paris, 1954, 91, No. 257; *Les plus beaux manuscrits de la Bibliothèque municipale de Reims*, Reims, 1967, 19, No. 11.

70. Troyes, Bibliothèque Municipale MS 27

Bible (Clairvaux Bible)
490 × 345 mm., ff. I + 219, 200, 191, 246 and 225, 2 cols., 29 lines (text), 46 lines (Prefaces, Interpretation of Hebrew Names)
Middle of the 12th century. Clairvaux

Ills. 165, 166, 167

Vol. I

Framed title page (f. 1v)

Ornamental initials: OLD TESTAMENT PROLOGUE, F (f. 2); PREFACE TO PENTATEUCH, D (f. 4); GENESIS, I (f. 7); EXODUS, H (f. 62); LEVITICUS, V (f. 104v); NUMBERS, L (f. 134v); DEUTERONOMY, H (f. 178); INTERPRETATION OF HEBREW NAMES, P (f. 215).

Vol. II

Framed title page (f. 1v)

Ornamental initials: PREFACE TO JOSHUA, T (f. 2); I (f. 2v); JOSHUA, E (f. 3v); JUDGES, P (f. 29); RUTH, I (f. 55v); PREFACE TO KINGS, V (f. 59v); I KINGS, F (f. 62); II KINGS, F (f. 99v); III KINGS, E (f. 130); IV KINGS, P (f. 165); INTERPRETATION OF HEBREW NAMES, A (f. 197).

Vol. III

Ornamental initials: PREFACE TO CHRONICLES, cut out; I CHRONICLES, A (f. 3v); II CHRONICLES, C (f. 37); PREFACE TO EZRA, U (f. 73v); EZRA, I (f. 74v); PREFACE TO TOBIT, C (f. 98v); TOBIT, T (f. 99); PREFACE TO JUDITH and JUDITH, cut out; ESTHER, I (f. 121v); PREFACE TO MACCABEES, M (f. 134); I MACCABEES, E (f. 135v); II MACCABEES, F (f. 168v).

Vol. IV

Framed title page (f. lv)

Ornamental initials: PREFACE TO ISAIAH, N (f. 2); ISAIAH, V (f. 4v); JEREMIAH, V (f. 56v); BARUCH, E (f. 118v); EZEKIEL, E (f. 127); PREFACE TO DANIEL, D (f. 180); DANIEL, A (f. 191v).

Vol. V

Ornamental initials: PREFACES TO GOSPELS, B (f. 1); S (f. 2); P (f. 2v); PREFACE TO MATTHEW, M (f. 3v); MATTHEW, cut out; PREFACE TO MARK, M (f. 29); MARK, I (f. 30); PREFACE TO LUKE, L (f. 47); LUKE, Q (f. 48v); PREFACE TO JOHN, H (f. 75v); JOHN, I (f. 76v); PREFACE TO ACTS, L (f. 97v); ACTS, P (f. 99); PREFACE TO CATHOLIC EPISTLES, N (f. 127); JAMES, I (f. 127v); I PETER, P (f. 131); II PETER, S (f. 134); I JOHN, Q (f. 136); II JOHN, S (f. 139); III JOHN, S (f. 139v); JUDE, I (f. 140); PREFACES TO PAULINE EPISTLES, O (f. 141); P (f. 142); E (f. 142v); PREFACE TO ROMANS, R (f. 142v); R (f. 144); ROMANS, P (f. 144v); I CORINTHIANS, P (f. 155v); II CORINTHIANS, P (f. 166v); GALATIANS, P (f. 174); EPHESIANS, P (f. 178); PHILIPPIANS, P (f.182); PREFACE TO COLOSSIANS,

C (f. 184v); COLOSSIANS, P (f. 185); I THESSALONIANS, P (f. 188); II THESSALONIANS, P (f. 190v); I TIMOTHY, P (f. 192); II TIMOTHY, P (f. 195v); TITUS, P (f. 197v); PHILEMON, P (f. 199); HEBREWS, M (f. 200); PREFACE TO APOCALYPSE, I (f. 208); APOCALYPSE, A (f. 209).

The Clairvaux Bible represents a distinctive new structuring of the biblical text, undoubtedly undertaken deliberately. In place of the one or two-volume Giant Bibles that came to be the generally accepted format from the Carolingian period onward, the text is in this instance divided into six separate tomes — one of them, which must have contained the Psalms and Job, now missing. The writing is exceptionally large in scale, with a text column of only twenty-nine lines and, on average, no more than four words per line. Each volume begins with a framed title page listing the contents (missing in Vols. III and IV), and concludes with the interpretation of Hebrew names, conventionally attributed to Jerome, that figure in the biblical books at hand. The work was used for the Office and refectory readings *per circulum anni*, and contains marginal instructions for these readings (Vol. II, ff. 136v, 200v). The principal feature of the decoration is the provision of large ornamental initials for the biblical books and many of the prefaces, accompanied by *incipits* and *explicits* in capital letters arranged in alternating lines (or syllables) of red and green, though occasionally also blue and brown. The initials are painted in a monochrome or *camaieu* technique, making use of tones of blue, red, green, and more rarely, brown and purple, with a wash-like yellow for some of the painterly infill. The formal vocabulary consists almost exclusively of foliate and geometric elements, all traces of the figurative and zoomorphic having been banished, save for two instances of parts of letters in the form of elongated dragons (Vol. I, f. 104v; Vol. V, f. 174) that escaped the artist's self-censure. This vigorous rejection of the colourful pictorial repertory and lavish production of certain Romanesque illuminated manuscripts was inspired, it is generally agreed, by the promulgation of Cistercian legislation of statutes prescribing for books only letters 'of one colour' and 'without illustrations' (*sine historia*). It is believed that this stipulation, reflecting St. Bernard's criticism of luxury in monastic art, was adopted by the Order in 1151 or 1152. In its wake, a certain number of books illuminated in the *style monochrome* of the Clairvaux Bible were produced for different Cistercian houses, though the style appears almost entirely in large choir and refectory Bibles. At Clairvaux itself, an Old Testament of this type was written and illuminated for Bishop Samson of Reims (1140–1161) and given by him to the Cistercian monastery at Igny (Troyes, Bibl. Mun. MS 72). Fragments of a Bible with monochrome initials have been discovered by Y. Zaluska among the Cîteaux manuscripts (Dijon, Bibl. Mun. MSS 67 and 3099), and this type of decoration is found also in a five-volume Bible from the convent of the Célestins in Paris now divided between the St. Petersburg Public Library (MS Lat. f.v. I. 24) and the Bibliothèque de l'Arsenal (MSS 578–9); a five-volume Bible at Chaumont, perhaps made for Morimond (Bibl. Mun. MSS 1–5) and a copy of Radulphus Flaviacensis' Commentary on Leviticus, possibly from the same house (Bibl. Nat. lat. 17269). It does not seem to have been widely employed and went out of fashion in favour of an even more radical, and possibly more economical sobriety.

Although the restriction in the range of colour and the formal language lends to the illumination of the Clairvaux Bible the appearance of comparative uniformity, a closer examination of the work reveals differences in approach among the two or more painters who must have been involved in the project. The detail within this ornamental alphabet is sometimes fully modelled in body colour, but elsewhere rendered in a more linear and summary manner. While the initials as a rule present themselves as silhouetted forms against the bare parchment, the A of I Chronicles (Vol. III, f. 3v) is incorporated in a panel which includes the *incipit* word. The feathery and somewhat fussy character of this design contrasts with the stiff and expertly polished constructions found in the opening leaves of the first column (ff. 1, 4, 7), while an equally impressive group of initials for the Major Prophets in Vol. IV (ff. 4v, 181v) seems to mark out yet another direction within this purposefully self-denying aesthetic.

PROVENANCE: *Liber Sancte Marie Clarevallis* (verso, flyleaf); Clairvaux MSS A 20, 21, 22, 24 and 25 (15th- to 16th-century shelfmarks).

LITERATURE: A. Harmand, *Catalogue général*, Quarto Series, II, 1855, 25; H. d'Arbois de Jubainville, *Étude sur l'état intérieur des abbayes cisterciennes et principalement de Clairvaux au XIIe et XIIIe siècles*, Paris, 1858, 97; L. Morel-Payen, *Les plus beaux manuscrits et les plus belles reliures de la bibliothèque de Troyes*, Troyes, 1935, 78–80; J. Porcher in *Art cistercien* (Coll. Zodiaque), 1962, 329; *Manuscrits datés*, V, 1965, 447; F. Bibolet, 'Les manuscrits de Clairvaux', *Enluminure carolingienne et romane* (Les dossiers de l'archéologie, 14, Jan.-Feb. 1976, 89; G. Plotzek-Wederhake, 'Buchmalerei in Zisterzienserklostern', *Die Zisterzienser*, Cologne 1980, 357; Cahn, *Romanesque Bible Illumination*, 234, 282, No. 111; id., 'The Structure of Cistercian Bibles', *Studies in Cistercian Art and Architecture*, III, 1987, 88–89, No. 21; E. J. Beer, 'Zur Buchmalerei der Zisterzienser im oberdeutschen Gebiet im 12. und 13. Jahrhunderts', *Bau- und Bildkunst im Spiegel internationaler Forschung*, Berlin, 1989, 72, 85; Zaluska, *Scriptorium de Cîteaux*, 66, 165, 231, 253.

EXHIBITED: *Saint Bernard et l'art des cisterciens*, Dijon, 1953, 35–36, Nos. 60–1; *Manuscrits à peintures*, Paris, 1954, 100, No. 290.

71. Troyes, Bibliothèque Municipale MS 458

Bible

320 × 235 and 320 × 250 mm., ff. 251 and 234,
2 cols., 45 lines
Second quarter or middle of the 12th century.
Troyes (?) *Ills. 168, 169, 170*

Vol. I

OLD TESTAMENT PROLOGUE, F, Jerome as bishop, holding a tablet (f. 2); PREFACE TO PENTATEUCH, D (f. 4v); GENESIS, I, medallions with Creation scenes (f. 6); EXODUS, H (f. 26); LEVITICUS, V (f. 42); NUMBERS, L (f. 53v); DEUTERONOMY, H (f. 70); JOSHUA, E (f. 84); JUDGES, P (f. 93v); RUTH, I (f. 103); I KINGS, F, Elkanah and his two wives (f. 105v); II KINGS, F (f. 118v); III KINGS, E (f. 129v); IV KINGS, P (f. 142v); ISAIAH, V (f. 154); JEREMIAH, V (f. 172); BARUCH, E (f. 193); EZEKIEL, E (f. 197v); DANIEL, A (f. 217); HOSEA, V (f. 225); JOEL, V (f. 228); AMOS, V (f. 229); OBADIAH, V (f. 231v); JONAH, E, the Prophet cast into the sea (f. 232); MICAH, V (f. 233); NAHUM, O (f. 234v); HABAKKUK, O (f. 235v); ZEPHANIAH, V (f. 236); HAGGAI, I (f. 237); ZECHARIAH, standing Prophet (f. 238v); MALACHI, O (f. 241v); PREFACE TO THE INTERPRETATION OF HEBREW NAMES, P (f. 243).

Vol. II

PREFACES TO PSALMS, D, David with sceptre and book (f. 1); PSALMS, B (f. 1); PROVERBS, Solomon instructs his son (f. 23v); ECCLESIASTES, V (f. 31); SONG OF SONGS, O, mystical embrace of the Bride and Bridegroom (f. 34); WISDOM, D, personification of Wisdom (f. 36); ECCLESIASTICUS, bust of Christ as Wisdom (f. 42); JOB, V (f. 49); I CHRONICLES, A (f. 59v); II CHRONICLES, V (f. 70); EZRA, I (f. 92); NEHEMIAH, E (f. 95v); ESTHER, I (f. 101); TOBIT, T (f. 105v); JUDITH, A (f. 109); I MACCABEES, E (f. 114); II MACCABEES, F, Lapidation of Antiochus (f. 126); PREFACE TO GOSPELS, B (f. 133v); MATTHEW, L (f. 136); MARK, I, medallions with the Dove of the Holy Spirit, Baptism of Christ, bust of the Evangelist (f. 147); LUKE, Q, seated Evangelist with book (f. 154v); JOHN, I, medallions with the Dove of the Holy Spirit, bust of Christ, bust of the Evangelist (f. 166); ACTS, P, Christ in Majesty (f. 175v); JAMES, I (f. 188v); I PETER, P, bust of Peter with keys (f. 190); II PETER, S (f. 191); JOHN, Q, bust of John with scroll (f. 192); II JOHN, S (f. 193); III JOHN, S (f. 193v); JUDE, I, standing Apostle with scroll (f. 193v); ROMANS, P, Paul speaks to a group of Romans (f. 196); I CORINTHIANS, P, Paul speaks to the Corinthians (f. 201v); II CORINTHIANS, P (f. 206); GALATIANS, P (f. 209v); EPHESIANS, P, Paul saved from shipwreck and the bite of a viper (f. 211v); PHILIPPIANS, P, enthroned Apostle with scroll (f. 213); COLOSSIANS, P (f. 214v); THESSALONIANS, P (f. 215v); II THESSALONIANS, P (f. 216v); I TIMOTHY, P (f. 219v); PHILEMON, P (f. 220v); HEBREWS, M (f. 221); APOCALYPSE, A (f. 225).

This Bible is a manuscript of relatively small format. It bears several inscriptions ranging in date from the end of the 12th to the 14th century, indicating that it once belonged to St. Bernard, Abbot of Clairvaux from 1113 to 1153 (Vol. I, f. 1; Vol. II, ff. 235, 235v), and it is described in the same way in an inventory of the Clairvaux library made in 1472. Although there appears to be no evidence of Bernard's ownership of the manuscript datable in the saint's own lifetime, the style of the work does not contradict such an association, and the fairly small size of the volume might well point to a private ownership rather than a monastic library. But the decoration is not easy to reconcile with Bernard's well-known strictures on this subject and the Cistercian legislation which his views inspired. It includes both historiated and ornamental initials, many of them incorporating grotesque and composite creatures within their structure; gold, unambiguously proscribed in these pronouncements, is also used throughout for the backgrounds. Wilmart, seeking to account for the difficulty, suggested that Bernard might have received the manuscript as a gift from some prince, and noted that Clairvaux had accepted a collection of books with a fairly precious decoration from Henry, a son of Louis VI, when he became a monk there in 1145. However the apparent contradiction is explained, it was evidently less troublesome in the 12th century than it is to us, since the subdivision of the text of the Major Prophets into sets of triple lections indicates that the Bible was used in the readings of the nocturnal Office by the community. The theory of a gift, nevertheless, receives some support from the fact that the manuscript has no visible connection with Clairvaux book production of the mid 12th century. The manuscript was written by a single hand, except for Job (Vol. II, ff. 48–58), which is the work of another copyist, as Wilmart observed. Two hands, at least, were responsible for the execution of the initials, which are meticulously painted in body colour, outlined in black, and set in their allotted spaces without a frame. The compact nature of the work is also reflected in the treatment of the prefatory texts, which save for those that introduce the Old and the New Testaments, have small and unassuming decorative letters. The *incipits* are rendered in alternating red and blue capital letters, and reticently flourished two-line ornamental capitals indicate the chapter divisions, which were later modified to reflect the new subdivisions introduced by the University of Paris. The text as well as aspects of the iconography and style ally the work with the Bible of Saint-Etienne in Troyes (Troyes, Bibl. Mun. 2391), which also features among its illustrations of the Pauline Epistles the unusual scene of Paul's salvation from shipwreck and the bite of a viper (Vol. II, f. 211v). It may well be that both books were produced in one of the scriptoria of Troyes patronized by the Count of Champagne. The inclusion of the mystical interpretations of Hebrew names at the end of both vol-

umes, however, standard in Bibles of the Gothic period, but rare in the 12th century, is an element common to the work and the Clairvaux choir Bible (Troyes, Bibl. Mun. MS 27; no. 70).

PROVENANCE: Clairvaux MS A 28 and 29.

LITERATURE: A. Harmand, *Catalogue général*, Quarto Series, II, 1855, 205; id., 'Notice sur la Bible de St. Bernard', *Mémoires de la Société académique de l'Aube*, XX, 1842, 247–52; H. d'Arbois de Jubainville, *Étude sur l'état intérieur des abbayes cisterciennes et principalement de Clairvaux au XIIe et XIIIe siècles*, Paris, 1858, 37; A. Wilmart, 'L'ancienne bibliothèque de Clairvaux', *Mémoires de la Société académique de l'Aube*, LIII, 1917, 127–90; L. Morel-Payen, *Les plus beaux manuscrits et les plus belles reliures de la Bibliothèque de Troyes*, Troyes, 1935, 65–70; A.-M. Harmand, *Saint Bernard et le renouveau de l'iconographie au XIIe siècle*, Paris, 1944, 26 and *passim*; Grabar and Nordenfalk, *Romanesque Painting*, 139; F. Bibolet, 'Les manuscrits de Clairvaux', *Enluminure carolingienne et romane* (Les dossiers de l'archéologie, 14), Jan.-Feb. 1976, 86–93; L. Eleen, *The Illustrations of the Pauline Epistles in French and English Bibles of the Twelfth and Thirteenth Centuries*, Oxford, 1982, 52, 76, 85, 87–8, 99–100, 116; Cahn, *Romanesque Bible Illumination*, 231–4, 282, No. 113; *Saint Bernard et le monde cistercien*, ed. L. Pressouyre and T. N. Kinder, Paris, 1991, 207–8, No. 21.

EXHIBITED: *Saint Bernard et l'art des cisterciens*, Dijon, 1953, 36, Nos. 62–3.

72. Paris, Bibliothèque Nationale MS lat. 8959

Flavius Josephus, Antiquitates Judaicae and De bello judaico
438 × 301 mm., ff. 251, 2 cols., 52 lines
Middle of the 12th century. Troyes (?)
Ills. 171, 172

Historiated and ornamental initials.

Antiquitates Judaicae: Preface, H (f. 1); Bk. I, I, Three scenes of Creation, Rivers of Paradise (f. 1v); Bk. II, P, Isaac cooks a pot of venison for Esau (f. 9); Bk. III, I (f. 17); Bk. IV, H (f. 24); Bk. V, M (f. 31); Bk. VI, T (f. 39v); Bk. VII, P (f. 49); Bk. VIII, D (f. 59v); Bk. IX, I (f. 70v); Bk. X, C (f. 78); Bk. XI, P, Cyrus on horseback, carrying a banner (f. 85); Bk. XII, A (f. 92v); Preface of Bk. XIII, Q (f. 101v); Bk. XIII, Q (f. 102); Bk. XIV, A (f. 113v); Capitula, S, and Bk. XV, S (f. 126); Bk. XVI, I (f. 135); Bk. XVII, A (f. 143).

De bello judaico: Preface, Q (f. 154v); Bk. I, C (f. 155); Bk. II, T (f. 173); Bk. III, N (f. 187v); Bk. IV, Q (f. 195v); Bk. V, A (f. 200v); Bk. VI, T (f. 205v); Bk. VII, C (f. 215). *Antiquitates Judaicae:* Bk. XVIII, C (f. 228v).

The manuscript comprises Books I–XVII of Josephus's *Jewish Antiquities* (ff. 1–154), curiously interrupted at this point by the *Jewish Wars* (ff. 154v–228) and resuming thereafter with Bks. XVIII–XX of the first-mentioned work (ff. 228v–251). It was written by two distinct hands, the first and more oldfashioned one being responsible for Bks. I–XII of the *Jewish Antiquities* (ff. 1–101) and most of the *Jewish Wars* (ff. 158–237) and the second for the rest. This division of the labour is echoed in the contrasting decoration of these different parts. The sections written by Hand A have fully painted initials. These, as P. Stirnemann was first to observe, are the work of the illuminator of the two-volume Bible of Montiéramey, near Troyes (Troyes, Bibl. Mun. MS 28). The pages of Hand B, written in a more open and angular manner, have two painted ornamental initials of a Channel Style design (f. 126) which recalls the illumination by the Simon Master of another product of Troyes, the Capucins Bible of the Bibliothèque Nationale (MSS lat. 16744 and 16746; no. 79). The other initials of sections of the manuscript by Hand B are beautifully drawn decorative initials of stylized foliage in multi-coloured inks. Stirnemann has discovered initials by the same artisan in Sigebert of Gembloux's continuation of the World Chronicle of Eusebius, Jerome and Prosper of Aquitaine (Bibl. Nat. lat. 14624). The provenance of this volume, which was at Saint-Victor in the 13th century, is not known, but the wording of one of the historical entries suggests that it may have been made for a royal prince, Henry of France, Bishop of Beauvais, and later Archbishop of Reims (d. 1175), as Stirnemann has suggested. According to Stirnemann, the Montiéramey Bible painter began the Josephus, and the sections of Hand B by the illuminator of the Saint-Victor World Chronicle were carried out later. But since the parts attributable to the two scribes alternate in the volume and complete one another, it is more likely that the work is a collaborative venture on their part.

PROVENANCE: Unidentifiable owner, 15th-century inscription (f. 1). Suppl. lat. No. 332. Acquired by the Bibliothèque Nationale in 1822.

LITERATURE: F. Blatt, The *Latin Josephus* (Acta Jutlandica, XXX. Aarsskrift for Aarhus Universitet, XXX), Aarhus, 1958, 62, No. 99; P. Danz Stirnemann 'Quelques bibliothèques princières et la production hors scriptorium au XIIe siècle', *Bulletin archéologique du Comité des travaux historiques et scientifiques*, XVII–XVIII, 1981–2, 7–38.

73. Paris, Bibliothèque Nationale MS lat. 796

Breviary (Temporale)
430 × 305 mm., ff. 254, 2 cols., 45 lines
Middle of the 12th century. Montiéramey
Ill. 173; Col. pl. XI

One independent miniature: Three Maries at the Sepulchre (f. 149v).

Historiated and ornamental initials: O, Christ in Majesty (f. 6); B (f. 10); A, bust of the Lord and below, male figure with book (f. 11); E (f. 11); V, Isaiah, three men (f. 11v); O, personification of Wisdom (f. 41); P, Annunciation to the Shepherds (f. 52); N, Nativity (f. 52v); P (f. 66v); S (f. 69v); H (f. 70); P, Paul writing (f. 88); P (f. 98v); D (f. 102v); E (f. 149v); P (f. 158); P (f. 172); P (f. 174v); D (f. 182); A, Descent of the Holy Spirit (f. 182); H (f. 188v); F, Hannah presents the child Samuel in the Temple (f. 191v); F (f. 195v); E, King David, a man and Abisag the Sunnamite (f. 196v); P, enthroned Solomon (f. 198); V, Job scraping his boils, his wife and three temptors (f. 200v); T, Tobit carrying a corpse, accompanied by his son who carries a shovel for burial (f. 203); A, beheading of Holophernes (f. 204v); E (f. 205v); E (f. 208); E, Vision of Ezekiel of the four living creatures (f. 209v); F (f. 212v); H (f. 219); E, Ezekiel, hand of the Lord, three Elders of Judah (f. 216v); D, crowned woman with chalice and host, inscribed *Virgo Mater Ecclesia* (f. 235); F, the Lord in Majesty, Cherubim, Seraphim, musicians and a tumbler, along with a king, a priest, and a figure sacrificing a calf (f. 235v); R (f. 236v); Q, Christ and Zaccheus (f. 237v); E, Christ disputing with Jews (f. 238v).

The presence of an Office for St. Victor, designated as *patris nostri* (ff. 251–251v) and the emphasis given to this saint in the Litany led Delisle, following the catalogue of the Royal Library of 1744, to suppose that this manuscript came from the celebrated Parisian abbey of Saint-Victor or one of its dependencies. Leroquais, however, demonstrated that it must have been made for a Benedictine house in the diocese of Troyes where there was a cult of the Confessor St. Victor. He identified the community in question as Saint-Pierre at Montiéramey, a 9th-century monastic foundation located about twelve miles east of Troyes. The manuscript shows extensive traces of wear and has lost some pages at the beginning. The decoration is the work of an outstanding talent, working in a manner that could be described as half way between drawing and painting. A broad range of colours is used, with gold for the backgrounds and some touches of silver, but the modelling is essentially linear. The most important of the illustrations are the independent vignettes of the Three Maries at the Tomb, which precedes a hymn for the Vigil of Easter Sunday (f. 149v); the remarkable Descent of the Holy Spirit, introducing a sermon of St. Augustine read at Pentecost (f. 182), and the initial with Christ in Majesty superimposed on a domed Temple of Solomon at the beginning of a lection from the Book of Kings read on the feast of the *Dedicatio ecclesiae* (f. 235v). The artist favours letters with a panelled construction bristling with lively foliage. Some of the ornamental initials incorporate fantastic figurative or zoomorphic subjects: putti (f. 149v); confronted lions (f. 174v); a bird bitten by a dragon (f. 188v); a man fighting dragons (f. 195v); a woman musician and a juggler (f. 212v). The same painter executed three initials in the fourth volume of a collection of works of Augustine from Clairvaux (Troyes, Bibl. Mun. MS 40, ff. 1, 2v, 9v), and the decoration of a badly mutilated Bible from Sainte-Colombe at Sens (Sens, Bibl. Mun. MS 1; no. 75). A copy of Deuteronomy with the glosses of Gilbert the Universal (Bibl. Nat. lat. 186) should be added to his *oeuvre*, as pointed out by P. Stirnemann.

PROVENANCE: Maréchal de Noailles, MS 13. Acquired by the Royal Library in 1740.

LITERATURE: Delisle, *Cabinet des manuscrits*, III, 231; Haseloff, *Miniatures*, 308–9; Lauer, *Enluminures romanes*, 65–6; id., *Manuscrits latins*, I, 277; Leroquais, *Bréviaires*, II, 1934, 449; H. Anglès, *La musica a Catalunya fins al segle XIII*, Barcelona, 1935, 294; J. Leclercq, 'Un Missel de Montiéramey', *Scriptorium*, XIII, 1959, 247; id., 'Saint Bernard écrivain d'après l'office de Saint-Victor', *Revue bénédictine*, LXXIV, 1964, 158; J. Smits van Waesberghe, 'Eine merkwürdige Figur und ihr musik-geometrisches Geheimnis', *Festschrift Bruno Stäblein zum 70. Geburtstag*, ed. M. Ruhnke, Kassel, Basel, Paris, London and New York, 1967, 234–38; id., *Musikerziehung. Lehre und Theorie der Musik im Mittelalter*, Leipzig, 1969, 66–67; R.-J. Hesbert, *Corpus Antiphonarium Officii*, V (Rerum Ecclesiasticarum Documenta. Series Maior, Fontes, XI) Rome, 1975, 13 and *passim*, No. 782; P. Stirnemann, *Bulletin monumental*, CXLIII, 1985, 365–6; A. Davril, 'La longueur des leçons de l'Office Nocturne. Étude comparative'. *Rituels. Mélanges offerts à Pierre-Marie Gy*, Paris, 1990, 183–97.

74. Paris, Bibliothèque Nationale MS lat. 1626

Origen, Homilies on the Old Testament
350 × 250 mm., ff. 279, 2 cols., 35 to 41 lines
Middle of the 12th century.
Sens or Saint-Denis (?) *Ills. 174, 175*

Historiated and ornamental initials: O, medallion with the Lamb of God displayed by a pair of angels (f. 30v); V (f. 33); S, gesticulating half-length figures (f. 35v); M (f. 41v); D (f. 50); M (f. 52v); P (f. 56v); O, Christ in Majesty (f. 60v); S (f. 65); Q (f. 68v); Q (f. 71); L (f. 74); I (f. 76v); S (f. 80); D, three gesticulating figures (f. 83); D (f. 87); S, three-quarter length figure in medallion (f. 92v); E, unfinished (f. 97v); M, half-length speaking figure (f. 117); Q, enthroned figure (f. 139); D (f. 151).

Marginal drawings: human-headed leonine creature (f. 25v); monster with flower in jaws (f. 79v); bearded face (f. 99).

The manuscript contains the collection of Origen's Homilies for the Hexameron, Song of Songs and Isaiah, in the translation of Rufinus of Aquileia, and Jerome's Latin rendition of the homilies for Jeremiah and Ezekiel. Of this last series, only the beginning is preserved on the last folio of the volume. In the classification of W. Baehrens, the text belongs to Group C, said to descend from an archetype written in France before the 9th century, and perhaps as early as the beginning of the seventh. The text was written by a number of not overly fastidious hands. Given the lack of refinement of the scribal technique, the high quality of the initials comes as a surprise. The illuminator responsible provided a certain number of the homilies with them, but did not finish his task. An attractive ornamental V (f. 33) is by another hand, but the spaces left by the scribe were in many cases filled with modest calligraphic initials in a summary attempt to bring the work to completion. The manuscript is one of a very small number of illuminated books to have survived the dispersal and repeated pillage of the Saint-Denis library from the 16th century onward. The initials of the major artist are drawn in black outline and shaded in light blue, green, red, and washes of ochre and yellow. They are closely related to the work of an illuminator active in the region of Troyes and Sens who worked on the Bible of Sainte-Colombe of Sens (Sens, Bibl. Mun. MS 1; no. 75) and a second Bible of which there are fragments in collections of Paris, Berlin, Brussels, Toledo (Ohio) and Bryn Athyn (Pennsylvania). In favour of an attribution to Saint-Denis, Stahl has noted stylistic relations of the manuscript with a mid 12th-century Antiphonary of the abbey, which has a single painted initial featuring the Three Maries at the Sepulchre (Paris, Bibl. Nat. lat. 17296, f. 136v), and minor, though distinctive calligraphic initials for which the Origen offers near-identical parallels. Expanding on the English connections of the Sens Bible and related fragments identified by Swarzenski, Stahl cites as sources of the Origen illuminator the initials of a Bible from Winchester in the Bodleian Library (MS Auct. E infra 1) and contemporaneous painting from St. Albans, speculating that the illuminator's familiarity with English art may have been acquired by way of northern French intermediaries.

PROVENANCE: Saint-Denis shelfmark OR+ (13th century) and XIII. IIIc. XIIII (15th century) Nicholas Lefèvre (f. 1). J.-A. de Thou (ff. 1, 279v). J.-B. Colbert, MS 799. Acquired by the Royal Library in 1732. Regius 3731[1].

LITERATURE: Delisle, *Cabinet des manuscrits*, I, 201, 203; W. Baehrens, *Überlieferung und Textgeschichte der lateinisch erhaltenen Origeneshomilien zum Alten Testament* (Texte und Untersuchungen zur Geschichte der altchristlichen Literatur, 3e Ser., XII), Leipzig, 1916, 40, 44; Lauer, *Manuscrits latins*, II, 97; Avril, *Royaumes d'Occident*, 192, 368; H. Stahl, 'The Problem of Manu-script Painting at Saint-Denis during the Abbacy of Suger', *Abbot Suger and Saint-Denis. A Symposium*, ed. P. L. Gerson, New York, 1986, 167–71; D. Nebbiai-Dalla Guarda, *La Bibliothèque de Saint-Denis en France du IXe au XVIIIe siècle*, (Documents, études et répertoires publiés par l'Institut de Recherches et d'Histoire des Textes), Paris, 1985, 206–7.

75. Sens, Bibliothèque Municipale MS 1

Bible (Sens Bible)
452 × 290 mm., ff. 226, 2 cols., 41 lines
Middle of the 12th century. Sens (?)

Ills. 176, 177, 178

One independent miniature preceding DEUTERO-NOMY: Moses with the tablets of the law and Aaron with a group of Israelites (f. 90).

Historiated and ornamental initials: OLD TESTAMENT PROLOGUE, F, cut out (f. 1v); PREFACE TO PENTATEUCH, cut out (f. 4v); GENESIS, Days of Creation in medallions (f. 6); EXODUS, beginning missing; LEVITICUS, V, mutilated (f. 48v); NUMBERS, cut out (f. 62); DEUTERO-NOMY, H, partially cut out (f. 91); JOSHUA, missing; JUDGES, P, partly mutilated; what remains shows Jael killing Sisera (f. 116); I KINGS, missing; II KINGS, F, David receives the Amalekite messenger (f. 135v); III KINGS, E, medallions with a lion and hippocamp (f. 148v); IV KINGS, P, Ascension of Elijah (f. 163v); ISAIAH, missing; JEREMIAH, beginning missing; PRE-FACE TO EZEKIEL, H (f. 228); EZEKIEL, E, Vision of the four living creatures (f. 228).

This badly mutilated manuscript retains only part of its decoration, and some of it in damaged condition. The initials are designs of high quality, showing a luxuriant and curiously spikey vegetation fastened on a metallic trellis-like structure. The gyrating, incorporeal little figures of the illustrative matter are cloaked in drapery showing 'damp-fold' effects. H. Swarzenski noted the influence of English art on this decoration, especially the style of the Lambeth Bible (London, Lambeth Palace Library, MS 3). However, the Sens Bible was illuminated by an artist otherwise active in nearby Champagne, whose hand can be recognized in the Breviary of Montiéramey near Troyes (Bibl. Nat. lat. 796; no. 73) and in three initials in the fourth volume of Augustine's *Enarrationes in Psalmos* from Clairvaux (Troyes, Bibl. Mun. MS 40). Swarzenski also associated with the Sens Bible a series of fragments from a second, stylistically related Bible manuscript. The major surviving element of this work is the upper part of a parchment leaf with tables of concordance (Canons V–X), now in the Musées Royaux d'Art et d'Histoire in Brussels (No. V. 2912). The list of cuttings from this manuscript, which measured approximately 500 mm. in height, now stands as follows: eighteen initials once in the collection of the Paris art dealer Léonce Rosenberg,

sold at auction in 1912, present location unknown; a Genesis initial in Berlin (Staatliche Museen, Dahlem, Kupferstichkabinett, Inv. No. 929); an initial of the Book of Daniel in the Toledo Museum of Art; a miniature of David and his musicians, pasted in a manuscript of the Bibliothèque Nationale (lat. 6755); an initial of the Book of Judges, bound into another volume of the same library (Nouv. acq. lat. 1630, f. 27)); and the H of Exodus in the Glencairn Museum, Bryn Athyn, Pennsylvania. Swarzenski conjectured that this dismembered manuscript was a work of English origin that might have been brought to Burgundy in the train of the exiled Thomas Becket, where it served as a model for the Sens manuscript. Although English elements are undeniably present, both books seem at home in northern Burgundy or Champagne, and were perhaps products of the same scriptorium. The reconstruction and localization of the dismembered work is somewhat complicated by the record of yet another Bible, of which the Job initial was engraved for F. Denis' *Histoire de l'ornementation des manuscrits*, inserted in that author's *Appendice à l'Imitation de Jésus Christ*, Paris, 1858, 75 (the image is reversed). Judging by the reproduction, this was clearly a book decorated in a very similar manner, and possibly by the hand represented in the cuttings which have been enumerated. Denis indicates that this Bible was part of the Bibliothèque Motteley, a collection then housed in the Louvre. This library was destroyed by fire during the Paris Commune in 1871. The Motteley Bible presumably perished in this disaster, but there remains the possibility that the cuttings might stem from this lost work. (M. Vachon, *La Bibliothèque du Louvre et la collection bibliographique Motteley*, Paris, 1879, 30 and 109).

The Sens Bible is now completed by a second tome (Sens, Bibl. Mun. MS 2) which, however, is the work of another scribe and whose decoration is confined to simple pen-work initials. It must be assumed that the original companion volume disappeared at an early date or was for some reason never executed.

PROVENANCE: Marginal inscription, *'Johannes rhenonis presbiteri humilis prior…monasterii ste columbe de sen'* (15th century, f. 111). Sainte-Colombe de Sens, MS I.A.I (18th century *ex libris*, f. 1).

LITERATURE: A. Molinier, *Catalogue général*, VI, 1887, 148–49; H. Swarzenski, 'Fragments from a Romanesque Bible', *Gazette des Beaux-Arts* (Mélanges Porcher), 1963, 71–80; Cahn, *Romanesque Bible Illumination*, 281, No. 110.

EXHIBITED: *Manuscrits à peintures*, Paris, 1954, 114, No. 335.

76. Autun, Bibliothèque Municipale MS 132 (S. 154)

Sacramentary
300 × 210 mm., ff. 145, 28 long lines
Middle of the 12th century. Autun
Ills. 179, 180, 181, 182

Three framed full-page miniatures: Annunciation (f. 9v); Nativity (f. 10); *Majestas Domini* (f. 11); Crucifixion, two-thirds of a page (f. 12).

Historiated and ornamental initials: *Per Omnia* (f. 10v); *Vere Dignum* (f. 11v); *Te Igitur* (f. 12); E (f. 17); C (f. 21v); O, Christ in three-quarter length, with Cross Staff and globe (f. 44); D (f. 58v); D (f. 59v); C (f. 66v); D (f. 69); D (f. 80v); E (f. 101); D (f. 112); S (f. 113).

Liturgical observances of the cathedral of Autun are strongly marked in the manuscript. The Calendar includes commemorations of the *Dedicatio ecclesiae sancti Nazarii* on 13th June and 19th November, the elevation of the relics of the patron saint on 25th October, along with an Octave (3rd August) and a feast for Nazarius and his companion Celsus (27th June). Lazarus is represented by the feast of the *Revelatio* on 20th October and a commemoration on 16th November, *Lazarus Martyr et Marthe soror eius*. There are also entries for the early bishops of Autun Simplicius (24th June) and Racho (5th December) and the *Translatio* on 28th January. Two 13th-century additions were made for two more Autun bishops, Reticius (24th June) and Pragmatius (23rd October). The *Revelatio* of St. Lazarus, first celebrated in 1146 in the new basilica constructed in his honour, fixes the *terminus post* for the execution of the work.

The text has titles in red and pen-work initials in red, ochre and blue, flourished in a reticent and occasional manner throughout. Larger, mostly ornamental initials were provided for the Preface and the Canon of the Mass and for the Masses of the major feast days, as well as the commemorations of Saints Nazarius and Celsus, and of Lazarus in the Sanctorale. The voids of these letters are filled with spiralling foliage scrollwork. Only three are fully finished, with applications of colour — gold for the body of the letter, with ochre and blue in the interstices of the design (f. 17) — while the others remain in the state of outline drawings. The choice and arrangement of the larger illustrations is somewhat odd. The *Majestas* and the Crucifixion are of different sizes and do not, as might be expected, form a diptych. The images of the Annunciation and the Nativity, which do, follow the *Preparatio missae* (ff. 5–9v) and precede the Canon Preface. Handsomely framed within arches and surmounted by a cupola, they convey the impression of having been excerpted from a more extensive cycle, though there is no evidence that more pictures were initially extant. The miniatures are executed in a mixture of painting and draughtsmanly techniques, the latter tending to

predominate in the total effect. The pictorial elements are drawn in outline and shaded in a somewhat convulsive way in red, blue and green colours, with a few touches of gold for the haloes and *clavi* of the garments. The purple background of the Nativity adds a more solemn touch. The *Majestas* picture bears a distinct resemblance to the corresponding subject in the Sacramentary of Saint-Vaast at Arras (Arras, Bibl. Mun. MS 721; no. 103), though the possible significance of this connection remains to be explored. The execution of the Autun miniatures is uneven. In the Nativity, delicate linear passages are in evidence in the figures of the Virgin and St. Joseph, both shown in oddly gesticulating stances. The Annunciation, *Majestas* and Crucifixion, on the other hand, are more summarily rendered, and the major features of the composition heavy-handedly outlined in black. The artist responsible for these miniatures also illuminated a second Sacramentary of Autun (Bibl. Mun. MS 8* [S. 10]), a book whose original core is preserved within a reworking of the text of a later date.

PROVENANCE: Cathedral of Autun. 14th-century inscription (f. 5): *Istum librum habet Petrus Audieri in custodia…*

LITERATURE: G. Libri, *Catalogue général*, Quarto Series, I, 1849, 46; M. Pellechet, *Notes sur les livres liturgiques des diocèses d'Autun, Chalon et Mâcon*, Paris-Autun, 1889, 49–50, No. 54; Leroquais, *Sacramentaires*, I, 298, No. 148; A. Gillot, 'Les premiers manuscrits enluminés à l'usage de la cathédrale d'Autun, *Mémoires de la Société Eduenne*, XLVII, 1935, 424–25; id., 'Notes sur les manuscrits et les livres anciens de la Bibliothèque municipale d'Autun', *Mémoires de la Société Eduenne*, XLIX, 1943, 119; *Manuscrits datés*, VI, 1968, 49; N. Stratford, 'Autun and Vienne', *Romanesque and Gothic. Essays for George Zarnecki*, Woodbridge, 1987, 199.

77. Autun, Bibliothèque Municipale MS 130 (S. 152)

Evangeliary
280 × 200 mm., ff. 159, 23 long lines
Last quarter of the 12th century. Autun
Ill. 183; Col. pl. X

Two full-page portraits of the Evangelists with their symbols: Mark (f. 73); Luke (f. 135).

Painted ornamental initials: ff. 1, 7, 9, 10, 48v, 73v, 83, 84, 127v, 130, 136, 139, 141, 143.

The text is composed of Gospel readings for the feasts of the Proper of Time (ff. 11–127), the Sanctorale (ff. 127v–148) and some lections for special occasions (ff. 148v–152v). The portrait of Mark precedes the pericope for Easter Sunday, which is taken from this Gospel (Mk. 16:1ff.) while Luke prefaces the reading for the Vigil of the feast of St. John the Baptist (Lk. 1:5ff). Two pages (ff. 84 and 85 in the 15th-century foliation) are missing, one of them probably with a portrait of St. John to mark the reading from that Gospel for Pentecost (f. 86). It is tempting to assume that a fourth portrait, devoted to St. Matthew and serving to introduce the pericope of Advent, was once extent, but no trace of this can now be found in the manuscript. As the foregoing indicates, the decorative scheme of the Autun Evangeliary represents an adaptation of the pictorial programme normally to be expected in an early medieval Gospel Book. The two remaining portraits are paintings of outstanding quality, evidently conditioned by a familiarity with the Byzantine tradition. Both figures, facing towards the right, are depicted in the act of writing under the inspiration of their symbols, on unfurled scrolls that are rather implausibly draped over tilted-up lecterns. The haloed zoomorphs appear as in flight, with only the upper parts of their bodies in view beyond the frame on the right side of the page. St. Mark has white hair and a short white beard, while Luke, with darker features and curly hair, is given the conventional characterization of a Syrian. It is certain that the Autun painter must have had before him a set of Evangelist portraits of Byzantine origin, but how faithfully he copied them will remain a matter for argument. In the Byzantine sphere, Evangelists are sometimes depicted in the act of copying the sacred text from an open scroll resting on a lectern into books resting in their laps. A miniature in a Greek Gospel Book in St. Petersburg dated in the late 13th century shows the Evangelist, as in the Autun manuscript, transcribing the words directly onto a scroll (Public Library gr. 101, f. 50v), but this formula seems rare in the eastern tradition. The combination of author and symbol is of course largely identified with Evangelist portraiture in western medieval art in the period of the early and the High Middle Ages. But zoomorphic symbols of the Evangelists are not entirely unknown in Byzantine art of the corresponding era.

A pair of miniatures excised from a Sacramentary and preserved in the Musée Rolin at Autun, one showing the Nativity and the other, the Entry of Christ into Jerusalem, are in a comparable style and probably products of the same local (?) scriptorium. Within Burgundy, this style is illustrated a little earlier and in a more modest and unpolished way in the opening initial of Hugh of Fleury's Chronicle of Vézelay (Auxerre, Bibl. Mun. MS 227), and it has a crude offshoot in the Evangelist portraits added near the end of the 12th century to the 11th-century Bible of Odilo, Abbot of Cluny (Paris, Bibl. Nat. lat. 15176).

PROVENANCE: Cathedral of Autun (inscription, f. 5).

LITERATURE: G. Libri, *Catalogue général*, Quarto Series, I, 1849, 36; M. Pellechet, *Notes sur les livres liturgiques des diocèses d'Autun, Chalon et Mâcon*, Paris–Autun, 1889, 57, No. 67; A. Gillot, 'Les premiers manuscrits enluminés à l'usage de la cathédrale d'Autun', *Mémoires de la Société Eduenne*, XLVII, 1935, 424–25; id., 'Notes sur les manuscrits et les livres anciens de la Bibliothèque Municipale d'Autun', *Mémoires de la Société Eduenne*, XLIX, 1943, 119–2; W. Cahn, 'Autour de la Bible de Lyon. Problèmes du roman tardif dans le centre de la France', *Revue de l'art*, 47, 1980, 17; Avril, *Temps des croisades*, 178.

78. Heiligenkreuz, Stiftsbibliothek Cod. 226

Hugh of Fouilloy, Liber Avium (ff. 129–145v);
De volutione rotarum (ff. 146–153v)
265 × 175 mm., ff. 153, 2 cols., 42 lines
Late 12th century.
Burgundy or Champagne. Morimond (?)
Ills. 184, 185, 186, 187

Liber avium: Allegory of the hawk and the dove (f. 129v); Allegorical diagram of the dove and its moral qualities (f. 130).

Textual illustrations: the three doves, Christ, David and Noah (f. 130v); hawk (f. 132); palm tree and turtledove (f. 133v); Count Theobaldus in the cedar tree (f. 135); sparrow (f. 135); pelican (f. 135v); night owl (f. 136); raven (f. 136v); cock (f. 137v); ostrich (f. 138); vulture (f. 139); crane (f. 140); kite (f. 140); swallow (f. 140v); stork (f. 141); merle (f. 141); horned owl (f. 141v); crow (f. 142); goose (f. 142); heron (f. 142v); *caladrius* (f. 142v); phoenix (f. 143); partridge (f. 143); quail (f. 143v); hoopoe (f. 143v); swan (f. 144); peacock (f. 144); eagle (f. 145).

De volutione rotarum: Wheel of the good religious life (f. 146); Wheel of the wicked religious life (f. 149v).

Hugh of Fouilloy (Hugo de Folieto) was born in the early years of the 12th century. He became a monk in the small community of Saint-Laurent au Bois, near Heilly in Picardy, and served as its prior after it became a house of Augustinian Canons, between 1152 until his death before 1174. The Heiligenkreuz manuscript contains two of his works, appended here to several writings by and concerning St. Bernard, the widely disseminated moral commentary on the attributes of birds, and the rarer short tract on the virtues to be cultivated by monks and the vices to which they are exposed (*De volutione rotarum*, also known as *De rota verae et falsae religionis*, ed. C. de Clercq, *Archivum latinitatis medii aevi*, XXIX, 1959, 219–28, and XXX, 1960, 15–37). Heiligenkreuz, the first Cistercian foundation in Austria, was established in 1133 at the behest of Otto, the son of the Babenberg Margrave Leopold III, who was to be-

come the future Bishop of Freising and historian. The original nucleus of the community came from Morimond in Champagne. The manuscript is either of the same origin or a faithful copy made locally.

The illustrations are drawn with the pen, using red and brown inks, with a few added tints of the second colour. This disposition towards sobriety is in line with Cistercian ascetic ideals, expressed in the statutes of the Order after the middle of the 12th century, which permitted painting on glass and illumination only in monochrome. The Heiligenkreuz codex, together with the manuscript from Lorvão in Portugal, dated 1184 (Lisbon, Torre do Tombo, MS 90) count among the oldest extant copies of the *De avibus*, in which the entire series of illustrations is found. The opening full-page illustration (f. 129v) refers to the first prologue of the work, in which Hugh addresses a certain Raynerius, a former knight who has been converted to the religious life. Hugh, a former secular cleric, is compared to the dove, and Raynerius to the hawk. Both birds are seated on a common perch, symbolizing the regular religious estate, the former standing for the contemplative life, the other, as a *conversus* (lay brother), for the *vita activa*. The second major illustration on the facing recto concerns the allegorical properties of the dove, depicted within a series of concentric circles at the centre of the page. The illustrations of the text begin with the three doves mentioned in the Scriptures and the figures of Noah, David and Christ with which they are associated, the theme of Hugh's opening chapters. The following picture is that of the hawk whose allegorical meaning is taken up next. The allegorical commentary of the palm and the turtle dove, inspired by a passage in Job, is visualized in the next drawing, followed by a discussion of the cedar of the Song of Songs (5:15), shown as a tree filled with birds, in the midst of which is seated a figure identified in the accompanying inscription as Count Theobaldus. As Willene Clark has suggested, the latter should be identified as Thibaut, Count of Heilly, who was a co-founder and benefactor of Hugh's priory of Saint-Laurent au Bois. The third and final section of the work is the aviary proper, and contains small drawings of birds in quadrangular, circular, lozenge-shaped or multi-lobed drames, set at the appropriate place within the text column.

The illustrations pertaining to the second work, *De volutione rotarum*, are contrasting diagrams of virtues and vices, though cast in the iconographic formula of the Wheel of Fortune. In the first wheel, devoted to the virtues appropriate to the monastic estate and called *Rota religiosi vita*, the good monk rises to become the prior of his community against his will, occupies the office of abbot with dignity tempered with charity and renounces his position out of humility. The bad monk, on the other hand, whose misdeeds occupy the *Rota hypocritae vita*, becomes a prior through bribery, rules his community through pride, falls through negligence, and is deposed.

PROVENANCE: Heiligenkreuz inscription *Liber sanctae Marie virginis*, 13th century (f. 153v). Cod. Litt. E. 18, 18th century (flyleaf).

LITERATURE: B. Gsell, *Xenia Bernardina*, I, Vienna, 1891, 178; E. Winkler, *Die Buchmalerei in Niederösterreich von 1150 bis 1250*, Vienna, 1923, 17, 20; D. Frey, *Die Denkmale des Stiftes Heiligenkreuz* (Österreichische Kunst-Topographie, XIX), Vienna, 1926, 261–2; A. Katzenellenbogen, *Allegories of the Virtues and Vices in Medieval Art from Early Christian Times to the Twelfth Century* (Studies of the Warburg Institute, X), London, 1939, 62; F. Ohly, 'Probleme der mittelalterlichen Bedeutungsforschung und das Taubenbild des Hugo de Folieto', *Frühmittelalterliche Studien*, II, 1968; F. Walliser, *Cisterzienser Buchkunst. Heiligenkreuzer Skriptorium in seinem ersten Jahrhundert, 1133–1230*, Heiligenkreuz-Vienna, 1969, 14, 118; C. de Clercq, 'La nature et le sens du "De avibus" d'Hugues de Fouilloy', *Methoden in Wissenschaft und Kunst des Mittelalters* (Miscellanea Medievalia, VII), Berlin, 1970, 279–302; J. Leclercq, *Revue bénédictine*, LXXXI, 1971, 290; A. Schneider, *Die Cistercienser. Geschichte, Geist, Kunst*, Cologne, 1974; H. Peters, '"Miles Christianus" oder Falke und Taube', *Festschrift für Otto von Simson zum 65. Geburtstag*, ed. L. Griesebach and K. Renger, Frankfurt, Berlin and Vienna, 1977, 53–61; N. Häring, 'Notes on the "Liber Avium" of Hugh of Fouilloy', *Recherches de théologie ancienne et médiévale*, XLVI, 1979, 74, No. 26; M. H. Caviness, 'Images of Divine Order and the Third Mode of Seeing', *Gesta*, XXII/2, 1983, 113–14; F. Bibolet, 'Portraits d'oiseaux illustrant le "De Avibus" d'Hugues de Fouilloy (Manuscrit de Clairvaux, Troyes 177)', *Mélanges à la mémoire du Père Anselme Dimier*, Arbois, 1984, IV, 409–47; W. B. Clark, *The Medieval Book of Birds. Hugh of Fouilloy's "De Avibus"*, Binghamton, 1991.

EXHIBITED: *Romanische Kunst in Österreich*, Krems, 84, No. 46; *Die Kuenringer*, Zwettl, 1981, 242–43, No. 248; *Codex Manesse*, Heidelberg, 1988, 367–68, No. K 23.

79. Paris, Bibliothèque Nationale MSS lat. 16743–46

Bible (Capucins Bible)
450 × 330 mm., ff. 213, 240, 234 and 175,
2 cols., 38 lines
Last quarter of the 12th century.
Champagne *Ills. 188, 191, 192, 193, 194, 195*

lat. 16743

Historiated and ornamental initials: OLD TESTAMENT PROLOGUE, F (f. 1); PREFACE TO PENTATEUCH and GENESIS, missing; EXODUS, H, Moses and the Israelites pursued by the Egyptians, Crossing of the Red Sea, medallions with the appearance of the Lord in the Burning Bush, Moses and Aaron before the Pharaoh (f. 36); LEVITICUS, V, the Lord instructs the Israelites concerning the rites of sacrifice, Offering of rams and doves (f. 62); NUMBERS, L, the offering of the Nazarite and cutting off of hair; in the stem of the letter, medallions with the punishment of Korah, Dathan and Abiram (f. 81); DEUTERONOMY, E (f. 108v); JOSHUA Preface, T (f. 131v); JOSHUA, E (f. 132v); JUDGES, missing; RUTH, I (f. 165); PREFACE TO CHRONICLES, S (f. 167); I CHRONICLES, A (f. 170); II CHRONICLES, C, Solomon enthroned, Temple of Jerusalem (f. 190).

lat. 16744

Historiated and ornamental initials: PREFACE TO ISAIAH, N (f. 1); ISAIAH, V, the ailing King Hezekiah attended by the Prophet (f. 3v); PREFACE TO JEREMIAH, H (f. 34); JEREMIAH, V, the Prophet before the Lord, beholding an almond branch (f. 37v); PREFACE TO EZEKIEL, H (f. 78v); EZEKIEL, E, the Lord thrusts a scroll into the Prophet's mouth (f. 79); PREFACES TO DANIEL, V, D (f. 116v); DANIEL, A (f. 118); PREFACE TO MINOR PROPHETS, N (f. 132v); HOSEA, V (f. 133); PREFACE TO JOEL, I (f. 137v); JOEL, V (f. 138); PREFACE TO AMOS, A (f. 139); AMOS, V (f. 139); PREFACE TO OBADIAH, A (f. 143v); OBADIAH, V (f. 143v); PREFACE TO JONAH, I (f. 144); JONAH, E (f. 144); PREFACE TO MICAH, M (f. 145v); MICAH, V (f. 145v); PREFACE TO NAHUM, N (f. 148v); NAHUM, O (f. 148v); PREFACE TO HABAKKUK, A (f. 149v); HABAKKUK, O (f. 150); PREFACE TO ZEPHANIAH, S (f. 151); ZEPHANIAH, V (f. 151v); PREFACE TO HAGGAI, A (f. 153); HAGGAI, I (f. 153); PREFACE TO ZECHARIAH, Z (f. 154); ZECHARIAH, l (f. 160); PREFACE TO MALACHI, M (f. 154), MALACHI, O (f. 160); BARUCH, E (f. 162); PREFACE TO PSALTER, R (f. 165); D (f. 165v); R (f. 166); D (f. 166v); B, T (f. 167); P (f. 167v). PSALMS, B (f. 176); Psalm 26, D (f. 181v); Psalm 38, D (f. 185); Psalm 51, Q (f. 188); Psalm 52, D (f. 188); Psalm 68, S (f. 191v); Psalm 80, E (f. 195v); Psalm 96, C (f. 199); Psalm 101, D (f. 199v); Psalm 109, D (f. 203); PREFACE TO EZRA, U (f. 211v); EZRA, I (f. 212v); II EZRA, E (f. 218); III EZRA, E (f. 228).

lat. 16745

Historiated and ornamental initials: PREFACE TO KINGS, V (f. 1); I KINGS, F, Hannah before Eli (f. 3); II KINGS, F, the Amalekite brings Saul's insignia to David, Slaying of the Amalekite (f. 28); III KINGS, E, David reclining with Bathsheba before him, addressed by the Prophet Nathan (f. 48); IV KINGS, P (f. 71v); PREFACE TO PROVERBS, C (f. 93); PROVERBS, P, Solomon enthroned, exhorting his son, Personification of Wisdom (f. 94); ECCLESIASTES, V, seated monarch with an astrolabe (f. 108); SONG OF SONGS, O, Christ with Ecclesia (f. 112v); WISDOM, D, seated monarch with sword, blinding of a prisoner (f. 116); PREFACE TO ECCLESIASTICUS, M (f. 125v); ECCLESIASTICUS, O, Christ in Majesty (f. 127); PREFACES TO JOB, C, I, I (f. 153); JOB, V, Dialogue of the Lord with Satan;

Job on the dunghill, his wife, and the three temptors (f. 154); PREFACE TO TOBIT, C (f. 170v); TOBIT, T, blinding of Tobit in the presence of his wife and son (f. 171); PREFACE TO JUDITH, A (f. 177v); JUDITH, A, Beheading of Holophernes (f. 178v); PREFACE TO ESTHER, L (f. 187v); ESTHER, I, medallions with Esther and Ahasuerus, Haman before the king, Haman leading Mordecai in triumph, banquet in the palace, hanging of Haman (f. 188); PREFACE TO MACCABEES, M (f. 196v); I MACCABEES, E, idolatrous sacrifice in the Temple, killing of the impious Jew (f. 197v); II MACCABEES, F (f. 219v).

lat. 16746

Historiated and ornamental initials: PREFACE TO GOSPELS, N, E, S, P (ff. 1, 1v, 2, 2v); CANON TABLES (ff. 3v–5); PREFACE TO MATTHEW, M (f. 5v); MATTHEW, Tree of Jesse (f. 7v); PREFACE TO MARK, M (f. 27v); MARK, I, medallions with the Baptism of Christ, Temptation in the Desert, Calling of Peter and Andrew (f. 28v); PREFACE TO LUKE, L (f. 41); LUKE, Q, Annunciation to Zacharias in the Temple (f. 42); PREFACE TO JOHN, H (f. 63v); JOHN, I, medallions of John designating Christ as the Lamb of God, meeting of Christ and Peter, meeting of Christ and Philip (f. 64v); PREFACE TO PAULINE EPISTLES, P (f. 80v); PREFACES TO ROMANS, R, R, E (f. 78); ROMANS, P, Paul speaks to a group of Romans (f. 80v); PREFACE TO I CORINTHIANS, C (f. 88); I CORINTHIANS, P (f. 89v); PREFACE TO II CORINTHIANS, P (f. 97v); II CORINTHIANS, P (f. 98); PREFACE TO GALATIANS, G (f. 103v); GALATIANS, P (f. 104); PREFACE TO EPHESIANS, E (f. 106v); EPHESIANS, P (f. 107); PREFACE TO PHILIPPIANS, P (f. 110); PHILIPPIANS, P (f. 110); PREFACE TO COLOSSIANS C (f. 112v); COLOSSIANS, P (f. 112v); PREFACE TO I THESSALONIANS, T (f. 114v); I THESSALONIANS, P (f. 115); PREFACE TO II THESSALONIANS, A (f. 117); II THESSALONIANS, P (f. 117); PREFACE TO I TIMOTHY, P (f. 118v); I TIMOTHY, P, bust of Paul (f. 118v); PREFACE TO II TIMOTHY, I (f. 120v); II TIMOTHY, P (f. 120v); PREFACE TO TITUS, P (f. 122v); PHILEMON, P (f. 124); LAODICEANS, P (f. 124); PREFACE TO HEBREWS, I (f. 124v); HEBREWS, M (f.124v); PREFACES TO ACTS, L, A, C (ff. 131, 131v); ACTS, P, Ascension of Christ (f. 133); PREFACES TO CATHOLIC EPISTLES, N, I, I, I (ff. 152, 152v); JAMES, I, standing Apostle (f. 153); PREFACE TO I PETER, D (f. 154v); I PETER, P, Peter with keys (f. 154v); PREFACE TO II PETER, P (f. 157); II PETER, S (f. 157); PREFACES TO I JOHN, R, H (f. 158v); I JOHN, Q (f. 158v); PREFACE TO II JOHN, E (f. 161v); II JOHN, S (f. 161v); PREFACE TO III JOHN, G (f. 162); III JOHN, S (f. 162); PREFACES TO JUDE, I, I (f. 162); JUDE, I (f. 162); PREFACES TO APOCALYPSE, I, I, B, A (f. 163); APOCALYPSE; A, Adoration of the Lamb by the Twenty-Four Elders (f. 163).

The medieval provenance of this handsome four-volume Bible from the library of the Capucins convent in Paris, founded in the 17th century, is not known. In his contribution to A. Michel's *Histoire de*

l'art (1906), A. Haseloff, who commented on its illumination for the first time, recognized that the initials of Volumes II and IV were the work of the painter of the Saint-Bertin Psalter in St. John's College, Cambridge (MS C.18; no. 121). The Bible came thus to be accepted as a product of the same scriptorium, localized in the Abbey of Saint-Bertin at Saint-Omer near the Channel Coast. In an essay published in 1963, however, Louis Grodecki was able to demonstrate that the illumination of Volumes I and III of the Bible had connections with Troyes in Champagne. A copy of Peter Lombard's Commentary of the Psalms from Clairvaux (Troyes, Bibl. Mun. MS 92) has initials by the same painter, and a number of stained glass panels once in the Cathedral of Troyes, but possibly from the destroyed collegiate church of Saint-Etienne, now scattered in various collections of Europe and America, exhibit much the same style (on this glass, see most recently E. C. Pastan, *Speculum*, LXIV, 1989, 338 ff.) An attribution to a Troyes workshop is thus the best that can for the moment be made. Recent scholarship, it should also be noted, has rendered much more hypothetical the connection of the of the St. John's College Psalter with Saint-Bertin, and thus further weakened the case for the earlier attribution of the Bible.

The 'Saint-Bertin' painter has been shown to have been the author of a considerable *oeuvre*, which has been expanded in recent years through new discoveries. Perhaps a lay professional, he was employed at St. Albans under the bibliophile Abbot Simon (1167–83), while other manuscripts that can be ascribed to him in full or in part, like the present Bible, illustrate a later phase of his activity on the Continent. In the Bible, his customary repertoire of single figures or small groups in dialogue is much amplified in the spirit of fuller narrative and symbolic elaboration appropriate to the genre of Romanesque Giant Bibles. This expansive mode reaches its grandest point in the splendid initial with the Tree of Jesse at the beginning of the Gospel of Matthew (lat. 16746, f. 7v). In the iconography, there are some connections with English illumination. The relationship of the Tree of Jesse to the corresponding subject in the Lambeth Bible was noted by A. Watson, and the illustration of the Prophet Ezekiel consuming his scroll at the command of the Lord (lat. 16744, f. 79), a rare subject in Bible illumination, is also found in the Lambeth Bible. The Annunciation to Zacharias at the beginning of Luke's Gospel (lat. 16746, f. 42) has a parallel in the late 12th-century Bible in the Bodleian Library, MS Laud Misc. 752). The art of the second painter, associated with Troyes, has a clear Mosan affiliation, as Grodecki convincingly pointed out. Whether the illustrations of ancient physicians in the medical anthology of the British Library (Harley 1585) also belongs to this group from Troyes, as the same author believed, is less certain, but the decoration of a copy of the Letters of St. Cyprian (Paris, Bibl. Nat. nouv. acq. lat. 1792) has been con-

vincingly linked by P. Stirnemann with the Mosan Master of the Bible, along with a series of other books more or less clearly tied to the same Champagne milieu. The influence of Mosan art in Champagne is also apparent in the typological window of the Cathedral of Châlons-sur-Marne, and in a series of enamels in the treasure of Troyes Cathedral.

The now generally accepted division of labour in the illumination of the Capucins Bible has obscured the participation in the enterprise of a third hand, whose exclusively ornamental vocabulary has yet to be localized like that of his two collaborators. This division of the work is as follows: the decoration of Vol. I was carried out by the Mosan-influenced painter of Champagne with the exception of the initials on ff. 131v and 132v, and Vol. III in its entirety. The St. Albans or 'Saint-Bertin' painter was responsible for the initials of Isaiah, Jeremiah and Ezekiel in Vols. II and all of those in Vol. IV. The third painter is represented by two initials in the first tome and by all those in Vol. III from Daniel (f. 116v) onward. The date of the manuscript remains conjectural, but the execution of the work is most plausibly situated in the 1180s.

PROVENANCE: Library of the Capucins, Paris, MS 11. Acquired by the Bibliothèque Royale in 1796.

LITERATURE: Lauer, *Enluminures romanes*, 137; A. Watson, *The Early Iconography of the Tree of Jesse*, Oxford, 1934, 110–12; Haseloff, *Psalterillustration*, 20, 102; T. S. R. Boase, *English Art, 1100–1216*, Oxford, 1953, 181–2; L. Grodecki, 'Problèmes de la peinture en Champagne pendant la seconde moitié du XIIe siècle', *Acts of the Twentieth Congress of the History of Art*, Princeton, 1963, I, 129–41 (repr. in *Le moyen âge retrouvé*, Paris, 1986, 565–80; L. M. Ayres, 'A Tanner Manuscript in the Bodleian Library', *J.W.C.I.*, XXXII, 1969, 46; Dodwell, *Painting in Europe*, 206. L. Grodecki, 'Nouvelles découvertes sur les vitraux de la cathédrale de Troyes', *Intuition und Kunstwissenschaft. Festschrift für Hanns Swarzenski*, Berlin, 1973, 200ff. (repr. in *Le Moyen âge retrouvé*, 581–91; W. Cahn, 'St. Albans and the Channel Style in England', *The Year 1200: A Symposium*, New York, 1975, 195ff.; id., *Romanesque Bible Illumination*, 202, 208, 220, 278–79, No. 97; P. Stirnemann, 'Quelques bibliothèques princières et la production hors scriptorium au XIIe siècle', *Bulletin archéologique du Comité des travaux historiques et scientifiques*, XVII–XVIII, 1984, 14ff.; U. Nilgen, 'Das grosse Walrossbeinkreuz in den 'Cloisters'', *Zeitschrift für Kunstgeschichte*, L, 1985, 58–64.

EXHIBITED: *Manuscrits à peintures*, Paris, 1954, 58, No. 130; *The Year 1200*, New York, 1970, 248–49, No. 247.

80. Paris, Bibliothèque Nationale MS lat. 15177–80

Bible
510 × 360 mm., ff. 191, 253, 176 and 231,
2 cols., 36 lines
Last quarter of the 12th century.
St. Mary, Foigny *Ills. 189, 201*

lat. 15177

Consanguinity Tree (f. 2); genealogical and historical tabulation of the generations from Adam to Christ (ff. 2v–11) with miniature of the Nativity (f. 11).

Ornamental initials: PREFACE (Theodulph), Q (f. 11v); PREFACE TO OLD TESTAMENT, F (f. 13); PREFACE TO PENTATEUCH, D (f. 17v); GENESIS, I (f. 19v); EXODUS, H (f. 54); LEVITICUS, V (f. 82v); NUMBERS, L (f. 101v); DEUTERONOMY, H (f. 129); PREFACE TO JOSHUA, T (f. 153v); JOSHUA, E (f. 154v); JUDGES, P (f. 171v); RUTH, I (f. 188v).

lat. 15178

Ornamental initials: PREFACE TO KINGS, V (f. 2v); I KINGS, F (f. 4v); II KINGS, F (f. 27v); III KINGS, W (f. 46v); IV KINGS, P (f. 69); PREFACE TO ISAIAH, N (f. 90); ISAIAH, V (f. 92); PREFACE TO JEREMIAH, H (f. 125v); JEREMIAH, V (f. 128); BARUCH, E (f. 169); PREFACE TO EZEKIEL, H (f. 174); EZEKIEL, E (f. 175); PREFACES TO MINOR PROPHETS, N, T (f. 211); HOSEA, V (f. 211v); PREFACES TO JOEL, I, S (f. 216v); JOEL, V (f. 217); PREFACES TO AMOS, A, O (f. 219); AMOS, V (f. 219); PREFACE TO OBADIAH, A, I (f. 223); OBADIAH, V (f. 223v); PREFACES TO JONAH, I, S (f. 224); JONAH, E (f. 224v); PREFACES TO MICAH, M, T (f. 226); MICAH, V (f. 226); PREFACES TO NAHUM, N, N (f. 229); NAHUM, O (f. 229v); PREFACES TO HABAKKUK, A, Q (f. 230v); HABAKKUK, O (f. 232); PRAYER OF HABAKKUK, O (f. 233); PREFACES TO ZEPHANIAH, T (f. 233v); ZEPHANIAH, V (f. 234); PREFACES TO HAGGAI, S, H, A (ff. 235–236); HAGGAI, I (f. 236v); PREFACE TO ZECHARIAH, Z (f. 237v); ZECHARIAH, I (f. 237v); PREFACES TO MALACHI, M, D (f. 243); MALACHI, O (f. 243v).

lat. 15179

Ornamental initials: PREFACES TO CHRONICLES, S, E (ff. 3, 3v); I CHRONICLES, A (f. 5); II CHRONICLES, C (f. 27); PREFACE TO EZRA, U (f. 53v); EZRA, I (f. 55); PREFACE TO ESTHER, L (f. 72v); ESTHER, I (f. 73); PREFACE TO WISDOM, L (f. 82v); WISDOM, D (f. 82v); PREFACE TO ECCLESIASTES, M (f. 94); ECCLESIASTICUS, O (f. 95); PREFACE TO JUDITH, A (f. 125v); JUDITH, A (f. 126v); PREFACE TO TOBIT, C (f. 136); TOBIT, T (f. 137); PREFACE TO MACCABEES, M (f. 144v); I MACCABEES, E (f. 145v); II MACCABEES, F (f. 169v).

lat. 15180

Ornamental initials: CANON TABLES (ff. 2–5); PREFACES TO GOSPELS, B, P, E, S (ff. 6, 8, 8v, 9); PREFACE TO

MATTHEW, M (f. 9v); MATTHEW, L (f. 12v); PREFACE TO MARK, M (f. 38v); MARK, M (f. 38v); PREFACE TO LUKE, L (f. 58); LUKE, Q (f. 61v); PREFACE TO JOHN, H (f. 91); JOHN, I (f. 93); PREFACES TO ACTS, L, N (ff. 115, 115v); ACTS, P (f. 116v); PREFACE TO CATHOLIC EPISTLES, N (f. 142); JAMES, I (f. 143); PREFACE TO I PETER, D (f. 145); I PETER, P (f. 146); PREFACE TO II PETER, S (f. 148v); II PETER, S (f. 149); PREFACE TO JOHN, R (f. 150v); JOHN, Q (f. 151); II JOHN, S (f. 153v); III JOHN, S (f. 155v); JUDE, I (f. 156); PREFACES TO PAULINE EPISTLES, E, P (f. 156v); PREFACES TO ROMANS, R, P (ff. 158v–159); ROMANS, P (f. 160); PREFACE TO CORINTHIANS, C (f. 169v); I CORINTHIANS, P (f. 171); PREFACE TO II CORINTHIANS, C (f. 180v); II CORINTHIANS, P (f. 181v); PREFACE TO GALATIANS, G (f. 188); GALATIANS, P (f. 188v); PREFACE TO EPHESIANS, E (f. 192); EPHESIANS, P (f. 193v); PREFACES TO PHILIPPIANS, P, I (f. 198); PHILIPPIANS, P (f. 198); PREFACE TO COLOSSIANS, C (f. 199); COLOSSIANS, P (f. 199); PREFACE TO THESSALONIANS, N (f.202); THESSALONIANS, P (f. 202); PREFACE TO II THESSALONIANS, A (f. 205); II THESSALONIANS, P (f. 205); PREFACES TO TIMOTHY, T, H (ff. 206, 206v); TIMOTHY, P (f. 207); PREFACE TO II TIMOTHY, I (f. 209v); II TIMOTHY, P (f. 210); TITUS, P (f. 212v); PREFACE TO PHILEMON, P (f. 212v); PHILEMON, P (f. 212v); PREFACES TO HEBREWS, I, A (f. 214v); HEBREWS, M (f. 215); PREFACE TO APOCALYPSE, I (f. 223); APOCALYPSE, A (f. 224).

St. Mary at Foigny, located near Vervins (Aisne), was a Cistercian monastery affiliated with Clairvaux and founded in 1121 by Barthélemy de Jur, Bishop of Laon. The conventual library was dispersed and an undetermined date and little of it seems to survive (see A. Bondéelle-Souchier, *Bibliothèques cisterciennes de la France médiévale*, Paris, 1991, 99–100). The biblical text in the four-volume Foigny Bible is preceded by a lengthy exposition of the genealogy of Christ *secundum carnem*, setting forth and attempting to reconcile the differing enumerations of his ancestry found in the Gospels of Matthew and Luke. This material, accompanied by a moralizing elaboration, is disposed within finely designed arcaded frames and the genealogical relationships expressed by diagrammatic arrangements of circles. The same text, apparently, is found in two manuscripts from Premonstratensian houses in Flanders, the Bibles of Floreffe (London, Brit. Lib. Add. 17737–38) and St. Mary at Parc, near Louvain (Brit. Lib. Add. 14788–90). The idea of prefacing the biblical text with such a genealogical tabulation is earlier illustrated in the Bibles of 960 and 1162 from León, though whether the northern manuscripts owe something to this Spanish usage is unclear.

As in the Floreffe and Parc Bibles, the genealogies of the Foigny Bible begin with a full-page painting of a Consanguinity Tree, though the design strikes an original note through the inclusion of a serpent at the top, designating it further as the Tree of the Knowledge of Good and Evil in the Garden of Eden. The miniature of the Nativity which brings the ge-

nealogical matter to a close is the only other explicitly illustrative feature of the decoration. The rest consists of ornamental initials for all the biblical books and prefaces. There is a reliance in these on the vocabulary of the Channel Style with its spiralling foliage inhabited by small leonine creatures, which are in evidence particularly in the monumental *In principio* initial (lat. 15177, f. 19v). But the Foigny illuminator eschewed the diminutive effects that normally characterize this style in favour of a grander presentation appropriate to the scale of the work and in line with the tradition of Giant Bibles. Colour, on the other hand, is reduced in its range, and ochre substitutes for gold, likely in response to Cistercian legislation against the use of the precious material in manuscripts. In the Nativity miniature, the pliant linear modelling comes close in its effect to the illumination of the Mosan hand in the Capucins Bible (no. 79).

PROVENANCE: *Liber sancte Marie fusnice* [or *fusniacensis*], followed by an anathema, 12th century (lat. 15177, f. 191). Collection of Cardinal Richelieu (arms on the binding). Library of the Sorbonne, MS 224, and MS 291 (flyleaf) in 1784. Acquired by the Bibliothèque Royale in 1796.

LITERATURE: H. Köllner, 'Zur Datierung der Bibel von Floreffe. Bibelhandschriften als Geschichtsbücher?', *Rhein und Maas. Kunst und Kultur, 800–1400*, Cologne, 1973, II, 373ff.; *Manuscrits datés*, III, 1974, 409; Cahn, *Romanesque Bible Illumination*, 230, 278, No. 96; S. Martinet, 'Les manuscrits de Foigny', *Mémoires des Sociétés d'histoire et d'archéologie de l'Aisne*, XXVIII, 1983, 31–34; Y. Zaluska, 'Entre texte et image: les stemmata bibliques au sud et au nord des Pyrénées', *Bulletin de la Société Nationale des Antiquaires de France*, 1986, 144–47.

81. Paris, Bibliothèque Sainte-Geneviève MSS 8–10

Bible (Manerius Bible)
525 × 360 mm., ff. 266, 302 and 308, 2 cols., 36 lines
Late 12th century.
Champagne *Ills. 196, 197, 198, 199, 200*

MS 8

Historiated and ornamental initials: OLD TESTAMENT PROLOGUE, F, Jerome and Paulinus (f. 1); PREFACE TO PENTATEUCH, D, Jerome inspired by the Dove of the Holy Spirit (f. 5v); GENESIS, I, Days of Creation, Temptation in the Garden, Expulsion from Paradise, Labours of Adam and Eve, Offerings of Cain and Abel, Murder of Abel (f. 7v); EXODUS, H, finding of the infant Moses in the Nile (f. 41); LEVITICUS, V, Moses receives the commandments from the Lord (f. 69v); NUMBERS, L, the Lord speaks to Moses (f. 88v);

DEUTERONOMY, H, Moses addresses the assembled Israelites (f. 116v); PREFACE TO JOSHUA, T (f. 140v); JOSHUA, E, Joshua on horseback (f. 141v); JUDGES, P designation of Judah as Joshua's successor (f. 157v); RUTH, I, medallions of Ruth and Elimelech on their way to Moab, death of Elimelech, *Luxuria* with snakes at her breast (f. 174); PREFACE TO KINGS, V (f. 176); I KINGS, F, Elkanah with his two wives (f. 178v); II KINGS, F, David receives Saul's insignia from the Amalekite messenger (f. 208v); III KINGS, E, David with Abisag the Sunnamite (f. 223); IV KINGS, P, Death of King Ahaziah (f. 245v).

MS 9

Historiated and ornamental initials: PREFACE TO ISAIAH, N (f. 1); ISAIAH, I, Vision of Isaiah (f. 1v); PREFACE TO JEREMIAH, H (f. 33); JEREMIAH, V, Vision of the boiling cauldron (f. 33v); PREFACE TO EZEKIEL, H (f. 75); EZEKIEL, E, Vision of the four living creatures (f. 75v); PREFACE TO DANIEL, D (f. 109); DANIEL, A, entry of Nebuchadnezzar's troops into Jerusalem (f. 111); PREFACE TO MINOR PROPHETS, N (f. 125v); HOSEA, V, Hosea embraces Gomer (f. 125v); JOEL, V, standing Prophet with scroll, architectural prospect (f. 130v); AMOS, V, standing Prophet (f. 132v); OBADIAH, V, Prophet with scroll and book (f. 136v); JONAH, E, Jonah cast into the sea and emerging from the whale (f. 137v); MICAH, V, standing Prophet, architectural prospect (f. 138v); NAHUM, O, seated Prophet with scroll (f. 142); HABAKKUK, O, standing Prophet with scroll (f. 143v); ZEPHANIAH, V, seated Prophet with scroll, dove with scroll (f. 145); HAGGAI, I, bust of an angel with scroll, standing Prophet, architectural prospect (f. 147); ZECHARIAH, I, bust of an angel with scroll, standing prophet with scroll, crowd within an architectural prospect (f. 149); MALACHI, O, enthroned Prophet, Dove of the Holy Spirit (f. 154v); BARUCH, E, standing Prophet with scroll, men within an architectural prospect (f. 155v); PREFACE TO JOB, C (f. 161); JOB, V, Dialogue of the Lord with Satan, Job on the dunghill, wife and three temptors (f. 162); PREFACE TO PSALMS, I, D (ff. 178v, 180v); PSALMS, B, horseman with shield and lance, David fighting the lion, David and Goliath (?), David harping, Saul struggling with an evil spirit (f. 194); Psalm 26, D, enthroned monarch with sword and sceptre (f. 200v); Psalm 38, D, seated David with viol and scroll (f. 204v); Psalm 51, Q, beheading of a man (f. 208v); Psalm 52, D, figure before an altar on which a goat stands (f. 209); Psalm 68, S, bust of the Lord with scroll, kneeling figure with scroll (f. 213); Psalm 80, E, dialogue of two men with scrolls (f. 218); Psalm 97, C, enthroned figure with scroll, demon blowing trumpet (f. 222v); Psalm 101, D, standing figure with scroll, architectural prospect, Dove of the Holy Spirit (f. 223); Psalm 109, D, Christ in Majesty flanked by angels, trampling two small figures (f. 227v); PROVERBS, P, enthroned Solomon with scroll, three figures (f. 237v); ECCLESIASTES, D, monarch with scroll (f.

253v); SONG OF SONGS, O, standing Bride receiving inspiration from the Dove of the Holy Spirit, architectural prospect (f. 258v); WISDOM, D, personification of Wisdom (f. 262); PREFACE TO ECCLESIASTICUS, M (f. 273); ECCLESIASTICUS, O, seated figure with scrolls (f. 274v).

MS 10

Historiated and ornamental initials: PREFACES TO CHRONICLES, S, E (ff. 1, 1v); I CHRONICLES, A, combat of knights, scene of execution (f. 3v); II CHRONICLES, P, Solomon offers a sacrifice (f. 22); PREFACE TO EZRA, U (f. 46); EZRA, I, medallions with Ezra, Cyrus and figures commanded to reconstruct the Temple (f. 47); PREFACE TO ESTHER, L (f. 62v); ESTHER, I, medallions of Esther and Ahasuerus (f. 63); PREFACE TO TOBIT, C (f. 71); TOBIT, T, Tobit accompanied by the angel Raphael, takes leave of his father (f. 71); PREFACE TO JUDITH, A (f. 77v); JUDITH, A, beheading of Holophernes (f. 78); PREFACE TO I MACCABEES, M (f. 86v); I MACCABEES, E, sacrifice of the idolatrous Jew (f. 87v); II MACCABEES, F, Antiochus speaks to the mother of the Maccabees, who embraces her children (f. 110). CANON TABLES: healing of the blind man of Jericho and the possessed Gadarene (f. 127v); Balaam and his ass, healing of the paralytic (f. 128); the rich man in hell and Lazarus in the bosom of Abraham (f. 128v); Dormition and Assumption of the Virgin (f. 129); healing of the blind man, Transfiguration (f. 129v); (final section of Canon X, cut out); PREFACE TO GOSPELS, P (f. 130); PREFACE TO MATTHEW, M (f. 132); MATTHEW, L, Tree of Jesse, Evangelist symbol (f. 132); PREFACE TO MARK, M (f. 152v); MARK, I, medallions with Christ, Evangelist symbol, writing Evangelist (f. 153); PREFACE TO LUKE, L (f. 166v); LUKE, Q, writing Evangelist, symbol (f. 169); PREFACE TO JOHN, H (f. 191); JOHN, I, standing Evangelist with book, Christ and Evangelist symbol (f. 191v); PREFACE TO ACTS, L (f. 208); ACTS, P, Ascension of Christ (f. 209v); PREFACE TO CATHOLIC EPISTLES, N (f. 231v); JAMES, I, standing Apostle with book (f. 233); I PETER, enthroned Apostle with book (f. 236); II PETER, cut out (f. 238); I JOHN, Q, seated Apostle (f. 240); II JOHN, S, the Roman governor orders John to drink poison, two malefactors who have taken the liquid collapse (f. 242v); III JOHN, S, John orders his tunic to be placed on evildoers, who miraculously come back to life (f. 242v); JUDE, I, standing Apostle with book, Dove of the Holy Spirit (f. 244v); PREFACE TO PAULINE EPISTLES, P (f. 244v); PREFACE TO ROMANS, R (f. 245); ROMANS, P, Paul exhorts a group of Romans (f. 247v); I CORINTHIANS, P, Paul preaches to a group of Corinthians (f. 256v); II CORINTHIANS, P, Apostle preaching to the Corinthians (f. 268); GALATIANS, P, Paul preaches to the Galatians (f. 271); EPHESIANS, P, Paul preaches to a group of Ephesians (f. 274); PHILIPPIANS, P, Paul preaches to a group of Philippians (f. 277); COLOSSIANS, P, Paul and a group of Colossians (f. 279v); I THESSALONIANS, P, Paul exhorts the

Thessalonians (f. 281v); II THESSALONIANS, P, standing Apostle with scroll, man with book, architectural prospect (f. 283v); I TIMOTHY, P, Paul and Timothy (f. 285); II TIMOTHY, P, Paul and Timothy (f. 287v); TITUS, P, Paul with Titus (f. 289); PHILEMON, P, Paul speaks to Philemon (f. 290v); HEBREWS, M, Paul exhorts a group of Hebrews (f. 290v); PREFACE TO APOCALYPSE, I (f. 298); APOCALYPSE, A, John prostrate beneath the throne of the Lord (f. 298).

The Manerius Bible takes its name from the scribe who identifies himself in a long colophon (MS 10, f. 308v). In this text, he qualifies himself as *scriptor Cantuariensis* and gives a playful etymological derivation of Manerius from the combination *mana* and *gnarus*, or skilled hand. He also mentions his grandparents, parents, four brothers and a sister, whose names he similarly explains by way of etymology. The father, Wimundus, is mentioned in the Canterbury documents as having been a mercer, and the mother, Liveva, held a plot of land in rent from the Cathedral in the Burgate ward within the city (W. Urry, *Canterbury under the Angevin Kings*, London, 1967, 174 and 231). Where the Bible was written and illuminated is not known. Basing itself on a literal reading of the colophon, scholarly opinion tended initially to regard its as a work of English origin. But following C. R. Dodwell's comprehensive study of Canterbury illumination, the manuscript is now generally regarded as a Continental product, and Manerius himself as likely to have been a lay professional who might travel and offer his services for hire (the colophon makes no reference to a clerical status). The Bible was in the possession of the Benedictine monastery of Saint-Loup at Troyes, where it was seen by E. Martène and U. Durand at the beginning of the 18th century, but it is not mentioned in an inventory of the library of Saint-Loup made in 1544 (C. Lalore, *Collection de documents relatifs à la ville de Troyes*, Troyes, 1893, II). In spite of this, it is not unlikely that it originated in Troyes. Incidental features of the decoration occur in other manuscripts from that Champenois centre, as P. Stirnemann has observed, while the partial copy from Saint-Germain-des-Prés (Bibl. Nat. lat. 11534–35; no. 92) and connections on a more general plane with the Pontigny Bible (Bibl. Nat. lat. 8823; no. 82) roughly delimit the geographic orbit within which the work is best situated.

The biblical text of the Manerius Bible is accompanied by a very full set of prefaces and *argumenta*, the prefatory matter for the Psalms being exceptionally extensive (MS 9, ff. 178v–94) and including pieces by Origen, Augustine and Isidore. There are painted initials before all the biblical books and the major prefaces and prologues, with a large panel of Creation scenes preceding Genesis. The Psalms have a ten-part subdivision marked by historiated initials whose unusual iconography deserves to be noted, and a cycle of the life of Christ centred on his miracles occupies the Canon Table lunettes. The illumination,

though fairly homogenous in style, must have engaged a number of hands. Markings in drypoint adjoining the initials were interpreted by Robert Branner as 'signatures' of the illuminators. P. Stirnemann, however, has shown that these marks merely serve to indicate the number of painted initials included in one gathering, while others are instructions to the painter on colours to be used. The initials of the Manerius Bible are densely compacted designs filled almost to excess by visual incident. The ornament betrays a connection with the Channel Style, as is apparent in the dense trellis-work of diminutively scaled foliage and the use of large naked figures or composite creatures bearing the body of the letter in the manner of an *atlante*. In the historiated initials, the figures who are characterized as speaking brandish scrolls, sometimes filling the space around them with multiple twisting and overlapping trailers which may extend beyond the confines of the design. The dominant tonality is bright and deeply saturated, with an emphasis on red and blue, along with a good deal of gold — the latter employed for the backgrounds and tooled in places with a blunt, punch-like instrument. *Incipits* and *explicits* are rendered in alternating lines or red and blue majuscule letters. *Incipit* words appear in gold on painted stripes attached to right edge of the initial. Stirnemann has discovered reflections of the Manerius style in a series of manuscripts of vernacular literary texts in all likelihood produced in Champagne from the end of the 12th century through the first three decades of the 13th century.

PROVENANCE: Written by Manerius of Canterbury, according to a lengthy colophon (MS 10, f. 308v). Saint-Loup de Troyes, 17th century (*ex-libris* on f. 1 of each volume). Entered the Library of Sainte-Geneviève, Paris, in 1748, and MS A.I.5.

LITERATURE: C. Kohler, *Catalogue des manuscrits de la Bibliothèque Sainte-Geneviève*, Paris, 1893, I, 8–12; *Palaeographical Society*, II Ser., 1184–94, 116–18; A. Boinet, 'Les manuscrits à peintures de la Bibliothèque Sainte-Geneviève', *Bulletin de la Société française de Reproduction de manuscrits à peintures*, V, 1921, 21–9; A. Watson, *The Early Iconography of the Tree of Jesse*, Oxford, 1934, 112; Haseloff, *Psalterillustration*, 12–13; C. Nordenfalk, 'Insulare und kontinentale Psalterillustrationen aus dem XIII. Jahrhundert', *Acta Archaeologica*, X, 1939, 110; H. Swarzenski, *The Berthold Missal*, New York, 1943, 44, 47, 85; T. S. R. Boase, *English Art. 1100–1216*, Oxford, 1953, 187–8; C. R. Dodwell, *The Canterbury School of Illumination, 1066–1200*, Cambridge, 1954, 109ff.; Grabar and Nordenfalk, *Romanesque Painting*, 170, 173, 195; R. Branner, 'The Manerius Signatures', *Art Bulletin*, L, 1968, 183; Dodwell, *Painting in Europe*, 207; P. D. Stirnemann, 'Nouvelles pratiques en matière d'enluminure au temps de Philippe Auguste', *La France de Philippe Auguste. Le temps des mutations* (Colloque

internationaux du Centre de la recherche scientifique, 602), Paris, 1980 (1982), 955–80; L. Eleen, *The Illustration of the Pauline Epistles in French and English Bibles of the Twelfth and Thirteenth Centuries*, Oxford, 1982, 66–7, 96 n. 30, 97; Cahn, *Romanesque Bible Illumination*, 180, 208, 221, 279, No. 99; P. Stirnemann, 'Some Champenois Vernacular Manuscripts and the Manerius Style of Illumination', *Les Manuscrits de Chrétien de Troyes/The Manuscripts of Chrétien de Troyes*, ed. K. Busby, T. Nixon, A. Stones and L. Walters, Amsterdam, 1993, I, 195–226.

EXHIBITED: *Manuscrits à peintures*, Paris, 1954, 113–14, No. 334.

82. Paris, Bibliothèque Nationale MS lat. 8823

Bible Fragment
535 x 370 mm., ff. 9, 2 cols., 30 lines
Last quarter of the 12th century.
Pontigny *Ill. 190*

Historiated and ornamental initials: GENESIS, I, Days of Creation (f. 1); PREFACES TO GOSPELS, B, S, P (ff. 2, 3v, 7); Canon Tables (ff. 4–7); there are Evangelist symbols in the lunettes of Canon I (f. 4) and a bust of Christ flanked by angels in Canon II (f. 5); PREFACE TO MATTHEW, M (f. 8v); MATTHEW, L, Tree of Jesse, with the reclining patriarch inscribed 'Abraham' (f. 9v).

This fragment of nine leaves is made up of a page, presently misbound, with the beginning of Genesis (recto) and *capitula* (verso), followed by a larger section of eight folios which represents the beginning of the text of the New Testament with prefaces and Canon Tables. A number of additional cuttings from the manuscript have been identified. Two fragments with initials of Exodus (H) and Leviticus (V), once in the Hachette Collection, have recently appeared in a dealer's catalogue (S. Hindman, *Medieval and Renaissance Miniature Painting*, Bruce Ferrini Rare Books, Akron, Ohio, and Sam Fogg Rare Books and Manuscripts, London, 1988, Nos. 2 and 3). The initial of I Chronicles, an A, is bound with a collection of miscellaneous leaves in a manuscript of the Bibliothèque Nationale (nouv. acq. lat. 2525, f. 1), while a cutting with the initial of the Ezra preface, U, is in the Houghton Library at Harvard University (MS Typ 315). It is possible, but not yet proven, that another cutting with two episodes from the story of Jonah incorporated in the initial for that Book, which was sold at Sotheby's (*Western Manuscripts and Miniatures*, 5 December 1978, 9, No. 8), may also stem from the work. An inventory of the Pontigny library made near the end of the 12th century (Montpellier, Bibl. de l'École de Médecine, MS 12) lists two Bibles in five volumes, a format that seems to have enjoyed a certain favour in Cistercian houses of Burgundy and Champagne. The fragmentary work was written in a fairly large script covering only thirty lines per page, and it is thus very likely to be the remnant of one of these works.

The Genesis page of the Pontigny Bible fragment is framed by an ornate border and incorporates a large initial showing the Days of Creation in successive roundels. The painting has evident links with the Creation initials of the Manerius Bible (no. 81) and its relative from Saint-Germain-des-Prés in the Bibliothèque Nationale (no. 92). The style is closer to the more relaxed manner of the second of these works. The Tree of Jesse of the Matthew initial (f. 9) is a fairly faithful version of the corresponding subject in the Saint-Germain-des-Prés Bible (Bibl. Nat. lat. 11534, f. 207v). On the other hand, the design and iconography of the Canon Tables are different, and the Genesis panel more compact. The scenes of Creation also diverge from the pattern of the Manerius and Saint-Germain Bibles, omitting the figure of the Lord, except for the activities of the fourth and sixth days. A bifolium with another monumental Genesis initial I incorporating medallions of the Days of Creation, also said to have come from Pontigny, is preserved in the museum at Clamecy (C. Guillot-Chêne, 'Deux enluminures romanes provenant de Pontigny au Musée de Clamecy', *Mémoires de la Société Académique du Nivernais*, LX, 1977, 21–4).

The ambitious painted decoration of the manuscript, including historiated initials, is somewhat unexpected in a Cistercian manuscript at this date. The existence of a body of book illumination from Pontigny datable in the second half of the twelfth century, however, does provide something of a context for the execution of the Bible, even if it does not fully explain it. An important local product in an older style is the dismembered copy of Gratian's *Decretum* of which leaves survive at Auxerre (Bibl. Mun. MS 269), the Cleveland Museum of Art (No. 54531), the Victoria and Albert Museum (No. 8985 B-F) and the National Library of Wales at Aberystwyth (MS 4874 E, No. 2). Contemporaneous with the Bible or somewhat later specimens of local book illumination of a more modest variety are found in Origen, Homilies on Matthew (Brit. Lib. Add. 26761), a Decretals Collection in Montpellier (Bibl. de l'École de Médecine, MS 13), and a miscellaneous volume including a *Passio S. Vincentii* and Marbod of Rennes' *De preciosi lapidibus* in the same library (MS 35). On the other hand, the expansive view of Pontigny as a significant centre of manuscript illumination in the third quarter of the 12th century favoured by an earlier generation of scholars is largely unsubstantiated.

PROVENANCE: *Ex bibliotheca Pontiniacensi 6*, 18th century (f. 2). Supplément latin 453 (f. 1).

LITERATURE: Lauer, *Enluminures romanes*, 86; T. S. R. Boase, *English Art, 1100–1216*, Oxford, 1953, 187; W. Cahn, 'A Twelfth-Century Decretum Fragment from

Pontigny', *Bulletin of the Cleveland Museum of Art*, February 1975, 47, 53; G. Plotzek-Wederhake, 'Buchmalerei in Zisterzienserklostern', *Die Zisterzienser*, Cologne, 1980, 359; Cahn, *Romanesque Bible Illumination*, 180, 277, No. 91; M. Peyrafort-Bonnet, 'La dispersion d'une bibliothèque médiévale: les manuscrits de l'abbaye de Pontigny', *Cîteaux. Commentarii Cistercienses*, fasc. 1–2, 1984, 107; S. Hind-

man, *Medieval and Renaissance Miniature Painting*, Akron and London, 1988, 5–7, 96–8, Nos. 2 and 3.

EXHIBITED: *Manuscrits à peintures*, Paris, 1954, 114, No. 337; *The Year 1200*, New York, 1970, 249, No. 248; *Art français du moyen âge*, Quebec-Montreal, 1972–73, No. 30; *The Bible in the Twelfth Century*, Cambridge, MA, 1988, 14–16, No. 2.

V. PARIS AND REGION

83. Amiens, Bibliothèque Municipale MS 24

Four Gospels
275 × 200 mm., ff. 135, 29 long lines
End of the 11th century. Beauvais (?)
Ills. 203, 204, 205, 206

Evangelist portraits: Matthew (f. 15); Mark (f. 53); Luke, (f. 77v); John (f. 108v).

Canon Tables (ff. 8–13).

Ornamental initials and monograms: PREFACES TO GOSPELS, B (f. 2); P (f. 3); MATTHEW, L (f. 15v); MARK, I (f. 53v); LUKE, Q (f. 78); JOHN, I (f. 109).

This Gospel Book is one of the outstanding works of Romanesque manuscript illumination, though neither its date nor its origin are as yet firmly established. The decoration consists of author portraits and pen-drawn ornamental initials or monograms, heightened with colour for the prefaces and the opening words of the four Gospels, the latter larger in scale and accompanied by *incipit* words of ornate capital letters arranged in narrow columns of multiple lines. Canon tables on ten sides with pen-drawn triple or quadruple arches borne by striated columns precede the Gospel text. The full-page Evangelist portraits are housed in arched frames with striated columns and festooned with agitated draperies. The four sacred authors are haloed and shown receiving inspiration from lively symbols in downward flight from implicit skies. The impassive Matthew, seated frontally, receives a scroll from a diminutive, gesticulating man-angel. Mark is a balding figure with crossed legs who stares intently at his airborne and apparently bellowing lion. Luke is seated at a lectern and writes under the guidance of a plummeting ox, while John, seated on a faldstool, brandishes a furled scroll as he pauses to receive the divine word from the eagle. The figures have curiously large hands and angular features. They are drawn in a fine outline, heightened by broad stripes of colour. A restricted range of bold and flatly applied colours is employed

for shading, and the backgrounds — a vivid purple, blue, green, along with touches of silver and gold for details of ornament. The dynamic conception of these portraits and the lively draughtsmanship seems ultimately to derive from 9th-century models of the Reims School. The bold stylization and striped effects of the modelling, however, presuppose 11th-century intermediaries of Flemish origin, as initially noted by Schott, who compared the Amiens Evangelists with the author portraits of a Gospel Book of undetermined Franco-Flemish origin in Brussels (Bibl. Royale, MS II. 175).

In spite of its Corbie provenance, the manuscript does not have an identifiable connection with that scriptorium. As pointed out by F. Avril, the hand of one of the scribes can be discovered in a copy of Augustine's Commentary on Genesis which stems from the abbey of Saint-Quentin at Beauvais (Beauvais, Bibl. Mun. MS 25), whose decoration of historiated and ornamental initials is also by the artist of the Amiens codex. The Beauvais Augustine carries a signature in the form of letters placed at the end of each gathering, which register the name of a priest named Rothardus (*Rothardi Levithe*), probably the name of the scribe. Avril has discovered the same name among the signatories of a charter dated 1091 in the cartulary of Saint-Quentin at Beauvais (Paris, Bibl. Nat. nouv. acq. lat. 1921), though the same author points out that an obit for a Rothardus also occurs in the martyrology of Nevelo from Corbie (Bibl. Nat. lat. 17767, f. 56v; no. 95). This might suggest that the scribe worked first at Beauvais and then moved to the Picard monastery, where he enjoyed a second career, but the occurrence of identical names may be a mere coincidence. H. Swarzenski dated the Amiens manuscript as early as the second quarter of the 11th century, founding himself on comparisons, like Schott, with Flemish illumination assigned by him to Liège (Brussels, Bibl. Royale, MSS 10791 and 18383), but most scholars have situated the genesis of the work in the second half of, or towards the end of the century. The later date is more plausible, and

supported by the evidence furnished by the Beauvais cartulary. Yet another manuscript with clear links to the *oeuvre* of Rothardus has been identified by Avril in a Glossed Genesis of unknown provenance, formerly in the Phillipps Collection (MS 3380; present whereabouts unknown).

PROVENANCE: Saint-Pierre, Corbie (17th century *ex libris*, f. 2).

LITERATURE: M. Rigollot, 'Essai historique sur les arts du dessin en Picardie depuis l'époque romaine jusqu'au XVIe siècle', *Mémoires de la Société des Antiquaires de Picardie*, III, 1839, 349–51; E. Coyecque, *Catalogue général*, XIX, 1893, 15–16; Haseloff, *Miniature*, 748; M. Hauttmann and H. Karlinger, *Die Kunst des frühen Mittelalters*, Berlin, 1929, 737; M. Schott, *Zwei lüttische Sakramentare in Bamberg und Paris und ihre Verwandten*, Strasbourg, 1931; W. H. Frere, *Studies in the Early Roman Liturgy. II. The Gospel Lectionary* (Alcuin Club Collection, XXX), Oxford, 1934, 204; W. Weisbach, *Manierismus in mittelalterlicher Kunst*, Basel, 1942, 25; Swarzenski, *Monuments of Romanesque Art*, 52, No. 81; Grabar and Nordenfalk, *Romanesque Painting*, 102; Porcher, *French Miniatures*, 30; J. J. G. Alexander, *Norman Illumination at Mont Saint-Michel, 966–1100*, Oxford, 1970, 177–8, 182–3; Dodwell, *Painting in Europe*, 85, 94; F. Avril, 'Un manuscrit de Beauvais et le Maître des Évangiles de Corbie (Manuscrit Amiens 24)', *Cahiers archéologiques*, XXI, 1971, 181–90; id., *Royaumes d'Occident*, 190; C. Nordenfalk, 'Der inspirierte Evangelist', *Wiener Jahrbuch für Kunstgeschichte*, XXXVI, 1983, 188.

EXHIBITED: *Treasures of Medieval France*, Cleveland, 1967, 47; *Manuscrits à peintures*, Paris, 1954, 58, No. 131; *Art roman*, Barcelona and Santiago de Compostela, 1961, 47, No. 55.

84. Paris, Bibliothèque Nationale MS lat. 12054

Missal
315 × 200 mm., ff. II + 298 + II, 23 long lines
Beginning of the 12th century.
Saint-Maur-des-Fossés *Ill. 202*

Full-page illustration: Last Supper (f. 79); independent drawing: Kiss of Judas (f. 79v).

Major ornamental initials: A (f. 9); D (f. 15); E (f. 16); D (f. 21); D (f. 27); D (f. 40v); O (f. 73v).

Lesser initials, historiated and ornamental: ff. 16, 17, 18v, 19v, 21 (angel forming the stem of the letter), 21v, 22v, 24 (Annunciation), 25, 25v, 27, 27v (two figures in dialogue), 29v, 33v, 34v, 40v (seated figure), 66v, 73v (Entry of Christ into Jerusalem), 77v, 80v, 86, 86v, 90, 92 (Mary Magdalene), 99v, 103v, 106, 109, 112,

156v (Martyrdom of St. Stephen),172v (Presentation of the Child in the Temple), 199 (Peter and Paul), 218v (Assumption of the Virgin), 227v (crowned woman), 240 (seated Christ with book, three saints with books), 262 (Christ in Majesty).

The origin of the manuscript is indicated by the Calendar (ff. 1–7), which comprises three separate commemorations of St. Maurus, including the anniversary of the *Adventus S. Mauri Abbatis Fossatensis et Dedicatio Basilicae ipsius* (13th November). The Common of the Saints (f. 267v) also comprises a daily Mass to be said in honour of the same personage. This points to Saint-Maur-des-Fossés, a Benedictine monastery founded in the 7th century and situated in a bend of the Marne River, some seven miles south-east of Paris, as the place for which the work was made. Beyond its rich component of pen-drawn and lightly tinted initials, the manuscript contains an unfinished drawing of the Last Supper, which precedes the Good Friday Mass. On the verso of this leaf, there is an unframed drawing by another hand of the Kiss of Judas, while the facing recto (f. 80) is blank. It may be supposed that a sequence of Passion scenes was initially intended for these pages, but the rather casual positioning of these images in the volume makes it more likely that they came into being as a kind of afterthought, in order to fill pages unaccountably left bare. The manuscript was further altered in the middle of the 13th century through the addition or replacement of a section of thirteen leaves (ff. 142–54) containing the Preface and Canon of the Mass, along with full-page miniatures of the Crucifixion and Christ in Majesty (R. Branner, *Manuscript Illumination in Paris during the Reign of St. Louis*, Berkeley, Los Angeles and London, 1977, 92–3, Cat. No. 225). In the original sections of the volume, the larger number of the initials are executed in a lively and informal manner which retains much of the illusionistic flavour of 11th-century draughtsmanship in northern France. The more important of these letters are placed within squarish frames. There is a sharp contrast between these designs and the monumentally-conceived Last Supper, the fully Romanesque character and early 12th-century date of which cannot be doubted. Its style, which calls to mind the bold abstraction of manuscripts of Aquitaine around 1100 like the Moissac Josephus (no. 30), marks a stage in Parisian book illumination beyond the gentler draughtsmanship illustrated in the mid 11th-century production of Saint-Germain-des-Prés connected with the scribe and illuminator Ingelardus. The drawing must nonetheless be contemporaneous with the rest of the manuscript, since some of the initials, like the historiated letters with the Annunciation (f. 24) and the Entry into Jerusalem (f. 73v), exhibit fairly similar stylistic conventions. Among the manuscripts from Saint-Maur there is a copy of Augustine's Commentary on the Gospel of John (Bibl. Nat. lat. 12197) which has illumination of a

generally similar cast. Jonathan Alexander has noted that the incongruous groups of fighting figures in the Stoning of St. Stephen (f. 156v) are duplicated in the frontispiece design of a Glossed Psalter of unknown origin in the British Library (Add. 18297, f. 3).

PROVENANCE: Saint-Maur-des-Fossés, MS 39 (f. 1). Saint-Germain-des-Prés, MS 697 (17th century, f. 1), and 1061.

LITERATURE: Leroquais, *Sacramentaires,* I, 201; Swarzenski, *Monuments of Romanesque Art,* 51, No. 71; J. J. G. Alexander, *Norman Illumination at Mont-Saint-Michel, 966–1100,* Oxford, 1970, 144–5, 156, n. 6 and 171, n. 4; *Manuscrits datés,* III, 1974, 269; E. B. Garrison, 'Three Manuscripts for Lucchese Canons of S. Frediano in Rome', *J. W. C. I.,* XXXVIII, 1975, 37; B. Dirlam, *Les sculptures médiévales de Saint-Maur-des-Fossés,* Saint-Maur, 1983, 28; J. J. G. Alexander, *Medieval Illuminators and Their Methods of Work,* New Haven and London, 1992, 91-2.

EXHIBITED: *Manuscrits à peintures,* Paris, 1954, 86–7, No. 241.

85. Baltimore, Walters Art Gallery MS W.17

Four Gospels
274 × 224 mm., ff. 161, 2 cols., 13 lines
c. 1100. Region of Paris (?) *Ills. 207, 208*

Full-page portrait of Matthew (f. 8v). Large painted LI monogram for MATTHEW (f. 9); large pen-drawn initials: LUKE, Q (f. 80); John, I (f. 123). Lesser monochrome initial for the GOSPEL PREFACE, N (f. 1). The remainder of the initials were not executed (ff. 2v, 5, 50v, 77, 122).

The illumination of this manuscript of the four Gospels was left unfinished, most of the prefaces and *argumenta* having spaces for initials left blank. Pages at the beginning of Mark, Luke and John, which very likely contained portraits of these Evangelists, have also been excised. The decoration remaining is of an uneven cast. The splendid author portrait which fills the space below the last five lines of the summaries of Matthew's Gospel, along with the initial monogram and the adjoining text in display capitals, are carried out with great care and announce a work of some artistic ambition. However, the other elements of the decoration still extant, comprising the opening initial of Luke's Gospel and the *incipit* page of John, are more casually and even economically executed. At the end of the manuscript (ff. 160–161), is an addition in a 12th-century hand of the anonymous

description of the Holy Land known as *Innominatus I,* whose composition has been placed around the year 1098 (R. Röhricht, *Bibliotheca Geographica Palestinae. Chronologisches Verzeichnis der auf die Geographie des Heiligen Landes bezüglichen Literatur…*Berlin, 1890, 28–9).

The localization of the Walters Gospel Book is still an unsettled question, southern France or northern Spain being most frequently, if gingerly, suggested. The portrait of Matthew is painted in bright and flatly-laid colours, with grey-blue and red predominating. Contours and internal elements of the design are boldly outlined in black. The seated Evangelist, attending to an open book, is framed by an arch, while his symbol in the form of an angel flies down towards him from a patch of clouds at the upper right. In the LI monogram on the facing page, the stem of the letter I houses a pair of helmeted warriors in chain mail, one lifted up on the shoulders of the other. Beyond the 'southerly' connotations of the vivid colours used, there is nothing that markedly points to the Midi or to Spain in this decoration, or in the lesser embellishment of the manuscript. The clambering warriors are most plausibly associated with the Anglo-Norman tradition of 'inhabited' ornament. The vigorous concatenation of sharply-bounded and highly coloured forms in evidence in the depiction of Matthew may be compared to the Evangelist portraits in a Gospel Book from Saint-Corneille de Compiègne in the Bibliothèque Nationale (lat. 17970; no. 86)

PROVENANCE: Léon Gruel, Paris, No. 1094 (Bookplate). Henry Walters (1848–1931).

LITERATURE: S. de Ricci and W. J. Wilson, *Census of Medieval and Renaissance Manuscripts in the United States and Canada,* New York, 1935–40, I, 767, No. 65; C. U. Faye and W. H. Bond, *Supplement to the Census of Medieval and Renaissance Manuscripts in the United States and Canada,* New York, 1962, 195, No. 65; Walters Art Gallery, *Handbook of the Collection,* Baltimore, 1936, 70; D. Diringer, *The Illuminated Book, Its History and Production,* London, 1958, 370; M. Drogin, *Medieval Calligraphy. Its History and Technique,* Montclair, N. J. and London, 1980, 53–4; L. M. C. Randall, *Medieval and Renaissance Manuscripts in the Walters Art Gallery,* I, Baltimore and London, 1988, 9–11, No. 4.

EXHIBITED: *Arts of the Middle Ages,* Boston, 1940, No. 28; *Illuminated Books of the Middle Ages and Renaissance,* Baltimore, 1949, 10, No. 21; *L'art roman,* 54–5, No. 77; *Illuminated Manuscripts. Masterpieces in Miniature,* Baltimore, 1984, pl. 8.

86. Paris, Bibliothèque Nationale MS lat. 17970

Four Gospels
220 × 155 mm., ff. 227, 22 long lines
Beginning of the 12th century.
Region of Paris *Ills. 209, 210*

Canon Tables (ff. 6v–13v).

Full-page Evangelist portraits: Matthew (f. 14); Luke (f. 115v); John (f. 181). Full-page *incipit* and initial L, evangelist Symbol with scroll (f. 14v).

Ornamental initials: GOSPEL PREFACES, B (f. 1); P (f. 3); PREFACE TO MATTHEW, M (f. 5v); PREFACE TO MARK, M (f. 71); LUKE, Q (f. 116); PREFACE TO JOHN, L (f. 178v); JOHN, I (f. 181v).

The monastery of Saint-Corneille de Compiègne was founded around the year 876 by the emperor Charles the Bald, who bequeathed to it part of his collection of books. The later history of the monastic library is not well known, but a remnant of some two hundred volumes, including the present Gospel Book, was acquired by the Bibliothèque Impériale in 1802. The writing and decoration of the work are not uniform. The first six folios with the Gospel prefaces, the preface of Matthew and the accompanying initials are the work of a separate and distinctive hand, quite probably of English origin, and not elsewhere in evidence in the volume. The Canon Tables which follow are spread over fifteen pages and displayed within simple arcaded structures of three (ff. 8v–11) and four (ff. 6v–8, 11v–13v) intercolumniations. The pen-drawn initials in the rest of the volume, contributed by different scribes, are fairly sketchy or impressionistic in their effect. Three Evangelist portraits remain, along with a framed purple page bearing the *incipit* words of Matthew's Gospel. Unlike the wispy initials, they are painted in a deliberate manner, using an opaque medium and a rather saturated range of colours, the forms being given added relief by heavy black outlines and white highlights. The portraits of the sacred authors are framed by acanthus borders with angular interlace knots at the four corners. The figures, set against panelled backgrounds, are depicted as they receive inspiration from their symbols. The symbols themselves display unfurled scrolls as they descend from the heavens in the upper zone of the composition. The source of these images may well have been a Gospel Book with Evangelist portraits in the Remois style from the Court School of Charles the Bald, localized by some scholars in Compiègne, like the manuscript of unknown provenance now at Darmstadt (Hess. Landesbibl. Hs. 746). In the Roman *Capitulare Evangeliorum* at the end of the volume (f. 226v), the feast day of St. Vincent of Saragossa on 23rd January is written in capital letters, the only entry so distinguished.

PROVENANCE: Saint-Corneille de Compiègne (*ex libris*, 17th or 18th century, f. 1). 'Comp. 86' (19th century, f. 1). Acquired by the Bibliothèque Impériale in 1802.

LITERATURE: *Manuscrits à peintures*, 90, No. 252.

EXHIBITED: In Paris, 1954, as above.

87. Paris, Bibliothèque Nationale MS lat. 14516

Richard of Saint-Victor, Works,
including *In Ezechielem*
330 × 201 mm., ff. 253, 2 cols., 39 to 31 lines
Third quarter of the 12th century.
Saint-Victor, Paris *Ills. 215, 216, 217*

Historiated and ornamental initials for various works of Richard of Saint-Victor included in the volume: *Beniaminus maior*, M (f. 2v); *Beniaminus minor*, B (f. 82v); *De exterminatione mali et promotione boni*, Q, seated king (f. 119); *De statu interioris hominis*, S (f. 142); O, seated figure in a thoughtful or melancholic stance (f. 143).

Illustrations for the Commentary on the Vision of Ezekiel: plan of the walls of the temple complex (f. 211v); plan of the atrium of the temple (f. 212); plan of the entire complex (f. 213; plan of the outer walls with entrance gates (f. 216); schematic plan of the entrance porticus (f. 217); plan of the left side of the porticus (f. 219); plan of the entrance porticus, its chambers and central passage (f. 220v); diagram of the inclination of the mountain (f. 239); frontal elevation of the entrance porticus (f. 240); lateral view and partial section of the entrance porticus (f. 240v); plan of the temple (f. 244v); elevation of the building on the north (*aedificium vergens ad aquilonem* (f. 248); elevation and section of the altar of the Holocausts (f. 252).

Richard of Saint-Victor is believed to be of English or Scottish origin. He was a student of Hugh of Saint-Victor, became prior of Saint-Victor in 1162, and died in 1173. The present volume is not a unified whole, but seems to have been pieced together at a fairly early date from separate elements in an attempt to assemble the author's writings into a collected edition, of which other parts are found in Bibl. Nat. lat. 14518, 14519 and several other codices. The character of the script and of the decoration, which consists of painted initials of variable quality at the head of the individual works, and architectural illustrations placed within the commentary on Ezekiel's Temple vision, make it possible to envisage a date for the production of these texts within the author's own lifetime, or very shortly thereafter. Although Richard is reputed primarily for his writings on mystical contemplation, the Ezekiel commentary (*Pat. Lat.*

CXCVI, 527–600) exhibits him in another role, as a defender of the literal exegesis of Scripture. Contradicting the opinions of earlier authors, notably Jerome and Gregory the Great, who held that the difficult account of Ezekiel's vision of the Temple on the Mountain (Ez. 40–48) was to be understood on the symbolic level only, Richard maintains that this account could be literally construed. The illustrations in the work are an integral part of his demonstration. Thirteen copies of the text of the Ezekiel commentary are known, most of them datable in the later decades of the 12th century, or in the first half of the 13th (list in Cahn, *Gesta*, XV, 1/2, 254, n. 11, to which should be added Paris, Bibl. Nat. lat. 16702, Prague, Public and University Library, Cod. 2528, and Durham Cathedral, Dean and Chapter Library, MS A.III.22). The first group of four diagrams concerns the plan of the entire temple complex. The following series of seven illustrations accompanies the author's reconstruction of the eastern gate house (*porticus*), of which he furnishes ground plans as well as frontal and side elevations. Of the temple proper, there is only a ground plan, but the blank verso of the same leaf perhaps indicates that an elevation was intended, though for some reason not carried out. For the rather shadowy structure described as *aedificium vergens ad aquilonem*, on the other hand, there is an elevation of one of the narrow sides, but no plan. The verso of the leaf on which this illustration appears is also blank, however, and another view of this building might also originally have been planned. The last diagram, showing the disposition of the Tribes in the Promised Land (*Descriptio seu divisio terrae promissionis*) is missing in the manuscript, though found in a number of the copies. The illustrations of Richard's Ezekiel commentary are of great interest, since they mark a break with the dominant mode of architectural representation of the Early Middle Ages: following the literal bent of the Victorine's exegesis, they purport a comparably analytical and concrete approach to the subject. The ground plans of the Ezekiel commentary thus fairly accurately reflect the measurements given by the biblical text. The altogether novel attempt to correlate ground plan and elevation in the reconstruction of the *porticus* is not otherwise documented in architectural practice until centuries later. Where the prophet's description of the Temple was incomplete or difficult to disentangle, however, Richard or his draughtsman were compelled to rely on experience and judgement shaped by their environment, and their reconstructions, in the elevations especially, make evident references to Romanesque civic and military architecture. A second literal commentary on Ezekiel's Temple vision by Richard's near contemporary Adam of Saint-Victor exists in four medieval copies (ed. M. Signer, *Corp. Christ., Cont. Med.*, 53E). But these have no illustrations, and the relationship of this work to Richard's tract remains to be clarified.

PROVENANCE: Saint-Victor, ownership inscription and anathema, 16th century (ff. 2v, 81). Saint-Victor shelfmark h. h. 16 (16th century) and Inv. No. 82 (18th century). Acquired by the Bibliothèque Nationale in 1796.

LITERATURE: W. Cahn, 'Architectural Draftsmanship in Twelfth-Century Paris: The Illustrations of Richard of Saint-Victor's Commentary on Ezekiel's Temple Vision', *Gesta*, XV, 1/2 (Essays in Honor of Sumner McKnight Crosby), 1976, 247–54; id., 'Architecture and Exegesis: Richard of Saint-Victor's Ezekiel Commentary and Its Illustrations', *Art Bulletin*, LXXVI, 1994, 53-68.

EXHIBITED: *1789. Le Patrimoine libéré*, Paris, 1989, 171, No. 100.

88. (a) Cambridge, Trinity College MS B. 5. 4

Glossed Psalms (Psalms I–LXXIV, v. 4)
450 × 317 mm., ff. 184, 2 cols., 26 lines (text); 52 lines (gloss)

(b) Oxford, Bodleian Library MS Auct. E infra 6

Glossed Psalms (Psalms LXXIV–CL)
492 × 348 mm., ff. I + 142, 2 cols.,
26 lines (text); 52 lines (gloss)
c. 1173–77. Paris (?) *Ills. 211, 212, 213, 214*

(a) Trinity College, MS B.5.4.

Historiated and ornamental initials: Dedicatory epistle, D, Herbert of Bosham presents the volume to Thomas Becket and ornamental initial (f. 1).

PSALTER PREFACES, D (f. 4); I (f. 4v); P, Jerome writing at a pulpit (f. 6v); S (f. 6v); C, four half-length Prophets in discourse (f. 10); Psalm I, missing ; II, Q (f. 11v); III, D (f. 13v); IV, C (f. 15); V, V (f. 17v); VI, D (f. 20v); VII, D (f. 22v); VIII, D (f. 26); IX, C (f. 27v); X, I (f. 33v); XI, S (f. 35v); XII, U (f. 36v); XIII, D (f. 37v); XIV, D (f. 39v); XV, C (f. 40v); XVI, E (f. 42v); XVII, D (f. 45); XVIII, C (f. 52); XIX, E (f. 55); XX, D (f. 56); XXI, D (f. 58); XXII, D (f. 63); XXIII, D (f. 64v); XXIV, A (f. 66); XXV, I (f. 70); XXVI, D (f. 71); XXVII, A (f. 74); XXVIII, A (f. 75v); XXIX, E (f. 77); XXX, I (f. 79v); XXXI, B (f. 84v); XXXII, E (f. 86v); XXXIII, B (f. 90); XXXIV, I (f. 93); XXXV, D (f. 96v); XXXVI, N (f. 98v); XXXVII, D (f. 102v); XXXVIII, D (f. 105); XXXIX, E (f. 107v); XL, B (f. 110v); XLI, Q (f. 112); XLII, I (f. 114); XLIII, D (f. 115); XLIV, E (f. 118v); XLV, D (f. 121v); XLVI, D (f. 122v); XLVII, M (f. 123v); XLVIII, A (f. 125v); XLIX, D (f. 127v); L, M (f. 130); LI, Q (f. 134); LII, D (f. 135v); LIII, D (f. 136v); LIV, E (f. 137); LV, M (f. 140v); LVI, M (f. 142v); LVII, S (f. 144); LVIII, E (f. 145v); LIX, D (f. 148); LX, E (f. 150); LXI, N (f. 151); LXII, D (f. 153); LXIII, E (f. 154v); LXIV, T (f. 155v);

LXV, I (f. 157v); LXVI, D (f. 159v); LXVII, E (f. 160v); LXVIII, S (f. 165v); LXIX, D (f. 170v); LXX, I (f. 171); LXXI, D (f. 174v); LXXII, Q, (f. 177); LXXIII, E (f. 180); LXXIV, C (f. 183).

Marginal illustrations: Cassiodorus (f. 10v); man on fire (f. 11v); personification of *Ethica* with the dove of *Simplicitas* and the serpent of *Astutia* (f. 15); man on fire (f. 26); Augustine (f. 33v); Augustine (f. 35); personification of *Ethica* with *Simplicitas* and *Astutia* (f. 35v); Augustine (f. 36); Augustine (f. 43); Cassiodorus (f. 43v); Augustine (f. 47v); Virgin and Child (f. 52); Cassiodorus (f. 63v); David kneeling before Christ (f. 71); Jerome (f. 82); an old cleric with a birch switch and a younger man at his feet (f. 84v); Cassiodorus (f. 90v); Augustine (f. 102v); Augustine (f. 123); Solomon (f. 134v); Augustine (f. 135v); Augustine (f. 146v); Cassiodorus (f. 147v); mourning Prophet (f. 180); Jerome (f. 180v). Many additional illustrations of this kind have been cut out, though some can still be identified by remaining inscriptions or bits of scrolls or other attributes still visible: ff. 10, 13, 20v, 22v, 35, 39v, 40v, 42v, 43, 58, 64v, 67, 70, 71, 74, 77, 90, 98v, 102v, 106, 112, 127v, 130, 135v, 157v, 165v, 173v, 175, 181v.

(b) Bodleian, MS Auct E. infra 6.

Historiated and ornamental initials: dedicatory epistle, C (flyleaf, verso); Psalm LXXIV, C (f. 1); LXXV, N (f. 2v); LXXVI, V (f. 4v); LXXVII, A (f. 7); LXXVIII, D (f. 14v); LXXIX, Q (f. 16v); LXXX, E (f. 19); LXXXI, D (f. 21v); LXXXII, D (f. 22); LXXXIII, Q (f. 24v); LXXXIV, B (f. 26); LXXXV, I (f. 27v); LXXXVI, F (f. 29); LXXXVII, D (f. 30); LXXXVIII, M (f. 32); LXXXIX, D (f. 36v); XC, Q (f. 39) XCI, B (f. 41); XCII, D (f. 43); XCIII, D (f. 44); XVIV, V (f. 46v); XCV, C (f. 47v); XCVI, D (f. 49); XCVII, C (f. 50); XCVIII, D (f. 51); XCIX, I (f. 52v); C, M (f. 53); CI, D (f. 55v); CII, B (f. 59); CIII, B (f. 61v); CIV, C (f. 66v); CV, C (f. 70v); CVI, C (f. 75); CVII, P (f. 78v); CVIII, D (f. 80); CIX, D, ornamental and lesser initials with a lamenting Prophet (f. 81); CX, C, bust of Christ, Dove of the Holy Spirit (f. 83); CXI, B (f. 86); CXII, L (f. 87); CXIII, I (f. 88); CXIV, D (f. 91); CXV, C (f. 92v); CXVI, L (f. 92); CXVII, C (f. 93); CXVIII, B (f. 96); CXVIII, Lit. II, I (f. 97v); Lit. III, R (f. 98v); Lit. IV, A (f. 99v); Lit. V, L (f. 100v); Lit. VI, E (f. 102); Lit. VII, M (f. 103); CXX, L (f. 105); CXXI, L (f. 106); CXXII, A (f. 107); CXXIII, N (f. 108); CXXIV, Q (f. 109); CXXV, I (f. 109v); CXXVI, N (f. 111v); CXXVII, B (f. 112); CXXVIII, S (f. 113); CXXIX, D (f. 113v); CXXX, D (f. 114v); CXXXI, M (f. 115v); CXXXII, C (f. 118); CXXXIII, E (f. 119); CXXXIV, L (f. 119v); CXXXV, C (f. 122); CXXXVI, S (f. 124); CXXXVII, C (f. 125v); CXXXVIII, E (f. 127v); Psalms CXXXVIII–CXLIII, missing with two text signatures; Psalm CXLIV, E (f. 127v); CXLV, L (f. 130); CXLVI, L (f. 131v); CXLVII, L (f. 133v); CXLVIII, L (f. 135); CXLIX, C (f. 136v); CL, L (f. 138).

Marginal illustrations: man on fire (f. 21v); Augustine (f. 119). Cut out: 6v, 7v, 10, 14v, 16v, 19v, 22, 23v, 26, 27v, 36v, 39, 47v, 49, 50, 55v, 66v, 70v, 75, 78v, 80, 83, 87, 91v, 93, 96, 119, 124.

Herbert of Bosham was a member of the household and theological adviser of Thomas Becket, following his master to France after the dramatic confrontation of the archbishop with Henry II at the Council of Northampton (1161). He remained with Thomas during the following six years of exile on the Continent and accompanied him on his triumphal return to England in 1170. He seems to have returned to France shortly thereafter on a diplomatic mission, came home briefly in 1184, and finally withdrew to the Cistercian abbey of Ourscamp, where he completed his biography of the martyred prelate. He died there in 1186. In the period of his second residence on the Continent, Bosham procured a luxury copy of Peter Lombard's Glosses on the Psalms and the Pauline Epistles (*Magna Glossatura*). As C. de Hamel points out, he did not make a material revision of Lombard's text, but gave it a new and more orderly *mise-en-page*, 'checking the references, distinguishing by red lines patristic comments made by the glossator himself, breaking the biblical text into verses which he made clear by illuminated initials…' The work is dedicated to William, Archbishop of Sens. Since Becket is qualified in Herbert's dedicatory preface as a saint, it must have been written after 1173, the date of the canonization, and before 1176 (or 1177), when William became Archbishop of Reims. It has been shown, however, that the first gathering was altered soon after the completion of the work in order to lay greater stress on Becket's connection with it (De Hamel, *Essays Presented to Margaret Gibson*, 1992, 179-84). An earlier portrait, perhaps of William of Sens, was excised and replaced by the image on fol. 1 of the Cambridge volume, which is accompanied by a still partly legible inscription *Scs. Thom[…ma]rt. & pontifex*. Remnants of the older dedicatory portrait are still visible on a stub between present folios 7 and 8. The two volumes complete each other, but were conceived to be self-contained. They were given to Christ Church, Canterbury, by Herbert. The word BOS appears on folio 2 of the Bodleian volume, and the manuscript is listed in Prior Eastry's 14th-century inventory of the Christ Church library under the heading *Libri Magistri Herberti de Boseham*.

C. R. Dodwell, who first studied the decoration of the Bosham books, suggested that they were copied at Pontigny or at Sainte-Colombe in Sens, since Becket had spent his years in exile there, while Herbert himself had been sent to Sens in 1170 and had chosen to put his work under the patronage of the local archbishop. There is little that survives of the book production of Sainte-Colombe to test this hypothesis (cf. no. 75). In the case of Pontigny, which had an active scriptorium in the second half of the

12th century, the evidence is more plentiful, though ultimately inconclusive. Although manuscripts from that house with decoration in various Late Romanesque or 'Transitional' modes can be cited (cf. no. 82), recent scholarship has cast doubt on the existence of a Pontigny school of illumination as the primary source of books of biblical commentary designed for an external clientele, and has tended to favour Paris as the more likely centre of this publishing activity. De Hamel discerns a close similarity between the script of Bosham's Glossed Books and the Life of St. Thomas written by him, of which one volume survives (Private Collection). This and particularities in the textual corrections of the Glossed Books have led him to suggest that Herbert may have written these manuscripts himself. The illumination, however, although not of the highest quality, is surely the work of well-trained and specialized hands.

Bosham's Glossed Psalms has a complicated page layout which places the biblical text and the vast commentary pertaining to it side by side and on a verse by verse basis. Since the Psalms are cited in both the Hebrew and Gallican versions, there are in effect three painted initials for each verse — one for each of the two Psalm citations, and one for Lombard's adjoining glosses. The larger initials, to which painted strips with a few additional letters of the first word are attached, are found at the beginning of each Psalm. The following verses and the accompanying commentary have smaller, three-line painted initial letters. This decoration is a particularly exuberant example of the lively, diminutively-scaled ornament found in books of biblical commentary, Canon Law, and pre-scholastic theology often associated with clerics trained in the Parisian schools. De Hamel associates with the Bosham books a set of glossed books of the Bible formerly preserved in the Bibliothèque Municipale at Chartres, which appear to have been written in a very similar hand. The *Decretum Gratiani* of the J. Paul Getty Museum (MS 83. MQ 163) is illuminated in a very similar style, as is, among numerous other manuscripts touched by this current, a copy of Peter Lombard's Sentences in the Walters Art Gallery (W. 809). One aspect of the decoration, also in evidence in Bosham's Glossed Pauline Epistles (Cambridge, Trinity College, MSS B. 5. 6 and B. 5. 7), is the inclusion in the margins of small and animated figures, some of them depicting Patristic authors who point to their writings cited in the gloss, others unnamed authorities who dispute the interpretations presented with words like '*Ego non approbo*', '*Hic michi caveas*', or similar phrases inscribed on their scrolls. Still others are personifications of virtues, figures of Prophets, and there are several nude men surrounded by flames, accompanied by the inscription '*Homo in igne/ Deus in homine*' (Cambridge, Trinity College, MS B. 5. 4, ff. 11v, 26; Oxford, Bodleian Library, Auct. E. infra 6, f. 178v).

PROVENANCE: Given to Christ Church, Canterbury, by Herbert of Bosham. Eastry Catalogue, No. 854. Given to Trinity College by Thomas Nevile, Dean of Canterbury and Master of Trinity College (1593–1615). Oxford Volume: Eastry Catalogue, No. 855. Given to the Bodleian Library in memory of Richard Colfe, Prebendary of Canterbury, by his sons Abraham, Isaac and Jacob, 1616.

LITERATURE: M. R. James, *The Ancient Libraries of Canterbury and Dover*, Cambridge, 1903, 85, 154; id. *The Western Manuscripts in the Library of Trinity College, Cambridge*, Cambridge, 1900–1904, I, 188–94. S. R. Cockerell, *Burlington Fine Arts Club. Exhibition of Illuminated Manuscripts*, London, 1908, 11–12, No. 24; T. Borenius, 'Some Further Aspects of the Iconography of St. Thomas of Canterbury', *Archaeologia*, LXXXIII, 1933, 172-3; B. Smalley, ' Commentary on the 'Hebraica' by Herbert of Bosham', *Recherches de théologie ancienne et médiévale*, XVIII, 1951, 45; T. S. R. Boase, *English Art, 1100–1216*, Oxford, 1953, 185–7; C. R. Dodwell, *The Canterbury School of Illumination, 1066–1200*, Cambridge, 1954, 104–7; O. Pächt and J. J. G. Alexander, *Illuminated Manuscripts in the Bodleian Library, Oxford*, Oxford, 1973, III, 22, No. 201; J. J. G. Alexander, *The Decorated Letter*, New York, 1978, 21; C. de Hamel, 'Manuscripts of Herbert Bosham', *Manuscripts at Oxford, an Exhibition in Memory of R. W. Hunt*, ed. A. C. de la Mare and B. Barker-Benfield, Oxford, 1980, 39–40, No. VIII, 1; R. H. Rouse and M. A. Rouse, '"Statim invenire". Schools, Preachers and New Attitudes to the Page', *Renaissance and Renewal in the Twelfth Century*, ed. R. I. Benson and G. Constable, Cambridge, 1982, 208–9; C. de Hamel, *Glossed Books of the Bible and the Origins of the Paris Book Trade*, Woodbridge 1984, 2, 22, 42–3, 44, 45, 54, 57–8; A. G. Watson, *Catalogue of Dated and Datable Manuscripts c. 435–1600 in Oxford Libraries*, Oxford, 1984, 9, No. 48; J. P. Turcheck, 'A Neglected Manuscript of Peter Lombard's "Liber Sententiarum" and Parisian Illumination of the Late Twelfth Century', *Journal of the Walters Art Gallery*, XX, 1986, 57–8, 60ff; P. R. Robinson, *Catalogue of Dated and Datable Manuscripts, c. 737–1600 in Cambridge Libraries*, Cambridge, 1988, 92-3, No. 329; M. Carruthers, *The Book of Memory. A Study of Memory in Medieval Culture* (Cambridge Studies in Medieval Literature, 10), Cambridge, 1990, 216; C. de Hamel, 'A Contemporary Miniature of Thomas Becket', *Intellectual Life in the Middle Ages. Essays Presented to Margaret Gibson*, ed. L. Smith and B. Ward, London and Rio Grande, 1992, 179-84.

EXHIBITED: London, 1908, No. 24, see above, S. R. Cockerell; *Romanesque Art*, Manchester, 1959, 28, No. 47; *English Romanesque Art, 1066–1200*, London, 1985, 124, No. 69.

89. Cambrai, Bibliothèque Municipale MS 967

Gratian, Decretum
440 × 300 mm., ff. 233, 2 cols., 58 lines
Last quarter of the 12th century.
Paris (?) *Ills. 218, 219, 220*

Tree of Consanguinity (f. 1v); Schema of Affinity (f. 2).

Historiated and ornamental initials: I, four medallions with busts of crowned women with scrolls (f. 3); H, king and bishop (f. 10); Causa I, cut out (f. 63); Causa II, Q, seated bishop addressed by a petitioner (f. 76v); Causa III, Q, two bishops in dialogue (f. 87); Causa IV, Q (f. 91v); Causa V, I (f. 93); Causa VI, cut out (f. 94); Causa VII, cut out (f. 96); Causa VIII, I (f. 100); Causa IX, cut out (f. 101v); Causa X, Q, a bishop and a layman arguing over a church (f. 103v); Causa XI, Q, a group of clerics in argument (f. 105v); Causa XII, Q (f. 112v); Causa XIII, D, a group of figures bringing tithes, a lamb and a sheaf of grain (f. 118v); Causa XIV, C (f. 121); Causa XV, C, man struck on the head by another, grieving wife (f. 122); Causa XVI, Q, seated abbot (f. 124v); XVII, cut out (f. 132); Causa XVIII, Q (f. 135); Causa XIX, cut out (f. 136v); Causa XX, D (f. 137v); Causa XXI, A (f. 139); Causa XXII, Q, a bishop and a layman in dialogue an arcade (f. 140); Causa XXIII, Q (f. 144v); Causa XXIV, E (f. 159); Causa XXV, cut out (f. 166v); Causa XXVI, Q (f. 169); Causa XXVII, Q, men fighting over a woman (f. 173v); Causa XXVIII, Q, a man and a woman beguiled by a demon who beats a drum (f. 178v); Causa XXIX, cut out (f. 181); Causa XXX, P (f. 182); Causa XXXI, U (f. 184v); Causa XXXII, Q (f. 185v); Causa XXXIII, Q (f. 191v); Causa XXXIV, Q (f. 213); Causa XXXV, Q, transaction between two men and a woman, burial scene (f. 214); Causa XXXVI, F (f. 218v); *De consecratione*, D, bishop dedicating a church (f. 219v).

The Cambrai copy of Gratian's *Decretum* is one of a number of manuscripts of this classic work of Canon Law which form a more or less coherent group. Closely related to the work is a *Decretum* from Clairvaux at Troyes (Bibl. Mun. MS 103) which is illuminated in a nearly identical style and repeats the same compositions in a certain number of the initials. *Decretum* manuscripts in Berlin (Staatsbibl. Lat. f. 1) and Paris (Bibl. Mazarine MS 1287) are illuminated in a more broadly scaled and mildly relaxed variant of the same style, while two more copies of the work at Trier (Stadtbibl. Cod. 906) and Douai (Bibl. Mun. MS 590), illuminated in a similar manner, give the impression of a slightly greater prolixity. The *Decretum* formerly in the Dyson Perrins Collection and now in the possession of the J. Paul Getty Museum at Malibu, California (MS 83. MQ 163) is a kind of cousin of the family, exhibiting a more dynamic version of this style, but a more restricted figurative

iconography. Still other volumes of Gratian's work from the later decades of the 12th century are illuminated in a kindred fashion (Paris, Bibl. Nat. lat. 3884; London, Brit. Lib. Royal 9 C. III; Siena, Bibl. Communale degli Intronati, MS G. V. 23). The localization of these manuscripts is still an unsettled question. The Cambrai codex was given to the Cathedral of Cambrai in the 16th century by a Canon of that church, Pierre Preudhomme, who is known to have owned a number of manuscripts from Ourscamp, the Cistercian monastery near Noyon (Cambrai, Bibl. Mun. MSS 211, 304, 358, 487, 561, 563, and possibly several other volumes in the same library). The related *Decretum* from Clairvaux was there at an early date, but is evidently not a local product. R. Schilling thought that the *Decretum* of the Dyson Perrins Collection was made at Sens, perhaps in the monastery of Sainte-Colombe, but her argument, based on the hypothetical localization of the stylistically comparable group of Glossed Books made for Thomas Becket and his secretary Herbert Bosham in Sens or in nearby Pontigny, has proved not to be well founded. A. Melnikas assigned some of the manuscripts in the group to the region of the Channel Coast and others, including the Cambrai codex and its relation in Troyes to one of the Cistercian houses of Burgundy or Champagne. C. Nordenfalk favours instead a workshop of lay scribes and artists in Paris as the source of these books. There are some good arguments for this assumption. An up-to-date text of the *Decretum* with its burgeoning apparatus of glosses is more likely to have been available in a city where Canon Law was taught in the University than in a comparatively isolated monastic community. It appears likely that Paris was a major source of the Channel Style decoration to be seen in the Cambrai, Troyes and related manuscripts. The Cambrai *Decretum* is an extremely accomplished specimen of that style and of the art of book production more generally. It has decorative flourished initials in red and blue throughout the text and painted initials twelve lines high in a uniform style before the prefaces and thirty-seven *causae*. Gold employed in the backgrounds is enlivened by tool marks in the form of rounded depressions. The characteristic foliate tendrils ending in polyp-like flowers (as Nordenfalk terms them) incorporate human-headed dragons (ff. 93, 137v), a man fighting a lion (f. 169), a blue man fighting a pink quadruped (f. 213) and similar motifs. The placement of the full-page Consanguinity and Affinity Trees at the beginning of the volume in the manner of frontispiece miniatures is unusual.

PROVENANCE: P. Preudhomme (d. 1628), inscription (ff. 1 and 2). Cathedral of Cambrai, MS 293 (f. 1).

LITERATURE: M. A. Durieux, *Les Miniatures des manuscrits de la Bibliothèque de Cambrai*, Cambrai, 1861, pl. X; A. Molinier, *Catalogue général*, XVII, 1891; S. Kuttner, *Repertorium der Kanonistik (1140–1234).*

Prodromus corporis glossarum, Vatican, 1937, 34; A. Melnikas, *The Corpus of the Miniatures in the Manuscripts of the Decretum Gratiani* (Studia Gratiana, XVI–XVIII), Rome, 1975, *passim*; C. Nordenfalk, Review of Melnikas, *Zeitschrift für Kunstgeschichte*, XLIII, 1980, 326–8; H. Schadt, *Die Darstellungen der Arbores Consanguinitatis und der Arbores Affinitatis. Bildschemata in juristischen Handschriften*, Tübingen, 1982, 144, 165f., 175, 181f.

90. Paris, Bibliothèque Nationale MS lat. 11565

Peter Lombard, Commentary on the Psalms
404 × 308 mm., ff. 172, 2 cols., 28 lines (text),
52 lines (gloss)
Last quarter of the 12th century. Paris

Ill. 221

Ornamental initials: Preface, C (f. 1); Psalm 1, B (f. 2); Psalm 26, D (f. 31v); Psalm 38, D (f. 49); Psalm 51, Q (f. 63); Psalm 52, D (f. 64); Psalm 68, S (f. 79v); Psalm 80, E (f. 98); Psalm 96, C (f. 114); Psalm 101, D (f. 117); Psalm 109, D (f. 129v).

Peter Lombard's glosses on the Psalms are thought to have been compiled in the period 1158–9. The present copy of the work, given to Saint-Germain-des-Prés by the Abbot of Saint-Victor, Guarinus (1172–93), is a production of high quality with typical Channel Style decoration. The text of the Psalms is written in a narrow column on each side of the central gutter, while the gloss, laid out so as to occupy two lines for every line of the Psalm text, takes up the wider adjoining space at the left (verso) and right (recto) of the page. The Preface and each of the Psalms in the normal ten-part division have large painted initials, all of them of a purely ornamental design, set in quadrangular panels to which are joined coloured bands bearing the opening words rendered in gold majuscule letters. The spiralling rinceaux which fill the letters are filled in the usual way with small leonine creatures, but also birds, diminutive naked men or animals playing musical instruments. The swash of the Q of Psalm 51 (f. 63) consists of an elongated naked man bearing the body of the letter in the manner of an *atlante*. A. Haseloff, who introduced the manuscript into the scholarly literature, supposed that it was likely to be of Parisian origin, though he stressed the English connections of its style. Studies of more recent date have tended to lend weight to Haseloff's hypothesis while showing that the key English parallels, like the glossed books of Herbert Bosham and Thomas Becket to which he might have pointed, were themselves imports from France. C. de Hamel has noted that the script is close to that of a copy of a Glossed Minor Prophets, probably one of the books given to Christ Church, Canterbury, by Ralph of Reims, a

member of Becket's entourage during his exile on the Continent (Cambridge, Pembroke College, MS 149). The initials of the manuscript are very similar to the ornamental letters of the Becket books, the Glossed Pentateuch in the Bodleian Library (MS Auct. F. infra 7) and the Glossed Minor Prophets in Trinity College, Cambridge (MS B. 3. 11). J. P. Turcheck has also drawn attention to the relation between the larger penwork initials in the codex and the incidental decoration of two books from the library of Ralph Foliot, archdeacon of Hereford Cathedral from 1179 to 1197. It is probable that these volumes also stem from a Parisian workshop. Stirnemann connects the decoration of the manuscript with that of a Titus Livius executed for the abbot of Saint-Denis, William of Gap (Paris, Bibl. Nat. lat. 5736), and a Peter Lombard Commentary on the Psalms (Bibl. Nat. lat. 12010).

PROVENANCE: Bequeathed to Abbot Guarinus of Saint-Victor (1172–93) with the possessions of a priest named Nicholas, and given by Guarinus to Saint-Germain-des-Prés for the salvation of his soul (inscription, f. 172v). Saint-Germain-des-Prés, MS 142 and Olim 66 (18th century, f. 1).

LITERATURE: J. Mabillon, *De re diplomatica libri VI*, Paris, 1709, 371; *Gallia Christiana*, VII, 671; Delisle, *Cabinet des manuscrits*, II, 43ff; Haseloff, *Miniature*, 308–9; A. Goldschmidt, 'English Influence on Medieval Art of the Continent', *Medieval Studies in Memory of A. Kingsley Porter*, Cambridge, 1939, II, 715, 717; *Manuscrits datés*, III, 1974, 641; R. Branner, 'Manuscript Painting in Paris Around 1200', *The Year 1200: A Symposium*, New York, 1975, 174; C. De Hamel, *Glossed Books of the Bible and the Origins of the Paris Book Trade*, Woodbridge, 1984, 22, 33, 47 and 50; J. P. Turcheck, 'A Neglected Manuscript of Peter Lombard's "Liber Sententiarum" and Parisian Illumination of the Late Twelfth Century', *Journal of the Walters Art Gallery*, 44, 1986, 64–5; P. Stirnemann, 'Fils de la vierge. L'initiale à filigranes parisienne: 1140–1314', *Revue de l'art*, 90, 1990, 62 and 72, No. 12.

91. Paris, Bibliothèque Nationale MSS lat. 14266–67

Peter Lombard, Glossed Pauline Epistles
390 × 270 mm., ff. 190 and 157, 3 cols.,
21 lines (text) 42 lines (gloss)
Last quarter of the 12th century.
Paris (?)

Ills. 223, 224

lat. 14266

Historiated and ornamental initials: PREFACE, P, St. Paul and Peter Lombard seated side by side, the latter inspired by the Dove of the Holy Spirit (f. 4); ROMANS, P, seated Paul with palm and book (f. 6); PREFACES TO I CORINTHIANS, C, Paul in the midst of a

group of Corinthians (f. 94); P (f. 94); I CORINTHIANS, P, Paul writing under the inspiration of the Dove of the Holy Spirit; an angel appears to him and points to a book resting on a lectern. In a medallion at the centre of the shaft of the initial, a group of Corinthians (f. 95); II CORINTHIANS, P, Paul writes on a scroll held by an angel before him; in a medallion, group of Corinthians in a building receiving Paul's letter (f. 148v).

Marginal drawings: a pair of lions back to back with joined tails (f. 4v); naked man with a switch, man swallowed by a monster (f. 13); dragons (f. 20v); ram (f. 22); horse with bridle (f. 30v); head of a ram or goat (f. 37v); head of an ox (f. 46); monster (f. 53v); monk beaten with a switch (f, 54); chancel barrier arrangement with hanging lamps and reliquaries (ff. 54v–55); man in a tub (f. 62); snail (f. 100); peacock (f. 101); stag chased by a dog, head of a man in a floral swag (f. 123); confronted men with shields and clubs (f. 131); figure brandishing cloth and sword (f. 140); cross, monk with censer (f. 146).

lat. 14267

Historiated and ornamental initials: PREFACE TO GALATIANS, P (f. 3); GALATIANS, P, Paul with a group of followers presents a book to a Galatian (f. 3v); EPHESIANS, P (f. 28v); PHILIPPIANS, P (f. 46v); COLOSSIANS, P (f. 59v); I THESSALONIANS, P (f. 71v); II THESSALONIANS, P (f. 80); TIMOTHY, P (f. 86); II TIMOTHY, P (f. 99v); TITUS, P (f. 107); PHILEMON, P (f. 112v); HEBREWS, M (f. 115).

Marginal drawings: paired dogs (f. 5v); hand feeding dog a morsel (f. 6); hare (f. 7v); frog (f. 8); eagles (f. 9); boat (f. 11v); man shooting arrow at a bird (f. 12); hand with sceptre, shoe (f. 12v); goat eating grapes (f. 13); hand with scythe, sheaf of wheat (f. 13v); stag, hounds (f. 14); head of a monk, fox and bait (f. 14v); fish (f. 15); vessels (f. 15v); foot (f. 16); head of a stork and owl (f. 16v); rooster, porcupine (f. 18v); dragon, ape (f. 19v); storks (f. 20v); stork, head of an animal (f. 21); porcupine pierced by a lance (f. 22v); head with pennant (f. 23); camel (f. 30); elephant (f. 31).

Peter Lombard's voluminous glosses on the Pauline Epistles began their rapid dissemination throughout the western European world in the early 1160s. The undated Saint-Victor manuscript is laid out in three columns, the biblical text being confined to a narrow vertical band in the middle of the page and the gloss taking up the wider spaces left and right. Large and handsome initials appear at the beginning of the Lombard's prologue, the prefaces of Romans, I Corinthians, Galatians and the remainder of the Pauline Epistles. The remaining prefaces in the second volume are introduced by smaller initials in gold with penwork flourishes, and those after II Thessalonians, with simpler red and blue flourished

letters. A remarkable feature of the decoration is the presence in the margins of lively and whimsical drawings in red and blue outline, which must count among the incunabula of the genre of Gothic marginal drolleries. The initials are the work of two distinct hands, and a third, less significant figure, who executed three ornamental letters near the end of the second volume (ff. 99v, 112v, 115v). The major artist, who was responsible for the initials in the first volume and several more in the second (ff. 3, 3v, 86) is an outstanding talent, whose style has both English and Mosan connections, the latter well observed by L. Ayres. His compositions are inventive variations on the theme of Paul as an author and exponent of doctrine. Their draughtsmanly quality is reminiscent of the illumination of the Mosan-oriented hand in the Capucins Bible (Bibl. Nat. lat. 16743–46; no. 79), and somewhat more distantly, of the work of the Master of the Morgan Leaf in the Winchester Bible. Whether the manuscript is the product of a Parisian scriptorium remains uncertain, though the note mentioning a previous owner, an Italian cleric named Jacobus, makes it evident that it was purchased there. R. Branner tentatively suggested that it might have been made at Saint-Victor itself. The same man also purchased and presumably gave to Saint-Victor a Glossed Gospels of Luke and John, datable around 1210, now in the Mazarine Library (MS 142). P. Stirnemann speculates that he might be the *Magister Iacobus diaconus noster* commemorated on 22nd March in the Obituary of the abbey (Bibl. Nat. lat. 14673, f. 167), who is said to have given the library 'four Gospels Books well glossed and certain other books'.

PROVENANCE: Given to the Abbey of Saint-Victor by Jacobus, a cleric of SS. Lorenzo e Damaso, Rome (note on the inner back cover). Saint-Victor ownership inscription and anathema, late 12th century (f. 1). *Ex libris*, 16th century (ff. 2 and 4) and Inv. Nos. N. N. N. 25 and 25 (16th century); 72 and 73 (18th century) and C. b. 1819.

LITERATURE: L. M. Ayres, 'A Miniature from Jumièges and Trends in Manuscript Illumination Around 1200', *Intuition und Kunstwissenschaft. Festschrift für Hanns Swarzenski*, Berlin, 1973, 122–6; R. Branner, 'Manuscript Painting in Paris Around 1200', *The Year 1200: A Symposium*, New York, 1975, 174; Avril, *Royaumes d'Occident*, 192, 369; C. de Hamel, *Glossed Books of the Bible and the Origins of the Paris Book Trade*, Woodbridge, 1984, 33; P. Stirnemann, Review of De Hamel, *Bulletin monumental*, CXLIII, 1985, 365; V. Pace, 'Cultura dell' Europea medievale nella Roma di Innocenzo III: le Illustrazioni marginali del Registro Vaticano 4', *Römisches Jahrbuch für Kunstgeschichte*, XXII, 1985, 59; J. P. Turcheck, 'A Neglected Manuscript of Peter Lombard's "Liber Sententiarum" and Parisian Illumination of the Late Twelfth Century', *Journal of the Wal-*

ters Art Gallery, 44, 1986, 54; J. Vezin, 'Un curieux meuble médiéval, le fauteuil à bras mobiles des scribes', *Mélanges de la Bibliothèque de la Sorbonne*, 8, 1988, 87–93.

92. Paris, Bibliothèque Nationale MSS lat. 11534–35

Bible
460 × 345 mm., ff. 345 and 348, 2 cols., 43 lines
Last quarter of the 12th century.
Paris (?) *Ills. 222, 225*

lat. 11534

Historiated and ornamental initials: OLD TESTAMENT PROLOGUE, F, Jerome and Paulinus (f. 1); PREFACE TO PENTATEUCH, D, Jerome receiving inspiration from the Dove of the Holy Spirit (f. 5); GENESIS, I, Days of Creation (f. 6); EXODUS, H, finding of Moses; a hand-maiden tells Pharaoh's daughter of the discovery (f. 33v); LEVITICUS, V, the Lord speaks to Moses (f. 57); NUMBERS, L, the Lord speaks to Moses (f. 74); DEUTERONOMY, H, Moses speaks to the Children of Israel (f. 96v); PREFACE TO JOSHUA, T (f. 115v); JOSHUA, E, Joshua in armour and on horseback (f. 116v); JUDGES, P, death of Joshua (f. 130); RUTH, I, medallions with the death of Elimelech and Naomi with her two sons (f. 144); PREFACE TO KINGS, V (f. 146); I KINGS, F, Elkanah and his two wives (f. 147); II KINGS, F, the Amalekite brings Saul's insignia to David (f. 166v); III KINGS, E, Abisag the Sunnamite before King David (f. 181); IV KINGS, P, death of Ahaziah (f. 199v); PREFACE TO ISAIAH, N (f. 216); ISAIAH, V, enthroned Prophet, architectural prospect (f. 216v); PREFACE TO JEREMIAH, H (f. 242); JEREMIAH, V, Vision of the Boiling Cauldron (f. 242v); BARUCH, E, standing Prophet preaching to a group of men (f. 278); PREFACE TO EZEKIEL, H (f. 281v); EZEKIEL, E, Vision of the Four Living Creatures (f. 282); PREFACE TO DANIEL, D (f. 310); DANIEL, A, siege of Jerusalem (f. 311); PREFACE TO MINOR PROPHETS, N (f. 324); HOSEA, V, Hosea embraces Gomer (f. 324); JOEL, V, standing Prophet with scroll (f. 328); AMOS, V, standing Prophet with scroll (f. 329v); OBADIAH, V, standing Prophet with scroll (f. 332v); JONAH, E, sailors in a boat, Jonah emerging from the whale (f. 333); MICAH, V, standing Prophet with scroll (f. 334); NAHUM, O, seated Prophet with scroll (f. 336v); HABAKKUK, O, standing Prophet with scroll (f. 337v); PRAYER OF HABAKKUK, D, the Prophet in prayer before the Lord (f. 338); ZEPHANIAH, V, seated Prophet with scroll (f. 339); HAGGAI, I, standing Prophet with scroll (f. 340); ZECHARIAH, I, the Lord speaks to the Prophet (f. 341); MALACHI, O, enthroned Prophet with scrolls (f. 347v).

lat. 11535

Historiated and ornamental initials: PREFACE TO JOB, C (f. 2); JOB, V, Job mocked by his wife and the three

temptors (f. 3); PREFACE TO PSALMS, D (f. 16v); P (f. 17); Psalm 1, B, David harping, David slaying the lion; combat with Goliath (f. 17v); Psalm 26, D, figure with a globe of the world (f. 23); Psalm 38, D, seated figure pointing to his eye and conversing with a demon (f. 26v); Psalm 51, Q, beheading of a man, dove with scroll (f. 30); Psalm 52, D, figure before an altar on which a goat stands (f. 30v); Psalm 68, S, bust of the Lord, figure in front of a body of water (f. 33v); Psalm 80, E, the Lord holding a wafer-like object, figure with scroll (f. 37v); Psalm 97, C, an altar with a crowned man and woman (f. 41); Psalm 101, D, kneeling figure, Dove of the Holy Spirit (f. 42); Psalm 109, D, seated Christ trampling two demons (f. 45); PREFACE TO PROVERBS, I (f. 53); PROVERBS, P, enthroned Solomon exhorting his son (f. 54); ECCLESIASTES, V, Personification of Wisdom (f. 65v); SONG OF SONGS, O, the Bride with the dove and lilies (f. 69v); PREFACE TO CHRONICLES, S (f. 71v); I CHRONICLES, A, a pair of seated figures; below, two groups of kneeling figures flanking the Ark (f. 73v); II CHRONICLES, C, Solomon makes an offering at an altar (f. 87); WISDOM, D, Personification of Justice with sword and scales (f. 105); PREFACE TO ECCLESIASTICUS, M (f. 113v); ECCLESIASTICUS, O, Personification of Wisdom (f. 114v); PREFACE TO EZRA, U (f. 137); EZRA, I, medallion with the Prophet and King Cyrus (f. 138); NEHEMIAH, V, architectural prospect, group of figures (f. 143); PREFACE TO ESTHER, L (f. 150v); ESTHER, I, medallions with Mordecai led in triumph, banquet of Ahasuerus, calling of Esther (f. 151); PREFACE TO JUDITH, A (f. 157v); JUDITH, A, siege of Bethulia (f. 157v); PREFACE TO TOBIT, C (f. 164v); TOBIT, T, Tobit healed by the angel Raphael (f. 165); PREFACE TO MACCABEES, M (f. 170); I MACCABEES, E, combat of warriors on horseback (f. 171); II MACCABEES, F, rider and group of figures (f. 188); PREFACES TO GOSPELS, B (f. 200v); S (f. 201); P (f. 201v); CANON TABLES, Healing of the possessed man and casting out of demons (f. 203v); Balaam and his ass, healing of the paralytic (f. 204); the rich man in hell and Lazarus in the bosom of Abraham (f. 204v); Dormition and Assumption of the Virgin (f. 205); Calling of Peter and Transfiguration (f. 205v); Christ with Martha and Mary, Resurrection of Lazarus (f. 206); PREFACE TO MATTHEW, M (f. 207); MATTHEW, L, Tree of Jesse (f. 207); PREFACE TO MARK, M (f. 224); MARK, I, Lion of Mark (f. 225v); PREFACE TO LUKE, L (f. 235); LUKE, Q, Ox of Luke (f. 235v); PREFACE TO JOHN, H (f. 253); JOHN, I, Eagle of John (f. 254); PREFACE TO ACTS, L (f. 267); ACTS, P, Ascension of Christ (f. 268v); PREFACE TO CATHOLIC EPISTLES, N (f. 285); JAMES, I, standing Apostle (f. 285v); I PETER, P, Apostle, Dove of the Holy Spirit (f. 287v); II PETER, S, Peter with keys, group of bystanders (f. 289v); I JOHN, Q, John at a lectern (f. 291); II JOHN, S, bust of John, group of figures (f. 293); III JOHN, S, bust of John, group of figures (f. 293v); JUDE, I, standing Apostle with scroll (f. 294); PREFACES TO PAULINE EPISTLES, P, I (ff. 294v, 300); ROMANS, P, seated Paul, Dove of the Holy Spirit (f. 300v); I CORIN-

THIANS, P, Paul as traveller on his way to Corinth (f. 307v); II CORINTHIANS, P, seated Paul, Dove of the Holy Spirit (f. 314v); GALATIANS, P, seated Paul, architectural prospect (f. 319); EPHESIANS, P, seated Paul, Dove of the Holy Spirit (f. 321v); PHILIPPIANS, P, standing Paul with scroll (f. 324); COLOSSIANS, P, standing Paul, architectural prospect (f. 326); I THESSALONIANS, P, seated Paul with book (f. 327v); II THESSALONIANS, P, standing Paul with a group of Thessalonians (f. 329); I TIMOTHY, P, standing figure at an altar (f. 330); II TIMOTHY, P, seated Paul with book, Dove of the Holy Spirit (f. 332v); TITUS, P, Paul, architectural prospect (f. 334); PHILEMON, P, seated Paul, architectural prospect (f. 334v); HEBREWS, M, bust of Christ, Paul in discourse with two Hebrews (f. 335v); PREFACE TO APOCALYPSE, I (f. 340v); APOCALYPSE, A, bust of Christ, John on Patmos (f. 341).

The manuscript belongs to a small group of late 12th-century Bibles in which the decoration achieves a systematic disposition rare or unknown at an earlier date. This decoration, whether by a single painter or a well integrated team, has an evenly-weighted and uniform appearance throughout. All the biblical books and the divisions of the Psalter have historiated initials, while the prefatory texts (setting aside the opening Old Testament prefaces) have ornamental letters. The work is in many aspects of its illumination so similar to the Manerius Bible in the Bibliothèque Sainte-Geneviève (MSS 8–10; no. 81) that a direct relation between the two manuscripts must be assumed. Many of the initials in the two Bibles, as well as the cycle of illustrations in the lunettes of the Canon Tables are more or less identical in iconography and composition. The cases of complete or near identity are most numerous in the first volume (roughly corresponding to the contents of the first two volumes of the Manerius Bible). There are also initials similar to those in the Sainte-Geneviève manuscript in their subject, yet sufficiently divergent in the interpretation, to make it doubtful that they were directly copied from that work. The interesting cycle of Psalter illustrations falls in this category. The style of the painting in the manuscript of the Bibliothèque Nationale, which includes a tooling of the gold grounds with the help of little circles and dot patterns in triplets, is somewhat looser than that of its relation, and much of Manerius' painstaking detail is reproduced in simplified or abridged form. It is clear that the Manerius Bible (or a hypothetical sister manuscript) must have been consulted by the artist, though this seems not to have been his exclusive source. He was perhaps an assistant of Manerius who later struck out on his own. The text of the two Bibles is similar in its main lines but there are, here too, enough divergences to cloud the picture of affiliation. The manuscript was at Saint-Germain-des-Prés in the 15th century, but whether it was made there is uncertain. Delisle's statement (*Cabinet des manuscrits*, II, 45) that lat.

11534 came from the collection of the Président de Machaux (1655) who is known to have owned a number of manuscripts from the Norman abbey of Préaux could not be substantiated.

PROVENANCE: Saint-Germain-des-Prés, 15th-century note: '*Frater Nicolaus Delot, religiosus de sancto Germanno*' (lat. 11534, f. 344v). Saint-Germain-des-Prés MSS 5 and 6, then 19 and 20. Acquired by the Bibliothèque Nationale in 1795-6.

LITERATURE: Delisle, *Cabinet des manuscrits*, II, 45; Berger, *Histoire de la Vulgate*, 193, 408; G. Haseloff, *Die Psalterillustration im 13. Jahrhundert*, Kiel, 1938, 12; C. Nordenfalk, 'Insulare und kontinentale Psalterillustrationen aus dem XIII. Jahrhundert', *Acta Archaeologica*, X, 1939, 110, 112; T. S. R. Boase, *English Art, 1100–1216*, Oxford, 1953, 187; L. Eleen, *The Illustration of the Pauline Epistles in French and English Bibles of the Twelfth and Thirteenth Centuries*, Oxford, 1982, 55; Cahn, *Romanesque Bible Illumination*, 208, 224, 277–8, No. 93; M. H. Caviness, *Sumptuous Arts at the Royal Abbeys in Reims and Braine*, Princeton, 1990, 8, 127–8, 130.

EXHIBITED: *Manuscrits à peintures*, Paris, 1954, 114, No. 335; *The Year 1200*, New York, 1970, 247, No. 246.

93. Paris, Bibliothèque Nationale MS lat. 17716

Liturgical and historical compilation concerning Cluny
360 × 255 mm., ff. 102, 2 cols., 30 lines
(ff. 15–100v)
Late 12th century (after 1189).
Saint-Martin-des-Champs *Ills. 226, 227, 228*

Miniatures of varying sizes: Transfiguration (f. 7v); a monk, probably Peter the Venerable, kneeling before the Virgin and Child (f. 23); miraculous healing of Robert, a man of Paris, on Mount Sainte-Geneviève (f. 35); apparition of St. Peter, St. Paul and St. Stephen to Gunzo, Abbot of Baume, and dialogue of Gunzo with St. Hugh, Abbot of Cluny (f. 43); dedication of the abbey church of Cluny by Pope Urban II (f. 91).

Historiated and ornamental initials: O, praying monk (f. 8); A (f. 9); A (f. 12); A (f. 13v); C, Peter the Venerable speaks to a group of monks (f. 25); St. Hugh of Cluny speaks to Robert, a man of Paris, whom he heals (f. 35); P (f. 36v); R, William the Conqueror sends a letter to Abbot Hugh (f. 37v); S (f. 39); E (f. 40v); C (f. 46); P (f. 73); C, Duke William of Aquitaine addresses two monks of Cluny (f. 85); A (f. 95).

Assembled in this volume are a series of texts pertaining to the history of the abbey of Cluny. These include sections of Peter the Venerable's *De miraculis* and other accounts of miracles drawn from the life

of Abbot Hugh of Semur (ff. 25–47); an extract from the life of St. Odilo (f. 47); letters and other writings of Hugh (ff. 70–75); information concerning relics of St. Basil and St. Stephen at Cluny (ff. 75v–77); a letter of Peter Damian addressed to Cluny (ff. 80–85); the testament of Duke William of Aquitaine providing for the foundation of the monastery in 910 (ff. 85–87); papal privileges in favour of the abbey issued by Gregory VII, Urban II and Lucius II (ff. 88v–94v); and the annals of Cluny from 910 to 1215 (ff. 95–100). This material is preceded by an anthology of liturgical compositions with musical notation, one of them a piece in honour of St. Hugh (f. 4), another for the feast of the Transfiguration, attributed to Peter the Venerable (f. 8). The date of the work is established by a break in the Cluny Annals, which up to 1189 are in the original hand, while the entry for that year referring to the departure of Philip Augustus and Richard the Lion Heart for the Crusade, is a slightly later addition, as are those up to the year 1215 that follow. The collection of material contained in the manuscript is unique, and this fact, together with the luxurious presentation of the volume, suggests that it must have been prepared for some special purpose or occasion.

The illumination is the work of a single painter, who used bright colours, applied in a flat and pasty manner, along with much gold. His style is linear, brittle and rather coarse. Nothing in Parisian art of the late 12th century, then committed in its main lines to a more relaxed, proto-Gothic manner allied with English and Franco-Flemish developments, can be compared with it. The subject matter of the illustration is unusual, as is the text itself. It centres on the glorification of Peter the Venerable, and especially of St. Hugh, Abbot of Cluny from 1049 to 1109, and builder of the great abbey church (Cluny III). The solemn dedication of the abbey church of Cluny III on 25th October 1095 is depicted, along with the approbation given for this extraordinary project by Cluny's patron saints in an apparition to Abbot Gunzo of Baume. The fact that the priory church of Saint-Martin-des-Champs was itself an ambitious

construction with intimations of the new Gothic style perfected a few years later in the choir of Suger's Saint-Denis might have motivated the compiler and illuminator of the manuscript to make a prominent reference to these events. Hugh's biographers credit him with having transformed Saint-Martin from a house of canons into a monastery. The miraculous healing of the paralysed knight Robert (f. 35) was no doubt given pictorial emphasis because of its Parisian setting, not too distant from Saint-Martin.

PROVENANCE: Saint-Martin-des-Champs, MS 35 (f. 1). Acquired by the Bibliothèque Nationale in 1796.

LITERATURE: L. Delisle, *Inventaire des manuscrits de la Bibliothèque Nationale. Fonds de Cluni*, Paris, 1884, 223–6, No. 129; Dom A. L'Huillier, *Vie de Saint Hugues, abbé de Cluny, 1024–1109*, Solesmes, 1888, *passim*; Haseloff, *Miniatures*, 308; Lauer, *Enluminures romanes*, 140–42; A. Wilmart, 'Le poème apologétique de Pierre le Vénérable et les poèmes connexes', *Revue bénédictine*, LV, 1939, 59–69; G. Constable, 'Manuscripts of Works by Peter the Venerable', *Petrus Venerabilis, 1156–1956* (Studia Anselmiana, 40), Rome 1956, 228; D. Bouthillier, 'La tradition manuscrite du 'De Miraculis' de Pierre le Vénérable. Bilan d'une première recherche', *Revue d'histoire des textes*, VI, 1976, 199ff.; *Manuscrits datés*, III, 1974, 589; M. Huglo, 'Les débuts de la polyphonie à Paris: les premiers "organa" parisiens', *Forum musicologicum. Basler Beiträge zur Musikgeschichte*, III, 1982, 128–9, 146; G. Ladner, *Die Papstbildnisse des Altertums und des Mittelalters* (Monumenti di Antichità Christiana, IIe Ser., IV), Città del Vaticano, 1984, 114–15; C. C. Carty, 'The Role of Gunzo's Dream in the Building of Cluny III', *Gesta*, XXVII/1–2, 1988, 113–23.

EXHIBITED: *Manuscrits à peintures*, Paris, 1954, 102, No. 296; *Ornamenta Ecclesiae*, Cologne, 1985, I, 185, No. B 20; *Cluny III. La maior ecclesia*, Cluny, 1988, 116–18, No. 131.

VI. PICARDY, ARTOIS AND FLANDERS

94. Saint-Quentin, Chapter Library, MS 1 [on deposit in the Bibliothèque Municipale]

Life and Miracles of St. Quentin
285 × 180 mm., pp. 184, 21–22 long lines
Beginning of the 12th century.
Saint-Quentin (?) *Ills. 230, 231, 232, 233*

Framed *incipit* page with haloed bust of a cleric holding a quill and an ink-well (p. 4); framed page with initial D (p. 5); St. Quentin seated within an arcade accepts a book tendered to him by a cleric (p. 6); full-page framed *incipit* for the text with initial T (p. 7); St. Quentin leaves Rome with eleven companions (p. 9); arrest of St. Quentin, who is brought be-

fore the prefect Rictiovarus and led to prison (p. 11); St. Quentin brought before Rictiovarus (p. 13); torture of St. Quentin, who is whipped by his tormentors (p. 16); new appearance of St. Quentin before Rictiovarus, who orders him to be locked up in a dark cell (p. 18); an angel breaks St. Quentin's chains and liberates him (p. 19); Quentin preaches before a multitude at Amiens (p. 20); Quentin baptises a group of converts (p. 23); St. Quentin's absence is noted by his jailers, who have converted to his faith and so inform Rictiovarus (p. 25); Rictiovarus orders Quentin brought before him to deny his faith (p. 26); torture of St. Quentin, whose arms are twisted with angular bars (p. 29); Quentin is tied to the ground and lacerated with rakes (p. 30); Rictiovarus orders him to be tortured with flaming torches (p. 32); hot vinegar with mustard and other substances are poured into his mouth (p. 34); two guards seize Quentin and lead him away (p. 36); Quentin is charged with chains and beaten (p. 37); Quentin is led to Augusta Viromandorum by a knight and brought in chains before Rictiovarus (p. 38); a blacksmith and his assistants forge nails and hooks for more tortures (p. 41); Quentin is tortured with spikes driven in his shoulders and under his nails (p. 42); St. Quentin is condemned to death; he asks to pray (p. 43); decapitation of St. Quentin (p. 45); the headless body of St. Quentin is thrown into the river Somme (p. 47); the soul of St. Quentin is taken into heaven (p. 49).

This collection is a *libellus* containing an account of the martyrdom of St. Quentin and additional texts concerning the discovery and translation of his body, miracles performed through his intercession, and sermons to be recited at liturgical celebrations in his honour. Quentin, known in legend as a Roman missionary active in the company of St. Lucien at Beauvais and Amiens, is thought to have been martyred in the years between 282 and 286. The location of his body was miraculously revealed to a blind woman named Eusebia in 340, but the *acta* concerning these events are thought in their present form to date from the 7th or the early 8th century only. The present manuscript, which in the local tradition is called the *Authentique* (*authenticum*) is either a copy of this material or a reworking. Antiquarian scholarship of the 17th and the 18th centuries identified as the author or editor the figure of the haloed cleric with a quill and inkhorn, inscribed Raimbertus, who is represented above the title of the prologue of Quentin's *passio* (p. 4) in the manuscript, but not mentioned anywhere in the text. According to the *Augusta Viromandorum* (1643) of Cl. Hemeraeus and writers after him, Raimbertus was the first holder of a canonicate possessed by Countess Adèle of Vermandois at Saint-Quentin, and given by her in 1104 to the abbey of Saint-Quentin at Beauvais after the death of her husband, Count Hugh, in the course of the First Crusade. Hemeraeus gives no source for these state-

ments, however, and a charter of King Philip of France which alludes to the transfer of this canonicate, places the transaction in 1089 and makes no mention of Raimbertus (M. Prou, *Recueil des actes de Philippe 1er, roi de France*, Paris, 1908, 302–4, No. CXIX). Thus, although the date furnished by Hemereus' putative source is not contradicted by the palaeography and style of the manuscript, no objective datum seems to support it. The interpretation of the portrait of Raimbertus also presents some difficulties and the way in which his relation to the manuscript should be construed has been differently assessed. The quill and inkhorn would seem to designate a scribe rather than an author, but the commanding position of the figure within the composition, and not least, his halo, would tend to point to someone of higher religious or social standing. The question is further complicated by the presence of a second, unidentified cleric, who with veiled hands tenders a book to St. Quentin (p. 6).

The Saint-Quentin manuscript is a luxury production, written by several hands. The body of the text has capital letters in gold at the beginning of sentences, and the name Quintinus is also rendered in majuscule gold or red letters throughout. The illuminator's energies are chiefly concentrated on the account of Quentin's martyrdom (pp. 4–50). In addition to its illustrations, this section has full-page framed *incipit* pages with gold capital letters and ornamental initials for the Prologues and the beginning of the text (pp. 5, 6, 7), as well as painted initials in gold and other colours at the head of the separate chapters, while the first line of these sub-sections is emphasized by a green stripe. Thereafter, the decorative scheme becomes less elaborate, consisting only of ornamental initials, one of them rather ambitious in scale and design (p. 51), the rest much simpler.

Relatively little is known about Quentin's life, but the travails which he is said to have endured for his faith on the orders of a Roman magistrate named Rictiovarus are detailed at length and with a relish unusual even by the standards of the genre. Beyond an iconic portrait of Quentin (p. 6) and equally conventional apotheosis following his execution (p. 49), the painter thus supplied numerous illustrations of the ingenious tortures inflicted upon him, alternating with appearances before his Roman tormentor. These paintings are executed in a fairly pallid range of body colour, mainly light blue, pink, lilac and olive green, supplemented by gold and silver. The scenes, which are accompanied by versified *tituli* in red uncials (p. 9) and Carolingian minuscule afterward, are generally unframed and not too elegantly fitted into their allotted spaces, spilling out here and there into the margins. Where the illustration occupies an entire page, two episodes of an oblong format are combined (pp. 11, 32, 34 and 42), but there are instances where the artist sought instead to adapt a single scene to the available space, sometimes

through the addition of incidental details or staffage, as in the case of the pair of fallen torturers in the scene of the beating of St. Quentin (p. 16), the depiction of a blacksmith heating nails for more tortures (p. 41), and the four soldiers with lances below the scene of the beheading (p. 45). These complications, as well as certain features of the style raise the possibility that these miniatures were copied from an older set of text illustrations consisting of single, separate scenes. Given the dating of the textual compilation in the Carolingian period, it is conceivable that the illustrations were created at the same time.

The collegiate church of Saint-Quentin possesses a 9th-century Gospel Book connected with the School of Reims (C. Fierville, *Bulletin du Comité des travaux historiques*, 1883, 40–45), but there is no other evidence of a local scribal activity that would provide a comparative basis for the dating and localization of the *Vita*. The work has no very clear parallels or relations, though its archaizing idiom evokes in general terms the illustrations of the First Life of Saint-Amand (Valenciennes, Bibl. Mun. MS 502) and the active Carolingian strain discernible in books illuminated in other north-eastern French and Flemish scriptoria in the 11th and early 12th century. So far as is known, the manuscript has since the Middle Ages been preserved in the basilica of Saint-Quentin (it has been deposited, since 1990, in the Bibliothèque Municipale). It was in all likelihood made for use in the Romanesque predecessor of the present splendid 13th-century monument. The book has suffered from wear, and the paintings are somewhat depreciated by abrasion. Two of the original miniatures — the discovery of the body of the saint in the Somme River (p. 47) and the apotheosis (p. 49) — are lost and replaced in the manuscript by 19th-century copies. A gouache copy of the entire work was made in 1816 (Saint-Quentin, Bibl. Mun. MS 98) and served as the basis of these replacements. It is of fairly mediocre quality, but given its early date, of considerable historical interest.

PROVENANCE: Written (?) by Raimbertus (p. 4). Collegiate Church of Saint-Quentin.

LITERATURE: Cl. Hemeraeus, *Augusta Viromandorum vindicata et illustrata*, Paris, 1643, 125–6; L.-P. Colliette, *Mémoires pour servir à l'histoire ecclésiastique, civile et militaire de la Province du Vermandois*, Cambrai, 1771, I, 39ff., and II, 45; *AA.SS.*, Oct., XIII, 727–30; C. Gomart, 'L'authentique-manuscrit de Saint-Quentin', *Mémoires de la Société académique d'archéologie, sciences et arts du Départment de l'Oise*, II, 1852, 420–23 [also published in *Bulletin monumental*, XXI, 1855, 422–6]; F. Wormald, 'Some Manuscripts of the Lives of the Saints', *Bulletin of the John Rylands Library*, XXXV, 1952, 257–8 (repr. in *Collected Writings*, II, London, 1988, 48–9); Swarzenski, *Monuments of Romanesque Art*, 52–53, No. 82; Grabar and Nordenfalk, *Romanesque Painting*, 148; Dodwell, *Painting in*

Europe, 84; *Colophons*, V, 1979, 199, No. 16.363; C. Hahn, *Passio Kiliani/ Ps. Theotimus, Passio Margaretae/Orationes* (Codices Selecti, LXXXIII), Graz, 1988, 80, 150–1.

EXHIBITED: *Manuscrits à peintures*, Paris, 1954, 71, No. 180; *Les volets du retable de Nucourt et l'iconographie de Saint Quentin*, Pontoise, 1963, 27–31.

95. Paris, Bibliothèque Nationale MS lat. 17767

Martyrology, Rule of St. Benedict and Obituary
320 × 225 mm., ff. 197 + I, 23–30 (ff. 11–166) and 47 (ff. 193–96) long lines
c. 1102–23. Saint-Pierre, Corbie *Ills. 229, 234*

Independent illustrations: Nevelo presents his book to St. Peter (f. 11v); Nevelo humbles himself before St. Benedict (f. 134).

Martyrology

Marginal drawings: John the Evangelist with a chalice (f. 12v); David enthroned (f. 12v); St. Sabina (f. 13); January, a man bearing a barrel or a load of wood (f. 13v); St. Telesphorus (f. 15); February, figure warming himself by a fire (f. 23v); March, figure carrying a shovel and a plant (f. 29v); April, figure pruning tree (f. 34v); May, figure in fancy dress holding plant (f. 40v); June, figure scything hay (f. 52); August, figure with scythe (f. 76v).

Historiated initials: I, standing Virgin nursing the Child (f. 12); A, martyrdom of St. Stephen (f. 12); I, St. Celerinus (f. 24); I, St. Philaeas (f. 25v); I, St. Eulalia (f. 26); I, St. Agabus (f. 26); I, St. Polyeuctus (f. 26); I, St. Polychronius (f. 27); I, St. Simeon (f. 27); I, St. Nestor (f. 29); I, St. Leander (f. 29); I, St. Romanus (f. 29v); I, St. Felicitas (f. 30); I, St. Patricius as a shepherd (f. 32v); I, St. Cuthbert (f. 32v); I, St. Paul (f. 33); I, Annunciation (f. 33v); I, St. Gerald (f. 35); I, St. Euphemia (f. 36); I, St. George (f. 38v); I, St. Jerome (f. 40v); I, St. Silvius (f. 44); I, tower (f. 45v); I, St. Pontius (f. 47v); I, St. Dioscorus (f. 49); I, St. Medardus (f. 58); I, St. Albanus (f. 62v); I, Aaron (f. 66v); I, St. Euplus (f. 84); I, St. Ursacius (f. 85); St. Privatus (f. 86v); I, St. Bartholomeus (f. 87); I, St. Victorinus (f. 94); I, St. Sosius (f. 104); I, Archangel Michael (f. 106); I, St. Apollinaris (f. 109); I, St. Caprasius (f. 112v); I, St. Marcus (f. 113v); I, St. Felix (f. 114); I, St. Martin (f. 119); I, St. Andrew (f. 127).

Rule of St. Benedict

Marginal illustrations: A, St. Benedict with a kneeling monk (f. 135); I, standing abbot (f. 140); I, haloed monk (f. 147); I, haloed monk with staff (f. 147v); I, standing monk (f. 149v); I, standing monk (f. 149v);

I, standing monk drinking from a cup (f. 152v); I, standing abbot with staff (f. 162v).

This interesting work, examined and analysed on more than one occasion in the past, has not come down to us in its original state. The body of the text, consisting of a version of the Martyrology of Ado (ff. 11–134) and Rule of St. Benedict (ff. 134v–166) was written by Nevelo, a monk of Corbie, who did so 'with his own hand and at his own cost' *(propriis sumptibus elaboratum et propria manu prout potui descriptum)*. The date of the enterprise can be approximately situated between 1102 (obit of Abbot Eustace of Saint-Père at Chartres, f. 41v) and 1123 (obit of Abbot Nicholas of Corbie, f. 30, which is added in a later hand). The following section consisting of an Obituary (ff. 67v–184v) and part of the Epistles and Gospel readings for the church year is a later addition dated by Mérindol between 1126 and 1152, and intended to replace Nevelo's own transcription of this material, judged to be inconveniently arranged. The final part (ff. 193–196v), once again in the hand of Nevelo, is an abridged version of the Hieronymian Martyrology, called by the scribe Liber de capitula. In this, Nevelo thrice more identifies himself and asks that he be remembered by the reader. Mérindol has discovered that part of Nevelo's original redaction of the Epistles and Gospel readings displaced by the later emendation of the manuscript survives in Bibl. Nat. lat. 12410 (ff. 1–16).

The illustration of the manuscript consists of frontispiece designs for the Martyrology (f. 11v) and Rule of St. Benedict (f. 134v), as well as pen-drawn initials and lively marginal-drawings. Two artists seem to be involved. The more monumentally-inclined, precisionist draughtsman was responsible for the Martyrology frontispiece showing Nevelo presenting an open volume to the enthroned St. Peter, the patron of Corbie, and possibly for the drawings of St. Romanus as a monk and a labourer personifying March (f. 29v). The inscription mentioning the scribe above Nevelo's head is partially scratched out, but was recopied at the bottom of the page in the early 13th century. Another inscription in bold letters which ran along the contours of the kneeling figure's back and probably identified him was, in a similarly unfathomable way, erased. The frontispiece of the Rule of St. Benedict, which shows Nevelo once more, humbling himself at Benedict's feet, is like the initials and marginal drawings in the body of the manuscript attributable to a second draughtsman, perhaps assisted by another hand, and working in a more informal and small-scaled manner. The drawing is incorporated within the ornate rendering in decorative majuscule letters of the *incipit* words. The same subject is repeated again on the following recto, with the rest of the phrase. The numerous initials, drawn in red and black, consist of KL monograms for each of the months in the martyrology, and historiated and ornamental letters at the head of the entries for each day of the Calendar. The KL monograms are accompanied by drawings of the Labours of the Months, though the scheme was not carried out in a systematic fashion to the end of the text and trails off after the month of June. The historiated initials are for the most part standing figures employed for the letter I. The same mixture of ornamental letters of stylized foliage and standing figures where I's are required occurs in the Rule of St. Benedict, though on a more sparing basis.

Beyond the present manuscript, Nevelo's hand can be recognized in a number of Corbie manuscripts in which he made various additions. The decoration of lat. 17767 has no known local antecedent. The style of the first draughtsman, in which there are reminiscences of the Saint-Germain-des-Prés books of the scribe-illuminator Ingelardus, seems to be perpetuated, though in a drier form, in the frontispieces of two other Corbie manuscripts of the first half of the 12th century, a copy of Jerome's Commentary on Ecclesiastes (Bibl. Nat. lat. 13350) and Paschasius Radbertus' *Liber de corpore et sanguine Christi* (Bibl. Nat. lat. 12299). The second, more informal artist and his associate are closer to Remois production of the later 11th century. Their influence can be felt in the decoration of the Corbie Lectionary (Bibl. Nat. lat. 13392).

PROVENANCE: Written by Nevelo, a monk of Corbie (ff. 11, 134v and 196v). Corbie Nos. 5 (f. 1) and 127 (f. 1). On deposit in the Bibliothèque Municipale at Amiens in 1791, and acquired by the Bibliothèque Impériale in 1803.

LITERATURE: Delisle, *Cabinet des manuscrits*, II, 118; id. 'Recherches sur l'ancienne bibliothèque de Corbie', *Mémoires de l'Académie des Inscriptions et Belles-Lettres*, XXIV, 1864, 288; A. Molinier, *Les Obituaires français au moyen âge*, Paris, 1890, 55–6 and 202–3, No. 248; W. Wattenbach, *Das Schriftwesen im Mittelalter*, Leipzig, 1896, 443; H. Quentin, *Les Martyrologes historiques du moyen âge*, Paris, 1908, 467, 475, 677–8; A. Wilmart, *D. A. C. L.*, III, 1914, 2931–2; L. W. Jones, 'The Scriptorium at Corbie. I. The Library', *Speculum*, XXII, 1947, 199; F. Avril, 'Un manuscrit de Beauvais et le Maître des Évangiles de Corbie (Manuscrit Amiens 24)', *Cahiers archéologiques*, XXI, 1971, 189, n. 14; *Manuscrits datés*, III, 1974, 591. *Colophons*, V, 1976, 236, No. 13955; Mérindol, *Corbie*, II, 998–1001 and *passim*; J.-L. Lemaître, *Répertoire des documents nécrologiques français* (Recueil des Historiens de la France. Obituaires, VII), Paris, 1980, II, 856-8, No. 2008; C. de Mérindol, 'Les peintres de l'abbaye de Corbie au XIIe siècle', *Artistes, artisans et production artistique au moyen âge. I. Les hommes*, Paris, 1986, 311–26; id., 'Le recueil de Névelon pour l'abbaye de Corbie et son modèle: quelques sources de l'art roman', *Cahiers archéologiques*, XXXV, 1987, 81–112.

EXHIBITED: *Manuscrits à peintures*, Paris, 1954, 59, No. 134.

96. Ghent, Centrale Bibliotheek van de Rijksuniversiteit Cod. 1125 (92)

Lambert of Saint-Omer, *Liber Floridus*
370 × 204 mm., ff. 289, 25 to 40 long lines
Before 1121. Saint-Omer
Ills. 235, 236, 237, 238, 239, 240

St. Audomarus enthroned (f. 6v); the villa of Sithiu and castle of Saint-Omer, with a portrait of Lambert in the act of writing (f. 13); diagram of the concordances of the Gospels (f. 15); T Map with the peoples of the world (f. 19); rota of the six ages of the world (f. 19v); Minotaur in the Labyrinth (f. 20); rota of the ages of the world and microcosm (f. 20v); rota of the twelve winds (f. 24); the five climactic zones (f. 24v); diagram of the course of the sun through the solstices and equinoxes (f. 25); diagram of the phases of the moon, four winds, elements and seasons (f. 25v); *Sphaera Apulei* (f. 26); Paradise (f. 52); lion and porcupine (f. 56v); man-eating griffon (f. 58v); dragon (f. 60v); crocodile (f. 61v); Devil riding on Behemoth (f. 62); Antichrist riding on Leviathan (f. 62v); Heavenly Jerusalem (f. 65); allegory of the Palm Tree (f. 76v); Christ with the Lamb of God, the four elements, altar of God and abyss (f. 88); sun and planets (f. 88v); signs of the zodiac (ff. 89–91v); diagram of the course of the sun and moon around the earth (f. 92); map of the world with the five climatic zones (f. 92v–93); phases of the moon and planets (f. 93v); planets and constellations of the northern sky (f. 94); diagram of the course of the seven planets (f. 94v); Tree of Consanguinity (f. 102v); computistic rota (f. 130); Augustus enthroned holding the globe of the world (f. 138v); allegory of the plants in the Song of Songs (ff. 139v–140); Alexander on Bucephalus (f. 153v); Rome with the enthroned St. Peter (f. 168); framed text of the Donation of Constantine (f. 188v); Charles the Bald (f. 207); Noah's Ark (f. 208v); the five celestial zones (f. 221v); harmonic ratios (f. 222); World Map with the phases of the moon and the planets (f. 225); orbits of the seven planets (f. 225v); spheres of the planets, constellations, cycles of the moon (f. 226); orbits of the planets (f. 227); planets, celestial zones, zones of the earth (f. 227v); orbits of the planets and zones of the earth (f. 228); diagram of the planets, elements and humours (f. 228v); allegory of the lily (f. 230v); Trees of Virtues and Vices (ff. 231v–232); Dream of Nebuchadnezzar (f. 232v); map of Europe (f. 241); Christ with Synagoga and Ecclesia (f. 253); the church of Saint-Omer (f. 259v); St. Audomarus as standing figure (f. 260).

Ornamental initials: A (f. 3v); S (f. 15); C (f. 68v); G (f. 77); N (f. 86v); A (f. 110v); Q (f. 141v); V (f. 144v); S (f. 156); O (f. 166v); B (f. 168v); A (f. 191); E (f. 207).

The Ghent manuscript is the autograph copy of the *Liber Floridus*, a copiously illustrated encyclopedic compilation made by Lambert, a canon of the church of Saint-Omer, which St. Bertin of Sithiu founded in the 9th century. The author identifies himself in the prologue as the son of one Onulfus, who had himself been a canon of the same house (f. 3v); The *obit* of Onulfus, entered in the annals that are part of the compilation (f. 43v), indicates that he died in 1077. Lambert also provided a portrait of himself at work within a symbolic representation of the church and castle of Saint-Omer (f. 13). On the basis of a variety of historical data included in the manuscript, it can be concluded that the *Liber Floridus* was completed before 1121, and probably in 1120. The work draws on a wide range of sources, Orosius, Isidore of Seville, Bede, Freculph of Lisieux and Rabanus Maurus being among the more frequently mentioned authorities cited in the text. A. Derolez was able to identify some of the manuscripts from the library of Saint-Omer used by the compiler and containing annotations in his hand. Lambert's own assembly of this material has been judged rather severely by modern scholarship, Delisle characterizing the results as 'une compilation assez bizarre et mal ordonnée' (*Notice*, 579). However, a detailed codicological study of the manuscript made by Derolez has shown that the author, having begun the work around 1112, made repeated additions and modifications in the course of his labours, which had the effect of obscuring an initially logical scheme. The volume has suffered losses amounting to some forty folios, according to the calculations of Delisle, and the fading ink caused some of the text to be written over in the late Middle Ages. The missing text and illustrations can be reconstructed on the basis of the copies of the work which were made from the middle of the 12th up to the 15th century. The lost illustrations and the articles of Delisle's catalogue of the contents of *Liber Floridus* which refer to them, are as follows: Solomon enthroned (28); the cosmological diagram of the *Spera mensium XII et elementorum* (29); the Virgin Mary (31); Apocalypse cycle (32); diagram of the *Mappa vel Oresta Mundi* (47); the zodiacal diagram with Christ in Majesty (130); and the map of the earth with the three continents, entitled *Spera Geometrica* (173).

The *Liber Floridus* is written on leaves made of a coarse parchment, the dimensions of which are not all the same. Some of the pages have added strips designed to bring them to full size, and others attachments that fold out. These procedures and the fact that some of the leaves appear to have been reused after being scraped indicate that the Ghent manuscript is very much an author's working copy rather than the finished product of a well-organized scriptorium. It is now generally accepted that Lambert both wrote and illuminated the manuscript, as is suggested also by the statement which concludes the genealogy of his family that he inserted in the work:

Lambertus filius Onulfi, qui librum fecit (f. 154). Lambert expended much effort on the decoration, and nearly every page has some sort of calligraphic embellishment. At the beginning of the different sections of the work, there are ornate titles in majuscule letters enlivened with touches of colour, and multicoloured, pen-drawn ornamental initials incorporating stylized foliage. The illustrations are drawn in a combination of black and red outline, with flat colours, chiefly blue, acid green and red, filling different parts of the design. Some of these images were evidently borrowed from older sources. The signs of the zodiac (ff. 88–94) and the cosmological schemata are found in illustrated scientific compendia of the early Middle Ages chiefly assembled from the writings of Isidore of Seville and Bede. The Apocalypse cycle, missing from the Ghent codex, but found in later copies of the *Liber Floridus* like the manuscript at Wolfenbüttel (no. 117) and the mid 13th-century volume from the Chartreuse of Montdieu (Paris, Bibl. Nat. lat. 8865) is allied with a recension that includes the Apocalypse illustrations of the 11th-century Roda Bible, the wall paintings of Castel Sant'Elia at Nepi, and the illustrations of Haymo of Auxerre's Commentary on the Revelation in Oxford (Bodley MS 352), as Peter Klein has demonstrated. The illustrations of the lion, griffin, dragon and crocodile (ff. 56v, 58v, 60v, 61) are borrowed from the Physiologus, though rendered by Lambert in a highly inventive way. The portraits of St. Omer (ff. 6v, 260) and the portrait of the author (f. 13) are stock types that could be discovered in the illumination of the nearby abbey of Saint-Bertin and other houses of the region. On the other hand, some of the images included in the *Liber Floridus* are rare or altogether unique: the picture of Paradise, for example (f. 52), the allegories of the Palm Tree (f. 76v) and of the plants mentioned in the Song of Songs (ff. 139v–140), the lily (f. 230), Alexander on Bucephalus (f. 153v) and Antichrist riding on the Beast (f. 62v).

PROVENANCE: Written by Lambert, a canon of Saint-Omer (f. 3v). At St. Bavo in Ghent by 1287, or in the 14th century.

LITERATURE: G. H. Pertz, 'Lamberti Floridus', *Archiv der Gesellschaft für ältere deutsche Geschichtskunde, VII, 1839, 540–46; J. Zacher, 'Lamberti Floridus', Serapeum, III, 1842, 145–54, 161–72; J. de Saint-Genois, 'Notice sur le Liber Floridus Lamberti canonici, manuscrit du XIIe siècle', Messager des sciences historiques de Belgique, 1844, 473–506, and 1845, 264–7 [repr. in Pat. Lat. CLXIII, 1003–32]; id., Catalogue méthodique et raisonné des manuscrits de la Bibliothèque de la ville et de l'université de Gand, Ghent, 1849–52, 14–44, No. 16; L. Bethmann, 'Lamberti Floridus, nach der Genter Handschrift', Serapeum, VI, 1845, 59–64, 79–80; L. Delisle, 'Notice sur les manuscrits du 'Liber Floridus' composé en 1120 par Lambert, chanoine de Saint-Omer', Notices et extraits, XXXVIIII, 1903, 581–*

8; O. Holder-Egger, *Neues Archiv der Gesellschaft für ältere deutsche Geschichtskunde*, XXXII, 1907, 524–5; V. Vander Haeghen, 'Le manuscrit gantois du Liber Floridus et ses illustrations (XIIe siècle)', *Bulletin de la Société d'histoire et d'archéologie de Gand*, XVI, 1908, 112–18; E. M. Sanford, 'The Liber Floridus', *The Catholic Historical Review*, XXVI, 1940–41, 469–78; J. de Smet, 'Anteekeningen over Lambert van Sint-Bertijns, Lambert van Sint-Omaars en Petrus Pictor inverband met het Liber Floridus', *Miscellanea historica in honorem Leonis van der Essen*, Brussels and Paris, 1947, I, 229–43; F. Saxl, 'Illustrated Medieval Encyclopedias', *Lectures*, London, 1957, 242–53; Grabar and Nordenfalk, *Romanesque Painting*, 158–9; L. Behling, 'Ecclesia als Arbor Bona. Zum Sinngehalt einiger Pflanzdarstellungen des 12. und 13. Jahrhundert', *Zeitschrift für Kunstwissenschaft*, XIII, 1959, 139–54; G. I. Lieftinck, 'Een Handschriften-Filiatie van vier Eeuwen: De Liber Floridus van Lambert van Sant-Omaars, 1120–1512', *Tidschrift van de Vrije Universiteit Brussel*, VIII, 1965–6, 69–82; A. Derolez, 'Un colloque sur le 'Liber Floridus'', *Scriptorium*, XXI, 1967, 307–12; id. ed., *Lamberti S. Audomari Canonici Liber Floridus. Codex autographus Bibliothecae Universitatis Gandensis...*, Ghent, 1968; H. Toubert, 'Une fresque de San Pedro de Sorbe (Catalogne) et le thème iconographique de l'Arbor Bona-Ecclesia, Arbor Mala-Synagoga', *Cahiers archéologiques*, XIX, 1969, 180–3 [repr. in *Un art dirigé. Réforme grégorienne et iconographie*, Paris, 1990, 77–9]; J. Poesch, 'The Beasts from Job in the 'Liber Floridus' Manuscripts', *J. W. C. I.*, XXXIII, 1970, 41–51; Dodwell, *Painting in Europe*, 171; F. Masai, 'L'autographe d'une encyclopédie illustrée du XIIe siècle: Le Liber Floridus de l'Université de Gand', *Scriptorium*, XXVI, 1972; G. I. Lieftinck, 'Lambert de Saint-Omer et son Liber Floridus', *Miscellanea in memoria di Giorgio Cencetti*, Turin, 1973, 81–7; *Liber Floridus Colloquium. Papers Read at the International Meeting Held at the University Library, Ghent, on 3–5 September 1967*, ed. A. Derolez, Ghent, 1973; P. O. Mayo, 'The Crusaders under the Palm. Allegorical Plants and Cosmic Kingship in the Liber Floridus', *Dumbarton Oaks Papers*, XXVII, 1973, 31–67; D. N. Dumville, 'The "Liber Floridus" of Lambert of Saint-Omer and the "Historia Brittonum"', *Bulletin of the Board of Celtic Studies*, 26, 1974-76, 103-22 [repr. in the author's *Histories and Pseudo-Histories of the Insular Middle Ages*, Aldershot, 1990, No. XII]; A. Derolez, 'Quelques problèmes méthodologiques sur les manuscrits autographes: le cas du 'Liber Floridus' de Lambert de Saint-Omer', *La paléographie hébraïque médiévale*, Paris, 1974, 27–36; A. Derolez, *Lambertus qui fecit librum: Een codicologische Studie van de Liber Floridus-Autograf* (Ghent, Universiteitsbibliotheek, Handschrift 92) [Verhandelingen van de Koninklijke Academie voor Wetenschappen, Letteren en Schone Kunsten van Belgie], Brussels, 1978; P. K. Klein, 'Les cycles de l'Apocalypse du haut Moyen Age (IX–XIIIe s.)', *L'Apocalypse de Jean. Traditions exégétiques et iconographiques* (Actes du Col-

loque de la Fondation Hardt, 1976), Geneva, 1979, 135ff.; B. Munk Olsen, *L'étude des auteurs classiques latins aux XIe et XIIe siècles*, I, Paris, 1982, 185–6, No. C.167; A. Derolez, 'Le "Liber Floridus" et l'énigme du manuscrit Cotton Fragments Vol. 1', *Mittelateinisches Jahrbuch*, XIV, 1982, 120–9; R. Hamann-MacLean, 'Die Reimser Denkmale des französischen Königtums im 12. Jahrhundert. Saint-Remi als Grabkirche im frühen und hohen Mittelalter', *Nationes. IV. Beiträge zur Bedeutung der französischen Nation im Früh- und Hochmittelalter*, Sigmaringen, 1983, 147, 176 and 239ff.; J. G. Arentzen, *Imago Mundi Cartographica. Studien zur Bildlichkeit mittelalterlicher Welt- und Ökumenekarten unter besonderer Berücksichtigung des Zusammenwirkens von Text und Bild* (Münstersche Mittelalter-Schriften, 53), 1984, 88–94, 208f., 245f. and *passim*; A. Derolez, 'La restauration du Liber Floridus', *Le Respect de l'oeuvre d'art. Le Manuscrit*, (Archives et Bibliothèques de Belgique, LVI) 1985, 238–56; E. Sears, *The Ages of Man. Medieval Interpretations of the Life Cycle*, Princeton, 1986, 67–89. R. K. Emmerson and S. Lewis, 'Census and Bibliography of Medieval Manuscripts Containing Apocalypse Illustrations, ca. 800–1500 (III)', *Traditio*, XLII, 1986, 458, No. 148; D. Lecoq, 'La mappemonde du "Liber Floridus" ou la vision du monde de Lambert de Saint-Omer', *Imago Mundi*, XXXIX, 1987, 9–49; D. Verhelst, 'Les textes eschatologiques dans le "Liber Floridus"', *The Use and Abuse of Eschatology in the Middle Ages*, ed. W. Verbeke, D. Verhelst, and A. Welkenhuysen (Mediaevalia Lovanensia, Ser. 1, Studia XV), Louvain, 1988, 299–305; A.-D. von den Brincken, *Fines Terrae. Die Enden der Erde und der vierte Kontinent auf mittelalterlichen Weltkarten*, (M. G. H. , Schriften, 36), Hannover, 1992, 73–76.

EXHIBITED: *Monumenta Annonis*, Cologne, 1975, 89ff., No. A 37.

97. Valenciennes, Bibliothèque Municipale MS 75

Gospels of Matthew and John, Apocalypse and Song of Songs, with glosses
335 × 135 mm., ff. 186, 3 cols.,
14–20 lines (text), 53 lines (gloss)
First quarter of the 12th century.
Saint-Amand (?) *Ill. 241*

Portrait of St. John (f. 63v).

Ornamental initials: L (f. 3v); H (f. 62v); I (f. 64v); A (f. 138); O (f. 170).

The 12th-century catalogue of the library at Saint-Amand lists a number of glossed books of the Bible given to the monastery by one of the monks, Master Gilbert (Delisle, *Cabinet des manuscrits*, I, 309 and II, 449) who, as has been shown, died in 1095 (Boutemy, *Scriptorium*, I, 1946, 13–14). Setting aside two com-

mentaries on the Psalms, one of which was possibly a work of his own, the list consists of a Glossed Song of Songs, Matthew, John and Apocalypse — an unusual combination of texts reflecting a relatively early stage in the compilation of the biblical Gloss, now generally associated with the School of Laon. The contents of the present manuscript suggest that it must have been based on the books in Gilbert's collection. The work is laid out in three columns, with both interlinear and marginal glosses, the latter occupying the narrow columns at the sides. The competent but unexceptional ornamental initials at the beginning of the different books, delineated in red, green, ochre and blue, feature letter forms made up of dragons, plant stems and interlace, with a filling of stylized vegetation. The presence of stubs between ff. 136v–137 and 168v–169 suggests that there were initially full-page paintings at the beginning of each of the biblical books, though only the portrait of John remains. This decoration, predating as it does the large scale production of Glossed Books with Channel Style illumination (cf. nos. 88, 90) gives the work the more traditional cast of a Gospel Book or patristic commentary. The portrait of John, framed by parted curtains, is enclosed within an arcaded structure consisting of a gabled and tiled canopy with pinnacles resting on columns. The scroll on which he writes is draped over a lectern on which his symbol, the eagle with wings outstretched, is perched. The painting, executed in green, light blue, red, yellow and a mixture of mauve and ochre, fills spaces vigorously articulated by linear patterns. The style, though clearly anchored in the region, does not seem to have a distinct connection with the book illumination of Saint-Amand as it is known to us.

PROVENANCE: *Liber sancti Amandi* and anathema, 12th century (flyleaf); *Liber cenobii sancti Amandi episcopi*, 16th century (f. 1).

LITERATURE: J. Mangeart, *Catalogue descriptif et raisonné des manuscrits de la Bibliothèque de Valenciennes*, Paris and Valenciennes, 1860, 61, No. 68; A. Molinier, *Catalogue général*, XXV, 1894, 221; Boeckler, *Abendländische Miniaturen*, 95; C. Niver, 'A Twelfth Century Sacramentary in the Walters Collection', *Speculum*, X, 1935, 336.

EXHIBITED: *Manuscrits à peintures*, Paris, 1954, 66, No. 161; *Scaldis. Art et civilisation*, Tournai, 1956, 81, No. 7; *Archéologie du livre médiéval*, Valenciennes, 1990, 15–16, No. 1.

98. Cambrai, Bibliothèque Municipale MS 234

Missal
235 × 150 mm., ff. 410, 22 long lines
c. 1125. Cambrai *Ill. 242*

Three framed pages: *Per omnia*, P (f. 1); *Vere Dignum*, monogram with the Lamb of God in a roundel, superimposed on the Cross, displayed by a pair of angels (f. 1v); *Te Igitur*, Throne of Grace within a mandorla, Evangelist symbols (f. 2).

This Missal from Cambrai Cathedral is an unassuming work with only titles in red and simple penwork initials in red, green, blue and ochre as a modest embellishment of the text. The artistic interest of the work is entirely concentrated on the first two folios, which give the impression of being almost a foreign body in the volume, characterized by a much higher level of draughtsmanly sophistication than the rest of the text. The body of letters and such details as haloes, *clavi*, and — in the major miniature on f. 2 — the mandorla and the edges of the Lord's throne, are rendered in gold. The substance of the illumination is drawn in red, blue and green, some of the elements acquiring greater salience through their placement on dark blue backgrounds enlivened by white dots in pairs or triplets. Great iconographic interest attaches to the representation of the Trinity in the form known as the Throne of Grace or *Gnadenstuhl*, of which this, along with the variant version in the Perpignan Gospels (no. 50) may be the earliest known examples. The composition shows the enthroned God the Father, surrounded by the symbols of the Evangelists, displaying the body of Christ on the cross. The Dove of the Holy Spirit does not descend from the Lord upon the figure of the Crucified as is customary in this iconographic formulation, but flies laterally, its wings extended to touch at once the lips of the Father and the Son. Exceptional also is the depiction in the Cambrai miniature of the symbols of Matthew and John not as isolated entities in the upper corners of the design, but turning towards one another in the act of dialogue. The basis of this may have been the desire to manifest both the human and divine attributes of the Godhead in Trinitarian doctrine, the first through the Incarnation (Matthew) and the second through the Logos (John). According to W. Braunfels, the iconography of the Throne of Grace renders in a precise fashion the order of ideas expressed in the Supplications of the Canon of the Mass (*Te Igitur*). The same scholar also looks on depictions of the Crucified with the Dove and the blessing hand of God, seen apparently for the first time on the back of the Lothar Cross at Aachen (*c.* 1000), as the antecedent stage in the development of the image of the Throne of Grace.

PROVENANCE: Cathedral of Cambrai. ('Missale XXXI', 12th-13th century, f. 410v).

LITERATURE: M. Le Glay, 'Catalogue descriptif et raisonné des manuscrits de la Bibliothèque de Cambrai', *Mémoires de la Société d'Emulation de Cambrai*, XII, 1830, 162, No. 224; A. Molinier, *Catalogue général*, XVII, 1891, 77–8. *La Paléographie musicale*, III, 1892, pl.

162a; Leroquais, *Sacramentaires*, I, 222–24; W. Braunfels, *Die heilige Dreifaltigkeit*, Düsseldorf, 1954, 37, 52; S. Soltek, 'Ein Tragaltar des 12. Jahrhunderts aus Hildesheim', *Niederdeutsche Beiträge zur Kunstgeschichte*, XXIV, 1985, 12.

EXHIBITED: *Manuscrits à peintures*, Paris, 1954, 70, No. 177.

99. Cambrai, Bibliothèque Municipale MS 559

Augustine, *De doctrina christiana*, and Sermons XLVI (*De pastoribus*), LXXXVI (*De avaritia et luxuria*), and *De mendacio*
320 × 215 mm., ff. 101, 2 cols., 36 lines
Second quarter of the 12th century.
Cambrai *Ills. 243, 244*

Full page drawing: St. Augustine enthroned (f. 1); three smaller miniatures: Augustine as shepherd (?) in dialogue with a haloed abbot (f. 57v); Augustine with scales, personifications of *Avaritia* and *Luxuria* (f. 69v); a woman ensnared in a rope held by an *eros*-like child, animal head (or hellmouth?) (f. 73v).

Ornamental initials: S (f. 2v); D (f. 4); Q (f. 13v); H (f. 40v); S (f. 57v); E (f. 69v); M (f. 73v).

This collection of writings by St. Augustine comes from the Benedictine monastery of Saint-Sépulcre at Cambrai, founded by Bishop Liebert of Cambrai in 1064, on the site of a chapel built by his predecessor Gerard in the cemetery outside the walls of the city. The interesting decoration of the manuscript was left unfinished, with only three initials (ff. 2v, 4 and 13v) fully painted and modelled. Of the rest and the four independent illustrations, some have remained in the state of outline drawings, while others are in varying stages of completion. The decoration in its entirety appears to be the work of a single hand, notable for his command of a delicate, sinuous linear style and the use of an appealingly odd range of colours, like aquamarine, light blue and salmon pink. The full-page portrait of the author which preceded the *De doctrina christiana* is enclosed within a frame filled with meandering foliage and shows Augustine as a bishop, seated in the midst of four ornate yet dissimilar bookstands bearing open volumes. The second illustration, like the two which follow, are panels with curiously elongated proportions filling the width of a single text column. It precedes Augustine's sermon on Ezekiel 34:1–16 (*Sermo XLVI. Pat. Lat.* XXXVIII, 270–95) called in the Cambrai manuscript *De pastoribus*. In this sermon, Augustine defines the proper duties of a shepherd and, inveighing against the Donatists, criticizes those pastors who do not feed their flock, but only themselves. The miniature shows Augustine exhorting a haloed abbot, perhaps to be identified as St.

Benedict. The third miniature prefaces the sermon on Matthew 19:21ff. (*Sermo* LXXXVI. *Pat. Lat.* XXXVIII, 523–30) entitled here *De avaritia et luxuria*. The sermon speaks of man's heart as sometimes under the sway of two mistresses, Avarice and Love of Pleasure, who tear each other apart. Avarice says to him 'Conserve', while Love of Pleasure's message is 'Spend'. The two personified vices are depicted in the miniature delivering their commands, while Augustine, armed with scales, evaluates their conflicting claims. The third miniature stands at the beginning of the treatise *De mendacio* (*Pat. Lat.* XL, 487–518), which is followed in the manuscript by a second work on the same topic, *Contra mendacium ad Consentium* (ibid., 517–18). The artist depicts lying by a kind of personification, a woman who is ensnared in coiling ropes grasped by a putto, and threatened by the prospect of a fall into the mouth of hell. No other medieval illustrations pertaining to these texts are known.

PROVENANCE: Saint-Sépulcre de Cambrai, shelf-mark, 17th century (f. 2).

LITERATURE: V. Durieux, *Les Miniatures des manuscrits de la Bibliothèque de Cambrai*, Cambrai, 1861, 324, pl. XII; A. Molinier, *Catalogue général*, XVII, 1891, 214; Boutemy, *Trésor*, 118; Porcher, *French Miniatures*, 38, 41; J. and P. Courcelle, 'Scènes anciennes de l'iconographie augustinienne', *Revue des études augustiniennes*, X, 1964, 66–7; J. Gutbrod, *Die Initiale in Handschriften des 8. bis 13. Jahrhundert*, Stuttgart, 1965, 134–5; M. W. Evans, *Medieval Drawings*, London, New York, Sydney and Toronto, 1969, 27 and pl. 42; M. Camille, '"Him whom you have ardently desired you may see": Cistercian Exegesis and the Prefatory Pictures in a French Apocalypse', *Studies in Cistercian Art and Architecture*, III, 1987, 143.

EXHIBITED: *Manuscrits à peintures*, Paris, 1954, 70, No. 178.

100. Boulogne-sur-Mer, Bibliothèque Municipale MS 46

Augustine, Confessions (ff. 2v–70v) and *De diversis haeresibus* (ff. 71–79)
295 × 220 mm., ff. 79, 37 long lines
Second half of the 11th century
[added miniature, *c.* 1125–35].
Saint-Bertin *Ill. 245*

The body of the manuscript with writings of Saint Augustine is a work of unassuming quality with penwork initials datable in the middle or second half of the 11th century. To this was added (f. 79v) a copy of a letter addressed by Burchard of Worms to Bishop Walter of Speyer, dated 1012 (*Pat. Lat.* CXL, 663) and inserted by him in his Decretal Collection (XX,

ccxxvii). The frontispiece which is of concern to us was designed for another context, but bound into the present volume by the 14th or the 15th century. The page has been cut down in size, an operation that has resulted in the loss of part of the design, along with the border along the bottom. The surface has also suffered losses through erosion and more purposely inflicted damage. The inscriptions and some details of the drawing have been partially renewed, but some of the legends, of which there are traces along the inner left and upper border, are lost.

The composition, framed by a border filled with curling leafy tips in alternating colours, is drawn in brown, green, red, blue and mauve inks, and the backgrounds are flat areas of the same hues. The subject is a kind of epitaph for Lambert, Abbot of Saint-Bertin from 1095 to 1125. The figure of the abbot is shown reclining in the manner of a *gisant* on a tomb slab. Above, his soul, personified by a youthful naked figure with outstretched arms, is borne aloft by a pair of angels. In the upper part of the scene, the seated Christ is seen within a mandorla, flanked by personifications of *Elemosyna* (left) and *Patientia* (right) in half-roundels. Charity is a crowned and haloed woman carrying a vase and displaying a small globe marked by a Greek Cross, while Patience, whose hands are joined submissively and whose neck is pierced by a sword, wears a long robe and a Greek Cross on her breast. Below these personifications are seen two somewhat larger figures also enclosed in half roundels: the Virgin Mary displaying the diminutive model of a church (left) and the haloed St. Bertin, patron of the monastery, bearing a book. Mary's depiction in all likelihood alludes to the chapel that Lambert erected in her honour within the monastery, one of the many benefactions with which he was credited (*Cartulaire de l'abbaye de Saint-Bertin*, ed. M. Guérard [Collections des cartulaires de France, III], Paris, 1840, 275).

The Abbot Lambert, who was an occasional correspondent of St. Anselm and engaged in other literary activity (F. Liebermann, *Neues Archiv*, XIII, 1888, 527ff.) is remembered chiefly for his efforts to attach Saint-Bertin to Cluny, an action which provoked a violent rift within his community. What may be regarded as an offshoot of this conflict is a highly flattering portrait of Lambert and his accomplishments given in an anonymous short treatise, *Tractatus de moribus Lamberti abbatis S. Bertini*, begun between 1116–18, but expanded thereafter (ed. O. Holder-Egger, *M. G. H., Script.* XV, 2, 946–53). The work is known on the basis of two manuscript witnesses (Oxford. Bodl. Laud 668 and Saint-Omer, Bibl. Mun. 788). It may be conjectured that the prefatory miniature in Boulogne 46 was originally designed to serve as the frontispiece for a presentation copy of this text, or possibly, that it adorned the extensive section devoted to Lambert's tenure in the combination of chronicle and cartulary of Saint-Bertin written at his request by his disciple Simon (Guérard, *Cartulaire*, 210–91).

PROVENANCE: *Liber sancti Bertini*, followed by an anathema, 12th century (f. 2); *Titulus sancti Bertini* and *De libraria sancti Bertini* in hands of the 12th and 13th century (f. 1). MS 33 (f. 2).

LITERATURE: F. Lefebvre, 'Notice sur la miniature d'un manuscrit de la Bibliothèque de Boulogne-sur-Mer', *Mémoires de la Société des Antiquaires de la Morinie*, IX, 1851, 35–46; H. Michelant, *Catalogue général*, Quarto Series, IV, 1872, 601–2; P. Héliot, 'Les manuscrits illustrés de la Bibliothèque de Boulogne', *Bulletin du Comité flamand de France*, 1934, 197, 206; A. Katzenellenbogen, *Allegories of the Virtues and Vices in Medieval Art*, London, 1939, 40, n. 4; A. Boutemy in E. de Moreau, *Histoire de l'église en Belgique*, Brussels, 1946, II, 338; id., *Trésor*, 118; Swarzenski, *Monuments of Romanesque Art*, 61; Porcher, *French Miniatures*, p. XXVII; K. Bauch, *Das mittelalterliche Grabbild*, Berlin, 1976, 46.

EXHIBITED: *Manuscrits à peintures*, Paris, 1954, 61, No. 127.

101. Saint-Omer, Bibliothèque Municipale MS 34

Origen, Homilies on the Old Testament
450 × 300 mm., ff. 307, 2 cols., 38–48 lines
c. 1125–30. Saint-Bertin *Ill. 246*

Historiated and ornamental initials: I, medallions with the Lord creating the Sun and Moon, offerings of Cain and Abel, killing of Abel, Abraham and the three Angels, Sacrifice of Isaac; along the outline of the initial, medallions with personifications of virtues (f. 1v); O (f. 62v); D (f. 108); D, medallion with the *agnus dei* surrounded by the Evangelist symbols (f. 191); E (f. 192v); M (f. 193); P (f. 194v); D (f. 196); Q (f. 197); D (f. 200); P (f. 202); H (f. 205); S (f. 206); S (f. 212v); O (f. 221); I (f. 222); L, archer shooting bird (f. 223); R (f. 224v); Q (f. 226); D, rooster (f. 228v); O (f. 242v); Q (f. 246); A (f. 250); V (f. 251); O (f. 253v); E (f. 255v); D (f. 256); Q (f. 259); C (f. 264); S (f. 269); P (f. 286).

This copy of Origen's Homilies on books of the Old Testament in the Latin translation of Rufinus of Aquileia is a work of unassuming quality, written in a workmanlike but unrefined transitional minuscule, and embellished with initials drawn and coloured by a number of hands that similarly do not rise above a modest level of interest. The opening initial, however, was contributed by an artisan of altogether greater stature, whose hand is otherwise not elsewhere in evidence in the manuscript. He is the figure who executed the miniature showing the soul of Abbot Lambert transported to heaven in another Saint-Bertin manuscript (Boulogne-sur-Mer, Bibl. Mun. MS 46; no. 100), or a close ally, and something

of his style can also be recognized in the initials of the *Vita S. Winnoci* at Bergues (Bibl. Comm. MS 19; no. 102). The monumental I initial (*In Principio*) in the present manuscript, which occupies the entire height of the text column, is a drawing of great delicacy, carried out in a combination of red and brown line reinforced by a flat colouration of the backgrounds in light tones of green, yellow-orange, blue and mauve. The composition is a descendant of the *In Principio* I of the Stavelot Bible, completed in 1096 (London, Brit. Lib. Add. 28106), which is also the basis of the Saint-Bertin illuminator's lively and small-scaled handling of figures and compositional groups. The five roundels with scenes from Genesis are described and commented on by a versified inscription in majuscule letters which runs along three sides of the initial's outline. This paraphrase of Scripture (whose author has not yet been identified) seems to have been the illuminator's programmatic guide, rather than Origen's text. Of the eleven female busts enclosed in roundels embedded in the frame of the initial, one is identified by inscription as *Fides*, and two more can be recognized through gesture or attribute as *Prudentia* with her snake and *Patientia*, whose neck is pierced by a sword. The figure holding a chalice and cross-stamped wafer (right, fourth roundel) duplicates the personification inscribed *Elemosyna* in the miniature of Boulogne 46. The multiplication of personified virtues in the form of female busts is a feature also of the *Liber Floridus* (Ghent, Univ. Lib. Cod. 92, f. 231v) from the same milieu, and which may have been known to the illuminator.

PROVENANCE: *De libraria sancti Bertini*, 12th-13th century (f. 1).

LITERATURE: H. Michelant, *Catalogue général*, Quarto Series, III, 1861, 28; A. Katzenellenbogen, *Allegories of the Virtues and Vices in Medieval Art*, London, 1939, 34, n. 3; A. Boutemy in E. de Moreau, *Histoire de l'église en Belgique*, Brussels, 1945, II, 338; Swarzenski, *Monuments of Romanesque Art*, 61, No. 127; H. G. Franz, *Spätromanik und Frühgotik* (Kunst der Welt), Baden-Baden, 1959, 177; P. Springer, 'Trinitas-Creator-Annus. Beiträge zur mittelalterlichen Trinitätsikonographie', *Wallraf-Richartz-Jahrbuch*, XXXVIII, 1976, 27–8.

EXHIBITED: *Art du moyen âge en Artois*, Arras, 1951, 50, No. 22.

102. Bergues, Bibliothèque Communale MS 19

Life and Miracles of St. Winnoc and
St. Oswald; Translation of St. Levinna
237 × 157 mm., ff. 164, 20 long lines
First half of the 12th century. Bergues
Ills. 252, 253; Col. pl. XIII

Full-page framed miniatures: standing St. Winnoc and adoring monk at his feet (f. 1v); St. Winnoc seated within an arcade (f. 3v); standing St. Oswald with an adoring monk (f. 77v); St. Oswald enthroned, with a kneeling petitioner (f. 78); St. Levinna, standing in an orans pose, with an adoring monk (f. 111v); St. Levinna crowned by an angel, adoring monk (f. 112); writing monk (Drogo?) seated at a lectern (f. 113).

Historiated and ornamental initials: C, vintagers in foliage (f. 4); B (f. 6v); S (f. 27v); A (f. 29v); M (f. 36v); I (f. 65); D (f. 65v); O, bust of St. Winnoc (f. 67v); T, crucified Christ (f. 68); C (f. 68v); G (f. 72v); I (f. 73); C, bust of St. Oswald (f. 75); P (f. 79); O (f. 80v); I (f. 81v); S (f. 103v); A (f. 107); D (f. 113v); O (f. 115); V (f. 118).

The Bergues manuscript contains an anonymous re-working of the life and miracles of St. Winnoc, known as the *Vita secundi* (ff. 1v–60), along with two compositions of an 11th-century monk of the monastery of Saint-Winnoc at Bergues, Drogo: a rhymed Office of St. Winnoc and of the Anglo-Saxon king and martyr Oswald (ff. 60–109v), followed by the *Historia translationis Sanctae Lewinnae*, an account of the translation from Seaford in Sussex to Bergues of the relics of St. Levinna, an obscure 5th-century Anglo-Saxon virgin martyr, an event said to have taken place in 1058. The original hand comes to an end on f. 135v, and the remaining twenty-eight folios of the matter concerning Levinna were rewritten in the 14th century, but in a manner clearly modelled on the older script. A religious community was established at Bergues in the 7th century, when Winnoc was sent there with monks of Saint-Bertin to convert the local Morini people. The community became in due course a house of secular canons. In 1022, or shortly before, it was transformed into a Benedictine monastery at the instigation of the Count of Flanders, Baldwin IV. Of the monastic buildings, only the Romanesque crossing tower of the church and traces of Gothic attachments remain, along with the octagonal tower of the original west facade (P. Gelis, *Congrès archéologique*, CXX, 1962, 246–7). The body of the text, which is equipped with indications for lections, was written by a single hand, with red one-line initial letters at the beginning of each sentence, and larger, two-line decorative pen-work letters in red, blue and green for the chapter divisions. The production of the work accords with other *libelli* of this kind (nos. 1, 9, 94, 126, 129, 143) in lending to the manuscript a quasi-liturgical degree of formal elaboration. The names of Winnoc, Oswald and Levinna are written whenever they occur within the text in majuscule letters of alternating red, blue and green. The major divisions of the text are signalized by pen-drawn initials in red outline, filled with light blue, green and a burgundy hue played off against the lighter red colour defining the structure of the generally foliage-filled letters. The style of these refined, delicately drawn initials is connected with the production of illuminated books at nearby Saint-Bertin.

The major components of the embellishment of this manuscript consist of two sets of full-page portraits placed at the beginning of the three major subsections of the text. One set (ff. 1v, 77v, 111v and 113) is drawn in a thin and spare brown outline, with reticent touches of shading in wash for hands and faces. Winnoc, Oswald and Levinna are shown as standing figures, with an adoring monk appearing in the lower left corner of the composition, cut off at the waist by the frame. The fourth portrait is that of a scribe, perhaps to be identified as the author Drogo, who is represented among the furnishings of his atelier — a book, a parchment scroll, a folding writing tablet, a kind of basin, and a large book chest. The second set of portraits (ff. 3v, 78v and 112) is fully painted in a thick, gouache-like medium, enriched with gold for certain details. The portrait types in this second series are more varied. Winnoc is enthroned in iconic frontality within an arched space surmounted by an architectural prospect. Oswald, seated in a more relaxed fashion within a space graced by parted curtains, receives the homage of a kneeling monk, while the standing Levinna accepts a sceptre and crown from an angel, in the presence of another adoring monk. The execution of these paintings is expertly done, though somewhat cursory and in places mildly careless.

The duplication of the saints' portraits is not altogether easy to explain. The four drawings in the first series give the impression of being a good deal older in date. The drawn images of Winnoc, Oswald and Levinna have blank versos and are mounted on stubs, though the portrait of Drogo (?) is integral with the body of the manuscript and carries text on regular ruled lines on the verso. This might suggest that the drawings, perhaps prepared near the end of the 11th century, were saved and reused in a first stage of the production of the present manuscript at least a generation later. The painted portraits, giving the work a more up-to-date and sumptuous effect, were supplied by a painter whose style would seem to be an offshoot of Saint-Bertin illumination as represented by the Gospels of Hénin-Liétard (Boulogne-sur-Mer, Bibl. Mun. MS 14; no. 113) and related manuscripts.

The background of the Winnoc portrait was initially silver, as indicated by the dark stain on the recto. It was at some point overpainted in blue, presumably in order to minimize the unsightly effect of oxydation.

PROVENANCE: Saint-Winnoc, Bergues.

LITERATURE: *AA.SS*, Nov. III, 253–89 (Winnoc); Aug. II, 83–103 (Oswald); Iul. V, 608–27 (Levinna); *M. G. H., Script.*, XV, 2, 774–89, ed. O. Holder-Egger; J. Lepreux, 'Notices sur les manuscrits de la Bibliothèque de Bergues', *Mémoires de la Société des An-*

tiquaires de la Morinie, IX, 1851, 261–80; L. Bethmann, *Archiv der Gesellschaft für ältere deutsche Geschichtskunde*, XI, 1858, 530; A. Pruvost, *Chronique et cartulaire de l'abbaye de Bergues Saint-Winnoc de l'ordre de Saint-Benoît*, Bruges, 1873, I, xiv–xviii; J. l'Hermitte, *Catalogue général*, XXVI, 1897, 662–3; P. Bayart, 'Les offices de Saint-Winnoc et de Saint Oswald d'après le manuscrit 14 (sic) de la Bibliothèque de Bergues', *Annales du Comité flamand de France*, XXXIV, 1926, 1–132; Ch. de Croocq, 'Un saint de la Flandre française, St. Winnoc, abbé de Wormhout, patron de Bergues (vers 614–717)', *Annales du Comité flamand de France*, XLIV, 1944, 11-14, and *passim*; F. Wormald, 'Some Illustrated Manuscripts of the Lives of the Saints', *Bulletin of the John Rylands Library*, XXXV, 1952, 256 (repr. in *Collected Writings*, II, London, 1988, 48); Grabar and Nordenfalk, *Romanesque Painting*, 205; N. Huyghebaert, 'La 'Vita secundi S. Winnoci' restituée à l'hagiographie gantoise', *Revue bénédictine*, LXXXI, 3–4, 1971, 216–58; id. 'Un moine hagiographe: Drogon de Bergues', *Sacris erudiri*, II, 1971, 192–256.

EXHIBITED: *Manuscrits à peintures*, Paris, 1954, 71, No. 181; *Benedictus en zijn monniken in de Nederlanden, 480–1980*, Ghent, 1980, III, 296, No. 673.

103. Arras, Bibliothèque Municipale MS 721 (1027)

Sacramentary Fragment
250 × 165 mm., ff. 68, 22 long lines
Second quarter of the 12th century.
Arras *Ills. 247, 248*

Independent miniatures: Christ enthroned, adored by four angels, full page (f. 38v); Mary Magdalen at the feet of Christ, two thirds of a page (f. 39v).

Painted ornamental initials: *Per Omnia* and *Vere Dignum* (f. 39); *Te Igitur* (f. 39v).

Pen-drawn ornamental initials: D (f. 10v); D (f. 11); C, D (f. 12); E, D (f. 12v); O (f. 21v); C (f. 25v); D (f. 27v); O (f. 28); D (f. 42); D (f. 51v); F (f. 61); O (f. 66).

The *Apologia beati Ambrosii* (f. 3) and the major Masses are introduced by pen-drawn ornamental initials outlined in red, with light blue, green and ochre filling. Their tubular framework, swelling to divide in the middle and at the extremities, gives them a recognizably Mosan-Rhenish air. The more elaborate initials of *Per Omnia*, *Vere Dignum* and *Te Igitur* are rendered in the same colours, with the addition of gold. The two miniatures are the work of the illuminator of the copy of Jerome's Commentary on Jeremiah prepared at Arras on the occasion of the visit to Saint-Vaast of the Abbot of Cîteaux Stephen Harding in 1125 (Dijon, Bibl. Mun. MS 130; no. 104), or of a close associate. They mark, as in customary fashion, the Preface and Canon of the Mass, though

their subjects depart from the norm. The first is an image of the cosmocratic Christ, cast in the conventional schema of the *Majestas Domini* but surrounded by four animate and adoring angels rather than symbols of the Evangelists. The second, an altogether exceptional subject replacing the usual Crucifixion, shows the enthroned Christ with a diminutive Magdalen lying before him and wiping his feet with a strand of her hair. The words on the curving scroll displayed by the Lord — *Dimittuntur ei peccata multa quia dilexit multum* — are a paraphrase of his words to the woman in the house of the Pharisee Simon, as reported in Luke's Gospel (Lk. 7:47). Both paintings are executed in a rich and fairly saturated range of colours, with the gold background of the mandorla in the larger image of Christ with the angels incised with a pattern of swirling rinceaux. Both miniatures have suffered some losses through abrasion.

The manuscript lacks a Calendar. The *Gloria in excelsis, Benedictio salis*, and other prayers on the first two folios were added by another hand.

PROVENANCE: *Liber ecclesiae beate Mariae Atrebatensis*, 12th century (f. 3). Arras Cathedral. MS 165.

LITERATURE: Caron, *Catalogue des manuscrits de la Bibliothèque de la ville d'Arras*, Arras, 1860, 352; J. Quicherat, *Catalogue général*, Quarto Series IV, 1872, 406. Leroquais, *Sacramentaires*, I, 163–4; A. Boutemy, 'Notes sur quelques manuscrits de l'ancien archidiocèse de Reims', *Scriptorium*, II, 1948, 128; R. Hamann-MacLean, 'Die Reimser Denkmale der französischen Königtums im 12. Jahrhundert', *Nationes*, IV, 1983, 191, n. 274.

EXHIBITED: *Art du moyen âge en Artois*, Arras, 1951, 56, No. 46.

104. Dijon, Bibliothèque Municipale MS 130

Jerome, Commentary on Jeremiah
326 × 217 mm., ff. I+158+I, 2 cols., 31 lines
c. 1125–30. Saint-Vaast, Arras *Ill. 251*

Full-page miniature: the abbots of Cîteaux and Saint-Vaast at Arras dedicate their churches to the Virgin Mary in the presence of the scribe Oisbertus (f. 104).

Ornamental initials: Preface, P (f. 2); Bk. I, V (f. 2v); Bk. II, S (f. 27); Bk. III, L (f. 53v); Bk. IV, S (f. 79); Bk. V, Q (f. 107); Bk. VI, P (f. 133). Unexecuted: ff. 1, 1v.

This copy of Jerome's Commentary on Jeremiah was written by Oisbertus, a monk of Saint-Vaast at Arras, at the request of the abbot of Cîteaux Stephen Harding. Oisbertus, who describes himself as an oblate (*fratrem Oisbertum a pueritia euisdem congregationis nutritus*), must have received the commision on the occasion of Stephen's visit to Saint-Vaast in 1125, where he and Abbot Henry made an agreement to

establish a confraternity for the offering of mutual prayers between the two communities. These facts are set forth in a blank space of the right column on f. 103, near the end of Bk. IV of Jerome's Commentary (J. Marilier, *Chartes et documents concernant l'abbaye de Cîteaux, 1098–1182*, 84, Nos. 75–7). The full-page painting on the following page, which is the only visual embellishment of note in the manuscript, is concerned with this transaction. As a theme of pictorial art, it is altogether exceptional, and the painter seems to have taken as his point of departure a conventional scene of donation or dedication. The Virgin Mary, patron of Cîteaux, stands crowned, haloed and bearing a book above a cloth-draped altar at the centre. The abbots of Saint-Vaast (left) and Cîteaux (right) present to her models of their churches — the building displayed by the abbot of Saint-Vaast being larger and of a more elaborate design. Both men are unexpectedly haloed (neither was canonized, but Stephen Harding was venerated as a saint by the Cistercians in the later Middle Ages). The monk Oisbertus, who is smaller in scale, is depicted in a half-striding, half-kneeling stance at the bottom and outside the frame of the composition. He holds his book aloft and at the same time points to its open pages. The scene takes place within an arch apparently festooned by drapes and filled with a richly patterned and conch-like form which frames the upper part of the Virgin's body. It is rendered in a combination of painting and drawing. The two abbots and Oisbertus are outlined in brown, the Virgin in red, and shaded in tints of lilac, light blue, red, green, along with some gold for Mary's halo, *clavi*, the altar and the outline of the framing conch. The painting is comparable to another nearly contemporary example of Arrageois illumination, the Missal-Collectar of the Cathedral (Arras, Bibl. Mun. MS 721 [1027]; no. 103). P. Cerny presumes that the artist was a close follower of the Anchin illuminator whom he calls the 'Master of the Grotesques' or possibly the same artist. The initials at the beginning of the six books of Jerome's Commentary and its preface are not uniform in style, and several were left unfinished (ff. 107, 133) or unexecuted. Bks. I (f. 2v); and III (f. 53v), drawn in red, green and mauve, have a particularly clear stylistic profile, the latter featuring a characteristic letter L in the form of a vivacious dragon encountered in books of Arras, Anchin and Saint-Amand. The text is in other respects plainly written, with only red accents for the letters at the beginning of subsections, and *explicits* in capital letters in a scheme of alternating colours.

PROVENANCE: Written by Oisbertus, a monk of Saint-Vaast, Arras (f. 103). Notre-Dame de Cîteaux, 12th and 15th-century shelfmarks (ff. 158, 159); 15th century Cîteaux *ex libris* (ff. 2, 157).

LITERATURE: *Histoire littéraire de la France*, XI, 1759, 218; A. Molinier, H. Omont, S. Bougenot, and P.

Guignard, *Catalogue général*, V, 1889, 34–5; P. Blanchon-Lasserre, *Ecriture et enluminure des manuscrits, IX–XIIe siècles*, Solesmes and Saint-André-lès-Bruges, s. d., fasc. X, pl. LXXXVIII; Haseloff, *Miniature*, 305–6; C. Oursel, 'Les manuscrits à miniatures de la Bibliothèque de Dijon', *Bulletin de la Société française de Reproduction de manuscrits à peintures*, VII, 1923, 22–3; id., *Miniature de Cîteaux*, 7, 55, 79–80; J. Marilier, *Chartes et documents concernant l'abbaye de Cîteaux, 1098–1182* (Bibliotheca Cisterciensis, 1), Rome, 1961, 84, Nos. 75–7. *Manuscrits datés*, VI, 1968, 179; A. Schneider, *Die Cistercienser*, Cologne, 1974, 143, 437; Cerny, *Buchmalerei in Anchin*, 39–40; C. H. Talbot, 'The Cistercian Attitude Towards Art: The Literary Evidence', *Cistercian Art and Architecture in the British Isles*, ed. C. Norton and D. Park, Cambridge, 1986, 56; J.-B. Auberger, *L'unanimité cistercienne primitive: mythe ou réalité*, Achel, 1986, 197; Y. Zaluska, *Scriptorium de Cîteaux*, 29, 83, 267, 271–2, No. 94; id. *Manuscrits enluminés de Dijon*, Paris, 1991, 127–9, No. 100.

EXHIBITED: *Art du moyen âge en Artois*, Arras, 1951, 55, No. 45.

105. Amiens, Bibliothèque Municipale MSS 142–143

Lectionary-Homiliary
416 × 295 mm. and 400 × 280 mm., ff. 236 and 189, 2 cols., 36–37 lines
c. 1140–50. Saint-Pierre, Corbie (?)

Ills. 249, 250

MS 142

Historiated and ornamental initials: H (f. 4v); P (f. 12); A (f. 13v); P (f. 15); G (f. 20); S (f. 22v); A (f. 24); H, Christ in Majesty, with the Evangelist symbols and the Lamb of God (f. 29v); F (f. 31); P (f. 32v); C (f. 33); S (f. 34v); F, haloed human headed lion (f. 35); E (f. 36); P (f. 37); V (f. 38); D (f. 38v); D (f. 39v); V (f. 41); R (f. 42); T (f. 43); A (f. 44); E (f. 45v); F (f. 46v); I (f. 47v); E (f. 49); I (f. 50v); E (f. 51v); E (f. 52v); E (f. 54); H (f. 70); V (f. 73v); Q (f. 75); C (f. 78v); O (f. 79v); B (f. 80v); H (f. 82); D (f. 83v); O (f. 88); F (f. 89v); S (f. 94); H (f. 104v); M (f. 109); C, Virgin enthroned, displaying a jewel-like object (f. 115v); H (f. 117); A (f. 130v); A (f. 142); P (f. 146v); S (f. 148); L (f. 160); I, St. Martin with a pastoral staff (f. 167).

MS 143

Historiated and ornamental initials: V (f. 4v); O (f. 6); R (f. 14); P (f. 20); A (f. 29v); E (f. 32); E (f. 36); O (f. 39); H (f. 44); P (f. 46); S (f. 47v); A (f. 48v); E (f. 50); F (f. 51); F (f. 52); D (f. 58); F (f. 60v); N (f. 62); S (f. 65); A (f. 67); V (f. 73); E (f. 75); B (f. 81); O (f. 95v); F (f. 99v); C, Meeting of Saints Fuscianus and Victoricus with Gentianus (f. 107v); P (f. 113v); H (f. 116); H (f. 118);

T (f. 119v); P (f. 126); B (f. 127); T (f. 128); S (f. 129v); S (f. 131); P (f. 132v); S (f. 135v); B, St. Bathildis (f. 138); M (f. 139v); H, Presentation of the Christ Child in the Temple, (f. 140v); D (f. 143v); B (f. 145v); B (f. 147); C (f. 149v); H (f. 152v); R (f. 153v); G (f. 155); F (f. 157); B (f. 159v); S (f. 180); M (f. 181); B (f. 182v); M (f. 183v); S (f. 186v).

This handsomely illuminated set of volumes is the outstanding work from the Corbie library for the otherwise rather barren period between the Nevelo *Recueil* (Bibl. Nat. lat. 17767; no. 95) and the onset of the vast local production from the mid sixties onward, though whether it was executed at Corbie is uncertain. Both volumes are severely worn and have been badly trimmed by the binder as well as repaired. A number of pages were also added or replaced in the later Middle Ages (MS 142, ff. 200–236; MS 143, ff. 1, 120–21, 187–89). MS 143 covers the period from Advent to the feast of the Purification of the Virgin (2nd February) and MS 142 from the feast of St. John *a Porta latina* on 6th May to Advent. A third volume comprising the readings for Lent must once have existed, as Wilmart supposes. Included in the text are readings for figures particularly venerated at Corbie, among them St. Precordius, the sainted Merovingian Queen Bathildis, the 9th-century abbot of the monastery, Adalhard, and a more recent name, an official of the monastery Geraldus (d. 1095), who founded the abbey of Sauve-Majeure in Guyenne, for whom readings were added (MS 142, f. 198v). Bathildis and the three Amienois saints Victoricus, Fuscianus and Gentianus are the subject of historiated initials. There are simple two or three-line penwork letters in red, green or blue throughout, and excellent larger initials placed on multi-coloured panels, which give the impression of having been drawn and painted by a single artist or corporate personality. These now much darkened and eroded designs vary in size. In the larger initials, the outline of the letter is indicated in gold or gold-framed strips of interlace and braiding rendered in body colour. The technique privileges drawing, but the elements of the design, generally reserved on darker grounds, are themselves carefully shaded in red, orange, green and blue. Mérindol has rightly noted the isolated position of the manuscript within the surviving body of Corbie illumination. As is especially apparent in the dense spiralling foliage of the ornamental initials, inhabited by putti, dragons or other fantastic creatures, the style of this embellishment is related to manuscript illumination of the monastic communities in the diocese of Arras, like the local cloister of Saint-Vaast or nearby Anchin and Marchiennes. Coyecque's catalogue of Amiens manuscripts proposed a date after 1173 for MS 143 because of the presence in it of a life of Becket (f. 117v). But this short fragment is clearly a later addition, and the work is more accurately placed around the middle of the century or in the immediately preceding years.

PROVENANCE: 'L'an MCCCC et XX XIII en la ville de Corbye…' (MS 143, f. 189v). 'Ce present livre appartient a saint Pierre de Corby' (MS 142, f. 4). Corbie MS 28 D and 29 D. Acquired by the Municipal Library at Amiens in 1791.

LITERATURE: M.-J. Rigollot, 'Essai sur les arts du dessin en Picardie depuis l'époque romaine jusqu'au XVIe siècle', *Mémoires de la Société des Antiquaires de Picardie*, XXX, 1840, 355–6; F. Darsy, 'Recherches sur la nationalité et sur la famille de Saint Thomas de Cantorbery', *Mémoires de la Société des Antiquaires de Picardie*, 3e Ser., VIII, 1885, 242; E. Coyecque, *Catalogue général*, XIX, 1893, 65; A. Wilmart, *D. A. C. L.* III, 2, 1914, 2945; Boutemy, *Trésor*, 117; Anon., 'Les trésors de l'abbaye royale de Corbie', *Bulletin trimestriel de la Société des Antiquaires de Picardie*, 1962, 176, No. 24; H. Peltier, 'Adalhard, abbé de Corbie', *Mémoires de la Société des Antiquaires de Picardie*, LII, 1969, 20–21; Mérindol, *Corbie*, I, 260, 290–92, and II, 800–804.

106. Avesnes, Musée de la Société Archéologique

Two leaves from a Gospel Book
355 × 240 mm.
1146. Saint-Lambert, Liessies *Ills. 255, 256*

These portraits of the Evangelists Mark and John stem from a Gospel Book, which, it is generally agreed, was a manuscript completed in 1146 by a scribe named John for Abbot Wedricus of Liessies (1124–47) in Hainaut, and formerly in the possession of the Bibliothèque Municipale at Metz (MS 1151). Previously in the collection of Baron Salis, who had acquired it from an earlier owner at Lille in 1843, the manuscript was destroyed near the end of the Second World War. It was a volume of 345 pages, measuring 355 × 255 mm. P. Marot's summary description of 1933 indicates that it was then missing three folios, one of them containing a Gospel preface, the other two respectively the first and last leaves of the Eusebian concordances. It is possible that a double folio with Canon Tables presumed to have come from Liessies (340 × 235mm) in the library of the École des Beaux-Arts, Paris (Coll. Jean Masson) represents the last-mentioned items. Neither Marot, nor A. Boinet, who published a more detailed description of the manuscript, make any mention of portraits of the two remaining sacred authors, Matthew and Luke, which may be supposed to have once formed part of the decoration of the work.

The two portraits, brilliantly painted in body colour, exhibit on their versos the end of the *capitula* of the respective Gospels. Mark is depicted in the act of writing on a scroll as he receives the inspiration of the Dove of the Holy Spirit perched on his neck. The chariot with the Tetramorph of Ezekiel's vision appears at his feet. The Prophet himself is shown in a

half roundel lodged in the frame on the left side of the miniature, and the Baptism of Christ is depicted in the corresponding space at the right. Medallions at the four corners show busts of bearded figures writing or exhibiting scrolls. That at the lower left, the only one to be identified, is inscribed *Beda*. Dodwell regards the others as prophets, though Bede would perhaps be in a more appropriate company with other patristic authors, such as Augustine, Jerome and Gregory. As pointed out by E. Parker McLachlan, the association of St. Mark with Ezekiel's Tetramorph, which is as yet unexplained, occurs also in an initial of the Pembroke Gospels, an English manuscript of unknown origin datable in the second quarter of the 12th century (Cambridge, Pembroke College, MS 120, f. 31). The portrait of John shows the author with a portable desk in his lap as he pauses in the moment of inspiration to dip his quill into an ink-well tendered to him by Wedricus, who appears in a roundel at the right. The corresponding medallion on the left side is occupied by the Evangelist symbol, and above John's head, the divine hand releases the Dove of the Holy Spirit bearing the word into his ear. The medallions at the four corners exhibit scenes of John's life. At the upper left, he is tried before the Emperor Domitian, and in the lower left roundel, he suffers martyrdom in a tub of boiling oil. Having been miraculously saved, he arrives on the island of Patmos (upper right) and has his apocalyptic vision there (lower right).

In their original position within the manuscript, these leaves faced full page framed designs incorporating the initial letter of the Gospel, the *incipit*, and the *incipit* words. Boinet's photograph of the Mark page (p. 113) shows medallions at the four corners of the frame with half length representations of Moses, David, Malachi and Zechariah bearing texts excerpted from their prophecies. The initial of luxuriant rinceaux and animal masks crowned by a large interlace knot harbours yet another roundel, showing the Evangelist symbol displaying a scroll. The title page of John (p. 267) is a similarly lavish composition. In the initial, the patron appears once more, offering an open book inscribed *Wedricus abbas me fecit* to the enthroned Christ in a mandorla above. In the medallions at the four corners of the page, there were episodes of the story of the adulterous woman, based on John's Gospel (8:4–11). The treatment of the beginning of Luke (p. 167 [or 169]) was rather more restrained, and that of Matthew (p. 19) does not appear to have been recorded in descriptions of the work, but another decorative page preceded Jerome's prologue to the Gospels, with medallions showing figures of the four Evangelists holding books, and a fifth roundel at the top with a bust of Jerome holding a scroll (p. 14). Boinet reports the existence of large ornamental initials with foliage inhabited by human figures and animals in other places of the volume (pp. 2, 5, 15, 19, 110, 116 and 263).

The Liessies Gospel Book is a work of the painter of the Lambeth Bible, which has most plausibly been linked with Canterbury, though on somewhat circumstantial grounds. Since the artist or close followers produced illuminated books for other religious houses of England, he is best thought of as a travelling professional of Insular origin. The Liessies Gospels is unfortunately his only firmly dated work, and it has not thus far been possible to plot the development of his career in a convincing fashion. As Dodwell has observed, his performance in Flanders was coloured by local traits and expectations. The type of prefatory diptych consisting of an Evangelist portrait with a facing painted *incipit* page is reminiscent of continental luxury Gospel Books, the 9th-century products of the Court School of Charlemagne in particular. Attempts have been made (by Leclercq, *Liessies*, 58) to identify the scribe John among the monks of Liessies in the time of Wedricus, but the name is clearly too common for conclusive results. On the other hand, it may be that the strikingly original idea of showing Wedricus tendering an ink-well to St. John plays on the identity between the name of the scribe and the Evangelist. The case brings to mind the Canterbury Triple Psalter (Cambridge, Trinity College, MS R.17.1), in which the more or less contemporaneous portrait of Eadwine is pictorially elevated to the rank of a sacred author.

The activity of the painter of the Liessies Gospels or of painters schooled in the same style has left substantial traces in book illumination of the region (cf. nos. 108, 120, 126, 136).

PROVENANCE: Purchased from M. Bottiaux at Maubeuge, who had himself acquired the leaves at Lille (Boinet), or given to the Société Archéologique of Avesnes by M. Wallerand in 1852, who claims to have had them from his ancestors (Leclercq).

LITERATURE: Haseloff, *Miniature*, 119–20; A. Boinet, *Bulletin de la Société Nationale des Antiquaires de France*, 1919, 214–222 [Metz MS 1151]; P. Marot, *Catalogue général*, XLVIII, 1933, 393 [Metz MS 1151]; W. Koehler, 'Byzantine Art in the West', *Dumbarton Oaks Papers*, I, 1941, 63ff; A. Boinet, 'L'atelier de miniaturistes de Liessies au XIIe siècle', *La Bibliofilia*, L, 1948, 151–6; T. S. R. Boase, *English Art, 1100–1216*, Oxford, 1953, 166; J. Leclercq, 'Les manuscrits de l'abbaye de Liessies', *Scriptorium*, VI, 1952, 53–5; Swarzenski, *Monuments of Romanesque Art*, 62, No. 132; Grabar and Nordenfalk, *Romanesque Painting*, 192; C. R. Dodwell, *The Great Lambeth Bible*, London, 1959, 16–19, 32–4; Porcher, *French Miniatures*, 38; Dodwell, *Painting in Europe*, 163, 179; *Colophons*, III, 120, No. 8385 [Metz MS 1151]. C. M. Kauffmann, *Romanesque Manuscripts, Survey III*, 100; E. P. MacLachlan, 'The Pembroke College New Testament and a Group of Unusual English Evangelist Symbols', *Gesta*, XIV/1, 1975, 12–13; G. Henderson, *Bede and the Visual Arts* (Jarrow Lecture), Jarrow, 1980, 18.

EXHIBITED: *Manuscrits à peintures*, Paris, 1954, 69, No. 173–4; *Byzance et la France médiévale*, Paris, 1958, 65–66, Nos. 119–20; *English Romanesque Art, 1066–1200*, London, 1984, 116, No. 54; *Ornamenta Ecclesiae*, Cologne, 1985, I, 233–4, No. B 3.

107. Paris, Bibliothèque de l'École des Beaux-Arts MSS 12,13,15,16

Detached leaves from St. Basil, *Homilies on the Hexameron*
340 × 245 mm., ff. 4, 2 cols., 37 lines
Second quarter of the 12th century.
Saint-Lambert, Liessies *Ill. 254*

St. Basil of Caesarea's collection of nine homilies on the Six Days of Creation, translated into Latin around 440 by Eustathius, is described by E. Gilson as the prototype of the entire family of Hexameral writings of the Middle Ages. The manuscript from which these leaves stem is mentioned, along with several other works by the same author, in an inventory of the Liessies library printed by Sanderus (*Bibliotheca belgica manuscripta*, Lille, 1643, II, 22). Two of the leaves represent the opening pair of facing pages in the dismembered book, with Eustathius' preface addressed to a German deaconess named Syncletica. The other two pages exhibit respectively the beginning of the second and ninth homilies, each marked by an ornamental initials. The weight of the decoration, concentrated on the two opening pages, was left in an unfinished state. The first features an *incipit* of majuscule letters in alternating lines of blue, green and pink within a frame embellished by rosettes at the four corners, and a historiated initial showing St. Basil enthroned in the upper part of the letter and Eustathius in dialogue with Syncletica below. On the facing page is the *incipit* of the homilies text proper, introduced by an initial which shows St. Basil standing on a demonic enemy whose tongue he pierces with his crozier, along with a kneeling monk presenting a book. But the larger part of the page is given over to a panel with a Genesis initial and scenes of Creation. In the central shaft, the Lord presides over the Tree of Knowledge, the Four Rivers of Paradise, and the angel guarding the gates of Eden, while meandering branches on each side house medallions with the Sacrifice of Cain and Abel, the Murder of Abel, and multiple episodes of the building of Noah's Ark. Among the illuminated manuscripts of Liessies, the most significant in artistic terms is the Gospel Book formerly in the Municipal Library of Metz (MS 1151), executed for Abbot Wedricus (1124–67) of which only fragments now survive (no. 106). The style of the illumination of the Basil frontispiece suggests that the work dates from the same period, and it may well be that the kneeling monk at the feet of St. Basil is a portrait of Wedricus, who is depicted in the act of tendering an ink-well to the Evangelist

John in the Metz Gospels. The Creation panel of the Basil frontispiece in any case reflects the influence of the English painter's work. The frame punctuated by rosettes points in this direction, as does the style and character of the illustrations, which call to mind the New Testament scenes of the four detached leaves from a Canterbury Psalter, divided between the British Library, the Victoria and Albert Museum and the Pierpont Morgan Library. They are closely related to the art of the Lambeth Bible painter. The execution of the Liessies manuscript, however, must have been entrusted to a local and less skilful performer.

PROVENANCE: *Liber sancti Lamberti Lesciensis* (MS 12). Collection of Jean Masson, and given by him to the École des Beaux-Arts in 1925.

LITERATURE: A. Boinet, 'L'atelier de miniaturistes de Liessies au XIIe siècle', *La Bibliofilia*, L, 1948, 156–9; J. Leclercq, 'Les manuscrits de l'abbaye de Liessies', *Scriptorium*, VI, 1952, 59.

EXHIBITED: *Première exposition de la Donation Jean Masson*, Paris, 1927, 1–2, Nos. 1–3; *L'art graphique au moyen âge*, Paris, 1953, 12, No. 6.

108. Douai, Bibliothèque Municipale MS 250

Augustine, Enarrationes in Psalmos
445 × 300 mm., ff. 167, 211 and 212, 2 cols.,
47 lines
Middle of the 12th century.
Sainte-Rictrude, Marchiennes
 Ills. 257, 258, 259

Vol. I

Full-page portrait of Augustine enthroned; the frame incorporates medallions with portraits of the patron saints of Marchiennes: Adalbaldus, Rictrudis, Maurandus, Eusebia, Glotsendis and Adalsendis (f. 2).

Historiated initials: Psalm 1, B, Christ as judge, with the instruments of the Passion, seated on a rainbow; below, David harping, a second musician playing the viol, a third playing bells (f. 2v); Psalm 25, P, St. Paul in three-quarter length, displaying a scroll (f. 38); Psalm 36, O, Christ and his disciples with the Canaanite woman (f. 101v); Psalm 38, David with a scroll and a hand before his mouth; right, figure brandishing a stone (f. 107v); Psalm 39, O, Christ in three-quarter length, displaying a book and gesturing in blessing (f. 113v); Psalm 41, O, haloed bishop in three-quarter length, holding a book and crozier (f. 124); Psalm 42, D, bust of Christ with book, gesturing in blessing (f. 131); Psalm 44, H, Christ and the Virgin in dialogue; below, a pair of adoring monks (f. 134); Psalm 45, D, Christ in three-quarter length

with book, gesturing in blessing (f. 141v); Psalm 46, O, David in three-quarter length, with sceptre and scroll (f. 145).

Ornamental initials: ff. 3, 9v, 11v, 17v, 21v, 24, 28, 31v, 32, 33, 36, 36v, 40v, 45v, 49v, 50v, 52v, 55, 58, 63v, 64, 67, 71v, 74, 74v, 79, 85, 92, 130v, 134, 145, 149v, 150, 153v, 156v.

Vol. II

Two fully painted initials: Preface, P (f. 1v); Psalm 51, Q (f. 2v).

Lesser pen-drawn initials: ff. 5v, 7v, 10, 16, 22, 25, 31v, 32, 38v, 39v, 42, 43v, 49v, 54, 68 (Psalm 68, D, bust of Christ with book), 71v, 80, 80v, 84v, 88, 96, 100 (Psalm 71, Solomon in three-quarter length, with sceptre and scroll), 103v, 105v, 109v, 114, 114v, 116v, 121, 123v, 124, 132, 135v, 138, 142v, 143v, 149v, 159, 171, 173, 175v, 183v.

This copy of Augustine's Commentary on the Psalms, bound in the customary three volumes, is the major work of Romanesque manuscript illumination from Sainte-Rictrude at Marchiennes. The decoration of the work was carried out by several illuminators and embraces the first two volumes, the third one having only large but simple red and green pen-work initials. The handsome full-page portrait of Augustine and the large historiated *Beatus* initial at the beginning of the text are executed in body colour and a few touches of gold. The type of frame with medallions featured in the frontispiece was a speciality of the painter of the Lambeth Bible, an artist whose roots are assumed to lie in England, but who was also active on the Continent. This type of frame is employed in the Tree of Jesse miniature of the Lambeth Bible (Lambeth Palace, MS 3, f. 198), in the pair of unfinished leaves by the painter in Corpus Christi College, Oxford MS 2, and in the Evangelist portraits of the Liessies Gospels (Avesnes, Musée de la Société Archéologique), the latter completed in 1146 for a house situated in Hainaut (no. 106). There is also a strong dose of the Lambeth painter's style in the rendering of the figure of Christ in the upper loop of the *Beatus* initial, but his influence is less in evidence in the portrait of Augustine, whose hieratic aspect is softened by the loose, meandering configuration of the draperies in the saint's vestments. The art of the Master of Saint Augustine, as P. Cerny calls him, is reflected in the decoration of a Marchiennes Sacramentary (Douai, Bibl. Mun. MS 168), and more distantly in a number of other books of that house datable in the third quarter of the 12th century. The portrait of Augustine also served the model for the image of the enthroned Gregory, which prefaces a copy of Pope Gregory's Epistles from the nearby monastery of Saint-Martin at Tournai (Paris, Bibl. Nat. lat. 2288).

The rest of the initials in the first volume of the Marchiennes manuscript are the work of another hand, and they are executed more economically. They are fine, small-scaled designs placed at the beginning of the Psalms, but also before subsections of Augustine's commentary. Most are drawn in an emphatic red outline and filled with tints of green, yellow, and salmon pink. The ornamental letters are primarily filled with deftly outlined stylized foliage, with terminal points marked by beasts biting human heads or masks spewing foliage. One shows a man swallowed by a monstrous fish (f. 92). The historiated initials exhibit both Old and New Testament subjects, and their location follows no clear pattern. The most interesting of these, perhaps intended as a kind of donor portrait, introduces Psalm XLIV (f. 134) and shows two adoring monks proffering a book and a scroll to Christ and the Virgin, who are seated side by side in the upper part of the letter. The second volume introduces yet another artist, who executed two fully painted initials (ff. 1v, 2v) and carried out the rest, nearly all of them ornamental, in black outline drawing enhanced with passages of red, green, blue or light yellow. His work represents a kind of *Reduktionstil* based on illumination of Anchin and found in manuscripts that can be grouped around the *Enarrationes* written by the scribe Jordanus (Douai, Bibl. Mun. MS 253; no. 110). A letter F in the Marchiennes codex (Vol. II, f. 159), composed of a standing figure carrying a dragon thus duplicates in a summary form a design found in the Anchin copy of Augustine's commentary (MS 253, f. 114).

PROVENANCE: Inscription *Liber sanctae Rictrudis Marchianensis* in the original hand (Vol. III, f. 211v), and Marchiennes inscriptions at the end of many signatures in Vol. II. *Ex libris* of 1753 (Vol. I, f. 1v, and inside cover, Vols. II and III).

LITERATURE: C. Dehaisnes, *De l'art chrétien en Flandre. Peinture*, Douai, 1860, 41; id. *Catalogue général*, Quarto Series, VI, 1878, 130; Haseloff, *Miniature*, 307; Boeckler, *Abendländische Miniaturen*. 95, 121; E. Dacier and P. Neveux, *Les richesses des bibliothèques provinciales de France*, Paris, 1932, I, pl. XLVIII; A. Boutemy in *Histoire de l'église en Belgique*, ed. E. de Moreau, Brussels, 1945, II, 343; Grabar and Nordenfalk, *Romanesque Painting*, 201; Porcher, *French Miniatures*, frontispiece; H. Steger, *David, Rex und Propheta*, Nuremberg, 1961, 228–9, No. 51; H. Schrade, *Die romanische Malerei. Ihre Maiestas*, Cologne, 1963, 234–6; Dodwell, *Painting in Europe*, 163, 178–9, 230; F. Mütherich, *Propyläen Kunstgeschichte*, V, 1969, 275; L. M. Ayres, 'English Painting and the Continent During the Reign of Henry II and Eleanor', *Eleanor of Aquitaine, Patron and Politician*, ed. W. W. Kibler, Austin and London, c. 1976, 138; Garborini, *Der Miniator Sawalo*, 147; Cerny, *Marchiennes*, 59–65; J. J. G. Alexander, 'A Twelfth-Century Augustine on the Psalms,

Perhaps from the area of Soissons, Containing an Unpublished Library Catalogue', *Florilegium in Honorem Carl Nordenfalk octogenarii contextum* (Nationalmuseums Skriftserie, MS 9), Stockholm, 1987, 13–22.

EXHIBITED: *Manuscrits à peintures*, 63, No. 148; *English Illuminated Manuscripts*, Brussels, 1973, 58–9, No. 31.

109. New York, Pierpont Morgan Library MS M. 962

Glossed Minor Prophets
336 × 228 mm., ff. 143, 3 cols., 17 lines (text), 46–49 lines (gloss)
c. 1150–60. North-eastern France. Anchin (?)
Ills. 260, 261

Historiated and ornamental initials: HOSEA, V, the Lord flanked by Hosea and Gomer (f. 2); JOEL, V (f. 26); AMOS, V (f. 36); OBADIAH, V (f. 55); JONAH, E (f. 59); MICAH, V (f. 66); NAHUM, O (f. 81); HABAKKUK, O (f. 88); ZEPHANIAH, V (f. 94); HAGGAI, I, standing Prophet with scroll, trampling a beast (f. 98); ZECHARIAH, I, standing Prophet, unfinished sketch (f. 102); MALACHI, O, the Lord embracing Jacob and rejecting Esau (f. 133).

The manuscript is an early example of a 12th-century type of book destined to enjoy great popularity, the illuminated Glossed Book. The biblical text is written in the central column, and there are both interlinear and marginal glosses in a smaller script, the latter occupying the spaces left and right of this central block. The gloss belongs to the *Glossa ordinaria*, which is now credited to Anselm of Laon. However, this vast compilation was left unfinished at Anselm's death in 1117, and the glosses on the Minor Prophets are thought by B. Smalley to have been compiled by Anselm's brother Ralph (d. 1133) or by Gilbert the Universal (d. 1134). The manuscript of the Pierpont Morgan Library is attributable to the scriptorium of Saint-Sauveur at Anchin and must have been executed towards the middle of the 12th century. The finely outlined initials at the beginning of each of the twelve prophetic books are drawn in brown ink and enhanced with red and green linear modelling. Titles and *incipit* words are in green and red majuscule letters. The initials have close relations in the volume of Gregory's Epistles from Anchin (Douai, Bibl. Mun. MS 309) and in the masterwork of book illumination from the same scriptorium datable a decade or so later, the *Enarrationes in Psalmos* written by the scribe Jordanus (Douai, Bibl. Mun. MS 253; no. 110). The standing Haggai trampling a beast (f. 98) has a counterpart in the figure of Christ of Psalm 70 in the Douai *Enarrationes* (f. 87v), and the initial type the curving parts of which are defined by sleek and

elongated dragons (ff. 36, 55) can be found in a whole series of books from Anchin and nearby centres.

PROVENANCE: Notes, partly erased, of 1442 and 1443, with the words '...religieux d'anchin' (f. 143). Sir Thomas Phillipps, Cheltenham (1792–1872), MS 21948. Acquired by Chester Beatty in 1921. Sotheby's Sale, London, 9th May 1933, Lot. 42. St. John Hornby (1867–1946) Collection, MS 58. Major J. R. Abbey Collection, No. 3230. Sotheby's Sale, London, 4th June 1974, No. 2906. Acquired from H. P. Kraus.

LITERATURE: Sir Thomas Phillipps, *Catalogus librorum manuscriptorum...*, Middlehill, 1837, 408, No. 21948; E. G. Millar, *The Library of A. Chester Beatty. A Descriptive Catalogue of the Western Manuscripts*, Oxford, 1927, I, 91–3, No. 24; E. B. Garrison, *Studies in the History of Medieval Italian Painting*, Florence, 1953, I, 181, 188; J. Gutbrod, *Die Initiale in Handschriften des 8. bis 13. Jahrhunderts*, Stuttgart, 1965, 92–3; C. de Hamel, *Glossed Books of the Bible and the Origins of the Paris Book Trade*, Woodbridge, 1984, 18, n. 17; Cerny, *Anchin*, 38–9.

110. Douai, Bibliothèque Municipale MS 253

Augustine, Enarrationes in Psalmos
445 × 310 mm., ff. 196, 2 cols., 47 lines
c. 1150–60. Saint-Sauveur, Anchin
Ills. 262, 263, 264, 265

Historiated and ornamental initials: Preface, X(Chi), enthroned Christ with book in a mandorla (f. 1v); Psalm 1, B (f. 2); Psalm 26, D (f. 31v); Psalm 38, D (f. 48); Psalm 51, Q (f. 65); Psalm 68, S (f. 84); Psalm 80, E (f. 108); Psalm 96, C (f. 127); Psalm 101, D (f. 129); Psalm 109, D (f. 146v). Smaller initials in the same style: ff. 3, 4v, 5 (mermaid), 6, 7v, 8v, 11v, 15 (athletic figure, beast), 16, 17v, 18v, 20, 23, 24v, 25, 26, 29, 33, 35, 38, 39, 40v, 42, 44v, 46v, 49v (bent-over figure), 51, 52v (stag drinking in a stream), 54, 55v, 58v (naked figures in foliage), 61v (hair-pullers), 63 (Christ in Majesty with two adoring monks), 66, 66v, 67, 69, 70v, 71v, 74, 75v, 77v, 81 (hair and beard pullers), 87v (standing Christ treading on serpent), 91, 93, 95v (putto-gathering grapes), 98v, 100v (archer shooting dragon), 105, 106, 109, 110, 111v, 112v, 114 (standing figure holding winged dragon), 114v, 116, 120, 121v (figure with a pennant piercing dragon), 123, 124v, 125v, 127v, 128v, 131v, 136, 138v, 141, 144, 143, 155v, 170, 177, 182v, 189.

The volume has lost a page between folios 1 and 2, which along with the end of the preface, may well have been furnished with a large frontispiece painting. Jordanus, the scribe, is named in the initial of Psalm 50, showing a pair of monks bearing scrolls and kneeling before the enthroned Christ (f. 63). The manuscript has splendid initials of two distinct

types. The more modest variety consists of calli-graphic letters in blue, red and green, drawn with great verve and incorporating fantastic creatures or combinations: a mermaid attending to her hair (f. 5), a bent-over, winged figure (f. 49v), hair and beard pullers (ff. 61v, 81), putti gathering grapes (f. 95v), an archer shooting a dragon-like beast (f. 100v) and more. The weight of the decoration is distributed according to the liturgical divisions of the Psalms, and the Psalms marking those divisions (Psalms 1, 26, 38, 51, 68, 97, 101 and 109) have larger and more elaborate initials with the letter forms usually ren-dered in gold and set on multi-coloured panels. These are entwined by spiralling, wind-blown foli-age held in reserve and inhabited by acrobatic putti, hunters, helmeted creatures and a variety of beasts. The agile drawing of the foliage is in a dark greyish ink, doubled with thin red lines. The largest initials (Psalm 1 and 109) are combined with a monogram-like treatment of the *incipit* words.

The manuscript stands at the centre of a group of books written and illuminated at Anchin during the abbacy of Gossuinus (1131–65) in which the same stylistic features occur. The group is sometimes col-lectively associated with Jordanus, though Boutemy has pointed out that this type of decoration is found in manuscripts written by different scribes. Cerny has more recently proposed the name 'Master of the Grotesques' for the leading personality involved. Attributable to him also are the initials in the fine copy of Gregory's Epistles (Douai, Bibl. Mun. MS 309) in which the same combination of penwork letters enlivened with fanciful subjects along with more elaborate initials of foliate design enclosed within coloured panels is found. Other manuscripts illuminated by this figure or more likely, a team of associates and followers, are a copy of Jerome's Commentary on Isaiah (Douai, Bibl. Mun. MS 278), the Glossed Minor Prophets of the Pierpont Morgan Library (M. 926; no. 109) and a three-volume Gre-gory *Moralia* at Tours (Bibl. Mun. MS 318-20). The initials in the volume of Zachary of Besançon's Con-cordances on the Gospels (Douai, Bibl. Mun. MS 42), which are more stately in their scale and lack the expected complement of grotesque figures, probably represent a late phase of the style.

PROVENANCE: Written by Jordanus, a monk of An-chin, according to a versified colophon (f. 1). Own-ership inscription in the original hand: *Liber S. Salva-toris ecclesiae Aquiscinctensis qui abstulerit anathema sit* (f. 1).

LITERATURE: Abbé E. Escallier, *L'abbaye d'Anchin*, Lille, 1852, 101–3; C. Dehaisnes, *Catalogue général*, Quarto Series, VI. 1872, 131–3; Boeckler, *Abendländ-ische Miniaturen*, 96, 121; G. Haseloff, *Die Psalterillus-tration im 13. Jahrhundert*, Kiel, 1938, 19, and 102; A. Boutemy in E. de Moreau, *Histoire de l'église en Bel-gique*, Brussels, 1946, 342–3; A. Boutemy, 'Enlu-

mineurs d'Anchin au temps de l'Abbé Gossuin (1131/33 à 1165)', *Scriptorium*, XI, 1957, 237ff., 240–2, 253; *Colophons*, III, 1973, 565, No. 11988; Garborini, *Der Miniator Sawalo*, 180, n. 397; Cerny, *Anchin*, 41–2.

EXHIBITED: *Manuscrits à peintures*, Paris, 1954, 64, No. 155; *Scaldis. Art et civilisation*, Tournai, 1956, No. 14.

111. Baltimore, Walters Art Gallery MS W. 28 and 28 Add.

Sacramentary
235 × 140 mm., ff. 73, plus 46 leaves,
27 long lines
Middle or third quarter of the 12th century.
North-eastern France *Ills. 266, 267*

MS W 28

Full-page miniatures: Christ in Majesty (f. 3); Cruci-fixion (f. 4v).

Major ornamental initials: *Per Omnia, Vere Dignum* (f. 1v); *Te Igitur* (f. 5); *In natale sancti Silvestri*, D (f. 43).

Lesser ornamental initials: D (f. 9); D (f. 16); C (f. 20); D (f. 22v); D (f. 24); O (f. 26v); D (f. 29v); O (f. 49).

MS 28 Add.

Vigilia Epiphaniae, C (f. 3v); O (f. 19v); O (f. 21); D (f. 30v); O (f. 30v); E (f. 34); D (f. 44).

In the possession of the Beauvais Cathedral Library as early as the 15th century, the manuscript is a Gallican Sacramentary presently in an incomplete state. The text was written for the use of Reims, and as Charles Niver has demonstrated, it was almost certainly made for the cathedral there. The Sanc-torale includes Masses for St. Rigobertus, whose rel-ics were since the end of the 9th century preserved in Reims Cathedral, and for other Remois saints — Remi, Nicaise and Thierry. In line with the preroga-tives claimed by the Archbishops of Reims to confer the crown on kings of France, the codex also contains the text of the abridged coronation *ordines* (f. 1) and it also records the rare liturgical celebration of a Pentecost *Exultet* or Whitsun eve blessing of a candle as a parallel of the Holy Saturday candle-lighting rite for Easter (ff. 21–22). Dorothy Miner has postulated that the manuscript was written and illuminated for Henry of France, a brother of King Louis VII, who after a time as a monk of Clairvaux, became first Bishop of Beauvais (1149–62) and later Archbishop of Reims (1162–75).

Somewhat surprisingly, the decoration of the Wal-ters Sacramentary has no clear analogues in Reims illumination as it is known to us. The design of the major initials, which features letter forms painted in

gold and entwined with wiry and lightly shaded foliage left in reserve on blue and purple grounds, looks instead close to the style practised in book illumination of a more northerly region, particularly Saint-Sauveur at Anchin and the related production at Marchiennes. Initials that are very similar to those in the Reims Sacramentary occur in a number of Anchin books executed under Abbot Gossuinus in the second third of the 12th century, such as the copy of Gregory's Epistles (Douai, Bibl. Mun. MS 309), Augustine's *Enarrationes in Psalmos* (Douai, Bibl. Mun. MS 253; no. 110) and Augustine's Epistles (Douai, Bibl. Mun. MS 278). The two full-page miniatures are probably the work of other, less skilful hands. Both compositions have gold backgrounds, overlaid in the case of the Crucifixion with a lightly drawn diaper pattern. The forms themselves are not so much painted as built up of colour — pink and green for the flesh tones, and mainly blue, green and red for the garments — laid on with laborious strokes of the pen. The more wooden Crucifixion may be the work of an assistant, as Lillian Randall suggests.

PROVENANCE: Beauvais Cathedral Library, MS 26 (Inv. of 1650). Louis le Caron, Château de Troussures, MS 304 (18th-19th century), Sale, Paris, 9th July, 1909, No. 14. Léon Gruel, MS 995 (bookplate). Acquired by Henry Walters before 1914 (bookplate).

MS 28 Add.: acquired in 1950 from F. Roux-Devillas, Paris.

LITERATURE: *Manuscrits du VIIe au XVe siècle provenant de la Bibliothèque du Château de Troussures*, Part I, Paris, Hôtel Drouot, 9th July 1909, 14–15, No. 14; H. Omont, 'Recherches sur la bibliothèque de l'église cathédrale de Beauvais', *Mémoires de l'Académie des Inscriptions et Belles-Lettres*, XL, 1916, 60, No. 26 and 80; S. de Ricci and W. J. Wilson, *Census of Medieval and Renaissance Manuscripts in the United States and Canada*, New York, 1935, I, 775, No. 113; C. Niver, 'A Twelfth-Century Sacramentary in the Walters Collection', *Speculum*, X, 1935, 333–7; P. E. Schramm, 'Nachträge zu den Ordines-Studien II–III', *Archiv für Urkundenforschung*, XVI, 1939, 282; H. Swarzenski, 'Recent Literature, Chiefly Periodical, on Medieval Minor Arts', *Art Bulletin*, XXIV, 1942, 295–6; Exh. Catal. *Illuminated Books of the Middle Ages and Renaissance*, Baltimore, 1949, 10–11; A. Strittmayer, 'The Pentecost Exultet of Reims and Besançon', *Studies in Art and Literature for Belle da Costa Greene*, ed. D. Miner, Princeton, 1954, 304–400; C. U. Faye and W. H. Bond, *Supplement to the Census of Medieval and Renaissance Manuscripts in the United States and Canada*, New York, 1962, 198, Nos. 565–6; D. Miner, 'Since De Ricci', *Journal of the Walters Art Gallery*, XXXI–XXXII, 1968–69, 41–8; G. Austin, 'Liturgical Manuscripts in the United States and Canada', *Scriptorium*, XXVIII, 1974, 98 [here listed as MS 113]; L. M. C. Randall, *Medieval and Renaissance Manuscripts in the Walters Art Gallery*, I, Baltimore and London, 1988, 13–17, No. 6.

EXHIBITED: *Treasures of Medieval France*, Cleveland, 1967, 86–7 and 355, No. III 21; *Medieval and Renaissance Illuminated Manuscripts*, Los Angeles, 1953, 15, No. 11.

112. Lille, Bibliothèque Municipale MS 33

Four Gospels
310 × 220 mm., ff. A-N + 118, 2 cols., 27 lines
Middle of the 12th century.
Saint-Calixte, Cysoing

Ills. 268, 269; Col. pl. XV

Canon Tables, with symbols of the Evangelists in the lunettes of the arches (ff. Gv-M).

Full-page miniatures: Annunciation (f. Mv); Nativity (f. N); Matthew portrait (f. Nv); Christ crowning St. Calixtus (f. 31); Mark portrait (f. 31v); Luke portrait (f. 53); John portrait (f. 87).

Framed initial pages for the Gospels: Matthew (f. l); Mark (f. 32); Luke (f. 53); John (f. 87v).

Saint-Calixte at Cysoing, situated in the environs of Lille, was a 9th-century monastic foundation, transformed shortly after 1125 into an abbey of Augustinian Canons. The Gospel Book at Lille is the only illuminated manuscript of any note from this community thus far identified. It is bound in its original wooden boards, which bear the remains of a 15th-century ornamental copper gilt revetment. The depression in the back cover indicates that it once housed an ivory or metal plaque. The volume contains the four Gospels, with prefaces and summaries, concluding with the *Capitulare evangeliorum* for the readings of the year. The sequence of Canon Tables, distributed over twelve pages, features arcaded frames with Evangelist symbols of the corresponding Gospels in the lunettes above. There are seven full-page miniatures as well as framed *incipit* pages with ornamental initials for each of the four Gospels. Four of these are portraits of the Evangelists shown with their symbols enclosed in rectilinear (f. Nv) or half-circular fields above them. Two appear in contained spaces, and all are seated on thrones with curious extensions in the form of beast heads gripping ink-wells in their jaws. In the case of John the throne appears to incorporate a hybrid animal, which W. H. Hinkle has interpreted as a reference to the Tetramorph. These customary images are supplemented by a pair of miniatures on facing pages showing the Annunciation and the Nativity that are positioned preceding the Gospel of Matthew, and a third painting before Mark with a depiction of Christ placing a crown on the head of the kneeling St.

Calixtus, a 3rd-century pope of whom the abbey possessed a relic. The page facing this painting is inscribed with the text in a 17th-century hand of the oath sworn by the Lords of Cysoing to protect the temporal rights of the abbey, and Hinkle has suggested that the manuscript was used in the Middle Ages for the purpose of administering this oath to new incumbents on the assumption of their duties.

The illumination of the Cysoing Gospels was carried out by a single artist making use of densely applied opaque colours and a fair amount of gold. Slate blue, olive green and shades of pink and russet are the principal hues in evidence, along with strong black outlines for the definition of forms. It has generally been recognized that the style of this illumination stands under the strong influence of Anglo-Saxon art and particularly of Winchester School manuscripts. This influence is apparent in the heavy frames with large rosettes at the corners sprouting wiry acanthus foliage in the manner of the Benedictional of St. Ethelwold (London, Brit. Lib. Add. 48598) or the Pontifical of Robert of Jumièges (Rouen, Bibl. Mun. MS 369). A whole range of ornamental and iconographic motifs also find antecedents among these sources, and in Anglo-Norman painting of the 11th century more generally. The proximity of Cysoing to Saint-Omer near the Channel Coast is the probable basis for the painter's access to these English sources.

BINDING: Original wooden boards with remains of a copper gilt revetment, embellished (back) with precious stones (15th century) The sunken hollow with bevelled edges (back) must once have housed an ivory or metal plaque.

PROVENANCE: *Cisoing* (15th-century inscription, inner front cover).

LITERATURE: C. Le Glay, *Catalogue descriptif des manuscrits de la Bibliothèque de Lille*, Lille, 1848, No. 15; Ch. de Linas, 'Notice sur un Evangéliaire manuscrit de la Bibilothèque de Lille', *Revue de l'art chrétien*, I, 1857, 249–56; Berger, *Histoire de la Vulgate*, 385; H. Rigaux, *Catalogue général*, XXVI, 1897, 25; Boeckler, *Abendländische Miniaturen*, 96; H. G. Franz, *Spätromanik und Frühgotik* (Kunst der Welt), Baden-Baden, 1959, 180. W. H. Hinkle, 'The Gospels of Cysoing: The Anglo-Saxon and Norman Sources of the Miniatures', *Art Bulletin*, LVIII, 1976, 485–510.

EXHIBITED: *Manuscrits à peintures*, Paris, 1954, 71, No. 182.

113. Boulogne-sur-Mer, Bibliothèque Municipale MS 14 (I–II)

Four Gospels (Gospels of Hénin-Liétard)
325 × 205 mm., ff. 106 and 98, 28 long lines
Middle or third quarter of the 12th century.
Ills. 270, 271, 272

Vol. I

Canon Tables (ff. 1v–8v); full-page portrait of Matthew, writing, with (above) in a half circle, the Virgin Mary and Zacharias, the father of the Baptist (?) displaying roundels with bust portraits of their progeny; left and right, half roundels with female saints gesturing in homage (f. 22v).

Full-page decorative rendering of the first words of the text, with the initial L incorporating medallions with figures of Christ, St. Matthew, and an unidentified crowned figure (f. 23); Mark, cut out.

Ornamental initials: PREFACES TO GOSPELS, N (f. 9); A (f. 11v); S (f. 13); P (f. 15); PREFACE TO MATTHEW, M (f. 17); PREFACE TO MARK, M (f. 73).

Vol. II

Full-page portrait of Luke, writing, with (above) in a half-circle, Annunciation to Zacharias; left and right, half roundels with the Annunciation to the Virgin (f. 5).

Historiated and ornamental initials: LUKE, F (f. 5v); PREFACE TO JOHN, H (f. 56); JOHN, medallions with Christ in Majesty holding an orb, standing figure with a scroll and writing Evangelist (f. 60v).

This set of slim, elegantly proportioned volumes is conceived in the style of early medieval luxury Gospel Books. The text is written in a highly refined hand, with two-line gold initials flourished in red, blue and mauve at the head of every chapter. The Gospel text is preceded by Canon Tables spread over fifteen pages, with round, pointed or intersecting arches embellished with little turrets in the spandrels, executed in gold, red, green, blue and violet. The *incipits* are written in capital letters using the same colours in alternating lines. The manuscript seems to have been designed as two volumes from the start. There are only two Evangelist portraits, one for the opening text in each volume. The beginning of Mark, now missing in Vol. I, in all likelihood had only an elaborate *incipit* and a large decorative initial, as is found at the beginning of John in Vol. II. There is, however, no clear indication that portraits of Mark and John were ever extant. The work was carried out by the prolific painter who was also responsible for the illumination of the City of God from Saint-Bertin (Boulogne-sur-Mer, Bibl. Mun. MS 53; no. 114), the Gregory *Moralia* at Saint-Omer (Bibl. Mun. 12: no. 115), a severely mutilated Bible in the same library (Saint-Omer, Bibl. Mun. MS 1) and other books (see

below, no. 115). The brightly-toned and vigorously modelled full-page paintings have gold backgrounds tooled with dot clusters, spiralling tendrils, or diaper patterns drawn in a fine line on the surface. Matthew, seated on a massive throne to which his lectern is attached, is depicted in the act of writing. Luke, in a more nearly frontal position, sits on a cushion-bearing faldstool, dips his quill into an inkwell, and displays an open book. The geometrical segmentation of the page with half roundels filled with additional subjects has parallels in Mosan and Saxon art. In the figures bearing medallions depicting their offspring, incorporated in the Matthew portrait, the painter indulges in one of his favourite motifs, perhaps derived from the Byzantine iconography of the Virgin of the *platytera* type.

The manuscript bears no indication of provenance. Michelant's catalogue of the Boulogne holdings records it as having come from Hénin-Liétard, the source of a more modestly decorated Epistolary in the same library (MS 15). This was a community of regular canons, founded in 1044 under the patronage of St. Martin within the *bourg* of Hénin-Liétard, near Béthune (Nord). It was affiliated shortly before 1123 with the Congregation of Arrouaise and re-established at that time, under the name of St. Mary, in a more isolated setting nearby (J. Becquet, *L'abbaye d'Hénin-Liétard. Introduction historique. Chartes et documents, XIIe–XVIe siècle*, Paris, 1965, and id., *Revue Mabillon*, No. 247, 1972, 171–5).

PROVENANCE: Unknown, and on the authority of H. Michelant said to come from Hénin-Liétard. No. 234, 19th century (flyleaf).

LITERATURE: H. Michelant, *Catalogue général*, Quarto Series, IV, 1872, 579–80; P. Héliot, 'Les manuscrits illustrés de la Bibliothèque de Boulogne', *Bulletin du Comité flamand de France*, 1934, 197, 205–6; A. Boutemy, 'Notes de voyage sur quelques manuscrits de l'ancien archidiocèse de Reims', *Scriptorium*, II, 1948, 128; id. *Trésor*, 118; Porcher, *French Miniatures*, pl. XXIX; F. Mütherich, *Propyläen Kunstgeschichte*, V, 1969, 274; Dodwell, *Painting in Europe*, 1971, 163.

EXHIBITED: *Art du moyen âge en Artois*, Arras, 1951, 49, Nos. 19–20; *Manuscrits à peintures*, Paris, 1954, 56–7, No. 123.

114. Boulogne-sur-Mer, Bibliothèque Municipale MS 53

Augustine, City of God
440 × 315 mm., ff. 194, 2 cols., 50 lines
Middle of the 12th Century. Saint-Bertin
Ills. 273, 274

Historiated and ornamental initials: Preface (*Retractatio*), I, four roundels showing Christ flanked by the

Virgin and an angel in the heavenly city, St. Augustine and a haloed figure (Marcellinus?) seated next to him and writing on a scroll, two figures writing under the inspiration of demons, the Devil grasping two souls (?) in Hell (f. 1); Bk. I, G (f. 1v); Bk. II, S (f. 9); Bk. III, I, unfinished (f. 16); Bk. IV, D (f. 23v); Bk. V, Q (f. 30); Bk. VI, Q (f. 38); Bk. VII, D (f. 43); Bk. VIII, N (f. 50v); Bk. IX, E (f. 58); Bk. X, O (f. 63v); Prologue of Bk. XI, I, haloed and enthroned woman within a roundel at the top, perhaps a personification of Ecclesia; heavenly hierarchy, Christ separates the Good from the Wicked, the Devil chained in Hell; along the edge of the design, half roundels with angels (f. 73); Bk. XI, C (f. 73v); Bk. XII, S (f. 81v); Bk. XIII, E (f. 88v); Bk. XIV, D (f. 95); Bk. XV, D (f. 103v); Bk. XVI, P (f. 113v); Bk. XVII, P (f. 125); Bk. XVIII, D (f. 134v); Bk. XIX, Q (f. 148v); Bk. XX, D (f. 158); Bk. XXI, C (f. 171); Bk. XXII, S (f. 181v).

The major decoration of this manuscript is the large painted initial of Augustine's *Retractatio*, which serves as the preface of the City of God, and an even more imposing initial letter occupying the entire text column that stands at the beginning of a prologue placed before Bk. XI — inexplicably, a repetition of the same text. The painter was inspired by the hypertrophy of the Genesis I in Romanesque Bible illumination, and these designs — the second one especially — in the same way tend to obscure the boundary between initial structure and self-standing illustration. But the vertical format to be read from top to bottom is exploited by the artist in this instance also for the creation of a hierarchical arrangement reaching from heaven in the uppermost scene to hell on the lowest tier. Both compositions bring together elements found in Augustine's text, but neither has a specific source in it. The grand allegorical purpose which informs these images, rooted in the Augustinian vision of the two cities, is apparent also in the frontispiece miniatures of several other 12th-century manuscripts of the City of God: Florence, Bibl. Laur. Plut. 12.17, from Canterbury; Schulpforta, Bibl. der Heimoberschule, MS A. 10, from Posa in Saxony, as well as the pair of facing images in the so-called Devil's Bible (Stockholm, Royal Library, A. 148).

Each of the twenty-two books which make up the work has an initial carried out in a simpler spirit. These are large ornamental designs, with an outline of gold (or occasionally silver) and the body of the letter is filled with spiralling, frond-like vegetation. They are drawn in outline and summarily painted in light green and red, with blue filling the interstices of the foliage. A large human head serves as a finial (f. 9) and birds and dragons appear in the foliage of another initial (f. 38), but most of these letters, though the work of a skilled hand, were executed with a certain economy of means in relation to the fully modelled 'iconographic' pair of prefatory initials. A few appear to have been left unfinished (ff.

81v, 88). Initials in the same style, but even more summarily carried out, occur in a copy of the Decretals Collection of the Pseudo-Isidore from the same workshop (Boulogne-sur-Mer, MS 115). This manuscript can be dated between 1148 and 1152.

PROVENANCE: Written by Alexander, whose name is given in an acrostic poem beginning *Versus scriptoris finem signate laboris* and to be read *Huic ab Alexandro manus arsque vigens data libro* (f. 194v).

LITERATURE: H. Michelant, *Catalogue général*, Quarto Series, IV, 1872, 607–8; A. de Laborde, *Les manuscrits à peintures de la Cité de Dieu de Saint Augustin*, Paris, 1909, I, 80; P. Héliot, 'Les manuscrits illustrés de la Bibliothèque de Boulogne', *Bulletin du Comité flamand de France*, 1934, 197, 206–7; Boutemy, *Trésor*, 118; E. Marosi, *Die Anfänge der Gotik in Ungarn. Esztergom in der Kunst des 12.–13. Jahrhunderts*, Budapest, 1984, 65.

EXHIBITED: *Art du moyen âge en Artois*, 51, No. 26.

115. Saint-Omer, Bibliothèque Municipale MS 12

Gregory, Moralia in Job
510 × 350 mm., ff. 184 and 212, 2 cols., 47 lines
Third quarter of the 12th century.
Saint-Bertin *Ills. 275, 276*

Vol. I

Full-page painting with three superimposed scenes of the life of Job: the Lord with three angels and Satan (above); Job and his family (middle); Job on the dunghill, with his wife, the three friends, and the Lord in dialogue (below) (f. 5v).

Historiated and ornamental initials: Prologue, D, Gregory and Leander of Seville in dialogue (f. 4); Bk. I, I, medallions with the Lord enthroned, Pope Gregory with book and quill, Job with scroll (f. 6); Job extract, V (f. 9); Bk. II, S (f. 16); Bk. III, B, half-length figure (f. 28); Bk. IV, Q (f. 37v); Bk. V, C (f. 50v); Bk. VI, S (f. 65); Bk. VII, Q (f. 75v); Bk. VIII, P (f. 85v); Bk. IX, P (f. 101v); Bk. X, Q (f. 118); Bk. XI, Q (f. 128); Bk. IX, M (f. 137v); Bk. XIII, E (f. 146); Bk. XIV, S (f. 152v); Bk. XV, Q (f. 163v); Bk. XVI, Q (f. 174).

Vol. II

Full-page drawing of a scribe (Gregory?) seated at a pulpit and receiving inspiration from the Dove of the Holy Spirit (f. 1v).

Historiated and ornamental initials: Bk. XVII, Q (f. 2v); Bk. XVIII, P (f. 10); Bk. XIX, Q (f. 25); Bk. XX, Q, seated bishop or pope with book (f. 35); Bk. XXI, I (f. 49); Bk. XXII, Q, combat of men wielding clubs or axes (f. 55v); Bk. XXIII, P (f. 66); Bk. XXIV, H (f. 75v);

Bk. XXV, I, crowned woman standing on a cowering lion and holding a disk on which a half-length male figure appears (f. 84v); Bk. XXVI, I, male figure (Eliphaz?) with scroll standing on a cowering lion (f. 92v); Bk. XXVII, Q (f. 106); Bk. XXVIII, P, centaur with shield and sword, rabbit or weasel (f. 119); Bk. XXIX, D (f. 128); Bk. XXX, B, Dialogue of the Lord with Satan; below, Job on the dunghill tempted by the demon in the presence of his wife (f. 140v); Bk. XXXI, I, striding figure (f. 154); Bk. XXXII, S, dragon-like creature spouting a serpent (f. 170v); Bk. XXXIII, A, man slaying a dragon (f. 180v); Bk. XXXIV, Q (f. 194v); Bk. XXXV, Q, siren (f. 201v).

This large, two-volume set of Gregory's *Moralia in Job* was written and illuminated by two distinctive hands, and possibly in two separate phases. The text, prefaced by the author's dedicatory letter to Leander of Seville, is preceded by the Vision of Taio, a Bishop of Seville (7th-century), which relates the miraculous rediscovery of Gregory's work, said to have been misplaced through neglect (f. 1; *Pat. Lat.* LXXV, 507–510), and followed by two leaves from a commentary on the Psalms and the Pauline Epistles unrelated to the body of the manuscript (ff. 2–3v). The first scribe wrote Vol. I in its entirety and part of Vol. II. A second hand, using brown rather than black ink and featuring a broader, more vertical stroke, takes over, beginning with the right-hand column on f. 51v. The illumination divides along the same lines. The splendid full-page frontispiece (Vol. I, f. 5v) and the initials for the prefatory address to Leander and for Bks. I to XXI are the work of the very productive Saint-Bertin painter who illuminated the Gospels of Hénin-Liétard (Boulogne-sur-Mer, Bibl. Mun. MS 14; no. 113) and the following additional books: a badly mutilated Bible (Saint-Omer, Bibl. Mun. MS 1); copies of Saint-Augustine's City of God (Boulogne-sur-Mer, MS 53; no. 114) and the Pseudo-Isidore's *Collectio Canonum* (Boulogne-sur-Mer, MS 115), another exemplar of Gregory's *Moralia*, of unknown provenance, in the Vatican Library (Vat. Lat. 580) and, perhaps, a Collectar in the Bibliothèque Municipale at Bourges (MS 37). Carried out with some haste, his large and for the most part wholly ornamental initials are generally defined by a golden armature, which is in places cursorily tooled with circular depressions, and filled with large, schematized leaves. The painting, which exhibits the symptoms of the 'damp-fold' style, is executed in a bold and saturated combination of red, blue, green, purple and other colours, applied in a vigorous, though not overly refined manner. The story of Job inspired an even more extensive cyclical treatment in a roughly contemporaneous Flemish manuscript of Gregory's *Moralia* (Paris, Bibl. Nat. lat. 15675) and an allegorical interpretation in the Floreffe Bible (London, Brit. Lib. Add. l7738, f. 3v). The date of the Boulogne Pseudo-Isidore, which can be fixed between 1148

and 1152, roughly indicates when the painter of the Saint-Omer *Moralia* was active.

The second artist represented in the manuscript executed the superb frontispiece portrait of Pope Gregory in Vol. II and the initials of Bks. XXII to XXXIII, corresponding to the section of the text written by Hand B. His work takes the form of line drawing exclusively, and thus initiates a sharp contrast with the riotous colourism of his collaborator. A new graphic refinement also marks his style, with pliant fold structures and a fastidious modulation of light and shade by means of thin parallel lines. This style connects with the draughtsmanly finesse of Mosan book illumination of the third quarter of the century, as represented by the collection of medical texts in the British Library (Harley 1585) and the Old Testament scenes of a Psalter prefatory cycle in Berlin (Staatliche Museen, Kupferstichkab. MS 78 A 6) with related miniatures in Liège (Bibl. de l'Université, MS 2613) and London (Victoria and Albert Museum, MS 413). It also has ties with metalwork, like the engraved plaques of Barbarossa's candelabrum of Aachen Cathedral, and has been thought by Buschhausen to constitute one of the sources of Nicholas of Verdun's style.

PROVENANCE: *De libraria sancti Bertini*, 12th century (Vol. II, f. 1). Partly erased 13th century *ex libris* (Vol. I, f. 3v).

LITERATURE: H. Michelant, *Catalogue général*, Quarto Series, III, 1861, 16–17; Swarzenski, *Monuments of Romanesque Art*, 80, No. 211; H. G. Franz, *Spätromanik und Frühgotik* (Welt der Kunst), Baden-Baden, 1959, 168–9; J. Gutbrod, *Die Initiale in Handschriften des 8. bis 13. Jahrhunderts*, Stuttgart, 1965, 95; Dodwell, *Painting in Europe*, 163; H. Buschhausen, 'The Klosterneuburg Altar of Nicholas of Verdun: Art Theology and Politics', *J. W. C. I.*, XXXVII, 1974, 8 and n. 35; id., 'The Theological Sources of the Klosterneuburg Altarpiece', *The Year 1200: A Symposium*, New York, 1975, 121; id., *Der Verduner Altar*, Vienna, 1980, 105; E. Marosi, *Die Anfänge der Gotik in Ungarn. Esztergom in der Kunst des 12.–13. Jahrhunderts*, Budapest, 1984, 65.

EXHIBITED: *Art du moyen âge en Artois*, Arras, 1951, 51, Nos. 28–9; *Manuscrits à peintures*, Paris, 1954, 58, No. 129; *Byzance et la France médiévale*, Paris, 1958, 68, No. 129.

116. Saint-Omer, Bibliothèque Municipale MS 30

Zacharias of Besançon, Concordances of the Gospels
465 × 305 mm., ff. 236, 2 cols., 48 lines
Third quarter of the 12th century.
Saint-Bertin *Ill. 277*

Canon Tables (ff. 32–39v).

Historiated and ornamental initials: Prefatory section, I (missing); II, E (f. 6); III, V (f. 12v); IV, E (f. 24); D, fighting centaurs (f. 47); Prologue, M, Matthew writing at a pulpit (f. 54); U (f. 54v). Bk.I, I, three seated figures, probably symbolizing the Trinity; roundels with the Lord enthroned, holding a book; the Lord in Majesty surrounded by the symbols of the Evangelists; the Lord enthroned holding two vessels; at the four corners, roundels with the four Evangelists (f. 57); V (f. 57v); F (f. 58); E (f. 61); L (f. 62); E (f. 65); E (f. 65v); C (f. 67); Q, T (f. 68); D (f. 68v); P (f. 69); A (f. 69v); T (f. 72); T (f. 73v); A, fighting monkeys (f. 74v); A (f. 76); E (f. 76v); E, E (f. 77v); V, S (f. 79); V (f. 79v); A (f. 80v); A (f. 81); D (f. 81v); A (f. 82v); A (f. 83); A, E (f. 83v); D (f. 85); N, N (f. 85v); N (f. 86v); Q (f. 87); A (f. 88); N (f. 88v); O (f. 89); V (f. 89v); Bk. II, E (f. 92v); C (f. 93v); C (f. 94v); E, E (f. 95); V, E (f. 95v); E (f. 96); E (f. 96v); E (f. 97v); V (f. 98); E (f. 98v); T (f. 99v); T, A (f. 100v); H (f. 101); E (f. 102); P, man and bear locked in combat (f. 102v); T, man slaying dragon (f. 106); E (f. 106); P (f. 106); P (f. 107); E (f. 108v); F (f. 109v); E (f. 110); A, A, F (f. 112); V, F (f. 113); S (f. 114); S, man riding dragon (f. 114v); E (f. 115); V (f. 117); V (f. 118); E, confronted eagles (f. 119); R, birds; P (f. 122); E (f. 123v); E (f. 124); O, two-headed bird (f. 124v); P, winged monstrous creature (f. 126); E (f. 128); Bk. III, V, naked warrior fighting dragons (f. 131); A (f. 132v); E (f. 134); E (f. 135); R (f. 136); V (f. 136v); A, naked warrior slaying dragon (f. 137v); A (f. 139); E (f. 142); T (f. 142v); A (f. 143); E (f. 143v); E (f. 144); A (f. 145v); E (f. 146); D (f. 148v); S (f. 150); E (f. 151v); P (f. 152); A (f. 152v); E, E (f. 153v); E (f. 154); E (f. 155); E (f. 157); E (f. 159); A, M (f. 161); D (f. 162v); E (f. 162v); A (f. 163); E (f. 164v); T (f. 166v); P (f. 167v); E (f. 168v); C, man-headed winged monster (f. 169v); E (f. 172v); E (f. 173v); F (f. 175v); E (f. 176v); F (f. 178v); M (f. 179); E (f. 180v); T (f. 182); V (f. 185); E, E (f. 186); A, intertwined dragons and serpents (f. 189); T, eagle (f. 191v); S (f. 192v); S (f. 193v); D, winged monster and serpent (f. 189); E (f. 195); Bk. IV, E (f. 196); A, F (f. 196v); P (f. 197v); E (f. 199); M (f. 202v); E (f. 205v); T, dragon (f. 212v); E (f. 214); A (f. 215v); P (f. 216); M, E (f. 217); E (f. 218); E (f. 219); S (f. 220v); C, donkey playing harp (f. 225v); A, V (f. 226v); E (f. 228v); E (f. 229); P (f. 230); D, siren (f. 231); T, siren playing pipes (f. 232); P (f. 232v); E (f. 233v); V (f. 234v).

Zacharias Chrysopolitanus is recorded as a *scholasticus* in the cathedral school of Besançon in the years from 1131–1138, and later, as a canon of the Premonstratensian foundation of Saint-Martin at Laon. His Gospel Harmony *In unum ex quatuor (Pat. Lat. CLXXXVI, 10–620)* is thought to have been written between 1140 and 1145, and definitely before 1161, since Bishop Gotescalc of Arras, who died in that year, offered a copy to Clairvaux (Schmidt, *Theologische Quartalschrift*, LXVIII, 1886, 232–3). The work

enjoyed a certain popularity in the second half of the 12th century, and other handsomely illuminated copies are known (Auxerre, Bibl. Mun. MS 11; Douai, Bibl. Mun. MS 42; formerly Camarillo, Doheny Library, MS 7). The present manuscript, incomplete at the beginning, has red and green pen-drawn letters of varying sizes throughout the text, and monumental *incipits* and *explicits* of large flourished letters in the same combination of colours. The Canon Tables and initials at the head of the prefaces, the body of the text, and the 181 chapters into which it is subdivided, are rendered entirely and exclusively in line. The illumination adheres in this respect to the pattern initiated by the draughtsman who completed the probably somewhat older copy of Gregory's *Moralia in Job* (Saint-Omer, Bibl. Mun. MS 12), who perhaps worked on the present manuscript, though clearly with the help of one or more assistants. The predilection of the artist for images of naked warriors fighting dragons and other creatures comes to the fore in both works, though there is greater variety in the nature of the workmanship that this decoration exhibits, ranging from the fluent, though fairly summary, to the exquisite refinement of the *In Principio* I, on which the artist clearly lavished his most attentive efforts. The subtle iconography, not yet fully explicated, is rooted in the author's concern to find an underlying, Trinitarian unity in the varying testimonies of the four sacred authors. The artist's ties with Mosan and Rhenish art are, as in Saint-Omer 12, readily apparent. Saint-Omer 30 is part of a larger group of Saint-Bertin manuscripts of the third quarter of the 12th century with a similar monochrome draughtsmanly illumination, which includes the following codices: Boulogne-sur-Mer, Bibl. Mun. MS 36 (Ambrose, *Varia*); MS 70 (Gregory, Homilies on Ezekiel); Saint-Omer, Bibl. Mun. MS 1 (Bible); MS 73 (Augustine, *De Trinitate)* and MS 220 (Glossed Daniel and Minor Prophets).

PROVENANCE: Saint-Bertin.

LITERATURE: H. Michelant, *Catalogue général*, Quarto Series; III, 1861, 25; C. Schmidt, 'Zacharias Chrysopolitanus und sein Kommentar zur Evangelienharmonie. Eine exegetisch-historische Studie', *Theologische Quartalschrift*, LIX, 1887, 235; A. Boutemy in E. de Moreau, *Histoire de l'église en Belgique*, Brussels, 1945, II, 348; H. Schnitzler, *Der Schrein des heiligen Heribert*, Mönchengladbach, 1962, 48; B. de Vrégille, 'Notes sur la vie et l'oeuvre de Zacharie de Besançon', *Analecta Praemonstratensia*, XLI, 1965, 293–309; E. Klemm, *Ein romanischer Miniaturenzyklus aus dem Maasgebiet* (Wiener Kunstgeschichtliche Forschungen, II), Vienna, 1973, 96; P. Springer, 'Trinitas-Creator-Annus. Beiträge zur mittelalterlichen Trinitätsikonographie', *Wallraf-Richartz-Jahrbuch*, XXXVIII, 1976, 32; A. M. d'Achille, 'Sull'iconografia trinitaria medievale: La Trinità del santuario sul

Monte Autore presso Vallepietra', *Arte medievale*, 1991, 1, 61–2.

EXHIBITED: *Art du moyen âge en Artois*, Arras, 1951, 50, No. 24; *Manuscrits à peintures*, Paris, 1954, 57, No. 126; *Byzance et la France médiévale*, Paris, 1958, 67–8, No. 127.

117. Wolfenbüttel, Herzog August Bibliothek Cod. Guelf. 1. Gud. lat.

Lambert of Saint-Omer, *Liber Floridus*
425 × 298 mm., ff. I+104, 2 cols., 44 lines
Third quarter of the 12th century.
North-eastern France

Ills. 278, 279, 280, 281

Diagram of the concordance of the Four Gospels (f. 2v); world map and diagram of the six ages of the world (f. 5v); sphere of the world and microcosm (f. 6); seated Solomon; schema of the year with the four seasons, twelve signs of the zodiac, and months of the year (f. 8v); Annunciation (f. 9); Apocalypse cycle (ff. 9v–15v); diagram of the twelve winds (f. 16); *Sphaera Macrobii* (f. 16v); schema of *annus* with the seasons, humours, and winds (f. 17); sphere of life and death (f. 19); Minotaur in the Labyrinth (f. 19v); macrocosm and microcosm (f. 31); allegory of the lily of the Song of Songs (f. 31v); *Arbor Ecclesiae* (f. 32); lion and porcupine (f. 37v); man-eating griffon (f. 39v); dragon (f. 40v); crocodile (f. 41); Devil riding on Behemoth (f. 41v); Antichrist seated on Leviathan (f. 42); Heavenly Jerusalem (f. 43v); Christ in Majesty with the Lamb of God, the four elements and the altar of God over the abyss (f. 58v); diagram of the earth and the paths of the sun and moon around it (f. 59); earth, continents, nine spheres of the planets, zodiacal signs (ff. 59v–60); schema of the phases of the moon (f. 60v); schemata of the planets and the zodiac (ff. 62–63v); diagram of the zodiac around the earth, Christ in Majesty displaying the Cross (f. 64v); Consanguinity diagram (f. 68); Consanguinity Tree (f. 68v); map of the world (ff. 69v–70); allegory of the plants in the Song of Songs (ff. 76–76v); Alexander riding Bucephalus (f. 88); Rome with St. Peter (f. 99v).

Ornamental initials: A (f. 1); I (f. 1v); O (f. 98).

The Wolfenbüttel copy of Lambert of Saint-Omer's encyclopaedic compilation is in fact a separate edition of that work, with the contents set forth in an altogether different order. The manuscript is unfortunately incomplete, comprising only the first 126 of the 171 items listed in the table of chapter headings found at the beginning of the volume (ff. 1–1v); according to J. P. Gumbert's calculations, about 90 folios have been lost. Among the extant material in the Wolfenbüttel codex, however, are sections of the work that are missing in Lambert's autograph copy

in the University Library at Ghent (no. 96). The main element among these missing parts, corresponding to Nos. 28 to 32 in the inventory of the contents of the *Liber Floridus* made by L. Delisle (*Notice sur les manuscrits du Liber Floridus*, 44–8) is an extensive cycle of Apocalypse illustrations (ff. 9v–15v) for which the Wolfenbüttel manuscript is thus the earliest existing witness, though it is itself incomplete, lacking a certain number of the scenes found in the later copies of the work. As first noted by Delisle, the Wolfenbüttel codex belongs to a distinct recension within the known manuscripts of Lambert's text, which also includes four 15th-century copies: Chantilly, Musée Condé, MS 714; Genoa, Bibl. Durazzo; The Hague, Koninklijke Bibl. Cod. 72 A 23 and Cod. 128 C 4. Delisle also supposes that the entire group springs not directly from the original, but from a lost intermediary. Gumbert reports the discovery of another partial copy of the 15th century belonging to the family of the Wolfenbüttel manuscript.

Where the Wolfenbüttel codex was written and illuminated is not known. Like all the copies of the *Liber Floridus*, it omits the verses in praise of St. Omer and the accompanying portrait, along with the following illustrations of the *villa* of Sithiu or *castrum* of Saint-Omer with the portrait of Lambert (Delisle, *Notice*, Nos. 12–23) of the Ghent autograph. Lieftinck and Gumbert attribute the work to a monastic scriptorium of northern France or southern Belgium. H. Swarzenski localizes it in 'a hitherto unidentified Flemish scriptorium' and suggests Marchiennes as a likely place, basing himself on analogies between the style of the illumination and the initials in the first volume of Augustine's *Enarrationes in Psalmos* from that house (Douai, Bibl. Mun. MS 250; no. 108), These analogies are not such as to make a compelling case for a firm attribution, and it should be noted that St. Rictrudis, the patron of Marchiennes, is not included in the very extensive martyrology, (ff. 17v–18v), though the scribe of the Wolfenbüttel codex was on this point perhaps simply following his textual model, which does not include this saint. But a more persuasive argument than Swarzenski's has yet to be made.

The manuscript shows traces of extensive use. Its layout 'normalizes' the irregularities of the Ghent autograph and adapts its sometimes over-scaled contents to a more ordinary, two-column format. The writing was carried out by several hands in a workmanlike though not overly refined manner. *Incipits* are written in red, and the text features three-line pen-drawn ornamental letters in green and red, and smaller letters of the same type throughout. The illumination is the work of two hands, and consists of drawings using inks of various hues, with areas filled by flatly-laid colour. One artist, who gives his forms hard contours and an abstract, metallic cast, was responsible for the illustration of the enthroned Solomon and accompanying schema (f. 8v), the Annunciation (f. 9), the Apocalypse cycle (ff. 9v–15v),

the macrocosm-microcosm diagram (f. 31) and perhaps the drawing of Christ in Majesty and the zodiacal signs around the earth (f. 64v). The second artist, who executed the rest of the illustrations, has a more sketchy style, giving the impression of greater directness, and he employs a more varied range of colours, as may be seen in his lion (f. 37v), which has a pink body with red stripes and a greenish mane, and in his blue Behemoth with its monstrous, green-faced orange rider (f. 41v).

PROVENANCE: Marquard Gude (1635–1689). Acquired for the Ducal Library at Wolfenbüttel by G. W. Leibniz in 1710.

LITERATURE: F. A. Ebert, 'Handschriften der Herzoglichen Bibliothek zu Wolfenbüttel zur älteren deutschen Geschichte', *Archiv der Gesellschaft für ältere deutsche Geschichtskunde*, VI, 1838, 5–6; J. Zacher, 'Lambert Floridus', *Serapeum*, III, 1842, 145, 161ff.; L. Bethmann, 'Lamberti Floridus, nach der Genter Handschrift', *Serapeum*, VI, 1845, 59, 79ff.; *M. G. H., Script.*, IX, 308–313; R. Miller, *Mappae mundi*, Stuttgart, 1895, III, 126; O. von Heinemann, *Die Handschriften der Herzoglichen Bibliothek zu Wolfenbüttel*, Wolfenbüttel, 1884–1913, No. 4305; L. Delisle, 'Notice sur les manuscrits du 'Liber Floridus' composé en 1120 par Lambert, chanoine de Saint-Omer', *Notices et extraits*, XXXVIII, 1903, 593–600; E. Beer, *Die Rose der Kathedrale von Lausanne*, Bern, 1952, 68; Grabar and Nordenfalk, *Romanesque Painting*, 158; L. Behling, 'Ecclesia als Arbor Bona. Zum Sinngehalt einiger Pflanzdarstellungen des 12. und 13. Jahrhundert', *Zeitschrift für Kunstwissenschaft*, XIII, 1959, 139–54; *Katalog der Herzog-August Bibliothek Wolfenbüttel. IX. Die Gudischen Handschriften*, Frankfurt am Main, 1966, 77, No. 4305; W. Milde, *Mittelalterliche Handschriften der Herzog August Bibliothek*, Frankfurt, 1972, 92–104, Nos. 45–51; J. P. Gumbert, 'Recherches sur le stemma des copies du Liber Floridus', *Liber Floridus Colloquium*, ed. A. Derolez, Ghent, 1973, 37–50; G. I. Lieftinck, 'Observations codicologiques sur le groupe W des manuscrits du "Liber Floridus"', ibid., 31–6; H. Swarzenski, 'Comments on the Figural Illustrations', id., 28. P. Klein, 'Les cycles de l'Apocalypse du Haut Moyen Age', *L'Apocalypse de Jean. Traditions exégétiques et iconographiques*, Geneva, 1979, 146ff.; Cerny, *Marchiennes*, 64; J.-G. Arentzen, *Imago Mundi Cartographica. Studien zur Bildlichkeit mittelalterlicher Welt- und Ökumenekarten unter besonderer Berücksichtigung des Zusammenwirkens von Text und Bild*, (Münstersche Mittelalter-Schriften, 53), Münster, 1985, 91–4; E. Sears, *The Ages of Man. Medieval Interpretations of the Life Cycle*, Princeton, 1986, 68–9; R. K. Emmerson and S. Lewis, 'Census and Bibliography of Medieval Manuscripts Containing Apocalypse Illustrations, ca. 800–1500 (III)', *Traditio*, XLII, 1986, 459–60, No. 152; J. Zink, 'Moissac, Beaulieu, Charlieu — Zur ikonologischen Kohärenz romanischer Skulp-

turenprogramme im Südwesten Frankreichs und in Burgund', *Aachener Kunstblätter*, 56/57, 1988/89, 121.

118. Paris, Bibliothèque Nationale MS lat. 11575 and 11576

Florus, Commentary on the Pauline Epistles
475 × 340 mm., ff. 144 and 120, 2 cols., 48 lines
1163–64. Saint-Pierre, Corbie *Ills. 283, 284*

lat. 11575

Historiated and ornamental initials: ROMANS, P, Christ holding the globe of the world; below, Paul addresses his letter to the Deaconess Phoebe (16:1) recommending her to the Romans (f. 1); I CORINTHIANS, P (f. 77).

lat. 11576

Historiated and ornamental initials: II CORINTHIANS, P (f. 1); GALATIANS, P (f. 22); EPHESIANS, P (f. 39); PHILIPPIANS, P, Paul and Timothy seated side by side (f. 55); COLOSSIANS, P (f. 67v); I THESSALONIANS, P (f. 75v); II THESSALONIANS, P (f. 80); I TIMOTHY, P (f. 82v); II TIMOTHY, P (f. 96); TITUS, P (f. 104); HEBREWS, M (f. 104v).

The execution of this pair of volumes is precisely localized and dated in the colophon to the year 1164, but this text also places the completion of the work in the year of the Council of Tours, which met in May 1163. The scribe, Iohannes Monoculus, apparently a cleric, is represented in a mandorla-like space along the right side of the initial at the beginning of the first tome. Richerus, the sub-prior of Corbie, for whom the manuscript was written, appears in a reverential stance within a roundel lodged in the stem of the letter. The illuminator is not mentioned in the colophon, but depicted at work in another roundel of the same initial, below Richerus. An inscription identifies him as Felix, and his dress characterizes him as a layman. John wrote a number of other books for Corbie. A copy of Augustine's Sermons, executed for the same Richerus, who presented it to St. Peter, the patron saint of the monastery, can according to Mérindol be dated in the years 1160–61 (Bibl. Nat. lat. 12199). In the colophon of this work, he is called John of Amiens (*Iohannes Ambianensis*). In 1179, John wrote a Homiliary (Bibl. Nat. lat. 11700), and in 1183, a copy of Peter Comestor's *Historia Scholastica* (Bibl. Nat. lat. 16943). Mérindol, who on palaeographic grounds attributes to him several more manuscripts from the Corbie library, sets the beginning of his activity around 1150. Felix is not otherwise explicitly

documented, but his style can be recognized in the decoration of two other Corbie manuscripts, the already-mentioned Sermons of Augustine written by John, and a Psalter with the commentary of Gilbert de la Porrée (Bibl. Nat. lat. 12400). Mérindol considers him to be of English origin, but this conclusion is not persuasive.

The manuscript has large painted initials at the beginning of the commentary text of thirteen Pauline Epistles, assembled in the 9th century by Florus of Lyons from the writings of St. Augustine. The *incipits*, *incipit* words and *explicits* are rendered in alternating red, blue and green majuscule letters, and two or three-line letters of a flourished type mark the subdivisions of the text. The most important of the initials (lat. 11575, f. 1) occupies the full height of the text columns and incorporates the portraits of the scribe, patron and painter already-mentioned. The principal subject of this initial P, which fills the loop of the letter, is unusual and apparently unprecedented, drawn as it is from the text of Romans rather than the customary source of narrative illustrations of the life of St. Paul, the Acts of the Apostles. The Lord appears in the heavens in the upper part of the composition. Below, the Apostle commends Phoebe, a deaconess of the church of Cenchreae (Corinth), to a group of men who stand near the gate of the walled city of Rome. The remaining initials, for the most part ornamental letters, are filled with intersecting spirals of foliage. One (lat. 11567, f. 1) shows a warrior with sword and shield battling a dragon, and another features a nude black warrior (f. 67v). An initial is borne by an acrobatic, naked man, standing on a column (f. 75v), while others are delineated by leonine and dragon-like creatures. The style of these designs represents a comparatively early version of a late Romanesque decorative mode, widely diffused in north-eastern France from the 1170s onwards. Several Corbie manuscripts have initials of the same type, though a little coarser in their execution (Amiens, Bibl. Mun. MSS 39–40, 115).

PROVENANCE: Written by Iohannes Monoculus in 1163–64 on the order of the sub-prior of Corbie Richerus (lat. 11576, f. 120), and illuminated by Felix. Saint-Germain-des-Prés, Paris, 1638. Acquired by the Bibliothèque Nationale in 1795–96.

LITERATURE: Delisle, *Cabinet des manuscrits*, II, 114, and III, 290; F. de Mély, *Les primitifs et leur signatures*, Paris, 1913, 14–15; L. W. Jones, 'The Scriptorium at Corbie. I. The Library', *Speculum*, XXII, 1947, 198; C. Charlier, 'La compilation augustinienne de Florus sur l'Apôtre', *Revue bénédictine*, LVII, 1947, 132–3; A. Boutemy, 'De quelques enlumineurs de manuscrits de l'abbaye de Corbie dans la seconde moitié du XIIe siècle', *Scriptorium*, IV, 1950, 246–51; *Colophons*, III, 1973, 398, No. 10655; *Manuscrits datés*, III, 1974, 243; J. J. G. Alexander, *The Decorated Letter*, New York, 1978, 86–7; id. 'Scribes as Artists: The Arabesque

Initial in Twelfth-Century English Manuscripts', *Medieval Scribes, Manuscripts and Libraries: Essays Presented to N.R. Ker*, ed. M.B. Parkes and A.G. Watson, London, 1978, 112–16; Mérindol, *Corbie*, I, 15f. and *passim*; II, 834–7; id., 'Manuscrits et sculptures de l'abbaye de Corbie dans la deuxième moitié du XIIe siècle', *Bulletin archéologique du Comité des travaux historiques et scientifiques*, N. S., 14, 1980, 141ff.; id., 'Les peintres de l'abbaye de Corbie au XIIe siècle', *Artistes, artisans et production artistique au Moyen Age. I. Les hommes*, Paris, 1986, 311–26; B. Guineau, C. Coupry, M. T. Gousset, J. P. Forgerit and J. Vezin, 'Identification de bleu lapis-lazuli dans six manuscrits provenant de l'abbaye de Corbie', *Scriptorium*, XL, 1986, 157–71.

EXHIBITED: *Manuscrits à peintures*, Paris, 1954, 60, No. 140; *Art roman*, Barcelona and Santiago de Compostela, 1961, 48, No. 61; *Ornamenta Ecclesiae*, Cologne, 1985, I, 239, No. B 40.

119. Valenciennes, Bibliothèque Municipale MSS 1–5

Bible
500 × 335 mm., ff. 147, 157, 153, 156 and 178.
2 cols., 36 lines
Third quarter of the 12th century.
Saint-Amand

Ills. 282, 285, 286; Figs. 15, 17

MS 1

Ornamental initials: PREFACE TO PENTATEUCH, D (f. 3); GENESIS, I in framed title page (f. 5v); EXODUS, H (f. 34v); LEVITICUS, V (f. 58v); DEUTERONOMY, L (f. 75); NUMBERS, H (f. 98); PREFACE TO JOSHUA, T (f. 116v); JOSHUA, E (f. 118); JUDGES, P (f. 131v); RUTH, I (f. 145v).

MS 2

Ornamental initials: PREFACE TO KINGS, V (f. 1v); I KINGS, F in framed title page (f. 4); II KINGS, F (f. 25); III KINGS, E (f. 41v); IV KINGS, P (f. 61); PREFACE TO ISAIAH , N (f. 79); ISAIAH, V (f. 82); PREFACE TO JEREMIAH, I (f. 110); JEREMIAH, V (f. 112); BARUCH, H (f. 145); LAMENTATIONS, E (f. 149).

MS 3

Historiated and ornamental initials: PREFACE TO EZEKIEL, I (f. 1v); EZEKIEL, E in framed title page (f. 4v); PREFACE TO MINOR PROPHETS, N (f. 34v); HOSEA, V (f. 35v); JOEL, V (f. 40v); AMOS, V (f. 42); OBADIAH, V (f. 47); JONAH, E (f. 48); MICAH, V (f. 59v); PREFACE TO NAHUM, N (f. 52); NAHUM, O (f. 52v); HABAKKUK, O (f. 54); ZEPHANIAH, V (f. 56); HAGGAI, I (f. 58); ZECHARIAH, V (f. 60); MALACHI, O (f. 65v); PREFACE TO JOB, C (f. 67); JOB, V (f. 69); PREFACE TO PSALMS, D (f. 83v); PSALM I, B (f. 84v); Psalm 42, S (f. 93v); Psalm

73, A (f. 100v); Psalm 90, D (f. 105); Psalm 106, C (f. 109v); PREFACE TO PROVERBS, T (f. 119); PROVERBS, P (f. 120v); ECCLESIASTES, V (f. 133); SONG OF SONGS, O, Christ and Ecclesia embracing (f. 137v); PREFACE TO DANIEL, D (f. 140); DANIEL, A (f. 141).

MS 4

Historiated and ornamental initials: PREFACES TO CHRONICLES, S (f. 1); E (f. 2); I CHRONICLES, A in framed title page (f. 4v); II CHRONICLES, C (f. 22); PREFACE TO EZRA, U (f. 44); EZRA, I (f. 45); PREFACE TO ESTHER, L (f. 59); ESTHER, I (f. 59v); PREFACE TO JUDITH, A (f. 67); JUDITH, A (f. 67v); PREFACES TO TOBIT, T, C (f. 75v); TOBIT, T (f. 75v); PREFACE TO MACCABEES, M (f. 81v); I MACCABEES, E (f. 83); II MACCABEES, F (f. 102v); PREFACE TO WISDOM, P (f. 116); WISDOM, D (f. 121); PREFACE TO ECCLESIASTICUS, M (f. 130); ECCLESIASTICUS, O, the Lord enthroned (f. 131v).

MS 5

Historiated and ornamental initials: PREFACES TO GOSPELS, N, P, E, S (ff. 7v, 8, 8v); CANON TABLES (ff. 9v–14v); PREFACE TO MATTHEW, M (f. 15); MATTHEW, L in framed title page, with Christ in Majesty and the Evangelist symbols (f. 16v); MARK, I (f. 37); LUKE, Q, writing Evangelist with symbol (f. 51); JOHN, I, standing Evangelist with symbol (f. 72v); PREFACE TO ACTS, A (f. 88); ACTS, P, Luke and Theophilus in dialogue (f. 89); JAMES, standing Apostle (f. 109v); I PETER, P (f. 112); II PETER, S (f. 114v); I JOHN, Q, seated Christ with Cross staff (f. 116v); II JOHN, S (f. 118v); III JOHN, S (f. 119); JUDE, I (f. 119v); APOCALYPSE, A, Evangelist adoring the Lamb of God (f. 121v); ROMANS, missing; I CORINTHIANS, P (f. 140v); II CORINTHIANS, P (f. 148); GALATIANS, P (f. 153v); EPHESIANS, P (f. 156v); PHILIPPIANS, P (f. 159v); COLOSSIANS, P (f. 161v); I THESSALONIANS, P (f. 164); II THESSALONIANS, P (f. 166); PREFACE TO TIMOTHY, T (f. 167); TIMOTHY, P, Paul displays the model of a church (f. 167); II TIMOTHY, P (f. 169v); TITUS, P (f. 171); PHILEMON, P (f. 172); HEBREWS, M (f. 173).

These volumes figure in the mid 12th-century inventory of books of Saint-Amand, commonly called *Index maior*, as No. 254: *Vetus et novum testamentum in quinque voluminibus quae leguntur ad mensam*. The five-volume format is unusual and found in the 12th century only in a number of Bibles of Cistercian provenance. The disposition of the illumination is also exceptional. In addition to the customary sequence of initials at the beginning of the biblical books and the major prefaces, the first book in each volume is introduced by a composition occupying an entire page and incorporating the initial and *incipit* word within a splendid carpet of intertwined rinceaux. Above these frontispiece designs appears the identical inscription *SAWALO MONAC(US) SCI AMANDI ME FECIT*. Sawalo's name is also inscribed, employing the same formulation, in two

Saint-Amand manuscripts, a copy of Hilary of Poitiers' *De Trinitate* (Paris, Bibl. Nat. lat. 1699) and Peter Lombard's Sentences (Valenciennes, Bibl. Mun. MS 186). Beyond the manuscript signatures, two additional documents may also refer to Sawalo. Delisle drew attention to a Saint-Amand charter of 1143 in which a *Sawalo subdiaconi* appears among the signatories. The name is also inscribed on an ivory knife handle in the Musée des Beaux-Arts at Lille, whose carved decoration is broadly comparable to Sawalo's draughtsmanly style (A. Goldschmidt, *Elfenbeinskulpturen*, IV, 18–19). The word *fecit* in the manuscript signatures leaves the nature of Sawalo's precise role in the production of these works undefined. But one of the manuscripts, the Valenciennes Peter Lombard, is signed by the scribe Segarhus, and this may support the suggestion that Sawalo was the illuminator. In addition to the books identified by inscriptions, a substantial number of other manuscripts from Saint-Amand and others executed for nearby Marchiennes have been attributed to Sawalo or to collaborators on the basis of the style of their decoration (Garborini, *Der Miniator Sawalo*, 92ff., and 202–27).

The present Bible can be considered Sawalo's major work. He was responsible for the illumination of the first four volumes, and he also executed the Matthew frontispiece in the fifth, which was completed by two other painters. His initial pages with their luxuriant tapestries of foliage reminded Porcher of eastern textile patterns and Insular carpet pages, but it is more probable that their antecedents should be sought in the 11th-century illumination of Saint-Amand and Arras, as Garborini has argued. In the restricted scope given to pictorial illustration, Sawalo follows the earlier Saint-Amand Bible of Alardus (Valenciennes, Bibl. Mun. MS 9–11), where the same compositions appear in the initials for the Song of Songs and Ecclesiasticus. His handsome and otherwise wholly ornamental initials have a gold framework that is outlined in red, while the hollows within the letters are filled with curling and interlocking stems of foliage left in silhouette against a light blue ground. The letter is usually placed within a framed panel. Of the painters who are represented in the fifth volume of the Bible, the first much enlarged the figurative component in the decoration of the work. He was probably the artisan, working under English and Byzantine influence, who also illuminated a number of other Saint-Amand manuscripts, among them its notable Sacramentary (Valenciennes, Bibl. Mun. MS 108; no. 120). The second, whose initials occur in the later pages of the manuscript, is best regarded as a follower of Sawalo. Basing themselves on somewhat divergent conclusions about the sequence of the entries in the *Index maior*, Boutemy placed the execution of Sawalo's Bible between 1154 and 1159, while Garborini advances a date from 'before 1158' to 1165.

PROVENANCE: 'Made' by Sawalo, a monk of Saint-Amand (MS 1, f. 5v; MS 2, f. 4; MS 3, f. 4v; MS 4, f. 4v; MS 5, f. 16v).

LITERATURE: J. Mangeart, *Catalogue descriptif et raisonné des manuscrits de la Bibliothèque de Valenciennes*, Paris and Valenciennes, 1860, 1–3, No. 1; A. Molinier, *Catalogue général*, XXV, 1894, 193; Delisle, *Cabinet des manuscrits*, III, 448ff.; Boeckler, *Abendländische Miniaturen*, 95; P. Lefrancq, 'Quelques notes sur les manuscrits les plus importants de la Bibliothèque de Valenciennes', *Bulletin du Comité flamand de France*, II, 1935, 353–4; A. Boutemy, 'Quelques aspects de l'oeuvre de Sawalon, décorateur de manuscrits à l'abbaye de Saint-Amand', *Revue belge d'archéologie et d'histoire de l'art*, IX, 1939, 299–316; id. *Enlumineurs de l'abbaye de Saint-Amand*, 157f.; id. in E. de Moreau, *Histoire de l'église en Belgique*, II, 1945, 344–5; H. G. Franz, *Spätromanik und Frühgotik* (Kunst der Welt), Baden-Baden, 1959, 169–71; Dodwell, *Painting in Europe*, 178; Garborini, *Der Miniator Sawalo*, 52ff., 185–98, 202ff.; Cahn, *Romanesque Bible Illumination*, 282–3, No. 115.

EXHIBITED: *Manuscrits à peintures*, Paris, 1954, 66, No. 163; *Scaldis. Art et civilisation*, Tournai, 1956, 82, No. 10; 83, No. 18; *Byzance et la France médiévale*, Paris, 1958, 66, No. 121; *Archéologie du livre médiéval*, Valenciennes, 1990, 30–31, No. 28.

120. Valenciennes, Bibliothèque Municipale MS 108

Sacramentary
335 × 210 mm., ff. 110, 25 long lines
Third quarter of the 12th century.
Saint-Amand *Ills. 287, 288*

Full-page miniature: Crucifixion (f. 58v).

Historiated and ornamental initials: E (f. 9v); O, Nativity (f. 12); D, Stoning of St. Stephen (f. 12v); D, church with personification of Ecclesia (f. 40v); O, the souls in Abraham's bosom (f. 46v); P (*Per Omnia*) and VD (*Vere Dignum*) (f. 54v); O, Presentation in the Temple (f. 66v); D, death of St. Amand (f. 67v); D, Annunciation (f. 69v); D, Peter and Paul displaying the model of a city (f. 79); F (f. 88); F (f. 93).

Smaller ornamental initials: ff. 11, 13v, 24, 25, 27v, 27bis, 31, 33, 34v, 35, 41v, 51, 62v, 69v, 76, 77v, 84v, 87v, 95v, 101v, 102v, 103v, 105v, 106v, 107.

The Sacramentary is the only liturgical book of some significance among the 12th-century illuminated manuscripts of Saint-Amand. In the Calendar (ff. 3–8v), which is handsomely furnished with KL monograms in gold, the following commemorations, given special emphasis, are decisive for the question of provenance: *Depositio Sancti Amandi* (6th

February) and Octave (13th February); *Ordinatio et translatio Sancti Amandi* (23rd October) and *Dedicatio ecclesiae Sancti Amandi episcopi* (26th October; on the establishment of these feast days, see Leclercq, *D. A. C. L.*, XV, 1, 1950, 470–3). The feast of St. Thomas Becket, canonized in 1173, is an addition, and this must be the *terminus ante quem* for the execution of the work. Invocations for St. Thomas (f. 62v) and for St. Bernard of Clairvaux, canonized in 1174 (f. 88v) have also been added in the margins of the Sanctorale.

The major feasts of the Temporale (ff. 9v–59v) and the Sanctorale (ff. 63–109) are singled out with five or six-line initials painted in body colour and set within square panels of gold, or where gold is used for the framework of the letter, another colour. These initials are the work of the painter who illuminated the last volume of Sawalo's Bible (Valenciennes, Bibl. Mun. MS 5; no. 119). The purely ornamental designs are filled with spiralling foliage terminating in splayed or burgeoning leaves. Among the inventive and attractively composed historiated letters, several are of more than passing iconographic interest. The Masses for the *Dedicatio ecclesiae* (f. 40v) shows a half-length personification of the Church within a turreted structure. The Mass *Pro defunctis* (f. 46v) has as its subject a patriarchal Abraham enfolding the souls of five diminutive figures in his bosom: a king at the centre, flanked by a bishop, a monk and two less distinctively particularized men. The decoration is finely calibrated to set the major feasts apart from the second group of lesser commemorations, which have initial letters delineated in gold, with pen-drawn rinceaux in other colours, and still more ordinary masses, which have more modest flourished ornamental letters in combinations of blue and red, green and red, or all three colours, with accents in gold. A particularity of this scribal embellishment is the placement of P initials on their right side when they occupy the last line of the page in order to avoid the invasion of the margin by the descender of the letter. The Preface and Canon of the Mass (ff. 51–62), which have musical notation, are unaccountably repeated. This section is distinguished by ornamental initials in gold and by a full-page painting of the Crucified Christ between mourning figures of the Virgin Mary and St. John on a gold background (f. 58v). A shrouded figure of Adam prayerfully rising from his tomb is seen at the foot of the Cross, and personifications of the sun and moon, along with a pair of gesticulating angels, over its arms. The lower parts of Christ's body and the figure of Adam are unfortunately somewhat soiled and eroded. The manuscript as a whole shows the effect of wear, and a number of initials have been retouched with a heavy black outline, while others are badly worn or smudged (ff. 31, 33).

The brilliant linear sinuosities of the painting were taken by Koehler as an illustration of the impact of Byzantine art upon the West in the Romanesque period. In a more immediate sense, they indicate a stylistic connection with English illumination as exemplified by the Lambeth Bible, whose painter is known to have been active in nearby Liessies (cf. no. 106). Although the illumination of the Sacramentary presents a fairly homogenous appearance, the 'damp-fold' patterning of English derivation is more pronounced in the Crucifixion than in the initials, and more than one painter may have been involved in the project, as Porcher has suggested. Since Boeckler's survey of 1930, it has been customary to link the Sacramentary with a number of other illuminated manuscripts produced at Saint-Amand in the second half of 12th century: Valenciennes, Bibl. Mun. MS 12 (Ammonius, Concordances of the Gospels); MS 80 (Augustine, Commentary on St. John); MS 197 (Gilbert de la Porrée, Commentary on Boethius' *De Trinitate*); MS 512 (John the Deacon, Life of Gregory), and Paris, Bibl. Nat. lat. 2287 (Gregory, Letters), a list that has been substantially expanded by Boutemy. In these books, however, the painting has a more volumetric effect and does not show any traces of the abstract 'damp-fold' modelling. It likely represents a slightly later phase of the activity of the scriptorium or, at any rate, another direction.

PROVENANCE: Saint-Amand.

LITERATURE: J. Mangeart, *Catalogue descriptif et raisonné des manuscrits de la Bibliothèque de Valenciennes*, Paris and Valenciennes, 1860, 85–7, No. 101; A. Molinier, *Catalogue général*, XXV, 1894, 233; Leroquais, *Sacramentaires*, I, 269–72; Boeckler, *Abendländische Miniaturen*, 95; P. Lefrancq, 'Quelques notes sur les manuscrits les plus importants de la Bibliothèque de Valenciennes', *Bulletin du Comité flamand de France*, II, 1932, 353; W. Koehler, 'Byzantine Art in the West', *Dumbarton Oaks Papers*, I, 1941, 73; Boutemy, *Enlumineurs de l'abbaye de Saint-Amand*, 147–52; id., 'Les Évangiles du Musée Mayer van den Bergh', *Revue belge d'archéologie et d'histoire de l'art*, XVIII, 1949, 28; Swarzenski, *Monuments of Romanesque Art*, 63, No. 140; C. R. Dodwell, *The Canterbury School of Illumination, 1066–1200*, Cambridge, 1954, 56; Porcher, *French Miniatures*, 37–8; Garborini, *Sawalo*, 33, 68, 104.

EXHIBITED: *Manuscrits à peintures*, Paris, 1954, 68–9, No. 171; *Byzance et la France médiévale*, Paris, 1958, 66–7, No. 124; *Scaldis. Art et civilisation*, Tournai, 1956, 84, No. 29.

121. Cambridge, St. John's College MS C.18

Psalter and Hours of the Virgin,
with other Offices (Saint-Bertin Psalter)
324 × 210 mm., ff. 250, 19 long lines
c. 1175. French Flanders or Southern England

Ills. 289, 290, 291

Historiated and ornamental initials: Psalm 1, cut out (f. 9); Psalm 26, D, Anointing of David (f. 37v); Psalm 38, D (f. 55); Psalm 51, Q, Ahimelech hands to David the bread and the sword of Goliath (f. 70v); Psalm 52, D (f. 71v); Psalm 68, S (f. 87v); Psalm 80, E (f. 108); Psalm 96, C (f. 127); Psalm 101, D (f. 129v); Psalm 109, D, bust of Christ with book (f. 148); PRAYER TO THE TRINITY, T, standing Christ with scroll, kneeling petitioner (f. 218v); HOURS OF THE VIRGIN, D, half-length Virgin with book (f. 235).

Lesser ornamental initials: ff. 10, 31, 44v, 64, 78v, 96, 165v, 188.

Customarily known as the Saint-Bertin Psalter, this manuscript presents problems of dating and localization that have not yet been fully resolved. As first noted by S. Cockerell and M. R. James, and subsequently most fully discussed by Patricia Danz Stirnemann and R. M. Thomson, the Calendar and Litany are for the Use of St. Albans, but modified through the introduction of commemorations associated with Saint-Bertin, the important Benedictine house at Saint-Omer near the Channel Coast. Five obits in the original hand concern Queen Mathilda of England (d. 1152), *Willelmus senior* and *Willelmus junior*, castellans of Saint-Bertin, Count Baldwin of Flanders, and an *advocatus* of the abbey named Stephen. By the early 13th century, as Thomson suggests on the basis of a group of added obits, the manuscript had come into the possession of Matilda of Bailleul, a daughter of Count Baldwin who became abbess of the Benedictine nunnery of Wherwell in Hampshire some time before 1194. The wording of the special prayers following the Litany (ff. 212–34v) suggest that the work was made for a man, perhaps the figure wearing a white surplice and a grey cap shown at the feet of Christ in the initials of the Prayer to the Trinity (f. 218v). Among the original obits of the Calendar, the Count of Flanders can probably be identified as Baldwin VII, who died in 1119, and was buried at Saint-Bertin where he had become a monk. Stephen, the *advocatus*, is otherwise unknown to us, while castellans named William are all too plentiful in Saint-Bertin documents of the 12th century: the name was handed down in hereditary fashion with the office. However, one of the men commemorated in the Psalter may well have been the figure identified as William III, whose career roughly spanned the sixth decade of the century, since at least two of his close kin — a brother, the Templar Hosto, and a sister named Euphemia — have obits in the Calendar. The fact that St. Thomas Becket is absent, and that St. Bernard, canonized in 1174, is an addition, speaks for a date not later than the early or mid Seventies, though not with such force as to constitute hard proof. The initials in the manuscript were executed by a painter whose substantial *oeuvre* includes a number of manuscripts executed for the bibliophile Abbot Simon of St. Albans (1167–83), though, so far as is known, no other books with ties to Saint-Bertin. He seems to have been active on both sides of the Channel, and the broad diffusion of his work suggests that he may have been a professional free to travel and offer his services on demand. Whether he was of English or French origin is as uncertain as the trajectory of his lively career. He was acquainted with and a proponent of the Channel Style ornament identified with Parisian and north-eastern French illumination from the 1170s onwards, of which the ornamental initials of the Saint-Bertin Psalter furnish some excellent examples. His spare scenic compositions are peopled by somewhat stockily proportioned figures, whose fastidious modelling retains some traces of 'damp-fold' effects. He is recognizable also by the habit of rendering the act of speech by connecting the words in the adjoining text to the speaker by means of a kind of funnel reserved in the body of the initial (f. 218v). In the distribution of the historiated initials within the manuscript and the choice of subjects, the Saint-Bertin Psalter more or less adheres to the system found in two other luxury manuscripts of the third quarter of the 12th century, both of them made for patrons of northern England, the Copenhagen Psalter (Royal Library, Thott. 143.2º) and the Psalter of the Hunterian Library in Glasgow (MS 229). The latter, according to Stirnemann, were also executed by hired professionals with more southerly associations, and the Copenhagen codex in particular with the assistance of the artist of the Saint-Bertin Psalter, whose hand can be seen in a number of the initials.

PROVENANCE: Matilda of Bailleul, Abbess of Wherwell, Hampshire (obit). Wherwell Abbey. William Crashaw (1572–1626). Henry Wriothesly, Earl of Southampton, *c.* 1615. Given to St. John's College by his son Thomas in 1635 (bookplate).

LITERATURE: M. R. James, *A Descriptive Catalogue of Manuscripts in St. John's College, Cambridge*, Cambridge, 1913, 89–93, No. 68; G. Haseloff, *Die Psalterillustration im 13. Jahrhundert*, Kiel, 1938, 43–5; W. Cahn, 'St. Albans and the Channel Style in England', *The Year 1200: A Symposium*, New York, 1975, 191–2; C. M. Kauffmann, *Romanesque Manuscripts*, Survey III, 27–8; P. Danz Stirnemann, *The Copenhagen Psalter*, Diss. Columbia University, 1976, 236–43 and *passim*; R. M. Thomson, *Manuscripts from St. Albans Abbey, 1066–1235*, Woodbridge, 1982, I, 56–60, and 120–1, No. 74; P. R. Robinson, *Catalogue of Dated and Datable Manuscripts, C. 737-1600, in Cambridge Libraries,*

Cambridge, 1988, 86, No. 296; J.-C. Schmitt, *La Raison des gestes dans l'art occidental*, Paris, 1990, 263-5.

EXHIBITED: S. Cockerell, *Burlington Fine Arts Club. Exhibition of Illuminated Manuscripts*, London, 1907, 14, No. 32; *Romanesque Art, c. 1050–1200*, Manchester, 1959, 27–8, No. 28.

122. Douai, Bibliothèque Municipale MS 372

Works of Bernard of Clairvaux, Hildebert of Lavardin, and other authors
490 × 330 mm., ff. 204, 293 and 140,
2 cols., 53 lines
c. 1165–75. Saint-Sauveur, Anchin

Ills. 294, 295

Vol. I

Jacob's Vision of the Ladder at Bethel (f. 100).

Ornamental initials: R (f. 100v); Q (f. 107); V (f. 122); V (f. 127v); A (f. 130v); D (f. 136v); L (f. 141v); V (f. 156); S (f. 161v); M (f. 177v); N (f. 204v).

Vol. II

Large decorative panel with initial B, showing the scribe Sigerus at a pulpit (f. 4v).

Ornamental initials: U (f. 126v); S (f. 147v); B (f. 148); V and E (f. 158v).

Vol. III

Ornamental initial: D (f. 104v).

These three volumes represent the earliest attempt to realize a collected edition of the writings of St. Bernard, along with an imposing hagiographical dossier, an unusual undertaking which attests to the extraordinary reputation of the Abbot of Clairvaux not long after his death in 1151 and before his canonization in 1174. They may, indeed, have been conceived in order to promote Bernard's cause, which appears to have encountered some opposition. Jean Leclercq dates the work around 1165, or in the period 1165 to 1175. The work was written and perhaps illuminated by Sigerus, a monk of Anchin, whose name appears in all three tomes as well as in the form of the anagram *Suregis* inscribed above a portrait of the scribe at work in an initial of Vol. II (f. 4v); Sigerus is also mentioned in an Anchin charter dated 1161, where he is characterized as one of the senior members of the community (Escallier, *L'abbaye d'Anchin*, 116), and he was thus at that time already of a fairly advanced age.

The decoration is the work of several illuminators, and does not follow a completely predictable pattern. Each of the three volumes has several designs executed in body colour and with the help of silver and gold, while the rest of the embellishment — ornamental initials at the beginning of the various

tracts or sections thereof — is done in pen outline, with tints only of green, pink and blue. In Vol. I, the large initial which introduced Bernard's Sermons on the Song of Songs, has been excised (f. 1), and the weight of the decoration is concentrated on the treatise on the Twelve Steps of Humility and Pride, which is preceded by a painted miniature of great iconographic interest devoted to Jacob's dream–vision of the ladder, the starting point of the saint's meditation in this work, and an elaborate ornamental initial. Significant in the representation of the ladder is the depiction of the Lord in heaven flanked by two monks in contrasting habits, who should probably be identified as St. Benedict (left) and St. Bernard (right). Bernard's *De gradibus* was inspired by the allegorical treatment of Jacob's vision in the seventh chapter of the Rule of St. Benedict and makes explicit reference to it. Bernard is thus presented as another Benedict, an advantageous association that was occasionally to be exploited on behalf of the Cistercians in later times. Among the pen-drawn letters, it may be observed that the initial attached to Bernard's satire of the imagery of monastic cloisters, the *Apologia ad Guillelmum* (f. 156), does not differ from the rest and even incorporates a dragon. In Vol. II, there is one large painted initial featuring Sigerus's portrait at the beginning of the collection of Bernard's Letters while the rest of the initials are once again of a more modest and draughtsmanly character. The third, more battered and incomplete volume has a single painted initial set in the midst of the collection of Bernard's Sermons on the Gospels, and more pen-drawn letters enlivened with multi-coloured tints. The fully painted decoration in all three volumes was carried out by one illuminator, whom P. Cerny, who has sought to reconstruct his career, calls the Gregory Master. According to Cerny, he was schooled in a centre of southern England and came to Anchin in the 1160s from nearby Saint-Amand, where he contributed to the embellishment of the *Vita* of the local patron saint (Valenciennes, Bibl. Mun. MS 501; no. 126) and illuminated a copy of Pope Gregory's *Liber Pastoralis* Valenciennes, Bibl. Mun. MS 512; no. 127). At Anchin, beyond the collection of Bernard's writings, he is also thought to have painted the full-page author portrait in Gregory's Commentary on the New Testament (Douai, Bibl. Mun. MS 315 II). It is not altogether certain, however, that these works were all created by a single artistic personality. The pen-drawn initials, on the other hand, were contributed by a number of hands working in a manner deriving from the decorative vocabulary of the group of Anchin manuscripts gathered around the copy of Augustine's *Enarrationes* made by Jordanus (Douai, Bibl. Mun. MS 253; no. 110).

PROVENANCE: Written by Sigerus (Vol. I, f. 2; Vol. II, f. 4v; Vol. III, f. 132).

LITERATURE: E. Escallier, *L'abbaye d'Anchin*, Lille, 1852, 110 (cited as MS 367); C. Dehaisnes, *De l'art chrétien en Flandre*, Douai, 1860, pl. opp. 43; id., *Catalogue général*, VI, 1878, 202–8; Dom P. Séjourné, 'Les inédits bernardins du manuscrit d'Anchin', *Saint Bernard et son temps*, Dijon, 1929, II, 248–82; W. Williams, 'The Anchin Manuscript (Douai 372)', *Speculum*, VIII, 1933, 246–54 (repr. in the author's *Monastic Studies*, Manchester, 1938, 246–55); J. Leclercq, 'La plus ancienne collection d'oeuvres de Saint Bernard', *Études sur Saint Bernard et le texte de ses écrits* (Analecta S. Ordinis Cisterciensis, IX), Rome, 1953, 124–36; A. Boutemy, 'Enlumineurs d'Anchin au temps de l'Abbé Gossuin (1131/1133 à 1165)', *Scriptorium*, XI, 1957, 237, 244–5; Grabar and Nordenfalk, *Romanesque Painting*, 161; H. G. Franz, *Spätromanik und Frühgotik* (Kunst der Welt), Baden-Baden, 1959, 178, 184; J. Leclercq, *Recueil d'études sur Saint Bernard et ses écrits*, Rome, 1961–66, I–II, *passim*; *Colophons*, V, 1979, 299, No. 17080; Cerny, *Anchin*, 47; *Saint Bernard et le monde cistercien*, ed. L. Pressouyre and T. N. Kinder, Paris, 1991, 210, No. 27; W. Cahn, 'Benedict and Bernard: The Ladder Image in the Anchin Manuscript', *Ratio fecit diversum. San Bernardo e le arti*, (Arte medievale, 1994, 2), 33-45.

EXHIBITED: *Manuscrits à peintures*, Paris, 1954, 64–5, No. 156; *L'art roman*, 50, No. 64; *Saint Bernard et le monde des cisterciens*, Dijon, 1953, 210, No. 27.

123. Paris, Bibliothèque Nationale MS lat. 2287

Gregory, Epistles
465 × 320 mm., ff. 172, 2 cols., 44 lines
c. 1160–70. Saint-Amand *Ill. 306*

The volume contains the *Registrum Gregorii* (ff. 1–167v) to which is appended several short texts: John the Deacon, *Liber de ecclesia Lateranensis* (ff. 168–70); Pseudo-Seneca, *De remediis fortuitorum* (f. 170v), and a description of the Seven Marvels of the World (f. 172). The decorative treatment of these writings is fairly sober, with headings only in red, and three or four-line penwork initials of an early flourished type in red and blue or green for each of Gregory's Letters. The two components of the painted decoration are the splendid full-page portrait of Pope Gregory (f. 1v) and the ornamental initial with intertwined rinceaux on a gold ground enclosed within a blue and green frame for the pope's *Denuntiatio pro septiformi letania*, addressed to the people of Rome, which opens the *Registrum* in this volume (f. 2). The white-haired and bearded pope, wearing a mitre, sits on a broad, bench-like throne made of a black marble slab and with a yellowish base and seat. He wears the alb, dalmatic and an ornamental red chasuble over which the pallium is draped. The figure, whose glance is directed towards the right as if to address an unseen interlocutor, displays an open book in his left hand and gestures with his right as if speaking. Did the artist's model perhaps show two figures in dialogue? The manuscript figures as No. 279 in an inventory of Saint-Amand (*Index maior*), though among the additions made to the initial section of this catalogue. According to N. Garborini, these additions date from *c.* 1158 onwards, and the manuscript was probably executed a few years after or in the sixth decade of the 12th century. The same painter's hand has been discovered in other Saint-Amand manuscripts, but a clear consensus on the boundaries of his *oeuvre* has not yet emerged. Boeckler connected lat. 2287 with Valenciennes, Bibl. Mun. MSS 15 (Ammonius, *Concordia evangeliorum*) and 197 (Gilbert de la Porrée, Commentary on Boethius' *De Trinitate*; no. 128). Boutemy rejected the second of these works, but added to the list of the painter's books the Sacramentary of Saint-Amand (Valenciennes, Bibl. Mun. MS 108; no. 120), two miniatures in the Life of Saint-Amand (MS 500; no. 129), Augustine's Commentary on John (MS 80), Jerome's Commentary on the Song of Songs (Paris, Bibl. Nat. lat. 1808), and more tentatively, the last volume of Sawalo's Bible (Valenciennes, Bibl. Mun. MS 5; no. 119). These attributions were accepted by Porcher, though the illumination of the books listed is arguably the work of another, more conservative personality. Garborini has noted the similarity of the portrait type of Gregory and the depiction of the author in Hilary's *De Trinitate* (Bibl. Nat. lat. 1699) and Peter Lombard's Sentences (Valenciennes, Bibl. Mun. MS 186), both bearing Sawalo inscriptions.

PROVENANCE: 14th-15th century. Saint-Amand *ex libris* (inner back cover). Inv. No. F. 74, 16th century (?) (inner front cover). Charles-Maurice Le Tellier, Reims, MS 261. Acquired by the Royal Library in 1700. Regius 3587.3.

LITERATURE: Delisle, *Cabinet des manuscrits*, I, 318; Boeckler, *Abendländische Miniaturen*, 95; Lauer, *Manuscrits latins*, II, 387; E. van Moë, *Les enlumineurs français du VIIIe au XVIe siècle*, Paris, 1937, 19; id., 'Le portrait dans les livres', *Verve*, 1938, 20; A. Boutemy *Enlumineurs de l'abbaye de Saint-Amand*, 147 and *passim*; id., 'Les Évangiles du Musée Mayer van den Bergh', *Revue belge d'archéologie et d'histoire de l'art*, XVIII, 1949, 28, 34; Swarzenski, *Monuments of Romanesque Art*, 64, No. 142; Dodwell, *Painting in Europe*, 178; Garborini, *Der Miniator Sawalo*, 33, 83; M. Durliat, *L'art roman*, Paris, 1983, 278.

EXHIBITED: *Manuscrits à peintures*, Paris, 1954, 68, No. 169; *Byzance et la France médiévale*, Paris, 1958, 66, No. 122; *L'art roman*, 50, No. 63.

124. Lille, Archives Départementales du Nord MS 10 H 323

Cartulary of Marchiennes
340 × 225 mm., pp. 378, 2 cols., 37 lines
Second half of the 12th century (after 1171).
Sainte-Rictrude, Marchiennes *Ills. 292, 293*

Historiated initials: C, Pope Calixtus II gives a book to three kneeling monks of Marchiennes (p. 27); E, Pope Eugenius III (p. 33); A, Pope Alexander III (p. 36); I, Charles the Bald, with sceptre and scroll (p. 37); I, Lothar with sceptre and scroll (p. 38); E, Archbishop Samson of Reims (p. 39); E, Bishop Lambert of Arras (p. 41); E, Bishop Alvisius of Arras (p. 50); E, Bishop Gotiscalcus of Arras (p. 51); E, Bishop Andrew of Arras (p. 57); M, Bishop Milo of Thérouanne (p. 60); B, Bishop Burchardus of Cambrai (p. 63); E, Bishop Nicholas of Cambrai (p. 63); S, Bishop Simon of Tournai (p. 65); G, Bishop Geraldus of Cambrai (p. 66); E, Bishop Baldwin of Noyon (p. 69); P, Count Baldwin of Flanders on horseback (p. 104); E, Count Baldwin II on horseback (p. 106); E, Count Charles of Flanders on horseback (p. 109); P, Count Thierry of Flanders on horseback (p. 118); E, Count Philip of Flanders on horseback (p. 125); R, Count Radulfus of Vermandois on horseback (p. 127); E, Count Baldwin of Hainaut on horseback (p. 127); E, Simon of Oisy, castellan of Cambrai, on horseback (p. 129).

The Cartulary of Saint Rictrude at Marchiennes contains a 12th-century nucleus that was originally continuous but is presently separated in two parts by additions made in the later Middle Ages. The first section (pp. 27–71) comprises copies of papal, imperial and episcopal charters, beginning with a Bull of Calixtus II addressed to Abbot Amandus of Marchiennes in 1123 and terminating with diplomas of Bishop Theobaldus of Amiens and the Cathedral Chapter of Arras, both dated 1171, and the latest documents in the sequence. The second section (pp. 104–131) contains charters of secular powers in favour of Marchiennes, beginning with a privilege of Count Baldwin of Flanders, dated 1038. Count de Loisne's study of the manuscript led him to the conclusion that it was compiled after 1189, on account of the date of the latest document transcribed in it. But this seems to be based on a faulty reading, for the last item in the secular series, a charter of the castellan Hugh of Oisy, also bears the date 1171 (p. 130). This is therefore, the *terminus a quo* for the execution of the work, which was perhaps carried out at the behest of Abbot John (1158–82), to whom these final documents and a number of earlier ones included in the volume were addressed.

Many of the charters have handsome initials painted in body colour and backed by gold grounds. Almost all of those in the papal and episcopal first part exhibit three-quarter length portraits of bishops

carrying a crozier and gesturing in blessing. The exception is the somewhat larger and more elaborate initials attached to the opening privilege of Calixtus II, which shows the enthroned pope presenting the documents to three black-robed monks. The knights in the second section are mounted riders displaying shields and brandishing swords. The charters without painted initials are introduced by fairly elaborate pen-work letters, nine lines high, with filigree flourishes in red, grey-blue and aquamarine. The hand of the painter of the cartulary can be recognized in a second Marchiennes manuscript, the *Miracula sanctae Rictrudis* included with other saints' lives in a composite volume (Douai, Bibl. Mun. MS 846), for which he provided a standing portrait of the titular saint of the abbey, carrying a book and a flowering staff (f. 137v). The text of the *Miracula* contained in this manuscript is a revised version of the saint's miracles made, according to K. F. Werner, between 1164 and 1166, though worked over again shortly before 1174, and attributed by Werner to the local chronicler Andrew of Marchiennes.

PROVENANCE: Marchiennes.

LITERATURE: L. Bethmann, *Archiv der Gesellschaft für ältere deutsche Geschichtskunde*, XI, 1858, 84 and 527; Comte A. de Loisne, 'Les miniatures du cartulaire de Marchiennes', *Bulletin archéologique du Comité des travaux historiques et scientifiques*, 1903, 476–89; H. Stein, *Bibliographie générale des cartulaires français ou relatifs à l'histoire de France*, Paris, 1907, 320, No. 2327; K. F. Werner, 'Andreas von Marchiennes und die Geschichtschreibung von Anchin und Marchiennes in der zweiten Hälfte des 12. Jahrhunderts', *Deutsches Archiv für Erforschung des Mittelalters*, IX, 1952, 459–60; Cerny, *Marchiennes*, 67; S. Hindman, *Sealed in Parchment. Rereadings of Knighthood in the Illuminated Manuscripts of Chrétien of Troyes*, Chicago and London, 1994, 118.

125. London, British Library Cotton Caligula A.VII

Eight Leaves from a Psalter or Evangeliary
407 × 310 mm.
c. 1175–80. North-eastern France or Flanders (?)
Ills. 296, 297, 298, 299

Annunciation (f. 3); Visitation (f. 4v); Nativity (f. 5); Annunciation to the Shepherds (f. 6v); Massacre of the Innocents (f. 7); Presentation in the Temple (f. 8v); Adoration of the Magi (f. 9); Baptism of Christ (f. 10v).

These eight leaves with scenes from the Infancy of Christ, which have been drastically trimmed by the binder, most likely stem from a Psalter or Evangeliary. They were formerly bound as a kind of pic-

torial frontispiece in the 10th-century manuscript of the *Heliand* poem (E. Temple, *Anglo-Saxon Manuscripts, Survey II*) from which they were removed in 1931. In M. Mackeprang's catalogue of illuminated manuscripts in Danish Collections, which introduced them into the scholarly literature, they were linked on the basis of their style with a late Romanesque Missal fragment inserted in the portable altar of Heinrich Rantzau in the Copenhagen National Museum (No. 12135) and localized in Denmark. E. Kitzinger considered them probably to be of German origin, while the *Year 1200* exhibition catalogue speculated that they were either German, 'Anglo-Danish' or Flemish. C. Nordenfalk endorsed the connection with the miniature of the Rantzau altar, but more plausibly attributed that work and the London leaves to northern France and characterized them as close to the illumination of Saint-Amand. Among the works of this important centre, the leaves might be compared to the miniatures in the second life of Saint Amand (Valenciennes, Bibl. Mun. MS 500; no. 129), but they are apt to remind one more insistently of the illumination of the Marchiennes Cartulary (Lille, Archives Départementales du Nord, MS 10 H 323; no. 124) and the portrait of the titular saint in the *Miracula* of St. Rictrudis (Douai, Bibl. Mun. MS 846). A Franco-Flemish provenance seems the most likely.

The original composition of the cycle is unknown to us, but it must have included at least one additional miniature, a painting of the enthroned Virgin with the Child to receive the gifts proffered by the three Magi. (The irregular stubs that determine the present foliation reflect the arrangement made by Sir Robert Cotton's binder and not necessarily the original sequence of the pictures). Some iconographic features of the individual compositions deserve to be noted. The Nativity includes a scene of the bathing of the Christ Child carried out by two servants or midwives, an element borrowed from the Byzantine tradition but probably derived by the painter from an Ottonian intermediary. The Annunciation to the Shepherds shows an angel addressing the assembled rustics, while a row of six or more angels above ceremoniously displays a band on which the *Gloria in excelsis* is inscribed. The three Magi, following exegesis, are differentiated in order to personify three distinct ages. The Baptism is the most unorthodox picture of the group, showing John the Baptist laying hands on the head of Christ, while Jesus's hands appear to be joined in prayer, a gesture that the artist seems to have rendered with some difficulty. This last motif is a fairly regular feature of Italian painting of the Renaissance, but is not otherwise documented in Romanesque art. The Massacre of the Innocents is portrayed with exceptional violence.

The miniatures are painted and vigorously modelled in body colour. Light blue, green, red and ochre predominate, while the backgrounds and some incidental details are executed in gold laid over a red ground. These gold backgrounds are thinly incised with floral rinceaux and diaper patterns. Although the style of the paintings is on first glance of a globally uniform effect, there are in them differing inflections or inconsistencies perhaps attributable to the use of heterogeneous models or the participation of more than one painter. In the Annunciation and the Nativity, for example, where the composition is given a graphically accented delineation, the figures have small heads and elongated proportions. In the scene of the Magi and the Baptism, on the other hand, they are stockier and articulated in a smoother, more relaxed way.

PROVENANCE: Library of Sir Robert Cotton (1571–1631). Acquired by the British Museum on its foundation in 1753, and separately bound in 1931.

LITERATURE: Th. Smith, *Catalogus librorum manuscriptorum bibliothecae Cottonianae*, London, 1696, 33; *A Catalogue of the Manuscripts in the Cottonian Library…*, London, 1802, I, 43–4; G. Warner, *Illuminated Manuscripts in the British Museum*, London, 1903, pl. 17; M. Mackeprang, *Greek and Latin Manuscripts, X–XIIIth Centuries, in Danish Collections*, Copenhagen, 1921, 27; A. Haseloff, *Zentralblatt für Bibliothekswesen*, XL, 1923, 100–101; *Reproductions from Illuminated Manuscripts*, III, 1925, 9, pl. 12; E. Kitzinger, *Early Medieval Art in the British Museum*, London, 1940, 88, 113.

EXHIBITED: *Gyllene Böcker*, Stockholm, 1952, 31, No. 26; *The Year 1200*, New York, 1970, 291, No. 284.

126. Valenciennes, Bibliothèque Municipale MS 501

Life and Miracles of St. Amand
300 × 210 mm., ff. 123, 21 long lines
Third quarter of the 12th century.
Saint-Amand *Ills. 300, 301, 302; Col. pl. XIV*

Full-page paintings: portrait of the author Baudemundus (f. 5v); title page with large initial A containing a figure of St. Amand (f. 10); Vision of St. Aldegundis, to whom an angel shows St. Amand in heaven (ff. 30v–31); St. Amand gives his will to Baudemundus (f. 58v); St. Mommolinus and St. Reolus (f. 59); St. Vindicianus and St. Aldebertus (f. 59v); Abbot John of Mont Saint-Blandin and St. Bertin (f. 60).

Historiated and ornamental initials: S (f. 6); E (f. 32); P (f. 39); D (f. 43); D (f. 49v); I, St. James trampling a dragon (f. 54); Q (f. 61); D (f. 84); D (f. 109).

The manuscript contains a series of texts relating to the life of St. Amand, arranged through marginal indications to function as a lectionary. The contents

are the life of the 7th-century bishop and missionary, ascribed to a contemporary, one Baudemundus, but now generally thought to be an anonymous work of the 8th century (ff. 6–29; B. Krusch, *M.G.H., Script. rer. Merov.*, V, 1910, 395ff), and a series of addenda made in the 9th century by Milo of Saint-Amand and known as *Suppletio Milonis* (ff. 29v–123; Krusch, 450-83) into which has been intercalated an account of the saint's ascent to heaven by St. Aldegundis of Maubeuge, drawn from her 9th-century *Vita* (ff. 32–38; *AA.SS*, Ian., III, 652, 660, 665). This material is substantially the same as that contained in the 11th-century illustrated life of St. Amand (Valenciennes, Bibl. Mun. MS 502) and may be a partial copy of it, as Boutemy has suggested.

The work is a luxurious production with fine ornamental initials at the beginning of the various pieces, along with elaborate *incipits*, which in several places are done in gold (ff. 9v, 10v), and elsewhere, in monumental letters arranged in alternating green, red and blue lines filling an entire page. The major components of the decoration are a full-page portrait of Baudemundus as a scribe, which precedes the prologue of the first *Vita Amandi*; a title page incorporating the initial and *incipit* words of the text of the *Vita*; and six paintings occupying an entire page. Two of these form a diptych illustrating the vision of St. Aldegundis, while the remaining four have as their subject the dictation of St. Amand's testament, and the ecclesiastical dignitaries who witnessed the document, which forms part of the *Suppletio Milonis*. The pair of images on facing pages with the vision of St. Aldegundis shows the saint at an altar, her hand grasped by an angel who points out to her the visionary ascension of Amandus among the choirs of white-vested saints on the opposite page. The subject is found among the illustrations of the earlier life of St. Amand (ff. 118v–119), but the two representations of Amandus in glory differ substantially. In the older composition, the saint stands on a hillock as an angel descends from heaven to reward him with a large crown. In the later manuscript, the composition is much more formally and hieratically structured. The page is divided into a clear grid, with angels and groups of adoring saints filling separate panels. Amandus is superimposed on the central axis, his arms held up by two reverently-inclined women, that on the left identified as *Dilectio Dei*, that on the right *Dilectio proximi*. This feature of the vision, which does not seem to be found in any of the textual versions of the *Visio Aldegundis*, alludes to the raising of Moses' arms by Aaron and Hur (Exodus 17:12) as a sign of supernatural power (for the iconography, see M. Schapiro, *Words and Pictures*, The Hague-Paris, 1973, 22 and *passim)*. The composition of the page with its choirs of saints arranged in separate compartments has a clear antecedent in the depiction of the ascension of St. Audomarus in the 11th-century life (Saint-Omer, Bibl. Mun. MS 698, f.

26), and the painter must have known this or a similar work.

The first of the four paintings which follow the testament of St. Amand show the haloed Baudemundus transcribing on a scroll the words of the will dictated to him by the saint. Amandus, who is larger in scale and given a square nimbus, is enthroned and richly dressed in episcopal garb. He holds a crozier and, in the other hand, the quill with which he has subscribed to the document, as its concluding formula makes clear. The witnesses appear as standing figures grouped in pairs and displaying books or scrolls which exhibit the signatures that they have affixed to the document. All are given saintly haloes. The first painting in the sequence brings together the Archbishop of Reims, Reolus, and one of his suffragans, Bishop Mommolenus of Noyon and Tournai. The second pairs Vindicianus, Bishop of Cambrai, with an abbot named Aldebertus, whom tradition associates with the monastery of Saint Bavo at Ghent. A certain John, said to have been abbot of the monastery of Mont Saint-Blandin at Ghent, and Abbot Bertinus of Sithiu (later Saint-Bertin) appear together in the last painting. In this extraordinary parade of iconic images, the manuscript departs from the wholly narrative illustration of the earlier life of Amandus contained in Valenciennes 502. The will, which is dated 17th April of the year 674 or 675, contains no stipulations affecting property. Its principal concern is the saint's desire to be buried in the monastery that he had founded at Elnone, which is stated with great force and accompanied by anathemas against anyone who would dare to move the body elsewhere. It must have been the monks' evident interest in ensuring respect for the wishes of Amandus that led them to single out the document for this solemn pictorial treatment. In this use of illumination to add greater weight to legal instruments, the manuscript participates in a significant development in the conception of images, exemplified in varied yet sustained ways by the Canigou Charter (no. 55) and the series of illustrated cartularies of Vierzon, Mont Saint-Michel, and nearby Marchiennes (nos. 6, 22, 124).

The illumination of the manuscript is the work of several hands. The paintings related to the vision of St. Aldegundis and the testament of St. Amand are executed in a chromatically saturated palette, along with gold, and a tooled patterning of dots (f. 58v) and incised lines (f. 60). Their style is connected with mid-century illumination of Saint-Bertin, as exemplified by the group of manuscripts around the Gospels of Hénin-Liétard at Boulogne (no. 113). The portrait of Baudemundus, which is drawn and partially coloured rather than fully painted and modelled, along with the title page of Baudemundus' *Vita*, are close to the art of Sawalo. The initials have yet another source. Drawn with great finesse in red outline, with patches of dark blue, green and purple filling the interstices of the letters, they have close parallels

in manuscripts produced for Anchin, as Boutemy, citing Douai MS 42 (Zacharias Chrysopolitanus, Concordances of the Gospels), MS 253 (Augustine, *Enarrationes in Psalmos*; no. 110) and MS 309 (Gregory, Epistles), has pointed out.

BINDING: Calfskin over wooden boards.

PROVENANCE: Saint-Amand *ex libris*, 18th century (inside cover).

LITERATURE: J. Mangeart, *Catalogue descriptif et raisonné des manuscrits de la Bibliothèque de Valenciennes*, Valenciennes and Paris, 1860, 459–61, No. 460; A. Molinier, *Catalogue général*, XXV, 1894, 402–3; B. Krusch, *M.G.H., Script. rer. Merov.*, V, 1910, 416–17, No. B 6e (with plates 19–22). E. de Moreau, *Saint Amand. Apôtre de la Belgique et du Nord de la France*, Louvain, 1927, 258–9; P. Lefrancq, 'Quelques notes sur les manuscrits les plus importants de la Bibliothèque de Valenciennes', *Bulletin du Comité flamand de France*, II, 1935, 353; A. Boutemy, 'L'illustration de la vie de Saint Amand', *Revue belge d'archéologie et d'histoire de l'art*, X, 1940, 231–49; id., 'Quelques manuscrits peu connus de l'abbaye de Saint-Amand', *Revue belge d'archéologie et d'histoire de l'art*, XII, 1942, 215, 220; A. Boutemy, 'Rapports artistiques entre les abbayes d'Anchin et de Saint-Amand au milieu du XIIe siècle', *Bulletin de la Société Nationale des Antiquaires de France*, 1954–55, 75–8; Grabar and Nordenfalk, *Romanesque Painting*, 148, 182, 184, 186, 189, 190, 193, 198; H. G. Franz, *Spätromanik und Frühgotik* (Welt der Kunst), Baden-Baden, 1959, 167, 169; Dodwell, *Painting in Europe*, 163, 178, 206; F. Mütherich in *Propyläen Kunstgeschichte*, V, 1969, No. 391b; G. Coolen, 'Saint Omer et Saint Bertin', *Bulletin trimestriel de la Société des Antiquaires de la Morinie*, 1973, 1–24.

EXHIBITED: *Manuscrits à peintures*, Paris, 1954, 67–68, No. 168; *Byzance et la France médiévale*, Paris, 1958, 67, No. 126; *Art roman*, Barcelona and Santiago de Compostela, 1961, 47, No. 54; *Archéologie du livre médiéval*, Valenciennes, 1990, 27–8, No. 22.

127. Valenciennes, Bibliothèque Municipale MS 512

John the Deacon, Life of Gregory; Gregory, *Liber Pastoralis* (ff. 99–157); Life and Miracles of St. Nicholas (ff. 157–190); versified life of St. Faith (ff. 191–192v)
360 × 250 mm., ff. 193, 2 cols., 37 lines
Third quarter of the 12th century.
Saint-Amand *Ill. 303*

Full page miniature showing Gregory between his parents Gordianus and Silvia; below, the shipwrecked man to whom Gregory had given the silver

bowl of his mother appears to him in the guise of an angel; at the four corners, medallions of the cardinal virtues (f. 4v).

Historiated and ornamental initials: *Vita Gregorii*, Bk. I, G (f. 5); Bk. II, A (f. 16); Bk. III, T, man bearing a dragon on his shoulders (f. 35v); Bk. IV, H (f. 60); *Liber Pastoralis*, P, shepherd with his flock threatened by a wolf (f. 100v); B, enthroned St. Nicholas with crozier (f. 157v); C (f. 174).

The three separate texts that are contained within this volume were written by a single scribe; a second, less disciplined hand added a versified piece concerning St. Faith (ff. 191–92v); The body of the text has simple three-line penwork initials in blue, red and green, and some larger ones that are reticently flourished. Large initials painted in body colour and gold appear at the beginning of the four books of John the Deacon's Life of Gregory, the beginning of Gregory's *Liber Pastoralis*, and Life and Miracles of St. Nicholas in the version made by John (*B.H.L.* 6104). The manuscript is quite worn through use. The parchment has darkened a good deal and the painted decoration has suffered erosion. The principal contribution of the illuminator is the full page frontispiece enclosed within a frame filled with foliate ornament and incorporating medallions at the four corners with personifications of the cardinal virtues. The composition presents two separate scenes. Above, Pope Gregory, richly vestured in episcopal garb and raising his hand in a gesture of blessing, is seated at the centre in a strictly frontal pose. His father Gordianus, described by John as *vir clarissimus*, stands at the left, displaying a scroll on which his name is written. His mother Silvia, her name inscribed on the fore-edge of the book that she carries, appears at the right. The artist seems to have given this unusual family picture the characteristic form of a *Deesis* group, in which the figure of Christ is flanked by Mary and St. John. The scenes below are devoted to the story related by John the Deacon (I, 10; II, 23) of Gregory's encounter with a shipwrecked man to whom he gave twelve coins and his mother's silver bowl. When, at a later time, Gregory invited twelve poor pilgrims to dine with him, a thirteenth man joined the party in the guise of an angel. When Gregory asked him who he was, the stranger identified himself and announced to his benefactor that he would become a prince of the Apostles and a successor to St. Peter. In the illustration of the Saint-Amand manuscript, Gregory is seated on an elaborate throne and he displays and points to a scroll inscribed with a paraphrase of the question that he addresses to the stranger, '*Adiuro te per Deum ut te mihi manifestes*'. The angel, carrying the silver bowl, replies with an extended scroll on which appear the words: '*Ego sum naufragus ille cui dedisti scutellam argentea(m)*'. This scene, too, evokes

a traditional subject of Christian art, the Annunciation to the Virgin.

The manuscript has figured prominently in discussions concerning the relation of English and Flemish illumination around the middle decades of the twelfth century. A. Boeckler, who first called attention to it, saw in the hard-edged and actively patterned forms favoured by the painter a possible reflection of the style of the Eadwine Psalter (Cambridge, Trinity Coll. Lib. MS R. 17. 1), a Canterbury work datable around the middle of the century. C. R. Dodwell, on the other hand, stressed the impact of Flemish illumination in England, and cited Valenciennes 512 as one of the sources of the 'severely angular' style found in the second volume of the Dover Bible (Cambridge, Corpus Christi Coll. 4), while O. Pächt mentioned the manuscript in support of a Flemish origin of the 'striped' effects in the illumination of the St. Albans Psalter at Hildesheim. The more recent and most detailed attempt to reconstruct the career of the painter to date by P. Cerny reverses the flow of the action once again. For Cerny, the artist was schooled in a scriptorium of southern England. At Saint-Amand, beyond the illumination of Valenciennes 512, his hand can be recognized in a Glossed Pauline Epistles (Valenciennes, Bibl. Mun. MS 85), and he contributed an initial and possibly some additional minor decoration to the somewhat older collection of the Life and Miracles of the patron saint of the house (Valenciennes, Bibl. Mun. MS 501), as Boutemy had earlier observed. The portrait of St. Gregory, which serves as the frontispiece of the collection of extracts of his works (Douai, Bibl. Mun. MS 315, Vol. II, f. 1v) is a somewhat simplified version of the figure of the enthroned pope in Valenciennes 512, and Cerny convincingly attributes to him the painting of Jacob's Ladder Vision in the Anchin anthology in the three-volume Works of Bernard of Clairvaux (Douai, Bibl. Mun. MS 372; no. 122). So far as can be judged from old reproductions and the very damaged fragments of the work that still survive, he may also have been involved in the illumination of another key manuscript of Anchin book production of the decade 1160–70, a copy of Augustine's *De Trinitate* (Douai, Bibl. Mun. MS 257; Fig. 4).

PROVENANCE: Saint-Amand MS F. 201, 15th–16th century. (f. 2).

LITERATURE: J. Mangeart, *Catalogue descriptif et raisonné des manuscrits de la Bibliothèque de Valenciennes*, Paris and Valenciennes, 1860, 473–4, No. 470bis; A. Molinier, *Catalogue général*, XXV, 1894, 409–10; Boeckler, *Abendländische Miniaturen*, 92, No. 95; A. Katzenellenbogen. *Allegories of the Virtues and Vices in Medieval Art*, London, 1939, 32; A. Boutemy, 'Quelques manuscrits à miniatures peu connus de l'abbaye de Saint-Amand', *Revue belge d'archéologie et d'histoire de l'art*, XII, 1942, 215–28; C. R. Dodwell, *The*

Canterbury School of Illumination, Cambridge, 1953, 58; A. Boutemy, 'Enlumineurs d'Anchin au temps de l'abbé Gossuin (1131/1133 à 1165)', *Scriptorium*, XI, 1957, 235; O. Pächt, C. R. Dodwell and F. Wormald, *The St. Albans Psalter*, London, 1960, 202–3; P. Cerny 'Un manuscrit peu connu du XIIe siècle provenant de l'abbaye de Saint-Amand', *Eklitra. Tradition Picarde*, XIV, 1980, 39–53; id., *Anchin*, 45–7.

EXHIBITED: *Manuscrits à peintures*, Paris, 1954, 66, No. 162; *Scaldis. Art et civilisation*, Tournai, 1956, 84, No. 19; *Archéologie du livre médiéval*, Valenciennes, 1990, 29, No. 25.

128. Valenciennes, Bibliothèque Municipale MS 197

Gilbert de la Porrée, Commentary on Boethius' *De Trinitate*
325 × 220 mm., ff. 89, 2 cols, 40 lines (ff. 1–7);
20 lines (text), 39 lines (gloss)
Third quarter of the 12th century.
Saint-Amand *Ills. 304, 305*

Full-page miniature of Gilbert de la Porrée and his students (f. 4v); Gilbert's disciple Nicholas as a scribe (f. 5); Gilbert addresses Boethius, who is seated on a white horse; below, a scribe (f. 7); seated bishop displaying an open book on a pulpit (f. 9); table of the Greek alphabet, Latin transliteration, numerical equivalents (f. 89).

Ornamental initials: L (f. 2v); Q (f. 36v); P (f. 37).

Gilbert de la Porrée (*c.* 1080–1154) is thought to have completed his commentary on Boethius' *De Trinitate* or *Opuscula sacra* some time before 1140 (ed. N. Häring, Toronto, 1966). His opinions aroused complaints, leading Pope Eugenius III to order an inquiry, which came before the Council of Reims in 1148. Although the treatise was denounced there by Bernard of Clairvaux, Gilbert was acquitted of the charge against him upon the promise that he would correct any statement that conflicted with the position defended by Bernard. He made no modifications, however, and although the work was vigorously attacked by prominent figures like Geoffrey of Auxerre and Gerhoch of Reichersberg, it was frequently copied. The Saint-Amand manuscript is an exceptionally luxurious production of the treatise, which is here completed by a copy of a sermon by Gilbert on the Nativity not otherwise recorded (ff. 87v–88v; N. Häring, ed., *Medieval Studies*, 1961, 126–35) and a table of Greek and Latin alphabets, with their numerical equivalents (f. 89). Preceding Gilbert's second prologue is a full-page painting showing the enthroned and haloed author, in his episcopal vestments as Bishop of Poitiers, displaying an unfurled scroll in each hand. Below, seated on the ground, are three smaller haloed clerics with open books. They

are identified as Gilbert's students, Jordan Fantasma, Ivo of Chartres and John Beleth, who along with a fourth disciple, Nicholas, are deemed to be worthy of remembrance (*quia digni sunt memoria*). Jordan Fantasma (his name is sometimes rendered 'Fantosme') is mentioned as a cleric in the household of the Bishop of Winchester in documents of the years 1154–9 and 1160, and he is also known to have written vernacular poems concerning the English-Scottish wars of 1173–4. Ivo of Chartres, not to be confused with the better known canonist of the same name, was archdeacon of Notre-Dame de Paris from the mid-forties to the years 1155–6. In that year, he is mentioned in Chartres, where he became dean of the cathedral chapter. He died some time between 1159 and 1165, and is known to have written a long commentary on the Psalms, now apparently lost. John Beleth, who taught for a time in Paris, is best known for his *Summa de ecclesiasticis (divinis) officiis*. He is last heard of in 1182, when he was active in Amiens. The fourth disciple, Nicholas, is represented as a scribe at a pulpit in a separate vignette occupying approximately one third of the text column on the facing page. In the accompanying inscription he is said to have interpreted Gilbert's teachings with special insight, and he has been tentatively identified as the chronicler Nicholas of Amiens, about whom little is otherwise known. The grand pictorial treatment given to teaching and the ties of interdependence that bind master and pupil reflects the impact in the 12th-century consciousness of the intellectual activity promoted by the growing Schools. A comparable image appears in a late 12th-century manuscript of Hugh of Saint-Victor's *De archa Noe* from St. Albans, in which the author is seen in dialogue with three unidentified students (Oxford, Bodl. Lib. Laud Misc. 409, f. 3) and writings of consecrated authors of the past were sometimes fitted out with similar pictures.

The second major illustration of the Saint-Amand manuscript stands at the beginning of Gilbert's exposition of the prologue of the first part of Boethius' *Opuscula* on the Trinity. It shows Gilbert receiving from Boethius a scroll on which are inscribed the opening words of the work '*Investigatam divit (issime)*', while handing to a scribe seated below a second scroll bearing the first words of his own second prologue '*Omnium que rebus perspiciendis*'. The patrician Boethius is depicted as a dashing young man on a piebald horse, holding a falcon in his gloved hand, and Gilbert, once more clothed in episcopal garb, with mitre and crozier. Marginal inscriptions probably to be interpreted as artists' instructions identify the protagonists: '*Magister Gillebertus super cathedram*', '*Boetius super equ(u)m album*', and '*scriba*'. The illuminator supplied two more vignettes of seated bishops displaying open books, the first for the beginning of the text of Boethius' first *opusculum*, where the portrait of Boethius was called for and specified in a marginal note, the second for

the initial of Gilbert's prologue to his commentary on the third tract, *De bonorum ebdomade*.

These paintings are attributable to the illuminator of the Second Life of Saint-Amand (Valenciennes, Bibl. Mun. MS 500; no. 129), as has been generally recognized. The dates assigned to the work have ranged from the middle to the end of the 12th century or the beginning of the 13th century. The inscription below the portraits of Gilbert and his three disciples indicates that they were no longer alive when the painting was executed ('...*discipuli quorum anime requiescant in pace*') and this is also suggested by the presence of haloes. The earliest date that could be envisaged for the completion of the manuscript would thus be 1182, when John Beleth last appears in our sources. Nicholas, who is depicted separately and in a smaller scale, has no halo. According to the testimony of his own annals (M.-Th. d'Alverny, *Alain de Lille. Textes inédits*, Paris, 1965), he was born in 1147. He was therefore a much younger man than his colleagues and must have been a follower of Gilbert rather than his student. Considering the flattering characterization that he is given in the manuscript, for which there appears to be no real warrant, one might conjecture that he or someone allied to his cause had a hand in the project.

BINDING: Leather over wooden boards.

PROVENANCE: *Liber sancti Amandi Elnonensis coenobii*, followed by an anathema, 12th century (f. 87).

LITERATURE: E. Martène and U. Durand, *Voyage littéraire de deux Religieux Bénédictins de la Congrégation de Saint-Maur*, Paris, 1717, II, 99; J. Mangeart, *Catalogue descriptif et raisonné des manuscrits de la Bibliothèque de Valenciennes*, Paris and Valenciennes, 1860, 177–8, No. 189; A. Molinier, *Catalogue général*, XXV, 1894, 275; J. A. Clerval, *Les Écoles de Chartres au moyen âge*, Chartres, 1895, 185; H. Denifle, *Die abendländischen Schriftausleger bis Luther über Iustitia Dei (Rom. I, 17) und Justificatio*, Mainz, 1905, 344–5; M. Grabmann, *Die Geschichte der scholastischen Methode*, Freiburg im Breisgau, 1911, II, 415, 431, 464; Boeckler, *Abendländische Miniaturen*, 95; J. Lefrancq, 'Quelques notes sur les manuscrits les plus importants de la Bibliothèque de Valenciennes', *Bulletin du Comité flamand de France*, II, 1935, 354; Swarzenski, *Monuments of Romanesque Art*, 64, No. 143; N. M. Häring, 'A Christmas Sermon by Gilbert of Poitiers', *Medieval Studies*, XXIII, 1961, 126–35; id., *The Commentaries on Boethius by Gilbert of Poitiers* (Pontifical Institute of Medieval Studies, Studies and Texts, 13), Toronto, 1966, 29–30; P. Ratkowska, 'Illuminatio a pura sapientia. Observations sur une miniature du Ms. 197 de la Bibliothèque de Valenciennes', *Bibliothèque historique sztuki*, 1968, 337–45; Porcher, *French Miniatures*, 37; N. M. Häring, 'Handschriftliches zu den Werken Gilberts, Bischof von Poitiers (1142–1154)', *Revue d'histoire des textes*, VIII, 1978, 188, No. 168; id., 'Ein

Lehrgedicht des Gilbertschuler Iordanus Fantasma', *Sapientia Doctrina. Mélanges de théologie et de littérature médiévales offerts à Dom Hildebrand Bascour, O.S.B.,* Louvain, 1980, 96–8.

EXHIBITED: *Manuscrits à peintures*, Paris, 1954, 67, No. 199; *Scaldis. Art et civilisation*, 85, No. 24; *Archéologie du livre médiéval*, Valenciennes, 1990, 16–17, No. 3.

129. Valenciennes, Bibliothèque Municipale MS 500

Life and Miracles of St. Amand
310 × 215 mm., ff. 148, 25 long lines
c. 1170–85. Saint-Amand

Ills. 307, 308, 309, 310, 311

Full page illustrations (*italics indicate drawings*): St. Amand between his parents; arrival of St. Amand on the island of Yeu (f. 53); *destruction of the temple and idols by the people of Ghent; St. Amand exiled by Dagobert (f. 53v); Dagobert at the feet of St. Amand; Baptism of Sigebertus (f. 54);* St. Amand puts a serpent to flight; Serenus exhorts St. Amand to return home (f. 54v); St. Amand is tonsured at Tours, and visited in his cell by St. Outrille and St. Sulpicius (f. 55); *St. Amand invested with the bishopric of Maastricht; he receives a letter from Pope Martin (f. 55v); St. Gertrude at the feet of St. Amand; St. Amand takes leave of St. Ghislain (f. 56);* St. Amand chased from a church in Rome; apparition of St. Peter to St. Amand (f. 56v); St. Amand receives the episcopal insignia; he delivers a servant seduced by a demon (f. 57); *St Amand confronts a Basque blasphemer; healing of a blind man through contact with water touched by the saint (f. 57v); St. Amand and the assassins on the mountain; St. Amand and the blind woman who worshipped trees (f. 58);* apparition of St. Peter during a tempest; St. Amand is beaten and thrown into water (f. 58v); destruction of the temples and the idols by the people of Ghent; St. Amand exiled by Dagobert (f. 59); *St. Amand between his parents; arrival of the saint on the island of Yeu (f. 59v); St Amand puts a serpent to flight; Serenus exhorts him to return home (f. 60);* Dagobert at the feet of St. Amand; Baptism of Sigebertus (f. 60v); St. Amand and two companions with a bear carrying baggage; death of St. Amand (f. 61); *St. Amand sets prisoners free and instructs them; he intercedes for a malefactor before the Count of Tournai (f. 61v); hanging of a malefactor; St. Amand resuscitates the hanged man (f. 62);* the soul of St. Amand is received into heaven; burial of the saint (f. 62v); St. Amand is invested as bishop of Maastricht; he receives a letter from Pope Martin (f. 63); *St. Amand is tonsured at Tours; the saint in his cell with St. Outrille and St. Sulpicius (f. 63v); St. Amand chased from a church in Rome; apparation of St. Peter to St. Amand (f. 64);* St. Gertrude at the feet of St. Amand. St. Amand bids farewell to St. Ghislain (f.

64v); St. Amand faces the Basque blasphemer; healing of a blind man by contact with water touched by St. Amand (f. 65); *St. Amand receives the insignia of the episcopate; he delivers a servant seduced by a demon (f. 65v); apparition of St. Peter during a tempest; St. Amand is beaten and thrown into water (f. 66);* St. Amand and the assassins on the mountain. St. Amand and the blind woman who worshipped trees (f. 66v); Apotheosis of St. Amand (f. 67).

Historiated and ornamental initials: I, St. Stephen (f. 1v); L, bust of Lucian (f. 5v); F (11v); Q (f. 16); D (f. 22v); D (f. 26v); A (f. 28); A (f. 33); N (f. 38); R (f. 41v); S (f. 42v); B (f. 44); R (f. 71); D (f. 77); G (f. 78v); Q (f. 121); D (f. 127).

Philip, Abbot of the Cistercian monastery of l'Aumône, near Blois (1156–*c*.1171) was commissioned by Abbot Hugh II of Saint-Amand (1150–69) to correct the old biography of the saint by the Pseudo-Baudemundus. He made a new version, generally following the order of the narrative of his model, but abridging certain parts while amplifying others, supplying in particular information on significant religious figures who were contemporaries of Amandus and with whom he had dealings. The work was finished after Hugh II's death and delivered to his successor John (1168–82), as is indicated by letters addressed to both men which preface Philip's new *Vita*. In the present manuscript, this text (ff. 71–120), along with two items from the 9th-century addenda to the saint's biography by Milo (ff. 121–48), follows material relating to the martyrdom and translation of St. Stephen (ff. 1v–43v; *B.H.L.* 7848, 7850) and a *Passio* of Saints Cyricus and Iulitta also written by Philip of l'Aumône (ff. 44–52; *B.H.L.* 1814). The volume almost certainly corresponds to the entry No. 295 in the late 12th-century inventory of the library of Saint-Amand (*Index maior*), where mention is made of the golden letters at the beginning of the various chapters ('*Huius libri capitula aureis litteris praenotata sunt*').

The entire manuscript is written in a uniform hand, with three-line initials in gold for the chapter divisions throughout, as noted above, and lesser flourished initials in red, blue, and green. The decoration seems initially to have been planned on a more modest scale, since the present painted initials are executed on separate strips of parchment and pasted over simpler, pen-drawn designs, visible where the patches have come off. Drawn in red outline and composed of stylized foliage and elongated dragons, they are related to the art of Sawalo, which was dominant at Saint-Amand in the decades around the middle of the century. The manuscript was most likely begun not too long after 1170, when Philip of l'Aumône's text reached the monastery. Somewhat later, around 1180, the decoration was enhanced through the addition of more elaborate initials painted in body colour, whose construction

shows some touches of the Channel Style. The illustrations of the Life of St. Amand which precede Philip's *Vita* (ff. 53–68) were not part of the original manuscript, as Boutemy has shown, and they were probably inserted into the volume at the same time. This would explain why they were not mentioned in the entry of the *Index maior*.

These illustrations consist of two distinct cycles, one drawn in a fine brown outline over traces of a lead point underdrawing that is visible in places, the other fully painted in body colour over a gesso-like white ground. With one exception — the apotheosis of St. Amand among the painted scenes, which occupies an entire side (f. 68), two separate scenes are paired on the page. As might be expected, a substantial number of the scenes duplicate subjects included among the illustrations of the 11th-century life of St. Amand (Valenciennes, Bibl. Mun. MS 502). But there are incidents that do not occur in the old biography of the Pseudo-Baudemundus or in Milo's supplement, and refer instead to events narrated only in Philip's *Vita*. They are the story of Amandus' third trip to Rome accompanied by St. Humbert of Maroilles, in the course of which the pilgrims' donkey was devoured by a bear who, however, eventually consented to take the victim's place and carry the traveller's baggage (f. 61, above); the death of St. Amand at the foot of the altar of St. Andrew in the church dedicated to St. Andrew that he had founded at Saint-Amand (f. 61, below); the taking of vows by St. Gertrude of Nivelles at the instigation of Amandus (ff. 56, 64v); the meeting of Amandus and St. Ghislain at Mons (f. 56, below; f. 64v); and the reception of the letter of Pope Martin urging Amandus not to give up his mission (ff. 55v, 63). It is thus clear that the two cycles of Valenciennes 500 must have been elaborated on the basis of Philip's *Vita*, or at least altered to take the new text into account. But it might be noted that the full-page apotheosis of Amandus, which exists only in the painted sequence, follows the corresponding subject in the mid-century *Vita Amandi* (Valenciennes, Bibl. Mun. MS 501), while other illustrations, like the scenes devoted to the story of the sacrilegious Basque (ff. 65, above; 57v, above) or the healing of the blind idolator with water touched by St. Amand adhere in general terms to the 11th-century antecedents in Valenciennes 502. As Barbara Abou El-Haj has shown, however, the late 12th-century artists altered certain scenes of the 11th-century model in order to bring it into greater conformity with the different political and religious doctrines prevailing in their day. Thus, the scenes of the episcopal consecration of St. Amand (ff. 57, 65v) and his investiture as bishop of Maastricht (ff. 55v, 63) attempt to minimize or eliminate altogether the involvement of the secular power in the transfer of authority, though this is an explicit feature of the illustrations in the older manuscript.

The sequence of drawings and paintings in Valenciennes 500 largely duplicate the same subjects, but a few scenes occur only in one or the other cycle. There are thus no drawings corresponding to the painted depictions of the story of the saintly pilgrims on their way to Rome with their luggage-laden bear, and the death of St. Amand at the altar of St. Andrew, nor of the death, burial and apotheosis of the saint. On the other hand, there are drawings, but no paintings, for the scenes of Amandus redeeming and instructing captives, the king of the Franks charging Amandus with his mission, the hanging of a malefactor and Amandus resuscitating the hanged man (ff. 61v–62). Drawings and paintings are paired on facing pages and arranged in an alternating sequence. Boutemy has shown that three leaves were excised from the ensemble, which must have contained the missing subjects in both series, though there is some question whether St. Aldegundis' vision of the apotheosis of St. Amand, of which only the right half in the painted sequence now remains (f. 68) was ever extant in the cycle of drawings. In neither the drawings nor the paintings does the sequence of the events adhere to the order of the scenes as they are narrated in Philip's *Vita*, the arrangement of the drawings being the more arbitrary. Boutemy has plausibly suggested that the drawings served as models for the paintings. The irregularities in the order of the scenes resulted from the fact that the painter made use of the blank sides of the leaves with drawings and executed his miniatures on separate gatherings, so that the models could be most easily deployed before him. Inscriptions recording the subject of the paintings which appear in the upper margin or the edge of the page (ff. 63, 64v, 65, 66v) are perhaps instructions to the artist.

The painter's art exhibits the charged tonalities and smoothly modelled forms for which there are parallel manifestations in late Romanesque illumination, like the last copy of the Utrecht Psalter from Canterbury (Paris, Bibl. Nat. lat. 8846), the Souvigny Bible (Moulins, Bibl. Mun. MS 1; no. 43) or closer to hand, the Rabanus Maurus *De laudibus* from Anchin (Douai, Bibl. Mun. MS 340; no. 133). With respect to the situation at Saint-Amand, the style of the paintings has some connection with the work of the illuminator of the Epistles of Gregory (Paris, Bibl. Nat. lat. 2287; no. 123), but seems palpably more advanced. The painter generally followed the drawn compositions fairly faithfully. But while the drawings have only simple narrow bands for frames, the paintings have wider decorative borders, and the size of the area allotted to illustration is reduced as a result. The painted compositions thus have a more crowded effect, their components being smaller and pushed back further from the picture plane. More substantial alterations also occur. In the scene of the destruction of the idols of Ghent, the painter omitted the two kneeling figures of the drawing, and as Boutemy and Abou El-Haj have noted, he made more innocuous the rendering of the politically charged transactions of episcopal investiture and

consecration. The reason for the inclusion of both drawings and paintings in the manuscript remains unexplained. Boutemy supposes that the paintings were originally glued back to back, so that the drawings would not have been visible. But this remains unverified, and it leaves the entire working procedure behind the project unaccounted for.

BINDING: Oak boards, with inset for a round arched ivory or enamel plaque, now lost (front). The back cover shows traces of a rectangular inset.

PROVENANCE: *Liber ecclesie sancti Amandi cenobii elnonensis*, followed by an anathema, 12th century (f. 120).

LITERATURE: J. Mangeart, *Catalogue descriptif et raisonné des manuscrits de la Bibliothèque de Valenciennes*, Paris and Valenciennes, 1860, 456–9, No. 459bis; A. Molinier, *Catalogue général*, XXV, 1894, 400–2; Boeckler, *Abendländische Miniaturen*, 93, 98, 120; P. Lefrancq, 'Quelques notes sur les manuscrits les plus importants de la Bibliothèque de Valenciennes', *Bulletin du Comité flamand de France*, II, 1935, 353; A. Boutemy, 'Quelques aspects de l'oeuvre de Sawalon, décorateur de manuscrits à l'abbaye de Saint-Amand', *Revue belge d'archéologie et d'histoire de l'art*, IX, 1939, 310–11; id., 'L'illustration de la vie de Saint Amand', *Revue belge d'archéologie et d'histoire de l'art*, X, 1940, 231–49; E. de Moreau, 'La 'Vita Amandi' et les fondations de Saint-Amand', *Mélanges Paul Peeters* (Analecta Bollandiana, LXVII–LXVIII), I, 1949, 447–64; F. Wormald, 'Some Illustrated Manuscripts of the Lives of the Saints', *Bulletin of the John Rylands Library*, XXXV, 1952–3, 259 [repr. in *Collected Writings*, II, London, 1988, 50]; C. R. Dodwell, *The Canterbury School of Illumination, 1066–1200*, Cambridge, 1954, 206; Grabar and Nordenfalk, *Romanesque Painting*, 148, 193, 198; Porcher, *French Miniatures*, 37; Dodwell, *Painting in Europe*, 206; Mütherich, *Propyläen Kunstgeschichte*, V, 1969, 275, No. 391b; Garborini, *Der Miniator Sawalo*, 223–24, No. 38; B. Abou El-Haj, 'Consecration and Investiture in the Life of Saint-Amand, Valenciennes, Bibl. Mun. Ms. 502', *Art Bulletin*, LXI, 1979, 347ff.; id., 'Feudal Conflicts and the Image of Power at the Monastery of Saint-Amand de Elnone', *Kritische Berichte*, XIII, 1985, 11–12.

EXHIBITED: *Manuscrits à peintures*, Paris, 1954, 67, No. 167; *Archéologie du livre médiéval*, Valenciennes, 1990, 28–9, No. 23.

130. Paris, Bibliothèque Nationale MS lat. 16730

Flavius Josephus, Antiquates Iudaicae (I–XX) and De Bello Iudaicae
510 × 350 mm., ff. 280, 2 cols., 48 lines
c. 1170–80. North-eastern France.
Corbie (?) *Ills. 316, 317*

Historiated and ornamental initials: Preface, H, warning of the Lord to Adam and Eve concerning the Tree of Knowledge, Expulsion from the Garden (f. 1); Bk. I, I, medallions with Creation scenes (f. 2); Bk. II, P (f. 11); Bk. III, I, Moses with the tablets of the law and brazen serpent (f. 20); Bk. IV, H (f. 28); Bk. V, M (f. 35v); Bk. VI, T (f. 44v); Bk. VII, P, the Amalekite messenger brings Saul's insignia to David (f. 55); Bk. VIII, D, Bathsheba kneels before the enthroned Solomon (f. 66); Bk. IX, I, standing King Josaphat with branch-like rod (f. 79); Bk. X, C, Sennacherib besieging Hezekiah (f. 87); Bk. XI, P, Cyrus holding a model of the temple (f. 94v); Bk. XII, A (f. 103); Bk. XIII, Q, the High Priest Onias praying at an altar (f. 113); Bk. XIV, A, battles of Aristobulus and Hyrcanus (f. 132v); Bk. XV, S, capture of Jerusalem by Sosius (f. 134v); Bk. XVI, I (f. 144); Bk. XVII, A (f. 152); Bk. XVIII, C, Caesar Augustus on a faldstool instructs Cyrenius to go to Syria (f. 164); *Testimonium Flavianum*, Christ seated on the globe of the world (f. 165v); Bk. XIX, G, killing of Caius (f. 175); Bk. XX, M, Jewish rebels led to execution on the order of Claudius (f. 184v); Preface of the *Jewish Wars*, Q (f. 190v); Bk. I, C (f. 191v); Bk. II, A (f. 212); Bk. III, N, Nero invests Vespasian with power in Judea (f. 228v); Bk. IV, Q (f. 238v); Bk. V, A, beheading of the High Priests Ananus and Jesus (f. 245); Bk. VI, T, Titus on horseback before Jerusalem (f. 251); Bk. VII, C, siege of Jerusalem, with the assault of Sabinus, sufferings and self-sacrifice of the Jewish inhabitants (f. 262v).

The manuscript is presumably the volume listed in the Corbie inventory of the late twelfth or early 13th century (Vat. Reg. Lat. 520) under the title *Josephus antiquitatum et belli Judaicii*. At the end, there are copies of letters of Pope Alexander III to Bishop Andrew of Arras (1163) and Gerard of Tournai (1164–5) regarding the rights of Corbie, written in a hand that is contemporaneous with the body of the text, or only slightly later. But palaeographical and codicological evidence sets the work apart from Corbie book production, as pointed out by Boutemy, and more emphatically, by Mérindol. If the manuscript was written elsewhere, it must nevertheless have reached Corbie soon after its completion, and the illumination is more clearly connected to local painting than any other identifiable centre. Was the book perhaps illuminated at Corbie or nearby Amiens? The individual books of the *Antiquities* and of the *Jewish Wars* have painted initials, and a full-fledged historiated initial also singles out the interpolated

reference to the death of Christ (*Testimonium Flavi-anum*) in Bk. XVIII of the *Antiquities* (f. 165v). The provision of historiated initials for a substantial number of the books follows trends in contemporary Bible illumination and also locates the work within the sequence of illustrated Josephus manuscripts initiated in the Mosan region and the Rhineland in the earlier decades of the 12th century. With the exception of the Preface initial (f. 2), the painted decoration is the work of a single illuminator, a fluent practitioner whose performance is not notable for high refinement. A particular feature of his approach is that the placement of the illustrative matter of his initials has a tendency to occupy only part of the available space, the rest being given over to luxuriant spiralling rinceaux of foliage (ff. 87, 113, 262v). Among the Corbie books, his style stands closest to the group of manuscripts associated with Johannes Monoculus or John of Amiens and related works, like the *Moralia in Job* (Amiens, Bibl. Mun. MS 40), Amalarius, *De ecclesiastico officio* (Bibl. Mun. lat. 11580), and the Commentary on Leviticus by Radulphus Flaviacensis (Bibl. Nat. lat. 11564). A copy of Peter Lombard's Commentary on the Pauline Epistles (Bibl. Sainte-Geneviève, MS 77), said to have come from Senlis, and the frontispiece of a Bible of unknown provenance in the Mazarine Library (MS 36) might be added to this list.

PROVENANCE: Saint-Pierre, Corbie. 'Corb. 1', 17th century (f. 2). Acquired by the Bibliothèque Municipale at Amiens in 1791, and by the Bibliothèque Impériale, Paris, in 1803.

LITERATURE: A. Boutemy, 'De quelques enlumineurs de manuscrits à l'abbaye de Corbie dans la seconde moitié du XIIe siècle', *Scriptorium*, IV, 1950, 248, 251; F. Blatt, *The Latin Josephus* (Acta Jutlandica, XXX. Aarsskrift for Aarhus Universitet, XXX), 1958, 73, No. 12; *Manuscrits datés*, III, 1974, 713; Mérindol, *Corbie*, I, 48–51, and II, 985–9.

131. New York, Pierpont Morgan Library MS M. 44

Scenes of the Life of Christ
460 × 220 mm., ff. 16
c. 1175.
North-eastern France. Corbie (?)

Ills. 312, 313, 314, 315

Full-page miniatures: Annunciation (f. 1v); Nativity (f. 2); Adoration of the Shepherds (f. 2v); Flight into Egypt (f. 3); Presentation in the Temple (f. 3v); The Magi before Herod (f. 4); Adoration of the Magi (f. 4v); Baptism of Christ (f. 5); Temptation in the Desert (f. 5v); Entry into Jerusalem (f. 6); Last Supper (f. 6v); Washing of the Feet (f. 7); Betrayal and Arrest of Christ (f. 7v); Crowning with Thorns (f. 8); Scourg-ing of Christ (f. 8v); Carrying of the Cross (f. 9); Crucifixion (f. 9v); Deposition from the Cross (f. 10); Anointing of the Body of Christ (f. 10v); Three Women at the Tomb (f. 11); Harrowing of Hell (f. 11v); Noli me Tangere (f. 12); Doubting Thomas (f. 12v); Journey to Emmaus (f. 13); Supper at Emmaus (f. 13v); Ascension (f. 14); Descent of the Holy Spirit (f. 14v); Last Judgement (f. 15); Christ enthroned with two saints (f. 15v); Coronation of the Virgin in Heaven (f. 16).

This extensive cycle of miniatures of the Life of Christ lacks an accompanying text. Count Auguste de Bastard, who owned the single gathering of sixteen leaves in the middle of the 19th century, claimed that it had been 'drawn from an Evangeliary which came from the abbey of Saint-Martial of Limoges'. Bastard reproduced four of the miniatures in his *Peintures et ornements des manuscrits* (1835–69) and later published a lithographic facsimile of the entire work, the first integral publication of a French Romanesque illuminated manuscript to appear. It has not, however, been possible to find independent confirmation for this statement, though some scholars have either tacitly or explicitly accepted it. In the recent past, however, doubts have become more insistent, and though the work may conceivably have been discovered in Limoges, its style makes it most improbable that it was executed there. Porcher, who first questioned the Limousin provenance, believed the miniatures to be the work of one of the artists responsible for the stained glass windows of the west façade of Chartres Cathedral, or one of his pupils. He further argued that they might have served as a pattern book for glass painting. The connection with the Chartres glass is not sufficiently close to bear this out, and this thesis does not seem to have found any adherents. The suggestion made in passing by O. Pächt in 1960 in favour of a north French origin has much greater merit. The style of the miniatures has in fact much in common with the illumination of Corbie in the years between 1170 and 1180, as it is exemplified in the Jewish Antiquities of Josephus (Paris, Bibl. Nat. lat. 16730; no. 130) or a copy of the works of Amalarius of Metz and Rupert of Deutz (Bibl. Nat. lat. 11580).

The miniatures were executed by a single painter, working in a manner that falls well short of the highest refinement. Each is framed by a wide ornamental border sometimes overlapped by elements of the composition. Body colour is used, along with much gold, but there is a considerable reliance on drawing, which is summarily done and often fairly coarse. The interest of the work lies in the unusually expansive nature of the cycle, as well as in the rare iconography of some of the scenes. The ambitious scope of the sequence has no known parallels in France, but calls to mind the similarly extensive cycles of the Life of Christ in English manuscripts like the St. Albans Psalter, the Pembroke Gospels

from Bury St. Edmunds, or the older Christological cycles of Ottonian and Salian illumination. Among the rare iconographic themes or motifs in the sequence is the treatment of the Last Supper with Christ displaying the chalice and the Host; the Anointing of the Body of Christ takes the place of the customary Entombment; and a scene whose significance is not wholly clear, showing the enthroned Christ flanked by a pair of Seraphs and two kneeling saints, follows the Last Judgement. The final composition, devoted to the Coronation of the Virgin, is a relative newcomer in the sequence, reflecting iconographic developments close to the painter's own time.

PROVENANCE: Said to have come from Saint-Martial de Limoges. Henri Martin, Paris, c. 1810. Comte Auguste de Bastard d'Estang (1792–1883). A. Firmin-Didot. Sold in 1879 to Richard Benett and MS 101 in his collection (bookplate). Acquired by J. P. Morgan in 1902 with the Benett Collection.

LITERATURE: A. de Bastard, *Peintures et ornements des manuscrits*, Paris, 1835–69, pls. 250–251; id., *Histoire de Jésus Christ en figures. Gouaches du XIIe au XIIIe siècle conservées jadis à la collégiale de Saint-Martial de Limoges*, Paris, 1879; *Catalogue illustré de livres précieux, manuscrits et imprimés faisant partie de la Bibliothèque de M. Ambroise Firmin-Didot*, Paris, 1879, I, 26–7, No. 10; L. Delisle, *Les collections de Bastard d'Estang à la Bibliothèque Nationale*, Nogent-le-Rotrou, 1885, 254; A. Labitte, *Les manuscrits et l'art de les orner*, Paris, 1893, 153–5; *Quaritch Catalogue 164*, 1896, No. 1; M. R. James, *Catalogue of Manuscripts and Early Printed Books...Now Forming a Portion of the Library of J. Pierpont Morgan*, London, 1906, 149–51, No. 101; E. Mâle, *L'art religieux du XIIe siècle en France*, Paris, 1922, *passim*; Porcher, *French Miniatures*, 44–5; H. G. Franz, *Spätromanik und Frühgotik* (Kunst der Welt), Baden-Baden, 1959, 175–6; O. Pächt, C. R. Dodwell and F. Wormald, *The Saint Albans Psalter*, London, 1960, 92–3; Gaborit-Chopin, *Manuscrits à Saint-Martial*, 219; W. Cahn, *Art Quarterly*, XXXIII, 1970, 303–4; H. Swarzenski, 'Ein Abendmahl ohne Kelch', *Festschrift für Otto von Simson zum 65. Geburtstag*, ed. L. Griesebach and K. Renger, Berlin 1977, 95 and 99–100, n. 8.

EXHIBITED: S. Cockerell, *Burlington Fine Arts Club. Exhibition of Illuminated Manuscripts*, London, 1908, 61, No. 132; *Manuscrits à peintures* Paris, 1954, 111, No. 328; *The Year 1200*, New York, 1970, 243–4, No. 242.

132. Antwerp, Museum Mayer van den Bergh MS 297

Four Gospels
251 × 186 mm., 2 cols., 29 lines
c. 1175.
North-Eastern France, Saint-Amand (?)
Ills. 320, 321

Canon Tables (ff. 1–6v). Full-page Evangelist portraits: Matthew (f. 10v); Mark (f. 43v); Luke (f. 66v); John (f. 101v).

Historiated and ornamental initials: Matthew, L (f. 11v); Mark, I, medallion with the Evangelist symbol (f. 44); Luke, Q (f. 67); John, standing John the Baptist holding a scroll, medallion with the Evangelist symbol (above) and bust of a woman with a veil marked with the Cross, perhaps *Ecclesia* (below) (f. 102v).

The manuscript contains the four Gospels with prefaces and summaries, preceded by the Eusebian Concordances spread over twelve sides. After the *capitula* of Matthew, there is an alphabetical list of proper names of the New Testament with their mystical interpretation (ff. 9–9v). The four framed Evangelist portraits are painted in body colour and set on gold grounds. They are fairly faithful copies of 9th-century Evangelist portraits from the School of Reims. Matthew, who looks up to draw inspiration from his symbol appearing in the upper right corner of the painting while dipping his quill into an inkstand at the left, is modelled on the portrait type of St. Mark in the Ebbo Gospels (Epernay, Bibl. Mun. MS 1), but also incorporates the display of the unfurled scroll across the body of the sacred author which characterizes the Ebbo portrait of John. The portrait of Mark in the Antwerp Gospels, which shows the Evangelist with his head turned back to stare at his diminutive symbol in the upper left corner of the page, resembles the portrait of St. Matthew in another work of the Reims School, the Gospels of Saint-Thierry (Reims, Bibl. Mun. MS 7). In the remaining portraits, the Evangelists hold ink-wells in the form of horns, the type of vessel also seen in the hands of St. Matthew and St. Luke in the Ebbo Gospels. But the firm, continuous modelling technique in the 12th-century manuscript suggests that the model available to the painter was a Remois product in a somewhat later and more evolved style like the Blois Gospels (Bibl. Nat. lat. 265) or the so-called Hincmar Gospels of the Pierpont Morgan Library (M. 727).

As pointed out by A. Boutemy, the initial of the Gospel of St. John in the Antwerp Gospels (f. 102v) has an almost exact counterpart in a manuscript of Ammianus' Concordances of the Gospels from Saint-Amand (Valenciennes, Bibl. Mun. MS 15, f. 5v). The connection lends substance to his attribution of the work to a follower of Sawalo, the principal painter of Saint-Amand in the fifth and sixth decades

of the 12th century, though the style of the painting is closer to a later phase of local painting exemplified by the portrait of St. Gregory in the copy of that pope's *Epistles* (Bibl. Nat. lat. 2287; no. 123) and the 'Second' Life of St. Amand (Valenciennes, Bibl. Mun. MS 500; no. 129). H. Swarzenski has published a pair of Evangelist portraits in a Paris Private Collection which show a similar recourse to Remois 9th-century models and may be roughly contemporaneous products of the same scriptorium.

PROVENANCE: Collection of Beaucarme, notary at Ename, near Ghent. Purchased in 1895.

LITERATURE: A. Boutemy, 'Les Évangiles du Musée Mayer van den Bergh', *Revue belge d'archéologie et d'histoire de l'art*, I–II, 1949, 27–34; Swarzenski, *Monuments of Romanesque Art*, 34; J. de Coo, *Museum Mayer van den Bergh. Catalogus*, I, Antwerp, 157–8, No. 297; H. Swarzenski, 'The Style of Nicholas of Verdun: Saint-Amand and Reims', *Gatherings in Honor of Dorothy E. Miner*, ed. U. E. McCracken, L. M. C. Randall and R. Randall, Jr., Baltimore, 1974, 114.

EXHIBITED: *Benedictus en zijn Monniken in de Nederlanden, 480–1980*, III, Ghent, 1980, 238, No. 606; *Scaldis. Art et civilisation*, Tournai, 1956, 85, No. 23.

133. Douai, Bibliothèque Municipale MS 340

Rabanus Maurus, *De laudibus sanctae Crucis*
380 × 270 mm., ff. 49, 2 cols., 54 lines
c. 1175. Saint-Sauveur, Anchin
Ills. 322, 323, 324

Full-page miniature of the Emperor Louis the Pious (f. 8v); full-page Tree of Jesse, with (left) Ezekiel, a Sibyl, Solomon, Habakkuk, and (right), Jeremiah, Isaiah, John the Baptist and Daniel (f. 11); Half-page dedicatory miniature showing Rabanus Maurus tendering a scroll to Pope Gregory (f. 39v).

Historiated and ornamental initials: O, two clerics, identified as *Rainaldus scriptor* (left) and *Oliverus pictor* (right), with a cross in the middle of the letter (f. 9); H (f. 9v); E (f. 12); P (f. 13); M (f. 14); I (f. 15); I (f. 16); Q (f. 17); R (f. 18); D (f. 19); E (f. 20); S (f. 21); Q, angel with Cross staff in adoration (f. 22); Q, bust of a bearded man (f. 23); H (f. 24); I (f. 25); H (f. 26); S (f. 27); O (f. 28); Q (f. 29); H (f. 30); D (f. 31); H (f. 32); Q (f. 33); E (f. 34); C (f. 35); I (f. 36); I (f. 37); N (f. 38); D (f. 39); E (f. 40).

Carmina figurata: Figura I, Christ with arms extended (f. 11); *Figura II*, the Cross (f. 12v); *Figura III*, monogram CRUX SALUS (f. 13v); *Figura IV*, Cherubim (f. 14v); *Figura V*, the Cross and square of the spiritual edifice (f. 15v); *Figura VI*, Cross figure of the Cardinal Virtues (f. 16); *Figura VII*, Cross figure of the Quater-

nities (f. 17v); *Figura VIII*, Cross figure of the months, directions and winds (f. 18v); *Figura IX*, Cross figure (f. 19v); *Figura X*, Cross figure with the symbolism of the number 70 (f. 20v); *Figura XI*, Cross figure of the five books of Moses (f. 21v); *Figura XII*, figure of the name of Adam (f. 22v); *Figura XIII*, Cross figure of the days of Christ's stay in the Virgin's womb (f. 23v); *Figura XIV*, Cross figure of the days from the Creation to the Passion (f. 24v); *Figura XV*, Lamb with four Evangelist symbols (f. 25v); *Figura XVI*, Cross figure of the Seven Gifts of the Holy Spirit (f. 26v); *Figura XVII*, Cross figure of the eight Beatitudes (f. 27v); *Figura XVIII*, Cross figure of the number forty (f. 28v); *Figura XIX*, Cross figure of the number fifty (f. 29v); *Figura XX*, Cross figure of the number one hundred and forty-four (f. 34v); *Figura XXV*, Cross figure of the words Alleluia and Amen (f. 35v); *Figura XXVI*, Cross figure of the Prophets' words concerning the Passion and Redemption (f. 36v); *Figura XXVII*, Cross figure of the words of the Apostles (f. 37v); *Figura XXVIII*, Cross with adoring Rabanus Maurus (f. 38v).

The manuscript is a copy of the celebrated collection of figured poems in praise of the Cross by Rabanus Maurus, Abbot of Fulda (822) and later Archbishop of Mainz (847). Following the conclusions of H.-G. Müller's philological analysis, the Douai codex belongs to the family of manuscripts representing the third stage in the evolution of Rabanus's text (*Entwicklungstufe* III) subsequent to the author's last revision, undertaken around 844. It is said by Müller to descend directly or through the intermediary of a Fulda source. The work was written by Rainaldus and illuminated by Oliverus, who are depicted and identified by inscriptions in the initial at the beginning of Rabanus's dedication addressed to the Emperor Louis the Pious. Rainaldus wears a brown robe and Oliverus a bluish one. Both are shown with clerical tonsure. Rainaldus and Oliverus are mentioned again in a versified piece at the end of the volume in honour of the Cross (ff. 48v–49). An interesting note by the scribe (f. 7) asks the reader's indulgence for the inadequacy of his work, which resulted from the fact that the square grid into which Rabanus's poems had to be incorporated was in the Douai manuscript given a rectangular format more consonant with the vertical proportions of the page. He urges that this and other errors made by him not be repeated in copies that might be made from the manuscript. Rainaldus is depicted in another Anchin codex, a copy of Papias's *Elementarium* (Douai, Bibl. Mun. MS 751), whose transcription, according to the colophon, occupied him for ten years, from 1163 to 1173.

Oliverus provided the usual illustrative components for the imperial dedication and the twenty-eight poems of Rabanus — paintings of the standing emperor, the Crucified Christ, the Cross, the Cherubim and Seraphim, the monogram combinations and other *figurae* — as well as ornamental initials for the explanatory text on the pages facing each poem.

The dedication miniature (f. 39v), on the other hand, not tied to the configuration of the poems, reproduces the 9th-century model only very approximately. Rabanus, who is portrayed as a bishop, tenders a scroll to the enthroned Pope Gregory IV, the figures being enclosed within a double arcade with richly ornamented columns. The full-page painting of the Tree of Jesse (f. 11) inserted between the versified prologue and the *Figura prima* with the Crucified, is altogether exceptional in the corpus of manuscripts of *De laudibus*, Oliverus's style is recognizable in the decoration of another Anchin codex, a copy of Rabanus Maurus's Commentary on Exodus (Douai, Bibl. Mun. MS 339), which is written in a hand that may well be that of his collaborator in the present volume, Rainaldus. This style does not have local roots. Fluent, relaxed, though also verging on the coarse, it is an offshoot, as A. Boutemy and P. Cerny have recognized, of the type of painting practised in impressively prolific fashion at Corbie further south during the seventh and eighth decades of the 12th century.

PROVENANCE: Written by Rainaldus and illuminated by Oliverus, according to a versified colophon (ff. 48v–49); both are depicted in the opening initial (f. 9).

LITERATURE: Abbé E. Escallier, *L'abbaye d'Anchin*, Lille, 1852, 113 (cited as MS 786); C. Dehaisnes, *Catalogue général*, Quarto Series, VI, 1878, 179; A. Haseloff in A. Michel, *Histoire de l'art*, II, 1, 1906, 306; J. Prochno, 'Das Bild des Hrabanus Maurus', *Kultur und Universalgeschichte. Festschrift für Walter Goetz*, Leipzig, 1927, 19; Boeckler, *Abendländische Miniaturen*, 93, 95, 121; J. Baum, *Die Malerei und Plastik des Mittelalters. II. Deutschland, Frankreich und Britannien* (Handbuch der Kunstwissenschaft), Wildpark-Potsdam, 1930, Fig. 200; A. Watson, *The Early Iconography of the Tree of Jesse*, Oxford, 1934, 19, 105–6, 149; A. Boutemy, 'Adaptation d'enluminures carolingiennes dans un ms. du XIIe siècle (Douai, Ms. 340 d'Anchin)', *Scriptorium*, II, 1948, 296; id., 'Enlumineurs d'Anchin au temps de l'Abbé Gossuin (1131/1133 à 1165)', *Scriptorium*, XI, 1957, 244, 246–7; Dodwell, *Painting in Europe*, 206; H.-G. Müller, *Hrabanus Maurus, De laudibus sanctae Crucis* (Beihefte zum Mittellateinischen Jahrbuch, 11), Düsseldorf, 1973, 37 and *passim*; H. Butzmann, 'Einige Fragen zur Überlieferung und zu den Bildern der Laudes Sanctae Crucis des Hrabanus Maurus', *Codices Manuscripti*, IV, 1978, 70; O. Mazal, *Buchkunst der Romanik*, Graz, 1978, 109–10; *Colophons*, V, 1979, 206, No. 16.404. No. 610; Cerny, *Anchin*, 55–60; E. Sears, 'Louis the Pious as "Miles Christi". The Dedicatory Image in Hrabanus Maurus's "De laudibus sanctae crucis"', *Charlemagne's Heir. New Perspectives on the Reign of Louis the Pious*, ed. P. Godman and R. Collins, Oxford, 1990, 613.

EXHIBITED: *Manuscrits à peintures*, Paris, 1954, 64, No. 135; *Benedictus en zijn monniken in de Nederlanden, 480–1980*, Ghent, 1980, III, 242–3.

134. The Hague, Koninklijke Bibliotheek MS 76 F 13

Psalter (Fécamp Psalter)
232 × 169 mm., ff. 176, 22 long lines
c. 1180. Fécamp or Ham

Ills. 328, 329, 330, 331, 332

Full-page calendrical miniatures: January, Janus-faced man eating and drinking at a table laden with food (f. 1v); February, man warming himself by a fire (f. 2v); March, two labourers pruning and tying up plants; below, a labourer digging up the ground for a plant, and a second figure with a staff and shoulder basket (f. 3v); April, standing crowned man with a rich garment and sceptre (f. 4v); May, hunter with falcon on horseback (f. 5v); June, two labourers making a haystack; below, a man scything and another with a pitchfork (f. 6v); July, man cutting thistles or weeds (f. 7v); August, a man cutting wheat and a woman picking up the grain; below, a man riding a donkey drawing a cart with sheaves of wheat (f. 8v); September, a man with a basket of grapes, and a companion treading on them in a tub; below, a man cuts grapes on the vine and a second one eats the fruit (f. 9v); October, a man sowing grain and a woman with a distaff; below, a man rakes the ground with a harrow drawn by a horse or mule (f. 10v); November, a swineherd knocks acorns from a tree for his pigs (f. 11v); December, a man about to slay a pig with an axe; below, man roasting a pig on a fire (f. 12v).

Full-page illustrations: Annunciation (f. 14v); Visitation (f. 15); Nativity (f. 16v); the three Magi (f. 17v); Virgin and Child (f. 18); Baptism (f. 19); the two High Priests deliberating the fate of Christ (f. 20); Arrest of Christ (f. 21v); Flagellation (f. 22); Three Women at the Sepulchre (f. 23); Harrowing of Hell (f. 24v); Doubting Thomas (f. 25); Ascension of Christ (f. 26v); Descent of the Holy Spirit (f. 27); kneeling woman (f. 28v).

Major historiated and ornamental initials: Psalm 1, B, David harping; below, David slaying Goliath (f. 29); Psalm 26, D, Anointing of David by the Prophet Nathan (f. 49v); Psalm 38, D, David striding on the roof of a building (f. 62v); Psalm 51, Q, Doeg slays Ahimelech (f. 74v); Psalm 52, D, David and Abigail (f. 75); Psalm 68, S, Jonah and the Whale (f. 88); Psalm 80, E (f. 103v); Psalm 97, C, David receives a bowl with a drink proffered by a woman (f. 117v); Psalm 101, D, seated Christ, with a kneeling figure before him (f. 119v); Psalm 109, D, triumph of the Trinity over two prone enemies (f. 132v).

Smaller historiated initials: Psalm 46, O, praying figure (f. 70); Psalm 50, M, Christ and the Magdalen (f. 73v); Psalm 79, bust of a monk in prayer (f. 90); Psalm 104, C, grotesque bust, perhaps intended as a caricature of a Jew (f. 124); Psalm 114, D, Christ with an adoring figure (f. 135v).

The Fécamp Psalter (as it is usually called) is a splendidly illuminated manuscript with some unusual features. The twelve paintings of the Labours of the Months each occupy an entire page, with the calendrical data appearing on the recto sides opposite, along with three small and squarish vignettes showing the appropriate zodiacal sign and two scenes of bloodletting. The last-mentioned illustrations reflect the tenets of ancient and medieval medicine, which specified the days when phlebotomy could take place, in accordance with the course of the zodiac through the heavens. The large place given to the Labours is exceptional, evoking as parallels only such celebrated works as the Calendar of 354 and the Très Riches Heures of the Duke of Berry. The calendrical sequence in the Psalter is followed by a cycle of the Life of Christ. Most of these paintings are arranged in pairs in the manner of diptychs, with blank versos and rectos following. But some are now single miniatures without a pendant, and this fact, as well as certain iconographic gaps in the sequence must prompt the assumption that several paintings have been lost. Thus, the Nativity (f. 16v) once probably faced an Annunciation to the Shepherds, while the Baptism (f. 19) was probably paired with a Massacre of the Innocents. An Entry into Jerusalem would be expected and perhaps formerly preceded the unusual and isolated scene of the High Priests deliberating the fate of Christ (f. 20). Finally, the Crucifixion is missing before the scene of the Three Women at the Sepulchre (f. 23).

The manuscript was in all likelihood made for the elegantly dressed woman seen kneeling with hands joined in prayer in the last painting of the sequence. She faces the page with the Beatus initial and the opening verses of Psalm 1, and one may also wonder here whether this is the juxtaposition that was originally intended. Its visual effect is oddly disjointed, but beyond this there is no decisive indication that anything — an iconic image of the Virgin or one of the saints — might have been lost. The localization of the work has hinged on the inclusion in the Calendar of two feasts for St. Waningus (9th and 16th January), who is also the only figure with a commemoration for the octave, though he is not mentioned in the Litany. Waningus (d. 688) was venerated at Fécamp which he had founded. During the Norman invasions of the later 9th century, however, his relics were brought to Ham in Vermandois, where a community of secular canons, regularized in 1108, had been established. There is thus a good chance that the work should be associated with Ham rather than with Fécamp, and this possibility gains

some further support from the presence in the Calendar of a feast for an 11th-century bishop of Meaux, Gilbert (13th February), who is thought to have been born at Ham. There are added obits for several members of the princely houses of Flanders, Hainaut and Bar, for bishops of Liège and Cambrai, and for men and women from various other places in north-eastern France and Flanders. The feasts of Thomas of Canterbury and Bernard of Clairvaux are in the original hand, and the manuscript is therefore datable after 1174. The Psalter has a ten-part division marked by large historiated and ornamental initials. The other Psalms have lesser but still substantial painted initials two or three lines high, a few that are historiated, the rest couched in the ornamental vocabulary of the Channel Style, with its characteristic foliage, little leonine beasts, bluish giants, and animals harping or playing pipes. Letters in gold begin every verse. The decoration of the manuscript, stylistically homogeneous, is carried out in body colour, with red, blue, green and light brown predominating. Gold is used liberally and in places incised or otherwise tooled with various designs. The style stands close to some examples of English illumination of the later 12th century, among which might be mentioned the Psalter, Gough Liturg. 2 in the Bodleian Library that is thought to have been executed in Northern England, or the Psalter-Hours from Saint-Pierre-le-Vif at Sens in the Bibliothèque Nationale (lat. 10433), tentatively connected by some scholars with London.

PROVENANCE: Bequeathed by Gerard of Dainville, Bishop of Thérouanne and later of Cambrai, to a relative named Jeanne de Planches in 1369 (f. 176v). Acquired in 1767 by G.-F. Gérard and No. A.I in his collection (f. 1 and bookplate). Acquired by the Koninklijke Bibliotheek in 1832.

LITERATURE: *Catalogus codicum manuscriptorum Bibliothecae Regiae. I. Libri theologici*, The Hague, 1922, 5, No. 25; A. W. Byvanck, *Les principaux manuscrits à peintures de la Bibliothèque Royale des Pays-Bas*, Paris, 1924, 10–13; G. Haseloff, *Die Psalterillustration im 13. Jahrhundert*, Kiel, 1938, 44, 110–11; G. Zarnecki, *English Romanesque Lead Sculpture*, London, 1957, 18, 39–40, 66–7, 71–2; H. Steger, *David, Rex und Propheta*, Nuremberg, 1961, 244, No. 63; O. Koseleff-Gordon, 'The Calendar Cycle of the Fécamp Psalter', *Studien zur Buchmalerei und Goldschmiedekunst im Mittelalter. Festschrift K.-H. Usener*, Marburg, 1967, 209–24; J. P. J. Brandhorst and K. H. Brockhuisjen-Kruijer, *De verluchte Handschriften en Incunabelen van de Koninklijke Bibliotheek*, The Hague, 1985, 5–6, No. 7.

EXHIBITED: *Schatten van de Koninklijke Bibliotheek*, The Hague, 1980, 46–7, No. 18; *Codex Manesse*, Heidelberg, 1988, 297–8, No. H 14.

135. Paris, Bibliothèque Sainte-Geneviève MS 1041–42

Martianus Capella, *De nuptiis Mercurii et Philologiae*, with the Commentary of Remy of Auxerre
360 × 200 mm., ff. 129 and 113, 2 cols., 40 lines
Last quarter of the 12th century.
North-eastern France *Ills. 318, 319*

MS 1041

Half-page miniature with personifications of Grammar, Dialectic and Rhetoric (f. 1v).

Ornamental initials: T (f. 1v); P, with a medallion showing a seated scribe (f. 2). Marginal diagrams of harmonic ratios (f. 10v).

MS 1042

Ornamental initial V with female warrior personifying Geometry (f. 1).

The manuscript contains Martianus Capella's 5th-century encyclopaedic poem *De nuptiis Mercurii et Philologiae*, accompanied by the Commentary of Remy of Auxerre (*c.* 841-before 908), the latter representing *siglum* G in the critical edition of C. Lutz (*Remigii Autessiodorensis Commentum in Martianum Capellam*, Leiden, 1961, I, 51, 57–8). In Books I and II, sections of Martianus' text alternate with Remy's commentary pertaining to it. Books III to VII have the text in continuous fashion, followed by the unbroken commentary, while the last two books return to the alternating system of Books I and II. At the end of the second volume (MS 1042, ff. 113–113v), there is a list of books belonging to a church whose name has unfortunately been erased. The present work is listed in it as *Remigium super Martianum in II vols*, along with some fairly unusual works, including Geoffrey Babio's Glosses on Matthew and Sermons, Richard of Préaux's Commentary on Matthew, and a *Contra Robertum* by Roscelinus. The statement of Lutz that this is a catalogue of the library of Sainte-Geneviève, and that the manuscript was thus written there, is without a factual foundation.

Although the work was originally conceived as being divided into two volumes, the numbering of the gatherings is continuous. The intention was evidently to group the *artes* of the Trivium and Quadrivium separately. The miniature at the beginning of the first tome, occupying slightly more than half a page and showing personifications of Grammar, Dialectic and Rhetoric, makes the intended division explicit. But the Quadrivium in the second volume has only a painted ornamental letter in the style of the two initials at the head of MS 1041, incorporating a personification of Geometry. Beyond these painted initials, the subdivisions of the text are marked by eight-line pen-work initials of a rather stiffly flourished type, in red, blue and green cur-

sorily overlaid with a yellowish wash. The painted decoration is carried out in opaque colours, with red, blue and light brown predominating. The gold background of the single miniature is tooled with dots in clusters of threes and sevens. The small-headed figures are haloed and seated within an arcade surmounted by turreted buildings. Grammar wields a switch and addresses a small male figure seated before her displaying an open book. Dialectic carries her traditional serpent, while Rhetoric bears a shield and a bundle of spears, or possibly a taper or torch, as P. Verdier suggests on the basis of Martianus' characterization 'arma in manibus quibus se vel communire solita vel adversarios vulnerare fulminea quadam coruscatione renidebant'. The style of the painting might be compared with the illumination of the Saint-Fuscien Psalter (Amiens, Bibl. Mun. MS 19; no. 136), though the juxtaposition brings out its stiffer effect and slightly archaizing linearity.

PROVENANCE: Abbey of Sainte-Geneviève, Nos. V.1 and 2. Acquired in 1767.

LITERATURE: C. Koehler, *Catalogue des manuscrits de la Bibliothèque Sainte-Geneviève*, Paris, 1893, I, 481; A. Boinet, *Les manuscrits à peintures de la Bibliothèque Sainte-Geneviève* (Bulletin de la Société de reproduction de manuscrits à peintures, V), 1921, 30–31; F. Rademacher, 'Eine romanische Kleinbronze der 'Grammatik'. Ein Beitrag zur Darstellung der Sieben Freien Künste im Mittelalter', *Bonner Jahrbücher*, CLIX, 1959, 265–6; C. Leonardi, 'I codici di Marziano Capella', *Aevum*, XXXIV, 1960, 447, No. 177–8; P. Verdier, 'L'iconographie des arts libéraux dans l'art du Moyen Age jusqu'à la fin du quinzième siècle', *Arts libéraux et philosophie au moyen âge* (Actes du quatrième Congrès International de Philosophie Médiévale, 1967) Montreal and Paris, 1969, 309-10; K. Wirth, 'Eine illustrierte Martianus-Capella Handschrift aus dem 13. Jahrhundert', *Städel-Jahrbuch*, N.F.2, 1969, 43, n. 4; A. C. Esmeijer, *Divina Quaternitatis*, Assen, 1978, 36, n. 40; C. Jeudy, 'L'oeuvre de Remi d'Auxerre. Etat de la question', *L'Ecole carolingienne d'Auxerre de Murethach à Remi, 830-908*, ed. D. Iogna-Prat, C. Jeudy and G. Lobrichon (Entretiens d'Auxerre, 1989), Paris, 1991, 492.

EXHIBITED: *Manuscrits à peintures*, Paris, 1954, 72, No. 185; *Ornamenta Ecclesiae*, Cologne, 1985, I, 65–6, No. A 10.

136. Amiens, Bibliothèque Municipale MS 19

Psalter-Hymnary (Saint-Fuscien Psalter)
266 × 182 mm., ff. 245, 20 long lines
Late 12th century. Amiens (?)

Ills. 325, 326, 327

Full-page miniatures: Creation of Eve and Temptation in the Garden (f. 7); Murder of Thomas Becket; three clerics before the enthroned archbishop (f. 8); Resurrection and Harrowing of Hell (f. 9v); Doubting Thomas (f. 10v); Ascension (f. 11v); Last Judgement (f. 12v).

Historiated and ornamental initials: Psalm 1, missing; Psalm 22, D, Annunciation (f. 36); Psalm 38, D, Nativity (f. 51v); Psalm 52, D, Annunciation to the Shepherds (f. 66); Psalm 68, S (f. 81); Psalm 80, E (f. 99v); Psalm 98, C, Presentation in the Temple (f. 115v); Psalm 109, D, The Trinity (f. 133).

The manuscript belonged to a woman named Alaidis, whose anniversary was celebrated on 27th February, and it was perhaps made for her. There are other obits in the Calendar for men and women who were presumably her kin. The place names associated with these entries are villages situated in the Cambrésis, though of Alaidis herself, nothing further is known. The form of address of several prayers (f. 13v) also points to a female owner. In the 13th century, the work was adapted for the Use of the Benedictine abbey of Saint-Fuscien, south of Amiens. The hymnary section (ff. 190–238v) is an addition of the 15th century.

The decoration of the manuscript, consisting of prefatory miniatures, historiated and ornamental initials painted in body colour, is now considerably damaged through wear. The erosion of the paint surfaces has in some areas exposed the underdrawing, done in red. In the opening miniature of the prefatory cycle, cursive inscriptions which are probably instructions to the artist, are visible: *Iesus Christus*, adjoining the figure of the Creator; *angelus*, *Eva* and *Adam* for the serpent and the first parents in the Temptation in the Garden. There are also signs that the outlines were here and there strengthened at some point to restore some legibility to the forms. The sequence of the miniatures as presently constituted is somewhat problematic. The two-tiered miniature devoted to the story of Thomas Becket, one of the earliest representations inspired by this theme, is oddly placed after the Creation scenes. Two additional pages with miniatures whose stubs are visible between ff. 8 and 9 seem once to have been extant, and the *Beatus* page is also missing. But since the text begins in the middle of the first verse on f. 14v while the recto of the same page is blank, a miscalculation on the part of the painter must be suspected. In the Becket miniature, the depiction of three monks in discourse with the enthroned saint below the scene of martyrdom has not yet been satisfactorily explained. In the initials which mark the divisions of the Psalms, Psalm 51 unexpectedly has only a modest three-line decorative letter, and the otherwise fairly regular cycle of Infancy scenes thus lacks an Adoration of the Magi, as well as further incidents for the initials of Psalms 68 and 80.

Although the commemoration of Becket on 29th December is an addition to the Calendar, the manuscript was obviously executed after the canonization in 1173. The decorative scheme of Psalters involving a cycle of prefatory miniatures was more deeply rooted in England during the 12th century than on the Continent, and the style of the painting, as Dodwell has noted carries some echoes of the 'dampfold' effects of the Lambeth Bible. But the general character of the work is more relaxed and not too far removed from the style of several Corbie manuscripts, particularly the volume of Julian of Toledo's *Liber prognosticorum* and other writings (Bibl. Nat. lat. 12270) and Radulphus Flaviacensis' Commentary on Leviticus in the same library (Bibl. Nat. lat. 11564). The major foliate initials are in a fairly ripe version of the Channel Style, with the typical trelliswork of spiralling foliage enlivened by white, lion-like creatures in evidence. These designs are a shade less refined, but comparable to the initials in the Peter Lombard Commentary on the Psalms from Saint-Germain-des-Prés (Bibl. Nat. lat. 11565; no. 90), datable before 1193.

PROVENANCE: Made for a woman, possibly the Alaidis whose *obit* (f. 1v) on 27th February at least indicates that she once owned the manuscript ('*Obiit Alaidis cuius hoc psalterium fuit*'). Adapted for the Use of Saint-Fuscien, Amiens (13th century).

LITERATURE: M.-J. Rigollot, 'Essai historique sur les arts du dessin en Picardie depuis l'époque romaine jusqu'au XVIe siècle', *Mémoires de la Société des Antiquaires de Picardie*, III, 1840, 357–60; E. Coyecque, *Catalogue général*, XIX, 1893, 11–12; G. Haseloff, *Die Psalterillustration im 13. Jahrhundert*, Kiel, 1938, 41–3; A. Katzenellenbogen, *Allegories of the Virtues and Vices in Medieval Art*, London, 1939, 59, n. 4; Leroquais, *Psautiers*, I, 9–11; C. R. Dodwell, *The Canterbury School of Illumination, 1066–1200*, Cambridge, 1954, 56; id., *The Great Lambeth Bible*, London, 1959, n. 60; Mérindol, *Corbie*, I, 512–13. J.-L. Lemaître, *Répertoire des documents nécrologiques français*, Paris, 1980, II, 865–6, No. 2027.

137. Boulogne-sur-Mer
Bibliothèque Municipale MS 2

Bible
515 × 345 mm., ff. 248 and 299, 2 cols., 40 lines
Second half of the 12th century.
Saint-André-au-Bois *Ills. 333, 334, 335*

Vol. I

Historiated and ornamental initials: JUDGES, P, standing figure with scroll (f. 3v); RUTH, I (f. 17v); PREFACE TO KINGS, V (f. 19); I KINGS, F, David as a young boy, flanked by two white-bearded personages, probably the confrontation of Samuel and Jesse over the choice

of David (16:2ff.) In the frame of the letter, medallions with Hannah and the Prophet Eli, David overpowering a lion, Saul menacing David with a lance and combat of David and Goliath (f. 22); II KINGS, F, man with staff (f. 41); III KINGS, E (f. 58); IV KINGS, P (f. 76); PREFACE TO CHRONICLES, S (f. 93v); I CHRONICLES, A (f. 96); II CHRONICLES, C (f. 110v); PREFACE TO ISAIAH, N (f. 131); ISAIAH, cut out (f. 131v); PREFACE TO JEREMIAH, I (f. 158v); JEREMIAH, V (f. 159); LAMENTATIONS, cut out (f. 187); PREFACE TO BARUCH, L (f. 190); BARUCH, cut out (f. 190); BARUCH 6:1, cut out (f. 191v); PREFACE TO EZEKIEL, I (f. 194); EZEKIEL, E (f. 194); DANIEL, A, dream of Nebuchadnezzar concerning the idol with the feet of clay, Daniel in the Lions' Den (f. 211); PREFACE TO MINOR PROPHETS, N (f. 222v); PREFACE TO HOSEA, D (f. 222v); HOSEA, V (f. 223); PREFACE TO JOEL, I (f. 227); JOEL, V (f. 227); PREFACE TO AMOS, A (f. 228v); AMOS, V (f. 229); PREFACE TO OBADIAH, A (f. 232); OBADIAH, V (f. 232v); PREFACE TO JONAH, I (f. 233); JONAH, E (f. 233); PREFACE TO MICAH, M (f. 234); MICAH, V (f. 234); PREFACE TO NAHUM, N (f. 236v); NAHUM, O (f. 237); PREFACE TO HABAKKUK, A (f. 238); HABAKKUK, O (f. 239v); PREFACE TO ZEPHANIAH, cut out (f. 239); ZEPHANIAH, V (f. 239v); PREFACE TO HAGGAI, A (f. 240v); HAGGAI, I (f. 241); PREFACE TO ZECHARIAH, Z (f. 241v); ZECHARIAH, I (f. 242); PREFACE TO MALACHI, M (f. 247); MALACHI, O (f. 247); PREFACE TO PROVERBS, I (f. 248v).

Vol. II

Historiated and ornamental initials: PROVERBS, P (f. 2); ECCLESIASTES, V (f. 15); SONG OF SONGS, O (f. 20); WISDOM, D (f. 23); PREFACE TO ECCLESIASTICUS, M (f. 32v); ECCLESIASTICUS, O, Solomon and Jesus Sirach in half length; below, half-length figures of *Magister* and *Discipulus* in dialogue (f. 34); PREFACE TO JOB, (f. 59); JOB, V (f. 60); PREFACE TO TOBIT, T (f. 74v); TOBIT, T (f. 75); PREFACE TO JUDITH, A (f. 80); JUDITH, A (f. 81); PREFACE TO ESTHER, L (f. 89); ESTHER, I, standing Ahasuerus (f. 89); PREFACE TO EZRA, U (f. 96v); EZRA, I (f. 97); PREFACE TO MACCABEES, cut out (f. 111); I MACCABEES, E (f. 112); II MACCABEES, F, medallions with two men in dialogue (f. 132); *Passio Machabeorum*, P, slaying of the Maccabees (f. 146); PREFACES TO GOSPELS, P, Jerome writing (f. 151v); A, S (ff. 152v, 153); PREFACE TO MATTHEW, M (f. 153v); CANON TABLES (ff. 155v–158), with symbols of the Evangelists (ff. 155v–156); MATTHEW, cut out; PREFACE TO MARK, M, Evangelist with scroll, angel (f. 174); MARK, I, medallion with Evangelist symbol (f. 175); PREFACE TO LUKE, L (f. 188); LUKE, Q (f. 190), F (f. 190); PREFACE TO JOHN, H (f. 211); JOHN, I, Tree of Jesse (f. 212); PREFACES TO PAULINE EPISTLES, P, P, I, R (ff. 228v, 230); PREFACE TO ROMANS, cut out (f. 230v); ROMANS, P, Paul standing on the shoulders of Synagoga (f. 231); PREFACE TO CORINTHIANS, C (f. 239); I CORINTHIANS, P (f. 239v); PREFACE TO II CORINTHIANS, P (f. 247v); II CORINTHIANS, P, bust of Paul (f. 248); PREFACE TO GALATIANS, G (f. 253v); GALATIANS, P (f. 254); EPHE-

SIANS, P (f. 257); PREFACE TO PHILIPPIANS, P (f. 260); PHILIPPIANS, P (f. 260v); COLOSSIANS, P (f. 263); LAODICEANS, P (f. 265); I THESSALONIANS, P (f. 265v); II THESSALONIANS, P (f. 267v); I TIMOTHY, P (f. 269); II TIMOTHY, P (f. 271v); TITUS, P (f. 273v); PHILEMON, P (f. 275); HEBREWS, M (f. 276); JAMES, I (f. 282v); I PETER, P, three-quarter length Apostle (f. 285); II PETER, S (f. 287v); I JOHN, Q (f. 289v); II JOHN, cut out (f. 291v); III JOHN, S (f. 293); JUDE, I (f. 293v); PREFACE TO ACTS, L (f. 294); ACTS, P (f. 294v).

Six cuttings with ornamental initials are in the Bibliothèque de l'École des Beaux-Arts in Paris (Donation Masson): PREFACE TO ZEPHANIAH (MS 32); BARUCH (MS 31); BARUCH 6:1 (MS 30); PREFACE TO MACCABEES (MS 33); PREFACE TO ROMANS (MS 34); II JOHN (MS 29). Three additional cuttings with initials of II THESSALONIANS (MS 26), TIMOTHY (MS 27) and PHILEMON (MS 28) in the same style must come from another, closely related work.

The manuscript, which has suffered damage from rubbing and humidity, is also in a severely mutilated state, with about 125 leaves missing from the first volume, according to the calculations of Boutemy, and a smaller, though still substantial number from the second. However, contrary to Boutemy's opinion that the work originally included a third volume with the New Testament, it is more likely that the entire biblical text originally filled only two tomes. Some initials have also been cut out, though six of these, formerly in the collection of Jean Masson, were bequeathed to the École des Beaux-Arts, Paris, in 1926. The manuscript comes from Saint-André-au-Bois, a Premonstratensian foundation first established around 1130 at Aulnay, near Montreuil (Pas-de-Calais), and transferred in 1156 to another site in the same area. Initially a priory of the abbey of Saint-Josse (also known as Dommartin), it achieved independent status in 1163. The Bible is the only known illuminated manuscript among the small number of books of this community to have survived.

The style of the splendid initials in the Bible is connected to one of the major currents of Late Romanesque painting, variants of which appear to have been practised in Paris and in a number of centres of north-eastern France. It manifests itself notably in the books produced for Herbert of Bosham in the 1170s in an early, though already fully formed state, or in a work attributable to the same Parisian sphere, whose decoration parallels that of the Bible very closely, the copy of Gratian's *Decretum* formerly in the Dyson Perrins Collection and now in the J. Paul Getty Museum (MS 83 MQ.163). The principal hallmark of this style, which has often been described, is the extremely characteristic type of foliage consisting of spiralling tendrils equipped with a profusion of feathery leaves and blossoms, and inhabited by a fauna of little white lions, bird sirens

and other monstrous creatures, handled in a playful spirit. In the Saint-André-au-Bois Bible, this ornament is treated on a somewhat larger scale than is usually the case, in line with a striving for monumentality that typifies the construction of decorative initials in Romanesque Giant Bibles. The painter's awareness of this tradition also accounts for the introduction in his initials, though on a fairly limited basis, of figurative and narrative subjects, little cultivated in this type of decoration. The repertory of heroic or mock-heroic subjects that inhabit the foliage is also more varied through the inclusion of combats between rustics, men fighting dragons and lions, or a figure driving a spike into a naked man (Vol. I, 3v), for which the rich ornamental vocabularies of the Lambeth Bible or the Winchester manuscript (Bodleian Library, Auct. E. infra 1) provide antecedents. Contrasting with the generally diminutive effects of the Channel Style, there are also large standing figures in the manner of statuary (Vol. I, f. 3v, 41), though of a weightless and strenuously animated quality. The exceptionally ambitious nature of this illumination is indicated, beyond the seemingly inexhaustible convolutions of these designs, by the provision of three-line painted initials for the chapter headings (many of them also cut out), themselves incorporating on a smaller scale the same foliate and zoomorphic motifs.

PROVENANCE: *Ex libris* of Saint-André-au-Bois, 17th-18th century. (Vol. I and II, flyleaf, and Vol. II, f. 1).

LITERATURE: H. Michelant, *Catalogue général*, Quarto Series, IV, 1872, 571–2; C. Enlart, *Manuel d'archéologie française. III. Le Costume*, Paris, 1916, 160, 262; P. Héliot, 'Les manuscrits illustrés de la Bibliothèque de Boulogne', *Bulletin du Comité flamand de France*, 1934, 10; H. Swarzenski, *The Berthold Missal*, New York, 1943, 37; A. Boutemy, 'La Bible de Saint-André-au-Bois', *Scriptorium*, V, 1951, 222–37; C. R. Dodwell, *The Canterbury School of Illumination, 1066–1200*, Cambridge, 1954, 107; R. Schilling, 'The "Decretum Gratiani" in the Dyson Perrins Collection', *Journal of the British Archaeological Association*, XXVI, 1963 27–39; H. G. Franz, *Spätromanik und Frühgotik* (Kunst der Welt), Baden-Baden, 1969, 175, 183; Dodwell, *Painting in Europe*, 205; L. Eleen, *The Illustration of the Pauline Epistles in French and English Bibles of the Twelfth and Thirteenth Centuries*, Oxford, 1982, 69; Cahn, *Romanesque Bible Illumination*, 268, No. 56; A. von Euw and J. M. Plotzek, *Die Handschriften der Sammlung Ludwig*, Cologne, 1985, IV, 46. For the cuttings in Paris, see the Exh. Catal. *Arts graphiques du moyen âge*, Paris, 1953, 12, No. 7.

EXHIBITED: *Manuscrits à peintures*, Paris, 1954, 72, No. 183; *Art roman*, Barcelona and Santiago de Compostela, 1961, 56, Nos. 81–82. (cuttings): *Arts graphiques du moyen âge*, Paris, 1953, 12, No. 7.

138. The Hague, Koninklijke Bibliotheek MS 76 F 5

Psalter Fragment
255 × 165 mm., ff. 46
Late 12th century. Saint-Bertin

Ills. 336, 337, 338; Col. pl. XVI

Full-page miniatures: Map of Jerusalem and combat of knights (f. 1); Temptation in the Garden, Expulsion from Paradise, Labours of Adam and Eve, Killing of Abel (f. 2v); Joseph interprets Jacob's Dream, Joseph serves his brothers at Sichem, Joseph brings his brothers food, the brothers sell him into slavery (f. 3v); Joseph's brothers show Jacob Joseph's bloody garment, Joseph in prison, Dream of the Pharaoh, Joseph brought before the Pharaoh interprets his dream (f. 4v); Abraham with the three angels, Isaac blesses Jacob in the presence of Rachel and Esau, Joseph's silver goblet is found in Benjamin's sack, Joseph embraces Benjamin in the presence of his brothers (f. 5v); Finding of Moses in the Nile, raising of the Brazen Serpent, transportation of the Ark by Aaron and the Israelites, Jephtha and his daughter (f. 6v); Moses receives the tablets of the Law, he casts them down in the presence of the Israelites worshipping the Golden Calf, Crossing of the Red Sea and Drowning of the Egyptian Cavalry (f. 7); Ascension of Elijah, healing of Naaman, Job on the dunghill and restoration of Tobit's sight (f. 8); Judgement of Solomon, Resurrection of Lazarus, Habakkuk brought to Daniel in the Lions' Den (f. 9); Annunciation, Visitation, Nativity, Annunciation to the Shepherds (f. 10v); Adoration of the Magi, Massacre of the Innocents (f. 11v); Temptations of Christ in the Desert, Christ adored by the angels (f. 12v); Sermon on the Mount, Christ with Zaccheus, Christ and the Rich Young Man (f. 13); Christ calms the storm on the Lake of Genesareth, Calling of Peter, Miracle of the Loaves and Fishes, Healing of a crippled man at Bethesda (f. 14); Entry of Christ into Jerusalem, Washing of the Feet, Last Supper (f. 15v); Christ turns down a crown proffered to him, he is turned away by a group of men, Parable of Lazarus and the Rich Miser (f. 16); Transfiguration, Christ and the Adulterous Woman, penitence of the Pharisee, Parable of the Good Samaritan (f. 17v); Christ in the Garden of Gethsemane, Judas receives the thirty pieces of silver, Arrest of Christ (f. 18v); Christ denounced before Pilate, the High Priest before Pilate, Christ before Pilate, Flagellation, Pilate washes his hands (f. 19v); Pilate hands Christ over to be crucified, Carrying of the Cross, Crucifixion, Deposition from the Cross (f. 20v); Anointing of the body of Christ, Resurrection, Harrowing of Hell, saints rising from their tombs (f. 21v); Three Maries at the Sepulchre, Christ partakes of a meal with his disciples, Supper at Emmaus, Doubting Thomas (f. 22v); Christ appears to the disciples, who are fishing, Ascension, Peter calls on the people to convert, St.

Matthew and the Apostles (f. 23v); Descent of the Holy Spirit, Peter healing a crippled man, Conversion of Paul, Baptism of Paul (f. 24v); St. Gregory of Nazianzus receiving inspiration, St. Basil offers three breads to the Emperor Julian, Pope Gregory receiving inspiration, St. Mercurius addresses the Emperor Julian (f. 25v); Martyrdom of James Minor, Thaddeus, James Major and Matthew (f. 26v); Martyrdom of Thomas, Bartholomew, Philip and Barnabas (f. 27v); Martyrdoms of Lawrence, Vincent, Denis, Thomas of Canterbury (f. 28v); Decapitation of Paul, Martyrdom of John the Evangelist; below, Saints Stephen, Remigius, Anselm, Audomarus, (f. 29); Purification of Isaiah's tongue with hot coals, Death of John the Baptist, Martyrdom of Peter, Martyrdom of Andrew (f. 30v); Wise and Foolish Virgins (f. 31v); St. Benedict with St. Scholastica, Temptation of St. Agnes, St. Margaret with the dragon, St. Juliana fights a demon (f. 32); a monk praying to Saints Judocus, Winnoc, Giles and Bertin (f. 33v); Saints Faith, Mary Magdalen, Columba, Mary of Egypt (f. 34v); St. Maurice, Martyrdom of St. Sebastian, Martyrdom of St. Erasmus, Erasmus' soul is received into heaven (f. 35v); St. Polycarp, St. Quentin, St. Nicholas gives presents to the three maidens, St. Servatius receives a message from an eagle, St. Servatius receives his crozier as Bishop of Tongres from an angel (f. 37v); Saints Ambrose, Augustine, Martial, Nicasius (f. 38v); Martyrdom of Blaise, Blinding of Leodegarius, Story of St. Eustace and St. Felicity (f. 39); Martyrdoms of St. Catherine, Agatha, Cecilia and Lucy (f. 40); Story of Theophilus (ff. 41–42); Saul and the Witch of Endor, Anointing of David, Solomon and the Temple, Decapitation of Holophernes (f. 43); Last Judgement (ff. 44–45).

This extraordinary sequence of miniatures was probably designed as a prefatory cycle for a Psalter. The provenance is suggested by the representation of a monk with hands joined in adoration, kneeling before St. Bertin (f. 33v), the patron of the important monastic community bearing his name, located at Saint-Omer (Pas-de-Calais). But the paintings seem never to have been put to their originally-intended use. The blank sides of many pages are covered with texts in different hands and dates, some of them in French, others in Latin. The writing has an informal quality, indicating that these spaces were simply being put to casual use. The text on the verso of the first folio, partly trimmed on the left side, is the *Complainte de Jérusalem contre la cour de Rome*, a satire directed against the vices of the clergy, attributed to Huon de Saint-Quentin (ed. E. Stengel, *Codex manuscriptus Digby 86*, Halle, 1871). What follows consists of Collects for various saints, and a long moralizing treatise in French (ff. 21–33). An exception to this miscellaneous ensemble of notes is the carefully written page, in an English hand apparently, with calendrical and computistical material that might have been part of a liturgical Psalter (f.

43v). Many pages were simply left blank (ff. 11, 34–38, 39v, 40v, 41v, 43v).

The series of illustrations begins with a map of Jerusalem surrounded by important sites in the vicinity of the city and in the Holy Land. Below the map, St. George and St. Demetrius on horseback charge a group of fleeing mounted warriors, a scene inspired by the account of the legendary appearance of the two saints in the camp of the Crusaders at the Battle of Antioch in 1098. The following pages feature scenes of the Old Testament (ff. 2v–9, 43) and the New Testament (ff. 10v–24v), portraits of the saints and scenes of their lives or martyrdom (ff. 25v–42), culminating in the Last Judgement (ff. 44–45). In most instances, there are four separate scenes on each page, and each of the subjects is identified by a Latin inscription (transcribed in Delisle, *Mélanges*, 207–16). The expansive nature of the cycle connects the work with a series of English Psalters illuminated around the year 1200 where biblical illustration is equally conspicuous: the last copy of the Utrecht Psalter (Paris, Bibl. Nat. lat. 8846), the Psalter, sometimes associated with Gloucester, in Munich (Bayer. Staatsbibl. Clm. 835), or the Psalter of the Arundel Collection in the British Library (Arundel 157). N. Morgan has pointed out that an extensive hagiographical sequence, which sets the Saint-Bertin miniatures apart from these parallels, also occurs and with a similar layout of four scenes to a page, among the illustrations of the early 13th-century Huntingfield Psalter (New York, Pierpont Morgan Library, MS 43. N. Morgan, *Early Gothic Manuscripts*, Survey IV/I, London, 1982, 78). Among the saints represented by miniatures are, beyond the already-mentioned Bertin, a number of other saints of the region of the Morinie (Audomarus, Winnoc), Flanders (Judocus, Servatius) and north-eastern France, or Reims more specifically (Nicasius, Remigius). The Theophilus legend is given two full pages with multiple scenes (ff. 41, 42). This legend is also incorporated into two other Psalter prefatory cycles of this period and of Continental origin, the Ingeborg Psalter (Chantilly, Musée Condé, MS 1695), and the Psalter of the Bibliothèque Nationale associated with Troyes (lat. 238). The presence of illustrations of several saints of Eastern origin in addition to George and Demetrius (Gregory of Nazianzus, Basil, Mercurius and Polycarp) deserves to be noted.

The entire series of illustrations appears to be the work of a single painter. The painting is carried out in body colour, the individual scenes being set off against gold panels which are occasionally tooled with dotted patterns and crosses. The smoothly modelled figures are given sharp definition by means of strong black outlines. The modelling itself has the soft transitions and relaxed effect of painting on both sides of the channel on the last decade and a half of the 12th century. Illumination in a comparable style appears in the Leiden Psalter (Leiden, University Library MS B.P.L. 76.A), a northern English

work of the period 1190 to 1200, as noted by Morgan, or in the more or less contemporaneous Life of St. Cuthbert in the British Library (Yates Thompson 26). At Saint-Bertin, the work remains for the moment without an identifiable parallel.

PROVENANCE: Collection of Joseph Desiré Lupus, Brussels (No. A.3). Acquired by the Royal Library in 1832.

LITERATURE: A. Jubinal, *Lettres à M. Le Comte de Salvandy sur quelques-uns des manuscrits de la Bibliothèque Royale*, Paris, 1846, 11ff., 65ff.; L. Delisle, *Mélanges de paléographie et de bibliographie*, Paris, 1880, 207–16; K. Miller, *Die ältesten Weltkarten*, Stuttgart, III, 1895, 64; A. de Laborde, *La Bible moralisée*, Paris, 1911–27, IV, pl. 791–2; V, 9–10; *Catalogus codicum manuscriptorum Bibliothecae Regiae*, The Hague, 1922, 264, No. 725; A. W. Byvanck, *Les principaux manuscrits à peintures de la Bibliothèque Royale des Pays-Bas*, Paris, 1924, 13–15; W. Müller, *Die heilige Stadt*, Stuttgart, 1961, 55; F. Bucher, *The Pamplona Bibles*, New Haven, 1970, I, 86–7; J. P. J. Brandhorst and R. H. Broekhuisjen-Kruijer, *De verluchte Handschriften en Incunabelen van de Koninklijke Bibliotheek*, The Hague, 1985, 6–8, No. 9.

EXHIBITED: *Schatten van de Koninklijke Bibliotheek*, The Hague, 1980, 48–9, No. 19; *Ornamenta Ecclesiae*, Cologne, 1985, III, 76, No. H 4.

VII. EASTERN FRANCE

139. Verdun, Bibliothèque Municipale MS 8

Life of St. Airy
240 × 176 mm., ff. 25, 23 long lines
c. 1100. Saint-Airy, Verdun *Ill. 341*

Full-page miniature with three scenes of the life of St. Airy: Annunciation of the birth of the saint to his parents; consecration of St. Airy as bishop; Abbot Stephen of Saint-Airy dictates the life of the saint to a scribe (f. 1v).

Historiated initials: I, standing St. Airy (f. 2); D, bust of St. Airy (f. 2v).

This slim volume contains a Life of St. Airy (Agericus), the tenth Bishop of Verdun (521–88), written by or at the behest of Stephen, Abbot of the monastery of Saint-Airy in the years between 1062–84 (*B.H.L.* 143, 144). The character of the hand is a fairly conservative Carolingian minuscule, accented only by the rendering of the name Agericus in capital letters and red dots placed within the first letter of every sentence. The *Vita* (ff. 2–21) is followed by a short tract on the Nativity of the Virgin, whose 'emendation' is ascribed to St. Jerome (*B.H.L.* 5343, 5345), written by another and somewhat later hand (ff. 21–25). The only embellishment of note is the full-page prefatory miniature and historiated initials of modest interest marking the beginning of the prologue and the text of the *Vita*. Ronig has observed that the opening leaf on which the miniature is found is not an organic part of the first signature, but was pasted into the volume. This might indicate, according to the same author, that it was made for another context, or added to the present manuscript as an afterthought in order to enhance its appearance. However, since the style of the drawing is on all essential points identical with that of the admittedly somewhat scratchily drawn initials on the following page, the execution of the frontispiece on a separate leaf was more likely a matter of convenience.

The opening leaf features a kind of epitome of the life of Agericus in a mid 12th-century hand on the recto, which could be taken as a partial description of the scenes on the verso, and may conceivably have been designed to make these more intelligible. The miniature, which is drawn in brown outline, with areas of green and red, consists of two tiers of scenes. Above appear two episodes of the life of the saint, the Annunciation of his birth by an angel to his parents, who were farmers in the vicinity of Verdun, three years before the event (518), and his consecration as bishop at the highly symbolic age of thirty-three (554). The first of these scenes was no doubt calculated to remind the viewer of the Annunciation to the Shepherds in the Gospel narrative, and thus to institute a parallel between Agericus and Christ. In the scene below, the Abbot Stephen receives divine inspiration and dictates his biography to a scribe. Since the abbot is depicted with a square halo, Ronig has suggested that the manuscript was probably executed in Stephen's lifetime, but this argument probably cannot be considered wholly decisive. It is known that in the necrology of Saint-Airy, Stephen and his two predecessors were commemorated as *beati* (*G.C.*, XIII, 1166–67) and the square nimbus might well therefore be understood instead as a mark of posthumous respect. Among the manuscripts of Saint-Airy, the work is part of a small group

of books with pen-drawn and coloured decoration produced near the end of the eleventh or in the early 12th century, which includes a copy of the Rule of St. Benedict (Verdun, Bibl. Mun. MS 10) and of John Cassian's *Collationes* (MS 60).

The monastery of Saint-Airy was a Benedictine foundation established in 1037 by Bishop Raimbertus of Verdun on the site of the saint's tomb in the church of St. Andrew and St. Martin, and with the help of a group of monks brought to Verdun from Saint-Maximin in Trier. An inventory of precious liturgical vessels and forty-six books drawn up in the time of Abbot Stephen and dated 1070 is found in a Saint-Airy manuscript in Florence (A. M. Bandini, *Catalogus codicum latinorum Bibliothecae Mediceae Laurentianae*, Florence, 1775, II, Sp. 40, and *Mittelalterliche Schatzverzeichnisse*, ed. B. Bischoff, I, Munich, 1967, 100, No. 96).

PROVENANCE: Saint-Airy *ex libris*, 18th century (f. 1). Saint-Airy, MS 35.

LITERATURE: H. Michelant, *Catalogue général*, Quarto Series, V, 1879, 432–3; *Manuscrits datés*, V, 535; M. Souplet, *Saint-Airy, évêque de Verdun*, Verdun, 1965, *passim*; F. Ronig, 'Die Buchmalerei des 11. und 12. Jahrhunderts in Verdun', *Aachener Kunstblätter*, XXXVIII, 1968–9, 18, 27–31, 149–50; id., 'Die Buchmalerei des 11. und 12. Jahrhunderts zu Verdun und ihre Beziehungen zur Trierischen Kunst', *Kurtrierisches Jahrbuch*, XII, 1972, 8-9; 'Zur romanischen Buchmalerei in Verdun und ihre Stellung zwischen Rhein und Maas, '*Rhein und Maas*, Cologne, 1973, II, 335; J. van der Straeten, *Les manuscrits hagiographiques de Charleville, Verdun et Saint-Mihiel* (Subsidia Hagiographica, 56), Brussels, 1974, 96, 118–19.

EXHIBITED: *Écriture et enluminure en Lorraine au moyen âge*, Nancy, 1984, 170–1, No. 117; *Ornamenta Ecclesiae*, Cologne, 1985, I, 234, No. B 34.

140. Metz, Bibliothèque du Grand Séminaire

Four Gospels
303 × 210 mm., ff. 163, 27 long lines
First quarter of the 12th century.
Saint-Mihiel *Ills. 342, 343, 344, 345*

Evangelist portraits; Matthew (f. 8); Mark (f. 8v); Luke (f. 9); John (f. 9v); Canon Tables (ff. 10–17).

Historiated and ornamental initials: (f. 1); P (f. 2v); EA (f. 4); S (f. 5); M (f. 5v); L, Christ enthroned in a mandorla (f. 18); I (f. 56v); L (f. 79); Q (f. 83v); H (f. 123v); I (f. 125).

Marginal drawings of arcades for the concordances: ff. 25v, 26, 50, 58, 65v, 66; left unfinished: ff. 34, 41, 132, 139v, 140, 147, 148.

The volume contains the four Gospels, preceded by the customary prefaces and followed by the *Capitulare evangeliorum* (ff. 156–61). On blank spaces within the manuscript are found a transcription of an act, dated 1299, by Jean III d'Aspremont, Bishop of Verdun, settling a dispute between the monks of Saint-Mihiel and a knight of the region over one of their possessions (ff. 161v–62); a 16th-century transcription of the oath to be sworn by parents and friends of newly professed monks of Saint-Mihiel (f. 17); instructions in the same hand on the procedure to be followed for admitting a child oblate to the community (ff. 162–63); and a copy in the same hand of the *Forma iuramentum* for the election and confirmation of abbots of Saint-Mihiel (f. 155v). The domain on which the community was established is first mentioned in 775 when the Frankish king Pippin the Short donated these possessions to the abbey of Saint-Denis. A monastery was established there in the following years, though it was transferred to a new site on the Meuse River a short distance away by Smaragdus, a prominent literary figure of the Carolingian Renaissance, who was Abbot of Saint-Mihiel from 800 to 826. In the late 9th century, the monastery's ties with Saint-Denis were gradually severed, and it appears again in the High Middle Ages among the possessions of the Dukes of Haute-Lorraine and later Counts of Bar.

The manuscript was written by two or possibly three hands. In the section of the text executed by the first scribe, there are fine and highly ornate pen-drawn initials letters for the verses and titles in red shaded with a yellow wash (ff. 18–36v). In the following pages, there are only fairly plain two-line capital letters in red. The major initials at the beginning of the four Gospels are also the work of different hands, and their size and structure are not calibrated to produce an evenly weighted effect. The Matthew initial, which is the most elaborate of these designs, has a distinctly Ottonian cast, which is shared by a number of simpler ornamental initials in the manuscript, drawn in red outline (ff. 1, 1v, 2v, 56v). Schnitzler has noted the relation of its design, which combines the initial L with an image of the seated Lord within a mandorla, to the corresponding initial in the mid 11th-century Fulda (?) Evangeliary in Berlin (Preuss. Staatsbibl. theol. lat. 18, f. 17); and he also considered the composition in the Saint-Mihiel Gospels likely to be based on a lost model of the Trier Master of the Registrum Gregorii. The monastery is known to have possessed an 11th-century Reichenau (?) luxury Gospel Lectionary (Lille, Bibl. de l'Université; see K. Schmid, *Frühmittelalterliche Studien*, XVI, 1982, 143–60). Other initials, variously enhanced with yellow wash and touches of blue and green (ff. 79, 84) or fully painted (f. 125) seem to exemplify a more regionally bound idiom with links to book illumination of other Mosan centres to the north and west. A peculiar feature of the decoration is the enclosure of the marginal concordances within

arches whose capitals and bases may exhibit birds, lions or dragons. These arches appear only on the first recto and last verso of each signature, and were only partially carried out.

The major components of the decoration are the four Evangelist portraits, grouped exceptionally at the beginning of the volume following the prefaces, and the set of Canon Tables on sixteen sides which follow. The latter, like the marginal arches in the body of the text, are drawn in a combination of red and brown outline, with flatly-laid tints of colour filling the columns and the arcading, and ornate foliate capitals and bases enlivened by dragons, animal masks, confronted birds and quadrupeds left in outline. The Evangelist portraits are executed in the same mixed technique, involving drawing with some features modelled in paint and flatly-laid backgrounds of purple, olive green, blue and yellow. The Evangelists, alternately seated in profile (ff. 8, 9) and frontalized stances (ff. 8v, 9v) are depicted in the act of writing (ff. 8, 9) or pausing to receive the divine inspiration. The figures of Mark, Luke, and John are framed by parted curtains, a motif that is omitted in Matthew, whose symbol is unusually depicted in a seated stance and framed by a circular glory. These images are somewhat depreciated by smudging, chiefly caused by the oxydation of the silver haloes.

The style of this decoration, as F. Ronig has observed, has some connection with books illuminated at Verdun, particularly with the two-volume Homiliary of Saint-Vanne (Verdun, Bibl. Mun. MSS 1 and 119; no. 141). Porcher dated the work in the second half of the 11th century, while Ronig assigns it to the first half of the twelfth. A date in the first quarter of the 12th century, favoured by Schnitzler, seems closest to the mark.

PROVENANCE: Saint-Mihiel *ex libris*, 18th century (f. 1). MS A.I, 17th century. (inside cover). MS X. 4a (label on binding). Transferred to the Évêché de Metz in 1807.

LITERATURE: J.-B. Pelt, 'Un manuscrit des Évangiles du XIIe siècle', *Revue ecclésiastique de Metz*, VI, No. 6, 1895, 290–300; H. Schitzler, 'Fulda oder Reichenau', *Wallraf-Richartz-Jahrbuch*, XIX, 1957, 119–20, n. 598; F. Ronig, 'Die Buchmalerei des 11. Jahrhunderts in Verdun', *Aachener Kunstblätter*, XXXVIII, 1968-9, 142–5; F. Ronig, 'Zur romanischen Buchmalerei in Verdun und ihrer Stellung zwischen Rhein und Maas', *Rhein und Maas*, Cologne, 1973, II, 336; S. Collinet-Roset, 'Un manuscrit des Évangiles de l'abbaye de Saint-Mihiel (Meuse) conservé au Grand Séminaire de Metz (Moselle)', *Le Pays Lorrain*, LXV, No. 2, 1984, 118–24; F. Ronig, 'Eine verschollene Majestas Domini aus Trier', *Festschrift für Peter Bloch*, ed. H. Krohm and C. Theuerkauff, Mainz, 1990, 28.

EXHIBITED: *Manuscrits à peintures*, Paris, 1954, 92, No. 262; *Écriture et enluminure en Lorraine au moyen âge*, Nancy, 1984, 63, No. 34.

141. Verdun, Bibliothèque Municipale MSS 1 and 119

Homiliary
430 × 290 and 440 × 290, ff. A-J+264 and 161
2 cols., 39 and 37 lines
Second quarter of the 12th century.
Saint-Vanne, Verdun *Ills. 339, 340*

MS 1

Full-page frontispiece with the Days of Creation, the Seasons, Winds and personifications of Day and Night (f. J); vignette with the Annunciation to the Virgin (f. 27).

Historiated and ornamental initials: N (f. 1); I, standing St. Sebastian with palm (f. 8); P (f. 11); H (f. 14v); S (f. 20); G (f. 24v); F, half-length St. Benedict (f. 25v); D (f. 27); P (f. 29v); I, standing St. James with book (f. 30v); C (f. 32); N (f. 35v); O, half-length Peter and Paul (f. 38v); F (f. 45); M (f. 51v); B (f. 55); R (f. 56v); A (f. 57v); R, St. Lambert with book (f. 73v); S (f. 74v); D, bust of St. Maurice (f. 75v); A, combat of St. Michael with the dragon (f. 76v); P (f. 78v); P (f. 79v); St. Madalveus, three-quarter length (f. 80); P (f. 82); S (f. 83v); R, half-length St. Augustine with book (f. 88); L (f. 91); H (f. 94); OV (f. 98); I, standing St. Martin (f. 104v); C, half-length St. Cecilia (f. 112v); P (f. 116); V (f. 129); O (f. 157v).

MS 119

Nativity and Annuciation to the Shepherds (f. 28). Historiated and ornamental initials: P (f. 1v); N (f. 10); C (f. 25v); P (f. 28); Q, Pope Gregory enthroned with book (f. 33); N (f. 34); H, stoning of St. Stephen, to whom the Lord offers the crown of martyrdom (f. 39v); Z (f. 43v); D (f. 45); P (f. 47v); A (f. 49v); S (f. 51); S (f. 53v); P (f. 55); C, Adoration of the Magi (f. 56); P (f. 58); A (f. 62v); P (f. 63); N (f. 64v); D (f. 68v); I (f. 69v); R (f. 75); H (f. 76); P, man bearing the loop of the letter, filled with foliage and four male busts (f. 79); M (f. 79v); A, crouching figure (f. 80); D (f. 81); M, confronted bears (f. 82); Q (f. 83); H, the Lord flanked by a pair of angels; half-length St. Jerome with book (f. 84); V, half-length Jeremiah with book (f. 84); P (f. 85v); M (f. 87v); D (f. 88); ET, *atlante* (f. 90v); P (f. 94v); H (f. 96); M, Maries at the Sepulchre (f. 97); I, standing Pope Gregory with book (f. 98); F (f. 101v); P (f. 102); P (f. 103); I, standing St. James with book (f. 107); Q (f. 108v); P, *atlante* (f. 109v); P (f. 110); A (f. 115); C, half-length Christ with book (f. 120); F (f. 126); D (f. 132v); V (f. 133v); C (f. 136); T, Tobit carrying a corpse (f. 136v); A (f. 137); A (f. 137v); ET (f. 138v); F (f. 139v); H, bust figures of the Lord and St.

Jerome (f. 143); ET (f. 143); I, standing Pope Gregory with book (f. 147v).

As recognized by F. Ronig, these two manuscripts form a single set, MS 1 containing the homilies for the saints days (*De sanctis*), and MS 119 those for the ordinary feast days of the liturgical calendar (*De tempore*). MS 1 also contains an important collection of historical documents, including the Annals of Verdun from the year 136 to 1047 in the original hand (ff. A-Gv); Bertharius's *Gesta episcoporum Virdunensium*, in which are found indications pointing specifically to the monastery of Saint-Vanne (ff. 159–62; *M. G. H. Script.*, IV, 51, and X, 525–30), and other documentary and hagiographical material added later. The monastery of Saint-Vanne replaced in 951 an older house of canons established to the west of the cathedral on the site of the tomb of St. Saintain, reputed to be the first bishop of Verdun. It became an important centre of reform under Abbot Richard (1004–1046), who rebuilt the monastic church and other conventual buildings, lavishing on the new sanctuary precious liturgical furnishings and treasure.

The Saint-Vanne Homiliary is very worn through use and some pages were remade or supplemented in the second half of the 12th century (MS 1, ff. 119, 120, 121–8, 158v; MS 119, ff. 9, 122–5, 160v, 161). The individual readings are announced by titles in red, and the text is embellished with two to four-line penwork initials of the 'arabesque' type, executed in combinations of red, green, purple and yellow. The major decoration is of two distinct sorts. The frontispiece in MS 1 and a number of the initials in both volumes, generally marking the major feasts, are painted in body colour with a dense, almost waxy effect. Although most drastically affected by wear, this painting shows in its best preserved parts uncommonly stylish effects of modelling in smooth, continuous tone, which strangely call to mind the otherwise unrelated miniatures of the Life of St. Albinus of Angers (Bibl. Nat. nouv. acq. lat. 1390; no. 9). The second and much larger group of initials, along with two independent scenes (MS 1, f. 27; MS 119, f. 28) is the work of several hands and carried out in a delicate outline drawing, selectively enriched by transparent and flatly-laid areas of colour. The purely ornamental letters, with their thick-stemmed spiralling branches and lobed leaves attest to the impact of Ottonian book illumination in the area of Verdun, Metz and Toul, all linked by political and ecclesiastical ties to the Empire. Great iconographic interest attaches to the frontispiece miniature which places the biblical Creation within the framework of medieval encyclopaedic and cosmological *schemata*. The image makes reference to the cyclical pattern of liturgical performance throughout the yearly calendar. An antecedent for this religious appropriation of scientific allegory is to be found in the *Annus* miniature of the 10th-century Fulda Sacramentary at Göttingen (Niedersächs. Staats- und

Universitätsbibl. MS 231, f. 250v). The date of the Saint-Vanne Homiliary is uncertain. Porcher placed its execution around the year 1100. Ronig dates the frontispiece in the middle of the second decade of the 12th century, following a view put forward earlier by A. Heimann, and the rest of the work in the period 1140–50, But the frontispiece and the manuscript form a stylistic whole and were produced in a single campaign.

PROVENANCE: Saint-Vanne, MS 3 [MS 1]. Saint-Vanne, MS 8 [MS 119], 17th or 18th-century *ex libris* (f. 1).

LITERATURE: H. Michelant, *Catalogue général*, Quarto Series, V, 1879, 423–6, 494; U. Berlière, 'Les manuscrits de l'ancienne abbaye de Saint-Vanne de Verdun', *Le Bibliographe moderne*, I, 1897, 295–308; A. Heimann, 'The Six Days of Creation in a Twelfth Century Manuscript', *Journal of the Warburg Institute*, I, 1937–8, 269–75; E. Panofsky, *Studies in Iconology*, New York, 1939, 111; id., *Renaissance and Renascences in Western Art*, Uppsala, 1965, 99, n. 1; F. Ronig, 'Die Buchmalerei des 11. und 12. Jahrhunderts in Verdun', *Aachener Kunstblätter*, XXXVIII, 1968–9, 15–16, 52–80; id., 'Zur romanischen Buchmalerei in Verdun und ihrer Stellung zwischen Rhein und Maas', *Rhein und Maas*, Cologne, 1973, II, 337; id., 'Die Buchmalerei des 11. und 12. Jahrhunderts zu Verdun und ihre Beziehungen zur Trierischen Kunst', *Kurtrierisches Jahrbuch*, XII, 1972, 9-10; *Manuscrits datés*, V, 531, 630; J. van der Straeten, *Les Manuscrits hagiographiques de Charleville, Verdun et Saint-Mihiel* (Subsidia Hagiographica, 56), Brussels, 1974, 99–114.

EXHIBITED: *Manuscrits à peintures*, Paris, 1954, 93, Nos. 266, 267; *Art roman*, Barcelona and Santiago de Compostela, 1961, 44, No. 49; *Écriture et enluminure en Lorraine au moyen âge*, Nancy, 1984, 73, No. 46 and 176, No. 119.

142. Verdun, Bibilothèque Municipale MS 43

Four Gospels
240 × 160 mm., ff. 100, 2 cols., 34 lines
Second quarter of the 12th century
Saint-Vanne, Verdun *Ills. 346, 347, 348, 349*

Full-page Evangelist portraits: Matthew (f. 1v); Mark (f. 28v); Luke (f. 45v); John (f. 74v).

Ornamental initials: Matthew, L (f. 2); Mark, I (f. 29); Luke, Q (f. 46); John, I (f. 74v).

This Gospel Book is a work of comparatively small dimensions, and, as F. Ronig has noted, one whose sobriety departs from the customary presentation of the great luxury codices of the four Gospels of the Carolingian and Ottonian periods. There are no

Canon Tables or summaries, and the prefatory matter is restricted to the usual *argumenta*. A directory of readings for the liturgical year (*Capitulare evangeliorum*) follows the text of the Gospels (ff. 96v–99v). In keeping with this functional orientation, the text is rather exceptionally laid out in two columns, and written in a small, though well disciplined minuscule hand, with one-line red capital letters marking the inception of the chapters and small red accents on the first letters of the verses. The *argumenta* have four-line penwork initials in green, with red and yellow dotted ornamentation. The larger painted initials at the beginning of the four Gospels are based on Franco-Saxon models, not otherwise in evidence in the Romanesque illumination of Verdun, interpreted in a fairly faithful spirit. The adjoining *incipit* words take the form of capital letters reinforced with patches of red, green and ochre. The Evangelist portraits belong to the type known as 'inspired', the sacred authors being shown as they pause in their work to receive the divine word. Matthew, Mark and Luke are more or less frontal figures displaying books and dipping their quills in an inkwell. John, on the other hand, is shown in an active, profile position, looking upwards and gesturing at his symbol. The figures sit in spaces framed by squat columns with assertive bases and capitals, while the Evangelist symbols appear in keyhole-shaped (f. 1v), trefoil (f. 74v) or round-arched lunettes above them. There is some inconsistency in the design and execution of these portraits. That of Mark is smaller than the others as a result of the spill-over of six lines of text above the miniature. The symbols of Mark, the lion, and that of Luke, the calf, could not be fitted into the available space and have their hind legs cut off, while the eagle of John seems much too large, especially in relation to Matthew's diminutive angel. The miniatures are executed in a technique combining drawing with variously coloured inks and painting in a vivid though lightly-toned range of colours, chiefly shades of red, acid green, light blue, purple, and a wash-like yellow. Some *pentimenti* are visible in the portrait of Matthew, and parts of the painting, like the eagle of St. John, seem to have been left unfinished.

The artist responsible for these paintings can also be recognized in the striking Job miniature of another Saint-Vanne manuscript containing a miscellany of biblical and patristic writings (Verdun, Bibl. Mun. MS 62), while the related illumination of a Commentary on the Apocalypse (Verdun MS 66) is perhaps the work of a follower, as suggested by Ronig. The group can only be dated hypothetically, most plausibly in the third or fourth decade of the twelfth century.

PROVENANCE: Saint-Vanne, MS 7, 18th-century *ex libris* (f. 1).

LITERATURE: H. Michelant, *Catalogue général*, Quarto Series, V, 1879, 453; F. Ronig, 'Die Buchmalerei des 11. und 12. Jahrhunderts in Verdun', *Aachener Kunstblätter*, XXXVIII, 1968–9, 20, 80–96, 139; Avril, *Temps des croisades*, 204–5; F. Ronig, 'Zur romanischen Buchmalerei in Verdun und ihrer Stellung zwischen Rhein und Maas', *Rhein und Maas*, Cologne, 1973, II, 337, 339; id., 'Die Buchmalerei des 11. und 12. Jahrhunderts zu Verdun und ihre Beziehungen zur Trierischen Kunst', *Kurtrierisches Jahrbuch*, XII, 1972, 10-11.

EXHIBITED: *Manuscrits à peintures*, Paris, 1954, 93–4, No. 268.

143. Berlin, Staatliche Museen Preussischer Kulturbesitz, Kupferstichkabinett, MS 78 A 4

Sigebert of Gembloux and others,
Passion of St. Lucy
220 × 150 mm., ff. 68, 20 long lines
c. 1130. Saint-Vincent, Metz
Ills. 350, 351, 352, 353; Col. pl. XII

Full-page miniatures: St. Lucy and her mother visit the tomb of St. Agatha in Catania (f. 1); Lucy dreams that she is to be consecrated to the Lord; she informs her mother about the dream (f. 1v); Lucy converses with her mother; she gives alms to the poor and sick (f. 2); The nurse converses with the Lucy's bridegroom; the groom complains about Lucy to King Paschasius (f. 2v); Lucy in disputation with the king (f. 3); five Wise Virgins receive the Heavenly Bridegroom (f. 18); the Foolish Virgins are rejected by the Heavenly Bridegroom (f. 18v); Frater Rodulfus kneels and presents his book (f. 19); Lucy framed by an arch (f. 61); a team of oxen is yoked in order to remove Lucy to a bordello (f. 66); King Paschasius orders Lucy to be tortured; two men pour boiling oil over her (f. 66v); Lucy is struck by the executioner's sword; King Paschasius is led away in chains (f. 67); Lucy receives communion from a priest, accompanied by a deacon (f. 67).

Ornamental initials: C (f. 3v); I (f. 9); S (f. 19v).

The monastery of Saint-Vincent at Metz was founded by Bishop Thierry in 970 and established by him on an island in the Moselle River near the city. Thierry endowed it with a rich collection of relics, among them the bones of a 4th-century virgin martyr, St. Lucy of Syracuse, obtained by him at Corfinium in southern Italy, where they had been taken by the Lombard Duke Faroald in the first quarter of the 8th century. In the years from 1060–70, Sigebert of Gembloux, then established at Saint-Vincent, was asked by the brethren to write a life of the saint. The result, a poem of 370 strophes in 'Alchaic' verses, is included in the present manuscript (ff. 19–56; *B.H.L.* 4995), along with several other prose compositions

concerning the life of St. Lucy (ff. 3v–9, *B.H.L.* 4992; ff. 9–17v; *B.H.L.* 4999, and 56v–60), a hymn in her honour (ff. 61v–62) and two additional pieces with musical notation also dedicated to her (ff. 62v–65, 65v). The manuscript was perhaps written or illuminated by the kneeling monk identified as Frater Rodulfus shown tendering a book in a miniature placed at the beginning of Sigebert's poem (f. 19).

The manuscript is a handsome production, with an artful orchestration of image and text. The volume opens with five consecutive pages of scenes from the life of St. Lucy essentially focusing on the discovery of her vocation and consequent rejection of worldly entanglements. A second set of five pages with illustrations, placed in symmetry at the end of the codex, portrays the saint's passion. The remaining miniatures interspersed within the body of the work present images of a more neutral character, outside the sequence of the narrative. The depiction of the Sponsus with the Wise and Foolish Virgins (ff. 18, 18v) makes reference to Lucy's commitment to the Heavenly Bridegroom, and an icon-like portrait of the heroine framed by an arch prefaces the hymn section (f. 61). The illustrations, usually combining two separate incidents on a page, are drawn with the pen by an appealingly awkward, though expert hand. The drawing is shaded in tints of yellow, light green, red and mauve colour, with an opaque dark blue used more sparingly for haloes, details of furniture and borders. The principals in the action are often identified by inscriptions and the words spoken by them displayed on scrolls which they wield. The style of these illustrations may be compared to the drawings of the life of St. Martin from Saint-Martin at Metz, now at Épinal (Bibl. Mun. MS 73; no.144).

PROVENANCE: Saint-Vincent at Metz. J.-B. Maugérard, Koblenz, 1762 (f. 1). Josef Gregor Lang, parish priest of Neuendorf, early 19th century (bookplate and note on f. 68). MS 82, 19th century.

LITERATURE: E. Dümmler, 'Sigeberts von Gembloux Passio Sanctae Luciae Virginis und Passio Sanctorum Thebeorum', *Abhandlungen der königlichen Akademie der Wissenschaften zu Berlin*, Phil.-Hist. Klasse, 1, 1893, 20, 23–43; P. Wescher, *Beschreibendes Verzeichnis der Miniaturen—Handschriften und Einzelblätter—des Kupferstichkabinetts der Staatlichen Museen Berlin*, Leipzig, 1931, 8–10; W. Milde, 'Jean-Baptiste Maugérard et le manuscrit en l'honneur de sainte Lucie de Sigebert de Gembloux', *Histoire sociale, sensibilités collectives et mentalités. Mélanges Robert Mandrou*, Paris, 1985, 469–80; C. Hahn, 'Icon and Narrative in the Life of the Saints: The Berlin Life of St. Lucy', *The Sacred Image East and West*, ed. R. Ousterhout and L. Brubaker (Illinois Byzantine Studies, IV), Urbana and Chicago, 1994, 72–90.

EXHIBITED: *Zimelien*, Berlin, 1975, 95–6, No. 79; *Écriture et enluminure en Lorraine au moyen âge*, Nancy, 1984, 174–5, No. 118b.

144. Épinal, Bibliothèque Municipale, MS 73

Collection of texts relating to St. Martin
270 × 155 mm., ff. 44, 1 col., 30 lines
Middle of the 12th century
Saint-Martin, Metz (?) *Ills. 354, 355*

Half-page miniature of Richer writing his life of St. Martin with the help of Sulpicius's text, displayed before him by its author (f. 1); full-page miniature of St. Martin resuscitating three dead men and (below) healing a leper and two men possessed by demons (f. 5v).

Large ornamental initials: O (f. 6); E (f. 9); V (f. 30).

The life of St. Martin in verse contained in the present volume (ff. 1–29), a paraphrase of the celebrated 5th-century biography of Sulpicius Severus, was written by Richer, Abbot of Saint-Martin and Saint-Symphorien at Metz (*B.H.L.* 5634). Through a versified preface (ff. 4–5) the work is addressed to Bishop Stephen of Metz (1121–63). The author is mentioned as a witness to a charter dated 1135 and is known to have died before 1152. Richer's *Vita* is followed by a hymn and other liturgical pieces in honour of St. Martin (ff. 29v–44). The text seems to be the work of at least two scribes, the first responsible for Richer's *Vita* and two other pieces (ff. 1–36), the second for the rest (ff. 36v–44). Major titles are in capital letters with words or lines alternately in red, blue or ochre. Chapter titles are in smaller red capitals, and opening words are introduced by pen-work initials in red, summarily flourished with green and blue from f. 22 onwards.

The manuscript is not dated, but the style of the decoration suggests that it was written and illuminated in the author's own lifetime or not long thereafter. The two illuminations are drawings executed in brown ink, with some added touches of ochre for the borders, haloes, *clavi*, and furniture details. The first one precedes Richer's preface and shows the author at work, armed with the scribe's tools, and receiving guidance from Sulpicius Severus, who stands before him with an open book. A younger cleric with a crozier, who stands behind Richer, witnesses the action. The second drawing is inserted before the prologue of seventy-five Leonine distichs. It depicts in a conflated form several of Martin's more sensational miracles. In the upper panel, the saint raises three figures from their tombs, a scene which must refer to several acts of resuscitation attributed by Sulpicius to the saint (*Vita Martini*, Ch. VII and VIII). In the scene below, Martin kisses a leper and drives out a demon who had taken possession of a man through his bowels (*Vita Martini*, Ch.

XVII). The three large ornamental initials, placed at the head of the Prologue, *Vita* and *Obitus* of St. Martin respectively, are drawn in outline, with washes of yellow and ochre, along with more solid areas of dark brown, blue and olive green in the interstices of the letter and framing panel. The design consists of splayed shafts, with broad-gauged rinceaux inhabited by naked men, quadrupeds and birds. It is distinctly reminiscent of the manuscripts of Echternach produced in the wake of the Bible of Regimbertus (11th century) in the National Library of Luxembourg (MS 264).

This Echternach connection has another and more complicated dimension through the existence of a second copy of Richer's poem made for that house (Trier, Stadtbibl. Cod. 1378/103). The Echternach copy has illustrations which in part duplicate those of the Épinal manuscript. The depiction of Richer composing his work with the help of Sulpicius Severus's biography displayed to him by its author occurs there in nearly identical form, as does the illustration of St. Martin healing the leper and demon-possessed man, though not the scene of resuscitation combined with it in the volume from Metz. On the other hand, the Echternach manuscript presents a full-page miniature with scenes of the Charity of St. Martin and Christ appearing to the saint in a dream to acknowledge the gift of the cloak, subjects that are not found here. H. Swarzenski, whose opinion is reported by J. Porcher, thought that the Épinal manuscript was copied from the Echternach codex, but this view has been rejected by R. Kroos, who regards the Épinal work as the more authoritative formulation. A comparison of the compositions which are common to both manuscripts speaks in favour of this thesis, as does the observation of M. Manitius, who, knowing only the Echternach text, concluded that it could not be the autograph version because of its many errors (*Geschichte der lateinischen Literatur des Mittelalter*, Munich, 1911, III, 836). It cannot be altogether ruled out, however, that the two manuscripts might depend on a common and more fully illustrated archetype.

PROVENANCE: Benedictine Priory of Saint-Pierre de Châtenoy, 17th century (f. 1). Moyenmoutier, before 1739 (B. de Montfaucon, *Bibliotheca bibliothecarum*, II, 1180, No. 24).

LITERATURE: Dom A. Calmet, *Bibliothèque lorraine ou histoire des hommes illustrés qui ont fleuri en Lorraine…*, Nancy, 1751, 820–21; H. Michelant, *Catalogue général*, Quarto Series, III, 1861, 429–30; H. Lepage, 'L'abbaye de Saint-Martin-devant-Metz', *Mémoires de la Société d'archéologie lorraine*, 3e Ser. VI, 1878, 191–5; Porcher, *French Miniatures*, 23–4; M. Bernhard, 'Neues zu Leben und Werk des Richer von Metz', *Mittelateinisches Jahrbuch*, XIX, 1984, 155-61.

EXHIBITED: *Manuscrits à peintures*, Paris, 1954, 94, No. 271; *Die Zeit der Staufer*, Stuttgart, 1977, I, 570–80, No. 750; *Écriture et enluminure en Lorraine au moyen âge*, Nancy, 1984, 177–9, No. 120; *Ornamenta Ecclesiae*, Cologne, 1985, I, 234, No. B33.

145. Munich, Bayerische Staatsbibliothek Clm. 28565

Annals of Metz and Saints' Lives
305 × 235 mm., ff. 112, 31 long lines (ff. 38v–43, 53v–65, 71v–72v, 106–112v, 2 cols.)
Middle or third quarter of the 12th century
Saint-Vincent, Metz *Ills. 356, 357, 358, 359*

Full-page illustrations: standing male figure with floral attribute; standing female saint in an architectural prospect (f. 1v); three haloed female figures in architectural prospect (f. 2); seated ruler with globe extending his sceptre to a standing man (f. 2v); investiture of a haloed cleric, who receives a pastoral staff from a seated ruler (f. 3); seated ruler with sceptre and globe (f. 3v); seated ruler on a faldstool, with sceptre and globe (f. 4); kneeling cleric presenting a church, medallions with half-length saints and clerics (f. 4v); Christ in Majesty in a mandorla holding the globe of the world (f. 5); haloed seated cleric, inscribed *Benedictus papa*, dictating to a scribe (f. 5v); haloed seated cleric, inscribed *Iohannes papa*, dictating to a scribe (f. 6); two standing clerics with pastoral staffs, inscribed *Bruno archiepiscopus* and *S. Heribertus archiepiscopus* (f. 6v); two standing clerics with pastoral staffs, inscribed *S. Henricus* and *S. Egbertus archiepiscopus* (f. 7); two standing clerics with pastoral staffs, inscribed *S. Wuillelmus* and *S. Willigisus archiepiscopus* (f. 7v); two standing clerics with pastoral staffs, inscribed *S. Udalricus* and *S. No(t)kerus leode(nsis)* (f. 8); two standing clerics in dialogue, one (left) framed by a turreted gate, the other inscribed *S. Gerardus archiepiscopus* (f. 8v); three standing lay figures in an architectural prospect (f. 9); seated ruler with a petitioner grasping his sceptre (f. 9v); seated ruler with a petitioner grasping his sceptre, armed guard (f. 10); two standing crowned men flanking a crowned woman (f. 10v); two standing saints, one with a palm, the other with a book, inscribed *Divus Vincentius* and *Divus Valerius* (f. 11); two standing male saints with palms, one (left) inscribed *Divus Laurentius* (f. 11v); two standing bishop saints (f. 12v); two standing bishop saints (f. 13); three standing clerical saints with books in dialogue (f. 13v); three standing haloed laymen in dialogue (f. 14); three standing haloed laymen in dialogue (f. 14v); a bishop or clerical saint flanked by two haloed men (f. 15); two male saints flank a haloed woman bearing a palm (f. 15v); three female saints, two of them inscribed *Sancta Lucia* (centre) and *Sancta Odilia* (right) (f. 16); St. Felicianus received by St. Eleutherius (f. 73); Peter, John the Bap-

tist (?) and Paul in an architectural prospect (f. 96); six standing male figures in dialogue (f. 96v); six standing male figures in dialogue (f. 97).

Historiated and ornamental initials: R (f. 25v); S (f. 33v); C (f. 51v); S (f. 53v); F (f. 73v); S (f. 77v); E (f. 91); S (f. 92v).

Smaller initials in the same style: B (f. 38v); I (f. 43); C (f. 44); O (f. 45v); D, bust of a cleric (f. 65v); D (f. 65v); D, bust of a ruler (f. 65v); I (f. 67); F (f. 67v); P (f. 68v); S (f. 70v); B (f. 71); C (f. 72); Q, C (f. 75); I (f. 79); T (f. 80v); F (f. 83v); I (f. 88); C (f. 91v); I (f. 92v); I (f. 97v); L (f. 98); I, standing St. Lucy with palm (f. 100); S (f. 101); A (f. 102v); D (f. 103v).

The text consists of the Annals of St. Vincent of Metz (*M.G.H., Script.* III, 155–60) from the birth of Christ to the year 1284 (ff. 16v–24), followed by an anthology of lives of the saints. The most extensively represented are the Eleven Thousand Virgins, St. Felicianus, St. Faith, and especially St. Vincent and St. Lucy; the material on St. Lucy includes some pieces with musical notation (ff. 97v–105v). The Annals were written more or less continuously, though a break may be detected in the entries for the year 1158 recording a flood of the Moselle, and 1161, concerning the dedication of an oratory of St. Lucy, whose relics were venerated at Saint-Vincent (cf. no. 143) as well as those which follow. The martyrdom of Thomas of Canterbury was clearly added in a space between the years 1169–70. A date around the middle of the 12th century or before 1158 would be consonant with the style of the illumination.

The subsections of the text are introduced by initials of Ottonian derivation, pen-drawn in red, with some touches of colour in the interstices of the design. The textual matter is preceded by a sequence of full-page pen drawings distributed over the rectos and versos of the first sixteen folios. Four more drawings are scattered in the body of the volume. The drawings seem to have been executed by several draughtsmen. The appearance of the first five (ff. 1v–3) was modified by a kind of summary over painting probably carried out a few decades or more later, and others have been altered through the strengthening of outlines (ff. 3v–4, 5) or a localized application of colour. Around 1500, some of the drawings received inscriptions providing the subjects with identifications, the added names designating two popes, important ecclesiastical figures of the early medieval German Empire like Archbishop Egbert of Trier, Heribert of Cologne, Willigis of Mainz, Notker of Liège and Gerard of Toul, along with several saints. Most of them, however, remain unidentified, and the original meaning and purpose of the sequence is as yet unexplained. But a certain pattern can be detected in the choice of subjects and their arrangement. Thus, two scenes of investiture, one involving a layman, and the other a cleric, appear on facing pages (ff. 2v–3), and another spread

juxtaposes two sacred authors, each dictating to a scribe (ff. 5v–6). A series of standing saints or lay personages in groups of two or three (ff. 10v–16) seems to have been designed as a coherent ensemble of different types, including martyrs with palms and clerics of various ranks of affiliation. All this might support the hypothesis that the drawings, or at least a basic core among them, did not initially constitute a cycle of prefatory illustrations for the present manuscript, but more likely, an illuminator's model book.

PROVENANCE: *Liber sancti Vincentii Mettensis*, inscription in the original hand (f. 33). At Saint-Vincent through 1755, as indicated by the last entry of the Annals, which concerns the Lisbon earthquake in that year (f. 25). Jean-Baptiste Maugérard. Acquired by the Ducal Library at Gotha around 1800 and later Gotha, Landesbibl. MS I. 61. Acquired by the Bayerische Staatsbibliothek in 1952.

LITERATURE: Dom. A. Calmet, *Bibliothèque Lorraine*, Nancy 1751, col. 893; F. Jacobs and F. A. Ukert, *Beiträge zur älteren Literatur oder Merkwürdigkeiten der Herzoglichen öffentlichen Bibliothek zu Gotha*, Leipzig, 1836, II, 140–44; G. H. Pertz, *Archiv der Gesellschaft für ältere deutsche Geschichtskunde*, VII, 1839, 413–14; *M. G. H., Script.*, III, 155–60; S. Hirsch, *De vita et scriptis Sigeberti monachi Gemblacensis*, Berlin, 1841, 226. E. Dümmler, 'Sigebert's von Gembloux Passio Luciae and Passio sanctorum Thebeorum', *Abhandlungen der königlichen Akademie der Wissenschaften zu Berlin*, Phil.-Hist. Klasse, 1893, I, 20f; L. Traube and R. Ehwald, *Jean-Baptiste Maugérard. Ein Beitrag zur Bibliotheksgeschichte* (Abhandlungen der kaiserl. Bayerisch Akademie der Wissenschaften, III. Klasse, 23 Bd., Abt. 2, Paleographische Forschungen, 3) Munich, 1904, 359; S. H. Steinberg and C. Steinberg-Von Pape, *Die Bildnisse geistlicher und weltlicher Fürsten und Herren*, Leipzig-Berlin, I, 1931, 38ff., 123; Munich, Bayerische Staatsbibliothek, *Erwerbungen aus drei Jahrzehnten, 1948–78*, Wiesbaden, 1978, 23–5, No. 4; F. Staab, 'Eine Metzer Miniatur des Heiligen Willigis aus dem 12. Jahrhundert', *1000 Jahre St. Stephan in Mainz. Festschrift*, ed. H. Hinkel (Quellen und Abhandlungen zur mittelrheinischen Kirchengeschichte, 63), Mainz, 1990, 33-45; D. Kudorfer, *Katalog der lateinischen Handschriften der Bayerischen Staatsbibliothek München, Clm. 28461-28615* (Catalogus codicum manuscriptorum Bibliothecae Monacensis, IV, pt. 9), Wiesbaden, 1991, 174-78.

146. Strasbourg, Grand Séminaire
MS 37 (Ancien 78)

Calendar-Obituary, Homiliary, Rule of
St. Augustine, Commentary on the Rule, and
Constitutiones Marbacenses
(Codex Guta-Sintram)
355 × 270 mm., ff. 163, 31 long lines
(ff. 77–163, 2 cols.)
1154. Marbach-Schwarzenthann
Ills. 360, 361, 362

Major illustrations: confirmation of the privileges of
Marbach, with standing figures of Pope Calixtus II
and Provost Gerungo of Marbach displaying the
papal charter (f. 2); Guta and Sintram present their
work to the enthroned Virgin (f. 4); St. Augustine as
patron of the Order of Augustinian Canons, flanked
by a pair of men (left) and women (right) living
under his Rule (f. 5).

Decorative initials and illustrations of the Calendar:
January, KL monogram, sign of Capricorn (f. 7v);
under a triple arch, figure with staff presenting a dish,
seated figure tendering a scroll with medical precepts
to a man at the right (f. 8); March, KL monogram, sign
of Pisces illustrated by fisherman (f. 20v); labourer with
hoe, ecclesiastic displaying a scroll with medical pre-
cepts, gesticulating figure (f. 21); April, KL monogram,
sign of the Ram (f. 28); personification of April display-
ing a scroll with medical precepts; right and left, figures
with flowers (f. 29); May, KL monogram, sign of Taurus
(f. 36v); figure displaying medical precepts flanked by
a viol player and a woman with a peacock (f. 37); June,
KL monogram, sign of Gemini (f. 44v); July, KL mono-
gram, sign of Cancer (f. 52v); figure displaying scroll
with medical precepts, figure carrying bales of hay,
figure with an eye affliction (f. 61); September, KL
monogram, sign of Virgo (f. 68v); figure displaying
scroll with medical precepts, labourer harvesting fruit,
gesticulating figure (f. 69); October, KL monogram,
sign of Libra (f. 76v).

Major historiated and ornamental initials in the
Homiliary: T (f. 77); J (f. 77v); I, standing Holy
Woman; A, warrior, Samson carrying off the gates of
Gaza (f. 85v); H, Mary of Bethany (f. 100); M (f. 101);
F and S, Archangel Michael (f. 101v); P, gesticulating
man (f. 102); S (f. 106); H, standing St. Augustine (f.
110); N, Canon receiving a novice (f. 134v);

Lesser ornamental initials in the same style: ff. 78v,
80v, 97v, 98.

The volume contains several texts, now substantially
diminished by losses. The opening section (ff. 7v–
76v) is a Calendar and Obituary, lacking the months
of October (save for the opening page), November
and December, as well as two leaves from the earlier
months — 24 folios in all, according to an old pagi-
nation. This is followed by a Homiliary for the litur-
gical year (ff. 77–105), Rule of St. Augustine (ff. 106–

109v), the Commentary on the Rule attributed to
Hugh of Saint-Victor (ff. 110–133) and the Constitu-
tions of Marbach (ff. 133–163). This second section is
even more incomplete, having lost 54 folios. A series
of prefatory texts and images document the origin
and date of the manuscript with due clarity. The text
was written by Guta, a nun of Schwarzenthann, and
illuminated by Sintram, a Canon of the Augustinian
monastery of Marbach, near Egisheim in Alsace,
with which Schwarzenthann was associated. The
two collaborators finished their work in the year
1154. This information is set forth in the manner of a
charter (f. 4) preceded by a miniature showing Guta
and Sintram asking the Virgin Mary to look kindly
on them and their work. The names of both scribe
and illuminator, as well as of Sintram's mother Ade-
laide, are also inscribed in the Calendar-Obituary
which follows. Siegwart has suggested that a certain
Guta, mentioned at the head of a list of nuns of St.
Odilienburg found in Herrad of Landsberg's *Hortus
Deliciarum*, might be a reference to the Schwarzen-
thann nun at a later stage of her career. Beyond the
three prefatory miniatures, Sintram provided a dis-
tinctive framework for the Calendar-Obituary, and
both decorative and historiated initials for the later
sections of the manuscript. The opening miniature
showing Pope Calixtus and the provost Gerungo
displaying the papal confirmation of the privileges
granted by Urban II and Pascal II to Marbach has
reminded J. Walter of the thematically related sets of
12th-century textile hangings with royal and impe-
rial protectors of the monastery of Marbach, known
from descriptions and still displayed in the church
towards the end of the Middle Ages (*Bulletin de la
Société pour la conservation des monuments historiques
d'Alsace*, IIe ser. 2, 1864, 49–54). The Calendar-Obitu-
ary is laid out as a series of turreted arcades. The
headings for the respective months have large and
ornate KL monograms and zodiacal signs on the
versos, while the facing rectos have three separate
subjects: a figure displaying a scroll with medical
and hygienic precepts appropriate for that month in
the middle, and flanking Labours of the Months,
personifications or gesticulating men representing
various afflictions. The decoration throughout is car-
ried out in a firm and emphatic outline, with flat
patches of colour used for the backgrounds, and
selectively for the garments and a variety of details
within the composition. A characteristic feature of
Sintram's style is to combine drawing in several
colours within a single figure or subject. Heads,
hands, feet and outer contours in general may thus
be executed in black, while other parts and internal
modelling are done in another colour. As G. Cames
has noted, Sintram's art has affinities with Swabian
illumination of the same period, particularly with
the Choir Book for Prime from Zwiefalten (Stuttgart,
Württemb. Landesbibl., Cod. Hist. fol. 415) and the
Passionary of Hirsau in the same library (Cod. Bibl.
fol. 56–58). Manuscripts from the region whose deco-

ration can be compared to the *Codex Guta-Sintram* are an Alsatian or Upper Rhenish copy of Gilbert de la Porrée's Commentary on Boethius' *De Trinitate* (Basel, Universitätsbibl. Cod. O.II.24) and the Augustinian Customary from St. Arbogast at Strasbourg (Archives Municipales, Cod. 1291).

PROVENANCE: Written by Guta, a nun of the Augustinian Priory of Schwarzenthann and illuminated by Sintram, a Canon of Marbach Abbey, in 1154 (presentation miniature and inscription, f. 4). At Marbach in the 15th century (inscription, f. 2) and probably until the secularization of the abbey in 1786. Strasbourg, Grand Séminaire.

LITERATURE: J. Walter, 'Les miniatures du Codex Guta-Sintram de Marbach-Schwarzenthann (1154)', *Archives alsaciennes de l'art*, IV, 1925, 1–40; S. H. Steinberg and C. Steinberg-Von Pape, *Die Bildnisse geistlicher und weltlicher Fürsten und Herren*, Leipzig-Berlin, 1931, 87; J. Walter, 'Das Regelbuch des Augustinerchorherrenstifts St. Arbogast bei Strasbourg', *Archiv für elsässische Kirchengeschichte*, XI, 1936, 412–14; P. Bachoffner, 'Un calendrier enluminé de 1154. Le Guta-Sintram de Strasbourg et sa place dans l'histoire du médicament', *Revue d'histoire de la pharmacie*, CLXXIX, 1963, 181–93; id., 'Note sur les préceptes d'hygiène enluminés du Codex Guta-Sintram (1154)', *Veröffentlichungen der Internationalen Gesellschaft für Geschichte der Pharmazie*, N.F. 26, 1965, 7–22; *Manuscrits datés*, V, 445; J. Siegwart, *Die Consuetudines des Augustinerchorherrenstiftes Marbach in Elsass* (Spicilegium Friburgense, 10), Freiburg, 1965, 88 and *passim*; G. Cames, 'Les grands ateliers d'enluminure religieuse en Alsace à l'époque romane', *Cahiers de l'art médiéval*, V, 1967, 5ff; *Colophons*, II, 257, No. 5653; G. Cames, 'Un nouveau fleuron de l'enluminure romane en Alsace: l'Évangélistaire de Saint-Pierre, perg. 7 à Karlsruhe', *Cahiers alsaciens d'archéologie, d'art et d'histoire*, XV, 1971, 43, 52–4; H. Reinhardt, 'Eine Handschrift des 12. Jahrhunderts in der Basler Universitätsbibliothek, die Buchmalerei des elsässischen Klosters Marbach und eine Scheibe aus dem Strassburger Münster', *Basler Zeitschrift für Geschichte und Altertumskunde*, LXXVII, 1977, 5–21; G. Cames, 'Un joyau d'enluminure alsacienne: le Codex Guta-Sintram (1154) à Strasbourg', *Bulletin de la Société Nationale des Antiquaires de France*, 1978–79, 255–61; B. Weis, 'Die Nekrologien von Schwarzenthann und Marbach in Elsass', *Zeitschrift für die Geschichte des Oberrheins*, CXXVIII, 1980, 51–68; J.-L. Lemaître, *Répertoire des documents nécrologiques français*, Paris, 1980, II, 970–71, No. 2295; B. Weis et al., *Le Codex Guta-Sintram, manuscrit 37 de la Bibliothèque du Grand Séminaire de Strasbourg*, Lucerne and Strasbourg, 1983 [facsimile and commentary]; O. G. Oexle, 'Memoria und Memorialbild', *Memoria. Die geschichtliche Zeugniswert des liturgischen Gedenkens im Mittelalter*, ed. K. Schmid and J. Wollasch (Münstersche Mittelalter-Schriften, 48), 1984, 397; G. Cames,

L'enluminure et le livre médiéval en Alsace, VIIe-XVIe siècle, 53; id., *Dix siècles d'enluminure en Alsace*, n.p., 1989, 182; J. Hamburger, 'A "Liber Precum" in Sélestat and the Development of the Illustrated Prayer Book in Germany', *Art Bulletin*, LXXIII, 1991, 212.

EXHIBITED: *Manuscrits à peintures*, Paris, 1954, 95, No. 174; *Die Zeit der Staufer*, Stuttgart, 1977, I, 541–42, No. 721; *Ornamenta Ecclesiae*, Cologne, 1985, I, 245, No. B 44; *La Mémoire des siècles*, Strasbourg, 1988, 209, No. 11.

147. Reims, Bibliothèque Municipale MS 672

Liber Pontificalis (ff. 2–8v) and
Pseudo-Isidore, *Collectio Canonum* (ff. 9–224)
with 12th century additions (ff. 224v–226).
527 × 377 mm., ff. 226, 2 cols., 60 lines
1152–59 (with added drawing, *c*. 1170–80).
Lorraine (?) *Ill. 374*

The first section of the manuscript consisting of excerpts from the *Liber Pontificalis* has only simple two-line red and blue decorative letters. In the Pseudo-Isidore's Decretals which follow, on the other hand, there are fine ornamental initials drawn in red outline, with ochre, green, orange red and light blue filling, becoming somewhat simpler in their design and coloration after the first few folios and ceasing altogether after f. 121v. The rest of the volume has only large flourished red and blue letters. The attractive, exclusively foliate initials in the Pseudo-Isidore have a distinctly Mosan flavour. F. Ronig has observed that they are close to the initials of a Homiliary from Saint-Vanne in Verdun (Verdun, Bibl. Mun. MS 121). The date of the manuscripts can be established on the basis of several historical data. The decrees of the Councils of Reims (1131), Sens (1140), Reims (1148) follow the Pseudo-Isidore (ff. 224v–26). A list of popes (f. 8) goes to Hadrian IV (d. 1159) in the original hand, while Frederick Barbarossa (1152f.) is the last name in the adjoining list of emperors.

On the art-historical side, the manuscript is best known for the beautiful pen drawing of Aer with the Winds, along with Arion, Orpheus, Pythagoras and the nine Muses, which acts as its frontispiece. The drawing was pasted into the volume before the end of the 16th century when the work was given to the Cathedral of Reims, but it has evidently nothing to do with its contents and must have been made for another purpose, probably for an encyclopaedic or mythographic compilation. The impressive figure of Aer stands with legs outspread and in heroic near-nudity, displaying the winged heads of the four principal winds which simultaneously mark the four corners of the cosmos. In the inner circle encompassed by the body of Aer, Arion and Orpheus have stringed instruments, while Pythagoras wields a pair of scales and a hammer. Six of the nine personi-

fied Muses in the outer circle are also characterized as musicians. The composition in its larger sense draws its inspiration from the Platonic cosmological doctrine of the Harmony of the Spheres. The drawing is unfinished, the foliate rinceaux in the spaces around the roundels with the Muses having been completed only on the left side of the design. The surface is also somewhat eroded and some fine details of the musculature on the right side of Aer's body and the figure of Orpheus are now very faint. The style of the drawing is most closely approximated by the drawn initials of the Gregory *Moralia* from Saint-Bertin (Saint-Omer, Bibl. Mun. MS 12; no. 115) and the enamels of Nicholas of Verdun's Klosterneuburg Altar of 1181, to which the work has recently been connected. It must be two decades or so later than the manuscript in which it is now inserted, and is best placed within the 1170s or early 1180s.

PROVENANCE: *Jacobus Fromaeus loci de Bisseyo 1586* (ff. 112 and 116v). Given to Reims Cathedral by Canon François Josseteau, 17th century (ff. 1v, 41v, 123v–124) and MS B. 60 in the cathedral library (*Ex libris*, 18th century, ff. 2, 226).

LITERATURE: A.-N. Didron, 'La musique au Moyen Age', *Annales archéologiques*, I, 1844, 54–62; H. Loriquet, *Catalogue général*, XXXIX, 1904, 12–24; M. Tangl, 'Studien zur Neuausgabe der Bonifatius-Briefe. I', *Neues Archiv der Gesellschaft für ältere deutsche Geschichtskunde*, XL, 1916, 790; R. van Marle, *Iconographie de l'art profane, allégories et symboles*, The Hague, 1932, II, 277 and 295ff.; O. Schmitt, 'Zur Deutung der Gewölbefigur am ehemaligen Westlettner des Mainzer Domes', *Festschrift für Heinrich Schrohe*, Mainz, 1934, 72; J. Baltrušaitis, *Cosmographie chrétienne dans l'art du moyen âge*, Paris, 1939, 25; C. de Tolnay, 'The Music of the Universe. Notes on a Painting by Bicci di Lorenzo', *Journal of the Walters Art Gallery*, VI, 1943, 86, 89; E. Beer, *Die Rose der Kathedrale von Lausanne und der kosmologische Bilderkreis des Mittelalters*, Bern, 1952, 41; Swarzenski, *Monuments of Romanesque Art*, 80, No. 210; H. von Einem, *Der Mainzer Kopf mit der Binde* (Arbeitsgemeinschaft für Forschung des Landes Nordrhein-Westfalen, Heft 37), Köln-Opladen, 1955, 26–7; F. Ronig, 'Die Buchmalerei des 11. und 12. Jahrhunderts in Verdun', *Aachener Kunstblätter*, XXXVIII, 1968–69, 129, 132, 138; J. Smits van Waesberghe, *Musikerziehung. Lehre und Theorie der Musik im Mittelalter*, Leipzig, 1969, 154–5; M. W. Evans, *Medieval Drawings*, London, New York, Sydney and Toronto, 1969, 33 and pl. 80; S. Williams, *Codices Pseudo-Isidoriani. A Paleographical-Historical Study* (Monumenta Iuris Canonici, Series C: Subsidia, 3), New York, 1971, 55, No. 55: T. Seebass, *Musikdarstellung und Psalterillustration im früheren Mittelalter*, Bern, 1973, 49, 94ff.; M. H. Caviness, 'Images of Divine Order and the Third Mode of Seeing', *Gesta*, XXII/2, 1983, 109.

EXHIBITED: *Les plus beaux manuscrits de la Bibliothèque de Reims*, Reims, 1967, 20–21, No. 15; *Trésors de la Bibliothèque Municipale de Reims*, Reims, 1978, No. 26.

148. Vatican, Biblioteca Apostolica MS Pal. Lat 497

Epistolary
250 × 185 mm., ff. 111, 27 long lines
Middle of the 12th century (?)
Notre-Dame, Lixheim (Lorraine)

Ills. 363, 364

Illustrations of varying sizes: Annunciation with a kneeling monk at the foot of the Virgin's throne (f. 1v); Nativity and Annunciation to the Shepherds (f. 2v); Adoration of the Magi (f. 4v); Baptism (f. 5); Entry into Jerusalem (f. 31); Last Supper and Christ in the Garden of Gethsemane (f. 33); Resurrection (f. 37); Descent into Limbo and Three Maries at the Sepulchre (f. 37v); Ascension and Adoration of Christ by horn-blowing angels (f. 45); Annunciation and Visitation (f. 55); Martyrdom of St. Vitalis (f. 56v); Annunciation to Zacharias, Nativity of the Baptist and Naming of John (f. 58v); Crucifixion of Peter and Decapitation of Paul (f. 60v); Dormition of the Virgin and Assumption into Heaven (f. 63); Coronation of the Virgin (f. 66v); priest celebrating Mass; Christ and the Apostles with Zaccheus (f. 102v).

Historiated and ornamental initials: H, P (f. 1); M (f. 3); S (f. 5); H (f. 31v); I (f. 32); C (f. 32v); S, E (f. 36); I, bishop saint (f. 38); P (f. 45v); I, Sacrifice of Isaac (f. 47); D (f. 49v); I, standing Peter (f. 50); H (f. 53v); L (f. 55); I (f. 56); A (f. 59); I, half-length Peter (f. 60v); D (f. 63v); I, standing Virgin (f. 63v); E (f. 67); V (f. 102).

This copiously illustrated manuscript conveys the general effect of an Ottonian luxury Evangeliary or Gospel Lectionary, though transmuted into a simplified and faintly provincial *Reduktionstil*. The work was probably made for the kneeling priest who appears at the foot of the Virgin's throne in the scene of the Annunciation which acts as the frontispiece. The volume comes from Notre Dame at Lixheim (also occasionally written Luxheim), a Benedictine community founded by Count Volmar II of Metz in 1087 near Sarrebourg (Moselle). The first of a number of historical notes transcribed in a late medieval hand at the end of the work (f. 111) records Volmar's death in 1111. The monastery, which had been a dependency of St. George in the Black Forest, was ruined during the 15th century and later suppressed by papal decree (H. Kuhn, 'L'ancienne abbaye de Notre-Dame de Lixheim', *Mémoires de la Société d'Archéologie Lorraine*, X, 1868, 89–126). The manuscript has miniatures preceding the readings of the major feasts, some of them occupying an entire page, others of a smaller format, the larger paintings being horizontally subdivided into two or even three sepa-

rate scenes. As could be expected, the subjects conform for the most part to the Christological cycles of Ottonian and Salian book illumination. The full-page sequence of the Annunciation, Nativity and Naming of John the Baptist (f. 58v) is among the more unusual of these illustrations, and the Coronation of the Virgin (f. 66v) represents an iconographic invention then of recent vintage. The black bird in the hand of Judas in the scene of the Last Supper (f. 33) is an arresting detail, and beyond the expected attention to the feasts of St. Peter and St. Paul (f. 60v), there is a miniature devoted to the martyrdom of St. Vitalis, whose body is broken on a wheel (f. 56v). The *Dedicatio Ecclesiae* features a priest celebrating Mass before a group of six men and a woman, a scene combined with a depiction of Christ with his disciples and Zaccheus in the sycamore tree (Lk. 19:1–10). These miniatures are executed in a sketch-like and primarily linear technique, with some parts of the costumes and backgrounds rendered in a limited range of flatly-laid panels of colour — chiefly green, powder blue, red, and mauve — and finer details added in dark brown ink. There are large initials of varying quality and degrees of finish throughout the text, several incorporating portraits of saints, as well as numerous smaller ornamental letters. The major initials, drawn in a thin black outline and backed by bright patches of red, light blue and dark green, feature a broad range of ornament, with a kind of sluggish foliate scrollwork predominating in which an occasional crouching figure, *atlante*, grotesque mask or zoomorph may appear.

PROVENANCE: Notre-Dame de Lixheim, diocese of Metz (Annals from 1440 to 1503 and other historical notes concerning the monastery, ff. 111–111v). Palatine Library, Heidelberg, 1550. Pope Gregory XV, 1623 (bookplate).

LITERATURE: J. M. Tommasi, *Antiqui libri missarum Romanae Ecclesiae*, in *Opera omnia*, ed. A. F. Vezzosi, Rome, 1750, V, 320–423 [*siglum* P]; H. Stevenson and G. B. de Rossi, *Codices Palatini Bibliothecae Vaticanae*, Rome, 1886, I, 167; H. Ehrensberger, *Libri liturgici Bibliothecae Apostolicae Vaticanae*, Freiburg im Breisgau, 1897, 427–8; W. H. Frere, *Studies in Early Roman Liturgy*. III. *The Roman Epistle-Lectionary* (Alcuin Club Collections, 32), Oxford-London, 1935, 69; A. Chavasse, 'Les plus anciens types du lectionnaire de l'antiphonaire romain de la messe', *Revue bénédictine*, LXII, 1952, 10; P. Salmon, *Les Manuscrits liturgiques latins de la Bibliothèque Vaticane* (Studi e Testi, 253), II, 1969, 53–4, No. 101.

EXHIBITED: *XV Centenario della Nascità di S. Benedetto, 480–1980*, Città del Vaticano, 1980, 15, No. 23.

149. London, Private Collection

Bible (Justemont Bible)
534 × 360 mm., ff. 168 and 196 (continuously foliated), 2 cols., 33–46 lines
Second half of the 12th century.
Sainte-Marie, Justemont *Ills. 366, 367*

Vol. I

PREFACE TO JEREMIAH, I, standing prophet with scroll (f. 18v); Jeremiah, V (f. 19); JER. 51: 1, H (f. 43); JER. 52:1, F (f. 46); BARUCH, E (f. 46v); BARUCH 3:9, A (f. 48); BARUCH 4:12, N (f. 48v); BARUCH 5:1, E (f. 49); BARUCH 6:1, (f. 49); LAMENTATIONS, E (f. 50); LAMENTATIONS 5:1, R (f. 52v); PREFACE TO HABAKKUK, Q (f. 83); PREFACES TO JOB, C and S (ff. 84v, 85); JOB, V (f. 86); ESTHER, I (f. 91); PREFACE TO PSALMS, I (104v, cut out); PSALMS, B, David harping, Jerome writing (f. 105v); Psalm 26, D (f. 109); Psalm 80, L (f. 112v); Psalm 97, C, David playing a viol (f. 114); Psalm 101, D, David in prayer, hand of God (f. 114); Psalm 109, D (Christ in Majesty seated on the globe of the world (f. 117); PREFACES TO PROVERBS, T, T and C (ff. 124, 124v); PROVERBS, P (f. 125v); ECCLESIASTES, V, bust of an angel (f. 136); SONG OF SONGS, O (f. 140v); WISDOM, D, seated king with sword and sceptre flanked by attendants (f. 143); PREFACE TO ECCLESIASTICUS, M (f. 151); ECCLESIASTICUS, O, seated king with scroll (f. 152).

Vol. II

DANIEL 13: 1, E (f. 177); II CHRONICLES 20:13, C, crowd of men (f. 198v); II CHRONICLES 34:1, O, bust of Josias (f. 200v); PREFACE TO EZRA, U (f. 202); EZRA, I (f. 203); PREFACES TO GOSPELS, E and S (f. 239, 239v); PREFACES TO MATTHEW, M and N (f. 239v); CANON TABLES (ff. 241–242v); MATTHEW, L, Sacrifice of Isaac (f. 243); PREFACE TO MARK, M (f. 258v); PREFACE TO LUKE, L (f. 266); LUKE, Q, Annunciation to Zacharias in the Temple (f. 266v); LUKE 22:1, A (f. 277v); JOHN 1:15, I, standing Baptist with the *Agnus Dei* (f. 280); PREFACES TO ACTS, I and A (ff. 292, 292v); LUKE, P, Ascension (f. 293); PREFACES TO CATHOLIC EPISTLES, I, N (f. 309v); JAMES, I (f. 310); PREFACE TO I PETER, D (f. 311v); I PETER, P (f. 312); PREFACE TO II PETER, S (f. 313v); II PETER, P (f. 314); I JOHN, (f. 315); PREFACE TO PAULINE EPISTLES, E (f. 316); N (f. 316v); P (f. 320v); PREFACE TO ROMANS, R (f. 321v); PREFACE TO I CORINTHIANS, C (f. 326); I CORINTHIANS, P, Paul addressing two Corinthians (f. 327); PREFACE TO II CORINTHIANS, P (f. 332v); II CORINTHIANS, P (f. 333); PREFACE TO GALATIANS, G (f. 337); GALATIANS, P (f. 337v); PREFACE TO EPHESIANS, E (f. 339v); EPHESIANS, P (f. 340); PREFACE TO PHILIPPIANS, P (f. 341v); PHILIPPIANS, P (f. 342); PREFACE TO COLOSSIANS, C (f. 343v); COLOSSIANS, P (f. 344); LAODICEANS, P (f. 345); PREFACE TO I THESSALONIANS, I (f. 345v); I THESSALONIANS, P, busts of Paul and two Thessalonians; PREFACE TO II THESSALONIANS, A (f. 347); II THESSALONIANS, P (f. 347); I, T (f. 348); I TIMOTHY, P (f. 348v); PREFACE TO II TIMOTHY,

I (f. 350); PREFACE TO TITUS, T (f. 351v); TITUS, P (f. 351v); PREFACE TO PHILEMON, P (f. 352); PHILEMON (f. 352v); PREFACE TO HEBREWS, I (f. 352v); HEBREWS, M (f. 353).

The Justemont Bible is a badly mutilated work whose remnants were consolidated by the binder, in places inaccurately. The manuscript was originally divided in a different manner. The now missing books of the Octateuch and I–IV Kings were bound with the Major and Minor Prophets of the existing first volume. The original second tome began with Job, which is only partially extant, and included the rest of the text. Exceptional in manuscripts of the entire Bible, the Gospels are preceded by a directory of readings throughout the year (*Capitulare evangeliorum* and for special occasions (ff. 234v–238v). The Pauline Epistles include among their prefatory apparatus the rare Canons of Priscillian with the prologues of Peregrinus (ff. 316v–319; see Berger, *Histoire de la Vulgate*, 26–8). At the end of the second volume are copies of two undated charters concerning St. Mary at Justemont, the first written in a hand nearly contemporaneous with the manuscript, the second possibly added somewhat later. The first document is an agreement involving an abbot named Philip, while the second concerns the Abbot M. Neither seems otherwise recorded (*G.C.*, XIII, 948–53). The Abbey of Justemont, located near Thionville in the diocese of Metz, was founded around 1132, soon thereafter becoming a dependency of the Premonstratensian house of Belval. No other books of the apparently fairly small community have thus far been identified, but a significant body of manuscripts from Belval survives in the Bibliothèque Municipale at Charleville.

The Justemont Bible was written by several scribes and illuminated by as many as four different hands, of which two are particularly distinctive. One, working in a Mosan-Rhenish style, contributed the arcading for the Canon Tables and numerous initials of a metallic, wholly ornamental design, constructed of spiralling foliate scrollwork drawn in red, with blue, green, and touches of yellow in the interstices (ff. 1–83, 239–58, 266, 277v, 292–93, 309v–353). The second, who with the exception of the standing Jeremiah (f. 18v), can be credited with the historiated initials and a number of the ornamental ones, makes use of body colour and gold. His thickly-outlined and densely painted compositions have stylistic parallels in Lotharingian and Middle Rhenish book illumination, as represented by the Worms and Arnstein Bibles (London, Brit. Lib. Harley 2803–4 and 2798–9) and the Bible of St. Simeon in Trier (Stadtbibl. Cod. 2/1675–76). The Jeremiah initial (f. 18v) is in a different, more Gothicizing spirit, and other initials were supplied by expert, secondary hands. The decoration of the work was planned on an exceptionally elaborate scale, and is in this respect consistent with the markedly lavish character of the Premonstraten-

sian Bibles of Floreffe, Parc and Arnstein, all more or less coeval. Thus, Jeremiah and Baruch have substantial initials at various points in the text, and the secondary decorative letters at the head of chapters are unusually varied and elaborate, especially in the Psalms and Wisdom Books, where they contain dragons, heads in profile and other embellishments normally reserved for the major emphases of the illumination.

PROVENANCE: Sainte-Marie, Justemont (documents concerning the abbey transcribed in Vol. II, f. 364v). Montgolfier, Annonay, near Lyon (19th century watermark on the flyleaves). Guglielmo Libri (Sotheby's Sale, 28 March 1859, Lot. 160). William Gott, Leeds (bookplate). John Gott, Bishop of Truro (1891–1906). *Bibliotheca Pretiosa*, Sotheran and Co., 1907, No. 290. C. W. Dyson Perrins (Sotheby's Sale, 29 November 1960, Lot 100). Anonymous Educational Trust (Sotheby's Sale, 11 July 1978, Lot 37).

LITERATURE: G. Warner, *Descriptive Catalogue of Illuminated Manuscripts in the Library of C. W. Dyson Perrins*, Oxford, 1920, 282–6, No. 119; H. Swarzenski, *Die lateinischen illuminierten Handschriften des 13. Jahrhunderts in den Ländern an Rhein, Main und Donau*, Berlin, 1936, 26; Cahn, *Romanesque Bible Illumination*, 254, No. 11.

EXHIBITED: *Romanesque Art*, Manchester, 1959, 26, No. 43.

150. Colmar, Bibliothèque Municipale MS 429

Missal
310 × 220 mm., ff. 183, 22 long lines
Late 12th century. Murbach *Ill. 365*

Crucifixion (f. 65v).

Ornamental initials: A (f. 8); P (f. 11v); R (f. 35); S (f. 40v); D (f. 43v); *Per omnia* and *Vere Dignum* (f. 65); T (f. 66); D (f. 98); D (f. 102); D (f. 104); D (f. 110v); O (f. 113); D (f. 116v); D (f. 124); F (f. 133); D (f. 136); O (f. 139v); D (f. 146).

Smaller initials in the same style: ff. 72, 73v, 74, 74v, 75, 75v, 76.

The Abbey of Murbach, situated in a mountainous wooded site south of Lautenbach (Haut-Rhin), was founded in the 8th century by the missionary bishop and first abbot of Reichenau, Pirmin. In Carolingian times its library was of some importance, but the present Missal is the only manuscript of real artistic interest from the Romanesque period thus far identified to have survived. The body of the text is preceded by a Calendar (ff. 5–7v) in which are singled out for special emphasis, beyond the major feasts of

the church year, the *Dedicatio ecclesiae* (6th February) and two commemorations for St. Leodegarius (Léger) — the anniversary (2nd October) and *Excaecatio* (Blinding) on 25th August. Murbach received the cranium and other relics of this martyred Merovingian bishop of Autun in the 9th century, and Léger became thereafter its major patron. The manuscript contains some later additions: a copy of a document regarding the discipline of the community issued by Abbot Henry of Schauenburg in 1354 (f. 2); a charter of Abbot Conrad Werner of Murnhard concerning a chapel and altar of St. Mary Magdalen, dated 1341 (f. 71); an act of confraternity between Murbach and the abbey of Luxeuil, dated 1234 (f. 175), and a copy of the customs of Murbach in German (ff. 180–82).

The Missal has good penwork flourished initials throughout the text, large painted initials with silver and gold for the Preface, the Canon of the Mass and the major feasts, as well as a number of smaller letters in the same style. These initials are placed in rectilinear frames, the body of the letter being entwined with spiralling tendrils of foliage terminating in curling, saw-toothed leaves. Their style is not otherwise attested in the region, and is arguably closer to certain examples of Middle Rhenish illumination like the Steinfeld Missal (The J. Paul Getty Museum, MS 83 MG.79) and related manuscripts. The Crucifixion miniature, though somewhat damaged by wear, is a work of high quality. The painting has a gold frame outlined by narrow red and blue bands. The composition is placed on a blue background edged in green. Mary wears a purple cloak draped over a blue mantle, John a red robe over a blue garment. Haloes, *clavi*, and a few other details are rendered in gold. Among the unusual aspects of the design are the personification of the Sun and Moon over the arms of the Cross, which take the form of disks with frontal male and female heads partly shrouded in grief. Christ's feet rest on a gold and jewelled panel, and more remarkably, the Virgin and St. John are depicted not so much as mourners, but glancing upward and reverently contemplating the figure of the crucified.

PROVENANCE: Murbach.

LITERATURE: *La Paléographie musicale*, Solesmes, III, 1892, pl. 126a; H. Pfannenschmidt, 'Verbrüderungsbrief zwischen den Klöstern Murbach und Luxeuil 1234', *Zeitschrift für die Geschichte des Oberrheines*, N.F., IX, 1894, 175–6; Leroquais, *Sacramentaires*, II, 71; C. Wittmer, 'La Crucifixion dans un Missel de Murbach du XIIIe siècle', *Annuaire de la Société historique et littéraire de Colmar*, VII, 1957, 11–12; G. Cames, 'Recherches sur les origines du crucifix à trois clous', *Cahiers archéologiques*, XVI, 1966, 192; id., 'Les grands ateliers d'enluminure à l'époque romane', *Cahiers de l'art médiéval*, V, fasc. 1, 1967, 13-14; id., *L'enluminure et le livre médiéval en Alsace, VIIIe-XVIe siècles*, 53; id.,

Dix siècles d'enluminure en Alsace, n.p., 1989, 181; P. Schmitt, *Catalogue général*, LVI, 1969, 102–3, No. 219.

EXHIBITED: *La Mémoire des siècles*, Strasbourg, 1988, 214, No. 22.

151. London, British Library
MS Add. 42497

Scenes of the Life of John the Baptist
863 × 190 mm.
Late 12th century. Hohenbourg (Alsace)
Ills. 370, 371, 372, 373

Recto: woman in an attitude of wonder (incomplete); Zacharias records the name of John in the presence of St. Elizabeth; John baptizes a Jew; meeting of Christ and John; Baptism of Christ.

Verso: John remonstrates with Herod; John is thrown into prison; two men hunting birds, possibly in preparation for Herod's feast; feast of Herod and dance of Salome.

The work is a parchment strip pieced together from two sections of skin of unequal length, painted on both sides. Vertical marks which divide the surface into panels measuring approximately 55 mm. in width indicate that the object was formerly folded. The painting is in the style of the illumination of the *Hortus Deliciarum*, the vast edifying encyclopaedia compiled by Abbess Herrad of Hohenbourg (d. 1195) in Alsace, which was lost in the fire of the Strasbourg Municipal Library in 1871. E. G. Millar initially conjectured that the strip actually formed a part of the *Hortus*, which is known to have contained some inserts of differing dimensions. J. Walter gave a different view and argued that it was an object made for private devotion, a kind of miniature polyptych which could be folded for greater convenience in travel. But the hypothesis put forward by R. Green after Walter had himself considered the idea but rejected it, that the strip is the remnant of a liturgical fan or *flabellum*, has the greater weight of probability. The strip is presently incomplete, and there is some uncertainty about its original dimensions. There remain four 'panels' in the shorter section of parchment and thirteen in the longer one. Green has surmised that for symbolic reasons, there were originally twenty-four, and the shorter piece therefore consisted of eleven such units, of which four are now extant. Such symbolic considerations, however, are unlikely to prove a reliable guide on this question. On the right side (recto), the work is substantially complete, since the corresponding left edge on the verso has a border of stylized foliage. But some parchment is missing on the left side (recto), where a woman in an attitude of prayer or wonder now stands, and at the end of the cycle on the corresponding right side (verso), where Herod's Feast

with the Dance of Salome appears. At least two additional scenes, and possibly three, should be restored at the beginning of the cycle, the Annunciation to Zacharias and the Birth of John the Baptist. On the verso at the end, the narrative probably concluded with the beheading of the Baptist and burial, or another scene. The strip in its entirety was thus probably 40 to 50 cm longer in its original state.

The scenes of the Life of the Baptist occupy the upper two-thirds of the strip, while the dado-like area below is filled with a frieze of lozenges, each housing a leafy rosette. In the narrow space above the scenes, a series of Latin hexameters bearing on the events depicted are inscribed (transcription by E. G. Millar, *British Museum Quarterly*, VI, 4, 1932, 108–9). The design of both ornamental and figurative components is drawn in a sturdy black outline. Flesh tones are rendered with a thin film of paint leaving some of the parchment exposed. Garments are done with an opaque application of colour, mainly red, green or blue, though with little internal modelling. The backgrounds are treated as an alternating sequence of gold and silver panels — the silver having turned black through oxydation. The edge of these panels by no means invariably coincides with the outline of the individual scenes or with clear breaks within them, though their effect is to impose a sense of forward motion on the reading of the whole. The scenes are sometimes divided by trees or little turrets with open doors, a device that is earlier much in evidence in the narrative compositions of 11th-century manuscripts from Echternach. Among the more unusual subjects included in the cycle is the puzzling scene on the verso, intercalated between the Imprisonment of John and Herod's Feast, and showing an archer aiming his bow at a bird in a tree, while a second figure points to the target and holds a dead bird in the other hand. The scene is interpreted in a moral and mystical sense by Walter and Cames, though such a reading seems unwarranted in view of the straightforwardly narrative character of the sequence as a whole. Three of the episodes also occur in the *Hortus Deliciarum* (Green et al., *Hortus Deliciarum*, II, 156–7, Nos. 119–22), though only two of the compositions in the *Hortus* are known to us on the basis of 19th-century copies made for Count Auguste de Bastard. The scene of John baptizing a Jew or disciple features the same group of catechumens dressed in hooded robes marked with the Cross and carrying candles on the left side of the composition, though the Baptism itself is carried out in a tub on the *flabellum* strip rather than in the River Jordan, as in the *Hortus*. The Baptism of Christ on the *flabellum* sequence, on the other hand, could be described as a simplified version of the grand composition in Herrad's encyclopaedia.

PROVENANCE: Professor Gottfried Schweighauser, Strasbourg. Christian-Maurice Engelhardt, Stras-

bourg, 19th century. Acquired by the British Museum in 1931 from a Private Collection in Paris.

LITERATURE: A. Straub and G. Keller, *Herrade de Landsberg. Hortus Deliciarum*, Strasbourg, 1879–99, pl. XXIVter and quater; Suppl. 2, 5; E. G. Millar, 'Miniatures of the Life of St. John the Baptist', *British Museum Quarterly*, VI, 1931, 1–3; id., 'The Inscription of the St. John the Baptist Roll', *British Museum Quarterly*, VI, 1931, 108–9; J. Walter, 'Aurait-on découvert des fragments de l'Hortus Deliciarum?', *Archives alsaciennes de l'art*, X, 1931, 1–8; H. Swarzenski, *Die lateinischen illuminierten Handschriften des XIII. Jahrhunderts in den Ländern an Rhein, Main und Donau*, Berlin, 1936, I, 45, nn. 3 and 49; R. Green, 'The Flabellum of Hohenburg', *Art Bulletin*, XXXIII, 1951, 153–5; Grabar and Nordenfalk, *Romanesque Painting*, 160; D. H. Turner, *Reproductions from Illuminated Manuscripts*, V, London, 1965, 7; J. C. Klamt, *Die Monumentalmalerei im Dom zu Braunschweig*, Diss. Berlin, 1968, 87ff.; Dodwell, *Painting in Europe*, 171; G. Cames, 'Les grands ateliers d'enluminure à l'époque romane', *Cahiers de l'art médiéval*, V, fasc. 1, 1967, 8-9; id., *L'enluminure et le livre en Alsace, VIIIe-XVIe siècles*, 55; 'La scène de chasse dans le Flabellum de Hohenbourg à Londres', *Cahiers alsaciens d'archéologie, d'art et d'histoire*, XV, 1971, 77–83; F. Mütherich, *Propyläen Kunstgeschichte*, VI 1972, 264–5, No. 258; R. Green et al., *Herrad of Hohenbourg, Hortus Deliciarum* (Studies of the Warburg Institute, 36), London and Leiden, 1979, I, *passim*; G. Cames, *Dix siècles d'enluminure en Alsace*, n.p., 1989, 182.

152. Laon, Bibliothèque Municipale MS 550

Evangeliary
270 × 175 mm., ff. 23, 23 long lines
Late 12th century
Alsace. Marbach-Schwarzenthann (?)
Ills. 368, 369

Historiated and ornamental initials or monograms: L, Matthew seated at a lectern (f. 1v); N, John seated at a lectern (f. 2v); I, the Lord speaks to St. Stephen (f. 3v); I, the Lord speaks to John (f. 4); PC (f. 4v); P, Presentation in the Temple (f. 5v); I, Flagellation of Christ (f. 6); INM (f. 13v); IR (f. 14v); SI (f. 15v); I, standing Augustine with book (f. 16v); I, combat of the Archangel Michael with the dragon (f. 17v); I (f. 18); I (f. 18v); I (f. 19); I (f. 19v); I (f. 20v); I (f. 21); I (f. 22); I (f. 23).

The manuscript contains the Gospel lections for the major feast days of the year, among which are included the feast of St. Augustine (f. 19), the *Dedicatio Ecclesiae* and Octave (ff. 21–22), and Corpus Christi, the latter an addition of the 14th century (f. 23). A note on the opening folio indicates that it originally

had a precious binding incorporating relics, now lost. The front cover incorporated a representation in an unspecified material of the *Majestas Domini*, while a Cross (or more likely, the Crucifixion) appeared on the back. Among the relics listed, several concern saints with strong attachments to Alsace (Florentius, Odilia, Blasius). A second text, written in a slightly later hand (f. 23v), records the gift of the knight Henricus of Wetolsheim of a precious chalice to the twin monasteries of Augustinian Canons at Marbach-Schwarzenthann. While Porcher questions the Alsatian origin of the manuscript (*Manuscrits à peintures*, 95, No. 275), the inclusion of a pericope for Augustine, introduced by a portrait of the saint, reinforces the connection with Marbach.

The manuscript belongs to the type of lavishly illuminated *Festevangeliar* also exemplified in the region of the Upper Rhine by the Evangeliary of St. Peter in the Black Forest (Karlsruhe, Bad. Landesbibl. Cod. St. Peter perg. 7) and the Evangeliary from Speyer Cathedral (Karlsruhe, Bad. Landesbibl. Cod. Bruchsal I). The decoration consists of large painted initials and monogram combinations which have a gold and silver armature outlined in red and backed by coloured panels of blue and green. The ornamental letters display entwined foliage and an occasional upright dragon or fish. The historiated initials are for the most part single standing figures or small groups of two or three personages miming the letter I (*In illo tempore*) of many pericopes. J. Walter cites in connection with the Presentation in the Temple (f. 5v) a stylistically related rendering of the same subject in an Alsatian *libellus precum* of unknown provenance (Sélestat, Bibl. Hum. MS 104 [ex. MS 75]). The style of the Evangeliary suggests a date not too far removed in time from the painted parchment strip with scenes of the life of John the Baptist in the British Library from the workshop of the *Hortus Deliciarum* (no. 151).

PROVENANCE: Belonged at the beginning of the 13th century to the Augustinian Canons of Marbach-Schwarzenthann (f. 23v). Cathedral Chapter of Laon(?).

LITERATURE: E. Fleury, *Les Manuscrits à miniatures de la Bibliothèque de Laon*, Laon, 1893, I, 110–17: M. Houssart, *Catalogue général*, XLI, 1903, 394; L.-M. Michon, *Bulletin de la Société Nationale des Antiquaires de France*, 1929, 205–6; J. Walter, 'L'Évangéliaire de Marbach-Schwarzenthann de la fin du XIIe siècle (Cod. Laudun. 550)', *Archives alsaciennes de l'art*, IX, 1930, 1–20; E. J. Beer in F. A. Schmitt, ed., *Das Evangelistar aus St. Peter. Eine spätromanische Bilderhandschrift der Badischen Landesbibliothek Karlsruhe*, Basel, 1961, 40–41, 45; G. Cames, 'Les grands ateliers d'enluminure à l'époque romane', *Cahiers de l'art médiéval*, V, fasc. 1, 1967, 7; id., *L'enluminure et le livre en Alsace, VIIIe-XVIe siècles*, 57; id.,'L'iconographie de la Vision dans l'Évangéliaire de Marbach-Schwarzenthann à Laon', *L'information à l'histoire de l'art*, XV, 1970, 8–15; id., 'Un nouveau fleuron de l'enluminure romane en Alsace: L'Évangélistaire de Saint-Pierre, perg. 7, à Karlsruhe', *Cahiers alsaciens d'archéologie et d'histoire*, XV, 1971, 43–72 and *passim*; W. Reinhardt, 'Eine Handschrift des 12. Jahrhunderts in der Basler Universitätsbibliothek, die Buchmalerei des elsässischen Klosters Marbach und eine Scheibe aus dem Strassburger Münster', *Basler Zeitschrift für Geschichte und Altertumskunde*, LXXVII, 1977, 5–21; G. Cames, *Dix siècles d'enluminure en Alsace*, n.p., 1989, 182.

EXHIBITED: *Manuscrits à peintures*, Paris, 1954, 95, No. 275; *La Mémoire des siècles*, Strasbourg, 1988, 209–11, No. 12.

INDEXES

Scenes of Creation. Paris, Bibl. Nat. lat. 8823, f. 1 (cat. 82)

INDEX OF MANUSCRIPTS

Manuscripts are listed according to their present location. Those included in the Catalogue are referred to by their respective catalogue numbers. All other references are to page numbers in Volumes **I** *and* **II**, *followed by illustration references in italics.*

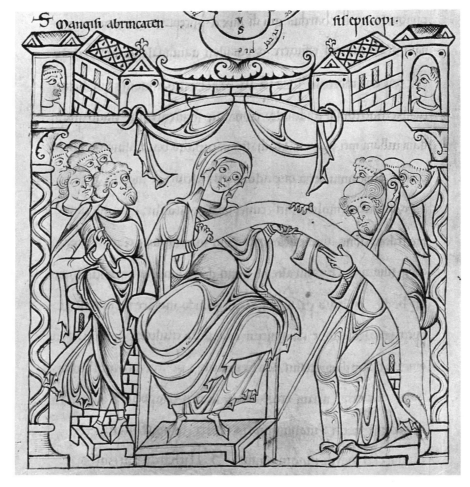

Donation of Gonnor. Avranches, Bibl. Mun. E. Le Héricher 210, f. 23v (cat. 22)

TYPES OF BOOK

PLACES OF ORIGIN

ICONOGRAPHICAL INDEX

This index is divided into five main sections. Subjects are arranged alphabetically, with the exception of CHRIST *under the heading* NEW TESTAMENT *where subjects follow the order of events of the Gospels; and* PAUL *under the heading* SAINTS *where references to his Epistles follow the New Testament order. All references are to catalogue numbers followed by illustrations numbers in italics.*

1. OLD TESTAMENT

2. NEW TESTAMENT

3. SAINTS

Philaeas no. 95
Philibertus no. 61
Philip no. 138
 with Christ no. 79
Polycarp no. 138
Polychronius no. 95
Polyeuctus no. 95
Pontius no. 95
Privatus no. 95
Processus and Martinianus no. 3; *1*
Quentin no. 138
 scenes of the life of no. 94; *230-33*
Radegund no. 61
Remigius no. 138
Reolus no. 126
Rictrudis no. 108
Romanus no. 95
Sabina no. 95
Scholastica no. 138
Sebastian no. 141
 martyrdom of no. 138
Servatius no. 138
Silvius no. 95
Simeon no. 95
Sosius no. 95
Stephen nos. 129, 138, 152
 stoning of nos. 38, 95, 120, 141; *84*
Symphorianus no. 61
Taurinus no. 61; *148*
Telesphorus no. 95
Thaddeus no. 138
Thomas of Canterbury, murder of nos. 136, 138; *326*
Ursacius no. 95
Valerius no. 145
Victoricus no. 105; *250*
Victorinus no. 95
Vincent nos. 3, 145
 martyrdom of no. 138
Vindicianus no. 126
Vitalis, martyrdom of no. 148
Winnoc nos. 102, 138; *252*

4. HISTORY AND GEOGRAPHY

Alexander on Bucephalus nos. 96, 117; *281*
Alexander III, Pope no. 124
Alvisius, Bishop of Arras no. 124
Ambrannus of Vierzon no. 6; *6*
Ananus and Jesus, beheading of no. 130
Andrew, Bishop of Arras no. 124
Andrew, Abbot of Vierzon no. 6
Aristobulus and Hyrcanus, battles of no. 130
Asinarius, Abbot of Vierzon no. 6
Aubertus, Bishop of Avranches no. 22; *43*
Augustus, Emperor no. 96
 sends Cyrenius to Syria no. 130
Baldwin, Bishop of Noyon no. 124
Baldwin, Count of Hainaut no. 124
Baldwin II, Count of Flanders no. 124; *293*
Baudemundus no. 126; *301, 302*
Benedict, Pope no. 145
Berengarius, Abbot of Vierzon no. 6
Boethius no. 128; *305*
Bruno, Archbishop of Cologne no. 145
Buchardus, Bishop of Cambrai no. 124
Caius, killing of no. 130
Cassiodorus no. 88; *212*
Calixtus II, Pope nos. 6, 24, 124; *292, 360*
Charlemagne, dream of no. 24; *56*
 his army sets out from Aachen no. 24; *54*
Charles the Bald nos. 6, 124

Charles, Count of Flanders no. 124
Christianus, Abbot of Vierzon no. 6
Chromatius and Heliodorus nos. 43, 44, 54, 64
Claudius, Jewish rebels led to execution on his orders no.
 130
Cluny, Dedication of Abbey Church no. 93; *227*
Constabulus, Abbot of Vierzon no. 6
Constantine, Donation of no. 96
Drogo, monk of Bergues no. 104
Eugenius III, Pope no. 124
Europe, map of no. 96
Eusebius of Caesarea no. 21
Eustathius no. 107
Geoffrey, Abbot of Vendôme no. 14
Gerald, Bishop of Cambrai no. 124
Gerard, Bishop of Toul no. 145
Gerungo, Provost of Marbach no. 146; *360*
Gilbert de la Porrée no. 128; *304, 305*
Gomez, scribe no. 57; *132*
Gonnor, Duchess of Normandy no. 22; *fig. II: p. 192*
Gotiscalc, Bishop of Arras no. 124
Gotiscalc, Bishop of Le Puy no. 57; *132*
Gratian no. 21
 Decretum, illustrations of no. 88
Gunzo, Abbot of Baume
 beholds Saints Peter, Paul and Stephen no. 93
 in dialogue with Hugh, Abbot of Cluny no. 93
Guta, scribe no. 146; *362*
Hadrian IV, Pope no. 6
Harding, Stephen, Abbot of Cîteaux no. 104
Henry, Abbot of Saint-Vaast, Arras no. 104
Henry, Archbishop of Trier no. 145
Henry of Huntingdon no. 21
Herbert of Bosham no. 88; *211*
Heribertus, Archbishop of Cologne no. 145
Hugh of Saint-Calais, Bishop of Le Mans no. 23; *45*
Jerusalem, map of no. 138; *col. pl. XVI*
 siege of no. 130
John, Abbot of Mont Saint-Blandin no. 126
John, Pope no. 145
Josephus no. 30
Lambert, Abbot of Saint-Omer no. 100; *245*
Lambert, canon of Saint-Omer no. 96; *238*
Leander, Bishop of Seville no. 13
Lothar no. 124
Louis the Pious no. 133; *323*
Lucian, priest no. 129
Martin, Abbot of Vierzon no. 6
Milo, Bishop of Thérouanne no. 124
Nero invests Vespasian with power in Judea no. 130
Nevelo, monk of Corbie, presents his book to St. Peter
 no. 95; *234*
 humbles himself before St. Benedict no. 95
Nicholas, Bishop of Cambrai no. 124
Nicholas of Amiens no. 128
Notker, Bishop of Liège no. 145
Odo, Abbot of Vierzon no. 6
Oisbertus no. 104; *251*
Oliverus, illuminator no. 133
Peter the Venerable no. 93; *226*
Philip, Count of Flanders no. 124
Rabanus Maurus no. 133
 De Laudibus sanctae crucis no. 133; *324*
Radulfus, Count of Vermandois no. 124
Raimbertus no. 94
Raimundus, Abbot of Vierzon no. 6
Rainaldus, scribe no. 133
Richard I, Duke of Normandy no. 22
Richard II, Duke of Normandy no. 22; *44*
Richer, Abbot of Saint-Martin and Saint-Symphorien,
 Metz nos. 144; *55*
Robert, healing of no. 93

5. LITERATURE, MYTHOLOGY AND SCIENCE

GENERAL INDEX

References are to page numbers in Volumes I and II.
For references to manuscripts catalogued or mentioned, see Index of Manuscripts.

List of Illustrations

Erratum

An error has unfortunately occurred in Illustration 352: instead of showing The Foolish Virgins on f. 18v, as captioned, it is f. 18 of Berlin, Staatliche Museen, Preussischer Kulturbesitz, Kupferstichkabinett, MS 78 A 4, that is reproduced depicting The Wise Virgins receiving the Heavenly Bridegroom. The same subject is illustrated in colour on Plate XII, and f. 18v has regretfully been omitted.

COLOUR PLATES

TEXT ILLUSTRATIONS

VOLUME TWO

Contents of Volume One

Photo Credits

The majority of illustrations in this publication was reproduced from material kindly provided by the Author, among which the following were from photographic agencies and archives: ACL, Brussels, ills. 320, 321; Bulloz, Paris, fig. 6; Giraudon, Paris, ills. 15, 16, 18, 33, 35, 43, 97, 98, 113, 115, 116, 133, 134, 160, 241-244, 254, 270-272, 275, 282, 287, 288, 294, 300-303, 305, 325, 333, figs. pp.12, 192 in Vol.II; Foto Marburg, fig. 9, ills. 2-5, 13, 14, 20, 21, 52, 53, 120-123, 173, 191, 194, 196-200, 203, 204, 206, 221, 247, 248, 251, 351, 368, 369; Rheinisches Bildarchiv, Cologne, ills. 184-187, 278-280. Other photographs were acquired from libraries, collections and institutions, as acknowledged. The Conway Library, Courtauld Institute of Art, London, provided photos for ills. 104, 161, 211-214, 255, 257, 259, 289, 290, 322, 323, 341, 346.